Photography at the Worcester Art Museum KEEPING SHADOWS

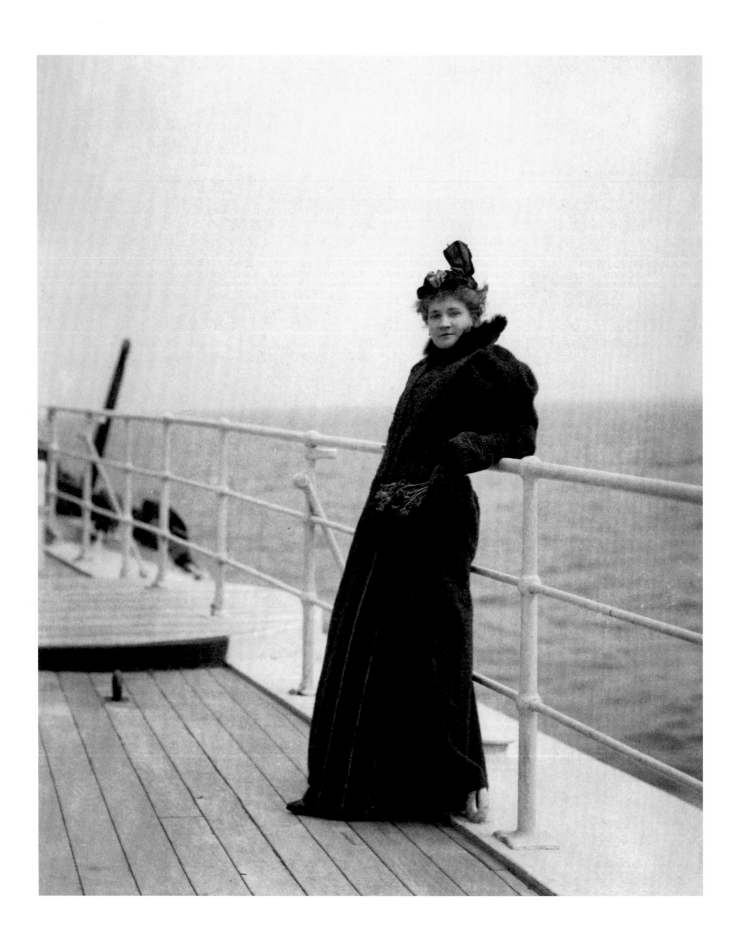

Photography at the Worcester Art Museum
KEEPING SHADOWS

David Acton

with contributions by

Stephen B. Jareckie

Ben Charland

Worcester Art Museum

in association with Snoeck Publishers

Worcester Art Museum
Worcester, Massachusetts
October 10, 2004 – January 2, 2005

The Orlando Museum of Art
Orlando, Florida
March 6 – May 22, 2005

Mary and Leigh Block Museum of Art
Northwestern University
Evanston, Illinois
September 22 – December 10, 2006

*Photography at the Worcester Art Museum:
Keeping Shadows*
was organized by the Worcester Art Museum,
Worcester, Massachusetts

Front, softcover: Charles Sheeler, *Zinnia and
Nasturtium Leaves*, 1915, gelatin silver print,
24.4 x 19.6 cm. Anonymous gift, 1977.144.

Front, hardcover: Karl Struss, *Nude*, about
1916, palladium silver print, 21.5 x 16.2 cm.
Sarah C. Garver Fund, 1999.19.

Endpapers: NASA (Jet Propulsion Laboratory),
Europa Near Jupiter's Great Red Spot, 1979,
dye coupler print from digital source,
32.5 x 49.7 cm. Gift of Michael Benson,
2004.10.

Frontispiece: Alfred Stieglitz, *Outward Bound*
(Lotte Linthicum on the Burgogne), about
1894, platinum print, 18.6 x 15.3 cm.
Eliza S. Paine Fund, 2003.117.

Back cover: Todd Webb, *Studio Stove, Paris*,
1952, gelatin silver print, 63.6 x 48.2 cm.
Museum purchase, 1962.82.

FIRST EDITION

Copyright © 2004 Worcester Art Museum
55 Salisbury Street
Worcester, Massachusetts 01609

All rights reserved. No part of this book may
be reproduced, stored in a retrieval system,
or transmitted in any form, or by other means,
electronic or otherwise, without the prior
written permission of the publisher.

Library of Congress Control Number:
2004096907
ISBN: 0-936042-10-9, softcover

Snoeck Publishers
Noordstraat 30
B-9000 Ghent

ISBN: 90-5349-508-8, hardcover
Legal deposit: D/2004/0012/26

Contents

Foreword

Photography has been a ubiquitous and popular feature of the Worcester Art Museum for as long as most can remember. The rich collection and compelling exhibitions are so well integrated that we have come to take them for granted among the many achievements of a dynamic institution. When we decided to celebrate the centennial of the photography program with a review of our collection and its history, it came as a delightful surprise to discover the distinction of this long-admired program. The Worcester Art Museum began exhibiting photographs as works of art very early in its history, even before the arrival of a professional staff. Indeed, it was the Museum's founding trustees who first embraced the creative possibilities of photography. These individuals presided over a booming industrial city at the turn of the century, a group that included technologically minded businessmen, physicians, and academic scientists. They inaugurated a series of exhibitions at the Worcester Art Museum that combined the amateur work of their neighbors with those of the finest creative photographers in the country, at a time when photography was only beginning its struggle for recognition as a legitimate art form. We have discovered, with the perspective of history, that the fortunes of the photography program have ebbed through the Museum's history, often in reaction to the change of directors. When, in 1962, the Museum finally committed itself to a permanent photography program, it received guidance from the country's leading curators and advisors, strove to exhibit and acquire the work of the finest creative photographers of the day, and began a collection of historical material as well.

All of these memories and facts had been lost in the shadows of history, and in the archival files of the Museum and the City of Worcester. These records make an intriguing parallel to the images themselves, composed of shadows and light, captured in an instant inside a camera, and printed on paper as an enduring record. In England, what we call a curator is known as a "Keeper." It is a good, direct term, for the essence of our profession is to keep the works of art safe and sound, for now and for perpetuity. We keep these precious shadows of lives gone by, of imagination and experience, in the mats and boxes and climate-controlled vaults so that we can all appreciate and enjoy them, and pass along their magic to future viewers. The process of bringing the photographs into the light from their secure storage, like the process of bringing to light the facts of our history from old archival files and newspaper accounts, is in a sense parallel to the function of a great museum. For this project that celebrates the Museum's one hundred years in photography, we are grateful to three scholars who span three generations. This exhibition underscores the distinguished career of our curator of photography emeritus, Stephen B. Jareckie, whose thirty years' work in building the Museum's photography collection is amply reflected in its magnificence, its record of distinguished exhibitions, and in these pages. We are grateful to David Acton, curator of prints, drawings, and photographs, who has overseen the photography collection since Mr. Jareckie's retirement in 1994, and has spearheaded this centennial exhibition and accompanying catalogue. His vision and enthusiasm for this major undertaking have been key to its success, bringing greater attention to the Museum's long commitment to one of the most significant of modern media. We would also like to acknowledge Dr. Acton's assistant, Ben Charland, who has been invaluable to the project, and we extend special thanks to many other members of the Museum staff who have contributed to the show, the catalogue, and the related programs.

This exhibition and catalogue were made possible by our corporate sponsors, FLEXcon Company, Inc., and National Grid. We are also grateful to the Richard A. Heald Fund, the Hall and Kate Peterson Fund, the Horace W. Goldsmith Foundation, and the Worcester *Telegram and Gazette*. Finally, we wish to express particular thanks to Richard Sergel and Susan Baggett, and Myles and Jean McDonough, for their generous support of the project and their ongoing commitment to the Museum.

JAMES A. WELU
Director, Worcester Art Museum

Acknowledgments

In many ways, the igniting spark of this project was the enthusiasm of Edward Osowski, a Worcester native son and astute collector of photographs, whose affection for his hometown Museum, its history and accomplishments, and his generous gifts and encouragement helped make this project a reality. A book and exhibition of this scope is not possible without the efforts and support of many colleagues at the Worcester Art Museum. Director James A. Welu has been enthusiastic about the project from its inception; Martin Richman and Kathleen Corcoran helped to arrange project funding; Debby Aframe of the Worcester Art Museum library was most helpful at every stage of research; paper conservator Alison Luxner treated the photographs and assisted Mellon fellow Philip Klausmeyer in scientific analysis of their media. The logistics of the traveling exhibition have been expertly managed by registrar Deborah Diemente; Patrick Brown designed and executed the exhibition installation with the assistance of John Hyden and Jason Ram; Anne Greene prepared the photographs for exhibition and prepared labels; the catalogue photography was done by Steven Briggs; and Selina Bartlett assisted with coordination of photographic materials. Curatorial department volunteers Julia McCandless, Joyce Sitterly, and Rebecca Niemiec aided the project as research assistants, as did Natasha Pavlova who also provided translations. Certainly most tireless of all has been Ben Charland, my curatorial assistant who made important contributions to literally every phase in the preparation of this book, the exhibition it accompanies, and ongoing management of the Museum's photography collection. I am also grateful to Stephen B. Jareckie, curator of photography emeritus, an instructive and delightful colleague for nearly two decades, who has always generously shared his vast knowledge of photographic history and an astounding institutional memory, helping to make the project an exciting adventure.

I owe a debt of gratitude to many of the photographers discussed herein, and their families and colleagues, for happily providing information, insights, comparative and study images, and rights of reproduction. For their efforts, information, and encouragement, I also wish to thank Chris Baer of the Hagley Museum and Library; Georgia B. Barnhill and Dennis R. Laurie of the American Antiquarian Society; Michael Benson; Verna Posever Curtis of the Library of Congress; Diane Denner; Nancy Gaudette of the Worcester Public Library; Anne Havinga of the Museum of Fine Arts, Boston; Charles Isaacs and Carol Nigro; Michael G. Kraus; Marilyn Kushner of the Brooklyn Museum of Art; George Labonte of the Worcester *Telegram and Gazette*; Leslie Laufer of the Peabody Essex Museum; Mack Lee; Sally Pierce of the Boston Athenaeum; Creilly Pollack; Michael Sakkalli of SDZ; Taran Schindler of the Beinecke Rare Book Library at Yale University; Aaron Schmidt of the Boston Public Library; Michael Sherbon of the Pennsylvania State Archives; James Stroud of Center Street Studio; Lesley Van Breen and Randall Perkins of Hudson Hills Press; William D. Wallace and Robyn L. Christensen of the Worcester Historical Museum; Rosalind Waters of the Princeton Historical Society; and Jay Williamson of the Newburyport Historical Society. The catalogue was edited with care and diligence by Denise Bergman, its elegant design was created by Susan Marsh, and once again I owe deep gratitude to these faithful collaborators.

DAVID ACTON

Creative Photography at the Worcester Art Museum

STEPHEN B. JARECKIE

At the end of the nineteenth century, as photography evolved from a documentary medium to a creative endeavor in the United States, the City of Worcester witnessed the changes with interest. From its foundation, the Worcester Art Museum played an important role in the process. The institution progressed, in phases, from supportive host, to a leader in the collecting, presentation, and interpretation of creative photography in New England.

Professionals dominated the first generation of photographers in the United States, craftspeople such as Albert Sands Southworth and Josiah J. Hawes in Boston, Mathew Brady in New York and Washington (no. 33), and Carleton E. Watkins in San Francisco (no. 37). Aside from possessing artistic talent, they knew chemistry and were able to master complex technical procedures. Amateur photographers proliferated during the 1880s, a watershed era in American photography. Convenient materials became commercially available and simplified methods made the practice more accessible. In 1880, George Eastman of Rochester, New York, started manufacturing DRY PLATES that were ready for EXPOSURE, and did not require immediate developing. Also in that year, the Platinotype Company in England began the production of ready-sensitized PLATINUM printing paper, which amateurs favored for its broad, aesthetically pleasing tonal range. Ready-to-use gelatin-base BROMIDE paper also came on the market, soon to supplant ALBUMEN printing paper. The early 1880s saw the introduction of detective cameras, small instruments that could be hidden, which utilized dry-plates and elementary SHUTTERS. Eastman capped the decade by introducing his roll film camera in 1888, coining the word "Kodak" for the hand-held camera that attracted a vast amateur market.

As photography became more popular, camera clubs formed along the eastern seaboard. Among the first was the Society of Amateur Photographers of New York, which convened its inaugural meeting on November 28, 1884.[1] The record book of the Worcester Camera Club, which is now in the American Antiquarian Society, documents an "informal meeting" on October 9, 1885, when it was decided that an organization be formed and that Dr. George E. Francis, Dr. E. V. Scribner, and Miss Hattie Clark would make up a committee to write bylaws.[2] They stipulated that anyone interested in amateur photography could become a member upon a two-thirds vote of the membership. Annual dues were set at one dollar for members and fifty cents for juniors under eighteen. Meetings were to be held on the second Thursday of each month, and during the 1880s they took place at the Natural History Society at 11 Foster Street in downtown Worcester. The bylaws were adopted at the meeting on October 16, 1885, when it was noted that the Providence Amateur Club, a sister organization, was in "flourishing condition."[3] The minutes for the club's meeting on December 10, 1885, record: "Mr. Thurston of the Boston Society of Amateurs was introduced. He has a collection of work by leading amateurs — mostly landscapes."[4] The Worcester Camera Club arranged exhibitions for members in the Natural History Society rooms, sponsored critiques, and subscribed to the *American Journal of Photography* and similar magazines for members' perusal. The Club also introduced members to technical advances, like magnesium lighting and new printing papers. In the minutes of the Club's meeting on October 11, 1888, Paul B. Morgan

Fig. 1. *Worcester Art Museum,* 1898.

recorded: "After general business Mr. C. A. Boyden exhibited the 'Kodack [sic] camera,' showing the details of its construction & also showing NEGATIVES taken with it."[5]

Dr. George E. Francis was the Worcester Camera Club's first president.[6] Members signed a register when they joined, revealing them to be a cross-section of Worcester society, including physicians, businessmen, teachers, housewives, and students. Between 1885 and 1889, approximately sixty people inscribed the club register.[7] Several club members later played important roles at the Worcester Art Museum (fig. 1).[8] The Reverend Austin S. Garver, a founding club member, exhibited his work in the Worcester Art Museum's first *Exhibition of Photographs* in 1904. He served as president of the Worcester Art Museum from 1913 to 1918. Paul B. Morgan joined the club as a junior member and was elected club secretary in 1889.[9] He became a leading industrialist, president of Morgan Construction Company from 1911 to 1941, and also served as president of the Worcester Art Museum from 1939 to 1946. Jeanie Lee Southwick, a graduate of the Boston Art Museum School, was a camera club member when she was named supervisor of drawing in the Worcester Public Schools. A noted watercolorist and world traveler, she served the Worcester Art Museum on the Committee of Instruction and as a corporator from 1905 to 1943.

In 1904, only six years after the Worcester Art Museum first opened its doors, local enthusiasm for amateur photography encouraged the fledgling institution to mount its first photography exhibition. The Museum *Annual Report* for 1905 states: "Four hundred and fifty photographs, by thirty-four amateurs, mostly from Worcester, were shown in the east gallery."[10] Among the exhibitors were Reverend Garver, Louis Fabian Bachrach, Lyford J. Chancey, Langdon B. Wheaton, Dwight Davis, Stephen C. Earle (nos. 70, 54), and C. F. Darling (fig. 2).[11] A major contributor to the 1904 exhibition was Frederick Haven Pratt (no. 66), who showed eighty-one photographs (fig. 3).[12] The son of Frederick Sumner Pratt, a Worcester Art Museum director (trustee), he seems to have taken a leading role in staging the exhibition. Pratt had allied himself to Alfred Stieglitz (no. 62) in the style of PICTORIALISM, and in the fight for the recognition of photography as a fine art.[13] Prior to this time, American salons took place outside museums, with the notable exception of the Philadelphia Photographic Salon, which opened at the Pennsylvania Academy of the Fine Arts on October 24, 1898. When the Worcester Art Museum put itself at the forefront of American museums in its recognition of photography, the institution was run by a board of directors — later called trustees — drawn from the community, with John G. Heywood serving as manager.

The *Second Annual Exhibition of Photographs* in

Fig. 2. C. F. Darling, *Man in a Row Boat*, about 1900, platinum print.

1905 drew far beyond the city to bring important creative work to Worcester. "The photograph exhibition includes some of the best amateur work in the country . . . ," the *Worcester Sunday Telegram* reported. "Great skill is shown in the mountings of some of the pictures, and in every respect the exhibit promises to be one of great interest to all."[14] The newspaper itemized the 163 Worcester entries accepted by a jury, each member of which "has been a photographer at one time or another, and several of them are today among the best amateur photographers in Worcester."[15] The catalogue reveals that the organizers secured individual loans from twenty-one nationally known Pictorialists, such as Clarence H. White of Newark, Ohio (no. 65), Herbert G. French of Cincinnati, and Mary R. and Katharine S. Stanbery of Zanesville, Ohio. The exhibition also had sizeable loans from F. Holland Day and Alfred Stieglitz (nos. 64, 62), then the two masters of American creative photography, who competed for leadership of the Pictorialist movement. Several of the works shown have come to be regarded as masterpieces of photography. Frederick H. Evans's (no. 61) *Wells Cathedral: "The Sea of Steps"* is the most famous photograph by England's leading Pictorialist, who raised his subject from documentary observation to a spiritual level. Mrs. Agnes Lee, a Boston collector and Day's close friend, loaned the work of eight photographers to the exhibition, including "*Blessed Art Thou Among Women,*" Gertrude Käsebier's (no. 67) most celebrated image, a portrait of Lee and her daughter Peggy.

Secession was in the air at the turn of the twentieth century. In 1892 German painters, who looked to French Barbizon and Realist artists in their preference for naturalistic landscapes and portraits as

Fig. 3. Frederick Haven Pratt, *Landscape*, from *Camera Work*, 1914, photogravure.

subjects, formed the Munich Secession in opposition to academicians who concentrated on traditional history painting. Also in that year, a group of creative photographers in England had broken away from the conservative Photographic Society of Great Britain — which changed its name when it won Royal sponsorship in 1894 — to form the Brotherhood of the Linked Ring. The "Links" established the London Salon, which held international importance until World War I. The Secession spirit spread to Vienna in 1897 and to Berlin in 1899, where Max Lieberman led a group of painters in a break from the Union of Berlin Painters.

So it was reasonable that in 1902, Stieglitz, who had studied in Germany and who maintained connections in England, should form the Photo-Secession in New York.[16] Leadership of the Camera Club of New York shifted at that time, and he found himself at odds with the new officers, who were unsympathetic to the ideals of the English naturalist photographer Peter Henry Emerson (no. 51) to which Stieglitz had allegiance. He resigned from his post as editor of the club magazine, *Camera Notes*, and went on to establish a competing organization. The Photo-Secession mounted its first group exhibition, titled *American Pictorial Photography*, at the National Arts Club in New York in March 1902. Before the year was over, Stieglitz founded *Camera Work*, a groundbreaking periodical that ran through fifty numbers to 1917, providing readers with news and critical essays on what was to become known as modern art. Superbly printed PHOTOGRAVURES reproducing work by Photo-Secessionists were bound into each issue.

Compelled by rivalry among American Pictorialists, Stieglitz established a permanent exhibition space for the Photo-Secession in 1905. With the aid

of Edward Steichen, he secured space on the top floor of 291 Fifth Avenue where he opened the "Little Galleries of the Photo-Secession." Stieglitz was in the midst of preparing for the gallery's first exhibition when Frederick Haven Pratt — a newly elected Photo-Secession member — approached him for loans to Worcester's *Second Annual Exhibition of Photographs*. "Gentlemen:" Stieglitz wrote to the Museum, "At the urgent request of Mr. F. H. Pratt I am shipping you to-day a small Collection of Photo-Secession Prints for your exhibition. It is the very best I can do for you with available material now on hand, but I trust it will help you in making the show a success. . . . This Collection should be hung as a unit. Kindly send Catalogues for above exhibition to me."[17] Among the Photo-Secession loans were a dozen photographs by Steichen, including his portraits *Rodin — Le Penseur* and *J. Pierpont Morgan*. Clarence H. White was represented by six photographs, including *The Orchard*, in which ladies gather apples in an idyllic country setting. Stieglitz sent four of his own pictures, including *Going to the Post*, the scene at a popular New York City racetrack, with riders rounding the bend before stands crowded with elegant ladies and gentlemen of the leisured class.

Though he was unable to obtain another Photo-Secession loan in 1906, Heywood borrowed photographs by twenty-one artists from outside Worcester to supplement the work of local contributors.[18] Day (no. 64) submitted loans, as did the Boston Photo-Secessionist Herbert A. Hess. An extensive group came from Wilfred A. French, the Boston publisher of *Photo-Era* magazine, including ten portraits of Native Americans by Edward S. Curtis (no. 58). French sent work by fourteen other photographers, including Boston portraitist John H. Garo — a Worcester native who later became Yousuf Karsh's teacher — and the New York Pictorialist Rudolf Eickemeyer, Jr. The *Third Annual* also featured a series of eighty-four photogravures, *Hamburgische Männer und Frauen am Anfang des XX. Jahrhunderts (Hamburg Men and Women at the Beginning of the Twentieth Century)*, by the German photographer Rudolph Dührkoop, a leading portraitist in Hamburg, where important amateur photographic exhibitions had been held since 1893.

The *Fourth Annual Exhibition* included 339 selected entries, again a large show by current standards. "People seem to be beginning to grasp the idea," wrote a critic in the *Worcester Sunday Telegram* on November 3, 1907, "that one must have a knowledge of composition, as well as of light and shade, for the foundation of any photograph which is to pose as a work of art, even in the humblest manner." The reviewer noted the work of local photographers and selected the images of George Seeley (no. 71) for criticism. Nevertheless, Seeley enjoyed a national reputation for his evoca-

Fig. 4. Arthur Wesley Dow, *Poppies*, about 1895, cyanotype.

and the Wyoming Valley Camera Club in Wilkes-Barre, Pennsylvania. Wilfred A. French, of *Photo-Era* magazine, loaned an international group of photographs, including works by Scottish, Swiss, and German Pictorialists. There were fourteen subjects by Dührkoop in the show, as well as five portraits by Nicola Perscheid of Berlin. Nevertheless, a review in the *Telegram*, on October 31, 1909, singled out work by William B. Post, one of the best-known of four Photo-Secessionists in the show: "*Summer* is one of those typical country scenes, a little pond with smooth surface, covered with lily pads and flowers, and at the back a farmhouse in the trees, which everyone who sees, remarks on and says 'How pretty.'"

For the *Sixth Annual Exhibition*, organizers once again combined the work of local amateurs, a handful of European photographers, and loans from the Department of Photography, Brooklyn Institute of Arts and Sciences, the Chicago Camera Club, the Jamestown (New York) Camera Club, and the Wyoming Valley Camera Club. "A Collection of Colored Plates" by Helen Messinger Murdoch of Boston, including views of the Grand Canyon, were exhibited in the Museum's reception-room windows on the first floor. These photographs were very likely AUTOCHROMES, color transparencies made by a process patented by the Lumière Brothers in France (see no. 71). The *Telegram* reported on November 5, 1909, that Professor Arthur Wesley Dow (no. 50) of the Columbia University Teachers College had spoken at the Museum the previous evening on "design as applied to architecture, painting, and sculpture." The influential artist and teacher, who once studied in Worcester, taught in New York and in his hometown of Ipswich, Massachusetts, on the North Shore, where he also experimented with photography (fig. 4).[19] Among his students were the Photo-Secessionists Gertrude Käsebier and Alvin Langdon Coburn (nos. 67, 63). However, Dow's most important contribution to the acceptance of creative photography had come in 1907, when he hired Clarence H. White (no. 65) to teach photography at Columbia.

The *Sixth Annual* proved to be the last in the series. Its end may have been decreed by Philip J. Gentner, who became the Museum's director in November 1908. Gentner was oriented to Old Master painting, having studied at Harvard University with Bernard Berenson and having been a Fellow in Medieval and Renaissance Art in the American School of Classical Studies in Rome. Though he oversaw the *Sixth Annual Exhibition of Photographs* in his first year in Worcester, he followed it with the *Exhibition of Paintings by Eduard J. Steichen* that ignored the artist's photographs.[20] Also during Gentner's tenure the Worcester Art Museum's annual painting exhibitions — which had attracted

tive figural reveries in the western Massachusetts countryside, and Stieglitz had reproduced two of his images in *Camera Work* in 1906. The work of East Coast Pictorialists was balanced in the *Fourth Annual* by masters of the style from the Pacific Coast, including thirty-one photographs by thirteen artists, Edward S. Curtis (no. 58) and Annie W. Brigman the most prominent among them. Brigman, a Photo-Secessionist, sent *The Lone Pine*, a depiction of a nude female figure embracing a gnarled, wind-driven pine on a high mountainside.

In its review of the *Fifth Annual Exhibition of Photographs* on November 8, 1908, the *Worcester Daily Telegram* noted that fifteen local photographers exhibited seventy-four prints. "Louis Fabian Bachrach is the only commercial photographer who exhibits. The others are what may be called amateurs from the standpoint of the professional photographer, but much of their work is as skillful as that of the professional and in many cases vastly more interesting. Each class works with a different end in view." The sisters Frances S. and Mary Allen of Deerfield, Massachusetts, each exhibited six photographs. Trained as schoolteachers, both were self-taught as photographers; they worked in collaboration and individually to create domestic scenes and rural landscapes that recall old-time New England. The *Fifth Annual* exhibition also featured group loans from three camera clubs: the Old Cambridge Photographic Club in Cambridge, Massachusetts, the Photo-Pictorialists in Buffalo,

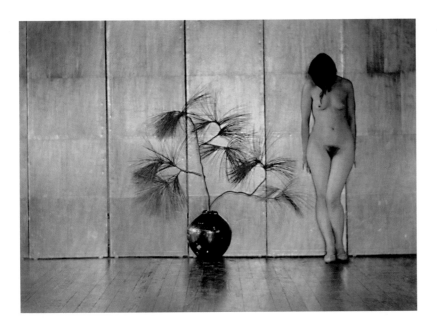

Fig. 5. Edward Weston, *In a Glendale Studio*, 1923, platinum print.

the work of such artists as Frank Benson, Willard Metcalf, and Edmund Tarbell — would end in 1912. Rather than presenting exhibitions, the director concentrated on building the collection. After the death of Stephen Salisbury III, the Museum's founder and chief benefactor, and the transfer in 1907 of his family collection and considerable financial assets, the institution had the means to pursue major acquisitions. Indeed, it was one of the richest museums in the country. Among Gentner's outstanding purchases were *The Fur Jacket* by James McNeill Whistler, *Water Lilies* by Claude Monet, and *Portrait of the Artist's Daughters* by Thomas Gainsborough. When Gentner left the Museum in 1917, trustee Frederick Sumner Pratt served as acting director. During his brief superintendence, Pratt — father of the photographer Frederick Haven Pratt (no. 66) — oversaw presentation of an *Exhibition of Work by Pictorial Photographers of America* in December 1917. The Pictorial Photographers of America was founded only months before by Clarence H. White, Gertrude Käsebier, and Karl Struss (nos. 65, 67, 69) following their break from Stieglitz's Photo-Secession. A more inclusive group, the organization intended to promote Pictorialist photography to a nationwide audience. Among the exhibitors in the show was Edward Weston (no. 82, fig.5), who then worked in the fashionable soft-focus style.[21]

Raymond Wyer "comes to us well qualified for the position by successful experience," stated the 1918 Worcester Art Museum *Annual Report*, "as well as by trained habits of the scholar and art critic." It was Wyer (who later changed his name to Henniker-Heaton) who, as director, introduced modern art to Worcester by exhibiting works by the Société Anonyme in 1921. The Worcester showing was arranged by Katherine Dreier of New York, who circulated the Société Anonyme exhibitions to

American museums and championed modern art on the lecture circuit. Prominent among the forty-one artists whose works were featured in the Worcester show was Man Ray (no. 94), a painter, sculptor, and photographer. It was he who had named the venture *The Société Anonyme, Inc.: Museum of Modern Art*. Dreier explained Man Ray's jest: "'Société Anonyme' is also the French for 'incorporated' and as we incorporated, we became incorporated incorporated."[22] Later, Henniker-Heaton organized an exhibition of works from *The Dial*, contemporary art owned by Worcester native Scofield Thayer, editor of the avant-garde literary magazine. Visitors saw modern masterpieces in American and French art, including works by Henri Matisse and Pablo Picasso. "It is my opinion," Henniker-Heaton wrote in his 1924 Director's Report, "that in transient collections of present-day art we can be constructive if our ideas are based on a belief in the best traditions of the past, a confidence in the present, and a fearless anticipation of the future." This was also a healthy time for amateur photography in America, when Pictorialism continued its widespread popularity, hobby magazines flourished, and manufacturers like Eastman Kodak, Ansco, and Agfa supplied amateurs with equipment and materials. Henniker-Heaton supported the presentation of photography, and in 1922 the Worcester Camera Club sponsored the *Exhibition of Photographs Selected by "American Photography"* at the Museum, 104 prize-winning prints from the magazine's Second Annual Competition, selected to show the best in pictorial photography. Of the seventy-six American and European exhibitors, only three are still recognized today: John Paul Edwards of California, Wynn Richards of Mississippi (no.119), and Karl Struss of Hollywood (no. 69).

The Worcester Photo Clan was founded in 1924, and in its first year mounted its inaugural group exhibition at the Museum. A close connection between the camera club and the Museum was fostered through Dr. Roger Kinnicutt (no. 73), a Clan founder and Museum corporator. The son of Lincoln N. Kinnicutt, a founding trustee of the Museum, Roger Kinnicutt became a trustee himself in 1925. Like Frederick Haven Pratt, a trustee's son who brought creative photography to the Museum twenty years earlier, Kinnicutt had earned a medical degree at Harvard and become a nationally recognized Pictorialist. The first Photo Clan exhibition introduced Worcester viewers to fifty-six works by eleven photographers. "Mr. Henniker-Heaton," wrote one reviewer, "tells me that more people throng to [an] exhibition of photographs than attend any other kind of show, a fact that is apparently a matter of common knowledge in the art world."[23]

When George W. Eggers (no. 86) succeeded

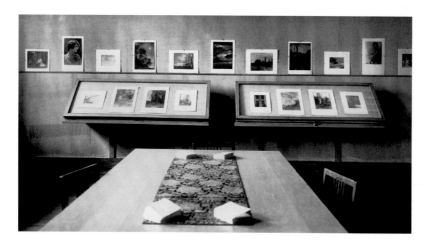

Fig. 6. *Second Annual Worcester Photo-Clan Exhibition* installation at the Worcester Art Museum, 1929.

Henniker-Heaton as director in October 1926, he continued a cordial relationship with the Photo Clan, by then the leading camera club in Central Massachusetts. Five months after his arrival, the Clan voted unanimously to make Eggers an honorary member. In April 1927 the director met with the club to discuss the Museum's current exhibition of photographs by Man Ray (no. 94). "It is by no means impossible," Eggers wrote in a catalogue for the Photo Clan's third exhibition in May 1927, "to see the art of the photographer as a more purely aesthetic process than that of the painter, unconfused as the former is by problems of representation. Perspective, anatomy and foreshortening become largely matters of a good lens, and composition and arrangement become the photographer's opportunities for the exercise of his creative genius. His picture may be freighted with sentiment, but its artistic triumph, like that of the painter is weighed in terms of pattern and design."[24] In 1929, the Photo Clan invited the Portland Camera Club in Maine to share half of its allotted space in the Museum's print room (fig. 6).[25] Two years later the Photo Clan had grown to fifteen members, who contributed seventy-five photographs to its group exhibition. Aldus C. Higgins, who served as Museum president from 1946 to 1948, was then a new member.

Francis Henry Taylor became the Worcester Art Museum's fourth director in June 1931, in the midst of construction of the Museum's major addition fronting Salisbury Street. Shortly after the new building opened on January 6, 1933, he opened *Photographs of Persian Islamic Architecture*, circulated by the American Institute for Persian Art and Archaeology. This exhibition was essentially supportive material for a show of Persian frescoes from the same lender, presenting photography as documentation, not as an art form. Nevertheless, it was Taylor who first presented motion pictures at the Worcester Art Museum, and spearheaded its pioneering film program. On January 11, 1934, the inaugural screening began with René Clair's *Le Million*, and it concluded in mid-March with the

German silent film *Berlin: The Symphony of a Great City*. This vanguard program for American museums focused on foreign, experimental, and educational films, and was ably directed by Mrs. Minnie G. Levenson, who came to the Worcester Art Museum in 1934 as secretary of school service and retired as curator of education in 1966. After the new building opened, the Photo Clan resumed its annual exhibitions, and in 1937 the club collaborated with the Museum on a major exhibition, conceived to celebrate the centenary of Louis-Jacques-Mandé Daguerre's first successful photograph. Taylor assigned the Museum's new docent, Horst W. Janson, to work with the Photo Clan in organizing the show.[26] The resulting exhibition took up four galleries and included important historical photographs. The American Antiquarian Society lent a group of fine daguerreotypes, made in Boston and Worcester during the 1840s, as well as an aerial view of Boston, taken from a balloon in 1860. Roger Kinnicutt loaned a set of portraits made in 1843 by David Octavius Hill and Robert Adamson (no. 2).[27] There was also recent work by Photo Clan members, and even photographs by Worcester high school students in the Consolidated Camera Club.[28]

"After the World War," wrote Janson in the Museum *News Bulletin and Calendar*, "a new generation of photographers did away with the 'artistic' aspirations of their predecessors. Fully recognizing the mechanical character of the camera's image, they established photography as a means of expression in its own right, ruled by principles entirely different from those of the fine arts. To present the work of these contemporaries is the main purpose of this exhibition. It is hoped that those intrigued by the problem of whether or not photography is a fine art may find in these prints the answer." There were also modern masterpieces of photography, borrowed from the Museum of Modern Art.[29] Among them were six prints by László Moholy-Nagy, including his famous bird's-eye view, *Marseille*. There were photograms by Man Ray (no. 94), dune studies by Edward Weston (no. 82), and Steichen's (no. 85) portrait of his brother-in-law, the poet Carl Sandburg. Imogen Cunningham (no. 83) loaned ten of her own plant studies and portraits, among them the stunning likeness of *Alfred Stieglitz* (fig. 7).[30] When this remarkable exhibition opened in May 1937, it should have been reported in local press as a major event. But there was no substantial coverage, for the papers were filled with exciting news of the destruction of the airship *Hindenburg* and the Duke of Windsor's forthcoming marriage to Mrs. Wallis Warfield Simpson.[31]

In January 1940, when Francis Henry Taylor became director of the Metropolitan Museum of Art in New York, Charles H. Sawyer came from the

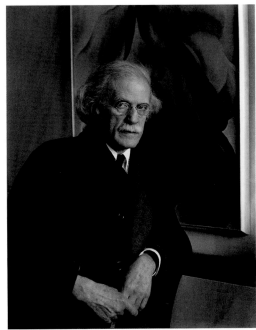

Fig. 7. Imogen Cunningham, *Portrait of Alfred Stieglitz*, 1934, gelatin silver print.

Addison Gallery at Phillips Academy to succeed him at the Worcester Art Museum. Sawyer sustained close relations with the Photo Clan, and the club's annual exhibitions continued through World War II. At that time, Sawyer was in the service, and curator Louisa Dresser, as acting-director, arranged for the Museum to host two exhibitions to support the war effort.[32] "*Wings over America* and *Our Navy in Action*," she wrote in the 1944 Annual Report, "two exhibitions of excellent official photographs, were found useful by recruiting offices in encouraging Air Cadet and Wave enlistments." At that time, the photographers worked in pools, and their images were not individually credited, but captioned simply *U.S. Army Signal Corps* or *Official U.S. Navy Photograph*. "*Our Navy in Action*," commented the *Worcester Evening Gazette* on July 7, 1943, "is the Navy's offering in thirty camera shots. . . . There [are], for instance, the first landing of American troops on the beach near Casablanca, a communion service on a South Pacific island . . . and the last moments of the airplane carrier *Wasp*." An Army truck delivered *Wings over America* to the Museum, accompanied by First Lieutenant Lynn D. Poole of the U.S. Army Air Corps to supervise the show's installation. Over a hundred photographs were shown, mostly representing the training of pilots and air crews. In Worcester, the installation was supplemented by models of Allied and Axis aircraft, made by industrial arts students of the Worcester Public Schools for civil defense and armed forces recognition training. To celebrate the exhibition, the actresses "Lola and Leota Lane of Hollywood, whose brother-in-law, Captain Joseph Howard, is stationed at the Victorville Army Air Field near Los Angeles where the exhibition was organized, attended the preview" (fig. 8), reported

the *Worcester Daily Telegram* on July 8, 1943.[33] A week later, Captain Arthur K. Stavelly and Lieutenant George Bartlett, a fighter pilot with combat experience in New Guinea, spent the day at the Museum meeting potential aviation cadets.

In fall 1945, the Museum hosted *Power in the Pacific*, an exhibition of photographs organized by Captain Edward Steichen, U.S.N.R. (no. 85), for the Museum of Modern Art. After seeing the show in New York, Dresser arranged for it to come to Worcester, where it opened seven days after Japan's surrender. Some of the most remarkable photographs in the show depicted Marines in close-up fighting in the Central Pacific (no. 129) on their way to Tokyo. The innovative installation of *Power in the Pacific* was designed by Herbert Bayer (no. 120) for the Museum of Modern Art, and Steichen advised borrowers to follow a predetermined order for installing the show and preserving its full impact. The 156 exhibition photographs of varying sizes (many as large as 50 x 40 inches) were mounted on panels, which were arranged thematically. Steichen adapted this mode of presentation for later exhibitions at the Museum of Modern Art, including his landmark *Family of Man* show in 1955. In Worcester, Admiral Wat Tyler Cluverius, U.S.N. (Retired), president of Worcester Polytechnic Institute, spoke at the preview of *Power in the Pacific*.

The mutually beneficial and lasting relationship between the Museum of Modern Art Department of Photography and the Worcester Art Museum grew strong during the war, when Nancy Newhall managed the department in place of her husband, Beaumont Newhall, who was then in the service. She organized a retrospective exhibition of the photographs of *Edward Weston* (no. 82) that came to Worcester in winter 1946. The show featured a survey of Weston's work to that time, with examples of his classic themes: Mexican subjects from the 1920s, nudes, close-ups of shells and peppers, and California's Point Lobos and dunes at Oceano.

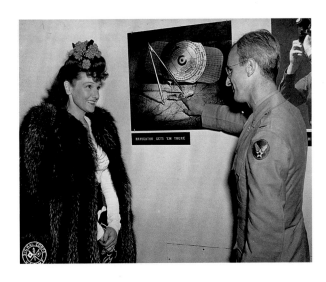

Fig. 8. Lola Lane visits *Wings over America* at the Worcester Art Museum, 1943 (U.S. Army Signal Corps).

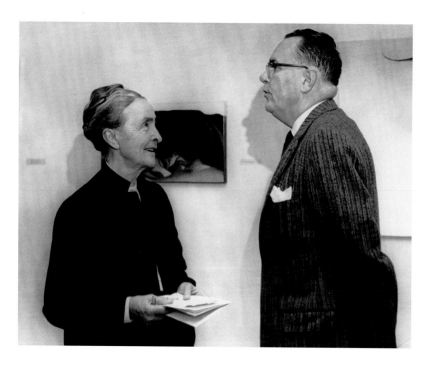

Fig. 9. Daniel Catton Rich and Georgia O'Keeffe at the Worcester Art Museum, 1960.

After the war, the Worcester Art Museum returned to its distinguished tradition of presenting the work of local photographers in a national context. Once again, the institution collaborated with the Worcester Photo Clan in the organization of the *National Photography Exhibition*. Clan members Richard A. Heald and Herbert W. Wagner selected works by outstanding amateurs across the country that were shown in conjunction with works by acknowledged masters of the medium borrowed from the Museum of Modern Art.[34] The *National Exhibition* was followed by the *First Worcester County Exhibition of Photography*, a juried show of amateur photography also mounted in collaboration with the Photo Clan. However, though it was billed as the *First Worcester County Exhibition of Photography*, it turned out to be the only exhibition of its kind ever held at the Museum.

By this time, George Stout had become director of the Worcester Art Museum, moving from his position as Head of the Department of Conservation at the Fogg Art Museum at Harvard University. He led the Museum when it helped celebrate the twenty-fifth anniversary of the Worcester Photo Clan with a sweeping exhibition. "Congratulations to the Photo Clan," proclaimed a headline in the Worcester *Sunday Telegram* on April 24, 1949, surmounted by images by the club's leaders from two generations, Dwight Davis and Richard A. Heald. The exhibition included 185 photographs by twenty-four Clan members past and present. The Museum influence was perhaps reflected in the show's impressive historical section. It featured a group of Civil War portraits lent by Ansco (formerly the Anthony & Scovill Company) a major photographic supplier in Binghamton, New York.[35] The installation also featured cameras, including a miniature

hand-camera made by Marion & Co., London, that utilized tiny glass DRY PLATES, and was reputedly used by Winslow Homer at Tynemouth, England, in the 1880s.[36] There was also an example of one of the first box cameras, made in 1888 and loaned by the Eastman Kodak Company, which also sent six other hand-held cameras manufactured between 1891 and 1915. Albert Marshall of Providence loaned a group of remarkable photographs from the mid-nineteenth century, including Hill and Adamson's *Newhaven Fishwives*, Édouard Baldus's *Church of Saint Trophîme, Arles*, and Julia Margaret Cameron's *Henry Wadsworth Longfellow*. F. A. Fraprie of Boston lent early daguerreotypes and framed American photographs from the 1850s to the Civil War. Emma Forbes Waite loaned a Civil War–era UNION CASE with the image of Asher B. Durand's painting, *The Capture of Major André* molded into its cover (no. 32).[37]

During the 1940s, the Worcester Art Museum also exhibited the work of news photographers, including surveys from the Boston Press Photographers in 1945 and 1946, and those on staff of the *Worcester Telegram* and *Evening Gazette* staff in 1949. Forty-three pictures by seven local photographers — George P. Cocaine, Paul W. Savage, Paul B. Moberg, Howard E. Smith, Edward A. Cournoyer, Marvin F. Richmond, and Myrton S. Reed — were selected for their aesthetic accomplishment and their vision of local history. "News photographers get the angle, whether it is a news or a fine arts shot," wrote Walter Merkel in the *Worcester Telegram*. "Through the rigorous training which work on large city dailies demands, they are alert to every possibility in a picture. Their trained eyes sweep a scene for light, for balance, for sentiment, for color, and the best moment of action. They have been taught to do work against a deadline, yet to achieve, in brief intervals, all the artistry a picture presents besides its value as a document."[38]

When George Stout became director of the Isabella Stewart Gardner Museum in 1955, Francis Henry Taylor returned from the Metropolitan Museum of Art to assume his former post in Worcester. Tragically, Taylor's second tenure was cut short by his death in late 1957. The next fall, Daniel Catton Rich came to Worcester from his position as director of The Art Institute of Chicago to begin twelve years as director. Rich (fig. 9) revitalized the Museum's dormant photography program, and then transformed it completely by beginning a permanent collection of photographs, as he had in Chicago.[39] "The recognition of photography as an art form is long overdue," Rich wrote in the Museum's *News Bulletin and Calendar* in November 1962. "For more than a hundred years, artists, critics and the public have confused themselves and each other by insisting that because a machine is used in the process the result

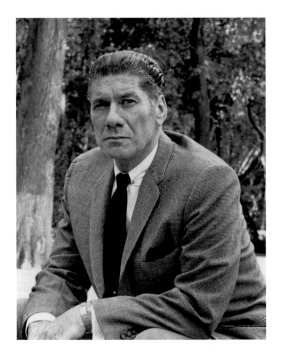

Fig. 10. Peter Pollack, 1965 (Creilly Pollack).

must be mechanical, and that the man behind the machine is only a technician. . . . Today there is a growing recognition that photography — the newest addition to the graphic arts — belongs in the museum along with etchings, woodcuts and lithography." To inaugurate the program, Rich called on Peter Pollack (fig. 10), author of the popular *Picture History of Photography*, who had been curator of photographs at the Art Institute for a decade, to organize a major exhibition of contemporary photography.[40] *Ideas in Images* (fig. 11) featured the work of ten outstanding American photographers, and after its presentation in Worcester, Pollack — by then director of the American Federation of Arts — sent the exhibition on a national tour.[41]

I became registrar at the Worcester Art Museum in July 1961, after earning my master's degree at Syracuse University, and working as education assistant at Munson-Williams-Proctor Institute in Utica, New York. The following summer, Rich asked me to be a part of the Museum's new program, and thus I became associate in photography.[42] I was to work with Rich and Pollack in carrying out future exhibition projects and in collecting photographs. The director felt strongly that the collection should be balanced in its representation of artists, and be consistently high in quality — in adherence with the Museum's policy for collecting the best in all media. We started by collecting the work of the late Dr. Roger Kinnicutt and five of the photographers who contributed to *Ideas in Images*; over time, the Museum acquired significant selections of the work by all of the photographers who exhibited in our pioneering show.

When the Worcester Art Museum began its photography collection in 1962, it became a bell-

Fig. 11. *Ideas in Images* installation at the Worcester Art Museum, 1962.

wether for the photography explosion in America. Only a few institutions had photography collections at that time: the Museum of Modern Art, George Eastman House, and The Art Institute of Chicago. The Library of Congress was recognized for its remarkable holdings of historical photographs, dating back to the nineteenth century. At the Metropolitan Museum of Art in New York, Ivan Dmitri had originated the influential series of exhibitions, *Photography in the Fine Arts*. In technologically inclined Worcester during the early 1960s, the community of amateur photographers continued to thrive. Camera clubs, like those at Norton Company and at Heald Machine Company, were an important force, but they perpetuated outmoded styles. Some serious amateurs had begun to use 35mm hand-held cameras, looking to *LIFE* and other picture magazines for inspiration. But few were then aware of the spontaneous imagery of Henri Cartier-Bresson (no. 167) or the gritty street pictures of Robert Frank (no. 149) that exposed the realities of an unvarnished America.

Prior to my new appointment, Rich had planned *Reflections: Color Photographs by Daniel Farber* (no. 166), as the program's second show. He was opposed to showing photographs under glass because of distracting reflections, so Edmond de Beaumont, the Museum's conservator, and I mounted Farber's nineteen dye-transfer prints onto Masonite panels, backing each with a wooden cradle so that they would stand away from the gallery wall. By removing the visual distractions of frames, mats, and glass, our installation focused on the

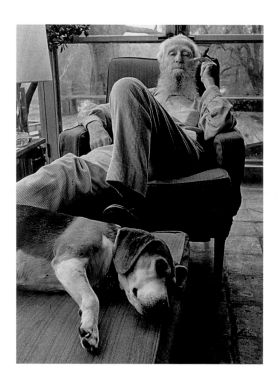

Fig. 12. Hans Hammarskiöld, *Edward Steichen and His Dog, Tripod*, 1968, gelatin silver print.

works themselves.[43] Though quite effective, the endeavor was so labor intensive that it was not repeated.

For summer 1963, Pollack arranged an exhibition of photographs by Brassaï (no. 114), who was famed for his black-and-white photographs of Parisian nightlife in the 1930s. Accepting the risk of displaying unglazed photographs, we dry-mounted Brassaï's twenty-seven exhibition prints on acid-free boards, and secured them with L-hooks to the gallery wall. As the show neared its end, we discovered with dismay that many had begun to yellow around the edges. Surmising that chemical reaction caused the discoloration, we wondered if we should have waited longer to install the photographs on the freshly painted gallery walls. When we returned the photographs to Brassaï, he imposed an "indemnity" as compensation for the discolored prints. The Museum purchased six prints from the Brassaï exhibition, of which five were damaged and returned for replacement, including two of the photographer's most famous images: *Evening at Maxim's*, a resplendent nightclub in postwar Paris, and *Picasso*, a portrait of the artist sitting beside a great stove in his rue des Grands-Augustins studio. It took four years of persuasive correspondence to secure the replacement photographs from Brassaï, who was known for taking his time. In 1964, the Museum exhibited a handsome gift of photographs by Eugène Atget (no. 78), famous for his images of Paris in the *belle époque*. These GELATIN SILVER PRINTS were made by Berenice Abbott (no. 105) from Atget's negatives, and issued in a portfolio to commemorate the centenary of his birth. We returned to the standard installation technique of the time by covering the matted photographs with glass before securing them to the wall with L-hooks.

Determined to regularize the Museum's photography program, Rich charged me with investigating other institutions with established departments, to learn how they displayed and stored their collections. First I visited the Department of Photography at the Museum of Modern Art, just after John Szarkowski succeeded Steichen as its director. The curator Grace Mayer introduced me to Steichen (fig. 12) and Nathan Lyons, who was then assistant director at George Eastman House, the great museum of photography in Rochester, New York.[44] I also studied the cream of the Museum of Modern Art's collection on view in a permanent installation. On my next field trip, in September 1964, I was welcomed to The Art Institute of Chicago by Hugh Edwards, Pollack's successor as curator of photography. When I arrived, he was seated at his desk reading *Popular Photography*, and I realized that I had been overlooking an important source for information. Edwards introduced me to the work of Robert Frank (no. 149), who had prepared the ground for social documentary photography of the 1960s, and artists such as Lee Friedlander, Diane Arbus, and Garry Winogrand (nos. 161, 158). I flew from Chicago to Rochester to visit George Eastman House, where my host, Nathan Lyons, introduced me to the director, Beaumont Newhall. I was delighted to see Edward Weston's (no. 82) photographs in storage and in the galleries, for I had just finished reading the first volume of the photographer's *Daybooks*, edited by Beaumont's wife, Nancy Newhall.[45] Lyons and I discussed contemporary photography and his efforts to exhibit work by promising young artists. "I'm off to bug Minor," he said in his witty way as we parted company. He was meeting Minor White (no. 148), who taught at nearby Rochester Institute of Technology. Lyons and White approached photography in different ways, and both actively published their ideas, Lyons in exhibition catalogues, and White as editor of *Aperture*, the quarterly journal that advanced photographic aesthetics.

During my thirty-three years as a curator at the Worcester Art Museum, I mounted over seventy-five photography exhibitions, and a few of those stand out, along with important loan shows, as formative to our program. In 1965, Pollack and I worked together on *Three European Photographers*, which featured the work of contemporaries Paolo Monti, Bill Brandt, and Lucien Clergue (nos. 123, 157). Monti, a photographer from Milan, contributed works with strong contrast and graphic energy parallel to Neorealist motion pictures produced by Vittorio De Sica in the early 1950s. The photographer presented closeup portraits and a variety of lyrical subjects, including an attic still life and a Venetian funeral barge. The British documen-

Fig. 13. Henri Cartier-Bresson, *Henri Matisse*, 1946, gelatin silver print.

tarian Brandt (no. 123) had shifted his attention after 1945 to the challenges of representing space and form. His exhibited work consisted of photographs of stone monoliths and prints from *Perspective of Nudes*, a series of distorted figures that redefined nude photography in the late 1950s.[46] Clergue sent examples from his bullfight series, *Toros Muertos* (no. 157), and a nude in the surf from his series *Naissances d'Aphrodite*.[47] Many of Clergue's bullfighting pictures focus on death, while his nudes affirm life.

In 1966, the Museum hosted *Frederick H. Evans*, a solo exhibition circulated by George Eastman House and organized by Beaumont Newhall.[48] By placing an ad in a London newspaper, he had recently located the photographer's son, Evan Evans, and suggested that I correspond with him. We were able to acquire five rare photographs from the artist's estate, including a *Portrait of Aubrey Beardsley* and *In Sure and Certain Hope, York Minster* (no. 106).

For *Photographs by Dorothea Lange*, the first major exhibition that I installed in Worcester, we returned to our tradition of collaboration with the Museum of Modern Art. John Szarkowski organized this defining retrospective, working closely with the photographer. Lange valiantly battled cancer during the planning of the show but did not live to attend its opening in New York.[49] The works ranged over her eventful career from her early portrait studio work, to Farm Security Administration pictures and her postwar photoessays in Ireland and Egypt. Szarkowski and his father attended the preview of the exhibition in Worcester.

Pollack and I decided to organize our own exhibition of the work of Paul Strand (no. 75), who was then living in France. In early 1967, I wrote to the photographer, who did not have sufficient prints to lend but recommended that I seek loans from specific American museums. Our exhibition presented

a survey of Strand's documentary work over forty years, from street pictures in New York in 1915 to close-ups of crofters in the Outer Hebrides in the mid-1950s.

When I learned that Szarkowski had visited Henri Cartier-Bresson (no. 167) to organize an exhibition for the Museum of Modern Art, I eagerly arranged for the show to come to Worcester. "Photography is an instantaneous operation, both sensory and intellectual," wrote Cartier-Bresson, "[It is] an expression of the world in visual terms, and also a perpetual quest and interrogation. It is at one and the same time the recognition of a fact in a fraction of a second and the rigorous arrangement of the forms visually perceived which give to that fact expression and significance."[50] His portrait of Henri Matisse drawing a dove (fig. 13) is among thirteen photographs that we acquired from the artist at the time of the show.[51] When the curator lectured in Worcester, he described working with Cartier-Bresson in Paris. Interested in learning about the artist's creative process, Szarkowski asked, "Henri, can you show me contact sheets?" Reluctant to show rejected images, the photographer produced a 35mm CONTACT SHEET with tiny images of all the exposures from a roll of film, saying "I have sinned thirty-six times."

Daniel Catton Rich retired in 1970 and was succeeded by Richard Stuart Teitz. Under his directorship, the Museum hosted two more exhibitions from the Museum of Modern Art. *Photographs by Clarence H. White* was a retrospective commemorating the hundredth anniversary of the artist's birth. The Worcester Art Museum was a fitting venue for the show, for in 1905 White's work was included in Worcester's *Second Annual Exhibition of Photographs*; in 1917 the Museum hosted the first exhibition of White's Pictorial Photographers of America, and in the mid-1930s the photographer came to town to speak to the Worcester Photo Clan. *Photographs by Diane Arbus* (no. 161) also came to us in 1973. Szarkowski, who had first given the artist widespread recognition in 1967, organized this commemorative exhibition from her estate. It was bold for the Worcester Art Museum to present Arbus, whose work was then controversial. "To the left of a grand staircase, waits a small elevator," wrote reviewer Deac Rossell in the *Boston Sunday Globe*. "The trip to the fourth floor is brief in time, but lengthy in impact: the doors of the functional machine open like floodgates of the River Styx to reveal three crisp white galleries where all architectural detail is abolished and 112 sombre photographs by the late Diane Arbus permit no distractions and no escape from the mind and vision of a single extraordinary artist. . . . The recognition that has come to her work in the past two years, while undoubtedly spurred by the fact that her suicide casts a long retrospective shadow over her

Fig. 14. Stephen B. Jareckie, 1991 (Mary Melikian).

photographs of lonely and alienated people, is still recognition well deserved. There is neither senti-mentality nor petition in her images. She presents void faces as a fact, with strength, often leaning slightly toward worked-up courage or defiance. Warm toward her freakish subjects, as was Leonardo in his drawing of grotesques, she is nev-ertheless uncompromising."[52] Within three years of the exhibition, Hall and Kate Peterson donated Arbus's portfolio, *A box of ten photographs* to the Museum, which includes *A Jewish Giant* (no. 161). In the early-1970s, easy-to-use 35mm cameras became readily affordable, and photography as a hobby boomed once again. Professional and cre-ative photographers presented popular workshops, and more universities established photography departments. Galleries and dealers began to treat the medium as fine art, and other museums gradu-ally integrated photography into their permanent programs. Pollack's notion "that a future of unimaginable richness lies ahead for creative pho-tography — individually created, mass viewed — the central art of the twenty-first century" was prov-ing prescient.[53]

A year after my appointment as Curator of Pho-tography in 1973 (fig. 14),[54] I turned my attention to Ansel Adams, and arranged through Andrea Rawle at the Metropolitan Museum of Art to bring a major retrospective, *Photographs by Ansel Adams*, to Worcester. The show was built around Adams's six major portfolios, and forty jewel-like POLAROID prints that had never been shown before, demon-strating that he was not only a master landscapist, but a superb portraitist.[55] Then, to help celebrate the nation's bicentennial, I organized *American Photography: 1840–1900*, a project supported by a grant from the National Endowment for the Arts.[56] The exhibition traced the development of American photography from its introduction in 1840 by

Daguerre's representative, François Fauvel-Gouraud, to the flowering of Pictorialism at the turn of the century. The chronological installation of *American Photography* reflected how the size of photographs changed throughout the nineteenth century according to purpose. Daguerreotypes by William and Frederick Langenheim from the early 1840s were tiny, and so was the standard CARTE-DE-VISITE, exemplified by Jeremiah Gurney's por-trait of Major Robert Anderson, the hero of Fort Sumter. To convey the majesty of the American West, Carleton E. Watkins and William Henry Jackson (nos. 37, 38) produced mammoth-plate (about 18 x 22–inch) albumen prints. By 1900, how-ever, Photo-Secessionists, like Stieglitz and White, had returned to intimate images designed for close scrutiny and appreciation of the tonal delicacy made possible by the platinum print. For the first time, several of the Museum's own rare daguerreo-types were exhibited, alongside photographic masterpieces from the American Antiquarian Soci-ety, such as Andrew J. Russell's photographs of the Union Pacific pushing the transcontinental railroad westward in 1869.

After the death of our honorary photography advisor, Peter Pollack, in 1978, Carl Siembab joined the staff to serve as photography consultant until the fall of 1982. Carl and I organized several print gallery exhibitions together, among them solo shows of the photographs of Wynn Bullock and Paul Caponigro (nos. 139, 169). When Tom L. Freudenheim became the director of the Worcester Art Museum in 1982, he called an offsite meeting of the curatorial division to brainstorm about future programs. I expressed my interest in doing a show on German photographers of the 1920s, who had received little attention in America since World War II. Tom — revealing incidentally that he was related to German novelist Alfred Döblin[57] — said "go with it!" Over the next three years, I immersed myself in Germany of the Weimar period, traveling as far as Berlin in the east and Santa Monica in the west for my research. On visits to Germany in 1984 and 1985 I selected loans from the Museum Ludwig in Cologne, the Museum Folkwang in Essen, and the Berlinische Galerie. The constant rain during my stay in Cologne aptly recalled many photographic images from the Weimar period. I remarked on the weather to the doorman of my hotel: "Köln Wasser" was his wry reply.

Photographers of the Weimar Republic focused on six photographers whose works represent the diversity of German photography in the 1920s.[58] The exhibition was installed so that each artist's work was seen as an entity, beginning with Hugo Erfurth's powerful and aesthetic portraits of the epoch's most prominent figures, including painters such as Max Beckmann and Otto Dix (no. 87), and architects such as Walter Gropius. A sense of the

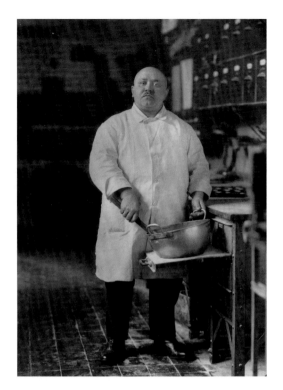

Fig. 15. August Sander,
Master Pastry Cook, 1928,
gelatin silver print.

Fig. 16. Garry Winogrand,
Couple Dancing from the
series *Women Are Beautiful*,
1969, gelatin silver print.

architectural and commercial environment of the period was reflected in the work of Werner Mantz (no. 92). The influential László Moholy-Nagy (no. 120) was represented by images of his "New Vision" aesthetic, which explored unusual angles of perception, like his straight-down views from the top of a Berlin radio tower. The *Neue Sachlichkeit* (New Objectivity) movement was represented in the crystalline images of everyday life in the industrial Ruhr region by Albert Renger-Patzsch (no. 103). August Sander (no. 77) was represented by a selection of portraits from his encyclopedic survey of the German nation, *Menschen des zwanzigste Jahrhunderts (People of the Twentieth Century*, fig, 15).[59] There were also photographs by Dr. Erich Salomon (no. 104), who invented the occupational

title *Bildjournalist* (photojournalist), including *Banquet at the Quai d'Orsay, Paris*, 1931, in which Aristide Briand, the French Foreign Minister, points to the uninvited Salomon and calls out: "Ah, le voilà! Le roi des indescrets" (Ah, there he is, the King of indiscretion!). "In more than 100 photographs taken in Germany between 1919 and the early 1930s," wrote Douglas C. McGill in the *New York Times*, "important trends of later American photography are revealed in embryonic form. They include the sharply focused, realist style explored by Edward Weston, the social-documentary approach of photographers like Walker Evans, and even the world's first paparazzi-style pictures and other photojournalism."[60]

In 1986, James A. Welu succeeded Tom Freudenheim as director, and we worked together until my retirement a decade later. Three projects stand out from this period, among them *A Panorama of Photography*, mounted fifty years after Horst W. Janson's centenary celebration of photography. The exhibition's historical overview of the medium could now be entirely drawn from the Museum's collection. It was also an occasion to showcase some outstanding new acquisitions, like William Henry Fox Talbot's *Loch Katrine* and *Hungerford Suspension Bridge* (no. 1), Samuel Masury's *North Shore Landscape* (no. 14), and Man Ray's portrait of the heiress *Nancy Cunard* (no. 94). *New York, New York: The City in Photographs* in 1990 was an exhibition that celebrated the city and its contributions to American culture. The exhibition traced the changing face of New York in the twentieth century through a wide range of pictures, from Stieglitz's *The Hand of Man*, a rail yard in Long Island City in 1902, to Jerry Dantzic's panoramic color photograph taken from the top of a downtown office building in the 1980s. The show also explored the lives of New Yorkers, in images like Weegee's *Napping Waitress* (no. 113) and Garry Winogrand's (no. 158) pictures of party goers at the Metropolitan Museum of Art's Centennial Ball in 1969 (fig. 16).[61]

Eye on the Ball: The Camera's Focus on Basketball came about in 1992, when the College of the Holy Cross hosted the National Collegiate Athletic Association (NCAA) playoffs, in the first round of the year's "March Madness" basketball tournament. When the local committee asked the Museum to mount an exhibition to celebrate the event and the centennial of the game, Welu and I found an opportunity to explore sports photography. I discovered exciting loans from several nearby sources. We borrowed historic objects from the Naismith Basketball Hall of Fame in Springfield, named for the game's local inventor, James Naismith. The Holy Cross archives provided photographs to trace both the history of the sport and the evolution of photographic technology, from the turn-of-the-

Fig. 17. Todd Webb, Harry Callahan, and Aaron Siskind at the Worcester Art Museum, for the opening of *Harry Callahan: New Color*, 1988 (James A. Welu).

twentieth-century team pictures to the college's 1947 championship squad carrying its coach in victory. There were also pictures of Holy Cross stars Bob Cousy and Tommy Heinsohn, both of whom went on to play for the Boston Celtics. Gus and Arlette Kayafas lent Harold Edgerton's multiple-flash color photograph of Cousy moving under the net to make a lay-up. The show also featured CYANOTYPES of Smith College women playing basketball, soon after the sport was introduced to women's athletics by Senda Berenson, sister of the art historian Bernard Berenson.

During the 1980s and early 1990s, the Worcester Art Museum hosted outstanding exhibitions from the Hallmark Photographic Collection in Kansas City, which often presented work by photographers who became memorable acquaintances and loyal friends of the Museum. In 1967, I had met André Kertész (no. 91) at the opening of a show of Lucien Clergue's photographs at Brentano's in New York. He was a courtly man, whose warm personality reflected his humane approach to photography, apparent in his solo exhibition in Worcester in 1984. Though Todd Webb and Harry Callahan had exhibited their work in *Ideas in Images* in 1962, I did not make their acquaintance until the late 1980s (fig. 17).[62] I met Todd and his wife, Lucille, when the photographer spoke at the Museum in January 1987 in conjunction with his exhibition *Todd Webb: Photographs of New York and Paris 1945–1960*.[63] Kind and straightforward, Todd was full of stories about people he had met over a lifetime of adventures. As an artist, he relied on his Quaker temperament, curiosity, and a genuine interest in others to capture images that tied people and their places together. Stieglitz, who befriended Todd in the 1940s, said that his work had "tenderness without sentimentality." I first met Harry Callahan at an exhibition preview at the Institute of Contemporary of Art in Boston. His impres-

sive academic career, at the Illinois Institute of Technology and the Rhode Island School of Design, distinguished Callahan as the country's preeminent teacher of photography. Yet Harry retained his down-to-earth manner. After hearing Keith Davis lecture in connection with the show *Harry Callahan: New Color* in Worcester, Harry remarked: "I didn't know I was thinking all those things."[64] Harry was at heart an intuitive artist.

Clarence John Laughlin (no. 132) came into my life about eight o'clock one evening in early 1965 when he telephoned to introduce himself and asked me to pick him up at the Worcester railroad station. He was on his way to Boston, and stopped in town hoping to see Daniel Catton Rich, who was away on leave. Before putting Clarence John up for the night, I looked at his photographs until two in the morning. When Davis offered us an exhibition of Laughlin's photographs in 1992, I was happy to book the show based on what I had seen almost three decades earlier.[65]

The Yale-educated photographer Ann Parker has also been a long and faithful supporter of the Museum.[66] In 1975, we presented a solo exhibition of her pictures of everyday country life in Portugal, revealing her human empathy and her anthropological interest in rural societies. We mounted another exhibition of Ann's work in 1993, a show of color photographs conceived to celebrate the 500th anniversary of Columbus arriving in the Americas. Ann photographed the painted backdrops used by the itinerant portrait photographers of Guatemala, and represented the country people of Central America and the Caribbean (fig. 18).[67]

Over nearly thirty-five years, I helped the Worcester Art Museum build a collection of 1,800 photographic prints. We endeavored to build the collection around major figures in the history of American and European photography, but took advantage of opportunities as they came up. We benefitted from several fortuitous discoveries. In the mid-1960s I found several old wooden boxes on a high shelf in the Museum's basement storage. Probably packed in the early 1900s, they held a small collection of photographs that had been left to the Museum on the death of its founder, Stephen Salisbury III. Among them were a pair of full-plate daguerreotypes representing the Salisbury Mansion and Salisbury House (no. 4), smaller family portraits, and daguerreotypes of prize livestock (no. 5). Later, the Museum's librarian, Alice Mundt, brought to my attention a number of photographs that had been in the library for years, including seventy-seven plates from Eadweard Muybridge's *Animal Locomotion* (no. 48), and 190 platinum prints of architectural subjects from the classical world by Smith College Professor Clarence Kennedy.[68] These works were originally acquired as teaching aids for the Museum School. In 1974, Mrs. Albert W. Rice

Fig. 18. Ann Parker, *The Red Window, Higüey, Dominican Republic*, 1982, dye coupler print.

brought the Museum several suit boxes filled with nineteenth-century photographs that had been stored in her attic for years. She told me that most of the photographs were mementos purchased abroad by a member of her husband's family in the 1870s. Among them were daguerreotypes (no. 7), stereographs, and albumen prints including works by such photographers as Francis Frith, Achille Quinet, Carlo Ponti, and the Alinari Brothers. Among my most satisfying purchases for the collection was the eight-volume set of the *Galerie contemporaine des illustrations Françaises*, published in the 1870s and 1880s, with essays about 141 notable Frenchmen of the day illustrated by their photographic portraits, among them Étienne Carjat's likeness of Charles Baudelaire (no. 39). Other significant purchases include three Civil War photographs: Timothy O'Sullivan's *The Field Where General Reynolds Fell, Gettysburg* (no. 34), George N. Barnard's *The Rebel Works in Front of Atlanta* (no. 35), and Brady's *General Robert E. Lee and Staff* (no. 33). These powerful images, which illustrate different dimensions of the conflict, form the core of our Civil War photographic holdings.

Irene Shwachman (no. 163), an instructor in the Museum's professional school, was a staunch supporter of our photography program, and made many gifts to the collection, including works by Julia Margaret Cameron, Lisette Model, and Minor White (nos. 42, 124, 148). Other important benefactors to the photography collection were William H. and Saundra B. Lane, who donated work by Charles Sheeler, Edward Weston, and Wynn Bullock; and Mr. and Mrs. Hall James Peterson, who presented

the large-format photogravure of Stieglitz's *The Steerage* (no. 62). The Petersons supported New England photographers by donating examples of work by Christopher James, Chester Michalik, Nicholas Nixon, and B. A. King (no. 171). In 1984 the Petersons established an endowed fund that has enabled the Museum to continue its activity in photography exhibitions. Since my retirement, it has been gratifying to see that program continue to thrive by organizing in-house exhibitions, and by hosting traveling photography shows by such artists as Robert Capa, Lewis Wickes Hine, and Weegee (nos. 128, 74, 113; fig. 19).[69]

My notes written for a *Leadership Series* talk given on February 27, 1996, are still relevant today. "Though a curator should strive to select works for their universal value, I have brought my personal view to bear in channeling photographs into the collection. In my view, I worked as a public collector (being not only responsible to myself, but ultimately to the director, trustees, and corporation). Some images, like Bruce Davidson's Jersey meadows, Bernd and Hilla Bechers' blast furnaces, or Frank Horvat's picture of [the writer] Antero Piletti eating spaghetti [in a Rome restaurant] reflect my personal enthusiasms. I have enjoyed working in a community that enthusiastically supports photography. From the first decade of this century, the Museum has consistently received support from photographers, from its directors, from the corporation and trustees, and from generous donors when the Museum began collecting photographs in the 1960s." Indeed, it has been a privilege to employ my lifelong interest in shaping a photography collection in a museum that has proven to be a pioneer in recognizing this now celebrated medium.

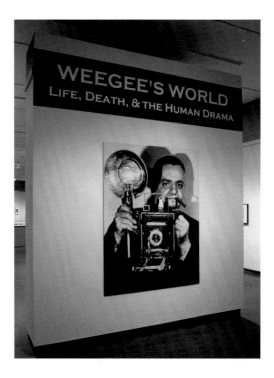

Fig. 19. *Weegee's World: Life, Death and the Human Drama* installation at the Worcester Art Museum, 2002.

The Invention of Photography

The miracle of photography was revealed slowly, beginning at the turn of the nineteenth century, through the efforts of scientists, artists, and technicians. Enlightenment-era confidence in the intelligibility of the universe encouraged their investigations of chemistry, physics, and imagery. The faith in human ingenuity that gave rise to the Industrial Revolution prompted a multidisciplinary approach. The personalities, struggles, and discoveries of these innovators are still coming to light.

For many centuries, philosophers and scientists had known about the LATENT IMAGE. Aristotle described the phenomenon after perceiving the round image of the sun passing undistorted through the tiny holes of a wicker basket. During the medieval period, astronomers used instruments similar to a CAMERA OBSCURA to observe the solar eclipse. Literally a "dark room," a camera obscura is a darkened chamber with a tiny hole in one wall, through which light passes to cast an inverted image of the outside scene onto the opposite wall (fig. 1).[1] Over time, scientists progressively reduced the size of the chamber and placed a LENS into the opening to focus and clarify the projected image. They made the camera obscura into an artists' tool by replacing the back of the box with a sheet of paper or ground glass, on which the out-

lines of the scene could be traced. A mirror was then mounted inside the chamber to correct the transposed image on the tracing screen. The thirteenth-century English scientist Roger Bacon knew this form of the device.

During the Italian Renaissance, Leonardo da Vinci was the first to understand that the camera obscura functions just like an eye. Around 1457, Leon Battista Alberti built a camera obscura for use as a drawing apparatus.[2] A century later, the Neopolitan physician Giambattista della Porta described the instrument in his scientific treatise *Magia naturalis*, popularizing and disseminating its use. The German scientist Johannes Kepler used a camera obscura in the early seventeenth century to record astronomical phenomena, and modified a portable tent into an apparatus for drawing landscapes. Many Netherlandish artists of the period employed the device, including Jan Vermeer, whose paintings faithfully reproduce its blurred focus and optical distortions.[3] In the eighteenth century the camera obscura became a popular amusement for the wealthy; craftsmen produced elegant instruments for their affluent customers, and constructed portable apparatus for amateur and professional artists. Canaletto was among the many painters of that era who used the device to record topographical compositions with accuracy.[4]

In 1806, the British scientist William Hyde Wollaston patented the CAMERA LUCIDA, a drawing instrument that enabled the operator to perceive a latent image in full daylight.[5] The name is misleading, for it has no chamber at all (fig. 2).[6] The device consists of a small glass prism with two silvered sides, mounted to an adjustable stick. The telescoping stand enables the artist to fix the prism above a flat surface that holds a sheet of paper perpendicular to the operator's line of sight. Light from the subject is reflected onto the observer's eye at the same time as light from the paper, so the artist perceives an illusion of the image on the paper and can trace its outline. The camera lucida was most popular with landscape artists, and the apparatus was also adapted for use with the microscope.

Fig. 1. *The Camera Obscura or Dark Chamber*, engraving from Frederick Barlow's *The Complete English Dictionary* (London, 1772).

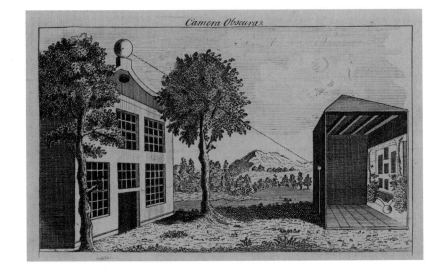

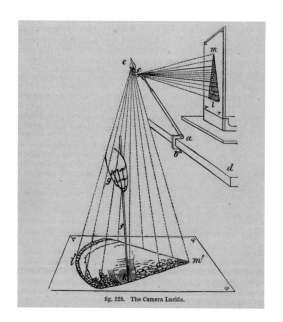

fig. 228. The Camera Lucida.

Fig. 2. *Using a camera lucida to enlarge a drawing,* wood engraving from Jabez Hogg, *Elements of Experimental and Natural Philosophy* (London, 1853).

At the turn of the nineteenth century, researchers were also at work on the other essential ingredient of photography, the chemistry of light-sensitive substances. In England, Thomas Wedgwood — son of the scientist and pottery manufacturer Josiah Wedgwood — attended meetings of the Lunar Society and knew many of his country's leading scientists. He and his colleague Humphrey Davy — a Royal Institution chemistry professor and later president of the Royal Society — collaborated on experiments with light-sensitive chemicals. After treating paper or leather with a solution of light-sensitive silver nitrate, they attempted to capture an object's shadow cast onto these surfaces. They also experimented with a camera obscura, and tried to copy paintings on glass by placing light-sensitive material underneath. Their theory was sound, but their silver nitrate compound was not sensitive enough to create legible images. Nor did they discover how to arrest its reaction and fix their pale and fugitive images. Nevertheless, reports of their experiments, published in 1802 in the *Journals of the Royal Institution of Great Britain,* provided a foundation for later attempts to capture an image through photomechanical reactions.[7]

The French inventor Nicéphore Niépce made the decisive advances in the development of photography.[8] As the son of a revenue collector for the Crown, he received a fine education. He was serving in the National Guard in 1789 when the French Revolution drastically altered his future prospects, and prompted Niépce and his elder brother to seek their fortune in technology and invention. They developed the *pyreolophore,* an internal-combustion engine that ran on vegetable oil, which they mounted for demonstration in a six-foot boat. In 1797 Napoleon's government granted them a ten-year patent. While his brother traveled in pursuit

of funding to develop their invention, Nicéphore Niépce stayed at the family estate, Le Gras at Chalon-sur Saône, investigating other ideas, including the camera obscura. He learned the basics of photochemistry from Louis-Nicolas Vauquelin and experimented with a range of light-sensitive materials, such as the sap of the Gaïacum fir tree, and asphalt, or bitumen of Judea. The inventor tried exposing different supports, like paper, leather, or stone, that had been coated with light-sensitive chemicals. However, he too had no way of arresting the chemical action and fixing the images before they blackened and disappeared.

In 1822 Niépce concentrated on reproducing linear images. He oiled a sheet of paper printed with a portrait etching to make it translucent, and then laid it on a pewter plate coated with brown bitumen varnish. When he exposed the masked plate in full sunshine for three or four hours, the light that filtered through the paper hardened the bitumen coating. When Niépce rinsed the plate in diluted lavender oil, he washed the asphalt from the unmasked areas to expose the bare metal, leaving the places between the lines of the print protected by bitumen. He then etched, inked, and printed the plate by the traditional intaglio process. Thus, he devised the basic technique of PHOTOGRAVURE, which is still in use today.

In about 1826, Niépce loaded his camera obscura with a similarly prepared pewter plate and aimed the lens out a window at Le Gras. After about eight hours' exposure he washed the plate with lavender oil, flushing away the areas where the bitumen of Judea had received less light and remained soluble. The plate carried a legible, negative image of the scene outside. Then he exposed the plate to iodine fumes, partially reversing the tones and heightening the contrasts. Though it is not completely stable, Niépce's *View from the Window at Le Gras* (fig. 3) is considered to be the world's first permanent photograph.[9]

Niépce bought his lenses and equipment from the Paris optician Victor Chevalier, who recommended to Louis-Jacques-Mandé Daguerre that he meet the inventor.[10] When the two experimenters met in December 1827, they realized the similarity

Fig. 3. Joseph Nicéphore Niépce, *View from the Window at Le Gras,* about 1826, heliograph.

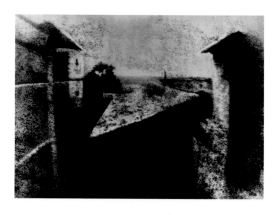

Fig. 4. Daniel Davis, Jr., *Self-Portrait*, about 1840, daguerreotype.

of their interests. They began to correspond, sharing ideas, experiments, and criticism. In December 1829, they established a formal partnership, which produced refinements of tree resins as photosensitive agents, and the distillation of lavender oil. When Niépce died in 1833, his son, Isidore, maintained the partnership, but it was Daguerre who continued the groundbreaking work. In 1837 he successfully captured the image of a still life in his studio. Two years later, at a joint meeting in Paris of the Academy of Sciences and the Academy of Fine Arts, the inventor made public the exact details of his process, which he called the daguerreotype. As recompense for disclosing the invention, the French government granted an annuity of 6,000 francs to Daguerre and one of 4,000 francs to Isidore Niépce.

Having published the details of the process, Daguerre tried to extend his profits by selling instruments, materials, and licenses. Soon after his announcement in Paris, he dispatched his associate François Fauvel-Gouraud to the United States to introduce daguerreotypy. Gouraud arrived in New York, where he presented lectures and demonstrations. Then he proceeded to Boston, where he met Daniel Davis, Jr., a scientist with the curiosity, motivation, and mechanical skills to try the tech-

Fig. 5. Advertisement from *Worcester Municipal Directory*, 1853.

nique immediately.[11] Davis hailed from Princeton, in Worcester County, and his daguerreotypes were among the first to be made in this country.[12] After meeting Gouraud in March 1840, Davis constructed his own camera and performed his own chemistry to make successful daguerreotypes. The first was a view of the German Catholic church on Suffolk Street — now Shawmut Avenue — in Boston. He also made self portraits (fig. 4).[13]

Davis grew up on his family's farm in Princeton and moved to Boston at age twenty. Fascinated with electricity, he found work installing lightning rods for Dr. William King, who sold these implements and made static electrical machines at his shop on Cornhill. In 1835 Davis opened his own shop at No. 11 Cornhill, where he manufactured electromagnetic instruments for demonstrating voltaic and dynamic electricity. In collaboration with Dr. Charles G. Page, he invented some of the first practicable electric circuits, movements, and machines.[14] Davis also invented the electrotyping process, in which woodcuts and printing type were electrostatically coated with copper to give them greater strength and longevity. He was the first to electroplate in silver and gold, and taught the process to others. To advertise the products and services of his shop, he wrote and published *Davis's Manual of Magnetism, Including also Electro-Magnetism, Magneto-Electricity and Thermo-Electricity*, which contained his original illustrations.[15] When the book appeared in 1842, it became the standard American primer on electrical technology and was used as a college textbook. Printed in many editions, it established Davis as the leading American expert on electricity. In 1844, Samuel F. B. Morse enlisted his expertise to make his concept for the electromagnetic telegraph practicable.[16] The two

Fig. 6. Andrew Wemple Van Alstin, *The Merrifield Fire*, 1854, daguerreotype.

scientists probably talked about photography, for Morse had visited Daguerre in Paris in March 1839 to learn about the newly announced daguerreotype. Before the age of forty, Davis returned to the family farm, where he enjoyed over thirty years in retirement with his wife and family.

By that time, several daguerreotype studios had come and gone in Worcester. One of the longest lasting was George Adams's Daguerrean Rooms, which, according to the *Worcester Palladium*, opened in 1847. Adams remained in business, in several locations, for twenty years. During that time he trained many daguerreotypists who later practiced independently in Worcester. Notable among them was Dr. Andrew Wemple Van Alstin (fig. 5).[17] He was born in Canastota, New York, the son of Dutch immigrants; the presence of one of his photographs in the Rijksmuseum in Amsterdam may suggest that he maintained family connections.[18] Although the photographer is sometimes listed as "Dr." Van Alstin, the records of his education have not been discovered. He seems to have been in Adams's studio as early as 1843; two years later he was working as a daguerreotypist in Lowell, Massachusetts. When he opened his own shop at Brinley Hall in Worcester in 1848, he advertised his five years of experience and his production of 6,000 daguerreotypes the previous year. Visitors were enticed to visit his rooms to see "pictures of a number of eminent men; and a

Daguerreotype of the 'MOON,' the largest ever made." He also sold supplies and equipment, and taught the process of daguerreotypy. Van Alstin was curious and ambitious, and in 1853–54 he traveled around the world, collecting specimens of foreign birds, which were later mounted and exhibited in his daguerreotype rooms. His photograph of a funeral cortege in front of the Daniel Waldo mansion on Main Street — where Mechanic's Hall now stands — documents the prosperity and elegance of the homes that then occupied the center of town.[19]

Van Alstin's studio was in the Union Block on Main Street, just a few doors away. Soon after noon on June 14, 1854, he climbed to the roof of the building to make a remarkable daguerreotype of a major fire in the Merrifield Building (fig. 6).[20] William T. Merrifield had built an enormous factory complex in the city, between Union and Cypress Streets, and Exchange Street in the north. He rented out places with power to a wide variety of manufacturers and machinists, including carpenters, straw-cutters, furniture makers, and a pistol manufactory. Since the most successful among them went on to build their own factories, this innovative complex contributed significantly to Worcester's growth and success as an industrial center. Van Altsin's daguerreotype seems to represent an early stage of the fire, which started in a fourth-storey workroom of sewing-machine manu-

Fig. 7. Thomas and William Hathaway, *Joshua Stoddard with His Steam Calliope*, about 1856, ambrotype.

facturers Hood, Battelle, & Co., whose employees had gone off to lunch. From their shop in the building's southwest corner — at the upper left in the daguerrotype — the conflagration quickly spread through the complex and many adjoining buildings. Before it was contained, around four in the afternoon, many of those buildings had also been destroyed, including most of the wooden structures in the center of the daguerreotype. When it was over, nearly 860 people were out of work. The fire's location was given much of the blame for its unmanageability, for firemen could not reach the fourth floor, inside or out, to fight its early stages. This helplessness is suggested by the daguerreotype, where people in their shirtsleeves gather in backyards to gaze upward as the black smoke spreads ominously across the roofline. Van Altsin's photograph is also remarkable for being a very early image of such a topical event. It is unlikely that he knew about George N. Barnard (no. 35), the daguerreotypist in Oswego, New York, who made two views of a great fire that consumed the Ames Mills a year earlier. Those sixth-plate daguerreotypes are generally acknowledged to be the earliest American news photographs.[21]

Thomas N. Hathaway was Van Alstin's assistant, and perhaps his student.[22] When the photographer was abroad, Hathaway managed his Union Block daguerreotype studio. Later he operated the shop at 197 Main Street in partnership with his younger brother. William N. Hathaway had begun

his career as a doorplate maker and bell hanger, and by 1852 he was working as a daguerreotypist in New Bedford, Massachusetts. At their Worcester studio, the brothers touted their use of Van Altsin's award-winning daguerreotype process, but within the year they had shifted their speciality to AMBROTYPE.

One of the Hathaways' most interesting extant works is their ambrotype portrait *Joshua Stoddard with His Steam Calliope* (fig. 7).[23] A retiring beekeeper who lived near Curtis Pond at Webster Square, Stoddard was also an inventor.[24] He developed the first practical steam-powered musical instrument, with a coal- or wood-fired boiler to develop steam that was forced through pitched metal whistles, each actuated by pressure on a key. In 1855 Stoddard received a patent for his design, which employed a unique puppet valve with a rotating studded barrel. He named his instrument the "calliope" after the Greek muse of eloquence and epic poetry. In the Hathaways' ambrotype he stands beside an early fifteen-pipe calliope; later models had thirty-two and perhaps as many as fifty-eight pipes.

Stoddard dreamed of outfitting churches with calliopes to call worshippers from afar. In 1856, he opened the American Steam Piano Company at Southbridge Street and Quinsigamond Avenue. He took his instrument to a political rally in Fitchburg and a Sunday afternoon concert in Springfield. The instruments were difficult to play, with their deafening volume, hot brass keys, showers of sparks, and plumes of steam.[25] In August 1856, the side-wheel tugboat *Union* carried a calliope through the waters around New York City, and the instrument became a permanent attraction on the Hudson River passenger steamer *Glen Cove*. The calliope's strident melodies could herald an approaching steamboat from five miles up river, and draw people across town for a circus parade. P. T. Barnum bought an instrument and mounted it onto an extravagant red and gold wagon, that was drawn by eight matched Percheron horses. Soon the calliope had become a symbol of the American traveling circus.[26]

Stoddard's calliope and the Hathaways' ambrotype reflect the willing acceptance of new technology in Worcester, a city of inventors, mechanics, and manufacturers. In the later nineteenth century, artisan-entrepreneurs such as Edwin B. Luce and Langdon B. Wheaton made photography more accessible in the city through their photography processing and supply companies, both of which continued to thrive through the twentieth century.

"How charming it would be, if it were possible to cause these natural images to imprint themselves durably, and remain fixed upon the paper!"[1] wrote **WILLIAM HENRY FOX TALBOT (1)** in 1833, describing his struggles to trace a drawing from the reflected image in a CAMERA LUCIDA. Later he experimented with light-sensitive chemistry, sharing his investigations with his friend, the eminent scientist Sir John Herschel.[2] A breakthrough came when Talbot prepared paper with a solution of table salt and silver nitrate. He placed plants or lace on the sheets and exposed them to sunlight. He called the images "photogenic drawings," associating them with art instead of with physics or chemistry.[3]

As a schoolboy at Harrow, Talbot was known for his experiments and explosions.[4] He used invisible ink to write to his sisters, who washed the letters in chemicals to unlock their secrets. Talbot conducted hundreds of experiments before his crucial discovery, the negative-positive process that he called the CALOTYPE, from the Greek word for beauty, *kalos*. In summer 1835, he produced his first negative on paper, the tiny image of an oriel window at his family estate in Wiltshire, Lacock Abbey. This advancement enabled Talbot to make many prints from one negative, and it remained the basic principle of chemical photography through the twentieth century. He announced his invention and exhibited his work at the Royal Institution in January 1839, just weeks after Louis-Jacques-Mandé Daguerre introduced his own process in Paris.

This view across the river Thames in London, to the Hungerford pedestrian bridge, exemplifies the character of Talbot's photographs. In 1841 the great engineer Isambard Kingdom Brunel began construction of the chain bridge, which was nearly 1,400 feet long and just 14 feet wide.[5] Talbot's photograph must date from soon after the span opened on May 1, 1845.[6] The image symbolizes Victorian culture and industry, and their challenge of nature. The bridge towers soar, appearing more solid and muscular by comparison to the willowy masts of nearby working boats. Their arched windows insistently point heavenward. Beneath the span, coal barges line the Thames, and rutted mud around the vessels evidences the labor they demand. Smokestacks, a prominent shot tower, and church steeples echo softening vertical notes as they seem to disappear into the distant London fog. The many workers on the river moved too quickly for Talbot's long exposure to capture them, and their seeming absence gives this image its peculiar silence. That very quiet, however, emphasizes the scale, strength, and robustness of the architecture and equipment, causing us to contemplate the power and majesty of the Victorian achievement. Ironically, the demands of the changing culture quickly made the Hungerford Bridge obsolete. It was demolished in 1860 to be replaced by the Charing Cross Railway Bridge, which remains there today.

Talbot mounted his photographs onto pages printed with typography, and published them in *The Pencil of Nature*, the first commercial book illustrated with photographs.[7] However, his curiosity soon drifted away from photography. "I do not profess to have perfected an art," Talbot later wrote, "but to have commenced one."[8]

In the early years of photography, partners **HILL AND ADAMSON (2)** synthesized the new technology with traditional artists' concepts and ideals. Hill was a leading portrait painter in Edinburgh, and his brother was one of Scotland's leading print publishers; together they conceived the portrait project that led the artist to photography.[9] In spring 1842, a faction of dissatisfied ministers broke away from the Church of Scotland. At an Edinburgh convention, 470 clergymen signed a Deed of Demission to found the Free Church of Scotland. D. O. Hill was one among many Scots who admired this brave act of conscience. He planned a commemorative painting of the Disruption, including all those present, that could be reproduced as a saleable engraving. His friend, Sir David Brewster — a colleague of William Henry Fox Talbot — persuaded him that photography could capture the features of each cleric and be

1

William Henry Fox Talbot
English, 1800–1877

The Hungerford Bridge, London, about 1845

Salted paper print
from calotype negative
17.4 x 20.9 cm
Stoddard Acquisition Fund,
1987.178

2

David Octavius Hill
Scottish, 1802–1870
and
Robert Adamson
Scottish, 1821–1848

Six Gentlemen, Edinburgh,
1845

Salted paper print
from calotype negative
23.5 x 27.6 cm
Gift of Mrs. Roger Kinnicutt,
1966.50

used later as accurate studies for his painting. Brewster introduced Hill to Robert Adamson, a young engineer who had just opened his own Edinburgh photography studio.

Hill and Adamson began taking photographic portraits in June 1843. The painter posed the sitters, and the photographer exposed and processed the negatives, then made the paper prints. Sitters were each photographed in profile and full face, and ministers were posed in groups of up to twenty-five, as if gathered in discussion. *Six Gentlemen, Edinburgh* is one of those studies, depicting the ministers surrounding a document as if discussing the Deed of Demission with Alexander Campbell Fraser, a noted professor at Edinburgh University.[10] They are gathered around a covered table, before a curtained backdrop in a makeshift outdoor studio. This still image suggests movement and animation. The sitters all avert their eyes from the harsh sunlight required by the LENS and CALOTYPE NEGATIVE. At first their postures and attention seem natural and conversational. However, one can see how each hand and elbow is balanced on an immobile surface, and each angled body leans on a stable object, so that these attitudes could be sustained for the duration of a long EXPOSURE. Hill arranged the composition around the geometric elements of the rectangular framed document, the strong circle marked by the underside of the brim of a tall hat, and the parallelogram of a thick book. Aside from the studies of each of the sitters, Hill and Adamson also photographed variant group poses of most of the same men.[11]

It took Hill and Adamson over a year to collect the portraits of all the Free Church clerics. During that time they developed a comfortable working relationship. Soon they found models among the upper middle class of Edinburgh. Over the next four years, the partners produced over 3,000 photographs, including portraits, landscapes, architectural studies, and the earliest social-documentary photographs, in the extensive series on the Newhaven fishermen and women. Hill and Adamson were the first to take the camera out of the studio, to capture people of all walks of life in their natural surroundings. Their partnership ended with Adamson's death in early 1848. A decade later Hill worked with another photographer in Glasgow, but produced little to compare to his earlier collaborations. It was not until 1867 that Hill finally completed his painting, *Signing of the Deed of Demission*.[12]

Hill and Adamson conceived photography as an artistic process, but its techniques were known primarily in the scientific community. **ANNA ATKINS (3)** combined both art and science in her work. She was the only child of John George Children, a keeper in the Department of Natural History at the British Museum.[13] By her early twenties she was skilled enough to draw specimens for the illustrations for her father's translation of Jean Baptiste Lamarck's "Genera of Shells."[14] The quality of these designs shows that they were not her first, and she remained an enthusiastic watercolorist throughout her life.[15]

In 1825, Anna Children married John Pelly Atkins, a county sheriff and railway promoter who owned coffee plantations in Jamaica. After retiring, John Children served as Secretary of the Royal Society, and he presided over its meeting in February 1839, when William Henry Fox Talbot (no. 1) first disclosed his "photogenic drawing" process. However Atkins's use of photography came directly from her acquaintance with her father's close colleague and family friend, Sir John Herschel. He conducted studies of the effects of light on chemicals, and first recognized that HYPO could FIX photographic images on paper. In 1842, Herschel devised a simple CYANOTYPE process, in which an object or photographic negative was placed on top of the sensitized sheet and exposed to the rays of the sun. The process soon became an entertaining game for everyone in the Herschel household. Their amusement undoubtedly convinced Anna Atkins that the process was ideal for recording the form of natural objects.

By this time Atkins had a deep interest in botany. Collecting aquatic plants was then a popular pastime, but she was a serious scientist who collected purposefully and traded specimens. The blue color of cyanotype may have given her the idea of using the process to record aquatic plants. Atkins carefully arranged them in compositions similar to traditional specimens in scrapbooks and botanical prints. Near the bottom of each image she placed an identifying inscription in a label or cartouche. Her captions and text pages were written in opaque ink on sheets made translucent with oil and then placed over the sensitized paper. Atkins produced hundreds of cyanotypes and collected them in *British Algae*, a publication conceived to illustrate William Henry Harvey's *Manual of Algae*, the handbook of professional and amateur botanists.[16] By the time she completed the book, in summer 1853, Atkins was sharing her PHOTOGRAM hobby with Anne Dixon, her closest friend since childhood.

Honey Locust Leaf Pod is a plate from *Cyanotypes of British and Foreign Flowering Plants and Ferns*, an album that Atkins gave to Dixon as a gift in 1854.[17] The folio included 160 plates with three photograms mounted on each page. By that time Atkins's compositions had become livelier, and her photograms depicted a variety of objects, like lace, feathers, and ferns. The photogram of an American plant — *Gleditsia tricanthos* — demonstrates her continuing interest in botany, and suggests that

3

Anna Atkins
English, 1799–1871

Honey Locust Leaf Pod,
about 1854

Cyanotype
34.0 x 24.5 cm
Stoddard Acquistion Fund,
1989.9

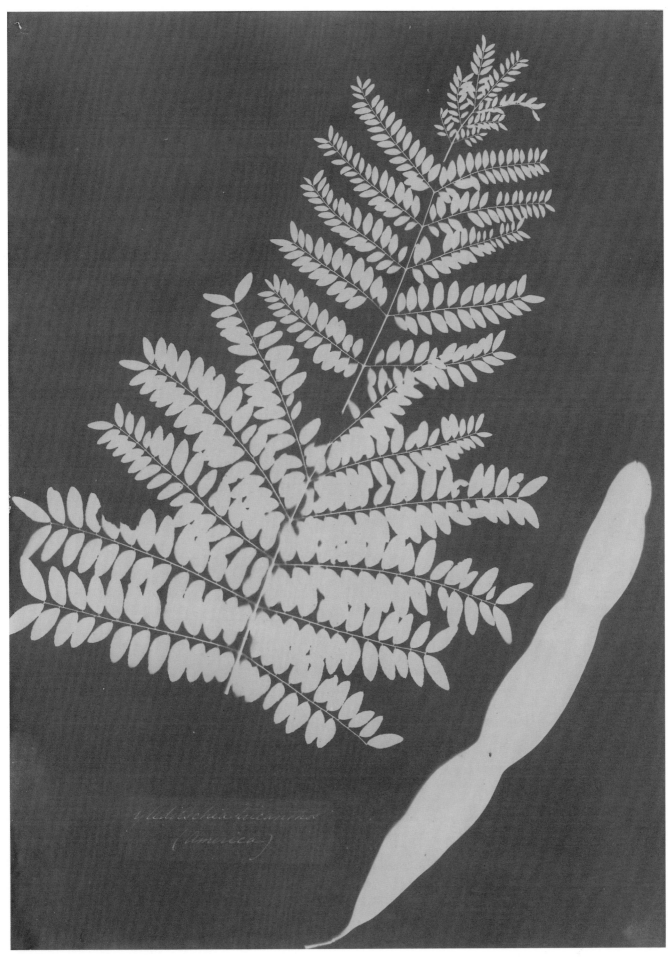

Mellechia tricemma
(America)

3

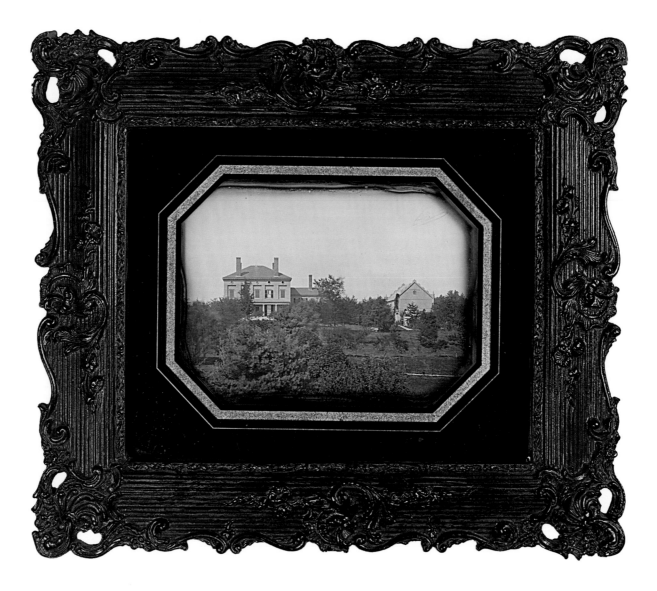

4

4

Unknown photographer
American, nineteenth
century

Salisbury House, Worcester,
1850s

Daguerreotype, full plate
16.2 x 21.2 cm
Bequest of Stephen
Salisbury, III, 1907.601

she continued using her father's wide scientific associations, and perhaps her husband's Caribbean contacts, to supply her curiosity and her collection.

During the 1840s, paper photography was eclipsed by the DAGUERREOTYPE, the method of producing unique positive images patented by Louis-Jacques-Mandé Daguerre.[18] Daguerre began his career in a panorama painter's studio in Paris. Later, he became an independent theatrical designer, dazzling audiences with illusions that combined large perspectival images with precise details cast onto canvas by a CAMERA OBSCURA. Building upon the investigations he shared with Nicéphore Niépce, Daguerre developed a photographic process that was presented by the French Sciences Academy on August 19, 1839.

Daguerre manufactured and sold cameras and materials, licensing the process to operators who opened their own studios throughout Europe and in the United States. His process was an instant sensation in the United States, where it became deeply seated and lasted longer than anywhere else.[19] Following the American journey of François

Fauvel-Gouraud, Daguerre's assistant and agent in fall 1839, studios sprang up across the country. Even in country villages, traveling photographers served middle-class consumers. In 1853, Daguerre's patent expired and anyone could open a studio without product licensing.

This remarkable daguerreotype **(4)** represents the showplace *Salisbury House*, the seat of Worcester's leading family in the nineteenth century.[20] Stephen Salisbury, a Boston hardware and merchandise importer, had come to Worcester in 1767 to open a branch store. He sold to both merchants and individuals, and quickly became the leading retailer in central Massachusetts. The store in Lincoln Square grew steadily, and he bought the adjacent farm and built a large house known as the Salisbury Mansion. His son, Stephen Salisbury II, who was born there, grew up to graduate from Harvard College, study law, and become one of Worcester's most influential businessmen.[21] He helped run local banks and railroads, became a major property owner and industrial developer, held city offices, and served as a state representative and senator. He was also a social and cultural

leader, member of the Massachusetts Historical Society, president of the American Antiquarian Society, and founder, benefactor, and first president of Worcester Polytechnic Institute.

Stephen Salisbury II married Rebekah Scott Dean in 1833, and two years later, soon after the birth of their son, he began planning for a new house.[22] The estate was designed by Elias Carter and sited on the hillside overlooking the Lincoln Square store and his parents' home. The main block of Salisbury House stands today near its original location. Each of its equal facades has four recessed bays, containing windows and surmounted by a bas-relief wreath. Records describe its original interior and main outbuildings, including woodhouse, coach house, and stables. The project was nearing completion in spring 1838, when William Kendrick of Newton supplied fruit trees and many varieties of flowers, including roses, lilies, dahlias, buckthorn, and cockspur. The lush daguerreotype view represents the east front of the house facing toward Lincoln Square, when the garden was full and the outbuildings were in place. The full-plate daguerreotype is pendant to a view of the Salisbury Mansion, Stephen Salisbury's Federal Period home as it stood in Lincoln Square.[23]

The dissemination of the daguerreotype in the United States is also reflected in *A Bull Calf* (5). The photograph was probably made for Stephen Salisbury II who, like his father before him, bred livestock as a hobby. Though the family led the county's business community, they also maintained a working farm, producing food for their own table and cementing relationships with the farmers who were their neighbors and customers.

This daguerreotype is one of three related portraits of cattle in the Museum collection; the others depict a cow and a heifer of the same breed, standing before the same fence as this vivacious calf.[24] An Ayrshire or Guernsey, he may have been acquired to be a herd bull. In the mid-nineteenth century, cattle were selectively imported to develop and improve American herds. Guernseys were first brought from Britain to New York in 1840, and importation to New England continued gradually up to the Civil War. If this was an imported calf, he would have been a rare and valuable animal, and appropriate for a photographic portrait.[25]

For many years Stephen Salisbury II was a prominent member of the Worcester County Agricultural Society, founded in 1789 to share agricultural technology. He was organizer, judge, and exhibitor at the Society's Annual Fair, which drew exhibitors from across central Massachusetts.[26] Other livestock and produce were also shown, but cattle were the chief attraction. "On the day of the fair," wrote Salisbury's teenage son in 1850, "the town is crowded with strangers of both sexes and all ages. The store keepers look forward to this day with great expectation, and lay on an additional supply of goods for the occasion, and the streets are thronged with peddler's carts, hand wagons, puppet shows and auctions on a small scale. A dinner is provided in a large hall, which proves to be of great advantage to the Association; for to people unaccustomed to these things a luxurious dinner is a great rarity. In the evening, there is a Grand Ball, at which all the dress and fashion of the County assemble, to dance on their fantastic toes. Many people come from a great distance to attend the festival, which has invariably met with everybody's expectation if not exceeded it."[27]

So far it has not been possible to determine the creator of these bovine portraits. Their copper

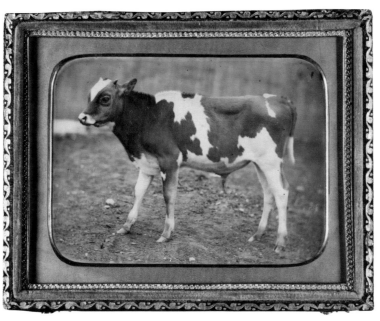

5

plates were trimmed unevenly by hand, perhaps suggesting the work of a traveling photographer. Advertisements for itinerant daguerreotype portraitists first appeared in Worcester newspapers in 1841, and they often attended county fairs, where potential customers from the countryside were encouraged by the festivity to splurge. However, the daguerreotypes may have been made early in the career of a Worcester photographer, before he could afford to affix any trademarks to his plates or casings. In late 1841 the *Worcester Spy* announced the Main Street business of George Evans as a manufacturer and dealer in daguerreotype equipment, who could provide "photographic miniatures taken in a few seconds."[28] George Adams had studios in Worcester, at various locations, for twenty years. There is no evidence that Adams photographed outside his studio, but he trained several daguerreotypists who later practiced independently in Worcester. One of them, Andrew Wemple Van Altsin, did take his camera into the streets, but made daguerreotypes in a very different style.

Daguerreotype portraits far outnumbered figural, still life, and landscape images and dominated the industry in the mid-nineteenth century. Though there were hundreds of portraitists in the United States, Mathew Brady's (no. 33) rooms became prominent in New York, the Southworth and Hawes studio was considered the finest in Boston, and **MARCUS AURELIUS ROOT (6)** was the leading portraitist in Philadelphia. According to family legend, he was the first child born of European parents in Licking County, Ohio.[29] His father named him after the Roman emperor and stoic philosopher of the second century, and hoped the boy would inherit his pioneer homestead. Root was more interested in drawing than farming, however, and after briefly attending Ohio University, he studied penmanship. In Philadelphia he studied with the painter Thomas Sully, who encouraged him to pursue the more secure and lucrative profession of a writing master. After opening his own writing school in Philadelphia, he published several books on penmanship.[30] Root learned the daguerreotype process from Robert Cornelius in 1843 and worked as an operator in other studios while saving the money to purchase J. A. E. Mayall's studio in 1846. Root's shop at 140 Chestnut Street quickly became one of the largest daguerreotype portrait studios in the country. Root published introductory articles on daguerreotypy, while the popular humorist, Timothy Shay Arthur, poked gently at hapless customers visiting Root's studio and described the process of sitting for a portrait.[31] From the late 1840s many prominent visitors to Philadelphia had Root make their portraits, including the author Edgar Allen Poe, the Swedish soprano Jenny Lind, and politicians Henry Clay, Daniel Webster, and Dorothea Dix.

Dix was a celebrated teacher, writer, and social worker, and the era's most influential woman in politics for her efforts to improve the understanding and treatment of mental illness.[32] The daughter of an alcoholic minister, she had a troubled childhood. She became a teacher, opened her own school for young women in Boston, and in 1824 was nationally recognized for her book for young readers, *Conversations on Common Things*.[33] When Dix's grandmother died in 1837, an inheritance enabled her to retire from teaching. Inspired by English reformers, she investigated the treatment of the insane in Massachusetts. Dix found appalling abuse and living conditions, and rallied prominent reformers in an appeal to the government. In 1843, the Massachusetts Legislature appropriated funds to provide for the mentally ill at the Worcester State Hospital. This success encouraged Dix to survey conditions across much of the Midwest and South. In 1848 she began fighting for federal reform of the treatment of mentally ill, blind, deaf, and mute people.

This daguerreotype is one from a group of portraits thought to have been made in 1848, when Dix was in Philadelphia after Congress had deferred her land-grant bill.[34] Other plates from the sitting show her looking directly at the camera in varied poses. In his technical manual on daguerreotypy, *The Camera and the Pencil*, Root recommended photographing women in elegant dress to reflect their femininity. "A lady's costume should receive special attention . . . ," he wrote, "to give it an appearance of amplitude and of falling from the figure in many graceful folds." However, Root posed Dix in an attitude usually reserved for accomplished men. "The most intellectual expression of a gentleman's face and head is generally gotten from the side showing the parting of the hair, as the intellectual organs are thus brought into view."[35]

Daguerreotypes were more popular in the United States than anywhere else. Improving and refining the process, Americans claimed three of the five medals awarded for daguerreotypes at the Great Exhibition in London in 1851. Since the technique was fairly simple, throngs of hopeful entrepreneurs opened their own studios. In the year ending June 1, 1855, the Commonwealth of Massachusetts recorded the sale of 403,626 daguerreotypes statewide. However, New York was the national capital for daguerreotypy, with eighty-six studios in operation. The leading shops were those of Mathew Brady (no. 33), Martin M. Lawrence, Jeremiah Gurney, and **RUFUS ANSON (7)**, which were clustered along Broadway, the city's smart promenade on weekends and summer evenings.

Little is known about Anson, who may have been born and raised in Duchess County, New York.[36] He first appears as a daguerreotypist in the

6

Marcus Aurelius Root
American, 1808–1888

Dorothea Dix, about 1848

Daguerreotype, half plate
14.0 x 10.5 cm
Gift of Mrs. William F.
Abbott, 1915.30

New York City Directory in 1852; the following year his address was 589 Broadway, near the most elegant studios. Anson was the "first to have the foresight and courage to risk seven or eight thousand dollars, in fitting a ground-floor reception room," wrote M. A. Root, "and pay $4,000 per annum for rent alone, for the single purpose of prosecuting our art. . . . His bold venture was justified by the speedy increase of his business fourfold."[37]

Daguerreotypists located their studios on the top floor so sunlight could illuminate their exposures, employing summer decks, skylights, glass walls, and reflectors to make the most of the light. At street level, cases displayed their work. Their reception rooms competed in elegance, comfort, and amusement, so that once customers arrived they were willing to wait their turns. "Anson's gallery is decidedly superior," wrote H. H. Snelling, editor of *Photographic and Fine Art Journal*, in early 1856. "It is most tasteful in its arrangement, and great order and cleanliness are preserved throughout. The specimens all show the artist's hand. The gallery deserves the most liberal patronage."[38]

The presentation of Anson's *Portrait of a Young Girl* reflects this taste and quality, in its leather case with the firm's name cut into the velvet lining and stamped into its brass preservers. In her ringlets and chintz frock, this girl appears proper. She

7

Rufus Anson
American, about
1821–1866

Portrait of a Young Girl,
about 1858

Daguerreotype with hand
coloring, quarter plate
8.2 x 6.9 cm
Gift of Mrs. Albert W. Rice,
1974.119

7

stands erect and attentive, leaning on a covered table with an open book beside her. The quarter-plate daguerreotype miniature is delicately tinted with pink and green watercolor, picking out the flowered fabrics, giving a blush to the girl's cheeks, and tightening her lips to a rosebud. The girl seems relaxed, but her direct and piercing gaze suggests an intense character. Since the subject had to remain still for about half a minute's exposure time, this combination of ease and personality was difficult to achieve. An operator who could capture this concentration and natural expression from a child was a skilled craftsman indeed. The image is formed on plate heavily silvered by electroplating, and hallmarked by the maker Holmes, Booth, and Hayden, a photographic supplier who had a shop in Anson's Broadway neighborhood.[39]

Daguerreotypes were also produced in the STEREOGRAPH format to impart a remarkable sense of space when seen through a stereoscopic viewer. The stereograph of a female nude attributed to **LAURE MATHILDE GOUIN BRAQUEHAIS (8)** was made in the mid-1850s. Nude figures first appeared in costly photographs for connoisseurs bearing the cachet of refinement and sophistication. Painters from Eugène Delacroix to Edgar Degas created their own nude photographs to use in place of living models, and many other artists collected nude images for this purpose. At the same time, there was a thriving demand for photographs that were more erotic than aesthetic. Often inferior in technique, these pictures appealed to collectors previously devoted to libidinous prints by artists such as Achille Deveria and Eugène Guerard.

In the mid-nineteenth century Paris was the European center for nude photography. Many commercial photographers produced erotic images as a lucrative sideline, often choosing not to sign this secondary work.[40] Bruno Braquehais proudly stamped many of his nude photographs. By 1850 he was producing color daguerreotypes in a studio in the Place de la Madeleine. He often placed models in exotic-looking settings reminiscent of the Near East, or posed them as in Old Master paintings. In Braquehais's photographs the models often seem isolated and indifferent, but his great skill in lighting gave sensuality to his nudes.

Braquehais was a mute, and his friend Felix Jacques-Antoine Moulin spoke for him at meetings of the Société Française de Photographie. Another colleague in the daguerrean fraternity was Alexis Gouin, a portraitist who also made nude studies. Around 1852, Braquehais contracted Gouin's daughter, Laure, to color his daguerreotypes and stereoscopic prints on waxed cloth.[41] In addition to her skill as a painter, she was an accomplished photographer.[42] Soon after Gouin's death in 1855, she and Braquehais married and took over her father's studio on rue Louis-le-Grand as partners. In 1863, Bruno and Laure Braquehais opened a new studio at 11 Boulevard des Italiens, under the name Gouin-Braquehais. The firm specialized in daguerreotypes and became the last professionals to employ the technique in Paris. The husband and wife created portraits and nudes, each retaining the working habits and scenic props they preferred before their marriage. Format also distinguished their work, for Bruno Braquehais continued to use two sixth-plate daguerreotypes for his stereographs, while Laure Braquehais preferred a single third-plate, as her father had taught her. Thus,

8

8

the format of the present daguerreotype supports an attribution to Laure Braquehais.[43] Like her father, she posed her figures to see their faces, and often photographed models who confronted the lens directly, in moments of friendly sympathy. Moreover, Laure Braquehais preferred settings, described by furniture, draperies, and staffage, that were contemporary to her time.

The pioneering amateur photographer **LOUIS-ADOLPHE HUMBERT DE MOLARD (9)** was unusual for the visual refinement of his work and its relationship with the fine arts. Born in Paris, the son of a baron of the Second Empire, he succeeded brilliantly in everything he tried.[44] He was even described as *escamoteur* — a conjurer — a proclivity that may have come from his uncle, Louis-Marc-Antoine Robillard d'Argentelle, who was noted in

Parisian salons for his magic tricks. When he died in 1828, Robillard left his nephew a small manor house and country estate at Argentelle, in the Calvados region, and his "Carporama," a collection of botanical models that he had made in wax.[45] In 1832, Humbert and his new wife settled in a fashionable apartment in Paris, where he became the keeper and guide to the Carporama. When his wife died in 1839, Humbert's friend Hippolyte Bayard taught him the techniques of photography to distract him from grief. The mysterious, almost alchemical qualities of the process appealed to this conjurer. He became an accomplished daguerreotypist, refined his cameras, and developed methods of using ALBUMEN on both glass and paper negatives. In August 1850 he exhibited portraits made by his own technique of albumen negatives on glass to the Académie des Sciences.

9

9

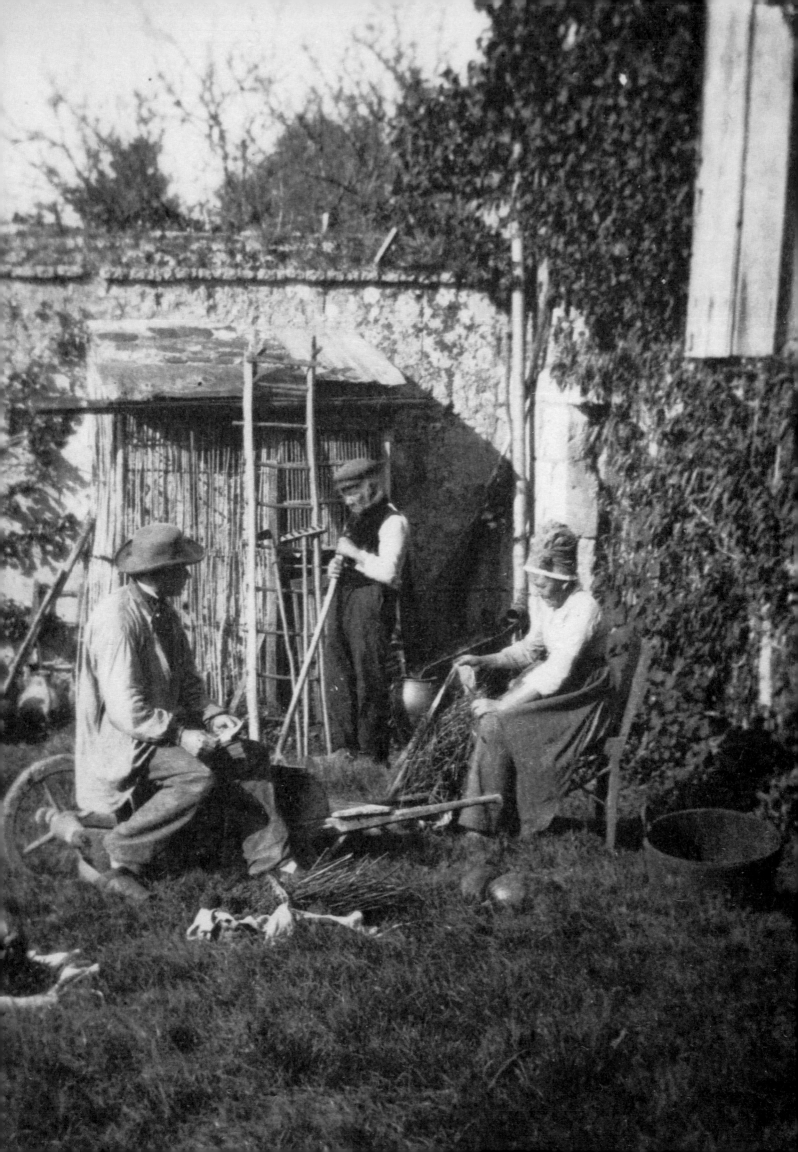

In its style, imagery, and technique, *The Visit* is typical of Humbert's works around 1850. It was taken in the garden of his manor at Argentelle, where he photographed many staged genre scenes of country life, including peasants and hunters posed against real or constructed backgrounds. Barrels, glazed pots, hoes, and rakes ornament the staged setting of this image, but its subject is not entirely clear. A bourgeois gentleman in a tie and broad hat appears to be visiting an elderly couple. Seated on a wheelbarrow, he holds a piece of paper in his hands. The old woman sits to converse with her visitor, who stares at her with rapt attention as she works. Humbert's salted paper process provided rich detail, unprecedented in paper photographs of his day. It required long exposures, however, that made his figures appear stiff and detached. Like William Henry Fox Talbot (no. 1), Humbert looked to Old Master paintings as models, and his images are reminiscent of the work of seventeenth-century Dutch painters like Pieter de Hooch or Adrien van Ostade, and French artists like the Le Nain brothers and Jean-Baptiste-Siméon Chardin. They are quite different, however, from the contemporaneous paintings of Jean-François Millet, or the photographs of Charles Nègre (no. 16) that reflect the filth, drudgery, and dignity of hard work. Humbert's peasants are romantic types, washed and well dressed, fitting harmoniously into balanced compositions. These images were expressive literary vehicles evocative for Victorian eyes, but they are ultimately still lifes, with the overtones of the wax museum.

AMBROTYPE, or collodion positive, is a variation of a technique that superseded both the daguerreotype and the calotype processes in the 1850s.[46] It remained the principal method of photography for the next quarter century. **JAMES AMBROSE CUTTING (10)** pioneered the technique in the United States. His controversial patent on the process overshadowed his photographic career.

Cutting was born in New Hampshire, and grew up on a modest farm near Haverhill, Massachusetts.[47] Beekeeping contributed to his family's livelihood, and Cutting made his own refinements to his hives. In 1844, he was granted a patent for his beehive design, which he began to manufacture. The success enabled him to move to Boston, where he became interested in photography. Cutting had his own daguerreotype studio in 1853. Continually experimenting with photographic techniques, he worked to refine the COLLODION process published by Frederick Scott Archer in England. In April 1854 Cutting was granted patents for three modifications of the collodion process, including ambrotype, which he named from the

10

James Ambrose Cutting
American, 1814–1867

Portrait of a Man, about 1855

Ambrotype with hand-coloring
6.2 x 5.0 cm
Bequest of Stephen Salisbury, III, 1907.584

10

Greek words for "immortal" and "print" while making a pun on his own name.[48] Many American photographers objected to restrictions placed on processes that had been in common use for years, and his patents were legally contested. Cutting was ever afterwards plagued by the divisions that the issue caused in the American photographic community and probably earned very little from the patents. In October 1856, *The Photographic and Fine Art Journal* announced that Cutting had taken A. A. Turner as his partner in the Boston Gallery of Art, on stylish Tremont Row. Turner provided the technical expertise and craftsmanship to complement Cutting's considerable business skills. "The reception room is on the first floor and is to be furnished in the most refined and elegant style, while the operating rooms are to be replete with every convenience. A large amount of capital is to be invested, and those who know the gentlemen will feel assured that taste will not be wanting in any department."[49] Cutting also joined with Lodowick H. Bradford in the invention of a method of PHOTOLITHOGRAPHY (no. 31).

Cutting's tiny ambrotype *Portrait of a Man*, mounted in a stamped brass mat, is contained in a leather cased lined with cut velvet. Posed before a featureless background, the middle-aged man confronts the camera directly, his penetrating blue eyes projecting a reassuring self-confidence. Since the process was easier, and the materials cheaper than for a daguerreotype, the ambrotype was a small, relatively inexpensive keepsake, without frills or pretension. However, the direct, sober image of a practical New Englander shines intensely from the image.

2 | Topographical and Travel Photography

Photography enabled viewers to see places they had read and dreamed about, and travel and topographical images were among the first to be captured and widely distributed via photography. For the French, Egypt carried a profound fascination in the early nineteenth century. The mysteries of an ancient civilization, and Napoleon's recent adventures there, imbued the distant land with powerful Romantic significance and intellectual fascination. The reveries were excited by Baron Vivant Denon's influential account of Napoleon's campaign, *Voyage dans la Basse et la Haute Égypte*, and by Victor Hugo's prose poem *Les Orientales*.[1]

Like many of his contemporaries, the young **MAXIME DU CAMP (11)** dreamed about the East.[2] As a schoolboy he read *Les Orientales*, and later he studied Egyptology and Arabic literature as a member of the Société Orientale. In 1849 he and his friend, the writer Gustave Flaubert, applied for a government grant to tour the East and document their travels in prose and photographs. They won the commission, partially on the strength of Du Camp's earlier books about Brittany and North Africa. Gustave Le Gray (no. 20) taught him the fundamentals of photography, and the Académie des Inscriptions et Belles-Lettres provided a list of sites and monuments to be photographed.

The companions toured Egypt, Nubia, Syria, and Palestine, visiting modern cities, villages, and encampments, as well as the major archaeological sites. Du Camp joined in the desert treasure hunting then common. "I broke up some of the mum-

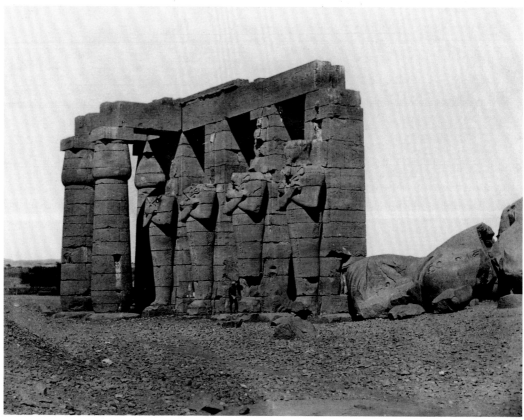

11

Maxime Du Camp
French, 1822–1894

The Peristyle of the Tomb of Osymandias, Qurna, 1850

Salted paper print from paper negative
16.8 x 22.1 cm
Eliza S. Paine Fund, 1990.30

11

12

Charles Marville
French, 1816–1879

The Open Gate, about 1853

Salted paper print from
calotype negative
15.8 x 20.8 cm
Eliza S. Paine Fund, 1987.81

12

mies, seeking scarabs in their bitumen-filled bellies," he later recalled of his visit to Thebes, "from one I took its gilded feet, from another its head with its long tresses of hair, from a third its dry, black hands."[3] In the blazing light and arid heat, photographing in the desert was a difficult task. The technical challenges of adapting processes of chemistry and physics developed in a temperate climate to a radically different environment were matched by the logistical problems of transporting cameras, chemicals, and fragile equipment by porters, camels, or mules.

The Peristyle of the Tomb of Osymandias, in the Valley of the Kings, is one of Du Camp's most famous images, published after his return to France. Osymandias was the name that Greek historians gave to Rameses II, the Egyptian Pharaoh of the Book of Exodus. He reigned for sixty-seven years over an empire that stretched to include present-day Iraq in the east, Turkey in the north, and Sudan in the south. Du Camp visited the site on May 9, 1850, and created an image to accompany the famous Romantic sonnet by Percy Byssche Shelley. The poet had been inspired by the colossal granite portrait of the Pharaoh in the British Museum, and imagined a traveler finding the crumbling monument in the sand. Du Camp's photograph suggests the scale of the tomb and its original grandeur and beauty. It evokes a meditation on the passage of time, for the grand temple of the greatest monarch of his epoch had become a ruin buried in rubble

and sand. "My name is Osymandias, King of Kings," reads the legend carved on the pedestal. "Look upon my works, ye Mighty, and despair!"[4]

Louis-Désiré Blanquart-Évrard, the audacious Lille merchant who printed Du Camp's photographs, pioneered photography publishing in France. He helped to popularize the CALOTYPE process there, but modified William Henry Fox Talbot's sensitizing procedure to avoid license fees. Like Talbot, he set up a photographic printing plant, the Imprimerie Photographique, at Loos-les-Lille. This establishment printed and published photographs, as French shops had long done with relief, intaglio, and planographic prints.

CHARLES MARVILLE (12) was among the first photographers to work with Blanquart-Évrard. Hundreds of his illustrations, carved into printing blocks by wood engravers, appeared in French magazines and books in the mid-nineteenth century.[5] Marville designed decorative letters, fillers, and narrative scenes, but his speciality was landscape. Outstanding among his works are the images in Charles Nodier's travel books *The Banks of the River Saone* and *The Banks of the River Seine*.[6] Marville's landscape ideas derived from the popular *Voyages pittoresque*, an enormous compendium of lithograph landscapes drawn by leading artists and published serially.[7] Soon after Marville made his first photographs in 1851, Blanquart-Évrard was printing and publishing them.[8]

The Open Gate was one of six of Marville's photographs published in 1853 in the album *Études photographiques*. In a modest way, this image combines an atmospheric natural landscape, the works of man, and a sense of the passage of time in a manner similar to images of the *Voyages pittoresque*. The simple image represents an open gate through a rustic fence, on a pathway that descends a hill and leads down a leafy avenue beside a pond and into the distance. Strong parallel diagonals, defined by the fence rails, draw the eye to the base of the path and into the composition. The dominant H-shape of the arbor portal provides a strong, stable, and inviting entry into a landscape of verdant fields, reedy ponds, and distant copses, beneath a shining sky. The open gate and receding path have an intriguing sense of possibility. The humility and invitation of this image are similar to one of Marville's illustration designs for a chapter headpiece. Landscape often engaged him early in his photographic career, though he became best known for his architectural work. His feeling for natural subjects is parallel to that of the painters of Barbizon, and to other photographers working in the Forest of Fontainebleau. Marville's 1854 calotype of Camille Corot and Narcisse Diaz de la Peña sitting on great boulders at Fontainebleau shows that he was acquainted with the artists.

Marville traveled as a photographer for Blanquart-Évrard, visiting Italy, Germany, and even Algeria. He documented the baptism of the Prince Imperial at Nôtre Dame in 1856, and photographed artworks in the Musée du Louvre. During the 1860s, the City of Paris commissioned Marville to photograph the city before, during, and after the sweeping urbanization projects of Baron Haussmann. He worked methodically, shooting each street in segments, from two vantage points, before demolition began. Then he photographed the successive stages of reconstruction along the dynamic lines of new boulevards.

Among the many photographers who pursued landscape with enthusiasm and inventiveness were the **BISSON BROTHERS (13)**, who helped build the foundations for professional photography in France. Their father, a heraldic and decorative painter, taught them to make daguerreotypes in 1840, after learning the process directly from Daguerre himself.[9] Soon the elder son, Louis-Auguste Bisson, was photographing for private and official commissions, and processing the photographs of others. In early 1841, he opened his own daguerreotype studio, drafting his brother — an inspector of weights and measures at Rambouillet — as his partner. Their busy shop near the Madeleine in Paris became a gathering place for photographers, artists, and intellectuals.

The Bissons produced a varied output, always concentrating on technical quality. They were among the first to photograph zoological specimens at the Museum of Natural History, and they produced a landmark series of daguerreotype portraits of the 900 members of the French National Assembly. They also made some of the first art reproductions for the Musée de Louvre, and photographed relief maps for Jean-Léons Sanis's European atlas. As the wet plate COLLODION process superseded daguerreotypy, the Bisson Brothers went directly to the large-format, glass-negative processes, bypassing PAPER NEGATIVES entirely. They published a popular line of architectural photographs, city views, and landscape views. The Bisson Brothers were among the founding members of the Société Française de Photographie, and were appointed official photographers to Emperor Napoléon III, and later to Pope Pius IX.

In the mid-1850s, the industrialist and glaciologist Daniel Dollfus-Ausset hired the Bissons to photograph the French Alps, and with his backing they opened a studio at 35 Boulevard des Capucines. Their first alpine photographs were straightforward records for topographical study. However, in 1860, when the brothers traveled with the imperial entourage to Savoy, they created a series of alpine views employing artistic conventions of landscape. On this journey Auguste-Rosalie Bisson became infatuated with Mount Blanc, Europe's highest mountain. The following year he returned to climb the mountain, along with twenty-five porters carrying cameras, a darktent, DEVELOPING chemicals and equipment, and large glass-plate NEGATIVES. Though the expedition failed to reach the summit, they ascended to nearly 16,000 feet. The selection of twenty-four photographs that resulted from the expedition transported viewers to exotic, inaccessible places within France. The most famous views from the series represent tiny figures on the *Mer de glace*, largest of the Mont Blanc glaciers.

The Chamonix Valley, Descent from Montauve, the final image in the series, shows the scene that climbers saw as they returned to the village of Chamonix, near the junction of France, Italy, and Switzerland, the starting point for glacier exploration. This well-ordered composition intentionally leads the viewer down and into the distance. Many of the Bissons' other alpine photographs of glaciers, peaks, and snowfields are also composed of almost geometricized natural forms, to convey the scale and natural forces of this remarkable environment. *Descent from Montauve*'s masterful composition seems at first glance to be centered around a strong vertical line, but is dominated by diagonals. The *repoussoir* elements in the foreground of rock, bushes, and fallen limbs have a precarious slant, pulling us down and to the right with almost palpable gravitational thrust. The diagonals of the flanking distant mountains seem to point to the center

13

13

Louis-Auguste Bisson
French, 1814–1876
and
Auguste-Rosalie Bisson
French, 1826–1900

The Chamonix Valley, Descent from Montauve, 1861

Albumen print from wet collodion negative
24.1 x 39.4 cm
Charlotte E. W. Buffington
Fund, 1993.75

of the composition, where the meandering Arve River also seems to meet at the base of the central pine tree. As the nexus of the composition and as the dominant vertical element, the soaring tree is the form with which we identify. It provides an emphatic upward arrow, symbolizing the human will to rise and climb. Though this image closes both the descent from the mountain trek and the photographic series, it reminds us of the purpose of the expedition, an aspiration that continues from this climb to the next.

When the Bissons exhibited their alpine photographs in their Paris studio, glowing reviews in the national press made them famous. Determined to summit Mont Blanc, Auguste-Rosalie Bisson returned to Chamonix in 1862. This time his expedition successfully reached its goal and produced additional, remarkable photographs of the Alps. However, critical praise for the Bissons' alpine photographs was not matched by sales. Their large, minutely detailed views could not be reduced in size and quality. As affordable STEREOGRAPHS and CARTES-DE-VISITE took over the market, the studio slumped into bankruptcy, and in 1863 they auctioned their stock and negatives.

One of the first Americans to create large photographic prints on paper was **SAMUEL MASURY (14)**, and his works are distinguished by aesthetic intention rare in this country in his day. After learning the processes of daguerreotype in 1842 from John Plumbe, Jr., in Boston, he opened a studio in his hometown of Salem, Massachusetts.[10] He joined S. W. Hartshorn in a second gallery in Providence, Rhode Island. An avid experimenter, he constantly improved his equipment and procedures, making photographs by reflected and artificial light. "By a recent discovery, I am prepared to take Miniatures in cloudy weather," Masury advertised in 1847, "and will warrant as good Pictures taken in cloudy, as in pleasant weather."[11] Soon afterward, he and Hartshorn took the celebrated daguerreotype of Edgar Allen Poe, a portrait that the author gave to his fiancée.[12] After selling his interest in the Providence gallery, in 1852 Masury opened a studio on Washington Street in Boston in partnership with George M. Silsbee. Two years later, both partners were injured in a studio explosion. It seems they were working with oxyhydrogen, or Drummond Light, and Masury was standing on a sixty-gallon bag of oxygen when the gas ignited and threw him across the room, destroying the shop front and breaking his leg.

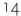

14

14

Samuel Masury
American, 1818–1874

*View of the Loring Estate
at Pride's Crossing, Beverly,
Massachusetts,* about 1856

Salted paper print from
calotype negative
25.3 x 33.7 cm
Eliza S. Paine Fund,
1987.40

In 1855 Masury traveled to France to study the latest photographic techniques. He worked with the Bisson Brothers (no. 13), and visited photographic manufacturers and suppliers. Masury also learned to use the calotype negative, and soon after his return to Boston, he advertised "daguerreotypes on paper." Since images from paper prints were readily transferred to wood blocks for engraving, illustrations based on his photographs appeared frequently in journals like *Ballou's Pictorial Drawing-Room Companion* and *Frank Leslie's Illustrated Newspaper.*

The Loring Estate at Pride's Crossing reveals Masury's artistic sophistication and demonstrates personal connections to artists parallel to those of French contemporary photographers. It is one of a handful of photographs he took at the Loring family compound on Cape Ann, north of Boston,[13] while a guest of his friend General Charles Greeley Loring, a prominent lawyer and the first director of the Museum of Fine Arts, Boston.[14] One of the

other photographs from the group, taken from a nearby vantage point, shows the painters John Frederick Kensett and J. A. Brown working at their easels. A canvas by Kensett also represents a similar view of the Beverly shore.[15] Together these works suggest a summer house party and reflect Loring's society with artists.

Masury's photographs of the Loring estate incorporate compositional elements found in contemporary painting. Like the Bissons' *Descent from Montauve,* the composition is organized around a central vertical axis, a pine tree highlighted by sun falling from behind the photographer. Against this stabilizing element are the receding diagonal coastline, and the vertiginous rise of rocks and hills from the sea. Two boys, sitting with their dog in the middle ground, facing out to sea, emphasize the evocative qualities of this image of light and atmosphere. This photograph evokes the magnificence of nature and the peaceful harmony of people within it.[16]

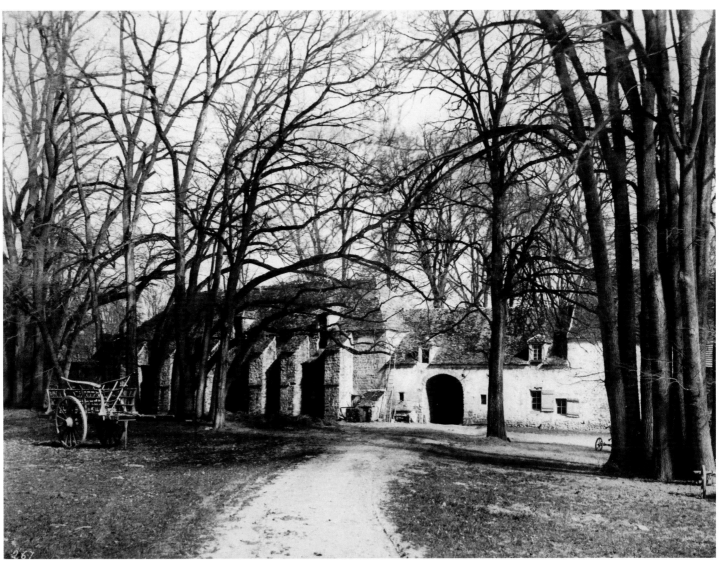

15

Many serious landscape photographers of the mid-nineteenth century associated closely with painters, who found inspiration in observable nature and everyday life. In France, Realism was the current style, characterized by the genre paintings of Gustave Courbet and the landscape of Jean Baptiste Camille Corot. Many of their followers settled near the village of Barbizon in the forest of Fontainebleau, including the photographer **EUGÈNE CUVELIER (15)**.

Cuvelier was born in the northern French city of Arras, where his father was a refiner and merchant of cooking oils and sugar.[17] Adalbert Cuvelier was also an amateur artist who photographed Arras, nearby farms, and portraits of peasants. He and two artist friends perfected the technique of CLICHÉ-VERRE.[18] Coating a glass plate with opaque pigment, they scratched a drawing through the film with a stylus, and then allowed the sun to print the image on sensitized photographic paper. The elder Cuvelier taught the process to many artists, includ-

ing Corot. Growing up near his father's friends and enthusiasms, Eugène Cuvelier developed his own interest for art and technology. He studied painting with Constant Dutilleux and Xavier Dourlens, but was more interested in mechanics. He designed and built a steamboat, a machine gun, and working models of steam locomotives. In 1873, these models were shown, alongside his photographs, in the exposition of art, agriculture, and industry in Arras.

Young Cuvelier first visited Barbizon in 1858. The following spring he married Louise Ganne, whose father kept the village inn where the artists gathered. This union placed him securely amidst the landscapists whose work led to the development of Impressionism. Cuvelier shared his father's *cliché-verre* technique with his friends, including Theodore Rousseau, Jean François Millet, and Charles-François Daubigny (fig.1), often printing their compositions.[19] Cuvelier and his wife settled down at the edge of the Fontainebleau forest, where he worked as a landscape painter and

Fig. 1. Charles François Daubigny, *The Goatherdess*, 1860s, *cliché-verre*.

16

Charles Nègre

French, 1820–1880

Harvesters near Grasse, 1865

Albumen print from wet collodion negative

15.0 x 15.0 cm

Stoddard Acquisition Fund, 1990.16

increasingly as a photographer. He employed both calotype and glass-plate collodion negatives for his paper prints. Concentrating chiefly on woodland views, he tried to capture the varied forest topography, and effects of light and atmosphere. Cuvelier used Claude-François Denecourt's famous walking guides to explore Fontainebleau, employing the author's identification of the picturesque sites to title his photographs.[20]

The Farmyard at the Château of Courance depicts a famous landmark about twenty kilometers west of Fontainebleau. Erected by a finance secretary for King Henri II in 1550, it was renovated in the early seventeenth century in the style of Louis XIII. Ignoring the moated château and elegant gardens, Cuvelier chose a segment of the outbuildings that seem timeless and informal. Their thick walls and heavy buttresses evoke the medieval architecture. Alternating shadows and highlights over the walls and windows create an engaging pattern. The shape of the buttressed wall is balanced and echoed by the copse of strong tree trunks, perhaps suggesting that the works of man echo the works of God. Despite the absence of the peasants who farmed the estate for centuries, the carts and garden tools evoke their labors. In Cuvelier's day, farming was carried on much as it had been for centuries. It was this genuine, honest, rusticity that fascinated painters like Millet, and other photographers such as Charles Nègre.

Throughout his career, **CHARLES NÈGRE (16)** worked simultaneously as a painter and photographer, believing the two disciplines should inform each other, and consequently produced an oeuvre more varied than his colleagues'. He was born at Grasse in the South of France, where his father had a small confectionary shop.[21] As a teenager he

studied drawing and moved to Paris in 1839 to study with Paul Delaroche at the Palais de l'Institut de France. Among his fellow students were Jean-François Millet and Charles Daubigny, who became painters, as well as Gustave Le Gray and Henri Le Secq (nos. 20, 17), who distinguished themselves as photographers. In 1843 Nègre started to exhibit at the Paris Salon, so he was already a painter of repute when he began making daguerreotypes the next year. His first photographs were of models posed in the studio as studies for his paintings.

Le Gray probably taught Nègre the paper negative technique, which he used to create images of activity in market squares and river quays. He used these images as models for his paintings and the intaglio prints he made with Le Secq.[22] Ernest Lacan, editor of *La Lumière*, later credited him with the invention of genre photography.[23] Using a combination of LENSES and calculated poses, he strove to create illusions of figural movement. In 1852, Nègre took his camera on his annual journey home to Provence, and photographed architectural and landscape monuments. In subsequent years he made hundreds of photographs of the region, sixty of which were published in the album *Le Midi de la France* (*The South of France*).[24] Nègre also experimented with PHOTOGRAVURE, and developed his own technique for the Duc de Luynes's competition for a viable photomechanical printing method. Although the technique was judged runner-up to Alphonse Poitevin's PHOTOLITHOGRAPHIC process,[25] the duke later commissioned a suite of photogravures from him, to illustrate his travel diary to the Holy Land.[26] In 1863, Nègre moved to Nice for his health, where he taught drawing at the Lycée Impérial and created a set of views of the South of France, conceived for sale to tourists.[27]

Harvesters near Grasse is one from Nègre's last series of Provençal photographs, a suite that included landscapes, picturesque sea views, and genre scenes. Its roundel shape was a format he used often; in this case, however, the image was cropped from a larger view in which another group of peasants toils in the middle ground at the left.[28] Nègre composed his images in spatial terms, defining illusionistic space with geometric objects, like the architectural haystacks. He also employed heavily modeled forms, such as the women's skirts and large hats, to suggest dimension and emphasize space. Nègre staged his composition thoughtfully, posing peasants as if they were moving, in contrast to distant laborers and blowing trees whose actual motion registered as blurs on the negative. For the city dwellers who were Nègre's audience, this picturesque image reflected country life close to nature, the sort extolled in the Realist paintings of Millet and Daubigny.

16

17

In 1851, the French government provided a potent artistic, scientific, and commercial legitimacy for photography when the Historic Monuments Commission of its Ministry of the Interior initiated the Mission héliographique, which employed photography to create a visual inventory of the country's architectural monuments.[29] The agency's director, Prosper Mérimée, appointed five leading photographers, Hippolyte Bayard, O. Mestral, Gustave Le Gray, Édouard Baldus (nos. 20, 25), and **HENRI LE SECQ (17)** to survey and document the country's architectural monuments and promote their preservation.

The son of a Parisian politician, Le Secq studied painting in the studio of Paul Delaroche at the École des Beaux-Arts.[30] In about 1848, he learned the techniques of photography from his fellow student Le Gray, at first using photography in preparation for his figural paintings. Le Secq created a series of masterful still lifes as well as landscape views that resemble the work of the Barbizon painters. When Paris faced the demolition and rebuilding campaigns of Baron Haussmann, Le Secq appointed himself documentarian of its historic architecture. With Charles Nègre (no. 16) — his atelier Delaroche colleague, and neighbor on the Île Saint Louis — Le Secq ventured into the medieval quarters of Paris, where they photographed the same subjects. Some of his early views of the city were printed by Louis-Désiré Blanquart-Évrard in Lille and published in the album *Paris photographique* of 1851. In that year, Le Secq was a founding member of the world's first photographic organization, the Société héliographique, along with Leon de Laborde, who also served on the Historic Monuments Commission and may have influenced the photographer's appointment to the *Mission héliographique*. To accomplish its survey systematically, the project divided the country geographically, sending the five photographers to different regions where they photographed the historical buildings, documenting their state of repair and identifying those requiring urgent restoration. Le Secq toured the regions of Alsace, Lorraine, and Champagne, which included some of the country's greatest Gothic architecture. One of the most magnificent monuments was the Cathedral of Nôtre Dame in Rheims. Constructed in the thirteenth century, it was the traditional coronation site for French kings until 1830. Portrait sculptures of the monarchs adorn the arcade.

The Tower of the Kings, the south tower of the cathedral, was in restoration, under the direction of Eugène Viollet-le-Duc, when Le Secq photographed the building. Le Secq shot this image from high in the opposite tower, clearly to emphasize details not visible from the ground. The precarious wooden structure of the scaffolding on the left is juxtaposed with the solid stone blocks and detailed carvings of the cathedral. Filled with architectural detail not ordinarily seen by the cathedral visitor, Le Secq's bold composition presents only a fragment of his view of the cathedral. The contrasting angles and the dramatic play of light and shadow draw the viewer into the composition, where the abundance of individual elements, filling most of the frame, flattens the image and gives it an unexpected appearance of decoration. For Le Secq, Gothic cathedrals, even in their most incidental parts, conformed to an order analogous to that imposed upon the photographer by the camera itself.

At midcentury, Le Secq was one of very few photographers who continued to work exclusively with paper negatives, resisting the new collodion technique. When calotype negatives were superseded completely around 1856, he gave up photography and returned to painting. Le Secq also became a serious collector of medieval ironwork and Old Master prints, and in about 1874, he printed a selection of his photographs of Rheims and Chartres cathedrals as photolithographs. *The Tower of the Kings* was one of the twenty-five prints in the portfolio *Fragments: Architecture et sculptures de la Catedrale de Chartres*, published by the Historic Monuments Commission.

The complex linear traceries of Le Secq's *front à front* architectural image make an intriguing comparison to the ship's rigging in a photograph by **PAUL-ÉMILE MIOT (18)**. The son of a French father and a Martinican mother, he was born in Trinidad in the West Indies, where his family owned cane sugar plantations.[31] He attended boarding school in Ireland and the Naval College in Paris, distinguishing himself as a talented draftsman and a capable photographer. Miot began publishing his drawings and photographs in 1851, in magazines like *L'illustration*. His first duty at sea was aboard the *Sibyl*, which took part in the blockade of Rio of Plate. Later, the young officer was given command of the *Ceres*, a French merchant vessel whose crew was stricken by yellow fever. With just a few able hands he took the ship safely to Bordeaux, and was rewarded with a knighthood of the Legion of Honor in 1853.

Crew on Deck is a photograph that Miot made on a journey to Newfoundland on the east coast of Canada. It is difficult to determine whether the image was made aboard the *Ardent*, on which Miot made his first voyage to Canada in 1857, or on the *Sesotris*, on which he sailed for his second posting the following year.[32] The photograph seems to depict a moment of relaxation with a candid familiarity available only to a crew member. Scattered figures measure the scale of the image: a horizontal expanse of the deck and the unseen height implied by the enormous twin masts create an impressive sense of space. Contrasting the bulk of the ship are the pennants flapping in the breeze,

17

Henri Le Secq
French, 1818–1882

The Tower of the Kings, Rheims Cathedral, about 1851

Photolithograph
57.2 x 40.3 cm
Charlotte E. W. Buffington Fund, 1993.53

registering only as ghosts on the negative. A similar movement is suggested by the skeins of rigging that almost seem to quiver. The whole effect is one of marvel that an object as big as this vessel can move. The negative for this photograph is now in the Musée de l'Homme in Paris.

In Newfoundland, Miot met George-Charles Cloué,[33] a senior officer who engaged the young lieutenant as his chief assistant in a project to correct and supplement *Le pilote de Terre-Neuve*, the first mapping of Newfoundland by Captain James Cook and Michael Lane, published in 1784.[34] Over the next three years Miot made some of the earliest photographic records of Atlantic Canada, its native peoples and colonists. He sent his negatives back to Paris, where they were printed by Furne and Tournier (no. 27), and occasionally published in magazines of geography and exploration like *Le monde illustré*, *L'illustration*, and *Le tour de monde*. Perhaps Miot's best-known Newfoundland photographs are the portraits of Native Canadians of the Mic Mac tribe.[35] Their close resemblance to wood-engraved illustrations of an article by Count Arthur de Gobineau in *Le tour du monde* suggest that they may have been made at Gobineau's bequest.[36] Miot ably worked his way through the ranks, becoming Commander in 1867. The following year, in command of the frigate *Astrée*, he sailed to Polynesia and the Marquise Islands, where he photographed the land and native peoples of the South Seas.[37]

The most important British military photographs of the mid-nineteenth century are the works of **ROGER FENTON (19)**, who was not a soldier but an originative professional photographer. In his meteoric career, he explored many techniques, strove to free photography of inhibiting patent restrictions, and worked to broaden its use and appeal. Fenton was the son of a prosperous banker, merchant, and onetime member of Parliament.[38] He enrolled at University College, London, but instead studied with the historical painter Charles Lucy. In 1841 Fenton went to Paris and entered the studio of Paul Delaroche, perhaps the first artist to understand the full implication of photography for the arts.[39] After returning to London, Fenton studied law, and in 1847, the year he began to practice as a solicitor, helped found the Calotype Society. He also continued to paint, exhibiting his work at the Royal Academy. In 1851, after the Great Exhibition demonstrated the popularity of photography, Fenton began to concentrate seriously on his own work, making landscapes and architectural views of London, Windsor Forest, and South Wales. He helped organize the Photographic Society exhibition in January 1854, and escorted Queen Victoria and Prince Albert through the show. That spring he photographed the royal family, and later he helped the British Museum establish a photography department to record its collections.

Fenton's best-known series of photographs documents the Crimean War, a bloody conflict of the

18

Paul-Émile Miot
French, 1827–1900

Crew on Deck, about 1857

Albumen print from wet collodion negative
26.4 x 20.5 cm
Eliza S. Paine Fund, 2004.15

19

Roger Fenton
English, 1819–1869

Major Burton and Officers of the Fifth Dragoon Guards, 1856

Salted paper print from wet collodion negative
15.6 x 20.4
Sarah C. Garver Fund, 1990.153

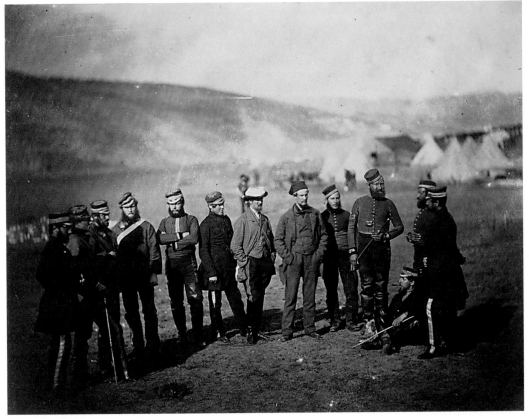

19

early 1850s between Russians and Turks, which made Britain and France allies. The London *Times* reported that English soldiers were dying from exposure and disease, not war wounds. To recover public support, the Ministry of War commissioned Fenton — through the Manchester publisher Thomas Agnew — to record English heroism and wellbeing in the Crimea. The photographer bought an old wine-merchant's carriage, and installed DARKROOM and living facilities to be as efficient as a ship's galley.[40] Fenton arrived in Balaklava on March 8, 1855, and during the next three months he exposed over 360 collodion-on-glass plates. He photographed the terrain, encampments, troops and officers, ships at harbor, and care of the wounded in field hospitals. In Fenton's most famous Crimean photograph, the so-called *Valley of the Shadow of Death*, a desolate wasteland strewn with hundreds of cannonballs marks the battle fought there. The unfamiliar climate presented many technical difficulties. The weather changed drastically during his visit, and frigid nights gave way to unbearable midday sun, when the "glare was so great from the sky and burnt-up ground, that no-one could keep his more than half eyes open."[41]

Major Burton and Officers of the Fifth Dragoon Guards was probably taken in the cool early morning, judging from the long shadows. This photograph typifies Fenton's Crimean groups, for he selected officers of different ages, in the varied uniforms of their different ranks and divisions, to give interest and variety to the image. His subjects seem healthy, alert, well fed, and properly turned out. The photographer arranged the officers in a frieze across the picture plane, ostensibly turning to heed the comments of Major Burton, who stands on the far right. In the background, out of focus, are the tent encampments and the unbroken desolate hills. A fascinating dynamic exists between the officers of the line, standing erect, all spit and polish in their pillbox hats, in contrast to ranking officers who are confident and casual in pose and demeanor.

It is often observed that Fenton's Crimean images represent a sanitized version of war. In fact, there was relatively little military action during his stay, and he was assigned to make pictures supporting an official view of the war, for an urbane Victorian audience. However, his letters and later comments contradicted his photographs' healthy view of camp life. He wrote about inefficient management and widespread disease that plagued the British campaign. Fenton left the Crimea after the failed attack on Sebastapol, on June 18, 1855, sick, exhausted, and having narrowly escaped a cholera outbreak.

A remarkable glimpse of military life during the Second Empire was created by **GUSTAVE LE GRAY (20)**, at the army base on the plain at Châlons-sur-Marne near Paris. The only child of a prosperous haberdasher, Le Gray was born at Villiers-le-Bel, near Écouen.[42] He began a career as a notary's clerk, but dreamed of becoming an artist. In Paris, he studied in the atelier of Paul Delaroche at the École des Beaux-Arts. In 1847, Le Gray became seriously involved with photography, perhaps as an adjunct to a career as a reproductive artist. He made daguerreotype portraits and technically sophisticated reproductions of works of art. The photographer experimented with wet-plate collodion on glass, which he described in his *Traité pratique de photographie sur papier et sur verre*. First published in June 1850, this popular manual was revised and reprinted in four editions over as many years.[43] By that time, Le Gray was at work on a process for dry WAXED-PAPER NEGATIVES, which remained sensitive for two weeks and, once exposed, remained viable for nearly a week before developing.

In 1851, Le Gray was a founding member of the Société héliographique, and appointed to the Mission héliographique.[44] With an assigned list of monuments and an itinerary from Paris to Poitiers, he and O. Mestral explored Renaissance châteaux, Romanesque churches, and the ramparts of Carcassonne, collaborating on their photographs. The project provided Le Gray with an intense period of experimentation, enabling him to master his equipment and test his dry waxed-paper negatives process. In 1854 Le Gray was a founding member of the Société française de photographie, and the following fall he opened a new studio on the fashionable boulevard des Capucines, with the financial support of Barnabé Louis Gabriel Charles Malbec de Montjoc, the marquis de Briges. During a trip to Normandy in summer 1856, he made his first seascapes. Since it was then technically impossible to record features of the sky simultaneously with those of land or sea, Le Gray exposed two negatives of the same scene, printing both on a single sheet of paper, merging the images at the horizon. His process resulted in such masterpieces of light and reflection as *The Great Wave*, photographed at the Mediterranean port of Sète.[45] In 1857, Le Gray won the prestigious commission, seemingly from the emperor himself, to document the military training camp at Châlons-sur-Marne. During his monthlong sojourn residence at the Camp du Châlons, he made formal portraits of the emperor, his generals and his officers, studies of troops in bivouac, a panoramic view of camp, and photographs of such events as a *plein-air* banquet and the celebration of imperial High Mass. Le Gray's photographs were gathered into albums, which the emperor presented to his generals.

The Zouave Barber is one of Le Gray's most intriguing genre scenes from the Camp du Châlons. A corps of Algerian infantrymen recruited into the

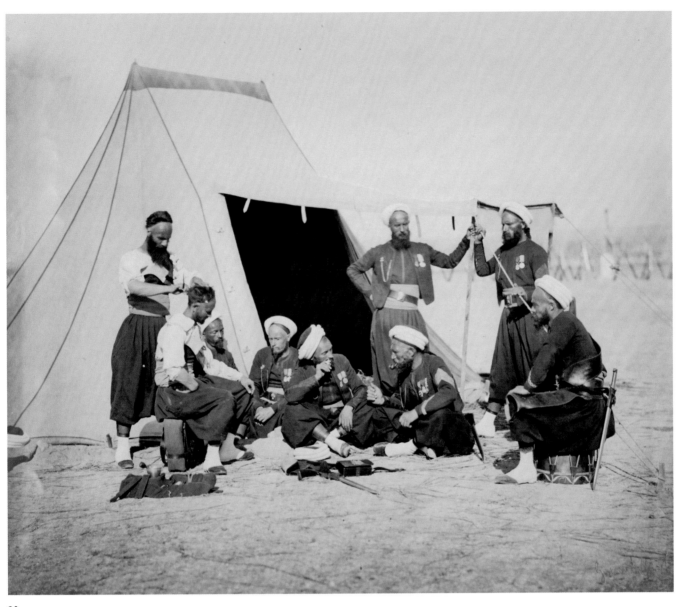

20

20

Gustave Le Gray
French, 1820–1884

The Zouave Barber, 1857

Albumen print from wet-
plate collodion negative
31.6 x 37.2 cm
Stoddard Acquisition Fund,
2000.30

French army in 1831 from the Zouaoua tribe of
Berbers living in the Jurjura mountains, the
Zouaves were first deployed abroad in the Crimean
War.[46] The Zouaves became well-known romantic
figures of French popular culture, made familiar
through heroic prints by Ernest Meisonnier, Auguste
Raffet, and others.[47] Le Gray made several photo-
graphs of these soldiers in camp, including images
of a storyteller and a group of gambling soldiers.
These narrative scenes were carefully staged, inte-
grating varied postures, picturesque dress, and
soldiers' personalities.

Nineteenth-century travelers who pursued the
centuries-old tradition of the European Grand
Tour purchased photographic views to help them
remember their trip of a lifetime. These elegant
topographical photographs, evolved from a print-
making tradition, particularly in Italy, were modern
versions of picturesque *veduti* by etchers such as

Giovanni Battista Piranesi or Canaletto. At a time
when an Italian tour was the qualifying culmination
of study for English and American artists, expatriot
photographers like James Anderson and **ROBERT
MACPHERSON (21)** catered to their needs. Mac-
pherson went to Rome to become a landscape
painter after leaving the study of medicine at Edin-
burgh University.[48] A distinctive member of the
British community in Rome, he was tall, gregari-
ous, auburn-haired, and wore the kilt of his clan in
the Mediterranean heat. He occasionally worked
as a journalist. As an art dealer, his outstanding
discovery was Michelangelo's panel painting *The
Entombment*.

Soon after his marriage to Gerardine "Geddie"
Bate, the niece of the British writer and art histo-
rian Anna Jameson, Macpherson took up photogra-
phy. Apparently self taught, he concentrated on
photographs of art, architecture, and city views,
which he sold exclusively at his studio on Via

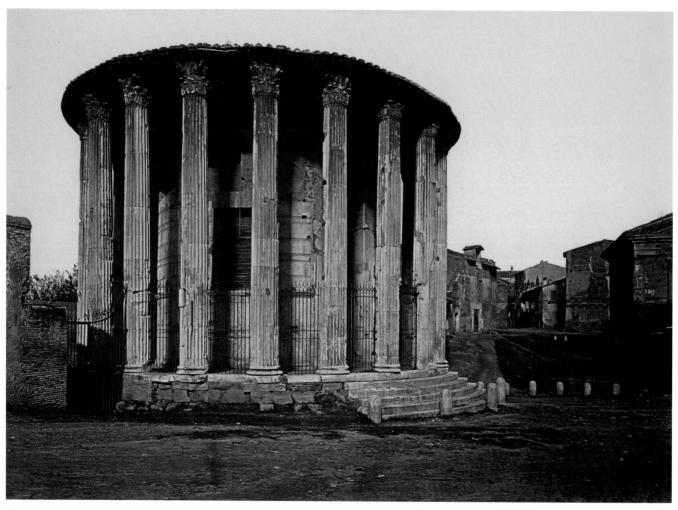

21

21

Robert Macpherson
Scottish, active in Italy,
1811–1872

The Temple of Vesta, Rome,
about 1858

Albumen print from
albumen negative
29.4 x 41.0 cm
Anonymous Fund, 1986.76

Ripetta. His occasional broadsheet catalogues describe photographs of views of Rome, Tivoli, the Campagna, and parts of Tuscany. There were 187 titles on the list in 1859, and 300 subjects in 1863. Though modest compared with such publishers as Fratelli Allinari, the list suggests a solid, thriving business.

The Temple of Vesta is the oldest marble building in Rome, erected in the late second century B.C.E., and still standing in the Piazza Bocca della Verità near the Tiber River.[49] Its circular *tholos* plan suggests that the temple may have been built by the Greek architect Hermodoros of Salamis, a notion supported by its construction in Pentelic marble from Attica. The Romans often consecrated circular temples to Vesta, goddess of the hearth, but this sanctuary was probably not hers. An inscription inside suggests that it was built by the wealthy olive oil merchant Marcus Octavius Herrenus, who probably dedicated the temple to the patron of the olive oil merchants, Hercules Olivarius. Macpherson's architectural photographs are distinguished by their formal balance and clarity. "Mr. Macpherson has taken these photographs under the special advantages which a long resi-

dence in Rome can confer," wrote a contemporary critic. "The traveller well knows that the production of photographs has now degenerated into a direct trade, and an extensive manufacture; we believe, however, that Mr. Macpherson himself has some better claims to the taste and knowledge of an artist."[50] The photographer presented his subjects as grand, unapproachable monuments, frozen in time. Like Piranesi's etchings, Macpherson's photographs emphasize the solidity and mass of the historical monuments. People seldom appear in his photographs, but when they do they are usually in Italian costume and suggest the scale of the site.

For its beauty and mysterious history, Venice was as popular a Mediterranean destination as Rome. In the mid-nineteenth century, among the most skilled of the contingent of Venetian photographers were Carlo Ponti and **CARLO NAYA (22)**. A native of the Veneto, Naya studied law at the University of Pisa.[51] After completing his degree he and his brother embarked on a tour of Europe, Asia, and Africa. In 1840 he purchased daguerreotype equipment in Paris, and began working as a

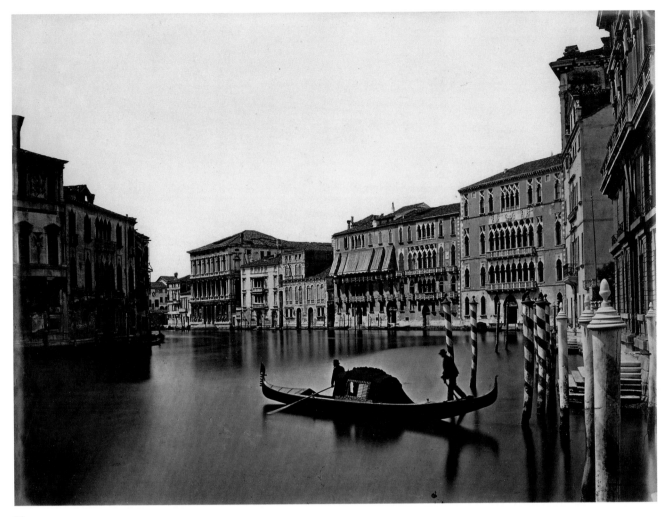

22

photographer. Settling in Venice in 1857, Naya photographed works of art and architectural views, which he sold through Ponti's shops. Two years later, he exhibited a series of photographs at the third exhibition of the Société Française de Photographie in Paris, and in 1862 his work won a medal at the Great Exhibition in London. In 1866 several of Naya's views of Venice were published in Ponti's series *Ricordi di Venezia,* and the following year he began documentation of the restoration of Giotto's frescoes in the Scrovegni Chapel in Padua. After a business dispute around 1868, Naya began selling his photographs independently at his own studio, which quickly expanded to include several employees. He began his own systematic documentation of Venice, in photographs meant for both tourists and scholars. Soon his catalogue provided a comprehensive repertoire of city views, landmarks, and panoramas, as well as staged costume and genre scenes.

View of the Grand Canal, Venice is typical of the sumptuous images that made Naya famous. The sweeping view of the Grand Canal pictures the city's largest Gothic palaces, the Palazzo Foscari and Palazzo Giustiniani. As in Eugène Cuvelier's

Farmyard of the Château at Courance (no. 15) no evidence of the nineteenth century is apparent, and Naya's image allows the viewer to imagine how Venice might have looked in the early Renaissance. When Doge Francesco Foscari bought his palace in 1450, it already had a series of aristocratic owners. To befit his station, he had the building moved forward onto the bank of the Grand Canal. The Gothic arcades of the second floor *piano nobile* are based closely on the loggia of the Palazzo Ducale, to identify the building and its owner with the city-state itself. The reconstruction campaign was hardly finished when Foscari was disgraced in 1457 and retired to his new home to end his days.

Beside the Palazzo Foscari on the Grand Canal stand two adjacent houses of the Giustiniani, one of the oldest and most distinguished families of the Venetian patriciate. These buildings were also rebuilt shortly before 1451, on a scale and with opulent decoration to demonstrate the economic and political power of the Giustiniani. Two great central window arcades, ornamented with tracery, illuminate huge halls behind them. Symmetrically arranged on either side of a central axis and a large watergate, the two palaces form a united pair.

23

23

John Murray
Scottish, 1809–1898

The Ladies Tower — Agra Fort, 1862

Albumen print from waxed-paper negative
35.7 x 45.4 cm
Stoddard Acquisition Fund, 2000.12

Despite their noble facades, the Grand Canal *palazzi* had fallen into disrepair in Naya's time. "This palace was a foul ruin," John Ruskin wrote of the Ca'Foscari after visiting in 1845, "its great hall a mass of mud, used as the back receptacle of a stone mason's yard; and its rooms whitewashed, and scribbled over with indecent caricatures."[52]

In Britain, France, and other nineteenth-century colonial powers, there was a ready market for images from distant provinces, which informed those at home of places in the news, and helped to clarify their compatriots' experiences abroad. Several British photographers documented the topography and culture of the Indian subcontinent, and some of them, including Captain Linneus Tripe, Captain Eugene Clutterbuck Impey, and **DR. JOHN MURRAY (23)**, were connected with the military.

The son of a farmer in County Aberdeen, Murray studied medicine at Edinburgh University.[53] With the East India Company, he sailed to Calcutta to work as a military surgeon at nearby Fort William. In 1835, following a prolonged illness, his knowledge of India deepened when he took a four-month walking tour from Simla to Tibet and back. As field surgeon to the force commanded by Sir Harry Smith, his efforts in battle earned him the Aliwal Medal in 1846. Soon afterwards he moved to Agra, where he helped to establish Thomason Hospital and oversee the construction of Saint Paul's church. In 1867 Murray was appointed Inspector General of Hospitals in the northwest provinces of India. During his four years in the post he led the fight against cholera, supervising treatments of the outbreak at the Hardwar Fair. His extensive experience with the disease prompted the government to commission further studies from him.

Murray began making photographs in 1849, perhaps inspired by his interest in Indian history, art, and architecture. He was the first to photograph the historic sites of Agra, Mathura, Sikandra, and Fatehpur Sikri, which took nearly a decade.

Fig. 2. John Murray, *The Ladies Tower — Agra Fort*, 1862, waxed-paper negative.

Murray's photographs were initially shown in the inaugural exhibition of the Bengal Photographic Society in March 1857. Later that year, he traveled to England with many of his negatives, and exhibited his work at J. Hogarth's Gallery in London. Eight of his photographs hung in the fifth exhibition of the London Photographic Society in May 1858, and later that year Hogarth published the series *Photographic Views in Agra and Its Vicinity*. The following year Hogarth issued *Murray's Picturesque Views in the North Western Provinces of India*, a portfolio of twenty-five prints.

The Ladies Tower — Agra Fort is one from a series of photographs that Murray executed in January 1862 for a suite that included views of the Taj Mahal and Fatehpur Sikri, as well as the Agra Fort. This print, and the waxed-paper negative used to print it (fig. 2), descended through generations of Murray's family.[54] The photographer used a very fine, strong commercial negative paper, permeated with wax to make it more translucent. He sensitized

and exposed the negative himself in an enormous, and undoubtedly heavy, camera. After developing, he painted out the area of the sky with black pigment so that it would print naturalistically as the brightest passage of the composition. When printing, Murray also selectively bleached the darkest areas of the negative, to allow them to print legibly. Both the negative and the final print display great clarity of detail, as in the piercings of the surrounding wall and the outlines of the distant buildings.

Murray set up his large wooden camera high in the south tower of the Akbar Mahal, and photographed along the east wall of the fort, looking north, parallel to the Jumuna River. His photographs of the matching north tower obscure other towers and lanterns adorning the east palisade of the fort. Murray titled his photograph with a Victorian name, which may have little basis in historical fact. Within this area of the Akbar Mahal there are many curtain walls carved in marble of complex geometric patterns, supposed by the

24

24

William Notman Studios
Canadian, born in Scotland,
1826–1891

Lorette Falls, Quebec, about
1861

Albumen print from wet
collodion negative
19.0 x 23.7 cm
Sarah C. Garver Fund,
1997.72

British to provide places for women of the Mughal
court to be concealed as they enjoy the river
scenery and the palace spectacles below.[55]

On the other side of the world and the British
Empire, **WILLIAM NOTMAN (24)** made photo-
graphs of Canada that earned him a truly interna-
tional reputation and the title "Photographer to the
Queen." The eldest of seven children of a Scottish
merchant, Notman became an amateur daguerreo-
typist while working in the family woolen busi-
ness.[56] When the company failed in 1856, he took
his wife and child to Montreal, where he opened a
portrait studio in his home. He produced miniature
AMBROTYPES and TINTYPES, and large paper prints
from collodion negatives that attracted customers
from all social classes.

In 1858, Notman won his first major commission
from the Grand Trunk Railway, to document the
construction of the Victoria Bridge over the Saint
Lawrence River. When the bridge was completed in
1860, Edward, Prince of Wales, made the first royal
visit to Canada to mark its opening. Notman pho-
tographed the celebrations and made formal por-
traits of the prince. He collected these images,
along with images of Edward's provincial travels

and other famous Canadian views in two large,
leather-bound portfolios. When the provincial gov-
ernment presented the albums to the prince,
Queen Victoria was impressed and recognized
Notman with a Royal Warrant. Notman printed the
motto "Photographer to the Queen" and a coronet
on the card mounts for his photographs, and dis-
played them on a new portico he built for his
Montreal studio. By the age of thirty, Notman had
established studios in Ottawa, Toronto, and Hali-
fax. The chain soon grew to over twenty studios,
including a shop on Park Street in Boston, less
than a block away from the State House.[57]

Lorette Falls, Quebec, is one from the suite *Views
of Canada*, produced between 1861 and 1872, and
originally published serially. In 1859, Notman trav-
eled widely and sent staff photographers to more
distant parts of British North America. Topographi-
cal views and images of natural wonders like Nia-
gara Falls and Chaudière Falls were all captured on
glass plates. *Views of Canada* eventually included
132 photographs, which were sold in Notman's stu-
dios, stationery stores, hotels, and railway stations
as stereographs and large prints, singly and
ensuite. In the nineteenth century, Lorette Falls was
a weekend destination and a spot of noted beauty

25

25

Édouard-Denis Baldus
French, 1813–1889

Place de la Concorde, Paris,
1859

Albumen print from wet
collodion negative
27.3 x 42.7 cm
Sarah C. Garver Fund,
1996.6

eight miles north of Quebec. The photographer
carefully chose a viewpoint that excluded the old
saw mills on the rocks over the river. "A poetic
observer standing on the margin of the river near
the Falls," wrote the Victorian journalist Charles
Roger, "might easily transmute the Grecian
imagery chanted by the Roman into the actual
scene before him; and can almost fancy without
any peculiar and visionary flights of the imagina-
tion that he beholds around him the principal and
most solitary dell of the ancient immortalized
Tempe. . . . The wild diversity of rocks, the foliage
of the overhanging woods, the rapid motion, the
effulgent brightness, and the deeply solemn sound
of the cataracts, all combine to present a rich
assemblage of objects highly attractive, especially
when the visitor emerging from the wood, is in-
stantaneously surprised by the delightful scene."[58]

The most successful French topographical pho-
tographer in the mid-1850s was **ÉDOUARD-DENIS
BALDUS (25)** whose works were unmatched for
their clarity. He was born in Grünebach, near
Cologne, in Prussia, where he taught himself to
paint.[59] In about 1837, he may have visited the
United States and worked as an itinerant portraitist

in New York. The following year he settled in Paris
to study painting. In the late 1840s he began mak-
ing photographs, and developed a method of gelat-
inizing paper negatives that produced prints noted
for sharpness and tonal breadth.

In 1851 Baldus was appointed to the Mission
héliographique, and toured the South of France,
including Fontainebleau, Burgundy, Provence, and
a small part of Languedoc.[60] Like many of his con-
temporaries Baldus found inspiration in the fifteen
published volumes of the *Voyages pittoresques*, lith-
ographs depicting France's ancient and medieval
architectural patrimony. The mystery and evocation
of the Romantic prints are reflected in Baldus's
view of the north gallery of the Romanesque clois-
ter of Saint-Trophîme in Arles, a remarkable piece
for which he spliced together ten paper negatives,
each separately exposed and focused on a different
segment of the scene.

The Mission héliographique convinced Baldus
of the appeal and aesthetic possibilities of architec-
tural photography, and he strove to capitalize on
his experience. In 1852, the Ministry of the Interior
commissioned him to photograph *The Towns of
France*, and he went again to the South in 1853.
In 1854 Baldus attended the Champs-de-Mars

agricultural fair and produced a fascinating series representing prize-winning livestock. Among his other projects of the mid-1850s were a series of landscape views of the Auvergne and a series representing the railroad route taken by Queen Victoria from Boulogne to Paris, on her way to the Exposition Universal. In 1856 the Ministry of the Interior commissioned him to report on the devastating floods from the Rhone river in Lyon, Avignon, and Tarascon. In 1855 Baldus won the handsome commission to document the construction of the new Louvre and the renovation of the Tuileries, the largest construction project of the Second Empire.[61] Over nearly three years, employing wet-plate collodion negatives on glass, he produced over 2,000 photographs of every aspect of the project in images of astounding monumentality. A year after beginning that project, he became a naturalized French citizen.

Place de la Concorde is one of the photographs from wet glass-plate collodion negatives, dating from 1859. The strong, formal composition and refined technique would later characterize Baldus's mature style of architectural photography. During the later 1860s, government and private commissions declined for the large, splendid photographs that were Baldus's specialty. Many photographers turned to smaller, inexpensive formats meant for broader, less demanding audiences. Rather than following suit, Baldus shifted his attention to photogravure, a reproductive method that interested him for over a decade. In 1875 he published a prints series, Principal Monuments of France, as well as series of the Louvre and the Tuileries; in 1877, the palace of Versailles; and in 1884, the sculpture of Jacques Androuet du Cerceau.

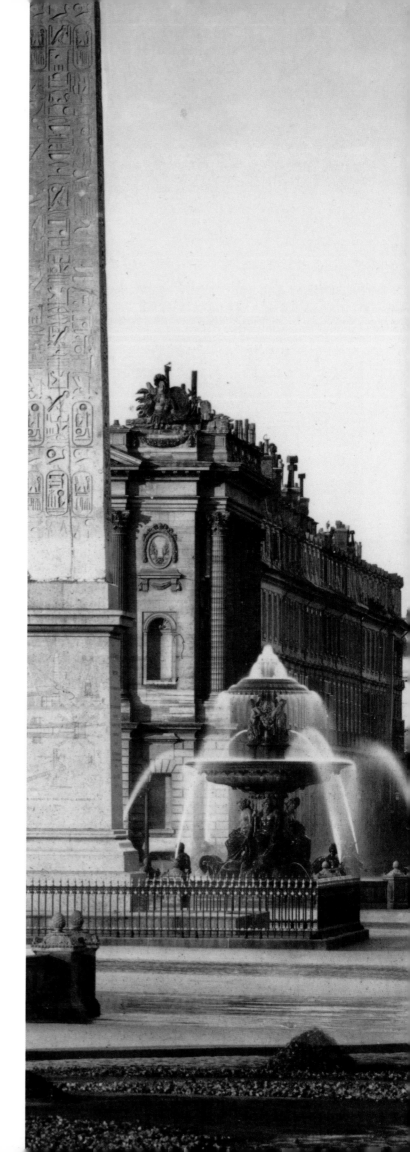

25 (DETAIL)

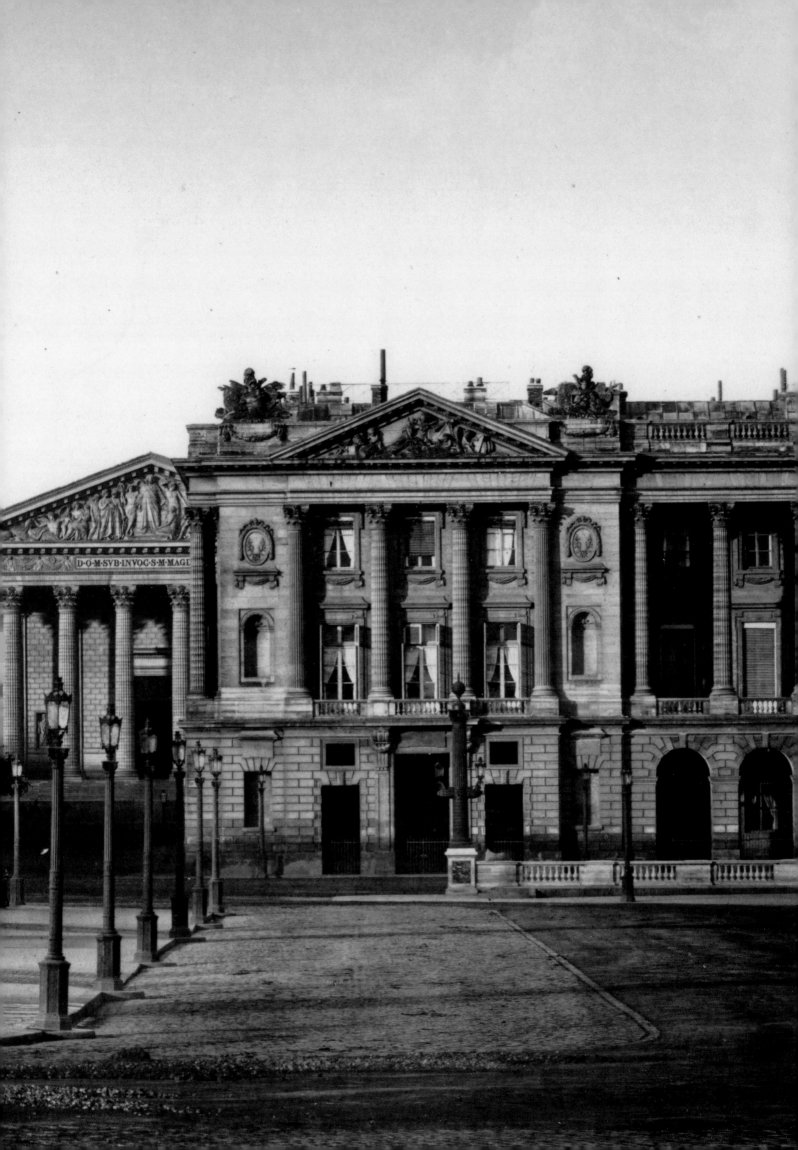

3 | Photographs To Buy

When reproducible photographic prints on paper became affordable during the 1850s, the photographic industry began to change rapidly. An expanding professional community produced works of varied subjects in different formats, conceived for a range of consumers. **LEONIDA CALDESI (26)** and his partner, Signor Montecchi, came to London from Florence to open a studio for the photographic reproduction of works of art. Their first British publication, *Gems of the Art Treasures Exhibition*, sold at their Pall Mall studio in 1857, along with images of artwork from The National Gallery and Buckingham Palace. By 1859 the partnership had dissolved, and Caldesi ran the West End gallery on his own, while also working at a studio in Portchester Terrace, Bayswater, where he may have lived.

In May 1857, Queen Victoria summoned Caldesi to Osborne House near Cowes on the Isle of Wight, where she had retired after the birth of her youngest child, Princess Beatrice.[1] He photographed the baby in the splendid cradle made for Victoria, her eldest sister. Each of the princes and princesses posed for him, as did the entire Royal family. His photographs are among the last to capture the family together, for wedding preparations were underway for Princess Victoria's marriage to Prince Frederick William of Prussia on January 25, 1858. *Princess Alice* and other portraits taken by Caldesi at the time, represent the royal family on the sunny terrace at Osborne. They suggest the ambiance of the Queen's favorite family retreat. Victoria and Albert had purchased the 1,000 acres in 1844, and the prince consort and his builder, Thomas Cubitt, erected a large italianate villa complete with bell towers, loggie, and Renaissance-style terraces. They planted acres of trees and imported a chalet from Switzerland for the children. This playhouse had a kitchen where the princesses learned practical housekeeping skills. Nearby was a miniature fort of stone and brick for the princes, with earthworks and a drawbridge.

Princess Alice enjoyed a happy childhood at Osborne House.[2] At age eleven, when she accompanied her mother on visits to wounded soldiers from the Crimean War, she discovered her ability to nurse and comfort. After Princess Victoria's wedding, Alice became closer to her parents. Prince Albert was delighted by her talents for music and drawing, and they shared a love of art. In November 1860, Alice became engaged to Prince Louis of Hesse Darmstadt, nephew of the reigning grandduke. The wedding plans were interrupted, however, by the death of the Duchess of Kent, her maternal grandmother. Then her father contracted typhoid fever, and Alice was his devoted nurse until his death on December 14, 1861. The devastated Queen Victoria went into seclusion, and Alice became her chief comfort, assistant, and liaison with government ministers. The family retired to Osborne House, and the Queen died there in 1901. Little has altered in the house since Albert's time, following Queen Victoria's orders that nothing be changed. Personal possessions, including many photographs of the royal family, are still there. On July 1, 1862, Alice's long-postponed marriage to Louis of Hesse took place at Osborne House. It was a grim event, attended only by royal relatives, and celebrated at an altar before Franz Xavier Winterthur's portrait of the royal family with its prominent figure of Prince Albert.

"Photography," wrote an English commentator in 1857, "has become a household word and a household want; . . . found in the most sumptuous saloon, and in the dingiest attic — in the solitude of the Highland cottage, and in the glare of the London gin-palace, in the pocket of the detective, in the cell of the convict, in the folio of the painter and architect, among the papers and patterns of the millowner and manufacturer, and on the cold brave breast on the battle-field."[3] Across Europe and the United States, new companies sprang up to meet this mounting demand. The evolution of the **FURNE FILS AND TOURNIER (27)** studio reflects the transformation of a booming industry.

Charles-Paul Furne, Jr., was the son of a hardworking customs administrator, who also ran a literary publishing house.[4] A nonconformist, he lived

26

26

Leonida Caldesi
Italian, active in England,
1856–about 1880

Princess Alice, 1857

Salted paper print from wet
collodion negative
20.8 x 16.2 cm
Stoddard Acquistion Fund,
2002.533

with his older mistress and their daughter. Perhaps in hopes of reforming him, his family seized on his interest in photography. In early 1857 they helped Furne establish a business partnership — *société en nom collectif* — with his cousin Henri Tournier. A judge's son, Tournier worked at the Ministry of Finance, and began as the company's business manager; later he learned photography himself. In summer 1857, Furne toured Brittany, creating photographs that revealed an isolated region still misunderstood by the rest of France. Furne's photographs brought to life the popular romantic memoirs of François-René de Chateaubriand, who grew up among the Breton forests and moors.[5]

Quimperlé — Local Costumes is from the resulting series, *Voyage en Bretagne*, an album combining STEREOGRAPHS with larger prints in the *semi-raisin* format. In this image, two couples meet casually on a Quimperlé street, while the background shop evokes a market day. Each man carries a walking stick and wears a broad hat and breeches with buttoned jambeaux over his calves; the women wear starched cotton coiffes and homespun aprons, traditional local Breton dress that varied from one region to another. Smudged breeches and threadbare woolens, wooden shoes — padded with straw for comfort — and other details show that these are working people in their daily business, not con-

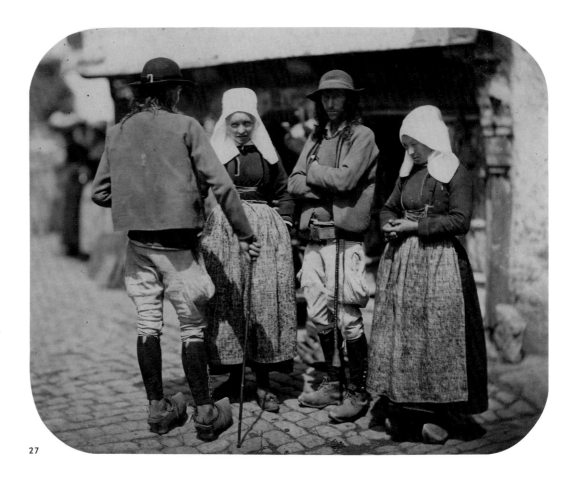

27

Charles-Paul Furne, Jr.
French, 1824–1875
and
Henri Alexis Omer Tournier
French, 1835 – after 1866

*Quimperlé — Local
Costumes*, 1857

Albumen print from wet
collodion negative
19.6 x 24.6 cm
Eliza S. Paine Fund, 1997.9

27

trived models. Nevertheless, Furne positioned
them carefully to show their attire from different
angles. Both men stand erect and confident, while
their partners, each with slight inclination of the
head, project an air of piety.

Furne and Tournier sold their publications in
the Paris shop of the prominent lithographer and
print publisher, Joseph Lemercier. The *Voyage en
Bretagne* photographs sold best one at a time, but
the stereographs outsold the deluxe prints. The
series evoked a modest critical success, and was
soon followed by similar travel folios of the Pyre-
nees, Provence and Laguedoc, and other places.
Demand seems to have determined the company's
product line, for Furne and Tournier increased its
productivity and broadened their subject matter.
Late in the decade they produced a cascade of
stereographs, including celebrity portraits, genre
scenes, still lifes, and animals.[6] Then came staged
tableaux, humorous harlequinades, and romantic
historical vignettes. They also published illustra-
tions of popular fiction, the songs of Pierre Jean de
Béranger, and the fables of Jean de la Fontaine.
Their output multiplied so rapidly that in October
1858 the firm began issuing a monthly newsletter,
*La Photographie, journal des publications légalment
autorisées*, informing collectors of their stock and
new publications.

Stereographs arrived in the United States in
1854, when the Langenheim Brothers began to
produce and sell them in Philadelphia. As in
Europe, other entrepreneurs quickly appeared
across America, scrambling to enter a burgeoning
market. Such was the case with **R. E. MOSELEY
(28)**, a jeweler and watch merchant in Newbury-
port, Massachusetts.[7] He expanded into photogra-
phy when he took on Carl Meinerth as a partner.
A pianist, violinist, and music teacher as well as a
photographer, Meinerth had immigrated from
Germany to Portsmouth, New Hampshire, in 1853.
Two years later he opened a daguerreotype studio,
where he soon shifted to paper prints and stereo-
graphs. After moving to Newburyport in 1864,
Meinerth passed along his techniques to Moseley,
who became a licensed photographer himself. The
Moseley and Meinerth imprint appears on high-
quality portraits and stereograph views of Cape
Ann and Portsmouth. They continued selling
watches, jewelry, and *objets de virtu*, as well as pho-
tograph cases and frames, at their studio at 62
State Street in downtown Newburyport. Theirs was
a fashionable address, next to Goodwin's Millinery,
beneath the awning on the right in the stereograph
Cutter and Team in the Snow.[8] These shops occu-
pied an addition built on the front of the Dr. Micah
Sawyer house, a Federal-period structure noted in
its day for the town's fanciest ballroom. Meinerth

28

Robert Ellis Moseley
American, born in England,
1817–1870

Cutter and Team in the Snow,
Newburyport, December 31st,
1866

Albumen stereograph
6.9 x 14.2 cm
Gift of Mrs. Albert W. Rice,
1974.199

28

may even have lived in the house, for he gave music lessons there in off hours.

Although the subject of this portrait has not been identified, the image brings to life an extraordinary moment in a small New England town in the Civil War era. On a snowy day, the young man has pulled up his cutter, a light sleigh, along Newburyport's main street. With its shiny pinstripe paintwork, the sleigh looks brand new. It is drawn by a handsome team of matching gray horses, each in its pristine harness with a string of sleigh bells across its shoulders. With such strong animals pulling so little weight, this elegant rig must have made bracing speed. The driver wears his fanciest clothes with a stovepipe silk hat and a fur robe warming his lap. A crowd has gathered, including gentlemen with mutton-chop whiskers, and a schoolboy with a book tucked under his arm. Newburyport is located near Salem, with its wealthy international traders and sea captains; the town was used to such elegance, so the making of this photograph may have been the noteworthy event.

Despite their success, Moseley and Meinerth did not have a harmonious partnership, and soon they were publishing photographs separately. This card is stamped and labeled with Moseley's name only.[9] A few months after its production, the collaboration dissolved. Meinerth took over the studio, and Moseley moved to Boston to open a new retail shop, allowing his photographer's license to lapse later that year. Meinerth continued his photographic work, and in 1867 he won a patent for "mezzotinto," a printing process that gave his portraits a fuzzy quality that resembled Old Master prints.[10]

The international popularity of the stereograph led to a fad for the visiting card, or CARTE-DE-VISITE. These small, affordable ALBUMEN portraits

from reprintable NEGATIVES were scaled to a common visiting card — the size of today's business card — and easily shared, mailed, or traded. Credit for the invention and popularization of the *carte-de-viste* is given to **ANDRÉ-ADOLPHE-EUGÈNE DISDÉRI (29)**.

After training to be a painter, Disdéri worked with the Grenelle Theater troupe from 1837 to 1840. He left the stage in 1843, when he married and began working as a lingerie maker.[11] Disdéri became interested in photography around 1847, and when his garment business folded, he took his family to Brest and opened a photography studio in 1849. Three years later Disdéri went to Nimes to learn the new COLLODION processes and developed his own formula that he claimed increased the light-sensitivity of his negatives. In 1854 he returned to Paris, and set himself up as a photographic portraitist. The support of a business sponsor, Chandielier, enabled him to expand his studio at 8 Boulevard des Italiens into one of the city's largest. Soon Disdéri perfected and received a patent for a more efficient process of producing miniature portraits. He divided a single glass-plate negative into eight—and later ten—segments, and loaded them into a multiple-LENS instrument, like a stereograph camera with a plateholder that slid from side to side. While the stereo camera took two pictures at the same time, however, the *carte-de-visite* camera was constructed to expose up to eight different images of the sitter on a single photographic plate, one at a time. Disdéri developed and printed the whole sheet of photographs at once. The compound print was cut into eight portraits, each mounted on a card that was usually marked with the photographic trademark and address. The use of unskilled help increased the productivity of the cameraman and printer eightfold. The distance from the camera, especially

29

29

André-Adolphe-Eugène Disdéri
French, 1819–1889

M. d'Osmonville, 1861

Albumen print from wet collodion negative
19.9 x 23.2 cm
Sarah C. Garver Fund, 1997.71

in the full-length portraits, eliminated the need and expense of careful lighting and time-consuming retouching. Middle-class consumers could now buy affordable costume portraits for gifts or mementos.

Monsieur d'Osmonville, the subject of an uncut sheet of *carte-de-visite* portraits from the Disdéri studio, exemplifies the bourgeois consumer and reveals something of the experience of having one's photo taken there. It remains mounted on a sheet from a studio album, and bears the subject's name and negative number on a hand-written label. Between frames, the subject moved through a series of poses undoubtedly suggested by the photographer. These images range from a casual view of him sitting to roll a cigarette, to a formal pose of the gentleman with his overcoat, hat, and gloves. In two exposures he holds out a *carte-de-*

viste. Disdéri had developed a repertoire of postures that suggested the look of instantaneity. The pose and attitude, however affected they may be, were meant to convey social standing more than personality. Costume, demeanor, and the bourgeois ambience of the studio and its trappings expressed this station.

Millions of stereographs, *cartes-de-visite*, and CABINET CARDS were produced in the second half of the nineteenth century. Their abundance and shoddiness gave rise to and sustained the idea that these were not works of art. A collecting urge compounded the popularity of *cartes-de-visite*, particularly when the images of celebrities became available. Disdéri may have begun this fad when he published portraits of Napoleon III, who stopped by his studio on his way to Italy. In England, 70,000 *carte-de-viste* portraits of Prince Albert were

30

George Kendall Warren
American, 1824–1884

*First Parish Church,
Cambridge*, about 1861

Salted paper print from wet
collodion negative
20.5 x 15.5 cm
Sarah C. Garver Fund,
1991.13

30

said to have sold in the week after his death in 1861, and at the outset of the American Civil War, portraits of the hero of Fort Sumter, Major Robert Anderson, sold at a thousand per day.[12] For the first time, a broad public could collect photographic images of famous people, along with the carte portraits of their family and friends, to mount in photography albums bound in tooled leather or plush velvet, by then common in the middle-class Victorian home.

Cartes-de-visite were followed by slightly larger cabinet card portraits and views also pasted on cardboard mounts. These affordable photographs became as common and collectible as stereographs. Famous in his day as a celebrity photographer, **GEORGE KENDALL WARREN (30)** was also the first professional academic photographer in the United States.[13] He grew up in Lowell, Massachusetts, in a house owned by the Boott Corporation, where his father was a foreman in a cotton mill. At age nineteen he bought his first daguerreotype outfit. His mother's diary records his months of struggle mastering the process and opening a portrait studio.[14]

In 1858 Warren photographed the Dartmouth

31

31

James Ambrose Cutting
American, 1814–1867
and
Lodowick H. Bradford
American, active 1845–1870

Portrait of James Ambrose Cutting, 1858

Photolithograph on Chine appliqué
20.0 x 15.0 cm
The Charles E. Goodspeed Collection, 1910.48.715

College senior class, and sold his salted paper prints to the students. The next year he visited several colleges, making student and faculty portraits, as well as campus views. To accommodate each purchaser, Warren began producing custom albums, combining about a hundred newly shot cabinet-size portraits and many stock campus views. Bound in tooled and gilt leather, the books usually had the buyer's name embossed on the cover. Warren developed contracts at many prep schools, colleges, and universities, from Bowdoin College in the north, to Columbia University in the south, and the University of Michigan in the west.

In 1861, securing a contract to photograph Harvard students, he soon moved his business to nearby Cambridgeport, and offered a broader choice of local views, teams, clubs, and staff. He even had portraits of campus characters, like the "Goodies," who cleaned students' rooms, and Picolo, the Harvard Square cigar boy.

First Parish Church, Cambridge represents a landmark on the Harvard campus, and seems to be one from the earliest group of Warren's stock images of the university. In 1636, the colony of Massachusetts appropriated funds for the college and located it near the First Parish in Newtowne, so that its

orthodox minister, Thomas Shepard, could provide theological guidance to the impressionable youth.[15] Students began studying in 1638 — the year Newtowne was renamed Cambridge — and worshiped at First Parish. Four successive meetinghouses of the First Parish stood in the corner of the college yard today occupied by Lehman Hall. To secure that land, the college helped to build a new meetinghouse in 1833 beside the seventeenth-century cemetery. Designed by Isaiah Rogers, the building has a decorative veneer of pointed arches cut from wood in Folk Gothic style. Tall windows, with diamond panes and delicate tracery, along with the insufficient wooden buttress forms complete the effect. The original specifications called for exterior surfaces to be dusted with sand after painting. On public occasions, Harvard continued to use Rogers's First Parish Church, retaining gallery seats for students. Commencement, the literary exercises of the Harvard chapter of Phi Beta Kappa, and important university occasions took place there. In 1837, the young Ralph Waldo Emerson delivered his famous address "The American Scholar" from its pulpit, where Edward Everett, Henry Wadsworth Longfellow, Charles Sumner, Henry Ward Beecher, and Oliver Wendell Holmes also spoke.

At his thriving Boston studio, James A. Cutting (no. 10) attempted to diversify into photographic reproduction in the partnership of **CUTTING AND BRADFORD (31)**. Expedient reproduction had always been a key objective of commercial photography. The prospect of printing images in large quantities simultaneously with text had transforming, profitable implications for publishing. Many believed that the key was in the combination of photography with lithography, then the most economical printing process. In France, a method of PHOTOLITHOGRAPHY was invented by Alphonse Poitevin.[16] "It furnishes a new mode of illustrating works of science and art," said the New York Tribune in early 1854, "and it gives the artist the most accurate studies from nature of every object which can be brought within the scope of the camera obscura."[17]

By that time, Cutting had begun work with the engraver and lithographer Lodowick Harrington Bradford, a prominent Boston printer who had worked with the artist Fitz Hugh Lane.[18] Their exper-

iments with photolithography began in 1856, and benefited from the contributions of Austin Augustus Turner.[19] He was Cutting's partner at the Boston Gallery of Art, and the chief photographic technician in its fashionable studio on Tremont Row. Turner had visited Paris where he probably acquired a basic knowledge of Poitevin's photolithographic method. In Cutting and Bradford's technique, an image is transferred onto the lithographic stone through a transparent POSITIVE rather than through a transparent negative. The light reaching the printing surface reacts with the colloid, and repels oily ink. The process received a patent in March 1858.[20]

The Portrait of James Ambrose Cutting was intended to introduce the new technique with fanfare in the Photographic and Fine Art Journal in the month of the patent's approval.[21] In fact, the portraits of both Cutting and Bradford were meant to appear, but Bradford's likeness was not completed in time. Cutting is depicted as a conventional-looking Victorian gentleman. He is alert and quite serious, every bit the New England truepenny. The image is remarkable in its detail, capturing the wrinkles around Cutting's eyes and his wiry whiskers. The quality of the inventors' portraits were unprecedented at that time in American photolithographs. Over the next few months the Photographic and Fine Art Journal published other photolithographs including portraits, art reproductions, and views, printed by Turner. In later years both he and Bradford concentrated their professional activities on photolithography, producing remarkable prints.

Photolithography contributed to Cutting's prosperity. The successful entrepreneur enjoyed sailing his yacht along the New England coast and collecting aquatic specimens. He displayed his growing collection at the Boston "Aquarial Gardens," an enterprise in which he partnered with Henry D. Butler.[22] The precursor to the New England Aquarium, this organization drew Cutting away from photography around 1860. With characteristic enthusiasm, he even trained the aquarium's seals.[23] Later he sold the specimens and exhibits to P. T. Barnum, who moved them to New York. By that time, however, Cutting had suffered an emotional breakdown, and was living out his final years in the Worcester State Hospital for the Insane.

The American Civil War was the first major conflict to be documented comprehensively by photographers. Camera operators joined field correspondents and artists, and their images were immediately transformed into wood-engraved illustrations for newspapers and magazines. Eventually prints from the original negatives were published in documentary series. Photographers first recorded the siege of Fort Sumter, the assault that started the war in April 1861. Afterwards, they sold portraits of the fort's commander, Major Robert Anderson, which helped him become the first Union hero of the war.[1]

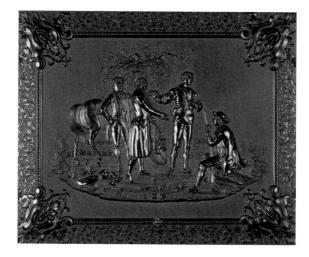

Fig. 3. Peck and Halvorson, *The Capture of Major André,* Thermoplastic Union Case, about 1860.

Demand for affordable photographic portraits continued in wartime, when soldiers wished to give a likeness to their families and to carry images of loved ones on campaign. Most of them were TINTYPES, small, durable photographs that could be carried in a pocket or sent through the mail. Like AMBROTYPES, these were unique COLLODION POSITIVE images, but formed on thin sheets of enameled iron instead of glass. The inexpensive photographs could be processed while the customer waited, and operators could produce several tintypes at once by using a multilens camera. During the war, scores of photographic entrepreneurs set up near training camps, and even followed the troops in the field, producing quick, inexpensive tintype portraits.

Union Army Sargeant (32) is typical of military tintypes that survive in the thousands, eloquent images though their creators and their subjects are not known. This elegant production shows a full-length figure on a relatively large plate, delicately hand colored, and even touched with gold paint. The orderly sargeant stands in full-dress uniform, with a nine-button frock coat, ceremonial sash, regulation trousers, and forage cap. Around his waist he wears the regulation noncommissioned officer's saber belt with eagle buckle, supporting a leather scabbard for the sword he holds in his right arm. He stands before a portable photographer's backdrop, painted with the fanciful scene of an army encampment beneath the stars and stripes, near a

lake in a mountainous landscape. Since the sargeant's uniform still appears new, it would seem that this photograph was taken before his deployment, in a training camp near Washington, DC, the chief Union staging site for the southern campaign.

The *Union Army Sargeant* is contained in a fine UNION CASE decorated with a military vignette (fig. 3). These durable cases were made from a plastic material produced by a method patented in 1854 by Samuel Peck, who heated a mixture of shellac, sawdust, and pigment, and poured it into a steel mold. This case, with a silk lining and gilt preserver, was made by the Peck and Halvorson Company, from steel dies created by a Frederick Goll.[2] The image is derived from the central group in Asher B. Durand's painting *The Capture of Major André*, which is now in the Worcester Art Museum.[3] John André was a British Army Major who conspired with the traitorous Benedict Arnold during the American Revolution, but their plot was foiled when three New York militiamen captured him. The legendary tale of common soldiers' cunning and gallantry is a fitting subject for an infantryman.

MATHEW BRADY (33) dedicated himself, professionally and personally, to the photographic

32

32

Unknown photographer
American, nineteenth
century

Union Army Sargeant,
about 1862

Tintype with hand-coloring
10.4 x 8.1 cm
Gift of Emma Forbes Waite,
1952.36

documentation of the Civil War. Progressively degenerating eyesight prevented him from doing much camera work at that time, but his stature, political connections, and able staff helped him to pursue this ambition. He collected photographs of war-related images from as many sources as he could locate, buying or copying thousands of prints from other photographers.[4]

Brady was born near Lake George, New York, into a struggling family of laborers.[5] In 1841 he accompanied the artist William Page to New York City to meet the painter-inventor Samuel F. B. Morse, who was then an enthusiastic daguerrean. He stayed in the city to become a professional photographer, and by 1844 he had his own portrait studio on Broadway. Using flattery and persistence Brady lured Daniel Webster, Henry Clay, and other celebrities to his studio, and traveled to photograph such subjects as Zachary Taylor.[6] In 1850, he had twelve of these portraits reproduced as lithographs by Francis d'Avignon to illustrate *The Gallery of Illustrious Americans*, a book that became a bestseller. Brady moved to a larger Broadway studio in 1853, and five years later he opened a second gallery in Washington, DC, managed by his associate Alexander Gardner. At the outbreak of the Civil

War, Brady conceived of documenting the conflict in photographs, and won permission for his photographers to follow the Union Army in the field. To raise funds for the project, he sold negatives and celebrity portraits to the publishing house E. & H. T. Anthony. In 1862 he exhibited Gardner's photographs of the aftermath of the Battle of Antietam in New York, some of which were then reproduced in *Harper's Weekly*. On his occasional visits to the south, the media-savvy entrepreneur arranged to be pictured with troops or officers.

General Robert E. Lee and Staff is one of five photographs that Brady and an assistant took days after the confederate general's surrender. Having arrived too late at the site of the ceremony at Appomattox, Virginia, Brady followed Lee to his home in Richmond.[7] At first he was politely rebuffed, but with the help of General Robert Ould and Mrs. Lee, he arranged an hour's sitting, enough time for five exposures. He set up his camera outside the basement under the back porch, brought a chair from the house, and prepared five glass plates for coating. When Lee arrived, wearing the uniform he had worn at the surrender, Brady first arranged a profile portrait.[8] "There was little conversation during the sitting," he later recalled, "but the General changed

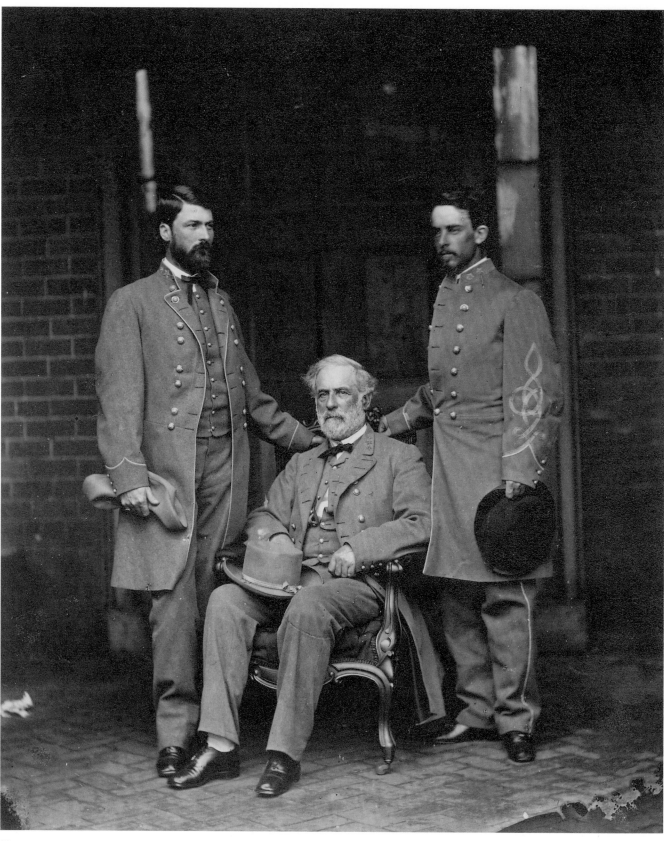

33

his position as often as I wished him."[9] Brady arranged the famous photograph with Lee's son, General George Washington Custis Lee, standing on his left, and his chief of staff, Colonel Walter H. Taylor, on his right. While his adjutants looked away, Lee gazed directly at the camera, with a mixture of exhaustion and brave dignity in his eyes.

The most gripping photographs of the Civil War documented the aftermath of the action. Long exposure times and the immediate demands of the wet-plate COLLODION technique prevented photographers from capturing the fighting, so they followed the troops at a safe distance, documenting the battle results. Among the notable photographers of the war were Alexander Gardner, John Reekie, Andrew J. Russell, and **TIMOTHY H. O'SULLIVAN (34)**. The son of Irish immigrants, O'Sullivan may have been born in Staten Island, NY, soon after their arrival.[10] As a teenager he apprenticed in the Broadway daguerreotype studio of Mathew Brady. When Brady opened a second gallery in Washington, DC, he moved there to be a darkroom technician. In December 1861 O'Sullivan was attached to the Army division commanded by General William Tecumseh Sherman, to follow its progress through South Carolina. His compelling and skillful photographs distinguished him as one of the leading photographers of the war. The following spring, when he returned to Washington with his exposed NEGATIVES, O'Sullivan joined the studio of Alexander Gardner. For the next three years he photographed soldiers before and after battle, the machinery of war, and the aftermath of such battles as Antietam, Fredericksburg, and Gettysburg.

The Field Where General Reynolds Fell, Gettysburg, is one from a series of photographs that O'Sullivan took on Independence Day, 1863, the morning after the three-day battle on farmland near Gettysburg, Pennsylvania, that marked a turning point in the war. There, the armies commanded by General Robert E. Lee faced the forces of George Gordon Meade, commander of the Army of the Potomac. O'Sullivan's photographs and other explicit images of the battle, in which 51,000 men died, impressed the country with the harsh reality and scope of war. In his photograph O'Sullivan protected the identities of the deceased soldiers and yet emphasized the activities of their fall. Their disheveled hair, bloodstained clothing, bent legs, and reaching hands all convey the sense of stopped action. The fact that these fallen soldiers have been stripped of their boots, belts, weapons, and ammunition brings home the heartless, harsh practicalities of war. "Some of the dead . . . lay stretched on their backs," explained the photograph's caption in *Gardner's Photographic Sketchbook of the War*, "as if friendly hands had prepared them for burial. Some were still resting on one knee, their hands grasping their muskets. In some instances the cartridge remained between the

33

Mathew Brady
American, about 1823–1896

General Robert E. Lee and Staff, 1865

Albumen print from wet collodion negative
21.5 x 17.9 cm
Sarah C. Garver Fund, 1988.155

34

Timothy O'Sullivan
American, 1840–1882

The Field Where General Reynolds Fell, Gettysburg, from *Incidents of the War*, 1863

Albumen print from wet collodion negative
17.4 x 22.7 cm
Eliza S. Paine Fund, 1988.169

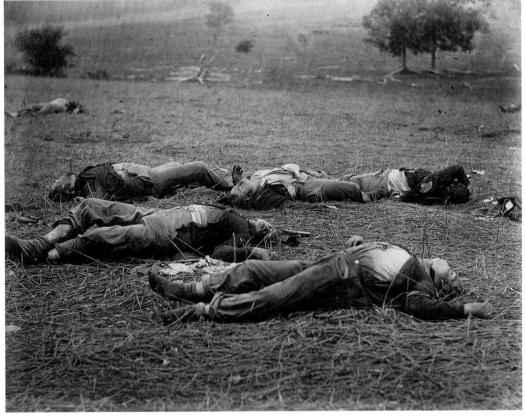

34

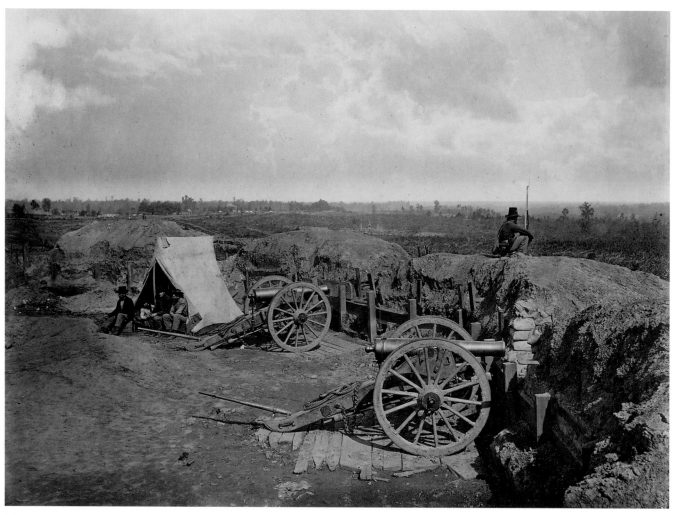

35

35

George N. Barnard
American, 1819–1902

*Rebel Works in Front of
Atlanta #4*, 1864

Albumen print from wet
collodion negative
25.6 x 35.7 cm
Stoddard Acquisition Fund,
1989.159

teeth, the musket was held in one hand, and the
other was uplifted as though to ward off a blow, or
appealing to heaven. The faces were all pale, as
though cut in marble, and as the wind swept
across the battle-field it waved the hair, and gave
the bodies such an appearance of life that the spec-
tator could hardly help thinking that they were
about to rise and continue the fight."[11] Four
months later, Abraham Lincoln visited the battle-
field. "We have come to dedicate a portion of that
field," said the President, "as a final resting place
for those who here gave their lives that the nation
might live . . . , but we cannot hallow this ground.
The brave men, living and dead, who struggled
here, have consecrated it far above our poor power
to add or detract."[12]

Before the Civil War, **GEORGE N. BARNARD (35)**
already had a distinguished career as a portraitist
and commercial photographer.[13] He opened his
first daguerreotype studio in 1843 at Oswego, New
York. On July 5, 1853, Barnard made two daguerreo-
type views of the great fire that consumed the
Ames Mills in Oswego, which are considered the

earliest of all American news photographs.[14] The
following year Barnard purchased Clark's Gallery in
Syracuse, where he began working in ambrotype
and later shifted to the wet-plate collodion process.
After an expedition to Cuba in 1860, where he pho-
tographed the sugar and molasses industries, he
settled in New York City to work in the studio of
Mathew Brady (no. 33). Like Timothy O'Sullivan,
Barnard went South to join Brady's team of pho-
tographers documenting the Civil War. In 1863
Barnard was appointed official photographer for
the United States Army, Chief Engineer's Office,
Division of the Mississippi. He accompanied Gen-
eral William Tecumseh Sherman's forces in their
march from Tennessee through Georgia to the sea,
and then north to the Carolinas. Technical limita-
tions confined him to images of the aftermath of
battle. In the Tennessee mountains, Barnard docu-
mented forests destroyed by shelling and Union
trestle bridges rapidly erected to replace spans
destroyed in the Confederate retreat. Sometimes
the photographer arranged his subjects for effect,
repositioning skulls, cannonballs, and other arti-
facts, to symbolize the devastation of war.

36

36

Unknown photographer
American, nineteenth
century

*Pennsylvania Railroad
Locomotive No. 166*, 1866

Albumen print from wet
collodion negative
27.4 x 43.5 cm
Alexander and Caroline
DeWitt Fund, 1993.4

Rebel Works in Front of Atlanta is one of Barnard's photographs of the eerie silence that fell upon the city after its capture on September 1, 1864. General Sherman turned Atlanta into an armed camp, evacuating all of its civilians, destroying the banks and railroad infrastructure. The photographer made several images of Confederate trenches and gun emplacements, built to protect the city. In the photograph, Federal cannon stand in the emplacement, which is guarded by Union sentries, who gaze out over the devastated city and countryside. The landscape has been deforested and literally flattened by shelling. Only the chimneys from one building, seen just over the edge of the battlements, remain standing. An encampment is visible in the distance at the left, and tents surround a background house, showing that it is now occupied by the Union army. It may well be the rising mists of morning that blur the distant landscape, but the effect is of land still smouldering from a great battle. Over the scene of desolation Barnard printed a luminous cloudscape from a second negative. The occupation of Atlanta was a prelude to Sherman's infamous March to the Sea at the end of 1864. As

his forces of 60,000 troops progressed through captured Confederate territory, they felt tacit license to destroy and pillage. Barnard claimed that the speed of the army's advance prevented him from photographing the devastation that so demoralized the Confederate cause. After the war, Barnard returned to Syracuse, where he produced *Photographic Views of Sherman's Campaign*.[15]

The remarkable photograph of Pennsylvania Railroad Locomotive No. 166 **(36)** depicts a machine with the care and insight usually invested in a portrait. It is an iconic image symbolizing the brawn and confidence of American industry in the north after the Civil War, when the railroad consolidated the country's industrial infrastructure.

No. 166 is one from an album of photographs documenting the locomotives of the Pennsylvania Railroad Company (PRR), taken at its headquarters in Altoona, Pennsylvania, between 1864 and 1868.[16] The PRR began in 1841 as a trunk line through the Allegheny Mountains from Pittsburgh to Philadelphia to compete with the Erie Canal. The company carefully surveyed the site for a new base of opera-

tion on the mountains' eastern slope, an area rich in coal, iron ore, and timber, where a locomotive could get the additional power needed to climb the mountains. In 1849, the PRR began building the town of Altoona, including shops to construct, repair, and maintain railroad cars and locomotives, as well as manufacture parts for iron bridges. At its incorporation in 1854, the town had 2,000 residents; by 1870 its population was 10,618. Altoona was a vital industrial and strategic center during the Civil War. In 1863, when General Lee led his armies into Pennsylvania, the town was on high alert. Fortifications were manned, and all portable equipment was prepared for evacuation. Forty locomotives with rolling stock were stoked to vacate immediately if the Confederates approached. They turned south, however, and eventually withdrew following the battle of Gettysburg.

After the war, the PRR standardized its machinery, making all parts economically interchangeable.[17] Old locomotives — built by the Baldwin, and Lancaster Locomotive works — were gradually retired and replaced with Altoona-built engines. The company refurbished the best of the old engines, and documented the results in photographs. The image of Locomotive No. 166 probably originated in the album *A Collection of Photographs of Locomotives Typical of Each Class on the Pennsylvania Railroad*, a folio of sixty-six builders' views, taken at Altoona workshops.[18] The prized old engine has just emerged from refurbishment in the Motive Power Shops. The 4-4-0–class passenger locomotive was built by the Lancaster Locomotive Company for the Philadelphia & Columbia Railroad in November 1853, when it was named "Wheatland."[19] It continued in constant service after the PRR bought it in 1857. Three years later, when Edward, Prince of Wales, visited North America to open the Victoria Bridge in Montreal — an event documented by William Notman (no. 24) — No. 166 pulled the Royal Train on its Pennsylvania tour.[20]

PRR Locomotive No. 166 was refurbished in 1866. In its record photograph the engine faces away from the repair shop and toward the open industrial landscape. The clear image of this pristine locomotive, with its flawless pinstripes, is one of strength and possibility. The photograph defies attribution. Before 1900, when the PRR Mechanical Department engaged a staff photographer, the company also employed commercial photographers for specific projects. The photographic records were kept at various locations and departments and were selectively discarded when deemed obsolete.[21]

In 1861, when **CARLETON E. WATKINS (37)** took his mammoth-plate camera into the Yosemite Valley, he inaugurated the premier school of American landscape photography. Born in Oneonta, New York, he was twenty-one years old when he went to California to seek his fortune in the wake of the gold rush.[22] In San Francisco, Watkins became a substitute camera operator for Robert H. Vance in 1854, and quickly learned the craft of daguerreotypy. As a portraitist at the James May Ford studio in San Jose, he learned the ambrotype and wet-plate collodion processes, and soon began working outdoors as a freelance landscape photographer. In 1861, Watkins hired a local cabinetmaker to build a camera that could EXPOSE mammoth-plate negatives measuring up to 18 x 22 inches, and fitted it with a wide-angle Grubb Aplanatic Landscape LENS. That summer Watkins carried the enormous instrument into Yosemite, along with its tripod, a full supply of mammoth glass plates, a stereo camera, DEVELOPING chemicals and equipment, a darktent, camping gear, and provisions. Conditions were equally challenging on site, where Watkins transported his unwieldy and delicate load, and water, along primitive and precipitous trails to his chosen viewpoints. The heat and humidity shifted during the day, warping camera parts and plate holders, and the summer sun made the black darktent unbearably hot. With unimaginable persistence, Watkins exposed thirty mammoth-plate negatives of the Yosemite Valley and Mariposa Grove. Back in San Francisco, he CONTACT-PRINTED the negatives onto sensitized ALBUMEN paper in direct sunlight. Later, a set of his photographs was sent to Senator John Conness of California, who proposed congressional legislation to protect Yosemite from commercial exploitation. When President Abraham Lincoln signed the bill

37

Carleton E. Watkins
American, 1829–1916

Yosemite Falls from Glacier Point, 1865–66

Albumen print from wet collodion negative
52.1 x 41.3 cm
Stoddard Acquisition Fund, 2002.524

Fig. 4. Albert Bierstadt, *Yosemite Falls*, about 1867, oil on canvas.

into law in 1864, he also initiated the development of the National Parks system.

Yosemite Falls from Glacier Point is a mammoth-plate view taken during expeditions in the summers of 1865 or 1866, when Watkins was a member of the California State Geological Survey.[23] It represents the Yosemite Valley and its north wall, with a view of Upper and Lower Yosemite Falls. By 1865, Watkins was adept at working in the wild. To avoid wind that moved his subjects and endangered the big camera set at the edge of a palisade, he worked early in the morning, even though the dawning light sometimes required exposures as long as an hour. It seems that Watkins himself named Glacier Point, the rocky promontory 3,200 feet above the valley.[24] Steeped in Yosemite science and lore, the photographer was familiar with Clarence E. King's theory that the valley had been formed by ancient glaciers. Watkins's photograph clearly shows the striated levels of rock along the valley's north wall to support the geologist's theory, so the name may indicate the outlook from which one could observe this evidence of glacial activity. After its appearance in J. D. Whitney's *Yosemite Book* — illustrated with Watkins's photographs — the name became universal.[25] Watkins's remarkable photographs were of immediate interest to artists. The painter Albert Bierstadt first visited Yosemite in 1863 to make drawings and oil studies for paintings he later executed in his New York studio. To further aid his studio work, he purchased a set of Watkins's mammoth-plate photographs of Yosemite made in 1865–66. The photographs may have influenced Bierstadt's view of Yosemite Falls from the valley floor (fig. 4) in its compressed vertical perspective, and the representation of the Upper Falls as a misty jet, as observed in a time exposure.[26]

After the war, many photographic documentarians found work with the scientific and military surveys of the American West. Their images caused the United States government to preserve parts of the West. In a remarkable career of nearly eight decades, **WILLIAM HENRY JACKSON'S (38)** work spanned from Western geographical exploration to the great Depression. Born in Keeseville, New York,[27] his mother taught him to draw as a child, and his father, a blacksmith and carriage builder who had experimented with daguerreotypy, allowed the boy to play with his camera. As a teenager he retouched photographs at a studio in Troy, New York, and later learned the techniques of photography from Frank Mowrey in Rutland, Vermont. Jack-

son served in the Union Army in 1862–63, working part of the time as an artist and mapmaker. He returned to Vermont after the war and worked in a succession of photography studios until 1866, when he decided to go West. With his younger brother Edward, he opened a photography studio in Omaha, Nebraska. Jackson persuaded the Union Pacific Railroad to grant him a commission for photographic views along their expanding western routes. Seeing these images, Ferdinand Vandeveer Hayden, director of the U.S. Geological Survey of the Territories, invited the photographer to join his survey team. In 1870, during his first season, the group surveyed the Lodge Pole, Chugwater, Platte, and Sweetwater Rivers. The following year Jackson accompanied the survey's exploration of Yellowstone and the Grand Tetons in the Montana Territory. The painter Thomas Moran also accompanied the team that summer, and they became good friends.[28]

Mount Hayden, or the Great Teton is a photograph from that summer's work, later printed and published in Washington, DC, as part of the survey report.[29] Its composition is parallel to many of Moran's oil sketches and finished paintings, conceived to express the scale and majesty of the mountain. In this image, the mountain dominates the centralized composition, while the perspective through two rocky pinnacles emphasizes the lofty point of perception. The view of the foot of the mountain defining an inverted cone shape follows valley pine groves surrounded by snowfields over progressively higher ridges to the distant summit. *Mount Hayden* was included in an exhibition of materials from the survey that helped to convince Massachusetts Senator Henry L. Dawes to join a campaign in Congress for the designation of Yellowstone as the first National Park in 1872. By the time of its publication, the largest peak in the Teton range had been named after the geologist Ferdinand Vandeveer Hayden.

During the 1880s Jackson opened a studio in Denver, in partnership with Albert E. Rinehardt. He received a prestigious commission to photograph the World's Columbian Exposition in Chicago in 1893,[30] and created tourist views for the Detroit Photographic Company from 1898 to 1924. A pioneer in the use of color photography,[31] Jackson turned to painting in retirement, and in 1936 worked in the mural painting division of the Federal Arts Program of the Works Progress Administration, transforming his photographs and experiences from the Geological Survey into wall paintings.

38

William Henry Jackson
American, 1843–1942

Mount Hayden, or the Great Teton, 1872

Albumen print from wet collodion negative
32.9 x 25.2 cm
Austin S. Garver Fund,
1977.5

MT. HAYDEN or THE GREAT TETON.

5 | Literary Images

At a time when authors were among the most respected figures in society, inexpensive photographic portraits satisfied the public's interest in their appearance. In France, the leading portrait photographers of the nineteenth century were Nadar (no. 43) and **ÉTIENNE CARJAT (39)**, friendly rivals in bohemian Paris. Both were authors, magazine editors and publishers, and social critics who expressed themselves through satirical prose and lithographs.

Born into a family of peasant farmers in a country village near Ain, Carjat was a child when his family moved to Paris, where his father became a concierge.[1] As a teenager he worked as an industrial designer, wrote poetry, frequented the theater, and dreamed of being a painter. He combined his interests in *Le théâtre à la ville*, a suite of lithographic caricatures of popular singers and actors, each accompanied by an original satirical verse. These prints led to Carjat's first commission from the journal *Le Figaro*, and soon he became a newspaper caricaturist. Around 1858, he learned the techniques of photography from Pierre Petit, and began taking portraits, perhaps to aid his caricature work. At his studio in the rue Laffitte, he photographed artists Gustave Courbet and Honoré Daumier, such writers as Victor Hugo and Émile Zola, and performers Charles Deburau, Sarah Bernhardt, and others. When he offered his photographs for sale they instantly became popular, providing a handsome income and enhancing the reputation of his subjects.

Carjat's portrait of Charles Baudelaire is his most famous, and the likeness by which we remember the poet.[2] His work reacted against Victorian codes of taste and conduct, and he came to personify the most lurid form of Romanticism. Baudelaire's work expressed passion and such heightened emotions as languor, fear, and lust, even to the point of self-destruction. Vain, impulsive, and extravagant, he had become addicted to opium and infected with syphilis when he was a law student. His most famous book of poetry, *Les fleurs du mal* (*The Flowers of Evil*), published in 1857,

prompted his conviction, along with the printer and publisher, for obscenity. The scandal only made the book more popular. His evocative language described shocking visions of desire and decay, and he was among the first to equate modernity with decadence and artificiality. "If poison, arson, sex, narcotics, knives, have not yet ruined us," Baudelaire wrote in *Les fleurs du mal*, "and stitched their quick, loud patterns on the canvas of our lives, it is because our souls are still too sick."[3]

In this portrait of Baudelaire, Carjat isolated the figure before an empty background, concentrating the viewer's attention on his intense expression. The image emphasizes the poet's vanity, and captures his slightly condescending self-possession. His costume is elegant with his velvet collar and white shirt, his tie perfectly arranged. Baudelaire fixes a defiant gaze on the camera, his eyes burning with pugnacious intelligence. However there is a pall of fatigue there, and perhaps a sense of cynical resignation. When the poet sat for Carjat, his health had begun to deteriorate from years of alcohol and drug abuse. Illness, depression, and financial difficulties clouded the last years of his life, spent in a sanatorium.

In 1853, the Glasweigan engraver **THOMAS ANNAN (40)** started a CALOTYPE printing business on the recommendation of his friend D. O. Hill (no. 2).[4] As the enterprise began growing, he recruited his brother Richard as business manager, and in 1855 opened the T. & R. Annan photographic studio on Sauchiehall Street in Glasgow. A century and a half later, this firm continues to thrive, still in family hands, on Woodlands Road. Annan fitted a hansom cab with his DARKROOM equipment, enabling him to photograph landscape and architecture.[5] When he turned his attention to portraiture, he discovered an aptitude for penetrating, popular images. He eliminated the studio props that were then fashionable, to concentrate on the sitter's personality. In 1866 Annan retained the Scottish patent rights to the CARBON PRINT process, soon after its invention by Sir Joseph Wilson Swan. His

39

39

Étienne Carjat
French, 1828–1906

Charles Baudelaire, about
1862

Carbon print
21.1 x 18.2 cm
Purchased through the gift
of Mrs. Joseph Goodhue,
1983.6.7

first production in the new technique was a repro-
duction of Hill's *The Signing of the Deed of Demis-
sion*, which included his own portrait.[6]

Archway in Outer Court is a photograph from
Annan's book *Memorials of the Old College of Glas-
gow*, a series that powerfully evokes Glasgow's aca-
demic and literary world in views of college
buildings and portraits of professors and authors.[7]
This image of the Old College entrance portal pres-
ents a metaphor for the process of education.
Through the darkened archway is a glimpse from
one court into lighted spaces beyond. The old,
sculptural passageway is inserted into an even

more ancient wall. It is decorated with classical ele-
ments of fluted columns supporting an ionic archi-
trave; surmounting the portal are Renaissance
decorative details, carved vases, and supporting
strapwork, flanking a heraldic escutcheon with the
college arms. These motifs symbolize the ancient
traditions upon which the institution was founded.
Each time students passed through this archway,
they set upon a journey based in long and honored
traditions. The path is crooked, but clear and
apparent, here marked by a Victorian innovation,
a succession of gaslights.

The deserted architectural spaces enhance their

40

Thomas Annan
Scottish, 1829–1887

Archway in Outer Court from
*Memorials of the Old College
of Glasgow*, 1870

Carbon print
25.4 x 18.0 cm
Sarah C. Garver Fund,
1987.42

40

unco atmosphere and prefigure another of Annan's outstanding projects. In 1868 the Glasgow Improvement Trust commissioned the photographer to record the slums of the old city, then scheduled for demolition. The project was similar to Charles Marville's (no. 12) photographs of Old Paris made twenty years earlier. It was a challenge for Annan to photograph in narrow, angular passages between tall tenement buildings, especially since the dim light required long exposure times. First published in 1871, *Old Closes and Streets of Glasgow* was

reprinted in three editions.[8] Many Annan images were published as PHOTOGRAVURES, the technique for which the savvy photographer acquired the British patent rights from Karel Klíč, who taught the process directly to his son, James Craig Annan, who joined the family firm, along with his brother John, in 1888.[9]

Another photographer of the academic world was the Reverend Charles Lutwidge Dodgson, an Oxford University lecturer and the author of several

41

41

Lewis Carroll

English, 1832–1898

Brodies, on Grass-Plot, 1861

Albumen print from wet
collodion negative
15.3 x 20.6 cm
Jerome A. Wheelock Fund,
1983.54

42

Julia Margaret Cameron
English, 1815–1879

Vivien and Merlin from the
series *Idylls of the King*,
about 1874

Albumen print from wet
collodion negative
33.1 x 25.7 cm
Anonymous Fund, 1986.75

books on logic and mathematics. He is better
known as **LEWIS CARROLL (41)**, the pen name he
used for his famous fantasy stories.[10] His mathe-
matical talent was recognized when he was a boy,
and in boarding school at Rugby he created maga-
zines with stories, poems, and drawings to enter-
tain his siblings at home. In 1850, he attended
Christ Church College at Oxford University where,
five years later, he became a lecturer in mathemat-
ics. He continued to write nonsense rhymes and
stories, collecting the best of them in a scrapbook
titled *Mischmasch*.[11]

Carroll was introduced to photography in 1855,
during summer vacation with a friend. The follow-
ing March he bought his own camera, and took it
along to dinner at the home of Henry Liddell, the
new Dean of Christ Church. The four Liddell chil-
dren charmed him; he photographed them that day
in the Deanery garden, and they all became friends.
After completing his Master of Arts in 1857, Carroll
attended Cuddleston Theological College and in
December 1861 was ordained as a deacon. Aca-
demic success curtailed his church aspirations, how-
ever, for by this time he was at work on his third
of six mathematical textbooks. He contributed
humorous stories and poems to *The Train* maga-
zine under pseudonymous initials. When asked
to provide a pen name, he sent four, from which
the editor chose Lewis Carroll.[12]

Brodies, on Grass-Plot portrays four of the five
daughters of Benjamin Collins Brodie, the Wayn-
flete Professor of Chemistry at Christ Church, and
the son and namesake of the renowned physiolo-
gist and surgeon.[13] Carroll took this portrait on
June 21, 1861, when he was a guest at their home in
Oxford.[14] That day in their garden he took several
photographs in addition to this plate: an image of
the sisters posed on a step ladder, a few images of
the girls singly and in pairs, and a portrait of the
professor sitting on a bench. Carroll probably
posed this photograph, which suggests the casual
comfort between Lilian, Margaret, Ida, and Ethel
Brodie. It also conveys a family affection that the
photographer, separated from his many younger
siblings, missed at Oxford. Carroll trimmed this
print to its arched shape, which encloses the com-
position from the upper corners, visually pressing
the children closer together and emphasizing their
physical and emotional proximity.[15] In Carroll's
scrapbook, to distinguish this image from other
shots of the family, he inscribed the title, "*Brodies,
on grass-plot.*"

A few weeks after this photograph was taken,
Carroll and a friend took three of the Liddell chil-
dren boating on the Thames. To amuse them he
made up a fantasy story involving the middle girl,
Alice. The children loved these stories, and Carroll
continued inventing them on two more river trips
with the children in August. In February 1863 he
completed his first draft of *Alice's Adventures in
Wonderland* and provided detailed sketches and
instructions to John Tenniel, whom he engaged to

do the illustrations.[16] When the book was published in June 1865, Carroll gave Alice Liddell her own copy, bound in white vellum. Carroll continued to photograph enthusiastically during this period. He made many portraits and shared his hobby with other children, including the Kitchins and the Salisburys. In March 1876, Carroll published "The Hunting of the Snark," and began *Through the Looking-Glass*, the sequel to *Alice's Adventures*.[17] He stopped making photographs in July 1880, and devoted his leisure time almost completely to writing.

JULIA MARGARET CAMERON (42) shared many of the friends of Carroll's literary and photographic circles. Born in Calcutta, she was the daughter of a Scottish official in the East India Company.[18] In 1838, she married the jurist Charles Hay Cameron, a member of the Supreme Council of India, and the owner of a tea estate. She raised a large family in Calcutta and served as a popular hostess for Anglo-Indian society. The Camerons retired in London, where they associated with many eminent Victorians including the painter George Frederic Watts, and the astronomer and photography pioneer Sir John Herschel. They became friendly with Poet Laureate Alfred, Lord Tennyson, and his family, visiting them often at Freshwater Bay on the Isle of Wight.

In 1860 Cameron bought a house on Freshwater Bay, which she named Dimbola Lodge, after the family tea estates in Ceylon. Three years later, she became interested in photography. "I turned my coal-house into my dark room," she later wrote, "and a glazed fowl-house I had given to my children became my glass house! . . . the society of hens and chickens was soon changed for that of poets, prophets, painters and lovely maidens."[19] Visitors to Dimbola Lodge were required to sit for portraits, and Cameron was adept at conveying the personalities of subjects she knew well, including Richard Burton, Thomas Carlyle, and Charles Darwin. Her best-known photographs are her *tableaux vivants*, featuring her family and friends as mythological and literary characters. Like the Pre-Raphaelite painters, Cameron looked to the early Renaissance paintings of Giotto, Fra Angelico, and Sandro Botticelli for ideas on composition and form.

Vivien and Merlin is a plate from Cameron's most ambitious project, an illustrated edition of *Idylls of the King*, Tennyson's retelling of the legend of King Arthur.[20] It represents the witch Vivien who cast a spell to imprison Arthur's mentor, the wizard Merlin, in an ancient oak. "There in one moment, she put forth the charm," Tennyson wrote, "of woven paces and of waving hands, and in the hollow oak he lay as dead, and lost to life and use, and name and fame."[21] Cameron had a hollow oak brought from Tennyson's nearby estate as a prop.[22]

By the time she came to this image — plate five of volume three — she was recruiting strangers from the village. "Mrs. Cameron had determined that I was to . . . portray the objectionable Vivien," wrote Agnes Mangles, a visitor to Freshwater. "To my dismay [she] had designed her husband for Merlin, for Mr. Cameron was given to fits of hilarity which always came in the wrong places. . . . He was to be sitting in the oak, and for this purpose a hollow fragment of a tree was brought into the studio, arranged with ivy leaves by Mary and the gardener, who spent quite half a day over it, and Merlin was seated inside. I was posed in due time, and the exposure commenced. But it was more than mortal could stand to see the oak beginning gently to vibrate, and know that the extraordinary phenomenon was produced by the suppressed chuckling of Merlin. In the first two negatives I was an unmitigated failure, in the third I had stood steady, having nerved myself to the visible propensities of the patriarch."[23]

Even more than Étienne Carjat (no. 39), **NADAR (43)** was omnipresent in the Parisian world of art and literature in the Belle Époque. Though most famous as a photographer, he was a caricaturist, author, and magazine publisher. The son of a Parisian printer, Gaspard Félix Tournachon worked a succession of jobs after school, as a smuggler, poacher, peat seller, secretary, and newspaper drama critic in Lyons.[24] He continued as a journalist in Paris, joining its bohemian subculture. By the late 1840s, Tournachon was also drawing newspaper caricatures, which he signed "Nadar," a contraction of his nickname, *tourne à dard*, or "bitter sting." His friendships with the artists he satirized is reflected by his membership in the Association des artistes des Inventeurs founded by Baron Taylor in 1849. At that time he created the *Panthéon Nadar*, lithographic caricatures of the day's leading personalities, a project that led him to photography as a practical way to record the subjects he intended to satirize.

Nadar made flattering photographic portraits; among the subjects were artists Gustave Doré and Eugène Delacroix, writers Alexander Dumas and Théophile Gautier, and musicians Gioacchino Rossini and Hector Berlioz. They appreciated the direct, natural quality of his images, a contrast to the typical stiff, formulaic portraits of the day. However, as Nadar's portrait studio expanded late in the 1850s and employed other photographers, and Disdéri's CARTES-DE-VISITE grew more influential, the shop produced more commercial images of lesser aesthetic quality. By 1860, Nadar had opened a sumptuous studio on the Boulevard des Capucines, with his trademark signature fifty-feet wide emblazoned across its facade. Nadar was the first to try aerial photography, taking his camera up in a hot-

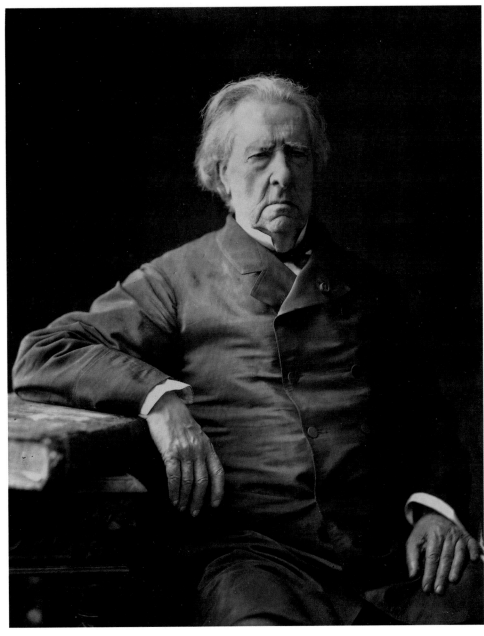

43

43

Nadar
French, 1820–1910

Baron Taylor, about 1872

Carbon print
24.0 x 19.1 cm
Purchased through the gift
of Mrs. Joseph Goodhue,
1983.5.9

air balloon for unprecedented views of Paris. In 1861, he made the first photographs with artificial light, descending into the sewers and the catacombs of Paris with magnesium flares to illuminate his exposures. By 1863, Nadar's studio had become the official headquarters of "The Society for the Encouragement of Aerial Locomotion by Means of Heavier Than Air Machines," with Baron Taylor prominent among its founders, the photographer as president, and Jules Verne as secretary. They worked to raise funding for helicopter-like machines, which at the time seemed an impossible dream.

Nadar's portrait of Baron Isidore-Justin-Séverin Taylor exemplifies the photographer's enduring skills late in his career. A man of many interests and achievements, Taylor was an old friend and colleague.[25] He is best remembered as the pub-

lisher of the *Voyages pittoresques et romantiques dans l'ancienne France*, lithographic views of French historical sites created by the era's leading artists.[26] Published serially from 1819 to 1878, the *Voyages pittoresques* eventually comprised twenty volumes of prints, and became the chief monument of French Romantic landscape. The lithographs had an enormous impact on painting and early photography. This is Nadar's most impressive likeness of his friend, an image that expresses the magisterial wisdom of his character.[27] The baron looks directly at the camera with a confrontational gaze, strangely powerful for his narrow eyes and imperious frown. His chiseled features and enormous bulk are accentuated by subtly orchestrated illumination. The lighting accentuates the wrinkled flesh, creased fabric, and halo of white hair, giving the image a sculpturesque presence.[28]

6 | Art and Photography

Artists were fascinated by the capabilities of early photography, and explored how it might serve their creative processes. In France, the revolutionary technology contributed to the country's impulse for reform. Acknowledging that the future belonged to mass production, in 1860, Prince Emperor Napoléon III began a campaign to reform manufacturing. His government instituted new policies for importing raw materials and products, and applied supporting initiatives to design education.[1] Traditionally, French designers were educated according to fine-arts curricula. Now new specialists were needed to create tasteful designs to be produced economically by machine, for international markets.

This seemed like an opportunity to **CHARLES-HIPPOLYTE AUBRY (44)**, who had been a designer of decorative tapestries, carpets, wallpapers, and fabrics for thirty years.[2] He had higher ambitions, however, and around 1857 he moved to the rue de la Reine-Blanche, near the Gobelins tapestry works.[3] Aubry believed that the reproductive prints traditionally used in French art instruction should be replaced by photographic models. Around 1862, he bought a camera with borrowed money, and began a bold venture that made him a pioneer of still-life photography. He set up a studio in his courtyard, and made photographs and plaster casts of natural objects to be used as artists' models. Aubry presented a portfolio of his best photographs, *Études de feuilles*, to the imperial prince. "In order to facilitate the study of nature," he wrote in the album's introduction, "I have seized from life, bringing models . . . to improve the industrial arts, which have been somewhat compromised by inadequate portfolios of the drawing schools. In dedicating this regenerative work to you, I affirm to the student workers that if you think of [fulfilling] their material needs with gifts, you think of what moralizes and develops the best feelings, the beautiful and the true."[4]

Campanula Flowers was not in the contemporaneous album, but reflects its style and imagery. Common in Europe, campanula — or bellflowers —

attracted artists throughout history with their elegant shape and growth in clusters. Aubry made use of the pyramidal shape of this bunch, with blooms facing every direction giving the viewer a sense of the whole form of the flower. Foreshortened, shadowed blooms furnish a sense of depth. The delicate, translucent petals contrasting with the prickly stalk and leaves are pictured in astounding detail for its time. Aubry's photographs reveal his concepts of design education, and suggest his own practice. Most of his images isolate foliage before dark backgrounds, emphasizing basic shapes and linear contours. Raking light falls over the objects to emphasize their plastic surfaces. The artist may even have dipped the leaves in plaster to unify their color and tone and to prevent them from shifting in the sun or wind during forty-five-minute EXPOSURES.[5] The images become progressively more complex through the album. In later plates, bouquets of cut flowers and fruit are arranged as still lifes, like the prints traditionally used by industrial-design students.

From the founding of the French Academy in the seventeenth century, art students began their studies by drawing from plaster casts of ancient and Renaissance sculptures before graduating to sketching from the live model. Supplementary exercises included copying images from engravings. In the early nineteenth century the prints were superseded by lithographic anatomical studies of muscled males striking athletic poses or engaged in dynamic tasks. Draftsmen like Félix Trezel and Bernard Romain Julien specialized in these lithographic models, known as *académies*, and figures from their prints regularly appeared in the paintings of École des Beaux-Arts students. By mid-century, the prints were replaced by photographic models, valued for their accuracy and heightened realism.[6] One of the first professional artists to explore photography was Eugène Delacroix, who in 1853 made several drawings from an album of male nudes created by the amateur photographer Eugène Durieu. Louis Adolphe Igout seems to have

44

Charles-Hippolyte Aubry
French, 1811–1877

Campanula Flowers, about 1864

Albumen print from wet collodion negative
36.2 x 24.1 cm
Stoddard Acquisition Fund, 2003.15

59 ch. aubry

44

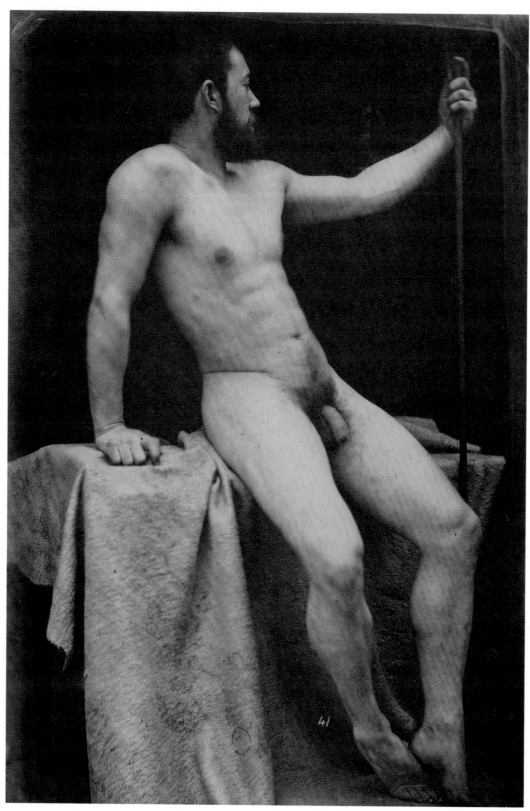

45

published the first photographic *académies* in the 1860s. These were followed around 1868 by works by **GUGLIELMO MARCONI (45)**.

Little is known of Marconi's life.[7] He was a professional photographer working in Paris in the mid-1850s, and a decade later he began selling prints to the École de Dessin, according to his entry in the Paris Botin, or professional directory. In addition to artists' studies, he produced portraits, photographic reproductions of artworks, and *tableaux vivants*. Marconi was part of the wider Parisian arts community, a subculture that included manufacturers and sellers of art supplies, picture framers and shippers, and professional models. At that time, all the models who posed for students, professors, and academicians at the École des Beaux-Arts and the École de Dessin were registered professionals. Marconi's study photographs were sold by the Services des Elèves de l'École des Beaux-Arts, and by local art suppliers. Generally, his *académies* presented male and female models in conventional poses based on academic tradition and the prints used by foregoing generations.

Marconi's *Academic Model* represents one of these professionals, seated on a felt blanket draped over a posing stand. He takes a posture conceived not only for anatomical study, but as a possible element of an infinite number of compositional variants. The model leans back so that his figure defines a diagonal from one corner of the composition to the other. He places his weight on his right hand, which is clasped in a loose fist as if it were holding an object. The pole he holds in his left hand raises his arm level with his face, which is turned away from the photographer to reveal a profile. In Marconi's photographs, models employ various blocks, staffs, and adjustable posing stands to help maintain uncomfortable postures. The figure and his support are brightly illuminated by a light source from the left, which lifts them out from the background, while revealing sharp, clear shadows, and emphasizing the modeling of the figure. Some of Marconi's extant photographs have been marked in pencil, gridded by an artist for transfer to a drawing or canvas.

During the 1860s, far from the rapid development of photography in urban centers, **AUGUST KOTZSCH (46)** quietly chronicled the life of his German village and its surrounding countryside. He published picturesque scenes of everyday country life, landscape, and still-life images, to be used as painters' models. Kotzsch's inhabited landscapes have much in common with the work of Romantic painters like Gaspar David Friedrich and Carl-Gustav Carus, and are in a sense parallel to photographs by Charles Nègre or Éugene Cuvelier (nos. 16, 15).

Kotzsch was born in the village of Loschwitz, near Dresden, where his father owned the Winterleithe vineyard in the hills along the river Elbe.[8] When he was sixteen years old, the painter Ludwig Richter rented a summer apartment on his family's farm and returned to the village every year thereafter. Richter gave drawing lessons to the boy, whose early sketches reflect his teacher's anecdotal imagery of everyday life. Kotzsch was also an assistant to his neighbor August Niemann, an amateur photographer; when he died, the young man bought his equipment. His first datable photograph depicts the celebration of a new ring of bells at the Loschwitz church on September 4, 1861. Kotzsch recorded life in the countryside that was his world, photographing the village, vineyards, fields, and forests. He ranged into other villages along the Elbe, but seldom ventured into Dresden.

Kotzsch built a modest business as a country photographer, executing portraits and recording village events. In 1873 he won a medal of merit at the World Exhibition in Vienna; two years later he won first prize and a diploma of honor at the Industrial Exhibition in Dresden. In 1877 Kotzsch began to publish his own picture postcards, and soon he began marketing them as "Study Photographs for Painters," which included genre scenes of village and country life. Some of his most remarkable images were still-life studies of fruit, vegetables, and plants, prosaically placed in an unadorned white plate set upon a dark wooden table. His photographs were widely distributed, and even sold by fine-art importers in New York and Chicago.

At Fensler's Well is one of several photographs of the natural well that supplied the farm on Kotzsch Berg owned by the neighbor Herr Fensler. Some concentrate on the well itself, and others on the young woman drawing and carrying water. On one inscribed print, Kotzsch recorded the place and identified his model as Fräulein Neubert.[9] She was probably Rose Neubert, the subject of several of his photographs of a young woman with a variety of farm implements. Kotzsch skillfully balanced the composition of this image with the figure and the well sharing its center. As the open grotto door points to the left, Fräulein Neubert steps off to the right, pointing her watering can before her. She wears a peasant's homespun costume, with a headscarf and leather mules. Her pose implies activity, but it seems clear that she was in place for a long camera exposure.

Many artists came to prefer working from a photographic model, for the sake of ease, economy, or versatility. So it was for **ALPHONSE MUCHA (47)**, the Czech master of Art Nouveau. During the 1880s, struggling to eke out a living as a magazine illustrator in Paris, Mucha required a constant succession of models.[10] For his long, meticulous process, live models were prohibitively expensive,

45

Guglielmo Marconi
French, 1842 – after 1885

Academic Model, about 1870

Albumen print from wet collodion negative
26.0 x 17.8 cm
Sarah C. Garver Fund,
1997.104

46

46

August Kotzsch
German, 1836–1910

At Fensler's Well, about 1870

Albumen print from wet
collodion negative
19.3 x 15.7 cm
Stoddard Acquisition Fund,
2003.47

and the sort of photographic *académies* produced by Gugliemo Marconi (no. 45) represented poses that were too traditional. So Mucha bought a camera, and made his own photographs of models in the idiosyncratic positions he required. He incorporated ideas and images from Impressionism, Symbolism, Art Nouveau, and a wide circle of artist friends, including Paul Gauguin with whom he shared a studio in about 1893. He also incorporated undulating plant forms with decorative motifs drawn from Byzantine, Celtic, and Moravian art.

Early in 1895, Mucha designed a poster for Sarah Bernhardt's play *Gismonda* that caused a sensation and made him a celebrity. For six years he designed all the costumes, sets, and posters for Bernhardt. These works attracted further commissions, enabling him to move to a new apartment and studio in the rue du Val de Grâce in 1898. The following year he designed the Bosnia-Hercegovina Pavilion for the Exposition Universelle, and began designing jewelry for the goldsmith Georges Fouquet, for whom he created a new boutique in the rue Royale. His notoriety and influence were also spread through his two books on design, *Documents décoratifs* and *Figures décoratives*.[11]

The *Painter's Model "Doris"* is typical of scores of Mucha's photographic studies made for specific projects. The professional model is seated on a stool, elevated on a table before a white canvas backdrop, in the artist's rue du Val de Grâce studio.

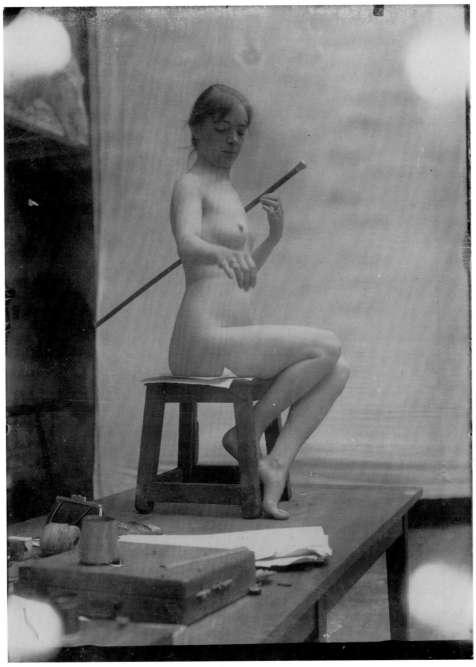

47

Alphonse Mucha
Czech, 1860–1939

The Painter's Model "Doris,"
about 1895

Albumen print from dry
plate negative
17.7 x 12.9 cm
Sarah C. Garver Fund,
1998.77

47

She shares the table with a paintbox, turpentine cans, a ruler, and balls of twine. Mucha posed the model with her legs twisted into a characteristically aesthetic pose; a cane tucked under her left arm helps to steady the delicate placement of her left hand. She glances down and to the right, as if observing an object lifted in her right hand. Prosaic details, like the model's purse kept close on the table, emphasize the study's practicality, as do the sheets of paper protecting her from the workshop stool. In such photographic sketches Mucha gave little attention to technique, and many are unfocused or clumsily DEVELOPED. He often drew on the prints, slightly modifying contour lines, or squaring the image for transfer to an enlarged quadrille on

paper or canvas. He used the camera as a toy and a tool, but it is unclear whether he considered it a creative medium for his own finished works.[12] Mucha invented a remote shutter mechanism to enable him to make self-portraits. Many of his photographs represent the life of a happy family, the artist's travels, and a lighthearted circle of friends. One amusing shot shows Gauguin at the harmonium in Mucha's studio wearing no pants.

Photography's ability to stop time is one of the most important ways that it has transformed human perception.[13] A pioneer in the study of this phenomenon was **EADWEARD MUYBRIDGE (48)**, whose photographic studies of people and animals

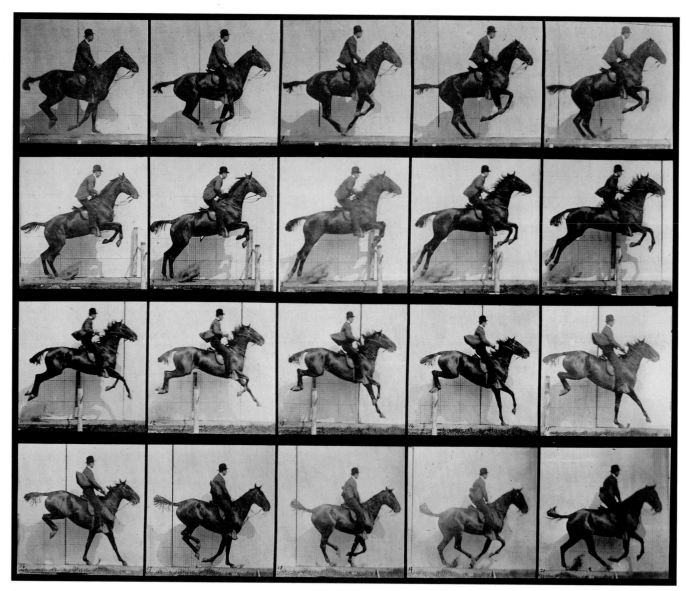

48

48

Eadweard Muybridge
English, active in United
States, 1830–1904

*Jumping the Bay Saddle
Horse, Daisy from Animal
Locomotion*, 1887

Collotype
25.4 x 30.7 cm
Gift of John Rogers, 1973.163

in motion revolutionized the understanding and representation of movement. Edward James Muggeridge was born in the village of Kingston-on-Thames, the son of a corn chandler.[14] Though little is known of his early life, his youthful ambition is apparent in the change of his name to Eadweard Muybridge, which he believed to be its original Anglo-Saxon form. In 1852, he joined the Gold Rush to California, where he began a career as a photographer and worked for the United States Geodetic Survey. His large photographs of the Yosemite Valley made him famous as a photographer of the American West.

Muybridge's work came to the attention of Leland Stanford, the railroad magnate, former California governor, future United States senator, and racehorse enthusiast.[15] He asked the photographer to help settle a wager with another racehorse owner, who disagreed about whether a trotting horse always has at least one foot in contact with the ground. In spring 1872, Muybridge set out to

produce a series of wet-plate NEGATIVES from cameras actuated by trip wires, to photograph the celebrated trotter, Occident, speeding along the track. Technical limitations of materials and equipment could not capture all the phases of the horse's stride, but the inconclusive results tantalizingly suggested that the horse's feet were simultaneously off the ground. Five years later, Muybridge set up many more still cameras, this time facing a white backdrop across a segment of the racecourse covered with rubber matting to prevent dust from obscuring the images. When he developed an electrical timer to trip the shutters sequentially at equal intervals, he could finally produce a photographic sequence to show conclusively that at times all four of a speeding horse's hooves were in the air.

In 1879 Muybridge invented a device to project his sequential photographs so that the animal appeared to move on a large screen. He printed the images around the circumference of glass disks, and projected light through the rotating wheels to

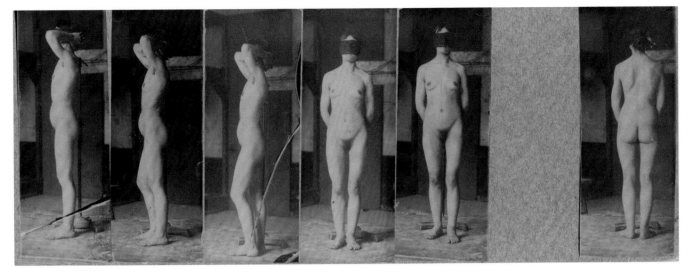

49

49

Thomas Eakins
American, 1844–1916

Lillie, about 1883

Albumen prints from dry-plate collodion negatives
3.0 x 10.0 cm
Theodore T. and Mary G. Ellis Fund, 1997.111

reveal such events as racing horses, somersaulting athletes, and flying birds. He called this combination of the zoetrope and the magic lantern projector the ZOOPRAXISCOPE. Muybridge presented the world's first theatrical moving picture at a meeting of the San Francisco Art Association in 1880. Its success led to the construction of a special "Zoopraxographical Hall" at the 1893 World's Columbian Exhibition in Chicago, which is remembered as the world's first motion-picture theater.

Through Thomas Eakins's advocacy, the University of Pennsylvania engaged Muybridge to continue his studies of locomotion in 1884–85.[16] He shot over 10,000 exposures of people, beasts, and birds in motion. A selection of these were printed by the new method of COLLOTYPE, in 781 plates of *Animal Locomotion*, a series sold by subscription.[17] *Jumping the Bay Saddle Horse, Daisy* typifies the images in the series, which represent sequential studies of movement and anatomy.

Muybridge's chronophotographic studies fascinated **THOMAS EAKINS (49)**, one of the first serious American artists to employ photography in his work. The son of a Philadelphia writing master, Eakins attended the Pennsylvania Academy of the Fine Arts.[18] From 1866 to 1870 he studied in Paris, chiefly with Jean-Léon Gérôme at the École des Beaux-Arts, then struggled to establish a painting career in Philadelphia. He continued the study of anatomy at the Jefferson Medical College, and there painted *The Gross Clinic*, a gripping portrait of Philadelphia's leading surgeon performing an operation before medical students.[19] In fall 1878, Eakins joined the staff of the Pennsylvania Academy of the Fine Arts as chief demonstrator in anatomy, and soon he became a professor of drawing and painting. The innovative teacher brought cows to pose in the modeling room, organized life-drawing classes with nude models, segregated by gender, and

arranged physicians' demonstrations with skeletons and weak electrical currents on living volunteers.[20]

In the early 1880s Eakins began making casual photographs of family and friends, as well as studies for his paintings. Soon he used photography in teaching, producing images of models and students. Since Eakins encouraged many of his students, friends, and family members to use the camera, it is difficult to attribute photographs to the artist himself with certainty. In 1882, when the Pennsylvania Academy was reorganized, he became its director. His own works of the period include oils and watercolors depicting fishermen along the Delaware River, derived from his DRY-PLATE photographs.[21] Eakins also experimented with stop-action photography, developing a camera with a rotating disk mounted behind the shutter to record several sequential movements on a single negative.[22] After seeing Muybridge's motion studies, Eakins invited the photographer to demonstrate his zoopraxiscope at the Pennsylvania Academy. He helped to arrange for Muybridge's research at the University of Pennsylvania that culminated in the publication of *Animal Locomotion*.

Lillie is one from a series of photographs produced by Eakins and his students at the Philadelphia Academy of the Fine Arts in the early 1880s. It was part of an extensive repertoire of figure studies known as the "Naked Series." Small, narrow dry-plate negatives were individually exposed and printed, closely-trimmed, and mounted side by side on a card. Each card represents a different model in the same sequence of poses. Thus, by comparing and contrasting the "Naked Series," students learned sophisticated lessons of varied body type and attitude. One of the seven photographs is absent from the *Lillie* set — an image of the figure from the rear, knees together, legs straight — and seems never have been glued to the card. The model is posed in a corner of the studio, before a

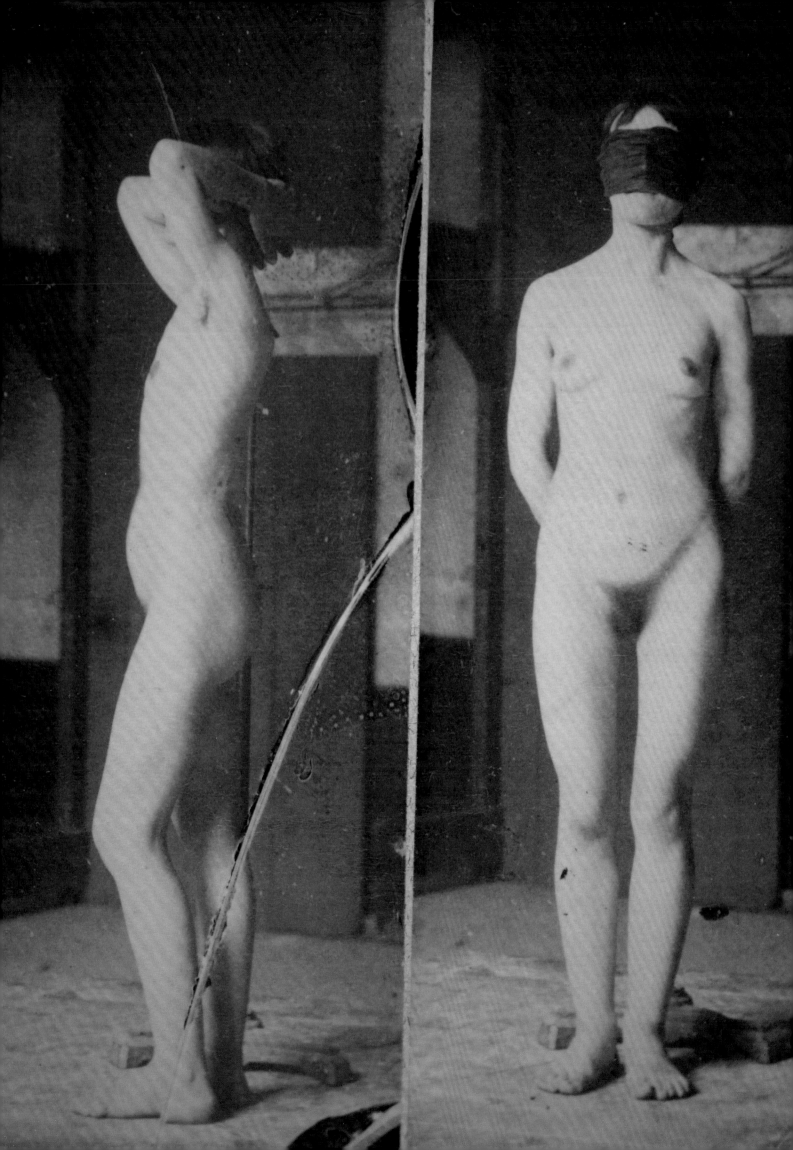

50

50

Arthur Wesley Dow
American, 1857–1922

Ipswich Landscape, about
1895

Cyanotype
12.7 x 20.2 cm
Sarah C. Garver Fund,
1997.73

Fig. 5. Arthur Wesley Dow,
View of the Marshes, Ipswich,
about 1900–05, oil on
canvas.

posing stand, which apparently helped to insure
that her position, and the placement of her shoul-
ders, remained constant through the entire series
of exposures. Many of the models for the "Naked
Series" were Eakins's students, and only the
women wore masks to protect their modesty.

ARTHUR WESLEY DOW (50) was the leading
American art educator in the generation following
Eakins's. His teachings integrated the influence
of the European Arts and Crafts movement with
Asian design, and he advocated new creative
media, including photography. Dow was born in
the coastal town of Ipswich, Massachusetts, and
after early studies in Worcester and Boston, he
went to Paris, where he studied at the Académie
Julian and the École National des Arts Décoratifs in
1884.[23] On a summer painting expedition to Con-
carneau on the Breton coast, he met the American
painter Alexander Harrison, who used the camera
to create studies for his paintings.[24] When Dow
returned to Ipswich in 1889, his picturesque home-
town became the chief subject of his work. He also
found inspiration in Japanese art, studying the col-
lection at the Museum of Fine Arts, Boston, with
the guidance of curator Ernest F. Fenollosa.[25] Dow
applied Japanese principles of design and the tradi-
tional Japanese technique of color woodcut to his
views of nearby Cape Ann. In summer he opened
the Ipswich Summer School of Art, which became

popular with art teachers on vacation. As a labora-
tory for Dow's developing teaching methods, the
program soon included photography.[26] Dow proba-
bly obtained photographic supplies and technical
guidance from George G. Dexter, the local profes-
sional photographer in Ipswich.[27] Dow favored the
process of CYANOTYPE, one of the first commer-
cially available processes that enabled hobbyist
photographers to make their own prints. He him-
self took photographs during the summer, as
sketches for the winter when he worked far from
his landscape subjects.

Ipswich Landscape is a view from "Bayberry Hill,"
the house that Dow built for himself in the town.
It stood at the top of Spring Street, among eleven
acres of meadows and rolling hills, studded with
juniper and wild apple trees. The site commanded

a magnificent view of salt marshes punctuated by the meandering Dragon Creek and the shores of Great Neck, Little Neck, and Plum Island. Dow may have used this photograph, or others like it, to develop his painting *View of the Marshes* (fig. 5), which represents the same view in late summer.[28] The imagery of Dow's photographs, paintings, and prints are closely linked, but their relationships are never exact. The photographs seem to have been *aides-memoir*, rather than fixed planning studies. The camera taught Dow lessons about perception and composition. He made a few flower studies, reminiscent of Japanese prints, and images of the village that examine buildings as geometric forms, reflecting contrasting tones from their adjacent facades. Most of Dow's photographs, however, represent distinctive Cape Ann landscapes. People are conspicuously absent from the photographs, but focal motifs like fishing shacks, working boats, and harvested hay establish human toil as a secondary theme in many of the cyanotypes. Later Dow photographed picturesque sites around New York City, like Pelham, Hastings-on-Hudson, and City Island, which also seem to be working landscape sketches. Just a handful of his larger, GELATIN SILVER PRINTS, taken after 1900 and professionally printed, appear to have been meant as finished works.[29]

In fall 1895, Dow joined the faculty of the Pratt Institute in Brooklyn. Soon he presented his codified design and teaching methods in *Composition: A Series of Exercises in Art Structure for the Use of Students and Teachers*.[30] The book was a phenomenal success, catapulting Dow into the position of America's preeminent art educator. In 1903 he became director of the Department of Fine Arts at the Teachers' College of Columbia University. He reorganized the department according to teaching methods, added photography to the curriculum, and hired Clarence H. White (no. 65) to organize and teach the program.

Dow's imagery of rivers and salt marshes is similar to that of **PETER HENRY EMERSON (51)**, an influential English photographer, naturalist, and author, who wrestled with the relationship of art and photography. Born on the family sugar plantation in Cuba, Emerson moved to England after his father's death in 1869.[31] He attended King's College, London, the medical school of Cambridge University. While continuing his studies at Clare College, Cambridge, he bought his first camera, joined the Photographic Society of Great Britain, and exhibited his work in the society's annual. In 1885, to celebrate the completion of his bachelor of medicine degree, Emerson hired a yacht and cruised the Nor-

folk Broads, the flat, marshy region of East Anglia. The beauty of the place affected him, and he was fascinated by the lives of the farmers and fishermen who lived there.

The *Village of Horning*, one of the images from this expedition, was later published in *Life and Landscape on the Norfolk Broads*, an elegant, limited-edition folio with original, meticulously printed photographs.[32] Water dominates every photograph, creating a theme that includes ample evidence of people at work in the landscape. This composition, like many in the series, emphasizes the peaceful coexistence of the fens and their inhabitants. The skyline is below the center of the composition, emphasizing the planar grassland, and Horning Village reclines, low and flat, close to the horizon. The strong axial line of the mast of the near wherry, elongated by its reflection in the river, balances the horizon, creating a quiet, stable composition. The boat floats silently on calm water, with its mast steadying the composition like a plumb bob. The stability is emphasized by the glassy water and the relaxed voyagers. The viewer identifies with these figures, journeying with them into an inviting landscape.

In 1887 Emerson published *Pictures from Life in Field and Fen*, which he followed through the 1890s with eight more illustrated books on nature and life in East Anglia.[33] At a time when painted backgrounds and theatrical props were common elements of photography, his images were fresh and straightforward. Emerson also advocated a technique described as "differential focusing," presenting the central subject in sharp focus, while softening the periphery to approximate human vision. His "Naturalist" mode of photography represented life as it really was, with honest subjects from everyday life. His esteem for authenticity was similar to the Arts and Crafts movement, which advocated the truth and quality of handmade objects as opposed to the mass-produced, machine-made uniformity of modern products. Emerson zealously advocated these ideas in lectures to the Royal Photographic Society and the (London) Camera Club, in magazine articles, and in his influential book, *Naturalistic Photography for Students of the Art*.[34] Surprisingly, however, around 1890 a "great painter" — perhaps James McNeill Whistler — convinced him that only painting could convey artistic truth. He renounced his belief in art photography in the privately printed, black-bordered pamphlet *The Death of Naturalistic Photography*.[35] By that time, however, Emerson's elegant photographs and eloquent arguments had initiated an international aesthetic photographic movement.

51

Peter Henry Emerson
English, 1856–1936

The Village of Horning, 1885

Platinum print
22.4 x 16.8 cm
Charlotte E. W. Buffington
Fund, 1994.280

51

Renowned in his day as the leading British photographer of China, **JOHN THOMSON (52)** was also a father of social-documentary photography. He had a remarkable ability to sympathize with his subjects, setting aside his own perspective to capture their humanity. Born and raised in Edinburgh, Thomson studied chemistry at Edinburgh University.[1] During the 1850s, he might have provided the technical expertise to the partnership of Ross and Thomson, which quickly established a strong business producing quality daguerreotypes and AMBROTYPES. In 1856, Thomson's work was included in the first exhibition of the Photographic Society of Scotland.

In 1862, at the age of twenty-four, Thomson took his camera to East Asia. "I frequently enjoyed the reputation of being a dangerous geomancer," Thomson later wrote, "and my camera was held to be a dark mysterious instrument which, combined with my naturally, or supernaturally, intensified eyesight gave me power to see through rocks and mountains, to pierce the very souls of the people and to produce miraculous pictures by some black art, which at the same time bereft the individual depicted of so much of the principle of life as to render his death a certainty within a very short period of years."[2] In 1869 he moved his studio to Hong Kong, from where he toured China for the next two years, producing, publishing, and exhibiting hundreds of photographs. Thomson wrote several books after finally returning to London in 1872, the best known of which was *Illustrations of China and Its People*.[3]

Thomson's work prompted the newspaper reporter Adolphe Smith to propose that they collaborate on a book about London's poor. Together they explored the city, photographing and conducting interviews. Smith's accounts aimed to convince readers that poverty was a remediable social problem. *Street Life in London*, the first serious effort to use photography for social documentation, was published serially, and later issued as a book illustrated by the newest method of photographic reproduction, the WOODBURYTYPE.[4] "What prin-

52

cipally excites admiration of this new process," Thomson wrote, "is that the proofs obtained by it are almost exactly similar to those produced by ordinary photographic process; they have the same colour, the same appearance, and the same fineness of quality."[5]

One of the book's illustrations, *The Wall Worker*, seems at first to be the familiar image of Englishmen meeting to share a smoke and a pint at a typical city pub, the Old Dunville. However, Smith's commentary reveals the hard luck beneath the collegiality. The white-haired figure is an old-clothes man, veteran of half a century of peddling. "[Trousers] were all honest wool when I took to collecting," he told Smith, "but now flash and flimsy is

52

John Thomson
Scottish, 1837–1921

The Wall Worker from *Street Life in London*, 1877

Woodburytype
11.5 x 7.6 cm
Anonymous gift in honor of
Stephen B. Jareckie, 1996.33

53

53

Jacob Riis
American, born in Denmark,
1849–1914

*Bandits' Roost, 59½ Mulberry
Street*, about 1888

Gelatin silver print
25.5 x 20.7 cm
Stoddard Acquisition Fund,
2003.44

the style. Steam-dressed goods, cotton and dye, and shoddy's all the rage. . . . It comes of the pride of the working classes, trades' unions and such like — and fashion, sir, fashion!"[6]

Sitting at his left without a drink or pipe, is his friend Cannon, the wall worker. Once he had a shoemaking shop with thirty employees, but when the Crimean War began some of his workers enlisted. Soon leather was diverted to the military and became too expensive. Cannon was bankrupted, reduced to sweeping a street crossing and "wall working." He paid a nominal fee for the right to the fences at his corner, where he hung paid advertising and posters each morning, and took them down at night. Advertisers were scarce, how-

ever, so Cannon covered his unrented boards with "dummies" calculated to make potential clients overvalue his spot. Eking a subsistence , he and his wife lived in an unfurnished room. "Their bed covering, even in cold weather, consists of a single sheet and an old coat which the husband wears during the day," wrote Smith. "This aged couple pays a weekly rental of half-crown, while the balance of their joint earnings goes 'for a crust of bread.'"[7]

Bandits' Roost, by **JACOB RIIS (53)**, is a similar exposé aimed at social reform. This alleyway, near Mulberry Bend in lower Manhattan, was reputed to be one of the most dangerous places in New York City. "On either side of the alley," Riis wrote, "are

stale beer dives in room after room, where the stuff is sold for two or three cents a quart. After buying a round the customer is entitled to a seat on the floor, otherwise known as 'lodging' for the night."[8] From the doorways, stoops, and windows of Bandits' Roost its denizens peer threateningly at the camera. There is not a welcoming face among the loitering men and women who surround the ash heaps and tattered laundry. The lane seems all the more threatening since there appears to be no escape. In 1882, Riis's Tenement House Commission documented the deaths of 155 children in Mulberry Bend, and fourteen people died that year at Number 59 — next to Bandits' Roost — eleven of them children.[9]

Riis was the third of fifteen children born to a poor family in Ribe, Denmark.[10] Defying his father's authority, he went to Copenhagen to become a carpenter's apprentice, and then emigrated to the United States in 1870. Finding it impossible at first to find carpentry work in New York, he labored in menial jobs for years, often sleeping in police-station lodging houses. Finally, in 1873 Riis became a news bureau reporter, and proved so skilled that the South Brooklyn News soon hired him, and in 1877 he became a police reporter for the New York Tribune. His difficult life left him little affected by sensational crime, but deeply moved by poverty and the living conditions in the immigrant slums. In 1882 Riis established the Tenement House Commission, to study and collate information on life in New York, and provide the data to reporters, scholars, politicians, and aid workers.

Frustrated by the images provided by the newspaper photographers, Riis taught himself the medium's techniques. In 1888 he joined the staff of the New York Sun, where his article "Flashes from the Slums" described how he and two other amateur photographers explored the city's most desperate areas at night, recording their discoveries.[11] They were among the first in America to use FLASH-powder illumination, invented in Germany by Adolf Miethe in 1887. Riis's article was illustrated with twelve line-cut images derived from his photographs, for at the time no reproduction technique suited the economy of the newspaper. He did make lantern slides from his photographs, to use in lectures about the city's poverty. Seeing photography for the first time, his audiences gasped, swooned, and called out to the projected images. Riis never printed or exhibited his photographs, and they were soon forgotten.[12] Then, in 1946, his son donated over four hundred COLLODION on glass negatives to the Museum of the City of New York. The photographer Alexander Alland produced gelatin silver print enlargements that were shown in a landmark exhibition, finally revealing Riis's achievements.[13]

STEPHEN CARPENTER EARLE (54), Worcester's leading architect of the nineteenth century, used the camera to record his architectural projects. His photographs provide fascinating records of the city's history, but also reveal his effortless sense of compositional harmony and his inclination to creative experimentation. Earle was born into a Quaker family at Leicester in Worcester County, where his grandfather, the painter Ralph Earle, settled in 1630.[14] His father died when he was a schoolboy and his mother left him in care of his cousin Edward, a former alderman, congressman, and mayor of Worcester. Earle received a sound education at the Friends Boarding School in Providence and at Worcester High School, before studying architecture at the Massachusetts Institute of Technology. He then became an apprentice in the New York studio of the noted architect Calvert Vaux. During the Civil War, Earle renounced his Quaker faith to enlist in the Union Army. He served in the medical corps of the Fifty-first Regiment of soldiers from Worcester County, commanded by Colonel A. B. R. Sprague.

After traveling to Europe to visit the great monuments of architectural history, Earle opened his own architecture office in Worcester in 1866. He built a successful studio by realizing a broad range of projects in the flourishing industrial city, including plans for town halls, fire houses, public libraries, factories, and office blocks. He designed buildings for Clark University, Worcester Polytechnic Institute, and the Worcester Art Museum. Ecclesiastical architecture, however, became Earle's speciality, and he designed twenty-three churches in Worcester alone. The versatility and effectiveness of his work demonstrates his skills and adaptability. He worked in a range of styles, but one of his favorite genres was Romanesque revival popularized by H. H. Richardson. Earle became a prominent figure in the Worcester business and cultural communities. He was one of the founders of Saint John's Episcopal Church, its first treasurer, and later a senior warden. He was also a member of the Worcester County Mechanics Association, the Worcester Art Society, and the Grand Army of the Republic, the Civil War veterans' organization.

Earle's photographs include CYANOTYPES, ALBUMEN PRINTS, and CABINET CARDS, some of which he probably DEVELOPED, and others that were professionally processed. Ten of his photographs were shown at the Worcester Art Museum in its first photography exhibition in 1904.[15] All ten were images of specific buildings — several of his own design — city views, and an interior study. If architectural documentation was the reason that Earle took up photography, he playfully explored its capabilities. Sometimes his images assume provocative viewpoints, stray to ancillary subjects, and settle upon bold compositional effects. His series docu-

54

Stephen Earle
American, 1839–1913

Worcester Building Site, 1890

Cyanotype
10.4 x 13.3 cm
Gift of Mr. and Mrs. Albert
B. Southwick, 1997.46

54

menting the pavilions and bridges of Institute Park, for example, concentrate on a baby in her carriage, or an unusual tree. *Worcester Building Site* is the peculiar, compelling image of the deep basement under excavation for Earle's YWCA building on High Street in Worcester.[16] The scale of the basement and its faceted walls minimize the activities of workers who dig at the soil and rock, loading wagons for carters to haul away along muddy pathways. The point of view from the bottom of the excavation further emphasizes the scale. Up on street level, beside Mrs. Chase's house, a surveyor works as passersby glance over into the hole. In the center of all this bustle stands a confident figure in a tie and jauntily tipped bowler hat, apparently the site foreman comfortably in command of this monumental project. Behind him the projecting end of a wall leads the eye up to Thomas Moore's grand house, across High Street, as if to suggest that this destructive process will lead to architectural triumph.[17]

SENECA RAY STODDARD (55) photographed the lakes and forests of the Adirondack Mountains of upstate New York during its heyday as a vacation retreat in the late nineteenth century. His images combined the natural grandeur of Western travel photography with the sense of the experience souvenir. Born in Wilton, New York, Stoddard grew up on the fringes of the Adirondack region.[18] He was a

talented draftsman and worked as an apprentice to a decorative painter of railway carriages. In the mid-1860s he took up photography and taught himself its techniques. By 1867 Stoddard was an established landscape photographer in Glens Falls with a ready market for his landscape photographs. The developer William West Durant engaged him to document the construction of a northern rail route to the area that would make travel more convenient and affordable and open the Adirondack region to middle-class summer visitors anxious to escape the heat of New York City.[19] Stoddard produced a wide range of photographs of the Adirondack mountains and forests, and of Lake George and its grand resort hotels like the Sagamore and Fort William Henry. In STEREOGRAPHS and larger prints conceived as tourist souvenirs, he represented the natural beauty of the area, as well as the refined pastimes and rugged adventures it offered. Stoddard also presented lectures to audiences of vacationers, illustrated by his own tinted lantern slides, that were also a forum for the sales of his products.

In 1872 Stoddard began the annual publication of *Adirondacks Illustrated*, a guidebook that was revised and reprinted forty times.[20] Illustrated with his drawings and photographs, the guide directed visitors to the local sites, amusements, and amenities, and provided practical information for novice adventurers, along with humorous accounts of

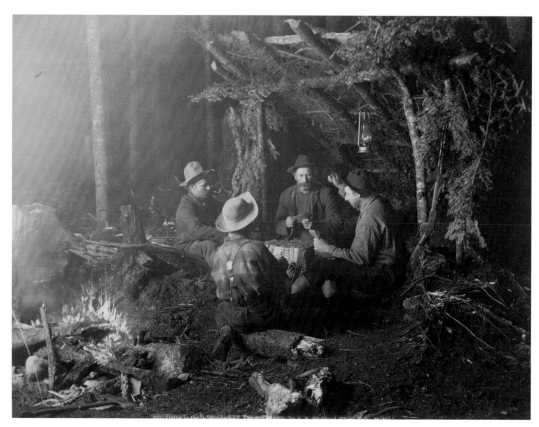

55

Seneca Ray Stoddard
American, 1844–1917

Game in the Adirondacks,
1889

Albumen print from dry
collodion negative
16.7 x 21.9 cm
Charlotte E. W. Buffington
Fund, 1998.112

55

Adirondack travel. Stoddard also published maps
and pamphlets, the last of which was a guide for
automobile touring in 1914.[21] He was a persistent
lobbyist, and his slide lecture to the New York State
Legislature helped to establish Adirondack Park. To
expand his pictorial stock, Stoddard also ventured
to faraway destinations. In the 1880s he paddled a
canoe up and down the eastern seaboard and pub-
lished the views of Long Island to Nova Scotia.
Later he traveled with his camera through Canada
to Alaska.

Game in the Adirondacks exemplifies Stoddard's
popular nocturnal tableaux, staged in the studio or
in the woods.[22] A foursome of grizzled mountain
men, wearing heavy flannels and crumpled felt
hats, amuse themselves with an evening card
game. Seated on fallen logs before a lean-to of pine
logs and boughs, they play cards on the makeshift
table of an upended pack basket, by the light of
lantern and campfire. Although their active poses
seem to suggest a lively game, the players needed
to hold them for the long EXPOSURE. These tough
bitten backwoodsmen seem a little too clean to be
believable, and their camp too spare to be a real
bivouac, but such objects as an axe and a Winches-
ter rifle imply other activities. The most remarkable
quality of this image, however, is its illumination,
for Stoddard — like Jacob Riis (no. 53) — was an
early exponent of flash photography. He took his
night scenes with intense, slow-burning magne-
sium flares. He supplemented the relatively dull

firelight that filled the left side of this image with
smoke emanating from the intense reflected flare.
However, the flames, which flickered too quickly to
be captured, were unconcertingly absent from the
image, so the photographer painted tongues of
flames onto the negative.

Stoddard's flash photographs were his most
remarkable technical achievements. He made dra-
matic night photographs in New York City of the
Washington Memorial Arch and the Statue of Lib-
erty, employing inexact, sometimes treacherous
technology. At the Washington Arch, he overloaded
the flash pan with magnesium. "Instead of boiling
up out of the cup, as any well-mannered charge
ought to have done, . . ." Stoddard recalled, "the
force of this one seemed to be downward, like
dynamite, exploding with loud detonation, tearing
the cup into fragments and boiling down over my
head and shoulders in a sheet of flame that singed
hair and beard, and seared my hands and the side
of my face as with a hot iron, so that after I had
got my slide in and saved my plate, I held an
impromptu reception of policemen and a sympa-
thetic crowd generally, followed by a free ride in an
ambulance to Saint Vincent's. But the photograph
was entirely successful!"[23] For his astonishing
photograph of the Statue of Liberty, Stoddard
suspended a huge magnesium flare on a wire,
stretched from Liberty's torch to a ship's mast at
her island's pier.

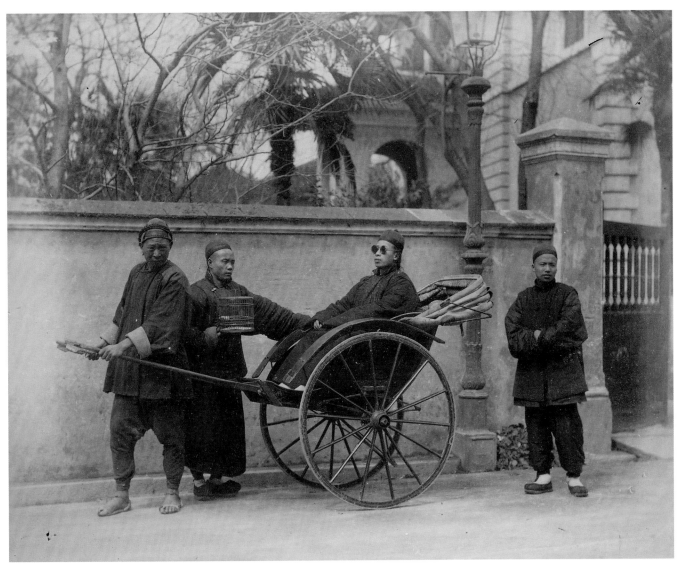

56

56

Sze Yuen Ming and Company
Chinese, active about
1890–1900

Jinrikisha, about 1890

Albumen print from dry
collodion negative
22.6 x 28.2 cm
Gift of Mrs. Ernest T. Clary,
1970.158.39

Aside from expeditionary photographs by artisans like John Thomson (no. 52), the first photographs in China were made during the 1840s in the Treaty Ports, especially Shanghai and Hong Kong. These trading communities, where Westerners were allowed to settle and live in direct contact with the Chinese, became commercial centers that attracted merchants from across China and around the world.[24] Europeans opened and operated photography studios to cater primarily to expatriots and tourists, but they created portraits for Chinese customers that became symbols of fashion and stature. However, topographic views and scenes of daily life in China were produced for an audience of Western inhabitants and tourists. The pioneering photographers in Shanghai were Denis Louis Legrand, Hans Finsler, and William Saunders.[25] Each employed Chinese assistants who went on to open their own studios; but since Chinese scholarly traditions discouraged foreign technology and influences, they confined their activities to the studio. As a result, amateur photography was slow to

establish itself. In the 1860s Chinese studios gradually superseded the foreigners' shops, producing images based on their predecessors' work, including picturesque landscapes, topographical views, and genre scenes that appeared distinctly Chinese and exotic to foreign viewers. Images of different social classes in their traditional dress were popular, as were scenes of street and market life including peddlers and walking food-sellers.

SZE YUEN MING AND COMPANY (56), a Shanghai studio of the late nineteenth century, produced genre scenes and views for Westerners, as well as portraits of Chinese subjects.[26] Little is known of the shop today. However its significant output, and its prestigious location on Nanking Road, the main thoroughfare leading from the Soochow River to the city center, suggest its size. Sze Yuen Ming produced photographs in a wide range of imagery and style, suggesting that the firm employed many photographers. The studio executed commercial projects, including a handsome series representing tea processing and packing,

likely done for a European company. The studio name also appears on a suite of photographs of the river Hong Kong, so geographically specific that it seems to have satisfied a commission.[27] Sze Yuen Ming and Company also produced a peculiar series of studio *tableaux vivants*, depicting animated groups of men eating, gaming, or mimicking street disputes, and brothel, opium den, or courtroom scenes. The actors exaggerate their poses and demeanor for humorous effect.

Jinrikisha is the staged image of a young gentleman of the literati class, poised for an outing in the city. His sunglasses and haughty disregard are tinged with caricature, while his well-dressed servants and sandaled coolie seem amiably aware of the camera. One of the young scholar's manservants carries a cage with his pet bird, suggesting that he may be on the way to a tea house for bird enthusiasts, a traditional establishment where appreciative conversations about specimens and birdsong led to more elevated discussions. Placing this scene outdoors, before a featureless white wall, with a view into a garden above, the photographer cleverly combined the contrived studio tableaux with a topographical setting. This may be a well-known Shanghai location, or one chosen for its modern appearance, for the grand building, walled garden, and gaslights appear in other photographs of the period. Another photograph by the Sze Yuen Ming studio, representing three men and a wheelbarrow, includes two of the models from the present image in the same dress, posed at the same place before the same tall stucco wall and apparently shot on the same day.[28] It may be, therefore, that this photograph is one from a series representing Chinese modes of transport for Western viewers.[29]

The widespread fascination with Native Americans at the turn of the twentieth century prompted a range of photographers to depict Indians, their cultures, and their lives, mainly for eastern urban audiences.[30] In a time of growing regret for their annihilation, there was new interest in their vanishing cultures. However, most of those who photographed Native Americans, including John Anderson, George Wharton James, Roland Reed, Frank Rinehart, and Adam Clark Vroman, were more concerned with engaging images than ethnographic accuracy. This incentive is apparent in photographs by the firm of **ROSE AND HOPKINS (57)** in Denver, Colorado.[31] Canadian-born pioneers John K. Rose and Benjamin S. Hopkins were brothers-in-law. They went west in 1881, and in 1885 became partners in a commercial photography studio in the Tabor Block on Sixteenth Street in Denver, where they made photographic portraits, landscape and architectural views, and images of local events and interest.

Each year from 1895 through 1912, Rose and Hopkins photographed the Festival of Mountain and Plain, Denver's regional fair. The week-long celebration featured parades, contests, ceremonies, and competitions; its exhibits celebrated ranch and industry, including such events as a horse show and a granite-drilling contest. One distinctively Western aspect was the delegation of over a hundred Native Americans, who pitched their tepees in City Park where they held ceremonies, dances, mock battles, and sporting events. It was a diplomatic occasion that allowed the city to recognize powerful local tribes. Rose and Hopkins took their cameras to the Indian camp, making portraits and genre studies, documenting games, and photographing white visitors mingling with the Indians. In some years, the photographers also welcomed Native Americans to their studios, where they created fascinating group and individual portraits.

Pedro — Ute Buck is a portrait from a series made at the Rose and Hopkins studio during the festival. Some of the photographs from these sessions — including the glass-plate NEGATIVE for this portrait — were retained in the Rose and Hopkins archives, now in the Hurlbert Photography Collection at the Denver Public Library. There are several studio portraits of the band from the Moache Tribe of Utes, led by their chief, Buckskin Charley. Among them are seated and standing studio portraits of the chief, whose stature is reflected in the Rutherford Hayes Peace Medal that he wears around his neck.[32] One image represents eleven men and women of the band.[33] There is also a full-length photograph of Pedro and Porrum, two young men standing in a studio before a painted background with the image of a mountain lake.[34] Apparently, the Rose and Hopkins studio sometimes attempted to make their subjects look the part by adding their own costume details; the fur stole that Pedro wears, for example, with its mirrored bosses, appears in many of their portraits of Indians from different tribes. Despite their exploitation of type, however, the Rose and Hopkins photographs are true portraits, for a moving combination of youthful naïveté and stoical acceptance seems apparent in Pedro's piercing gaze.

EDWARD SHERIFF CURTIS (58) dedicated his life's work to photographing the vanishing Native American peoples and cultures. "The passing of every old man or woman," he wrote, "means the passage of some tradition, some knowledge or sacred rite possessed by no other."[35] Curtis was born near Whitewater, Wisconsin, the son of a struggling farmer and part-time minister.[36] He took his first photographs as a teenager with a home-made pinhole camera, and later worked in a Saint Paul portrait studio. In 1887, Curtis moved with his family to the Washington Territory, where he mar-

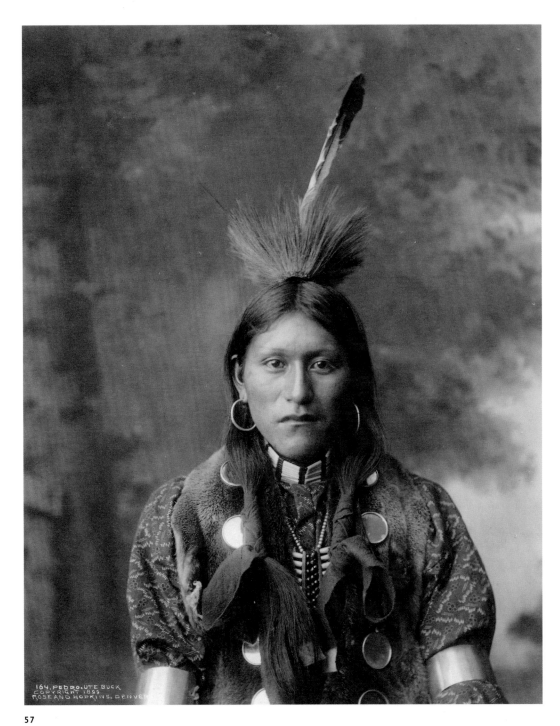

57

Rose and Hopkins
American, active 1885–1910s

Pedro — Ute Buck, 1899

Platinum print
23.6 x 18.6 cm
Museum purchase from the
Sarah C. Garver Fund,
2001.103

57

ried and bought a photography studio in Seattle specializing in society portraits. In 1896, he photographed local American Indians for his own interest, and two years later, as the photographer for a railroad magnate's Alaska expedition, he documented the lives of Native Canadians. In the first years of the century, Curtis resolved to create a comprehensive visual record of the disappearing American Indians. At the expense of his professional and personal life, he tenaciously dedicated himself to this project over the next thirty years. In 1904, President Theodore Roosevelt chose Curtis to portray his family, and introduced him to the fin-

ancier J. Pierpont Morgan, who granted funds for nearly a quarter of the project. Working mostly with a 6 x 8–inch reflex camera, Curtis traversed the continent, exposing over 40,000 negatives, and collecting 10,000 cylinder recordings of Native American languages, stories, and music. He often traveled with William E. Myers, a former journalist who conducted interviews and compiled written records for *The North American Indian*, which was published serially from 1907 to 1930.[37] Each of its twenty volumes was accompanied by an oversized folio of unbound PHOTOGRAVURES. Their subjects ranged broadly from portraits to landscapes, genre

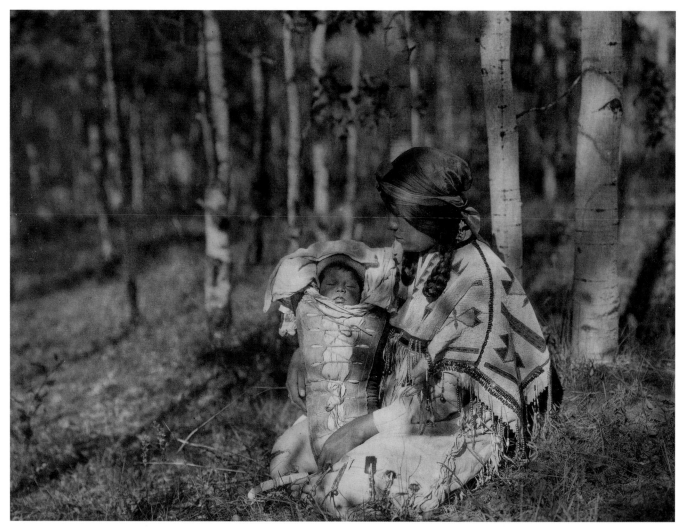

58

58

Edward Sheriff Curtis
American, 1868–1952

Assiniboin Mother and Child,
1926

Photogravure
29.6 x 39.6 cm
Jerome A. Wheelock Fund,
1973.28

scenes, rituals, artifacts, and architecture. Curtis favored tribes that best retained traditional ways of life. To appeal to buyers and sustain the project, however, the images were admittedly aesthetic rather than anthropological.

The *Assiniboin Mother and Child* exemplifies Curtis's PICTORIALIST-influenced style. The Assiniboin were an early offshoot of the Yantonai Sioux, living in the mountains and prairies of Montana, and ranging north into Alberta. The photographer evoked their woodland heritage in the image of a young mother and her baby among flickering lights and long shadows of an aspen grove. Curtis organized his composition around the central motif of the sleeping baby, whose innocence symbolizes the purity of native people who lived seemingly uncomplicated lives close to nature. For Curtis's audience the traditional Indian manner of swaddling and carrying a baby on a backboard had a reassuring familiarity. The mother is dressed in ceremonial garments, with a woven decorated poncho hung with strings of beads. The maternal mixture of tenderness and practicality in her gaze evokes Christian and European artistic traditions of Madonnas and infants, and makes the point of human univer-

sality. Curtis's photogravures were printed in reddish ink on tan paper, colors that evoke leather and earth hues. He had few qualms about posing his subjects and even provided culturally inappropriate clothing or props. These improprieties caused academics to dismiss his work. However, the scale of *The North American Indian* made it enormously influential.

An engaging exoticism characterizes much of the work of **ARNOLD GENTHE (59)**. The son of a Latin and Greek professor in Berlin, Genthe was educated in a European academic tradition.[38] His studies of philology culminated in a treatise on German slang, and a doctorate from the University of Jena in 1894. A family friend, Baron Heinrich von Schroeder, hired him to tutor his son, who had married an American heiress and moved to San Francisco. So it was that this sophisticated European arrived in the Bay Area in 1895. He was enchanted by the city, with its romantic mixture of the Wild West and the Far East, and to share its sights with his family and friends in Germany he began taking photographs. He was particularly drawn to the Chinese quarter — Tangrenbu — and

his street photographs had all the mystery of China itself. Old superstitions and fears of deportation caused Genthe's subjects to avoid being photographed. So he concealed his camera, surprising them around corners or in hidden doorways.[39] The photographer was captivated by the exotic character of these images, and he cropped or painted-out references to Western society, like street signs in English, telephone and electric wires, and even Caucasians on the street. In 1897, some of his photographs were published in the *Wave* magazine, and soon he began showing his work in the annual exhibition of the California Camera Club.

In the late 1890s Genthe opened his own portrait studio in San Francisco. Through von Schroeder he was acquainted with the city's social elite, who came to him for fashionable Pictorialist-style portraits. He also made portraits of local celebrities including the author Jack London, and such prominent visitors as the actress Sarah Bernhardt.

The location for *The Airing*, Portsmouth Square in San Francisco, is identified by the park's distinctive concrete boundary. Genthe adored the Chinese children, who appear in a majority of his Tangrenbu photographs. Relatively few children lived in Chinatown at the time, since federal exclusion and antimescegenation laws proscribed most Chinese from having families in the United States. The community cherished its young people, nurturing them carefully, clothing them in splendid costumes, and allowing them to play freely within the boundaries of the quarter. The well-dressed boys in

Genthe's image, with their skullcaps and artificial queues, seemingly respond to the photographer's call. The little girl — distinguished by a hat that covers her ears — concentrates on her fingers with the obliviousness of infancy. Most American or European viewers would see this as an image of family harmony, and affections universal to humanity. However, the children are in the care of a family servant, whose weathered face and worn clothes mark him as a laborer, a Californian Chinese "bachelor." Many thousands of these men came alone to California as economic refugees after 1840. They worked in isolated societies, lived frugally with other men, and faithfully sent their hard-earned money to their families in China, hoping that one day they might return to them. For Genthe's audience, however, these cultural realities went unrecognized. To promote an illusion of exoticism, the photographer altered his negative, etching areas of the background to simplify the composition and obliterate Western references. Genthe also cut the image from a larger photograph, cropping out another child standing on the left and the shadows of the photographer and his assistant in the lower third of the composition.

On April 18, 1906, Genthe's studio was destroyed in the great San Francisco earthquake. He borrowed a hand-held camera that morning and ventured across the city to document its destruction.[40] About two hundred of his Chinatown images had been safely stored in a bank vault, and they remain the chief photographic documents of this ethnic quarter before the earthquake.[41]

59

Arnold Genthe
American, born in Germany,
1869–1942

The Airing, Chinatown, San Francisco, about 1900

Gelatin silver print
15.4 x 22.2 cm
Austin S. Garver Fund,
2002.525

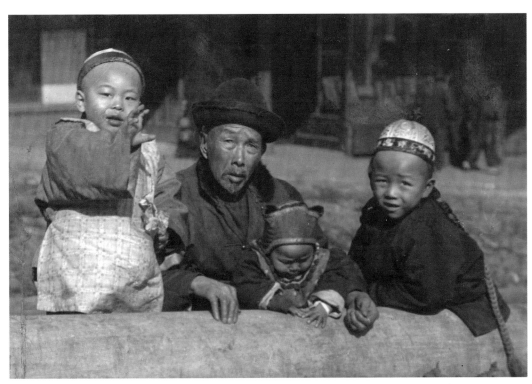

8 | Pictorialism

By 1880, continuing technological advances made photography ever more accessible, and an omnipresent feature of Western culture. DRY PLATE negatives eliminated the need for immediate DEVELOPING, and improved SHUTTERS worked fast enough to stop action. The development of the HALFTONE process finally made it possible to print photographic images by the millions with speed and economy, and they appeared regularly in newspapers and magazines.

A true revolution occurred in 1888, when the Eastman Dry Plate Company of Rochester, New York, marketed the first camera for middle-class consumers. Simplicity was the attraction of Eastman's Kodak No. 1, a small box camera with a shutter so quick that the photographer did not need a tripod. It had a fixed-focus LENS, so the photographer had to move forward or back to find the correct focal length from the subject. The Kodak held a roll of paper coated with enough light-sensitive film for 100 EXPOSURES, and the operator wound the roll forward frame by frame. After exposing them all, the customer mailed the whole camera to Rochester, where the company developed the NEGATIVES by sunlight on either GELATIN OR COLLODION PRINTING-OUT PAPER. The round CONTACT PRINTS, two and half inches in diameter, were returned to the customer along with the camera loaded with a fresh roll of film. The simple equipment limited the quality of snapshot photographs, but made the exhilaration of photography available to a vast new public, drawn in by Eastman's advertising slogan, "You press the button — we do the rest."[1] Popular access set a challenge to serious creative photographers, who believed that the medium could produce expressive, aesthetic images, which now had to be immediately distinct from millions of prosaic images. During the 1890s, however, artists disagreed about basic approaches to aesthetic photography. Some believed that to shed the taint of mechanical craftsmanship, photographs should reveal the hand of their creator. "A work of art must be a transcription, not a copy, of nature . . . ," declared the French amateur photographer

ROBERT DEMACHY (60), "If a man slavishly copies nature, no matter if it is with hand and pencil or through a photographic lens, he may be a supreme artist all the while, but that particular work of his cannot be called a work of art."[2]

Born into an affluent Parisian banking family, Demachy received a fine education.[3] He became interested in photography in 1880, and two years later he was elected to the Société Française de Photographie. The style and imagery of his photographs were inspired and influenced by the fashionable styles of Impressionism and Symbolism. He created portraits, figure studies, costume tableaux, genre scenes, and landscapes, distinguished by their conscious aestheticism, many extensively altered through PIGMENT PRINT techniques. In 1894, when the conservative Société Française de Photographie hesitated over Demachy's work, he began his own Secession, and founded the Photo-Club de Paris, along with his friend Émile Joachim Constant Puyo. Demachy wrote several books on photographic aesthetics and techniques, and published over a thousand articles in such magazines as the *Bulletin du Photo-Club de Paris*, and the *Revue de Photographie*.[4]

Demachy's *Untitled* exemplifies the handworked quality and emotional content of his images. The artist came to prefer the BROMOIL transfer process as a printing method, one of several of the era that enabled artists to alter the image from a negative by hand, making it look more like a painting than a photograph. A seated female figure with her lap covered in drapery gazes upward as if in a swoon. Her face occupies the darkest part of the composition, and her highlighted eyes emphasize her expression. The sinuous form slithers back from the lower left into the middle ground and up and back to the upper right, a direction continued through her glance. Her gaze is expressive but ambiguous, and we are uncertain whether her daze is spiritual or sensuous. The drapery covering her knees emphasizes her nakedness. The artist manipulated the shape of the figure, covering her left shoulder and torso with

60

Robert Demachy
French, 1869–1936

Untitled, about 1902

Bromoil transfer print
16.0 x 11.0 cm
Dwight A. Davis
Photography Fund, 2000.74

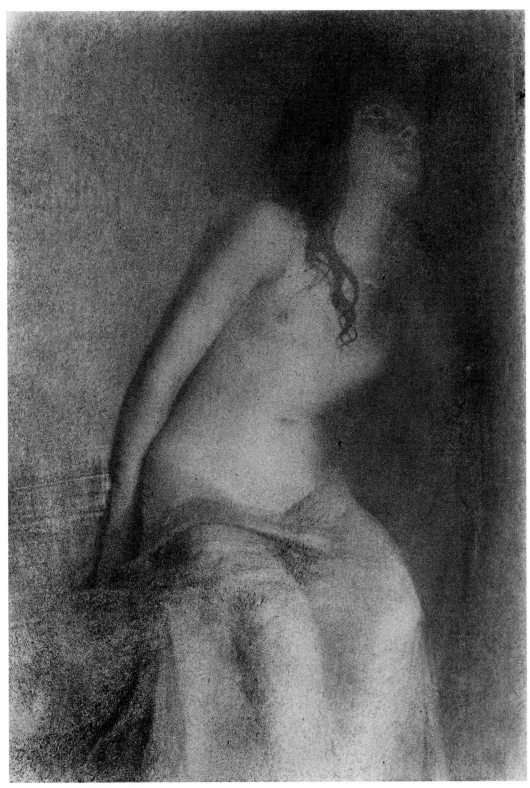

60

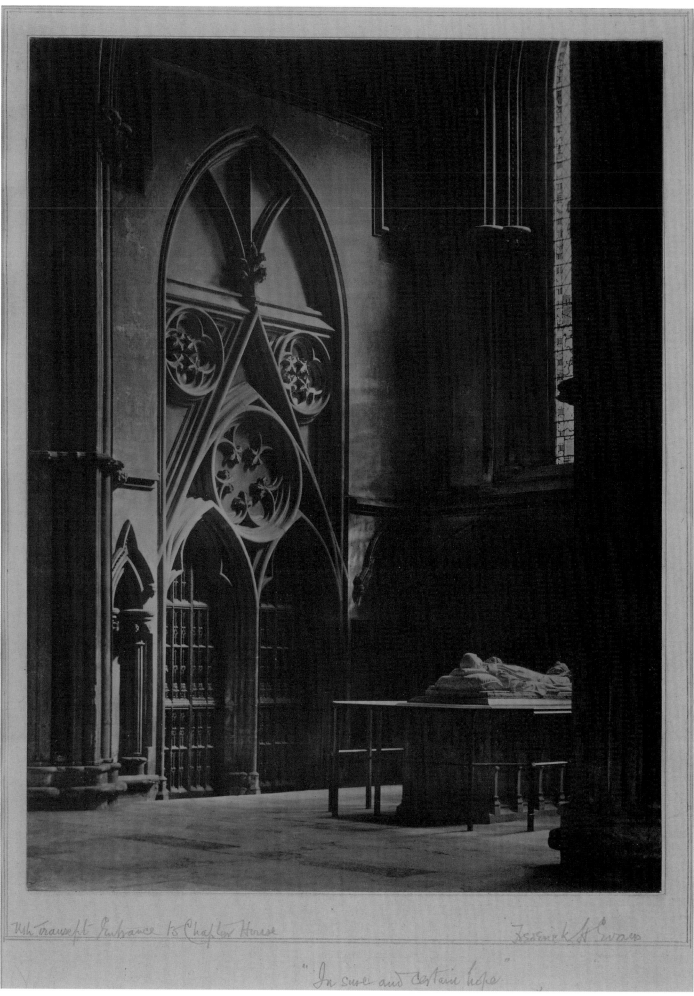

Nth Transept Entrance to Chapter House Frederick H Evans

"In sure and certain hope"

smoky gray fog. Demachy's photographs reveal the influence of Symbolism, its anguish, eroticism, and spiritual longing. They are reminiscent of the paintings of Pierre Puvis de Chavannes, Gustav Moreau, and especially the lithographs of Odilon Redon, works inspired by the writings of Arthur Rimbaud and Charles Baudelaire (no. 39).

Demachy's photographs attracted a popular audience when they were exhibited in Paris, Vienna, and New York. He was an honorary member of the Royal Photographic Society in Britain, and elected to the Brotherhood of the Linked Ring in 1905.[5] The following October, Stieglitz (no. 62) exhibited his work in New York, and published six of his photographs in *Camera Work*.[6] However, Demachy had many detractors among the photographers who advocated technical purity. His ideas were antithetical to the Naturalists, and Peter Henry Emerson (no. 51) characterized him as "the great and original gum-splodger."[7]

The purist's approach to aesthetic photography was supported by Emerson's countryman **FREDERICK H. EVANS (61)**, who believed in consummate technical control as a distinguishing feature. A respected London bookseller, Evans began experimenting with still-life photography in the early 1880s.[8] His microscopic photographs of shells won a medal at the Royal Photographic Society in 1887, wrongly categorized as scientific photographs. In that year Evans met F. Holland Day (no. 64), with whom he would trade his best pictures over the next twenty years. At that time Evans also became close to the young artist Aubrey Beardsley, for whom he arranged the breakthrough commission to illustrate an edition of Alfred, Lord Tennyson's *Morte d'Arthur*.[9] Both Beardsley and Evans strove for images that would elicit visceral sensations of beauty, and provoke intellectual considerations of history and spirituality. These were Evans's aims when he began to photograph English and French Gothic cathedrals in 1890. The works were widely exhibited and appreciated, and Evans left the bookshop to devote himself entirely to photography. A solo exhibition of his work was mounted at the Royal Photographic Society in 1900, and he was elected to the Brotherhood of the Linked Ring.

In Sure and Certain Hope, an image of the Chapter House entrance at York Minster, exemplifies Evans's masterful architectural images. Wishing to convey the majesty and timelessness of a building, he studied his subject carefully before shooting. Sometimes Evans spent weeks in a church as preparation, to explore camera angles, observe effects of space, and watch the natural illumination as it changed through the course of a day and in different weather. Generally, he tried to keep the camera as far as possible from the subject and to fill the frame with its image. To achieve maximum definition, he used a small APERTURE and a very long exposure. His straightforward printing methods brought out the full tonal range and detail of the negative. Aside from describing space, Evans photographed architectural materials, visually communicating the experience of textures. At York Minster, he concentrated on the carved framing elements of the Chapter House entrance and its carved doors. Dramatic light filtering through the leaded glass of the tall transept window picks out every molding and florette.

By choosing a familiar phrase from the *Book of Common Prayer* as its title, Evans specified a memorial but hopeful theme for his image. This is a segment of the Anglican burial service adopted by most Protestant denominations: "Earth to earth, ashes to ashes, dust to dust; in sure and certain hope of the Resurrection to eternal life. . . ."[10] The title directs the viewer to the recumbent tomb effigy, carved in white marble, facing the soft light in expectancy. In this context, the Chapter House portal of York Minster becomes an analogy for the gates of heaven.

With his exquisite taste, imperious personality, and uncompromising will, **ALFRED STIEGLITZ (62)** became the foremost champion of American creative photography at the turn of the twentieth century. Born in Hoboken, New Jersey, he was the son of a German-born wool merchant, and grew up in an affluent, cosmopolitan family.[11] When his father retired to Germany in 1881, Stieglitz received an outstanding continental education. He began taking photographs as a student at the Königliche Technische Hochschule in Berlin, and always carried his camera. As an assistant to Hermann Vogel, an expert on photographic chemistry, he aided in pioneering experiments with night and color photography. By 1885 Stieglitz devoted all his time to photography, sending his work to exhibitions and writing articles for German photography journals. In 1889, after seeing an exhibition in Vienna that included the work of historical photographers like William Henry Fox Talbot and Louis-Jacques-Mandé Daguerre (nos. 1, 4), he began a lifelong crusade for the recognition of photography as fine art.

In 1890, Stieglitz returned to New York and became a partner in the Photochrome Engraving Company. He continued his own photography, and became an editor of *American Amateur Photographer* and a leader in the Camera Club of New York. His marriage, in 1893, to Emmeline Obermeyer, the daughter of a prominent brewing family, enabled him again to give his full energy to photography. *Outward Bound* (frontispiece), one of many photographs taken on their honeymoon journey to Europe, reflects his concerns at that time.[12] The

61

Frederick H. Evans
English, 1853–1943

In Sure and Certain Hope,
1902

Platinum print
24.2 x 18.4 cm
Jerome A. Wheelock Fund,
1966.60

63

likeness of a fellow passenger juxtaposes everyday trivialities with momentous experiences that imply a grand, cosmic design. The young woman is bundled against the cold in a symphony of frilly textures: a tweedy coat with fur collar and cuffs, heavy woolen skirt, and hat of velvet and satin bows. The soft details of her collar, hat, pointed shoe, and the bouquet she received at quayside, contrast to hard, straight lines that underset the image. The parallel lines of the enameled iron railings recede into the distance, meeting the horizon at the edge of the image. They define a strong geometric composition that seems, like the ship itself, to speed toward its destination across the Atlantic.

In 1902, Stieglitz mounted a landmark exhibition of American PICTORIALIST photography at the National Arts Club, launching his own organization. He named the group the Photo-Secession, aligning it with European avant-garde movements that broke from the art establishment. In July 1903 *Camera Work* first appeared, the official magazine of the Photo-Secession, featuring original photogravures, as well as essays and reviews by leading authors. In 1905, Stieglitz opened the Little Galleries of the Photo-Secession in a brownstone at 291 Fifth Avenue, which became known simply as "291." Through his colleague Edward Steichen (no. 85), who lived in France from 1906 to 1914, he made connections with European photographers, artists such as Paul Cézanne, Pablo Picasso, and Constantin Brancusi, and American Modernists, all of whose works were shown at 291 and reproduced in *Camera Work*.[13] Years before the International Exhibition of Modern Art in 1913 — the celebrated

Armory Show — 291 brought the art of the European avant-garde to America.

The Steerage was one of Stieglitz's most influential photographs, a scene he observed aboard the *Kaiser Wilhem II*, while preparing to sail to Germany. As he gazed from the first-class deck to the steerage below, Stieglitz recognized the bustle of life amidst a visual setting that implied a universal structure and purpose. "A round straw hat, the funnel leaning left, the stairway leaning right, the white draw-bridge with its railings made of circular chains, white suspenders crossing on the back of a man in the steerage below, round shapes of iron machinery, a mast cutting into the sky, making a triangular shape. I stood spell-bound for a while, looking and looking. . . . I saw a picture of shapes and underlying the feeling that I had about life."[14]

In 1910, Stieglitz organized the landmark *International Exhibition of Pictorial Photography* at the Albright Art Gallery in Buffalo, New York, the largest presentation of creative photography to that date. When the United States entered World War I in 1917, he closed 291 and ceased publication of *Camera Work*. By then, Stieglitz had become involved with Georgia O'Keeffe, a young painter who would become his second wife, and whose career he guided and promoted for the rest of his life.

ALVIN LANGDON COBURN (63) was one of many talented American photographers gravitating to Stieglitz, who called him "the youngest star." Born into an affluent Boston family, Coburn received his first camera as a gift for his eighth birthday.[15] His widowed mother was an amateur

photographer who offered encouragement as he taught himself to shoot, develop, and print his own work. In 1898, Coburn met F. Holland Day (no. 64), an older, distant cousin whom he tutored in photographic printing and developing, while in return he learned lessons in aesthetics and art history. The following summer, Day took the teenager and his mother to England, where Coburn met Frederick H. Evans (no. 61), and to Paris, where he met Robert Demachy (no. 60). Coburn also met Edward Steichen (no. 85), the American photographer three years his elder, then painting in a studio in the boulevard du Montparnasse. They soon became affable colleagues.

Coburn probably made *Edward Steichen Sketching* near the house his friend rented at Mamaroneck, New York, in winter 1902. Its soft focus and dreamy woodland landscape relates closely to Steichen's Tonalist-style paintings and photographs of that time. In Coburn's image, a soft, deep screen of bare tree branches above the receding carpet of leaves define a mottled field. Before them is a delicate balance of positive and negative forms in the dark, silhouetted figure, his bright starched collar, and open sketchbook. Key to the image is the formal counterpoint between those forms, between dark and light, that creates a graceful balance. A slight document of experience, the photograph itself is like a little sketch, with the grainy surface and tonal delicacy of a charcoal drawing. The two young photographers shared experiments with faint illumination, measuring how narrow in tonal range a print could be and still produce definable forms of visual interest.

In 1902, Coburn attended Arthur Wesley Dow's (no. 50) Ipswich Summer School of Art. "Dow had the vision," he later wrote, "even at that time, to recognize the possibilities of photography as a medium of personal artistic expression. I learned many things at his school, not the least an appreciation of what the Orient has to offer us in terms of simplicity and directness of composition."[16] In the fall Coburn worked with Gertrude Käsebier (no. 67) in New York, developing his skills as a portraitist. At the end of the year, Alfred Stieglitz invited him to join the Photo-Secession, and the first issue of *Camera Work* included a selection of his photographs.[17] In January 1903 the first solo exhibition of Coburn's photographs was presented by the Camera Club of New York, and that winter he was invited to join the Linked Ring.

Coburn returned to London in 1904 and explored the city with his camera, creating a series of Whistlerian views. He visited George Bernard Shaw — whom he knew from Käsebier's studio — who introduced him to many celebrated British literary, artistic, and political figures, several of whom he photographed. A solo exhibition of Coburn's photographs was presented at the Royal Photo-

graphic Society in 1906. He visited Edinburgh to explore the castles and closes so important to photographic history, and met J. Craig Annan, who ignited an interest in the process of photogravure. Coburn bought a printing press after returning to New York and produced *London*, a limited-edition portfolio of gravures that he considered original photographic prints; in 1910 this album was followed by a pendant folio, *New York*.[18] The artist also published his portraits, in two books popular on both sides of the Atlantic.[19]

FRED HOLLAND DAY (64) was among the most influential photographers in the United States to advance the medium as fine art at the turn of the century. Born in South Dedham, Massachusetts, he was the only child of a wealthy leather merchant.[20] In 1882 when Oscar Wilde visited Boston, the schoolboy attended his lecture and got his autograph; Wilde's daunting intelligence, verbal flamboyance, and daring personal style made him Day's role model. When he graduated from Chauncey Hall Preparatory School, Day was already a bibliophile, and a founding member of the Club of Odd Volumes. He took up photography in 1887 for a European trip, with the intention of recording sites related to one of his favorite authors, Honoré de Balzac. During the journey he met William Butler Yeats, William Morris, and Frederick H. Evans (no. 61), with whom he traded his best photographs over the next twenty years.

In 1893, in partnership Herbert Copeland, Day started a new publishing house in Boston. Inspired by Morris's Kelmscott Press, they issued exquisitely designed books, and became notorious for the American edition of Wilde's *Salome*, illustrated by Aubrey Beardsley.[21] During the 1890s Day made costume photographs informed by Middle Eastern literature and European Orientalist painting. In his paper "Is Photography a Fine Art?" delivered to the Boston Camera Club in 1894, he advocated that photographers study art and literature as a painter would.[22] This seriousness of purpose perhaps led to his being the third American elected to the Brotherhood of the Linked Ring. In summer 1898, Day began an extended series of sacred images, photographing himself as Christ. He grew his hair and beard for over a year and fasted until his body was emaciated. Beginning with the Annunciation and ending with the Ascension, the series included events related to the Stations of the Cross. In another series, *The Seven Last Words*, closeups of Day as the crucified Christ were made with a long shutter release cable and a mirror attached to his camera to achieve the right facial expressions.[23]

As Day's reputation grew, he began considering a Boston-based American Association of Artistic Photography, similar to the Linked Ring, and organized a major exhibition of the work of potential

64

F. Holland Day

American, 1864–1933

Youth Seated on a Rock, about 1907

Platinum print
17.0 x 11.6 cm
Alexander and Caroline DeWitt Fund, 1996.16

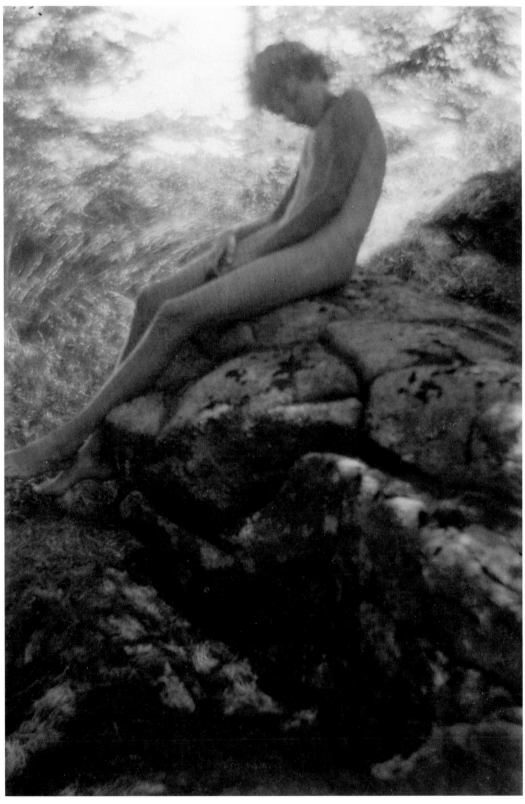

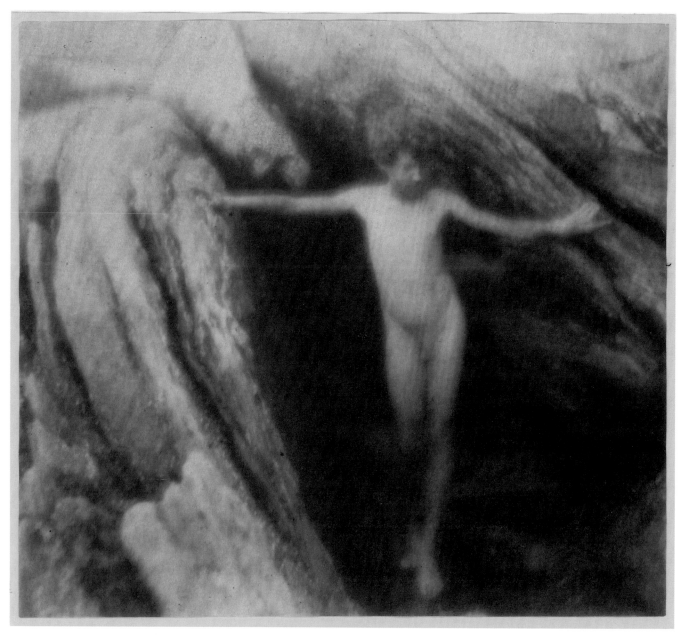

65

Clarence H. White
American, 1871–1925

Boy Among the Rocks, 1905

Platinum print
18.4 x 20.3 cm
Stoddard Acquisition Fund,
2002.532

members. The show was scheduled for the Linked Ring annual salon in London, to coincide with the showing of Day's work at the Royal Photographic Society. In spring 1900 he sailed to England with hundreds of photographs; but while he worked on the show in a rented London studio, Alfred Stieglitz (no. 62) lobbied against its presentation by the Linked Ring. As a result, the exhibition was consolidated with Day's own work, and shown at the Royal Photographic Society. As Stieglitz became the primary force in American art photography, Day turned his attention to the local photographic community. A dedicated philanthropist, he cultivated the talents of underprivileged boys in Boston. One was the Lebanese immigrant Kahlil Gibran, whom Day educated, mentored, and occasionally photographed.[24] In November 1904, the photogra-

pher's studio was destroyed by fire, and his equipment and eighteen years' work were lost. However, Day reacted as if the fire was cathartic. He bought new equipment that enabled him to photograph in the field, and began exploring the figure in natural settings.

Youth Seated on a Rock is one of many photographs made during Day's summer vacations in Maine. In 1898 he began spending the summer at Little Good Harbor, near Georgetown, where he hosted friends like Gertrude Käsebier, Clarence White (nos. 67, 65), Francis and Agnes Rand Lee, and Louis and Beatrice Baxter Ruyl, along with their families. They often brought Day's protégés from Boston, who became the bachelor's extended surrogate family. Many photographs were made on the seaside rocks near his cottage, where Day built a pergola, and in

a forest clearing where he erected a sculptural herm with the head of Pan. His enthusiasm for Greek drama, poetry, literature, music, and art was also indulged at Little Good Harbor.[25] Several photographs represent Day and his guests dressed in classical garb. The boy in *Youth Seated on a Rock* wears a laurel wreath, in a smoky image that could be a vision of ancient Arcadia. The slouching figure almost seems to melt into the stone. His elongated limbs and marmoreal skin contrast with the chunky, lichen-mottled rock. His form is silhouetted against the sunny glade behind, where sunlight filters through pine boughs and grasses that seem to move softly in the wind. The model was Nicola Giancola, a precocious Boston shoeshine boy. Day encouraged him to return to school, paid his tuition, and offered constant encouragement. He also photographed Giancola as Orpheus and Saint Sebastian, in images with an eroticism that must call into question the photographer's relationship to his model.

Boy Among the Rocks by **CLARENCE H. WHITE (65)** was made at Little Good Harbor the first summer that White and his family spent in Maine with Day. The two artists photographed each other and White's sons, ten-year-old Lewis and eleven-year-old Maynard, posed in a chiton or laurel wreath, or piping on a flute.[26] *Boy Among the Rocks* represents Maynard White gingerly stepping over the rocks, apparently down to the sea's edge. Like Day's photographs, the image evokes an ancient pagan reverence for human form, and the idyll of an Arcadian life in harmony with nature. Its soft focus is similar to Day's imagery, but the photograph is printed on a whisper-thin sheet of tissue paper, creating a translucent delicacy reminiscent of an Asian painting on paper or silk. Day became close to White and his family and was exceptionally generous to them, later supporting Maynard White's studies at Brown University.

White was born in West Carlisle, Ohio, a village where his father ran a tavern and grocery store.[27] Growing up he developed a love of nature and family that became enduring subjects of his work. After high school he worked as a bookkeeper for the wholesale grocery firm of Fleck and Neal in Newark, Ohio. He married in 1893, began his own family, and took up photography. Since he could afford only two plates a week, he thoughtfully planned for their exposure in his free time: at dawn, in the late evening, or on Sunday afternoons. White found inspiration in the fashionable images and ideas of James McNeill Whistler, and in Japanese design.

In 1898 White helped found the Newark Camera Club, modeled on Alfred Stieglitz's (no. 62) New York Camera Club. In that year his work won acclaim in the first Philadelphia Photographic Salon, and he met Day the next year when he served on the exhibition jury.[28] White's photographs were included in Day's *New School of American Photography* exhibition in London in 1900, and in Stieglitz's first Photo-Secession exhibition in New York in 1902. He was a charter member of the Photo-Secession, and his work regularly appeared in *Camera Work*.[29] In 1906, White moved to New York. The following year, Arthur Wesley Dow (no. 50) invited him to join the faculty of the Columbia University Teachers' College. He proved to be a sympathetic and effective teacher, and incorporated ideas of Modernism into his teaching. After buying a derelict farmhouse near Little Good Harbor in 1909, White opened the Seguinland School of Photography for serious hobbyists and art teachers.[30] Its success led, in 1914, to the Clarence H. White School of Photography in Manhattan, where many of the leading photographers of the following generation were students.[31] As the Photo-Secession waned, White remained committed to Pictorialism; in 1916 he founded the Pictorial Photographers of America, along with Gertrude Käsebier, Alvin Langdon Coburn (nos. 67, 63), and other colleagues. He served as first president of the organization, which, in contrast to the Photo-Secession, was inclusive, democratic, and supportive of many facets of art photography.

FREDERICK HAVEN PRATT (66), Worcester's most distinguished early Pictorialist, also made a group of classicizing photographs at Little Good Harbor. A descendant of pioneers and Revolutionary War patriots, Pratt was born in Worcester, where his family had a successful textile machinery business.[32] He became interested in photography in high school, taking pictures of his family and their home on the corner of West and Cedar Streets.[33] At that time his father, who had recently retired, devoted himself to painting. In 1890, the elder Pratt struck up a friendship with John Singer Sargent, who was in Worcester painting the mayor's family. That summer, seventeen-year-old Pratt took Sargent's portrait in the back garden of their West Street home.[34] When Sargent did two portraits of Pratt's sister Kitty, Pratt probably came to know the painter and was perhaps influenced in his artistic aspirations.[35]

Pratt graduated from Harvard University in 1896, and received a master's degree two years later. A bout of rheumatic fever interrupted his studies at Harvard Medical School in early 1901, and it seems that during the long recuperation, he became aware of the Photo-Secession. Pratt was back at Harvard in fall 1903, and a year later he showed eighty photographs at the Worcester Art Museum, including portraits, still lifes, and European landscapes.[36] He might have met F. Holland Day (no. 64) during the organization of the Museum's second annual exhibition, which included eleven of

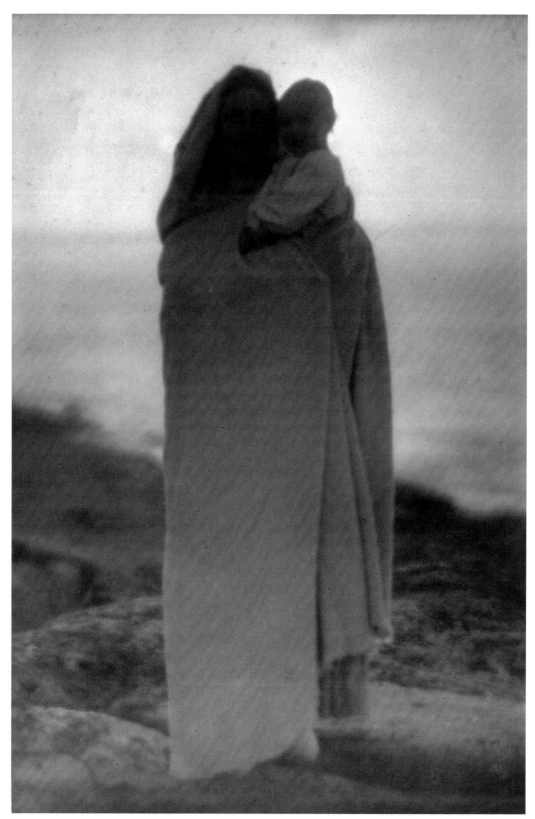

Pratt's photographs and a significant group borrowed from Day's collection. After qualifying as a doctor in 1906, Pratt spent a week with Day at "photo camp" at Little Good Harbor.[37]

Mother and Child is one of the photographs made during his visit. Standing on the rocky seashore before the rising sun, the tall, columnar figure of a woman becomes a generalized sculptural form. The softly focused image has an overall gray tone reminiscent of relief sculpture. The horizon falls behind her shoulders, locating the nexus of the composition before the bright sky, and creating a halo for both figures. She is dressed in a chiton and mantle, the garb of an ancient Greek matron, meant to place her in pagan Arcadia. However, for Pratt, the costumed figure must also have evoked the biblical Madonna and Child. For there is little to suggest that this conservative Harvard man, a faithful Episcopalian churchgoer, and a qualified physician, would have participated completely in the eccentricities of Day's circle.[38]

Pratt's models were Beatrice Baxter Ruyl and her year-old daughter, Ruth, who went by the aesthetic nickname "India," Day's close friends and frequent visitors to Little Good Harbor.[39] Indeed, India Ruyl was Day's goddaughter, and he made many photographs of her as a child. Her mother was a children's book illustrator and a designer at the *Boston Herald* newspaper.[40] Day met her and her husband, the book illustrator and etcher Louis H. Ruyl, in Paris in 1901. She introduced him to the six Costanza brothers, who worked as *Herald* newsboys, and later became his protégés and photographic models. During his week in Maine, Pratt made several photographs of India Ruyl, including images of her playing on the floor of a sunny interior, near a warm stove, with a dozing cat.

In fall 1907, Pratt began his teaching career at the Boston Normal School of Gymnastics, and the following year he became a professor of physiology at Wellesley College. After he married and began a family that would include five children, he continued working as an amateur photographer, sending his work to exhibitions across the country. In 1914 Pratt's mysterious landscape (p. 11, fig. 3) appeared in *Camera Work*, along with two views of New York at night by Paul B. Haviland.[41] During World War I, Pratt served in the cavalry of the New York State Guard. He then returned to Massachusetts and began a succession of temporary teaching positions at Clark University, Harvard University, Radcliffe College, and the Massachusetts Institute of Technology. In 1921, he became a professor of physiology at Boston University and taught there for twenty years.

Beatrice Ruyl also modeled for **GERTRUDE KÄSEBIER (67)**, another of the leading American Pictorialists. Born in Fort Des Moines, Iowa, Gertrude Stanton was the daughter of a mining entrepreneur.[42] When she was eight years old, her family crossed the plains in a covered wagon to join her father at Eureka Gulch, Colorado. They moved to Brooklyn, New York, in 1864, and her mother opened a boardinghouse. It was there that she met Eduard Käsebier, a shellac importer and German immigrant. They married in 1874, and began a family of three children. While studying painting at the Pratt Institute from 1889 to 1893, Käsebier photographed her growing children, applying lessons of composition and form.

After working as an apprentice to the Brooklyn commercial photographer Samuel Lifshey, Käsebier opened her own Manhattan portrait studio in 1897. She dispensed with props and scenic backdrops, and replaced the stiffness and artificiality of daguerrean portraits with naturally posed, thoughtfully illuminated compositions. Mark Twain and Booker T. Washington were among the many celebrities to pose at her studio. Some of Käsebier's most revealing portraits are those of the New York artists who were her friends and colleagues, including the influential Pictorialist photographers. Childhood memories of the West inspired her to entice the Native Americans in Buffalo Bill's Wild West troupe to her studio to have their portraits taken.

Beginning in 1898 Käsebier won acclaim in major photographic exhibitions for her images of mothers and children. Alfred Stieglitz (no. 62) invited her to be a founding member of the Photo-Secession, and her photograph *Blessed Art Thou Among Women* was among the photographs featured in the first issue of *Camera Work*.[43] Käsebier actively encouraged women to take up professional photography, hiring female apprentices and serving in 1910 as president of the Women's Federation of the Professional Photographers of America.

Silhouette is a portrait of Mrs. John Murray Anderson, one from a series made for *Vanity Fair* magazine in 1915.[44] In this remarkable series, the photographer extended soft focus into high contrast. She knowingly evoked the tradition of cut-paper silhouettes, a popular medium for all levels of American society from the mid-eighteenth century until the photographer's own time, and one often practiced by woman artists.[45] Typical early examples of the genre elaborate the severe shape of the erect profile head with the elegant shapes and arabesque details of Rococo coiffures and costumes. Käsebier adapts this form by tilting the woman's head down, to emphasize her slender neck and suggest more active engagement. She achieved a decorative delicacy not only in transparent wisps of hair and her lace collar, but in the remarkable setting with its lace curtains and translucent flower petals. The artist achieved delicate, painterly effects while printing and washing the gum bichromate emulsions. Occasionally she exploited hand-alteration methods

66

Frederick Haven Pratt
American, 1873–1958

Mother and Child, 1906

Platinum print
32.4 x 21.9 cm
Purchase through the gift of
Karl and Dorothy Briel,
2003.28

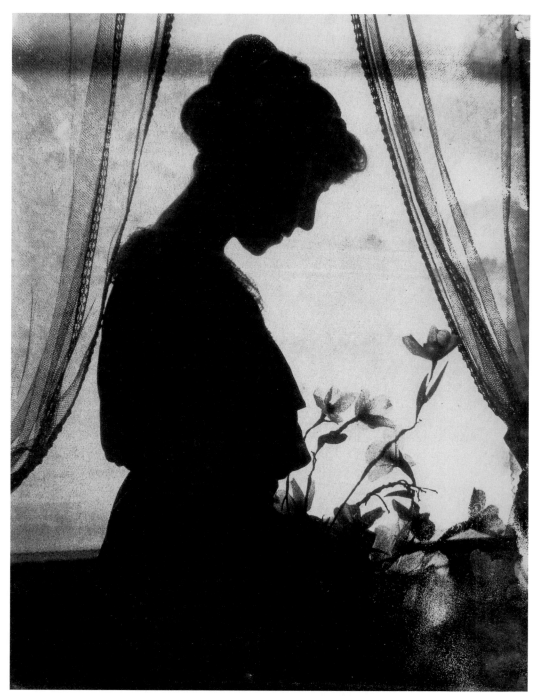

67

67

Gertrude Käsebier
American, 1852–1934

Silhouette, about 1915

Gum bichromate print
18.4 x 14.5 cm
Sarah C. Garver Fund,
1998.86

of the sort advocated by Robert Demachy (no. 60), yet employed straight techniques when they suited a project.[46] When Stieglitz and other photographers moved to sharp focus and abstraction, Käsebier continued working in the soft-focus style. In 1916 she joined Clarence White (no. 65) and other colleagues in the establishment of the Pictorial Photographers of America, which perpetuated the style and practice of Pictorialism that were quickly becoming outmoded.

Lotte Kühn, a portrait of the daughter of **HEINRICH KÜHN (68)**, exemplifies the continuing popularity of pigment print methods in continental Europe during the Pictorialist period. These richly toned photographs were often printed on textured and colored artists' papers, and possess a tactile quality common in elegant etchings or mezzotints of the period. While Lotte Kühn's portrait captures the appearance and character of the sprightly child, it also has a fashionable sophistication in its tapestry background, and the prominent laurel boughs seem laden with Symbolist significance. However, the immediate impact of the composition is one of fearless confrontation, her dark eyes framed by a porcelain face, with just the

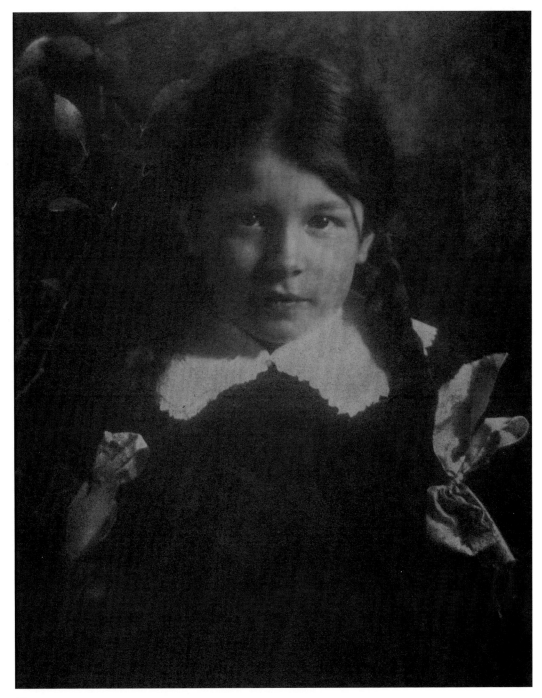

68

68

Heinrich Kühn

German, active in Austria,
1866–1944

Lotte Kühn, about 1907

Gum bichromate print
29.7 x 23.6 cm
Sarah C. Garver Fund,
1991.16

shadow of one lock of hair to suggest a childish mischievousness.

Kühn was born in Dresden, the son of a prosperous merchant and grandson of a professional sculptor.[47] He studied natural science and medicine in Leipzig, Freiburg, and Berlin, where he learned the techniques of microscopic photography at the Kochschen Institute. Seeking relief from a respiratory condition, he moved to Innsbruck, Austria, in 1888. In Vienna he saw the work of the Linked Ring photographers in the Vienna Camera Club's first international exhibition, and began experimenting with a Pictorialist style. In 1894,

Kühn married, started a family, and joined the Vienna Camera Club, where he met Hans Watzek and Hugo Hennenberg. The three men worked closely together, sharing technical and creative ideas. They became known as *Das Kleeblatt*, or the Trifolium, and each inscribed his photographs with a three-leaf clover beside his signature. After seeing Robert Demachy's (no. 60) pigment prints at the Salon of the Photo-Club de Paris, Hennenberg introduced the technique to his colleagues, who used it with enthusiasm for landscapes, portraits, and genre images. In spring 1896 Kühn became a member of the Brotherhood of the

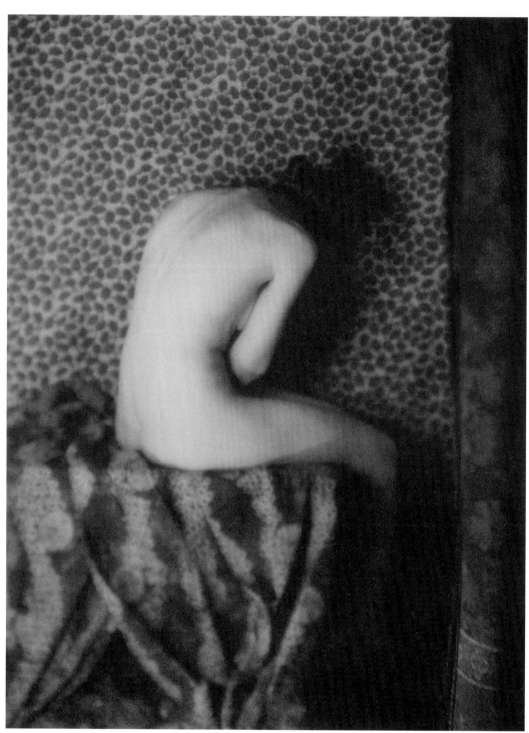

69

Karl Struss
American, 1886–1986

Nude, about 1916

Palladium silver print
21.5 x 16.2 cm
Sarah C. Garver Fund,
1999.19

69

Linked Ring, two years after Hennenberg and Watzek were admitted to the organization. The colleagues traveled together to Italy, Germany, and Holland in 1897. At that time their photographs were included in exhibitions of the Munich Secession and the Vienna Secession, and in a group show at the prestigious Galerie Schutze in Berlin. Trifolium photographs appeared in *Ver Sacrum*, the magazine of the Vienna Secession, and an entire issue of *Die Photographische Kunst im Jahre 1902* was given to their gum prints. However, the Tri-

folium came to an abrupt end when Hans Watzek died in May 1903. Henneberg soon turned away from photography to devote himself to painting and printmaking.

Kühn continued to make pigment prints, and gradually established connections to the international community of Pictorialist photographers. In 1908 he met Alfred Stieglitz, Edward Steichen (nos. 62, 85), and Frank Eugene at Tutzing, Bavaria, where they experimented with the new Lumière AUTOCHROME process. A similar meeting took

place five years later, when he met with Steichen, Eugene, Victor Singer, and Adolph de Meyer (no. 76). Kühn organized an exhibition of art photography for the comprehensive Dresden International Exposition of 1909 and arranged for his hometown museum to acquire photographs from the exhibition. The following year he helped the Dresden Museum purchase photographs from Stieglitz's *International Exhibition of Pictorial Photography*. Late in his career, Kühn published extensively on photographic technique.[48]

The American Pictorialist **KARL STRUSS (69)** experimented with Secessionist Symbolism and European Modernism, developing a stylistic versatility and technical command that eventually influenced Hollywood. Struss was born in New York, where his father owned a silk mill and a bonnet-wire factory.[49] He began taking photographs in high school, and went on to study with Clarence H. White (no. 65) at Columbia University Teachers' College. White introduced him to the Photo-Secession and to the compositional ideas of the European avant-garde. In summer 1909, when he traveled to Europe, the young photographer took two cameras, one fitted with a soft-focus lens of his own invention that came to be known as the Struss Pictorial lens. Alfred Stieglitz (no. 62) included Struss's photographs in the International Exhibition of Pictorial Photography in 1910, and published eight of his images in *Camera Work* in 1912.[50] These successes helped Struss open his own New York commercial studio in 1914. His photographs were published in *Harper's Bazaar*, *Vogue*, and *Vanity Fair*. Struss became a virtuosic technician during this period, mastering each new process, publishing technical articles in several journals, and serving as an editor of the *Platinum Print* magazine.[51] In 1914, he began manufacturing and sales of the Struss Pictorial lens, with some success. When cinematographer John Leezer used it to shoot Paul Powell's *The Marriage of Molly-O*, in 1916, it became the first soft-focus lens used in film.

In the figure of a female nude turned away from the camera, Struss experimented with the secrecy and decorativeness of Symbolism. The artist achieved a pleasing balance of form, tone, and pattern, and a beguiling image of opulence and comfort. Its soft focus enhances the delicacy of the model's flesh and hair, and the tactile subtlety of the various fabrics. These contrast to the riot of patterns surrounding the figure, which achieve a surprising tonal harmony. The mysterious ambiguity of this image engages and teases the viewer. For it seems unclear that the figure is aware of the camera, or if she turns away in modesty, in coy flirtation, or in grief. Indeed, the perceived impression reveals more about the viewer than the image, and this ability to entice served Struss well in his career.

In 1917, Struss joined the Army and taught photography in the Signal Corps during World War I. As antagonism toward German-Americans escalated, however, he was unjustly suspected of being a German sympathizer, and spent most of the war working at the military Barracks Guard Unit at Fort Leavenworth in Kansas. In 1919 he moved to Hollywood to work for Cecil B. De Mille, at first as a still photographer and later as a silent-film cameraman. He remained devoted to Pictorial photography, exhibiting his work with the Pictorial Photographers of America and Camera Pictorialists of Los Angeles. As a freelance cinematographer, Struss became famous for his work on *Ben Hur*, in 1925, for his use of filters to effect visual transformations. He was a founding member of the Academy of Motion Picture Arts and Sciences and, in 1929, along with his collaborator Charles Roscher, he won one of the first Academy Awards for his cinematography on F. W. Murnau's *Sunrise*.

DWIGHT DAVIS (70) was a leading amateur photographer in Worcester during the Pictorialist era, and a persuasive champion of photography at the Worcester Art Museum. Born in Sturbridge, Massachusetts, he began working as a teenager at Grout and Putnam, Worcester's leading office supplier.[52] In 1873 he bought out the interest of the store's founder, Jonathan Grout, to become its junior partner. It seems that Davis became interested in photography in the 1890s, joining the Worcester Camera Club during its first decade. It is possible that other city businessmen like Lyford J. Chauncey and Langdon B. Wheaton, who were enthusiastic amateur photographers, sparked his interest. In 1901, Davis took over the stationery store, which became Davis and Bannister.[53] Three years later he exhibited eighteen prints in the first Worcester Art Museum Exhibition of Photographs; these were chiefly landscapes that reflect the artist's interest in effects of light, with Impressionist radiance.[54]

In 1905, Davis was a juror for the Second Annual Exhibition of Photographs at the Worcester Art Museum.[55] His reputation had already begun to broaden, for in that year his photographs were included in Curtis Bell's Second American Salon.[56] Over the following decade, Davis sent his work to national exhibitions. He experimented with still life, staged genre images, and even explored color printing.[57] A measure of Davis's national stature at the height of his career is reflected in his lecture at the Brooklyn Institute of Arts and Sciences in 1913, part of a series that included talks by several of the day's leading photographers, such as F. Holland Day, Clarence H. White, and Karl Struss (nos. 64, 65, 69).[58]

Portrait of Miss U. is typical of Davis's delicate images, an Impressionist evocation of light and atmosphere that expresses a gentle, feminine per-

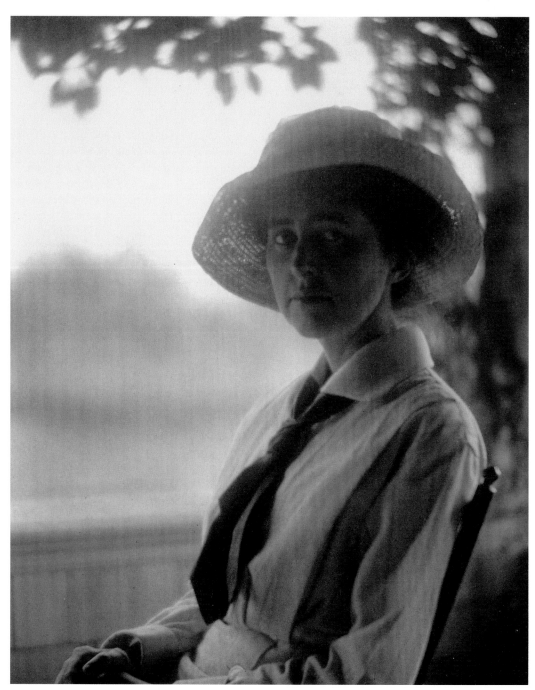

70

70

Dwight Davis

American, 1852–1943

Portrait of Miss U., about 1910

Platinum print
24.1 x 19.3 cm
Eliza S. Paine Fund, 1988.43

sonality. It was the artist's practice to identify the subjects of his portraits by initials or nicknames, presenting them as types rather than individuals. Miss U. sits close to the picture plane, with her head directly before the setting sun, leaving the tiled porch rail, the trees, and the background forms to melt into gray light. Her face is cast in soft shadow, and the sun glimmers through the unfocused background leaves and her porous straw hat. The well-worn sun hat contrasts with Miss U.'s neatly pleated shirt and jaunty tie, revealing a proper but capable countrywoman. In Davis's elegant compositional scheme the almond shape of

the hat enclosing her chignon echoes and emphasizes the shape of her wide eyes. The composition of simple shapes, along with the use of light to create an evocative atmosphere, characterize the style of Pictorialism.

Davis became a charter member of the Pictorial Photographers of America in 1916 and helped arrange for its first exhibition to be presented at the Worcester Art Museum. In 1920–21, his work appeared in the organization's yearbook, *Pictorial Photography in America*.[59] In 1923, two years after his retirement, Davis was a founder of the Worcester Photo Clan. He helped organize the club's first

exhibition at the Worcester Art Museum in 1924, and it was probably he who arranged for Clarence H. White (no. 65) to visit Worcester to speak to the Photo Clan. In 1949 Davis's photographs were shown as a memorial in the Twenty-fifth Anniversary Exhibition of the Worcester Photo Clan.[60]

The emerging technology of color photography intrigued the Pictorialists, several of whom experimented with the Autochrome process, invented by Louis Lumière and patented by him in 1904.[61] His Parisian company produced coated glass plates, providing unique positive transparencies, the first commercially available full-color photographs. Alfred Stieglitz, Edward Steichen (nos. 62, 85), and Frank Eugene made Autochromes in Europe soon after they became available in 1907, and the transparencies were exhibited at 291 in New York later that year.[62] In the spring, reproductions of three of Steichen's Autochromes appeared in *Camera Work*, along with his comments on the technique.[63] The artist and critic J. Nilsen Laurvik became a devotee of Autochrome, and visited Stockbridge, Massachusetts, in 1910, to teach the process to **GEORGE SEELEY (71)**.[64]

Still Life may have been one of the photographs Seeley took at that time, a meticulously organized composition of form, space, and hue. Compared to his figural images, the photographer's still lifes

evoke more personal contemplation, but they are flooded with the same atmospheric luminosity. Seeley built this image around a porcelain bowl with blue, red, and white decoration, and a bottle with iridescent glaze, placed upon a range of fabrics, printed in bright plaid and floral patterns. Highlights and reflections emphasize the superimposed forms, which give a sense of receding space. Soft, clear light streams from a window, emphasizing the varied textures and colors that glow like stained glass. These delicate passages are accented by the detailed forms and deep hues of the natural shapes of holly stems and marigolds. Their juxtaposition invites contemplation on the phenomenon of human creativity and craft. Seeley's delight in the peculiar glow and luminescence of Autochrome in this and some of his other transparencies, demonstrates his search for the unique capabilities of the medium.

Seeley spent his whole career in Stockbridge.[65] He grew up nearby at Linwood, the estate of the Boston attorney Charles H. Butler, where his father was superintendent. During his senior year at Williams Academy, Seeley became interested in photography. He went on to study at the Massachusetts Normal School (now the Massachusetts College of Art) in Boston, where he met F. Holland Day (no. 64), who offered encouragement. Returning to the Berkshires in 1902, Seeley became an art

71

George Seeley
American, 1880–1955

Still Life, about 1910

Autochrome transparency
10.1 x 12.9 cm
Stoddard Acquisition Fund,
2003.48

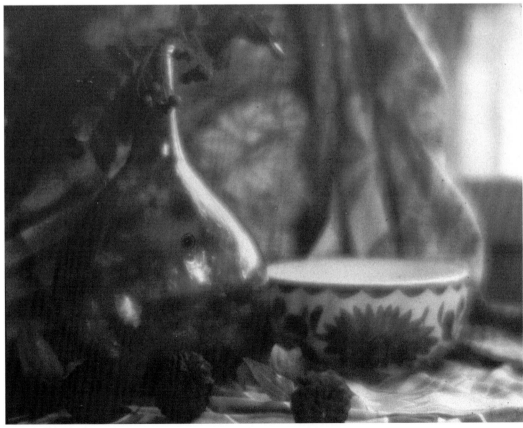

71

teacher in the public school system, and in two years rose to the rank of supervisor of art for the Stockbridge schools. During that time he made photographs of classicizing figures in evocative landscapes, similar to Day's work. Seeley's younger sisters, Lillian and Laura, became his favorite models, posing outdoors in flowing silk robes made by their mother. They often hold a globe, or copper bowl, casting the image with indecipherable Symbolist allegory. The most remarkable quality of these photographs is their luminosity, for Seeley employed soft-focus lenses to dissolve and simplify compositions, sometimes to the extent of abstraction.

After Seeley's work appeared in Curtis Bell's *First American Photographic Salon in New York* in 1904, Stieglitz invited him to join the Photo-Secession. He published two of Seeley's images in *Camera Work* in July 1906, and mounted a solo exhibition of his work at 291 in 1908.[66] Despite Seeley's unwillingness to leave Stockbridge, his stature in the Photo-Secession may be reflected in his inclusion in the jury for the *International Exhibition of Pictorial Photography* shown at the National Arts Club in New York in February 1909.[67] Twenty-three of Seeley's large gum bichromate prints appeared in the landmark *International Exhibition of Pictorial Photography* at the Albright Art Gallery in Buffalo, which purchased his work from the exhibition. Afterwards, Seeley was one of the photographers who left the Photo-Secession. Although his interest in showing his photography had begun to wane, he seems to have continued his Autochrome still-life compositions and turned to oil painting.

EDWIN HALE LINCOLN (72), another Pictorialist photographer of the Berkshires, was a methodical craftsman who found unsought recognition for masterful nature photographs made largely for his own pleasure. Lincoln was born at Westminster, in Worcester County, the son of a Universalist minister.[68] At age fourteen, he enlisted as a drummer in the Union Army and served during the Civil War in the Fifth Massachusetts Infantry. Later he became a page in the Massachusetts House of Representatives. As a salesman for a Brockton photography studio in 1876, he learned the techniques of photography.

Lincoln's fascination with the sea drew him to Boston harbor, where he made dry-plate photographs of sailing ships. Recognizing the profound changes coming to seafaring, he strove to photograph as many nineteenth-century sailing vessels as possible, often capturing them under sail. Lincoln shot from the decks of chartered tugboats, his camera fitted with a shutter that snapped with the aid of a rubber band. He was first to photograph the celebrated yacht *America* — namesake of the America's Cup — and its images brought him national recognition.[69] Lincoln built a successful business in Boston and Newport photographing the yachts of New England. He came to know affluent yachtsmen who engaged him to photograph their homes, and he found a new speciality in architectural and interior photography. In summer 1883, the New York banker Charles Lanier invited Lincoln to photograph his estate in Lenox, Massachusetts. Other commissions to document Berkshire homes followed, and a decade later Lincoln moved to Pittsfield to become a caretaker on the Allen estate.[70] In his spare time he continued to photograph wild flowers.

Large Yellow Lady's Slipper is one of the plates from Lincoln's portfolio *Wild Flowers of New England*, first published in 1905.[71] The artist executed every phase of this lavish handmade production himself, having forged his own pioneering method of botanical photography. After searching the countryside for a perfect specimen, he dug up the whole plant, wrapping its roots in moss. He carried the plant home, potted it, and coaxed it back to vigor. When the flowers were at their peak, Lincoln set them up in his living room studio. There, in natural light from a window, before a neutral-toned backdrop and free from shifting breezes, the artist could methodically adjust composition and exposure. His elegant, friezelike compositions balance the plant forms with negative space, like those of sails and spinnakers before the sky. He developed his exposures immediately, so he could reshoot if necessary before disturbing his subjects. Afterwards, he returned the plant unharmed to the spot in the woods where he had found it. A few of Lincoln's flower images appeared in Gustav Stickley's *Craftsman* magazine, accompanied by a plea for the preservation of native flowers. This publicity, and other images published in *National Geographic* magazine, enhanced his reputation and influence.

Local amateur organizations, like the Worcester Photo Clan, sustained the popularity of Pictorialism in New England. **ROGER A. KINNICUTT (73)** was a prominent Worcester amateur and, as president of the Worcester Art Museum, he continued the struggle for the legitimacy of photography. The descendant of Colonial families, Kinnicutt was born in Worcester, the son of a banker who was also a founding trustee of the Worcester Art Museum.[72] He studied at the Fisher and Delsalle schools in Worcester, and at Milton Academy before attending Harvard College and Medical School. After an internship at Massachusetts General Hospital, Kinnicutt joined the staff of the Worcester Memorial Hospital in 1911 as a pathologist. During World War I he served in France, as commanding officer of the laboratory of Army Base Hospital No. 6 in Bordeaux.

After his discharge, Kinnicutt returned to Worcester Memorial. He married, started a family,

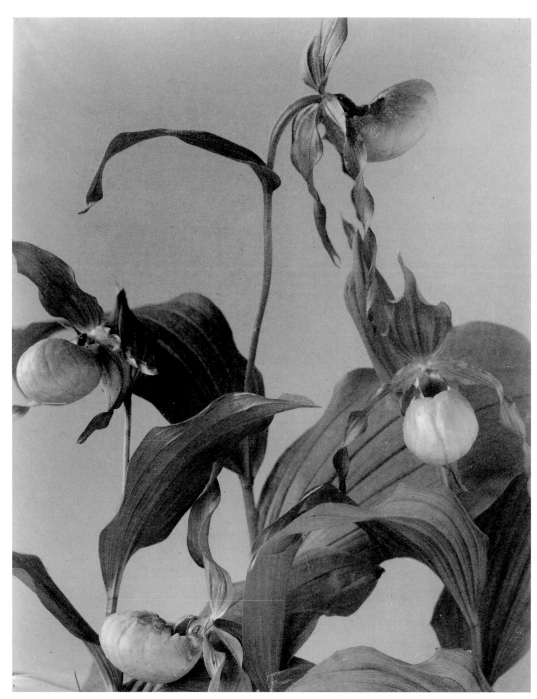

72

Edwin Hale Lincoln
American, 1848–1938

Large Yellow Lady's Slipper
1905

Platinum print
23.7 x 18.8 cm
Gift of Mack and Paula Lee,
1987.175

72

and sometime around 1915 took up photography. The enthusiastic novice came under the influence of Dwight Davis (no. 70) in the early 1920s. He adopted soft-focus techniques, and concentrated on fleeting effects of light. He joined Davis in 1924 as a founder of the Worcester Photo Clan, and was instrumental in organizing the club's first exhibition at the Worcester Art Museum in 1924, for he had been a Museum corporator for two years.[73] In 1925 he became a Museum trustee. Kinnicutt sponsored a close relationship between the Worcester Art Museum and the Photo Clan, and helped make

the Museum's new director, George W. Eggers (no. 86), an honorary member.

Worcester in the Fog exemplifies Kinnicutt's continued use of soft-focus Pictorialist imagery long after the style had become unfashionable. He captured the unusual appearance of the city on a foggy, chilly day. The slanted planes of the foreground roofs and thin rectangular chimneys create a measured geometric space that continues along the skyline of one of Worcester's hills. Plumes of steam and smoke create bright accents amidst layers of gray. Rain-soaked brick and stone, shiny wet

73

73

Roger A. Kinnicutt
American, 1880–1961

Worcester in the Fog, 1936

Platinum print
19.2 x 24.2 cm
Gift of Mrs. Roger Kinnicutt,
1966.20

rooftops, and decorative spires and smokestacks all contribute to an extraordinary moment when Worcester takes on an uncommon, poetic appearance. The weather casts a mood over the city and, we imagine, its inhabitants. This photograph was taken from an office window on Main Street.[74] It was Kinnicutt's practice to study his subjects under different light and weather conditions, waiting for the right moment to photograph.

In 1937, Kinnicutt spearheaded the Photo Clan's organization of a historical exhibition to mark the centennial of Daguerre's first successful photograph.[75] He also helped arrange for work by the

Photo Clan to be shown in England at the City Art Gallery, Worcester, and the reciprocal presentation of works by members of the Worcestershire Camera Club in the Photo Clan exhibition that year. The three photographs that Kinnicutt exhibited in the Third International Salon of the Pictorial Photographers of America represented soft-focus views of the New England winter countryside. In the latter half of his photographic career he concentrated his attention on nature and the countryside, particularly after his retirement in 1945, when he spent much of his time at his country house at Petersham in western Worcester County.[76]

9 | A Changing World

Inheriting the legacy of John Thomson and Jacob Riis (nos. 52, 53), **LEWIS WICKES HINE (74)** committed his photographic career to social reform. His work truly brought change to American industry and the problems of child labor in this country, and influenced documentarians of the New Deal era. Hine grew up in Oshkosh, Wisconsin, where his father ran a coffee shop.[1] He earned a master's degree in education at the University of Chicago, then continued with graduate studies in sociology at New York University. In 1901, Hine began teaching at the Ethical Culture School in New York. Three years later he added photography to his curriculum, taking his students to photograph immigrants at Ellis Island. In 1907 the Russell Sage Foundation began a comprehensive study of the steel industry in Pittsburgh and commissioned photographs from Hine to supplement the statistics and analyses of its report. Most of his images are straightforward, bust-length portraits, emphasizing the workers' character and commitment. Published in 1910, the Pittsburgh Survey promoted corporate reform and became model for future studies of its kind.

By that time, Hine had become staff photographer for the National Child Labor Committee (NCLC), assigned to tour the country, documenting working conditions of young children.[2] His photographs of textile mills in the Carolinas were among his first, representing children loading and operating looms and other machines. Often barefoot and shabbily dressed, they seem tiny and vulnerable next to the equipment. Threats by factory owners forced him to work surreptitiously. For a decade Hine continued exploring child labor across the United States for the NCLC, recording conditions at Pennsylvania coal mines, Colorado beet farms, Gulf Coast canneries, and many other industries.[3]

Girls at a Newspaper Stand captures the joy and frivolity of childhood, a common quality of Hine's images, though he photographed the appalling conditions of thousands of child workers. Here he captured a moment of mundane conversation, as three friends mind a corner newspaper stand. They are well dressed, their hair carefully braided and beribboned. Their safe work on the street suggests that these children are the cherished pride of the community. The serials on sale in their stand are printed in Yiddish, English, and a combination of both. They reveal that these are Jewish girls of Manhattan's Lower East Side, one of the city's most crowded and productive immigrant neighborhoods in the first years of the twentieth century. Comfortable, happy, and frivolous, these girls are the beneficiaries of their families' labors in America, a success to which they were expected to contribute.

During World War I, Hine went to Europe to work for the American Red Cross.[4] In Paris, he began photographing people at work, emphasizing their skill and craft. He continued this project after returning to New York, and documented the construction of the Empire State Building. Several of these photographs appeared in Hine's book *Men at Work*, of 1932, which revealed the central role of child labor in American industry.[5]

Hine's most important student was **PAUL STRAND (75)**, who learned the techniques of photography at the Ethical Culture School in New York.[6] When the class visited gallery 291 to meet Alfred Stieglitz (no. 62), Strand decided to become an artistic photographer. As a teenager Strand had joined the Camera Club of New York, where he learned advanced techniques. Photographs by Hine and Stieglitz prompted him to move toward clearer definition.

Blind Woman is Strand's best-known photograph from his early period of freelance work. The image of the street vendor presents an unsentimental glimpse of modern life. It is one from a series taken with a camera that shot at right angles, so the subjects remained unaware of his photographing them. The rectilinear grid and rusticated surface of the ashlar background places the woman in the city, as does the peddler's license that she wears like a broach at her neck. The boldly defined "BLIND" sign arrests the viewers' attention, providing essential information while drawing us to

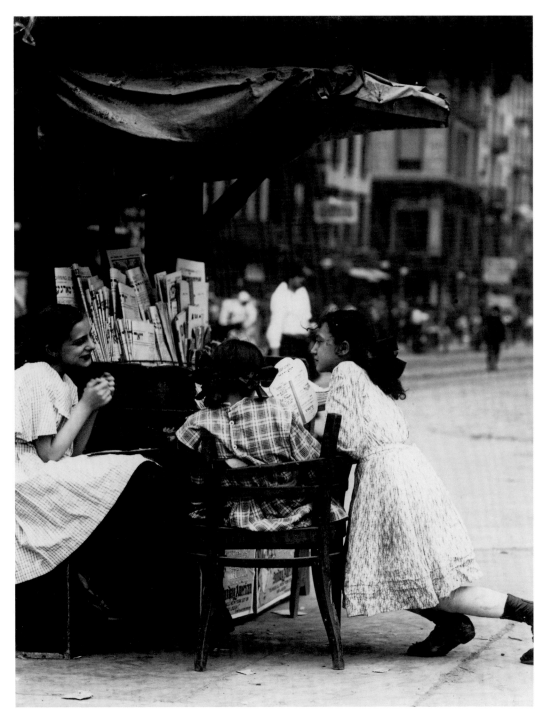

74

74

Lewis Wickes Hine
American, 1874–1940

Girls at a Newspaper Stand,
1910

Gelatin silver print
11.2 x 8.8 cm
Director's Discretionary
Fund, 1970.153

the woman's face. This image allows us to do what we would not do on the street: closely examine the physical deformity that sets this woman apart from society, and contemplate how she could be reduced — or enabled — to use the disability to sustain herself. It reflects upon human nature in a most provocative way. Ironically the camera sees clearly though his subject cannot. In Strand's later New York photographs, the city's inhabitants were progressively subordinated to their settings, until they disappeared into totally abstract geometric images.

During World War I, Strand served as an Army x-ray technician at Fort Snelling, Minnesota, and later worked on the production of medical films. When he returned to New York in 1918, he met Charles Sheeler (no. 80), and they collaborated on the short film *Manhatta*, a modernist celebration of architecture, set against Walt Whitman's poems of the city.[7] Over the coming decade Strand worked as a cinematographer, shooting sporting events, short documentaries, and scenes for Hollywood productions, simultaneously pursuing his still photography. In 1932, leftist politics drew him to Mexico,

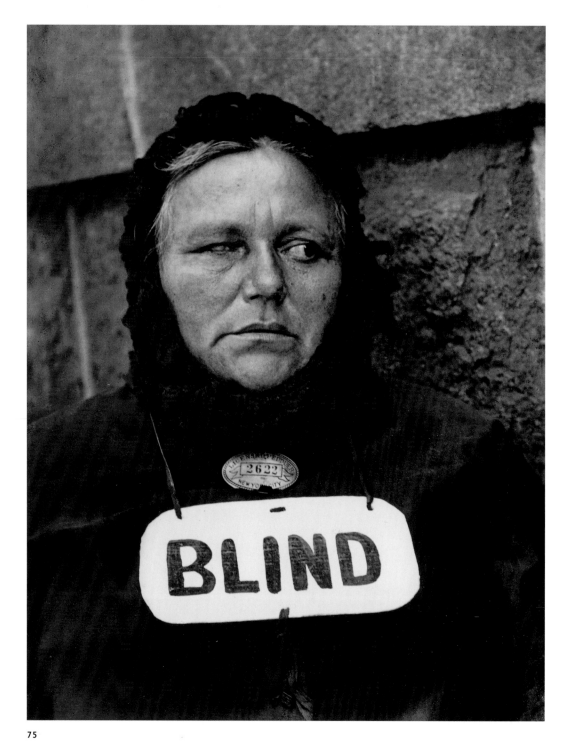

75

75

Paul Strand
American, 1890–1976

Blind Woman, New York,
1916

Gelatin silver print
32.7 x 24.8 cm
Gift of Michael E. Hoffman,
1991.7.2

76

Adolph de Meyer
American, born in France,
1868–1946

Marchesa Luisa Casati, 1912

Platinum print
21.6 x 10.8 cm
Stoddard Charitable Trust
Fund, 1987.14

where he worked with a government-sponsored film program. When Strand returned to New York two years later, he became involved with the Group Theater repertory company, and the leftist film group Nykino. He visited the Soviet Union to meet Sergei Eisenstein and other directors, and then began working for the New Deal Resettlement Administration. Strand joined with Leo Hurwitz and Ralph Steiner (no. 178) on the filming of Pare Lorentz's *The Plow That Broke the Plains*.

During World War II, Strand made government propaganda films. His photographs of rural Vermont were shown in 1945 at the Museum of Modern Art, the institution's first solo exhibition of a living photographer.[8] In response to the anti-leftist repression of McCarthyism, Strand moved to France in 1949. He settled at Orbeval, outside Paris, and produced the book *La France de Profil*, images of postwar life in the small town, complemented by the musings of poet Claude Roy. Similar book projects followed, documenting the land and cultures of Italy, the Outer Hebrides, Egypt, and Ghana. Acclaimed European exhibitions of Strand's work brought renewed respect for the photogra-

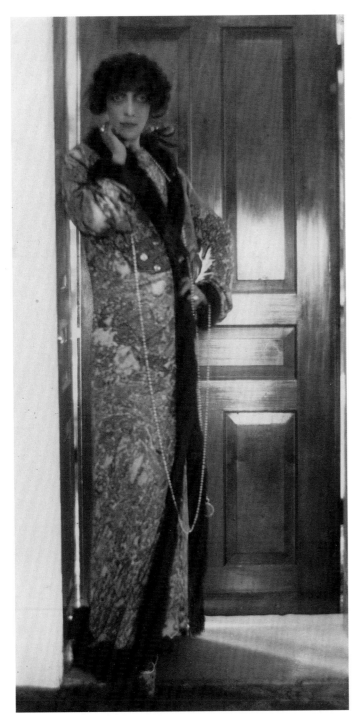

76

emphasized with big false lashes. She powdered her skin white, tinted her hair fiery orange, and was dressed by the day's finest designers. Casati wore live snakes as jewelry, and enjoyed moonlight strolls through her gardens, clad only in a fur coat, and leading a pair of cheetahs on diamond-studded leashes. The marchesa hosted the era's most famous and extravagant parties at her lavish villas in Venice, Rome, Capri, and Paris. Poets praised her peculiar beauty, and artists like Leon Bakst, Man Ray, and Cecil Beaton (nos. 94, 95) portrayed her.

Casati's most frequent portraitist, however, was **ADOLPH DE MEYER (76)**, the era's photographer of high society. He studied art in Paris in the early 1880s, and soon made his way to London and into the *beau monde*.[11] In 1899 he married the ultrachic Donna Olga Alberta Caracciolo, whose godfather — many said illegitimate father — was the Prince of Wales. In 1901, King Frederick-Augustus III of Saxony made de Meyer a baron, so that he and his wife could attend the Prince of Wales's coronation as Edward VII. With his impeccable continental manners and sartorial splendor, de Meyer succeeded in establishing a reputation as a society portrait photographer because his subjects considered him a peer. He transformed fashion illustration from diagrammatic costume images to photographs bearing the elegance of society portraits. Softly focused and indirectly illuminated, his images have a smoky, dreamlike quality. He began exhibiting his work in the mid-1890s, and was elected to the Brotherhood of the Linked Ring in 1898. Solo exhibitions of de Meyer's work were presented at Stieglitz's gallery 291 in 1907 and in 1912, when his work appeared in *Camera Work*.

De Meyer and his wife were patrons of Serge Diaghilev and devoted to the Ballets Russe, and they help bring the company to London in 1911–12. He photographed Vaslav Nijinsky and the corps de ballet in rehearsals and performances of Claude Debussy's *Prélude à l'après-midi d'un faune*, producing famous images that were later published as a book.[12] At the outbreak of World War I, de Meyer's Saxon title aroused suspicion, so he and his wife went to New York, where Condé Nast hired him to work for *Vogue* magazine. After the Armistice, a lavish offer from *Harper's Bazaar* lured de Meyer back to Paris, where he worked for the magazine from 1923 to 1934. However, his style was unfashionable by the mid-1930s, and in the prelude to World War II he returned to the United States to spend his last decade in Hollywood.

While de Meyer inadvertently documented changes in society in the *beau monde* at the beginning of a turbulent century, **AUGUST SANDER (77)** conceived a grand project to chronicle the whole spectrum of German society. Born into a farming

pher by the late 1960s, and a major retrospective exhibition of his work was organized by the Philadelphia Museum of Art in 1971.[9]

"I want to be a living work of art," said the Marchesa Luisa Casati, Europe's most famous celebrity before World War I.[10] Her notorious career, and devastating bankruptcy, marked the end of the era of European imperialism. Casati was a Milanese aristocrat born into immense wealth. Tall and svelte, she had a long nose and enormous eyes, which she lined with kohl and India ink, and

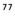

77

August Sander
German, 1876–1964

The Young General, 1915

Gelatin silver print
21.0 x 29.4 cm
Photography Discretionary
Fund, 1975.123

family in the village of Herdorf, near Cologne, Sander worked as a miner and served in the military before becoming interested in photography around 1892.[13] He perfected his skills as an apprentice in studios in Berlin, Magdeburg, and Halle. When he worked in Dresden, Sander also studied painting to learn the methods of pictorial composition. In 1904 he opened his own studio in Linz, and the first exhibition of his work was mounted at the Landhaus Pavilion two years later. The artist returned to Cologne in 1909, to open his own portrait and commercial studio.

Sander's seemingly effortless insight is apparent in *The Young General*, the portrait of a group of students at the Cologne Gymnasium in military dress to celebrate the Kaiser's birthday on January 27, 1915. Carefully turned out, the boys stand proudly at attention, as if the Kaiser himself would see their portrait. They all seem to exude the same confidence and pride, in their country, in their school, which looms in the background, and in

their own social status. Despite their range of kit — from fitted helmets and polished cuirasses to paper hat and lederhosen — all the boys seem as self-assured as the general described on the chalkboard. Their individualized characters are expressed through their apparent ease and eye contact with the camera. Before photographing, Sander sometimes spent an hour talking with his sitters.

Sander made his own character studies of Westerwald farmers, whom he saw as the archetypal contemporary man and the very foundation of society. Building upon these images, he compiled a comprehensive visual survey of the German people, *Menschen des zwanzigste Jahrhunderts* (People of the Twentieth Century).[14] Sander combined some of his studio portraits with the images of people he met in his rambles. He always strove to set his portraits in simple, revelatory settings, with costumes and details that suggest the sitter's origins and profession. Sander's portraits were shown in a solo exhibition at the Cologne Art

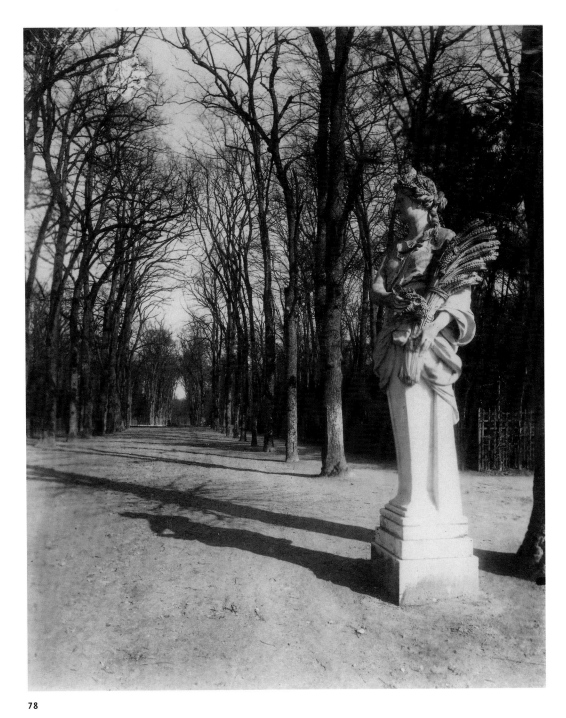

78

78

Eugène Atget
French, 1857–1927

A Path at Versailles, 1922

Albumen print from dry
collodion negative
21.7 x 18.2 cm
Stoddard Acquisition Fund,
1995.24

Society in 1927, and many were later included in his book *Face of Our Time*.[15] In 1931 he gave six lectures on the "Nature and Development of Photography" on Cologne radio. During the 1930s, Adolf Hitler and the Social Democratic Party imprisoned the photographer's son for his communist activities and condemned Sander's work, destroying the publisher's plates for *Face of Our Time*. From 1933 to 1939, he was compelled by the Nazis to photograph the German landscape.[16] Some 30,000 of Sander's negatives were destroyed in a wartime fire in Cologne. This prompted him to retire to the village of Kuchhausen in the Westerwald where he returned to *Menschen des zwanzigste Jahrhunderts*.

In 1951, a solo exhibition of Sander's photographs was mounted at the Photokina in Cologne, and the Stadtmuseum purchased Sander's archive of city views from 1935 to 1945.[17]

An achievement of similar scope is the work of **EUGÈNE ATGET (78)**, who photographed Paris for thirty years, producing a chronicle of topographical, architectural, and social changes to the city. Atget was born in Bordeaux, orphaned as a small child, and supported by an uncle.[18] He shipped to sea as a cabin boy, and then became an actor in Paris, studying for a year at the Conservatoire d'Art Dramatique. After fulfilling his military service, Atget

toured the provinces and suburbs with the popular theater. He became disillusioned with stage life, however, and found new dreams of becoming a painter. With no talent for drawing, he turned to photography around 1888.

Settling in Paris, Atget found a professional niche photographing plants, animals, and landscapes for painters and art students. Gradually, he narrowed his speciality to evocative urban views, to be used as settings for historicizing paintings. At that time, industrialization and mass migration from country to city brought drastic changes to Paris. Old neighborhoods were razed and replaced by factories, residential developments, and new transportation networks. Sensing the import of these changes, Atget began to chronicle the vanishing nineteenth-century city. He photographed storefronts, street life, tradespeople, and modes of transport. Later he recorded the Parisian quais, churches, gardens, and nearby châteaux, especially Versailles, Saint-Cloud, and Sceaux. The photographer built an extensive stock of negatives, printing photographs according to demand. In 1900 the Bibliothèque historique de la Ville de Paris began purchasing Atget's photographs systematically. The library collected some 3,500 of Atget's 10,000 images, many in albums assembled by the photographer.[19] Atget aimed for clarity, and preferred soft illumination to define and model three-dimensional form. His techniques were considered antiquated even in his own time. He persisted in the use of glass NEGATIVES, intuitively judging EXPOSURE times, and snapping his simple SHUTTER with a pneumatic bulb. He preferred to work in the early morning, when the light was cool and intense, and when there were few others about. Only when he photographed people did he open the diaphragm and focus critically on the center of interest, leaving the background out of focus.

A Path at Versailles exemplifies Atget's documentation of his surroundings.[20] The photographer captured a view down this inviting tree-lined avenue on an early winter's morning when leafless trees cast long shadows. A sculptural herm — her human body growing from an architectural pier — marks the beginning of the path. She carries cornflowers and sheaves of fruited wheat identifying her as Ceres, the goddess of fertility and the harvest. She appears almost dejected in the winter's quiet, and seems to turn away from the viewer. Her glance and long shadow direct us down the path, toward the sculptural fountain and the receding avenue. The winter reveals the bare bones of the meticulous garden. The linear calligraphy of the tree trunks and reaching branches possess a silent strength, like the piers and vaulting ribs of a natural cathedral, as we gaze down its nave toward its distant crossing and apse. This balanced, harmonious image is typical of Atget's photographs in its still, provocative objectivity.[21]

It was natural change that endlessly amazed **ANSEL ADAMS (79)**, both slow geological change, and the fleeting shifts of light and weather. By trying to capture this transience in his images of nature, he transformed photography. Adams was born in San Francisco, the only child of older parents, and the grandson of a wealthy timber baron.[22] He grew up near the Golden Gate, the cynosure of a household that included a maiden aunt and maternal grandfather. He was home-schooled, and daily outings in the dunes, along Lobos Creek and Baker Beach, became his relief from this coddled childhood. At age twelve, Adams taught himself to play the piano and read music, and he dreamed of a career on the concert stage. Two years later he first visited Yosemite with his family; he would return there every year of his life. Adams documented his nature expeditions with his Kodak No. 1 camera. He joined the Sierra Club in 1919 and made friends with the founders of the nascent conservation movement.

Vernal Fall, one of Adams's early images of Yosemite, provides a glimpse of his developing voice. The photograph expresses the drama and magnificence of nature. Taken from the stream at the base of the fall, it brings the viewer in contact with the energy, noise, and moist haze of the crashing water. The slash of foamy white against the dark, wet rocks emphasizes a tonal scale to match the immensity of the scene. This image is PICTORIALIST in conception, with all the elements of an aesthetic composition crowded into a complex space that recedes and rises at the same time. In succeeding years, the artist favored perspectives that reveal a startling depth of field, and momentary effects of atmosphere, light, and weather.

Adams first published his photographs in the Sierra Club *Bulletin* in 1922. The first solo exhibition of his photographs was at the club's San Francisco headquarters in 1928. He befriended Edward Weston and Paul Strand (nos. 82, 75), whose negatives inspired him to pursue photography as a career. In 1932, the photographer was among the founders of GROUP *f*.64,[23] and soon after the group's show at the De Young Museum in San Francisco, he had a solo exhibition of his photographs there. In subsequent visits to Yosemite, Adams developed his "Zone System," a method that encouraged him to previsualize the finished print, comparing the values of the subject with the chart of a tonal scale. In 1935, some of these ideas appeared in Adams's influential manual *Making a Photograph*.[24] The following year, Alfred Stieglitz (no. 62) mounted a solo exhibition of his work at An American Place, the successor to 291. Adams's technical expertise was unmatched; Weston and Strand came to rely on him for advice, and he served as consultant to such camera manufacturers as Polaroid and Hasselblad. His ten volumes on photographic

79

Ansel Adams
American, 1902–1984

Vernal Fall, 1920

Gelatin silver print
27.4 x 20.3 cm
Jerome A. Wheelock Fund,
1969.86

technique remain standard references. Through his support of the first museum department of photography, at the Museum of Modern Art, and the research-oriented Center for Creative Photography at the University of Arizona, Adams promoted photography as fine art. In the 1950s and 1960s, he collaborated on books and exhibitions with the writer and designer Nancy Newhall. Perhaps their most influential project was *This Is the American Earth*, a book that helped to launch the first broad-based citizen environmental movement.[25]

CHARLES SHEELER (80) approached photography with parallel seriousness of purpose and technical precision. Born in Philadelphia, the son of a steamship company clerk, he studied at the School of Industrial Art and at the Pennsylvania Academy of the Fine Arts, where he was a pupil of William Merritt Chase.[26] To study the art of the avant-garde, Sheeler traveled to Europe, and after his third trip his paintings progressed from Impressionist-influenced landscapes to geometric still lifes and architectural studies informed by the work of Paul Cézanne. In 1913, he exhibited six paintings in the landmark Armory Show in New York, which brought him recognition among American avant-garde artists and collectors.

In 1910, Sheeler and fellow painter Morton Schamberg rented an old farmhouse in Doylestown, Pennsylvania, and both took up photography to support themselves. To learn the craft, Sheeler produced a series of austere, aesthetic still lifes, such as *Zinnia and Nasturtium Leaves* (front cover).[27] To explore and analyze photographic techniques, he meticulously recorded the details of lighting, exposure, films, and printing papers. The vernacular architecture of Buck's County, Pennsylvania, became Sheeler's favorite subject in this period. *Barns* exemplifies his finest work, which depicts structures that combine pure geometrical formality, purpose, and practicality, and have all the tectonic elegance of Constructivist sculpture. Sheeler enhanced their form by concentrating on the illumination and atmosphere of their great scale, and he emphasized their presence by the tex-

tures of their materials and the details of their rural settings. The artist used his photographs as studies for paintings of related subjects, and his work in these media informed each other compositionally. Sheeler developed a successful career as a commercial photographer, and pursued concurrent artistic careers as a photographer and a painter.[28]

In 1918, Sheeler moved to New York. There, Alfred Stieglitz (no. 62) introduced him to Paul Strand (no. 75), with whom he collaborated on the short film *Manhatta* in 1920. Sheeler also made still photographs of the city, which he used to develop geometric urban landscape paintings. In 1921, the artist joined the Whitney Studio Club — which later evolved into the Whitney Museum of American Art — and a solo exhibition of his work was mounted there in 1924. Two years later, Edward Steichen (no. 85) hired Sheeler as a photographer at Condé Nast publications, and he became a regular contributor of fashion and celebrity photographs to *Vogue* and *Vanity Fair* magazines. In 1927, the Ford Motor Company commissioned Sheeler to photograph its new plant at River Rouge, Michigan, where Model A Fords were produced on a specially designed assembly line. His series of thirty-two photographs present the plant architecture and machinery as emblems of American industry and the machine age.[29]

In the early 1930s Sheeler turned away from photography to concentrate on painting but continued to develop the design of his urban landscapes from his earlier photographs. A retrospective exhibition of his paintings was mounted by the Museum of Modern Art in fall 1939.[30] During World War II Sheeler became a senior research fellow in photography at the Metropolitan Museum of Art. He took up the camera again for a series of photographs and paintings of the abandoned mill buildings of New England. These images became increasingly abstract, as the artist superimposed two negatives to create composite images that evoked actual sites while creating original, abstract designs. Sometimes he cut these composite images vertically, separating them into polyptych compositions, which extended their spatial effects.

80

Charles Sheeler
American, 1883–1965

Barns, 1915

Gelatin silver print
24.5 x 19.6 cm
Anonymous Gift, 1980.134

The precision and refinement of Charles Sheeler's architectural views find a parallel in the work of **PAUL OUTERBRIDGE (81)**, who believed that photography was the artistic medium most suited to the pace and progress of life in an age of modern science. The son of an eminent surgeon, he was the scion of an old New York City family.[1] After graduating from prep school, he took classes in aesthetics and anatomy at the Art Students League. During World War I, Outerbridge enlisted in the Army, and was trained as a photographer because of his art background. After the war, while apprenticed in a Wall Street brokerage firm, he took classes at the Clarence H. White (no. 65) School of Photography. From Max Weber he learned principles of European Modernist design, synthesized with Japanese concepts taught by Arthur Wesley Dow (no. 50).[2]

Outerbridge probably made *Socks and Garter* for one of his first commercial contracts. He strove in its design to achieve a harmonious balance of light and dark analogous to nature. In images like this, he "was not taking a portrait of these objects but merely using them to form a purely abstract composition."[3] With the financial means to pursue the highest possible quality in his photographs, he purchased the finest professional equipment. Although PLATINUM remained scarce and expensive in the years following the war, he printed only on platinum paper because of its superior tonal quality. Outerbridge inherited a surgeon's touch; his attention to the details of his designs and his meticulous technique produced prints of almost unrivaled finesse and elegance in his day. Confident from the beginning that his photographs would be appreciated as fine art, he confined this and many of his works to limited editions of about six prints. Another of his refined still-life experiments of 1921, *Kitchen Table*, appeared in *Vanity Fair* magazine, launching his successful career as an advertising photographer.

In 1925, Outerbridge moved to Paris, where he worked briefly for French *Vogue* and began a friendship and rivalry with Edward Steichen (no. 85). Urbane and confident, Outerbridge thrived in café

81

Paul Outerbridge, Jr.
American, 1896–1958

Socks and Garter, 1921

Platinum print
9.8 x 8.2 cm
Stoddard Acquisition Fund, 2003.27

81

society. Man Ray and Berenice Abbott (nos. 94, 105) introduced him to Pablo Picasso, Salvador Dalí, and other leading figures of the Parisian avant-garde, and he was energized by their ideas. In 1927 he set up a large, modern studio for the mannequin manufacturer Mason Siegel, and produced a Surrealist-influenced series representing its products in contorted positions with unusual props. The following year Outerbridge went to Berlin, where he worked with filmmaker Georg Wilhelm Pabst. His photographs were included in the Berlin *Werkbund* exhibition in 1929, and in the landmark *Film und Foto* exhibition in Stuttgart. Outerbridge returned to New York to open a commercial studio. His photographs regularly appeared in such magazines as *Vanity Fair* and *House Beautiful*, and he exhibited his work at the Julien Levy Gallery.[4]

EDWARD WESTON'S (82) vision transformed the look of art photography, shifting from the con-

82

82

Edward Weston
American, 1886–1958

Nude, 1925

Gelatin silver print
19.4 x 23.9 cm
Gift of William H. and
Saundra B. Lane, 1980.135

scious manipulation of PICTORIALISM to the clear, sharp representation of objects as formal compositions. His images prompted viewers to an intellectual, and even spiritual, contemplation quite different from the poetry of Pictorialism.

The son of a Chicago physician, Weston was just four years old when his mother died.[5] In 1902 his father gave him a snapshot camera, and the following year he bought a view camera. Photography provided some stability to the troubled teenager, who dropped out of high school. Weston attended the Illinois College of Photography in 1908, completing the courses in six months. He married the grade-school teacher Flora May Chandler and began a family with four sons. They moved to California in 1911, where Weston opened a commercial photography studio in Glendale. In 1917 Weston began keeping *Daybooks*, chronicles of his ideas on photography, his personal philosophy, and his loves.[6] Tina Modotti, a model and photographer whom he

met in 1921, admired his work and organized an exhibition of his Cubist-inspired photographs in Mexico City.[7] Soon he left his family and his commercial studio and moved to Mexico with her.

Nude, created in 1925, is one of the remarkable photographs he made in Mexico, images conceived to investigate the capabilities of his equipment to produce a wide range of delicate grays, and to model form in space. By carefully framing the image to fill the composition, Weston concentrates the viewer's attention on shape, light, and surface, preventing any consideration of the subject's personality. The projection of the figure beyond the frame emphasizes the sense of space. The photographer picked out form in clear detail, precisely focused, in elegant natural light, as the most powerful statement of what he believed was the camera's greatest potential. The photograph represents varied skin textures on different parts of the body. The attitude of the upraised left hand

echoes the pose of the arm and hand in Michelangelo's famous Renaissance sculpture *David*, and the brazen tone in this quadrant of the photograph also reminds the viewer of sculpture. To explore sculptural form he created suites of photographs of the same subjects, like the *Escusado* series of the porcelain toilet in his apartment.

After returning to California in 1929, Weston focused his sculpturesque vision on still-life photographs of shells, peppers, and other isolated objects, as well as on the rugged scenery of Point Lobos in Carmel, where he lived. He continued to explore the nude, photographing the model Sonya Noskowiak (no. 112), who introduced him to GROUP *f*.64, which he joined and supported for a time.[8] Weston began to photograph Charis Wilson in 1932, as part of a series of photographs of nudes and sand dunes that blurred the boundaries between figure and landscape. Weston and Wilson began living together in 1934, and were married from 1939 to 1946. Despite its deprivations, the Depression was one of Weston's most productive periods. In 1937, with the support of the first Guggenheim grant for photography, he and Wilson traveled across the West, documenting their expedition in the book *California and the West*.[9] It was followed by a special edition of Walt Whitman's *Leaves of Grass* accompanied by a selection of Weston's photographs that profoundly influenced a generation of photographers.[10]

IMOGEN CUNNINGHAM (83) used the device of exclusive closeup framing in *Magnolia Blossom*, the most famous from her remarkable series of photographs produced in the mid-1920s in Oakland, California. At that time her husband, the artist Roi Partridge, taught at Mills College and she stayed home to raise their three sons. She took many of her photographs around the house and backyard. Without studio equipment, she drew in closely to the flowers and other botanical specimens that were her subjects, concentrating on the formal qualities of their exterior forms and inner structures. Her son Padrais later recalled that she cut this magnolia blossom from a tree, placed it in a vase in the house, and — like Edwin Hale Lincoln (no. 72) — waited for three days as the flower opened until she sensed the right moment. Through her close vantage point and microscopic detail, Cunningham revealed information about the flower unapparent to the casual eye. Its form recalls human anatomy, and the delicate softness of its petals provides a subtle sexual metaphor.

Cunningham was the fifth of ten children in a poor rural family, and grew up on a remote family farm near Seattle.[11] When she became interested in photography as a teenager, her father built a wood-shed darkroom, covering its walls with tar-paper to block the light. In 1899 she studied chemistry at the University of Washington. Inspired by the work of Gertrude Käsebier (no. 67), she bought a 4 x 5–inch

83

Imogen Cunningham
American, 1883–1976

Magnolia Blossom, 1925

Gelatin silver print
26.6 x 34.2 cm
Purchased with funds granted by National Endowment for the Arts, 1975.51

84

84

Manuel Álvarez Bravo
Mexican, 1902–2002

Squash and Snail, 1928

Palladium silver print
15.0 x 11.3 cm
Richard A. Heald Fund,
1993.77

VIEW CAMERA, and taught herself to use it with a book from the International Correspondence School. After graduation, Cunningham worked for Edward S. Curtis (no. 58) and assisted with *The North American Indian*, learning the difficult process of PLATINUM PRINTING. She went to Germany in 1909 to study photographic chemistry at the Technische Hochschule in Dresden.

Returning to Seattle in 1910, Cunningham opened her own portrait studio. She also made soft-focus images of friends acting out scenes from romantic poems in the mists and forests of Mount Rainier, posing in the nude or in classicizing draperies. Cunningham may have been inspired by Pre-Raphaelite art and literature, or by the work of Julia Margaret Cameron (no. 42). In 1915 she married Partridge, and in 1920 they moved to the San Francisco Bay Area. In California, Cunningham was inspired by Modernism and abandoned Pictorialism for STRAIGHT PHOTOGRAPHY. In 1932 she was among the founders of Group *f*.64, with which she consistently exhibited throughout its brief activity.[12]

Cunningham opened her own studio in San Francisco in 1934, and through the following decade she maintained a national reputation for her celebrity portraits, published in magazines like *LIFE* and *Vanity Fair*. Recognized as an art photographer on the West Coast, she had a remarkable ability to penetrate her subjects, revealing unapparent dimensions of personality.[13]

"I was born in the city of Mexico," **MANUEL ÁLVAREZ BRAVO (84)** once wrote, "behind the cathedral, in the place where the temples of the ancient Mexican gods must have been built."[14] This sense of deep connection to the land, its history, and culture, characterizes the work of the pioneering creative photographer of Latin America. The son and grandson of painter-photographers, he carried with him childhood memories of the cannons' roar and dead men in the street during the Mexican Revolution. Álvarez Bravo left school at age thirteen, and in 1916 he began working as an accountant in the Treasury Department.[15] He bought his first camera in 1924, and taught himself to use it with the help of American photography magazines. In 1931, after winning first prize in a competition sponsored by La Tolteca, he decided to pursue photography as a full-time career. Many of Álvarez Bravo's photographs appeared in *Mexican Folkways* magazine, for which he photographed the work of such Mexican artists as Dr. Atl, José Clemente Orozco, David Alfaro Siqueiros, Diego Rivera, and Frida Kahlo during the 1930s. The first generation active after the Revolution, these artists helped forge a national identity through their work. Like them, Álvarez Bravo derived his imagery and style from Mexican life, art, and history. In his search for *mexicanidad*, he combined poetic observation with allusions to ancient myth, folklore, and ritual. His countrymen understood these hidden meanings, and he did not offer interpretations for other viewers.

Squash and Snail is a photograph often praised for the formal and textural counterpoint between its two components. It is also an analogy of cyclical fertility and creation. For the Aztecs, the snail was a symbol of conception, pregnancy, and birth. Its spiral shell signified the enduring within the changeable, and was associated with the phases of the moon; the Aztec lunar god Tecciztecatl wore a spiral shell.[16] As a powerful symbol of sexuality, the tumescence of the snail's horns connoted the male principle, while the form, motion, and excretions of its body represented the female principle. Depicting this creature on an indigenous fruit that had always provided for the Mexican people, Álvarez Bravo created a powerful allusion to the relationships of procreation and sustenance. The shape of the squash resembles the swollen belly of a pregnant woman, with a

85

Edward Steichen
American, 1879–1973

Jean Simpson in Profile, 1923

Carbro print
25.3 x 20.1 cm
Sarah C. Garver Fund, 1986.3

85

prominent navel to symbolize the umbilical connection to offspring.

Álvarez Bravo sometimes created more political images during the 1930s, when he was involved in the League of Revolutionary Writers and Artists. In 1938 he met André Breton, who commissioned the photographer to create *La buena fama durmiendo* (*The Good Reputation Sleeping*), for the cover of a Surrealist group exhibition in Mexico City. The Surrealists may have been inspired by Álvarez Bravo's work — whose obscure iconography seemed psychological to them — but Surrealism influenced him minimally.

From his indispensable contributions to the Photo-Secession to his sweeping curatorial projects of the 1960s, no one did more to advance creative photography in the twentieth century than **EDWARD STEICHEN (85)**. He was born in Luxembourg, the son of a copper miner and a milliner who immigrated to the United States when Steichen was two years old.[17] The family settled in Milwaukee, where as a teenager Steichen was an apprentice lithographer while studying painting at the Art Students League. Soon after he took up photography, his works were shown in the prestigious Second Philadelphia Photography Salon in 1899. Steichen

86

dreamed of being a painter, and continued his studies in Paris.[18]

The artist moved to New York in 1902, and joined with Alfred Stieglitz (no. 62) to build the Photo-Secession. It was Steichen who secured space for the Little Galleries of the Photo-Secession at 291 Fifth Avenue, and he designed and installed its first exhibitions. On regular transatlantic journeys, he made contacts with European Modernists for gallery 291 and *Camera Work*.[19] A solo exhibition of Steichen's paintings, mounted at the Worcester Art Museum in 1910, featured Tonalist landscapes, parallel to many of his thirty-one pho-

tographs included in the landmark *International Exhibition of Pictorial Photography* at the Albright-Knox Museum.[20] He remained loyal to the Photo-Secession in its final years, when Stieglitz shared his experiments with Modernist-influenced, straight photography. During World War I, Steichen enlisted in the Air Force, eventually attaining command of its photographic division, and pioneering the new field of aerial reconnaissance photography. In 1923, he joined the staff of Condé Nast Publications, and over the next fifteen years worked as a fashion photographer for *Vogue* magazine and as a portraitist for *Vanity Fair*.[21]

Steichen's portrait of Jean Simpson exemplifies his work of the mid-1920s in its clarity and stylishness. The artist met Simpson in the Paris studio of sculptor Auguste Rodin, and they became good friends. She was the daughter of a prominent New York attorney and collector who owned paintings by Steichen. In this portrait he envisioned her as a Renaissance maiden, wearing an amber necklace and a gold headband. Steichen used the CARBRO technique — an early method of color photography — to achieve the subtle tones of this delicate likeness. To produce a carbro print, three separate EXPOSURES were made, each in a different color. They were developed separately and exactingly printed in superimposition. The metallic cast of the photograph evokes the painted Italian panels of the fifteenth century, accented by gold leaf.

During World War II, Steichen headed the United States Naval Photographic Institute, directing all American combat photography.[22] To rally civilian support for the war, he organized three exhibitions of military photographs, which were shown at the Worcester Art Museum.[23] Later, as head of the pioneering Department of Photography at the Museum of Modern Art, he organized fifty exhibitions from 1947 to 1962. The most remarkable of these was *The Family of Man*, an international show that demonstrated the universality of human experience.[24]

While Steichen could subtly evoke the Renaissance maiden in a New York studio, **LAURA GILPIN (86)** displayed similar skill when portraying a cosmopolitan sophisticate in the Rocky Mountains. In February 1926, she made portraits of George W. Eggers, director of the Denver Art Museum, who is best remembered for his museum work, though he was also a skilled painter, author, and teacher.[25] Educated at the Pratt Institute in Brooklyn, Eggers taught there, at Columbia University Teachers' College, and at the Chicago Normal College, where he headed the art department from 1906 to 1916.[26] He then became director of the Art Institute of Chicago until 1921, when he moved to Denver. He was a sophisticated man who stood out in the West, and Gilpin's portraits emphasize his stature as a connoisseur. She photographed Eggers clad in a dinner jacket, in different poses and lighting conditions in his apartment. The setting suggests his sophistication, as he sits on a rocking chair atop a patterned kilim rug, before a bookcase surmounted by the Renaissance-style bust of a woman. In some photographs Eggers examines a Gothic ivory statuette by candlelight. These Pictorialist images seem pointedly aesthetic at a time when the soft-focus style was unfashionable in the East.

A Colorado rancher's daughter, Gilpin grew up on the western slope of the Rocky Mountains.[27] She began making photographs at the age of twelve, when she received a Kodak Brownie camera as a gift. She saved the profits from raising turkeys, and by 1916 she had enough money to move to New York and attend the Clarence H. White (no. 65) School of Photography, where she learned aesthetic and technical lessons for both expressive and commercial photography. In 1918, she returned to Colorado Springs to open a studio specializing in portrait and architectural photography.

Gilpin's first solo exhibition in New York, at the Art Center in 1924, featured landscape photographs, praised for their evocation of vast Western space. Two years later she published *The Pike's Peak Region*, the first of her books to capture the natural character and indigenous culture of a region. In 1930, when her friend Elizabeth Forster became a nurse in the Navajo settlement of Red Rock, she began a photographic record of this traditional native community. During World War II, Gilpin worked as a public-relations photographer for the Boeing Company. Her national reputation was galvanized at that time by *The Pueblos: A Camera Chronicle*, a book of photographs with a historical text unifying the continent's ancient history with native culture. In *Temples of Yucatán: A Camera Chronicle of Chichén Itzá*, Gilpin used images of archaeological sites to describe Pre-Columbian history of the Americas and the artistic heritage and talents of modern-day native people. Her third book, *Rio Grande: River of Destiny*, which combined landscape with images of the people whose lives were shaped by the river, established Gilpin as a landscapist and cultural geographer.[28]

When American photographers emerged from the aesthetics of Pictorialism during the mid-1920s, the style had already become unfashionable in much of Europe. There, the period of rebuilding after World War I spawned realistic styles that strove to represent the world without exaggeration. This era of consolidation is remembered in Germany as the Golden Twenties.[29] In the years after World War I, artists had reacted to Abstraction and the heightened emotion of Expressionism. The return to Realism and clarity came to be known as the *Neue Sachlichkeit* (New Objectivity). Gustav F. Hartlaub, the organizer of an exhibition at the Mannheim Kunsthalle in 1924, first used this term to describe stylistic affinities between the works of George Grosz, Otto Dix, Max Beckmann, Georg Schrimpf, and other artists. In photography, artists like August Sander, Albert Renger-Patzsch (nos. 77, 103), and **HUGO ERFURTH (87)** were influenced by the *Neue Sachlichkeit*, which was parallel to the "straight photography" in the United States practiced by Ansel Adams, Imogen Cunningham, and Edward Weston (nos. 79, 83, 82).

Erfurth studied at the Kunstakademie in Dresden from 1892 to 1896, then managed the Schröder

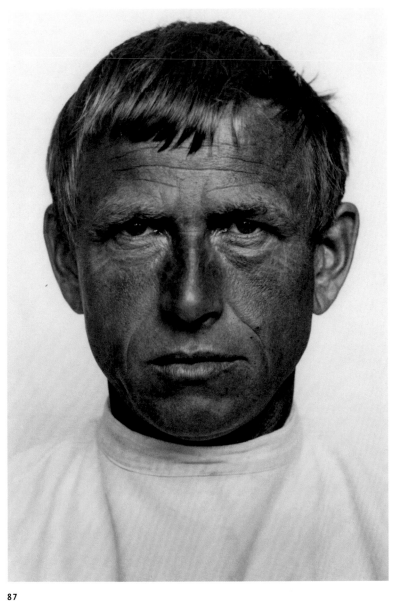

87

87

Hugo Erfurth

German, 1874–1948

Otto Dix, about 1925

Gelatin silver print
16.7 x 11.5 cm
Anonymous Fund, 1987.2

portrait studio for a decade.[30] During this period he worked in a Pictoralist style, producing formal, rather melancholy portraits, printed by the old CARBON and gum bichromate techniques. In 1906 the photographer moved his family to the Hof Lüttichau, an empire-style ducal mansion on Dresden's fashionable Zinzendorfstrasse. He set up his own portrait studio, and later an art gallery. In 1919 Erfurth was one of the founder-members of the German Gesellschaft Deutscher Lichtbilder (Society of German Photographers), and as the head of its exhibition jury from 1924 to 1948 he exerted considerable influence upon German art photography. During this period his studio became a gathering place where Dresden photographers, intellectuals, and artists, among them the painters Erich Heckel, Paul Klee, and Oskar Kokoschka, exchanged ideas and imagery. During the 1920s, Erfurth developed a particular friendship with the painter Otto Dix.[31] Their families spent leisure

time together, and they created several portraits of each other.

Otto Dix is one of the most arresting of these confrontational portraits, and reveals the influence of the *Neue Sachlichkeit* on Erfurth. From 1919 to 1933, he produced similarly revealing psychological portraits of the prominent artists, scientists, politicians, and businessmen of the Weimar Republic in Dresden.[32] This bright, explicit image is the antithesis of the photographer's soft, dark, brooding characterizations from the turn of the century. Its vivid illumination and featureless white background suggest the setting of Erfurth's Lüttichau studio, where twelve-foot-high windows along one wall flooded the space with daylight. Dix wears a white tunic that blends with the background, highlighting his facial features even more. Every hair and wrinkle is revealed to the viewer. It is difficult to meet the artist's dauntless, almost belligerent glare into the camera lens. The weathered face and penetrating eyes seem to reveal self-assurance borne of harsh experience and self-examination.

Dix was also influenced by the *Neue Sachlichkeit*, and during the 1920s he progressed from a personal Expressionist style to a more naturalistic manner, unmitigated in its political and emotional content. His provocative work alienated him from the Nazis, who forbade him to paint and forced him to leave Dresden. Dix took his family to Gaienhofen on Lake Constance. In 1934, Erfurth moved to Cologne, where his studio and much of his earlier work was destroyed by bombing during World War II. In 1945 he and his family moved to Gaienhofen, joining the Dixes there.

Realism also dominated the arts in the Soviet Union in the years between the world wars . There, photography was influenced by Socialist Realism, a painting style conceived to be clear and understandable to the full breadth of society, and meant to carry unambiguous political messages. Photographers of the period endeavored to build new traditions of reportage and documentary photography, often working with outdated equipment and under complex systems of official patronage and censorship. Photographers such as Max Alpert, Arkady Shaikhet, Georgy Zelma (no. 89), and **ARKADY SHISHKIN (88)** looked to art and cultural history as they synthesized a new language.[33]

Shishkin was the son of a carpenter, born in the village of Kukarka, in the Vyatka (now Kirov) district.[34] As a boy he worked as an apprentice to a portrait photographer in Kazan. Later he moved to Petrograd to take a course in film projection, and there he enlisted in the Red Army in 1918. After his discharge four years later, Shishkin returned to Kukarka, where he worked as a photographer for local newspapers and magazines. Despite antiquated equipment he managed to cap-

88

88

Arkady Vasil'evich Shishkin

Soviet, 1885–1985

A Woman's Lot, 1928

Gelatin silver print
18.7 x 28.5 cm
Sarah C. Garver Fund,
1997.27

ture provocative images of rural life in Vyatka that attracted attention throughout the Soviet Union. In 1925 Shishkin moved to Moscow to work for *Krestianskaya Gazeta* (*Peasants' Newspaper*). With a hand-held Leica camera, he documented daily life in the countryside and rural villages. Shiskin also photographed farm animals, and serfs working in fields and farmyards, and created still-life images of tools and farm implements that silently attest to the labors of their users. Shiskin's photographs trace the consolidation of small, traditional peasant farms into massive state-run farms, or *kolkhozes*.

A Woman's Lot is typical of Shishkin's images of *kolkhoze* life during the 1920s. Its title comes from a familiar Russian phrase, "how bitter you are, woman's lot," a stanza from the famous poem "Red-Nosed Frost" by Nikolai Alekseyevich Nekrasov.[35] With lyrical realism, this poem of 1863 represents peasant life in an encyclopedic fashion, like Shishkin's own photographs.[36] The striking image shows a fieldworker bending forward as she ties a bundle of hay with strong, calloused hands. At the center of the composition, the sheaf functions as a symbol for her heroic labors, and for the produce

that will sustain the Soviet people. The woman's muscular arms, heavy facial features, and patterned clothing worn in layers characterize her proletariat status and Ukranian heritage. Shishkin composed the image so that the decorative details of her dress and apron parallel the patterns described by the cross-hatched bundles of tied and baled straw. Bending down, her hunched figure echoes the shape of the haystacks opposite, which diminish in size as they go off into the distance and measure the space behind. Shishkin placed his camera low to the ground, bringing the viewer close to the experience of work and emphasizing the laborer's connections to the land. Silver-lined clouds suggest a sunset glow, implying that the woman works late into the long evening.

GEORGY ZELMA (89) was another pioneer of Soviet photojournalism of humble origins. Born and raised in Tashkent, Uzbekistan, he moved with his family to Moscow at age fifteen.[37] As a teenager he found an old Kodak camera and made photographs of the city. Zelma studied at the Photo Klub School, and in 1922–23 he learned the techniques of filmmaking at the Proletkino Film Studio. He

89

89

Georgy Anatolyevich Zelma
Soviet, 1906–1984

The Voice of Moscow, 1925

Gelatin silver print
22.3 x 15.7 cm
Sarah C. Garver Fund,
1997.31

began his professional career as an apprentice at the Russfoto Agency, where he met many of the country's leading photographers who supplied images to the foreign press. Zelma's first published photographs were images of the Zagorsk toy factory and old Moscow, which appeared in *Pravda Vostoka* (*East Truth*). In 1924, he returned to Tashkent as the Central Asian correspondent for

Russfoto. His knowledge of the region and Uzbek languages facilitated his work.

Like several of Zelma's most famous images, *The Voice of Moscow* represents the arrival of new technology in the Soviet Republics. An old man from the tribal regions of Uzbekistan sits in a Farghana street, donning headphones to hear the sound of radio for the first time. Zelma captured

90

90

Aleksandr Rodchenko
Soviet, 1891–1956

Workers' Club, 1925

Gelatin silver print
10.9 x 14.6 cm
Sarah C. Garver Fund,
1997.36

the moment of realization reflected on the old man's face. The wonder of the event is emphasized by the amusement of the old man's partner, whose attitude combines respect for his elder companion with anxious anticipation for his own turn. The tribesmen sit on a ground cloth, emphasizing their close connection to the land; their traditional garb, quilted robes, tall boots, and Muslim head coverings also reflect their lives on the steppes. The common experience of discovery and amusement gives this image a universality appropriate for the wide variety of viewers across the Soviet Union who were the intended audience of Zelma's photographs. Images like this became symbols of liberation from the history of repression and exploitation, and encouraged the Soviet people to believe that positive changes were occurring across the vast nation.

Following military service in 1927–28, Zelma became a freelance photographer, continuing to work in Central Asia. His work appeared in leading Soviet newspapers including *Krasnya zvezda* (*Red Star*), and *Izvestia*. Among his most famous photoessays of this period were a series of physical-

culture sessions in Tadjik mountain villages, and young women demonstrating on International Workers' Festival Day against compulsory wearing of the chadra — the traditional veil and headscarf for Muslim women — while the police protected them against their parents. In 1930 Zelma joined Soyuzfoto Agency, for which he collaborated with Roman Karmen on two influential photoessays, *The USSR Seen from Above*, and *Ten Years of the Soviet Republic in Yakutia*, published in Aleksandr Rodchenko's (no. 90) *USSR in Construction* magazine.

During World War II, Zelma was a front-line correspondent for *Izvestia*. His photographs of the Battle of Stalingrad became some of the most famous images of the Russian war.[38] Afterwards Zelma returned to his provincial journeys. His photographs appeared in illustrated books, in magazines like *Ogonyak* (*Sparkle*), and *Sovetskaya Zhenshchina* (*Soviet Woman*), and were featured in leading exhibitions across the USSR.

One of the most innovative and influential Soviet artists, **ALEKSANDR RODCHENKO (90)** embraced photography as a relevant vehicle for

social progress. He studied at the Kazan School of Fine Arts, where he met fellow student Varvara Fedorovna Stepanova, who became his wife and lifelong collaborator.[39] Together they embraced the style of Futurism, and in 1915 Rodchenko began exhibiting his work in a show organized by Vladimir Tatlin.

Rodchenko became deeply committed to the Bolshevik Revolution. In its early years Soviet government courted avant-garde artists, who searched for practical means for mass-communication. Rodchenko became a member of the IZO Narkompros (Department of Fine Arts in the People's Commissariat for Education), and INKhUK (Moscow Institute of Artistic Culture), and in 1920 he began teaching at VkhUTEMAS/VhUTEIN (Higher State Artistic-Technical Workshops). The following year he famously declared that painting was dead. New concepts could not be expressed in old ways, he reasoned, and artists should discover the distinctive capabilities of new media. This notion led to the Constructivist movement, and to a new stature for photography and film. Rodchenko began taking photographs while working as a designer for LEF (Left of the Arts), a magazine founded by his friend, the writer Vladimir Mayakovsky. He moved rapidly from portrait photographs to reportage, and then to abstraction. Believing that art should make the familiar seem unusual, he experimented with confused perspective, closeups, and multiple EXPOSURES.[40]

Rodchenko's photograph, the Workers' Club, is the record of a more elaborate project. It documents an exhibit in Paris at the Exposition Internationale des Arts Décoratifs et Industriels Modernes in summer 1925. To project a civilized and progressive image of the USSR, the artist conceived, designed, and built this tasteful modern lounge where workers could meet, relax, study, and share ideology. Rodchenko suggested that well-designed, purpose-built modernist spaces like this prototype might become universally available across his country. The display embodied revolutionary ideology by inferring both common literacy for Soviet workers and leisure time that they would wish to enjoy collectively with edifying materials and company. Rodchenko's spare design evoked a culture of hygiene, rationality, and economy. Clarity of design was meant to promote facility of understanding. Constructivist geometry dominates the furnishings, unornamented except for varied paint colors accenting their different planes. Each piece was meant to occupy a specific location within the space, thoughtfully placed for access, egress, and illumination. The furniture was adaptable for different uses; the hinged tabletop could be flat for work or inclined for reading, and the playing surface of the chess table revolved to give the players access to their seats. Rodchenko designed the stylized club signage,

and its posters, magazines, and newspapers, all meant to increase its impact by complementarity. The Club also included a "Lenin Corner," a space conceived as a memorial to the recently deceased leader, and a changing showcase of national portraits and awards, the predecessor of the "Red Corner" in every Soviet school and factory. Despite Rodchenko's idealistic planning, his Workers' Club was never more than an elaborate diorama.[41]

ANDRÉ KERTÉSZ (91) had a distinctive personal vision of the appropriate subjects for photography, and by isolating simple gestures and familiar objects he allowed his viewer to appreciate their beauty and long to understand their meaning. After studies at the Budapest Academy of Commerce, Andor Kertész became a clerk at the Hungarian stock exchange.[42] He bought his first camera in 1912, and began photographing on the street, recording the events of everyday life in a fresh and spontaneous style. During World War I, Kertész served in the Austro-Hungarian army, carrying his camera on march and chronicling life in the trenches. He was critically wounded in 1914 and during his long recovery came to value art more than business. Kertész moved to Paris, and settled in Montparnasse, joining avant-garde artistic and literary circles. Aside from his images of city life, he explored the creative approaches of the artists he befriended by photographing their studios and homes.

At Mondrian's House is atypical of Kertész's photographs of the period in its quiet and vacancy, but these very qualities evoke the personality of its occupant. When Kertész met Piet Mondrian in 1926, the Dutch-born painter had already progressed from Cubist- and Symbolist-style works to flat, strictly geometrical abstractions.[43] He was a prolific author, whose writings explain the progressive refinement of his abstraction and his deeply held spiritual beliefs.[44] During the 1920s, Mondrian's paintings consisted of unmodulated rectangles in black, white, gray, and primary colors. The meticulous placement of these elements, their formal correlations and rhythms, related to the foxtrot, a dance then popular. When Kertész explored Mondrian's house, he found a composition concentrated on overlapping geometric elements. The photographer balanced curved and rectilinear forms, instinctively trying to capture the spirit of Mondrian's paintings. "He simplified, simplified, simplified," Kertész later wrote. "The studio with its symmetry dictated the composition. He had a vase with a flower, but the flower was artificial. It was colored by him with the right color to match the studio."[45] Kertész placed the flower and vase before the gray wall, in a beam of light, to provide a central formal counterpoint. He used the overcoat and straw hat to evoke the presence of the artist,

adjusting his exposure so that the gray coat merged with the background hatrack, and emphasizing the geometric shape of the hat.

In 1927, Kertész began using a hand-held Leica camera that enabled him to work more spontaneously, and became a leading proponent of portable cameras and small negatives. When his photographs were featured in the landmark *Film und Foto* exhibition in 1929, Surrealism had begun to influence his work.[5] He created a series of distorted nudes, photographed with parabolic mirrors. Kertész settled in New York shortly before World War II and became an American citizen in 1944. Six years later, when he moved to an apartment above Washington Square, he began a series of photographs of the park, and the people who gathered there, that continued for the rest of his life.

The architectural photographer **WERNER MANTZ (92)** also explored the peculiar eloquence of absence. When he was fifteen years old, he bought a Kodak Brownie camera and made photographs of his hometown of Cologne.[46] He became fascinated with photography as a means of historical documentation. In 1920–21, Mantz studied photography at the Lehr- und Versuchsanstalt für Photographie (Institute for Education and Research in Photography) in Munich. Then, with a studio in his parents' house, he began a career as a commercial photographer and portraitist. When his exterior shots of a hairdresser's salon in the Pickenhahn building came to the attention of its architect, Wilhelm Riphahn, he engaged Mantz to photograph other buildings. For his records, Riphahn specifically needed clearly lighted views that revealed every formal and structural detail of a building. The photographer's personal rigor — and perhaps the influence of the *Neue Sachlichkeit* — was well-suited to the job. He strove to photograph buildings when they were new and pristine, without a person in sight, and perfectly illuminated. "I restricted myself always to available light . . . ," Mantz remembered. "It often happened that I had to wait half a year or so for the right light in or on a building. And for the same reason, I often had to rise at five in the morning."[47]

Facade Detail at Kalker Feld is one from Mantz's series of photographs from 1927 to 1930, documenting the housing estate at present-day Buchforst, near Cologne, designed by Riphahn and Grod.[48] This planned community included extensive apartment blocks, with one commercial business in each, interspersed with pedestrian spaces. Each of the long, residential facades was articulated by repeating units arranged around a doorway. The image of one unit exemplifies Mantz's knack for compositional harmony. By cutting off the building with the sides of the photograph, he emphasized its vertical scale. The photographer

stood to the side, photographing the facade from an acute angle, so the diagonal of the roofline allowed a glimpse of the sky. The shadows capture the plasticity of the facade and reveal the architect's careful balance of each window, mullion, opening, and overhang to achieve a harmonious whole. He suggested the building's comfortable use by revealing the patterned net curtains in the apartment windows. Mantz did not allow a view through the glass to distract from the architectural impact of his image, however. In all three windows of the central bay, he toned-back the passages to a soft gray by scratching the negatives with methodical cross-hatching.

Mantz worked for other Cologne architects, including Klemens Klotz, Erich Mendelsohn, and Bruno Paul. He also made eerily vacant photographs of architectural interiors, perfect spaces filled with brand new, unused furniture, and even complete table settings, but no people. Nevertheless, his views of theater, restaurant, hotel, and cruise-ship interiors brim with sociological information. When the Depression curtailed building in the Rhineland, Mantz worked in Maastricht, the Dutch city near the German border, while keeping his Cologne studio. He executed government commissions to document buildings and civil engineering projects for the Rijswaterstad, making remarkable, semiabstract perspectives of highways, bridges, and industrial developments. These precise formal studies of industrial machinery anticipated the work of Bernd and Hilla Becher (no. 191).

Simultaneous to the influence of the *Neue Sachlichkeit* in German photography in the 1920s was a trend toward technical and formal experimentation, pioneered by artists and students at the progressive Bauhaus school. There, the Hungarian-born László Moholy-Nagy, Swiss-born Herbert Bayer (no. 120), and others made creative photographs from peculiar viewpoints, and explored unusual lighting effects, DARKROOM effects, and PHOTOGRAMS. This open, playful attitude toward photography, and the multidisciplinary environment of the Bauhaus, are apparent in the photographs of **T. LUX FEININGER (93)**.

Theodore Feininger was one of three sons of the draftsman, painter, musician, and teacher Lyonel Feininger.[49] When he was nine, his family moved to Weimar, where his father had joined the faculty of the newly established Bauhaus as instructor of graphic arts.[50] Artists who were family friends, including Paul Klee and Vassily Kandinsky, became young Feininger's teachers when the precocious teenager became a Bauhaus student. Although photography was not then part of the curriculum, students and teachers experimented, particularly the metal workshop director László Moholy-Nagy, who lived next door to the Feiningers in a Dessau

91

André Kertész
American, born in Hungary,
1894–1985

At Mondrian's House, Paris,
1926

Gelatin silver print
24.4 x 18.8 cm
Gift of the artist, 1970.38

duplex. When fifteen-year-old Theodore Feininger became an enthusiastic photographer, his fervor earned him the nickname "Lux," or "light." He used the camera to make family snapshots and aesthetic experiments, and helped begin a fad for hand-held cameras among Bauhaus students.[51] He was also particularly interested in theater, and Oskar Schlemmer became one of his most influential teachers. Music was important in Feininger's family. Both of his paternal grandparents were concert musicians; his father had studied to be a violinist and continued his work as an organist and composer. So it was natural for the young Lux to associate with the students who made up the Bauhaus band. They performed a lively combination of German popular music and American Dixieland jazz, chiefly for student functions, but also as part of theatrical projects. Several of Feininger's photographs show that he was friendly with members of the Bauhaus band before he himself joined in 1926, playing both banjo and saxophone.

In Feininger's photograph *The Bauhaus Band*, the group's instrumentation, including many percussion instruments seen on the stage, suggest the rhythmic energy of their music.[52] This dramatic image evocatively melds the plastic and lively arts. The banjo players' blurred hands and the puckered saxophonist's cheeks show that the group is performing, with a vivacity accentuated by interaction between the musicians. The setting was the Bauhaus theater at Dessau, and the performers' theatrical costumes, with their striped rugby shirts, white pants, bowler hats, and dance shoes, were conceived for the spotlight. Like the costume designs of Oskar Schlemmer, their simple forms and contrasting tones provided bold flashing shapes as the performers moved.[53] The artists of the Bauhaus band consciously strove to integrate their music with a visual and theatrical presentation.

In 1927 Feininger began to sell his photographs through the DEPHOT agency in Berlin, which placed his images in publications throughout Germany. His work was included in the important *Film und Foto* in Stuttgart in 1929, the year that he received his diploma from the Bauhaus. He continued as a postgraduate resident at the school, where his paintings were shown, along with the work of his friend Clemens Röseler, in a joint exhibition in 1931. Also in that year, a solo exhibition of Feininger's work was mounted at the Kunstverein in Erfurt. He concentrated on painting when he lived in Paris during the years 1932 to 1934.

Feininger emigrated to the United States in 1937, leaving behind the majority of his negatives. He continued his focus on painting, in a semiabstract style, developing a dreamy, atmospheric manner for depicting ships and trains. Feininger's work was exhibited at the prestigious Julien Levy Gallery in New York, and included in the *American Realists and Magic Realists* exhibition at the Museum of Modern Art in 1943. Feininger continued his studies at the Institute of Fine Arts at New York University, and in 1950 he began a teaching career. He became a lecturer in drawing and painting at Harvard University in 1953. Retrospective exhibitions of his work were mounted at the Busch-

92

Werner Mantz
German, 1901–1983

Facade Detail at Kalker Feld, Cologne, 1927

Gelatin silver print
20.2 x 13.0 cm
Mrs. Albert W. Rice
Acquisition Fund, 1984.19

93

T. Lux Feininger
American, born in Germany, 1910–

The Bauhaus Band, 1927

Gelatin silver print
12.3 x 17.2 cm
Eliza S. Paine Fund, 1991.108

93

94

94

Man Ray
American, 1890–1976

Nancy Cunard, 1927

Gelatin silver print
8.3 x 6.4 cm
Eliza S. Paine Fund, 1987.80

95

Cecil Beaton
English, 1904–1980

Fred Astaire, 1928

Gelatin silver print
44.5 x 32.4 cm
Austin S. Garver Fund,
2001.91

Reisinger Museum at Harvard in 1953 and in 1962, when he joined the faculty of the School of the Museum of Fine Arts, Boston.

In Paris, the avant-garde style of Surrealism exerted deep and lasting influences on photography. During World War I, the American photographer **MAN RAY (94)** began a lifelong friendship with the Dada artist Marcel Duchamp in New York.[54] Together they moved to Paris in 1921 to join the circle of artists and writers in Montparnasse — including André Breton, Tristan Tzara, and Paul Éluard — who evolved the Dada movement into

Surrealism. Chance, melancholy, and desire are frequent themes in Surrealist art, giving it a wholly different tone than the rationality of Constructivism. Man Ray supported himself as a commercial photographer, bringing the surprise and provocation of Surrealism to fashion photography, and the leading Parisian designers soon became his clients. While working in the darkroom, Man Ray inadvertently discovered the PHOTOGRAM process, with which he made abstract images he called "rayographs." He placed combs, keys, and other objects directly onto photosensitive paper, to leave their shadows when the darkroom lights were

flashed. These ethereal Surrealist montages brought him immediate recognition as an avant-garde artist.[55] Man Ray made no qualitative distinction between these abstractions, his Surrealist photographs, his fashion work, or his portraits. His images of friends and colleagues, like Gertrude Stein, Marcel Proust, and Maria Casati (no. 76), reflect the same roiling synthesis of personality and creativity.

Nancy Cunard is Man Ray's portrait of the rebellious heiress to an English shipping fortune, who settled in Paris after World War I.[56] She was a poet and editor, whose verse was influenced by Dada and Surrealism. Man Ray portrayed the striking young woman in a fitted silk dress, printed like a mottled tortoise shell. Cunard's cropped and dyed coiffure, her pallid makeup, and dark lipstick emphasize the soft tone of her icy blue eyes. Her gaze is averted with stylish disregard, and her hands are clasped under her chin in a facetious parody of the traditional gesture of innocence. The pose shows off a collection of African ivory bracelets befitting tribal royalty.[57] In Modernist Paris, these bangles symbolized alliances with Cubists and other artists who preserved their respect for ethnographic art and culture. Indeed, Cunard was captivated by African and African-American culture. A liaison with the black American jazz musician Henry Crowder may have encouraged her to compile a cultural history of Africans in America, published at her own expense.[58]

In spring 1927, the Worcester Art Museum presented a solo exhibition of Man Ray's photographs, including Surrealist images, rayographs, and portraits.[59] However, during the 1930s he began to turn away from photography. When France was occupied during World War II, he returned to the United States, settling in Los Angeles to work solely as a painter. Later he repudiated the creative medium altogether in the essay "Photography Is Not Art."[60]

Another leading fashion and portrait photographer of midcentury, **CECIL BEATON (95)** led the genre from the smoky Pictorialism of Adolph de Meyer (no. 76) to a new clarity. Born in London into an upper-middle-class family, he was eleven years old when he got his first camera, and learned from his sister's nurse to develop and print photographs.[61] As a teenager Beaton photographed his sisters, emulating de Meyer and Emil Otto Hoppé, the day's leading society portraitist. He attended Harrow and Saint John's College, Cambridge. Friendships with the Sitwell family introduced him to the young socialites, writers, and artists in Edwardian London. His elegant portraits of the smart set became so popular that he set up a studio at his home in Sussex Gardens, London.

Beaton's portrait, *Fred Astaire,* marked a turning point in his career. When Edna Chase, the New York editor of *Vogue* magazine met him in London, she offered an introduction to the publisher Condé Nast. Visiting New York in 1928, Beaton took his camera along to a social evening in Nast's penthouse where Astaire was a fellow guest. The photographer did portraits of the entertainer in front of the marble panels that decorated Nast's apartment walls. These photographs led to a job at *Vogue* magazine, and Beaton continued to work for Condé Nast publications for the next twenty-five years. In 1928, Fred Astaire and his older sister Adele were stars of American vaudeville and British music halls.[62] They had grown up in the theater, having started dancing at ages four and six. Friends like George and Ira Gershwin, and Cole Porter, wrote songs and shows for them, including the hit *Lady, Be Good!* Five years after Beaton's portrait, after his sister retired to marry, Astaire partnered with Ginger Rodgers in the musical film *Flying Down to Rio.* It was the first in their series of hit movies for RKO Radio Pictures that made cinema history.

In Beaton's photographs the sitter was one element in an overall decorative design, integrating costumes and settings. Always aware of the current painting styles, he inventively combined their influences with his own impeccable sense of form. In 1931 Beaton visited Hollywood, and a selection of his movie-star portraits later appeared in his *Book of Beauty*, which also contained his sketches and drawings.[63] His popularity was enhanced by his activities as a gadabout and diarist.[64] After photographing Queen Elizabeth in 1939, Beaton became the official court photographer. During World War II, he served in the British Ministry of Information, and photographed British Royal Air Force bases and London during the Blitz.[65] Beaton broadened his activities after the war, creating sets and costumes for stage and screen.[66] In 1956 he designed the stage version of *My Fair Lady* in New York and London. His designs for the film *Gigi* in 1958 won him an Academy Award, as did his costume design and art direction of the film version of *My Fair Lady* in 1964.

The cosmopolitan **FLORENCE HENRI (96)** was a bold, creative photographer who synthesized the influences of Purism, Bauhaus experimentation, and subtle Surrealist ambivalence. She was born in New York, the daughter of a French oil engineer who moved often for his work.[67] Her mother died when she was a young child. She lived with her maternal grandparents in Silesia until the age of nine, when she joined her father in his worldwide travels and began to study music. Henri went to Rome after her father's death in 1908, to live with her uncle Gino Gori. Four years later, she moved to Berlin to study piano with Egon Petri and Ferruccio Busoni and to begin a concert career. However, in

1914, she turned away from music and to art. In order to move to France after the war, Henri married the house servant Karl Anton Koster, and took his Swiss nationality. In Paris, she became a pupil of André Lhote in 1923, and studied with Fernand Léger and Amédée Ozenfant at the Académie Moderne, developing a nonfigurative, Purist style of painting.

In 1926 and 1927, Henri attended the Bauhaus in Dessau. She concentrated on the *Vorkurs* foundation course taught by Josef Albers and by László Moholy-Nagy, who introduced her to photography. Her interest was also encouraged by his wife, Lucia Moholy, and by friends Herbert Bayer (no. 120) and his wife Irene Hecht, who were all experimental photographers. Using mirrors, panes of glass, and still-life elements, Henri made remarkable photographs in Cubist and Purist compositions.[68] These were included in the watershed *Film und Foto* exhibition in Stuttgart in 1929. By that time, she had returned to Paris to become a freelance photographer in Montparnasse, producing portraits, fashion photographs, and advertising images. Her creative work reflected the influence of Surrealism, the Modernist ideas of the *Cercle et Carré* group, and such friends as Piet Mondrian, Michel and Suzanne Seuphor, Jean Arp and Sophie Tauber-Arp, and Robert and Sonia Delaunay.

Henri's *Roma* comes from a group of photographs begun in the last weeks of 1931. She regularly visited Rome, where she had many friends and family. At that time she began to photograph ancient architecture, sculpture, and objects in the Forum and other archaeological areas. This photograph represents the garden of a museum, identifiable by its beaux-arts architecture, and the ancient sculptural relief built into its wall. Lining an exterior wall are a group of ancient objects: a Roman grave marker carved in marble standing between a pair of amphorae, and the sculptural figure of a seated headless woman. Probably a funereal monument, the carved figure holds one ringed hand in her lap, with a gesture projecting two fingers, and raises its right hand to her missing face. This figure on its plinth is overgrown by a laurel bush; the enveloping branches surround the sculpture. This motif is ambiguous, for the bush might be protecting the woman or in the process of strangling her, completing the violence that time began. Capturing a real scene as it does, this image depends upon the Surrealist notions of chance, in the incidental fact of these objects being together. The image merges the conventional and logical view of reality with the unconscious, dream experience. It is an ambivalent image, in which the elements and their combination could be interpreted as representing more than one subject. Some of Henri's Roman photographs recall the works of Giorgio de Chirico and elicit a wistful nostalgia and sense of the power of

96

time. In 1935 Henri printed enlargements of many of her Roman photographs, and cut them up to create rephotographed montages.[69] Some take the light of day, so tangible and descriptive in the documentary photograph, and transform it into indeterminate time and space. The style and imagery of Henri's photomontages recall the work of her friend Max Peiffer-Watenphul, who was also in Rome in late 1931, as a winner of the Prix de Rome. He made snapshots of Henri and her friends. Like Watenphul, Henri created PHOTOMONTAGES that evoked the passage of time and the great achievements of human culture. She published her photomotages in several periodicals, including *Arts et Métiers Graphique*, *Vogue*, and *La rivista illustrata del Popolo d'Italia*.

The Modernist and Surrealist avant-garde was also influential in Central Europe, where creative photography flourished after World War I.[70] The epicenter of this activity was Prague, particularly when the cosmopolitan city became the capital of the Czech Republic following its independence from the Austro-Hungarian Empire in 1918.[71] This Modernist school grew gradually from the ideas and images of Hungarian-born Lázsló Moholy-Nagy at the Bauhaus, and those of Aleksandr Rodchenko (no. 90) at VkhUTEMAS/VhUTEIN. Its early development can be seen in the career of **ADOLF SCHNEEBERGER (97)**. Born in Chocni, he moved to Prague when he was eight years old.[72]

96

Florence Henri
American, active in France, 1893–1982

Roma, 1931–32

Gelatin silver print
11.4 x 8.5 cm
Anonymous Fund, 1986.94

98

97

Adolf Schneeberger
Czech, 1897–1977

Girl on a Carnival Ride,
about 1925

Gelatin silver print
26.9 x 16.8 cm
Sarah C. Garver Fund,
1987.17

98

František Drtikol
Czech, 1883–1961

Untitled, about 1929

Pigment print
15.0 x 11.0 cm
Eliza S. Paine Fund, 1988.41

He studied to be a scientist, and learned the techniques of photography as a method of documentation. Schneeberger's early creative works were moody Pictorialist views, landscapes, and portraits, which he began to exhibit in 1919. He was influenced by the Photo-Secession and the work of Drahomír Josef Růžička, a Czech-American follower of Clarence White (no. 65) who on his periodic visits brought issues of *Camera Work* to Prague.[73] Růžička mounted a major solo exhibition of his work in the city in 1921.

Schneeberger was among the founders of Fotoklub Praha (the Prague Photo Club) in 1922, an organization of amateurs mainly devoted to Pictorialism. However, the very consociation that the club was meant to promote caused dissent between conservative amateurs and those stimulated by new ideas. The situation was exacerbated in 1923, when the brilliant and originative Karel Teige formed the avant-garde art association Devetsil. Photography and film were important experimental media for its artist members, who sought to build a pro-

gressive culture for a modern society. When Jaromír Funke, Josef Sudek (nos. 100, 151), and Schneeberger defended these new directions, bemoaning the provincial dilletantism of the Fotoklub Praha, they were expelled. Prague's secessionists founded the Ceska fotograficka spolecnost (Czech Photographic Society) in 1924. Schneeberger emerged as the leader of the group, even though he worked as an art director and editor, while both Funke and Sudek were commercial photographers.

Girl on a Carnival Ride demonstrates Schneeberger's response to avant-garde photography. Like Moholy-Nagy and Rodchenko (no. 90), he became aware of the visual structure that presented itself in everyday life, and set out to capture it. He saw a delicate kinetic sculpture in a carnival ride, the guy-wires that held it erect, and the moving seats suspended on chains beneath. An intriguing linear abstraction occupies most of his composition, dominated by a strong diagonal. By placing the young rider in the lower corner, Schneeberger emphasized the centrifugal force that propels her outward. The young girl looks directly at the camera as she whizzes by, wearing an expression mixing pleasure and apprehension, and lifts her hands into the air to enhance the thrill. Schneeberger found similar structure in architecture around Prague and the shadows cast by these buildings. Through most of his career, however, he continued to use soft focus, and favored the old technique of the pigment print.

Like Schneeberger, **FRANTIŠEK DRTIKOL (98)** progressed rapidly from Pictorialism to a Modernist style, but he developed a unique vision that brought international recognition to Czech photography. Drtikol was born in Příbram, near Prague, the son of a pragmatic shopkeeper who arranged an apprenticeship for his artistic son with the local photographer, Antonín Mattas.[74] Afterwards Drtikol studied at the Lehr- und Versuchsanstalt für Photographie (Institute for Education and Research in Photography) in Munich, at a time when the city was a center for *Jugendstil*, the German idiom of Art Nouveau. After fulfilling his national service in the Austro-Hungarian Army, Drtikol opened a photography studio in Příbram in 1907, moving to Prague two years later. Aside from portrait and commercial work, he experimented with nude studies influenced by *Jugendstil*. Drtikol joined the Ceska fotograficka spolecnost (Czech Photographic Society), and published photographs and reviews in Czech periodicals. He opened a photography school, in partnership with Augustin Škarda, that taught a range of creative photography techniques, including gum bichromate and oil PIGMENT PRINTING. Drtikol and Škarda also gained recognition for their folio *Z dvorůa dvorečků staré Prahy* (*The Courtyards of Old Prague*), an album of fifty pigment prints of romantic urban views.[75]

When Drtikol served in a rear unit of the Austro-Hungarian Army during World War I, the neglect of astigmatism caused the loss of sight in his left eye. Back in Prague in 1918, he became a favored portraitist of the new Czech elite, and among his best-known portraits were those of Tomas Garrigue Masaryk, the first president of the Czech Republic. In the early 1920s, Drtikol and his assistant, Jaroslav Rössler, experimented with nude studies dramatically modeled by intense illumination. He created semiabstract images by using nude figures and geometric props to cast shadows, in images incorporating influences from Art Deco, Cubism, and Constructivism. Drtikol designed forms and props that were made of painted plywood in the workshops of the National Theater in Prague, conceived to echo and accentuate the curves of the body. His lighting methods were equally innovative, for he set up arc lamps to project searing light from the side and rear, creating deep, distorted shadows. Drtikol's images possess an intriguing formal and spatial ambiguity, as figures, objects, and shadows seem to flatten and reassert their form.

Drtikol's Modernist nudes were widely exhibited and received international acclaim; he published a selection in the books *Le nus de Drtikol* (*The Nude of Drtikol*) in 1929, and *Žena ve světle* (*Woman in the Light*), nearly a decade later.[76] Gradually, the artist turned away from live models, but still used cut-out sets, dramatic illumination, and natural objects for photographs that became progressively more abstract. In 1935, at the height of his international fame, Drtikol gave up photography, sold his studio, and moved to a villa in the Prague suburb of Spořilov. He concentrated on the study of Asian philosophy, and expressed his spiritual aspirations in oil paintings that share motifs and compositions with his earlier photographs.

During the 1920s, the manipulation of shadows became a consuming preoccupation for Czech avant-garde photographers. Artists created assemblages of found objects or geometric forms they cut from cardboard, as well as transparent materials like bottles, panes, and spheres of glass, then cast strong light through their constructions, and photographed the shadows. They produced similar ethereal compositions by the photogram process, in works that followed photographic experiments by László Moholy-Nagy and Francis Bruguiere. In Prague, František Drtikol and Jaroslav Rössler created spectral photographs of this sort, as did Jaromír Funke, who called his images "shadowgraphs."

An *Untitled* abstraction by **JAROSLAV KYSELA (99)** exemplifies these intriguing, and deceivingly complex, images. The artist balanced two glass squares atop a stack of panes and against a wall, along with a photographic filter ring. By reflecting a

99

Jaroslav Kysela
Czech, 1913–

Untitled, about 1928

Gelatin silver print
38.0 x 28.3 cm
Sarah C. Garver Fund,
1987.16

beam of light off the flat sheets of glass, and through the assemblage of opaque and transparent objects, Kysela created a complex reflected and umbral design. The photographer also used the method of partial SOLARIZATION, the Sabattier effect, in his shadowy abstractions. Photographers frequently used studio and darkroom equipment — like Kysela's lens-filter ring — in their pictures and photograms. Often geometric in design, their simple, functional shapes carried provocative associations for those who recognized them. Most of these shadowy images are Constructivist in conception, but for the Surrealists, their illusive quality, and dependence upon unseen principles of physics made them as enigmatic as the subconscious.

Kysela typified the educated Czech intellectual who pursued Modernist photography as a hobby. Born and raised in Příbram, he studied economics at Prague University before taking a medical degree from Charles University. After buying a Zeiss view camera in 1926, he quickly progressed from Pictorialist views to sophisticated abstraction, sending his work to salons and exhibitions all over the world. When the university was closed during World War II, Kysela became an apprentice to Josef Sudek (no. 151). This experience transformed his style to a tranquil realism, informed by *Neue Sachlichkeit*, which he employed for views of Old Prague. In 1945, Kysela resumed his studies specializing in ophthalmology. During his subsequent medical career, he continued photography as a hobby, publishing his work in Czech magazines and journals.

"Shadowgraphs" were just one of many experimental strategies that **JAROMÍR FUNKE (100)** explored, as he endeavored to synthesize an integrated theory for avant-garde photography. This avid experimenter, always eager for new ideas, became the most influential Czech photographer of the Modernist period. A lawyer's son, he was born in Skuteč and grew up in Kolín.[77] Funke began taking photographs as a teenager, and continued the hobby while studying medicine during World War I. After obtaining his degree, he attended law school to appease his father, and also took classes in art history and aesthetics at Charles University in Prague. During this period, the style of Funke's photographs evolved from Pictorialism to Modernism. In 1922 he became a freelance photographer in Prague, began to exhibit his work, and published his first articles on photographic theory and criticism. Funke was a founder — along with Adolf Schneeberger and Josef Sudek (nos. 97, 151) — of the Ceska fotograficka spolecnost (Czech Photographic Society) in 1924, and emerged as its most advanced researcher. Late in the decade, he concentrated on Cubist linear abstractions, realized as "shadowgraphs," and photograms.

When Funke photographed the construction of the new electric power plant in Kolín with his friend — and former high school teacher — Eugen Wisnovský, he employed a clear, descriptive style informed by *Neue Sachlichkeit*. He taught at the School of Applied Arts at Bratislava from 1930 to 1934, and became an active member of Sociophoto, a Leftist group that advocated photography as an instrument for social reform. Still, his images of the conditions and experiences of the impoverished incorporated bold, Modernist compositions. Funke tried to integrate what he perceived as the three main movements in photographic art of the period — Reportage or Social Observation, Surrealism, and Functionalism — in a style he dubbed "Emotional Photography," and he presented this to his students as a foundation for all directions for the creative photographer.[78]

The subtlety and complexity of Funke's work is apparent in one of the photographs from *Fotografie vidi povrch* (*Photography Sees the Surface*), a book published in 1935, when he began a decade of teaching at the State School of Graphic Art in Prague.[79] Designed by the school's director Ladislav Sutnar, the book also contains photographs by his fellow professor Josef Ehm. The complex, effective compositions and exacting technical standards of its photographs made the book an instructional paradigm prized by students. This image of a woman, and the concentric forms of a hanging lamp, reflected in a textured glass tabletop typifies Funke's Constructivist compositions and unexpected points of view. He always established a strong geometric structure in his images, pressed into lively disequilibrium by a dominant diagonal.

Funke taught the concepts of "Emotional Photography" to students, and propounded them in articles on aesthetic theory and technique published in the magazine *Fotografickí Obzor* (*Photographic Horizons*), which he coedited with Ehm from 1939 to 1941. However, his progressive aesthetic and cultural ideas put him at risk during the German occupation of Czechoslovakia in World War II. His activities were restricted and he was then sent to a labor camp where he died in 1945.

The stronger influence of Surrealism in Czech photography is reflected in the work of **FRANTIŠEK VOBECKÝ (101)**, who used the medium to reform elements of reality for poetic effect. He was born in Trhovy Stepanov, and after studies in Prague, he lived in Paris in 1926–27, where he experienced the heyday of Surrealism.[80] When the artist returned to Czechoslovakia, he began a career as a painter, and took up photography to support himself in 1928. He joined the progressive Mánes Artists' Club in 1931, and frequently contributed his paintings to their exhibitions. While working in fashion and

100

Jaromír Funke
Czech, 1896–1945

Untitled from *Photography Sees the Surface*, 1935

Gelatin silver print
16.8 x 12.1 cm
Eliza S. Paine Fund, 1993.14

100

advertising, Vobecký also experimented with creative photography. Around 1935 he made photomontages from prints that he intentionally shot to be cut up and pieced together. These experiments were influenced by the work of Max Ernst, who pasted old prints collected from junk shops in Paris and cuttings from his own photographs into Surrealist dreamscapes. When rephotographing his montages, Vobecký sometimes used fragments from engravings and magazine clippings, as well as objects.[81]

Hallucination exemplifies the style of these intriguing images. While most photomontages and collages by Czech artists such as Karel Teige and Jindřich Štyrský derived from the graphic montages of Aleksandr Rodchenko (no. 90) and Lázsló Moholy-Nagy, surrounding objects with the blank page and employing typography,

102

Vobecký's montages command the whole image. Like the photomontages of Raoul Ubac (no. 121), they are more illusionistic, and more French. Some of the artist's images suggest mysterious tales of imaginary figures, others are purposely incomprehensible. Disparate motifs come together in chance encounters with the discontinuity of a dream. These images transport each viewer into a personal sequence of association, and can be read in ways unintended and inconceivable to the artist. In 1936, Vobecký helped organize an International Exhibition of Photography at the Mánes exhibition hall, and two years later he was one of the six photographers of the Mánes Club whose work was presented in a group show, which helped to establish him as one of the distinct voices in Czech creative photography.

The advent of quality hand-held cameras began to change photography during the 1920s. The finest of these early cameras were German, and **PAUL WOLFF (102)** was one of their first champions. Born at Mühlhausen, south of Stuttgart, he became interested in photography as a teenager.[82] He studied medicine and became a physician, but continued his hobby, publishing a series of romantic views of his hometown in 1914. In Strasbourg after World War I, however, the Vichy government prevented Wolff from practicing medicine, so he turned to photography to support himself, working freelance for a time and then opening a studio in

partnership with Alfred Tritchler. When Wolff's work was honored at the Frankfurt Photography Exhibition in 1926, his prize was a Leica hand-held camera. He became one of the first to employ these well-made instruments that exposed tiny negatives, 35-millimeters square, of a quality that enabled them to be enlarged to paper prints of various sizes and formats. In 1929, a book of Wolff's photographs of the zoo exemplified this new ability, soon followed by books on German ecclesiastical architecture and botanical study illustrated with Wolff's photographs.[83] By that time, he had made a successful career as an industrial photographer. Like Lewis W. Hine (no. 74), Wolff collected images of people working that reflected the vitality of German industry during the Weimar era.

Wolff's extraordinary *Zeppelin Technician* demonstrates the facility of the Leica to go where cameras had never been before. Riding in the airship gondola, the photographer aimed his camera down at the technician working near one of the zeppelin's spinning propellors, as the craft sped along thousands of feet above the earth. Indeed, much of the view of the mottled earth below is glimpsed through the propeller, rotating too fast to be seen. The composition of this image is a remarkable network of angles. Our eye gravitates immediately to the head and figure of the mechanic looking down and away from the camera, and

103

103

Albert Renger-Patzsch
German, 1897–1966

Main Rail Line in Winter —
Oberhausen, 1931

Gelatin silver print
16.8 x 22.8 cm
Eliza S. Paine Fund, 1986.47

amazement grows as we gradually become aware of the location and activity of his perilous job. The hard linear contours of the machine and its internal and external structure contrast to the amorphous clouds gliding by. The composition also emphasizes the image's sense of energy and motion; as the engine whirs and the propeller spins, the airship speeds forward to the right and the mechanic leans cautiously to the left, in the direction of the passing clouds and distant earth.

To complement his images of labor, Wolff also photographed the German people at leisure. He discussed these images, and his more placid landscape work, in the popular manual *Meine Erfahrungen mit der Leica* (*My Experiences with the Leica*), which was dedicated to Oscar Barnack, the camera's creator.[84] In the mid-1930s Wolff's photographs regularly appeared in such magazines as *Photographie* and *Art et Métiers Graphiques*. In the era of the Third Reich and during World War II, his photographs appeared in industrial books and reports, and in manuals on natural and urban landscape photography.[85] After the war, Wolff contributed to a popular book for photographic hobbyists on color photography.[86]

Improving photographic technology enabled artists disaffected by the sentimentality of Pictorialism to explore new, more precise imagery. Along with Karl Bloßfeldt, August Sander (no. 77), and other photographers of the 1920s, **ALBERT**

RENGER-PATZSCH (103) gravitated to the principles of the *Neue Sachlichkeit*. Born and raised in Würzburg, Renger-Patzsch was the son of a keen amateur photographer who taught him to use a camera when he was twelve years old.[87] After serving in the German Army during World War I, he studied photography at the Dresden Technische Hochschule from 1918 to 1920. He worked as a press and commercial photographer, and headed the photographic archive at the Folkwang-Verlag, a museum of the city's folk and ethnographic collections. When Renger-Patzsch collaborated with the editor Ernst Fuhrmann on *Die Welt der Pflanze* (*The World of Plants*), he employed an archivist's objectivity. He presented his subjects as if they were specimens, in a straightforward, frontal manner that facilitated scientific comparison. This visual clarity brought other commissions for scientific projects, and Renger-Patzsch began working as a freelance documentary photographer in 1925. For the rest of his career he organized and funded his own publishing projects; industrial commissions for photographs of factories, machinery, and products enabled him to issue books of his creative images of German cities and their architecture. In 1928, Renger-Patzsch published his most influential book, *Die Welt is schön* (*The World is Beautiful*), which quickly became a manifesto of the *Neue Sachlichkeit* movement in photography.[88] He conceived the volume as a sort of visual alphabet, presenting fifty pairs of objects in which natural forms

104

104

Erich Salomon
German, 1886–1944

*Lausanne, The Final Meeting
in Ramsay MacDonald's
Hotel Room,* 1932

Gelatin silver print
18.2 x 25.4 cm
Stoddard Acquisition Fund,
1986.78

are compared to built objects, highlighting their formal similarities. Renger-Patzsch's photographs were included in the *Kunst und Technik* exhibition at the Museum Folkwang at Essen in 1928, and in the landmark *Film und Foto* exhibition at Stuttgart the following year.

When the photographer moved to Essen in 1929, he began a new project to document the landscape of Germany's industrial heartland in the Ruhr river valley.[89] His industrial landscapes were similar to Charles Sheeler's (no. 80) contemporaneous photographs of Detroit, but Renger-Patzsch aspired to a comprehensive survey, similar in scope to August Sander's (no. 77) *Menschen des zwanzigste Jahrhunderts*, rendered in a parallel static, objective style. The *Main Rail Line in Winter — Oberhausen* is a photograph from the series that occupied the photographer until the mid-1930s. Rails plot the linear perspective in this view of Oberhausen, a center for coal mining and heavy industry since the mid-nineteenth century. In the misty, early morning, the trains are conspicuous by their absence. The strong lines of the rails evoke their power, however, and suggest deep space and expansive scale. Renger-Patzsch organized the composition so that rails emerge from the lower corners of the image, creating a visual sense of solidity and permanence. The softened focus of the distance seems to beckon the viewer to begin a journey to the world beyond.[90]

The development of hand-held cameras and faster lenses fostered a new kind of professional speciality, photojournalism. In the late 1920s, photographers like Felix H. Man and **ERICH SALOMON (104)** were able for the first time to get very close to their subjects, witness historic events, and capture their key moments. Two major German newspapers, the *Münchner Illustrierte Presse* and *Berliner Illustrierte Zeitung* modernized at that time, incorporating new technology, introducing new formats, and shifting editorial policies to increase the use of press photographs. Other journals followed, succeeded by profusely illustrated news magazines, in an international evolution that culminated in Stephan Lorant's *Picture Post* in Britain, and Henry Luce's *LIFE* magazine in the United States.

Salomon, a Berlin native, received a doctorate in law from the University of Munich.[91] He practiced only briefly, however, for in 1928 he concealed his Ermanox miniature-plate camera in an attaché case and made dramatic courtroom shots of an infamous murder trial. These images caused a sensation when they appeared in the *Berliner Illustrierte Zeitung*, and the resulting enthusiasm prompted him to pursue photographs of celebrities and statesmen for eager newspapers.[92] Salomon began using a Leica hand-held camera with a very fast lens and roll film that enabled him to shoot inconspicuously at political events and social gatherings. He captured the humanity of people who were previously known only from contrived formal portraits.

The photographer excelled at catching his subjects off guard, revealing unconscious expressions. The politicians who became Salomon's chief subjects were wary at first, but soon realized that his images could make them sympathetic to the public. Thus he attained unprecedented access to high-level political and diplomatic events. In 1930, French Premier Aristide Briand remarked that the three elements essential for a League of Nations conference were a few diplomats, a table, and Salomon. Many of the era's most famous politicians and celebrities appeared in Salomon's book *Berühmte Zeitgenossen in unbewachten Augenblicken* (*Celebrated Contemporaries in Unguarded Moments*), published in 1931.[93] Later that year, Salomon visited the United States and made candid photographs at Harvard.[94]

The Final Meeting in Ramsay MacDonald's Hotel Room exemplifies the voyeuristic attraction of Salomon's images. It records a meeting of the Reparations Conference at the League of Nations in Lausanne in 1932.[95] In an elegant, smoke-filled room, diplomats in evening dress puff their cigars around a baize-covered table, performing a complex ritual of power. A fascinating range of personalities and attitudes seems to reveal an intricacy of relationships and motivations. The photograph makes a fascinating comparison with Hill and Adamson's *Six Gentlemen, Edinburgh* (no. 2), created some ninety years before. The pioneers stretched the technical limitations of photography to record the appearance of conferees and simulate the appearance of a historic event; Salomon was a silent witness to such incidents. The photographer's informal, spontaneous style had a lasting influence on the way photojournalists captured famous figures.[96]

BERENICE ABBOTT (105) grew up in Ohio and began studies at Ohio State University, where she decided to become a sculptor.[97] After moving to New York she worked as an artist's model and waitress while saving money to go to Europe. In Paris in 1921, her interest in Surrealism brought her into contact with Man Ray (no. 94), and Abbott worked as his darkroom assistant from 1923 to 1926. After learning the techniques of photography, she opened her own portrait studio. The first solo exhibition of her photographs, at the Galerie au Sacre du Printemps in Paris, featured portraits of artists and writers that were praised for their psychological depth.[98] She greatly admired the work of Eugène Atget (no. 78), whom she met and befriended in Man Ray's studio. When he died in 1927, she purchased thousands of his glass-plate negatives and prints from his estate. Abbott carried Atget's archive to New York when she returned in 1929, and for many years she faithfully printed and promoted these neglected photographs.[99] Inspired by Atget's monumental documentary achievement, and his objective style, she set out to chronicle the rapid changes to New York as he had in Paris.

New York at Night, one of Abbott's most admired photographs, represents a personal victory, for she was afraid of heights. Moreover, careful planning was required to capture this image.[100] Since tall buildings sway appreciably in the wind, Abbott made technical adaptations to her equipment to assure clarity of focus in wide-angle shots. She worked methodically, testing camera angles, adjusting focus, and refining her composition. To create an image with clarity and glow, a fifteen-minute exposure was required, and it was a particular challenge to capture a night shot with all the office lights illuminated. Most offices closed in Manhattan at five o'clock in the afternoon and the workers switch off the lights. The shortest day of the year was the only one when it was dark enough to achieve the required contrast. Abbott planned for December 20, 1934, found a building with the perfect view, and acquired permission to shoot from a high window. Fortunately, on that day the weather was clear and calm enough for her to click her shutter at sunset.

In 1939, Abbott published *Changing New York*, a selection of ninety-seven prints, with notes by her life partner, the art critic Elizabeth McCausland.[101] The photographer turned her attention to scientific photography during the 1940s. She concentrated on physics and biology, in the belief that advances in these sciences were the dominant achievements of her time. She was inspired by the work of Harold Edgerton (no. 164) and his colleagues, and used photography to reveal images unapparent to the human eye, stilling rapidly moving objects and magnifying growing penicillin in a petri dish. To accomplish this work, Abbott often devised and refined her own techniques and equipment, and was granted several patents for these devices. In 1958, she joined the Physical Science Study Committee of Educational Services, Inc., at the Massachusetts Institute of Technology. She helped plan a new high school physics curriculum, and her photographs illustrated their physics textbook. At that time, a traveling exhibition of her *Images of Physics* toured the nation, sponsored by the Smithsonian Institution.[102]

105

Berenice Abbott

American, 1898–1991

New York at Night, 1932

Gelatin silver print
35.4 x 27.9 cm
Eliza S. Paine Fund, in memory of William R. and Frances T. C. Paine, 1970.19

A new "documentary" style of photography emerged in the United States during the 1930s. It was so called by one of its pioneers, **WALKER EVANS (106)**, whose literary background encouraged him to see himself in the American tradition of Walt Whitman, Herman Melville, and Henry David Thoreau. His photographs capture the everyday facts of American life, without sentimental or political interpretation, while possessing complicated poetry, tragedy, and dignity.

Evans was born in Saint Louis, the son of an advertising copywriter.[1] He grew up in affluence near Chicago, and in New York after his parents' separation. As a student at Phillips Academy, and for a year at Williams College, he aspired to a writing career. In 1926 he spent a year in Paris, auditing courses at the Sorbonne and the College de France. Evans took up photography soon after returning to New York, learning its technical rudiments from his friends and studying back issues of *Camera Work*. Using a small hand-held camera, he aspired to capture scenes dispassionately, as they really are, without revealing anything of himself. Evans portrayed the American experience through images of vernacular life; he photographed old houses and abandoned buildings, moldering advertising signs, and other worn, common objects. In 1933, his friend Lincoln Kirstein organized a show of his photographs of American architecture at the Museum of Modern Art.[2] In 1935, Evans began working for the Division of Information of the Resettlement Administration a government agency charged with documenting life in rural America. He traveled through West Virginia and Pennsylvania and later explored the Deep South with his camera. His themes remained the grandeur of simple things and the changes wrought by the passage of time. Evans transformed banal subjects into evocative symbols of life in all its complexity.

Easton, Pennsylvania, one of the photographs made during his tour for the Resettlement Administration, gives a vivid sense of American life. Though no one is to be seen, the photographer captured a community, carved into the deforested and mined Allegheny foothills. The jagged horizon of the distant hillside, with its angular patchwork of farm fields, is echoed in a foreground webwork of rails, power poles, electric lines, bridges, and fence posts. Like a cluster of crystals, the community of frame houses emerges from the hillsides, reflecting and refracting light from their planar roofs and walls. The prominent hilltop church, surrounded by gravestones, gives one indication of the human aspirations here; another suggestion of more mundane effort and comfort is the laundry flapping on clotheslines, the only motion in the picture.

For four weeks in summer 1936, Evans left the project to work in Alabama with author James Agee, who was doing research for a magazine article about impoverished tenant farmers. Living with one family in Hale County, Evans photographed every phase of their daily lives while Agee wrote voluminous notes. They eventually published their work in a popular and influential book, *Let Us Now Praise Famous Men*.[3] A solo exhibition of Evans's work was mounted at the Museum of Modern Art in 1938, the institution's first for a photographer. A book that accompanied the show, *American Photographs*, became a profound influence for a younger generation of photographers.[4]

The work of documentarian **P. H. POLK (107)** reflected the spectrum of African-American experience in the South during the twentieth century. He was born in Bessemer, Alabama, where his father worked as a coal miner and his mother as a field laborer.[5] His father died when he was a child, and his resourceful mother took a correspondence course to become a dressmaker and kept the family together. At thirteen, the end of compulsory education for black pupils, she enrolled him in the newly opened Tuggle Institute in Birmingham. In 1916, as a night student at the Tuskegee Normal and Industrial Institute (now Tuskegee University), he studied photography with Cornelius M. Battey.

Polk followed his family to Chicago in 1922, where he was an apprentice to commercial photog-

106

106

Walker Evans
American, 1903–1975

Easton, Pennsylvania, 1936

Gelatin silver print
18.4 x 23.6 cm
Gift of Dr. and Mrs. Robert
A. Johnson, 1981.338

rapher Fred Jensen. He married and began a family
that eventually included nine children, and took
them back to Alabama where he opened a private
portrait studio. With a new appreciation for his
roots in Macon County, Polk trekked the country-
side, making portraits and genre photographs of
black sharecroppers and farmers. He joined the
faculty of the Tuskegee Institute, and within five
years he had become the institution's official pho-
tographer. He became a ubiquitous campus figure,
documenting proms and graduations, weddings
and funerals, and producing hundreds of yearbook
photographs. During World War II, he recorded the
activities of the Tuskegee Airmen, African-American
pilots who trained on campus, then formed the
heroic 99th and 100th Pursuit Squadrons.

George Washington Carver (107) was the sub-
ject of several of Polk's Tuskegee portraits.[6] The
elegant gentleman, dressed in a suit, tie, and
boutonnière, emerges from the shadows and a
confusion of laboratory instruments. Polk's dra-
matic lighting and asymmetrical composition were
inspired by Rembrandt, whose work he knew

through his correspondence studies. The photogra-
pher captured Carver in rapt concentration, mixing
chemicals in a globelike flask. Placing this vessel
near the center of the composition, and skillfully
lighting its spherical form, Polk concentrated our
attention on Carver's work. In its shape and light-
ing, the sphere of the flask echoes the scientist's
bald head, prompting our contemplation of this
man's genius. Born a slave, and orphaned by a
Confederate raid, Carver triumphed over segre-
gated schools and discrimination to become an
eminent botanist and chemist. In 1896 Booker T.
Washington invited him to join the Tuskegee fac-
ulty. Carver's studies persuaded Southern farmers
to diversify their crops and grow peanuts and sweet
potatoes that are nutritive for the earth, rather than
soil-depleting cotton. As yields began to exceed
their demand as food products, Carver developed
new uses for these crops. He made cheese and
soap from peanuts, and synthesized flour and
rubber from sweet potatoes, transforming the pros-
pects of African-American farmers in the South
and changing agricultural practice worldwide.

107

107

Prentice Herman Polk
American, 1898–1984

George Washington Carver,
about 1930

Gelatin silver print
24.1 x 19.5 cm
Thomas Hovey Gage Fund,
2001.3

Polk's photograph suggests the dignified pursuit of intellectual and scientific endeavor. Carver appears as a modern alchemist, whose wisdom and perspicacity we glimpse through the shadows, and whose efforts bring facts to light out of the darkness of ignorance.

The Resettlement Administration was one of the New Deal programs established in 1935 by President Franklin Delano Roosevelt to manage agricultural programs, like farm loans, and the reestablishment of rural communities displaced by the Dust Bowl and other economic misfortunes.[7] The division was headed by Rexford Tugwell, a Columbia University economist, who understood the communicative

power of photography. He hired Pare Lorentz to establish a film unit, and Roy Stryker to manage a photographic section. The commission employed photographers to work in the field, collecting images for the use of government agencies and congressional committees, and for inclusion in government publications and the national press.

In 1937 the Resettlement Administration was transferred to the Department of Agriculture. Restructured and renamed the Farm Security Administration (FSA), it continued until 1943. Stryker employed eleven photographers over this period, four or five at a time.[8] He valued persuasive, documentary photography, and felt that creative expression could blunt its didactic function.

108

© COURTESY OF BEN SHAHN / LICENSED BY ... AL, NEW YORK

108

Ben Shahn
American, born in Lithuania,
1898–1969

Somerset, Ohio, about 1936

Gelatin silver print
8.2 x 13.1 cm
Stoddard Acquisition Fund,
2000.21

He chose not to print negatives in the FSA file that seemed too aesthetic. To focus photographers on an unambiguous theme, and to preserve documentary facts, he required them to submit a detailed caption for every shot. Gradually, Stryker came to view himself as a cultural historian building a visual archive. He recorded many urban and small-town subjects that had little obvious relation to farming problems but evoked the flavor of everyday life. From 1935 to 1943, the FSA files grew to include some 270,000 NEGATIVES, documenting the transformation of American life during this dynamic period. The agency's exhibitions of its photographs traveled across the country, to venues as modest as public libraries and grand as the Museum of Modern Art.

BEN SHAHN (108) was an established artist when he became an FSA photographer in 1935.[9] The son of an artisan, he was born in Kovno, Lithuania, and came to Brooklyn with his family when he was eight years old. As a teenager, he worked in a lithography shop while finishing high school at night. He attended New York University, the City College of New York, and the National Academy of Design. Shahn first gained public attention with a suite of watercolors representing the infamous Dreyfus Affair of nineteenth-century France. Deeply committed to political expression in his art, he painted Sacco and Vanzetti, and the trial

of labor leader Tom Mooney. These works led to a friendship with Diego Rivera, the Mexican muralist painter and committed Communist, who hired Shahn to assist with his controversial Rockefeller Center mural project. In 1929, the painter shared a house with Walker Evans (no. 106), who persuaded him that photography could record motifs for his paintings and was itself a medium for political expression. In 1935, Evans recommended Shahn to a position as a Resettlement Administration photographer.[10]

Somerset, Ohio is typical of the perceptive, anecdotal style of Shahn's photographs made for Roy Stryker on three photographic expeditions through the South and Midwest. The artist's representation of a sultry summer day in a little country town subtly reflects his conviction of the dignity and importance of the common man. On a hot summer afternoon only the retirees occupy the town square. Allied by their age, their lives' occupations are distinguished by the cut and materials of their broad-brimmed summer hats. The center of this bold composition is given to space and sunlight, expressing the warmth and stillness of the day and the flat topography of Ohio. The artist emphasized this effect even more by slightly overexposing his photograph, approximating the experience of a squint against the sunlight's glare.

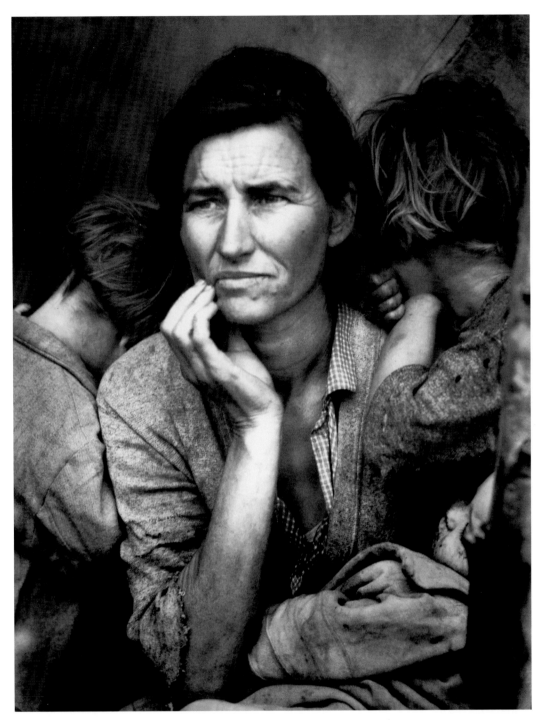

109

109

Dorothea Lange
American, 1895–1965

*Migrant Mother, Nipomo,
California*, 1936

Gelatin silver print
41.0 x 31.0 cm
Museum purchase, 1968.27

DOROTHEA LANGE (109) created some of the most stirring images of the Great Depression. She was born in New York, and as a child was stricken with polio, which permanently damaged her right leg causing her to walk with a limp.[11] A student at the New York Training School for Teachers, she met Arnold Genthe (no. 59), and later worked as his assistant while studying at the Clarence H. White (no. 65) School of Photography. In 1918, Lange packed her camera for a trip around the world, but when her traveling funds were stolen she was stranded in San Francisco. She found a job in a photography lab, and soon met Imogen Cunningham (no. 83) and Roi Partridge. Lange opened her own portrait studio, and in 1920 she married Maynard Dixon, an illustrator of the American West. In fifteen years together they raised two children. When her business languished during the Depression, Lange explored the city with her camera, making documentary photographs like *The White Angel Breadline*. Such sensitive images comprised the first solo exhibition of her photographs, in Willard Van Dyke's Oakland studio in 1934.[12] Paul Schuster Taylor saw the show, and realized that her vision

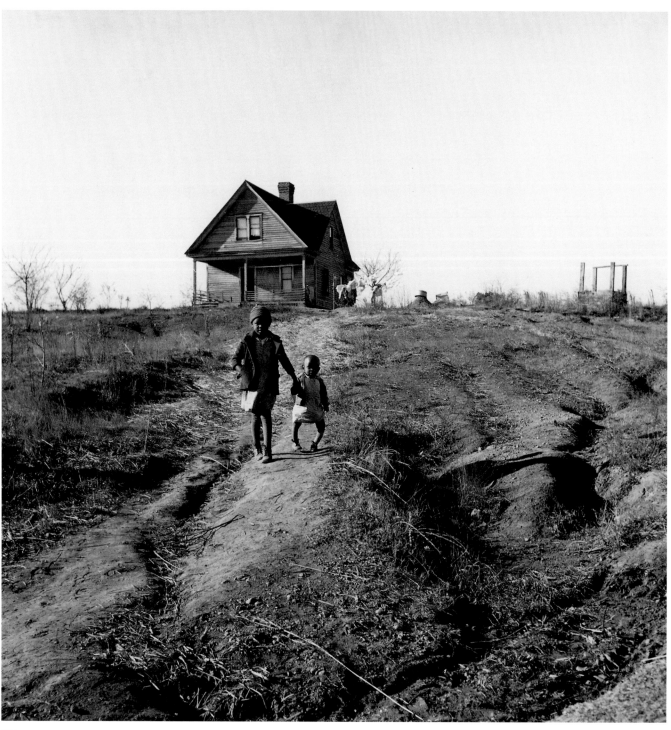

110

could provide an important aid to his work. The University of California economics professor was engaged in a study of migrant workers, sponsored by the State Emergency Relief Administration. Bankrupted tenant farmers fleeing the Dustbowl in the South were arriving in California by the thousands, lured by false rumors of work and prosperity. Lange's images enhanced the immediate gravity of Taylor's economic and sociological text.

Migrant Mother is the most famous image from the first trip that Taylor and Lange took together to the pea fields of Nipomo, near Santa Barbara,

California. A widow from Oklahoma, she was the mother of seven children. Broke and unemployed, she was stranded, having sold the tires to her car for cash. Her family was reduced to subsisting on peas in the fields. Lange, herself a mother, tried to make a portrait of empathy. She emphasized the Madonna-like aspect of the subject by concentrating on her concerned distraction and excluding the surrounding circumstance. Shortly after it was made, the photograph was published in the *San Francisco News*, where it helped to generated immediate relief for the Nipomo camp and the speedy

establishment of federal camps for the workers. Lange's skills came from her ability to tell a story, from her experience as a portraitist, and from her outsider's sympathy with her subjects. Her images also function as a metaphor of community. The photographer was particularly sensitive to women, whose experiences and memories reflected the rapid pace of social change.[13]

In 1935 Stryker recruited Lange as a Resettlement Administration photographer. She also continued working with Taylor, traveling with him in the South to investigate the causes of labor migration. They published their work in the book *An American Exodus*, which — along with John Steinbeck's novel *The Grapes of Wrath*, also published in 1939 — brought national attention to the problems of labor migration.[14]

Another FSA photographer whose works elicit immediate, emotional response was **MARION POST WOLCOTT (110)**. Her love of children and interest in psychology helped imbue her images with broad sociological implications. The second daughter of a physician in Montclair, New Jersey, Marion Post was twelve years old when her parents divorced.[15] Her mother went to New York City, to work for birth control advocate Margaret Sanger, and she went to board at the Edgewood School in Connecticut. Sympathetic teachers drew out her potential, and she became an impassioned advocate for progressive education. At the New School for Social Research and at New York University, Post studied education, psychology, and anthropology. After student teaching in Cambridge, Massachusetts, she joined the faculty of a progressive school at Whitunsville, in Worcester County. The owners of the local textile mill ran the school for their children and those of area professionals, while their workers' children went to public schools. Post lived by choice in a laborers' boarding house, and she was moved to find that each social class was totally ignorant of the other.

In 1932, Post used an inheritance to visit Europe and study in Berlin. She spent the summer in Vienna, where her sister Helen was a student of the photographer Trude Fleischmann. Receiving the gift of a "Baby Rollei" camera, she took pictures that impressed Fleischmann, who encouraged her to pursue photography seriously. After returning to New York, Post took freelance photography assignments to supplement her teacher's salary. In summer 1938, she was the still photographer for a Resettlement Administration film project in the Cumberland Mountains of Tennessee, headed by Paul Strand (no. 75). With his recommendation, Roy Stryker hired Post for the FSA. One of the first woman photographers to travel alone for the agency, she was often regarded suspiciously, and sometimes even denied lodging. These experiences

are reflected in her photographs, which subtly reveal hierarchies of class and race.

Unproductive Land, one of Post's most famous FSA photographs, represents the home and children of a tenant farmer near Wadesboro, North Carolina. "Thousands of Southern families are set adrift every year," reads her caption for this image, "because the soil is eroded or worn out — [the] result of years of neglect."[16] The photographer chose a low point of view, emphasizing the eroded ground, deeply rutted by rain water. Only withered weeds remain in the sterile soil. This arid waste is emphasized by defoliated trees and a brisk wind that flaps the drying laundry and lifts scraps of debris. In the midst of this desolation is a lonely hilltop house, and two little children, hastening down to meet us, spirited despite their plight. The barren landscape is portrayed in a way that makes it appear big and overwhelming, particularly to the tiny children. Post's low perspective silhouettes the children, calling attention to the toddler's legs, deformed by rickets, a disease of malnutrition. The photographer represented her subjects honestly and unsentimentally, trusting that viewers would relate to their experience.[17]

The work of **JAMES VANDERZEE (111)** presents a different view of the American scene in the period between the wars, that of a diverse black community with a burgeoning middle class. While some Southerners moved west searching for work during the Depression, others — particularly African Americans — migrated north to find factory jobs in cities like Pittsburgh, Detroit, and New York. James Augustus VanDerZee was born in Lenox, Massachusetts, where his parents had moved after careers on the domestic staff of ex-president Ulysses S. Grant in New York.[18] When he was twelve years old, VanDerZee earned a box camera by selling twenty packets of sachet powder. In 1907 he went to New York to form the Harlem Orchestra, for which he played piano and violin. His career as a musician lasted about eight years, until phonographs and radios became popular. Then he took a job as a darkroom technician in the Gertz Department Store in Newark, New Jersey.

In 1916 VanDerZee opened his own studio, Guaranty Photo, on 135th Street in Harlem. He made a reputation for his studio portraits, with sitters in creative poses, before painted backdrops, with elegant props like pianos and library shelves of books. He photographed family groups, clubs, athletic teams, and fraternities like the Elks and Masons, presented in fashionable oval or circular format, and hand-tinted. VanDerZee portrayed the country's leading African-Americans, including spiritual leaders such as Adam Clayton Powell, singers like Mamie Smith, the poet Countée Cullen, and boxing champion Jack Johnson. He also served

Marion Post Wolcott
American, 1910–1990

Unproductive Land, 1938

Gelatin silver print
27.8 x 26.0 cm
Charlotte E. W. Buffington
Fund, 1997.130

110

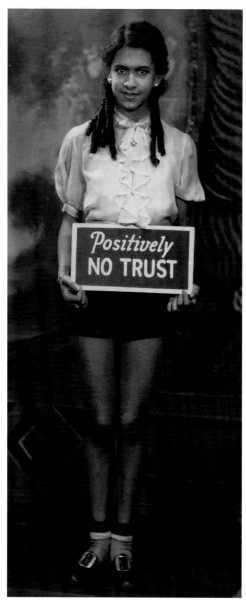

111

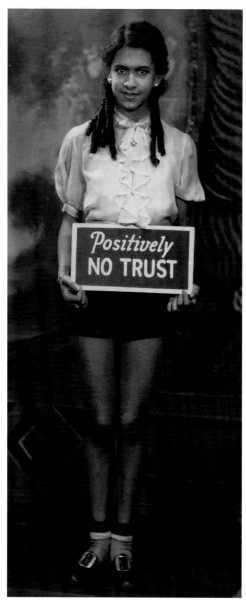

111

James VanDerZee
American, 1886–1983

Positively No Trust,
about 1930

Gelatin silver print
15.8 x 6.5 cm
Stoddard Acquisition Fund,
1987.158

VanDerZee's position in an extended commercial community.

In 1932, in partnership with his second wife, Gaynella Greenlee Katz, VanDerZee opened the larger GGG Studio, in a rented storefront on Lenox Avenue. They specialized in photographs of church groups and social organizations, and continued in relative prosperity through the Depression and war years.[19] In 1943 VanDerZee purchased the building he had been renting, but when family snapshots replaced formal portraits the business declined. He filed for bankruptcy in 1969, but at that time the Metropolitan Museum of Art presented a retrospective exhibition of his photographs.[20] The show sparked broad interest in VanDerZee's career, and initiated a late phase of activity.

For the FSA, Roy Stryker preferred a clear, legible photographic style, parallel to that of the *Neue Sachlichkeit* photographers in Germany. At the same time another group of photographers in the American West were using a similar style for aesthetic photographs of sculpturesque form and surface texture. GROUP *f*.64 was formed in 1932 by Willard van Dyke, Ansel Adams, Imogen Cunningham (nos. 79, 83), and **SONIA NOSKOWIAK (112)**.[21] The group took its name from the smallest APERTURE adjustment on the camera, thus identifying with the style and imagery of sharp focus.

Born in Germany and raised in Chile, Noskowiak moved with her family to California in 1915.[22] A decade later she was a receptionist in the studio of Los Angeles photographer Johan Hagemeyer, where in 1929 she met Edward Weston (no. 82), who was fourteen years her senior. She became his studio assistant, and they became romantically involved. In an entry in his daybook for February 17, 1930, Weston mentioned Noskowiak's first experiments with creative photography.[23] His vision and practice were fundamental to her development, but she quickly found her own style, and attracted her own portrait and commercial clients. Noskowiak brought Weston to *f*.64, and both photographers contributed to the club's first exhibition at the De Young Memorial Museum in San Francisco. Most of the works in the show were still-life studies emphasizing the forms and textures of natural objects. The images created a heightened reality, forcing the viewer to slow down and reexamine these familiar things. In 1933, solo exhibitions of Noskowiak's photographs were shown at the Ansel Adams Gallery in San Francisco, the Denny-Watrous Gallery in Carmel, and at Van Dyke's studio in Oakland.

Noskowiak's *Telephone* is a poetic study of texture and form. The image documents a range of components with hard, reflective surfaces: the enameled beadboard wall, the varnished oak

as official photographer for Marcus Garvey and the United Negro Improvement Association, chronicling the organization's conventions, parades, and rallies.

Positively No Trust is one of several images of its kind that VanDerZee produced for other Harlem businesses during the Depression. The little photograph represents an attractive child in a girlish costume, elaborately coiffed and made-up, all calculated to be nonconfrontational. Designed to be mounted to the back of a cash register, her friendly gaze, winning smile, and large clear sign would deny credit to all customers. VanDerZee produced a handful of these photographs, with the same beautiful girl variously costumed and posed, presenting variants of the same message in an impersonal, nonjudgmental fashion. They are fascinating for their reflection of both need and propriety in Depression-era Harlem. They also demonstrate

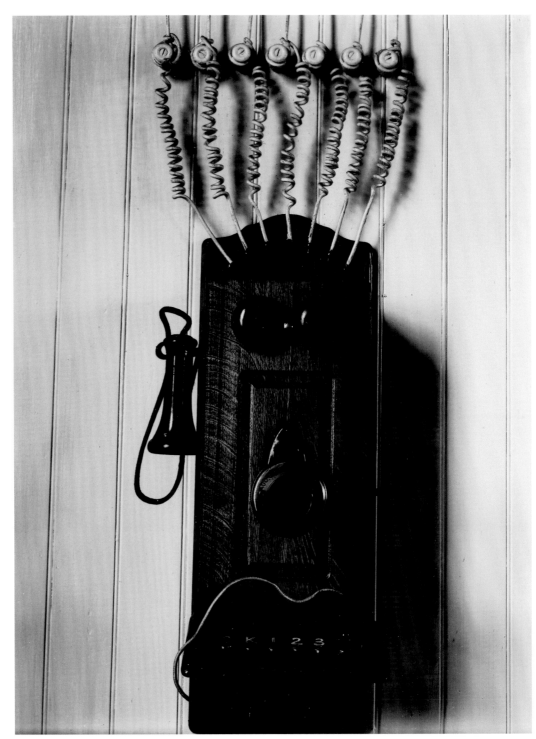

112

Sonya Noskowiak
American, born in Germany,
1900–1975

Telephone, 1930s

Gelatin silver print
24.0 x 17.8 cm
Eliza S. Paine Fund, 1993.12

112

telephone case, and its steel and bakelite fittings. However, the precise photograph reveals textural subtleties, like the woodgrain, the weave of the wire insulation, and the chipping paint from its twisted coils. By isolating the instrument from its use, Noskowiak made it into a sort of formal construction, a combination of form and line parallel to Dada sculpture. Today, this effect is even more emphasized by the distance of time and unfamiliarity. The image also has a touch of whimsy, for Noskowiak was well aware of its resemblance to a human face. Its personality presents a way of human connection.

After separating from Weston in 1934, Noskowiak opened her own studio in San Francisco. She was one of eight photographers hired by the California region of the Works Progress Administration / Federal Art Project to document artists and their work for project-sponsored touring exhibitions. During the 1940s, she did commercial work and portraits of the Bay Area's most creative figures, including Robinson Jeffers, Langston Hughes,

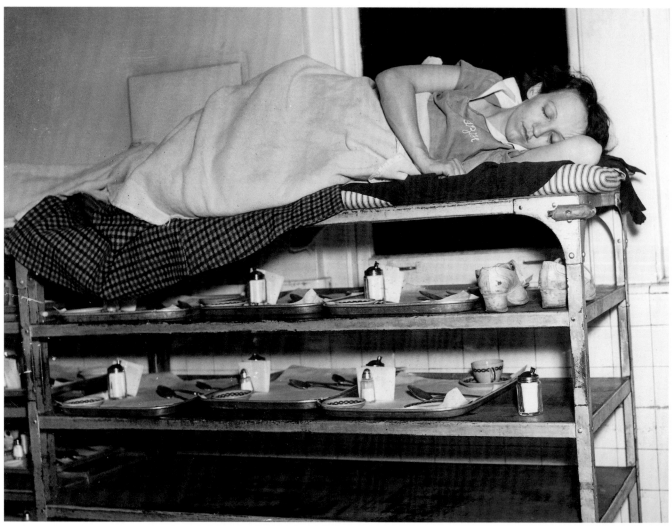

113

and John Steinbeck.[24] Through the decade she turned to architectural and industrial photography, in a style informed by European Modernism. Noskowiak documented modern highways, buildings, and industrial equipment, emphasizing their geometric form and scale.

WEEGEE (113) was the pseudonym, and carefully constructed alter ego, of a photographer whose gritty images of New York helped define American tabloid photojournalism. Born Usher Fellig in Zloczew, Poland, he changed his name to Arthur when he arrived at Ellis Island with his family at age nine.[25] Fellig grew up on the Lower East Side of Manhattan, quit school when he was fourteen years old, and soon left home. He learned about photography by assisting a hack who took children's portraits on the street. After working as a cameraman's assistant from 1917 to 1921, Fellig became a DARKROOM technician for the *New York Times*. Since he used a squeegee to clean photographic prints, colleagues called him "Squeegee Boy"; some said he resembled the character printed on the Ouija board — a popular fortune-

telling game — and the nickname evolved. He was delighted by its suggestion of clairvoyance. When he moved to the darkroom of the Acme News Service, Weegee often substituted for agency photographers on the night shift, and thus began publishing his own photographs. Monitoring the teletype, he was usually first to arrive at the scene of accidents or crimes. In 1935, when Weegee became a freelance photojournalist, he exploited the persona of a flinty, cigar-chewing cameraman in a fedora and rumpled trench coat. Beat cops and coroners were his friends, and he spoke their jargon in a gravely voice. He was one of the first civilians permitted to have a police radio in his car, and outfitted its trunk as a portable office. Weegee refined his technique to suit the tabloid newspapers that published his photographs. He used a 4 x 5–inch Speed Graphic camera, and a detachable flash gun that produced a searing flare that emphasized his primary subjects, minimized tonal gradation, and obscured the background in darkness.

Though Weegee built a career on scenes of nocturnal tragedy, many of his photographs depict average New Yorkers in the good-natured struggle

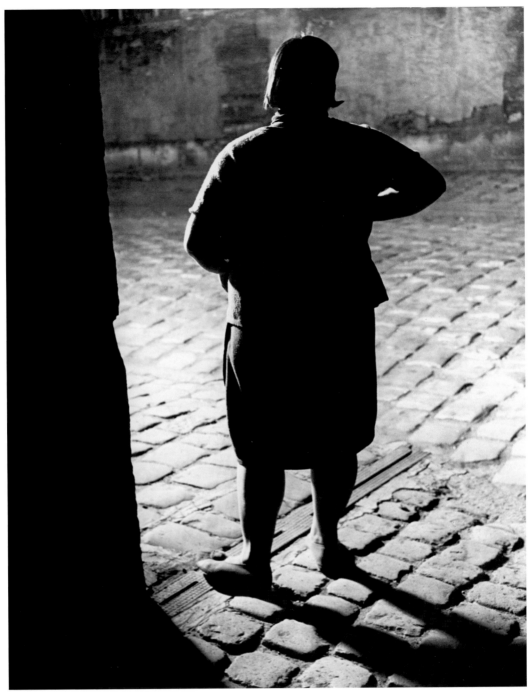

114

Brassaï
French, born in Romania,
1899–1984

*Streetwalker, Place d'Italie,
Paris*, 1933

Gelatin silver print
49.9 x 39.7 cm
Museum purchase, 1963.90

114

with everyday life. *Napping Waitress* exemplifies his knack for capturing people in unguarded but empathetic moments. Fatigued, it seems, by overwork, a hotel waitress has adapted a serving cart into a bed. Despite her exhaustion, she remains prepared to work, dressed in her uniform with her shoes ready with the breakfast trays. Though this is a picture of human frailty, it also represents strength and courage. For despite her struggle, the waitress seems to persevere. Weegee often found irony and even humor in tragedy, thus encouraging the viewer to persist through difficulty.

In 1940, Weegee began working for the newspaper *PM Daily*, and writing colloquial captions for his own pictures. As his literary voice emerged, his editor, William McCleery, helped organize *Naked City*, a book describing Weegee's work and experiences.[26] Its success led him away from newspaper work. In 1948, he went to Hollywood, ostensibly to sell *Naked City*, and became a consultant, helping to transfer the look and subjects of his work to "film noir."

Night in the city, its possibilities for adventure and for danger, also fascinated **BRASSAÏ (114)**, a remarkable chronicler of human nature, who lived

and worked in Paris. He was born Gyula Halász in Brassó, a small town in the Transylvanian Alps where his father was a university professor of French Literature.[27] At age seventeen he joined the Austro-Hungarian army, and served in the cavalry during World War I. Afterwards, he studied painting and sculpture at the Budapest Academy, and attended the Berlin-Charlottenburg Academy of Fine Arts, supporting his studies by working as a journalist. In 1924, Halász moved to Paris, and settled in Montparnasse to work as a painter. He befriended his countryman André Kertész (no. 91), who introduced him to photography. Halász began making photographs to illustrate his own articles for Hungarian and German magazines. To distinguish those images from his work as a painter, he credited them to "Brassaï," a name derived from his hometown. A night owl who slept all day, he became a devoted photographer when he took his camera into nocturnal Paris.

The famous *Streetwalker, Place d'Italie* is a photograph from Brassaï's first published series, representing nighttime in Paris.[28] Like many of the images from the series, this photograph depicts a denizen of the night, living on the fringes of respectable society. As an inhabitant of this realm, the photographer observed its revelers, performers, prostitutes, addicts, and hoodlums in a nonjudgmental fashion. For Brassaï — like Weegee (no. 113) — these outsiders represented freedom and nonconformity. In her shadowy world, the subject of his *Streetwalker* defies the fantasy of the prostitute as a lithe coquette. Her massive frame and solid pose suggest a knowing, indomitable personality. The photographer wrote about such women on the rue Quincampois, noted for the Rubenesque stature of its *filles de joie*. "Contrary to the mobility streetwalkers usually display," Brassaï reminisced, "they waited, immobile and placid, along the sidewalk like a row of caryatids."[29] When working at night, the photographer used available light, opening his SHUTTER for long EXPOSURES. He hid the light source behind trees or other barriers, to avoid problems of overexposure and halation in the plate. When Brassaï's nighttime photographs were published in his book *Paris de Nuit*, they shocked and delighted the public, and won critical acclaim. It was the first of over a dozen books of his photographs.

Brassaï was a regular contributor to the Surrealist magazine *Minotaure*, but he declined an invitation to join their movement. The photographer began working for *Harper's Bazaar* in 1935, and his portraits, especially images of writers and artists such as Thomas Mann, Samuel Beckett, Georges Braque, and Alberto Giacometti, regularly appeared in the magazine. During World War II, Brassaï remained in Paris. He refused a photographer's permit from the Germans, and had to stop photo-

graphing on the street. In 1944, he photographed the liberation of Paris, and three years later a collection of his postwar photographs was published under the title *Camera in Paris*.[30]

Compared to Brassaï's fascination with adventure, **ROBERT DOISNEAU'S (115)** photographs of Parisian life seem modest, and poetic. Both artists were observers of human nature who simply photographed what they encountered. "The marvels of daily life are exciting," Doisneau wrote, "no movie director can arrange the unexpected that you find in the street."[31] Born at Gentilly, in the Val-de-Marne, he studied engraving at the École Estienne in Chantilly.[32] Doisneau graduated only to discover that he was a journeyman in an antiquated industry that had been superseded by photomechanical printing. Adapting his skills, he worked as a lithographic printer and taught himself the techniques of photography. In 1931 he became an assistant to the photographer André Vigneau, and the following year published his images of a Parisian flea market in the magazine *Excelsior*. After completing his military service in 1934, Doisneau became an industrial photographer at the Renault automobile plant at Billancourt, producing images of factory facilities and their products. He also took his camera back to Paris, particularly photographing working-class suburbs and common people.

The Two Brothers, Avenue du Docteur Lecene exemplifies one of Doisneau's favorite subjects, children observed on the city streets. He also took photographs in homes and schools; some were candid, others posed. It is these characteristics of chance and naturalness that lend his images their affecting humanity. Children were natural unassuming and unselfconscious subjects, who could easily forget the presence of the photographer. Many of Doisneau's photographs represent the children as small figures dwarfed by the bleak, undecorated industrial spaces of the suburbs. Others show how they are oblivious to this desolation and display their ebullience and irrepressible personalities. The little street-corner drama in this photograph seems to be ignored by the passing workaday life of the neighborhood. The two brothers are a pair of show-offs demonstrating to the photographer how they can walk on their hands. They appear to be about the same age, and may in fact be twins in their matching shorts, laced boots with knee socks, and berets. It is easy to be amused by their childish enthusiasm and the mischief that they bring to the neighborhood. Its environment is suggested by another boy, stopping his scooter to watch. However, the most amusing detail of the image is the stark contrast between the scruffy, active brothers, and the passive pair standing behind them on the sidewalk. They are almost a caricature of coddled inactivity. Their

115

Robert Doisneau
French, 1912–1994

The Two Brothers, Avenue du Docteur Lecene, 1934

Gelatin silver print
27.4 x 25.2 cm
Sarah C. Garver Fund,
1998.71

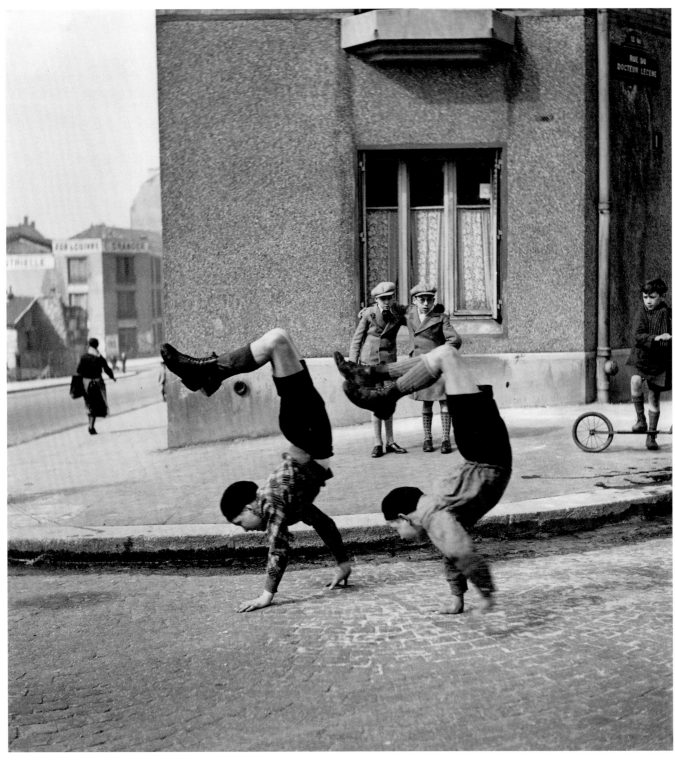

115

arms wrap around each other's shoulders as if to protect one another, or in a respectful pose for the photographer. They are more properly dressed with ties, and sensibly bundled against the chill in their overcoats, with each button fastened. Their double-breasted coats are well matched to their flat caps, and perhaps suggest their parents' bourgeois ambitions. The whiny reticence on one boy's face and his partner's eyeglasses complete the effect.

During World War II, Doisneau briefly fought in the infantry, and then joined the Resistance. His skills as an engraver and a photographer became invaluable, and he made counterfeit passports, identification papers, and other documents vital to Resistance operations. Doisneau photographed the Liberation of Paris in 1944, and the following year he joined the Alliance Photo agency. After the war, his photographs regularly appeared in magazines like *L'Album du Figaro* and *Le Point*, and he came to know poets such as Blaise Cendrars and Jacques Prévert, with whom he collaborated on books that combined original verse with his photographs. Doisneau won the Prix Kodak in 1948, and he worked for French *Vogue* from 1948 to 1951. Through the 1950s he published a series of influential books that lovingly reveal his attachment to Paris and the distinctive qualities of French culture and character.[33]

Everyday Jewish life in the shtetls of Eastern Europe is preserved in the photographs of **ROMAN VISHNIAC (116)**, who captured thousands of images of a fated world on the brink of the Holocaust. Born in Pavlosk, near Saint Petersburg, Vishniac was a child prodigy with a fascination for science.[34] He acquired his first camera at age six, and even made his own microscopic photographs as a child, developing them in an improvised darkroom. From 1914 to 1917 Vishniac served in the White Russian Kerensky Army. He attended Shanyarsky University in Moscow, and earned advanced degrees in zoology, medicine, and philosophy. A research project in endocrinology drew him to Berlin, where Vishniac married and began a family. He worked as a physician, and pursued university studies in art history. In 1925 he bought his first Leica camera, and soon he was selling his photographs to newspapers and magazines.

Around 1933 Vishniac began to photograph life in the Jewish communities of Central and Eastern Europe, neighborhoods similar to where he had grown up. He well understood the threat of the political ascendency of Adolf Hitler and the Social Democrats, and felt the growing urgency of his project as the decade progressed. During the years 1935 to 1938, Vishniac traveled in Poland, Russia, Hungary, and Romania with his camera. It was a challenging task, since the commandment against graven images prompted orthodox Jews to avoid having their photographs taken. There was also the danger of his being accused as a government spy, so Vishniac often used a concealed camera. The photographer was arrested eleven times in the mid-1930s and served sentences of hard labor in two concentration camps. Although he took over sixteen thousand photographs, all but two thousand of his negatives were confiscated and destroyed.

Warsaw is one of the photographs Vishniac made with a hidden camera on a bustling city street. A respected elder, retired to a life of prayer and study, dressed in sober winter clothes, carries a stack of books, perhaps on his way between synagogue and home. The infirmity of age is suggested by the cap set crookedly on his head, as the old man totters slowly on his cane. A light of wisdom gleams in his eyes as he unwittingly glances at the camera. The receding city street behind him symbolizes his place in the long journey of life. The transience of this moment, with people scurrying along the sidewalk, creates the sense of a lively, bustling community. Its business makes an interesting contrast to the old man's contemplative pace.

In 1940, Vishniac emigrated with his family to the United States where he worked as a freelance photographer, specializing in medical microphotography. He became an American citizen in 1946, and a selection of his shtetl photographs was published in the book *Polish Jews*.[35] During the 1950s and 1960s, Vishniac taught different subjects at several American universities. He pioneered new techniques of microphotography, as well as light-interruption photography and time-lapse cinematography.[36]

116

Roman Vishniac
American, born in Russia,
1897–1990

Warsaw, 1938

Gelatin silver print
31.3 x 26.3 cm
Eliza S. Paine Fund, 1993.11

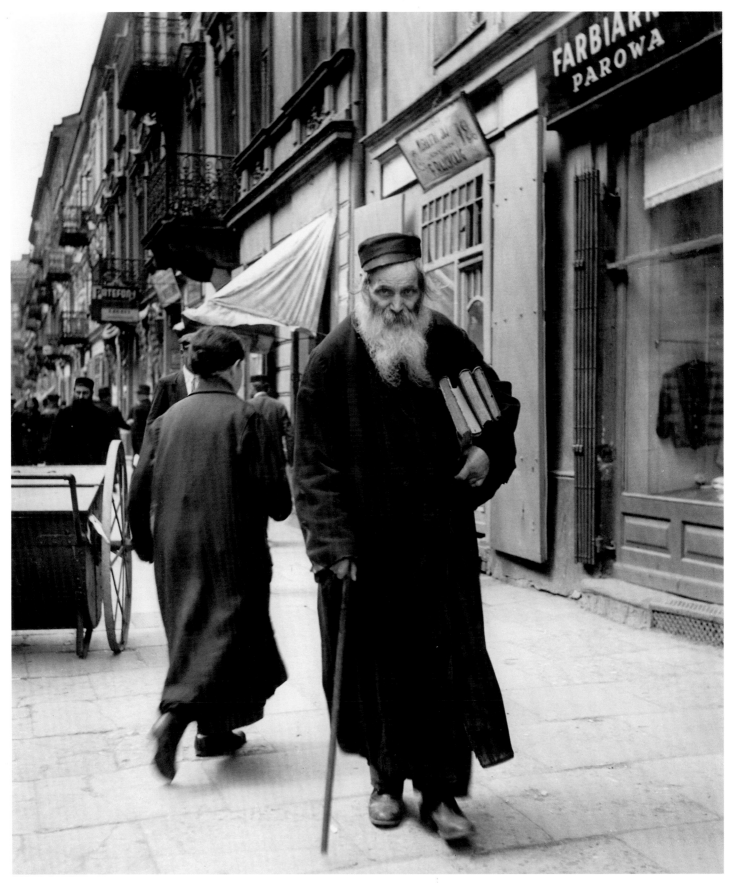

The versatile **LAURE ALBIN GUILLOT (117)**, another pioneer of microphotography, found beauty in both scientific and poetic imagery. Laure Meffredi was born in Paris, where she received a solid middle-class education.[1] She seems to have been a skilled photographer before her marriage, in 1901, to Dr. Albin Guillot, an expert in microscopic technology. Together they compiled an enormous archive of photomicroscopic images of geological, biological, and organic specimens. While her husband concentrated on optical and microscopic technology, she worked on photographic processes, developing printing papers that better conveyed the textural richness of their minute subjects. She even experimented with printing photographic images in carbon on supports of wood and precious metals. Laure Albin Guillot also explored creative photography, in landscapes and town views that progressed from Pictorialist soft-focus to a sharper, sculpturesque manner influenced by the *Neue Sachlichkeit*. She regularly exhibited her work in the annual Salon International de Photographie in Paris, and in 1922 she was awarded the gold medal for her work at an exhibition sponsored by *La Revue française de photographie*.

As a portraitist, Albin Guillot became well known for images of authors and artists who were her friends, such as Colette, André Gide, and Henry de Montherland. These appeared in popular magazines like *Arts et métiers graphiques* and *Vu*. Her husband died in 1929, and as a tribute to him she published *Micrographie décorative*, a portfolio of twenty HALFTONE prints of photomicrographs that are exquisite as geometric designs, some even printed in metallic inks.[2] During the 1930s, Albin Guillot became a prominent administrator for arts and photography in France. As head of the Archives Photographiques des Beaux-Arts, she opened the Cinémathèque Nationale at the Palais de Chaillot, and established a national collection of photography there. In 1935 Albin Guillot became president of the French Société des Artistes Photographes. She collaboratively published her creative photographs in elegantly designed folios in the mid-1930s with such writers as Paul Valéry and Pierre Louÿs.[3] In 1937 she organized the creative photography section of the Exposition Internationale des Arts et Techniques, and two years later she prepared a photographic report on the structures built to protect landmark buildings of Paris against the threatened devastation of World War II.

Albin Guillot's elegant *Untitled* nude study exemplifies her continuing creative work during the 1930s. She became well known for her photographs of male and female nudes, usually studio photographs of models before featureless backgrounds that possess a dreamy eroticism influenced by Surrealism. Carefully composed, tightly framed, with their faces obscured, the images concentrate on the plastic qualities of dancelike figures. Albin Guillot had a connoisseur's love of materials. Using the proprietary FRESSON technique, which printed her sculpturesque image onto textured paper, she created a tension between the illusion of depth and the physical presence of the object itself. She strengthened this paradox by allowing a margin of unmarked, textured paper below the image, and tearing the sheet along the sides to create bright fibrous edges. She intended that both the image and the object be beautiful.

ILSE BING (118) was another leading Parisian photographer who produced an oeuvre of similar diversity. She grew up in affluence in Frankfurt, and was well educated in music and art.[4] She began taking photographs to illustrate her doctoral dissertation on the German architect Friedrich Gilly at Frankfurt University. Bing became enthralled by the process, and in 1929 she bought a Leica camera and began publishing her photographs in the newspaper, the *Frankfurter Illustrierte*. After seeing an exhibition of the work of Florence Henri (no. 96), she abandoned her academic career and moved to Paris to become a creative photographer. Bing was the only professional in the city to work exclusively with a Leica. She used the hand-held camera to experiment with peculiar viewpoints and tilted angles suggested by the work of László

117

Laure Albin Guillot
French, 1879–1962

Untitled, about 1937

Fresson print
29.8 x 23.9 cm
Alexander H. Bullock Fund,
and Stoddard Acquisitions
Fund, 1999.8

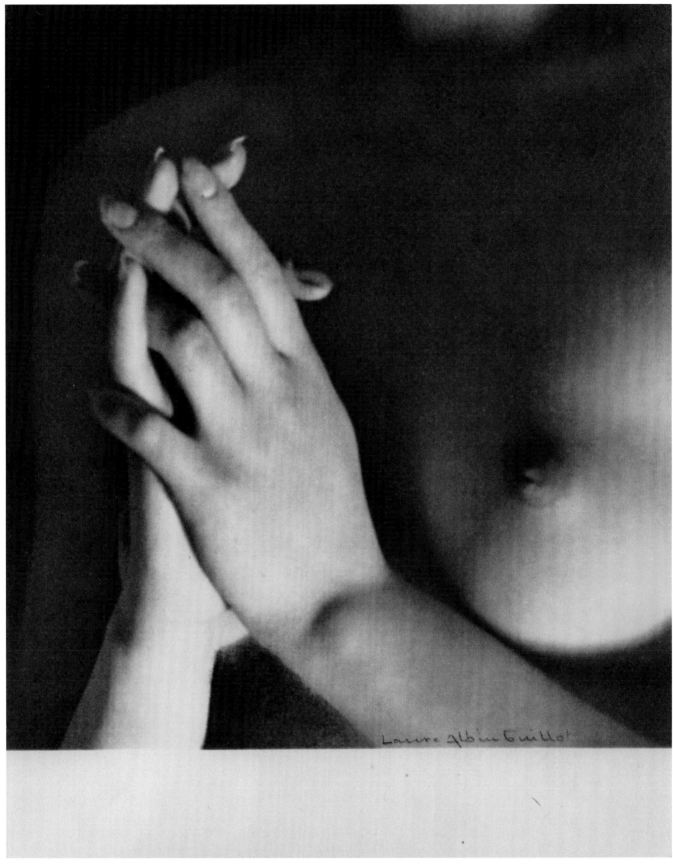

118

118

Ilse Bing
American, born in Germany,
1899–1998

Astrakhan Cap and Collar,
1933

Gelatin silver print
28.0 x 22.3 cm
Eliza S. Paine Fund, 1991.171

Moholy-Nagy, and other New Vision photographers in Germany. Her work was softened, however, by human and lyrical qualities derived from the photographs of André Kertész and Henri Cartier-Bresson (nos. 91, 167). Bing often worked at night, using available light for geometric studies of light and deep shadow. These images were made all the more ethereal by a technique she accidentally discovered in the darkroom — independently of Man Ray (no. 94) — by which she SOLARIZED the negative instead of the print.

Bing's fashion assignments for the designer Elsa Schiaparelli appeared in leading French fashion magazines. The skill and wit of her fashion

work is apparent in *Astrakhan Cap and Collar,* done for *Harper's Bazaar* magazine. With a designer's insight, she concentrated on the garments' elegant tailoring, revealing the cut and jaunty shape of the cap, the high fitted lines of the collar. Bing skillfully exploited the delicate tonalities of photography to convey the luxurious texture of the Astrakhan lambskin, using its intriguing organic patterns and silky texture as counterpoint to the garments' sculpturesque shapes. The model envelops herself in the collar to suggests its softness and warmth. Bing employed the fashion device of concealment to enhance the allure of her image. Since only a sliver of her profile is visible, the model seems more

119

119

Wynn Richards

American, 1888–1960

Untitled, about 1935

Gelatin silver print

12.5 x 6.8 cm

Eliza S. Paine Fund, 1991.56

Post in 1918. That summer, she attended Clarence H. White's (no. 65) course in New Canaan, Connecticut, and after returning to Mississippi she opened a studio in her family's carriage house and sold her own PICTORIALIST photographs.

When Richards met a *Vogue* magazine editor during a summer visit to Newport, Rhode Island, she agreed to join the magazine staff. She left her husband and took her young son to New York, but soon realized that her knowledge of studio techniques was insufficient for the job. She left the magazine, attended White's New York school, and built her own freelance commercial practice in advertising and fashion photography. Richards moved her studio and home to Tudor City, an address shared by other successful commercial photographers. Fearing that a woman's name might disadvantage her career, she used her two surnames professionally, even after her divorce. In the mid-1920s, Richards produced Modernist advertising still lifes. These photographs, like works of the period by Paul Outerbridge and Ralph Steiner (no. 81, 178), derived from White School classroom exercises. Richards's still-life photographs through the late 1920s often include closeup, overhead compositions of elegant accessories arranged to display texture and confound spatial relations. Richards was a woman of exquisite taste, congeniality, and Southern charm, and she brought grace to the fashion community. She helped establish the Fashion Group of New York, which later evolved into the industry's national professional organization. She also strove to present her work as art. In March 1931, Alma Reed mounted a solo exhibition of Richards's photographs at Delphic Studios; four years later, another solo show appeared at the Julien Levy Gallery, a space famous for presentation of European avant-garde art. In 1932 Richards married George Herbert Taylor, a retired British naval officer.[7]

In its precise framing and careful balance of light and dark, Richards's *Untitled* image of a woman in a veil reflects the influences of Clarence H. White and Japanese art. The photographer pushed her subject to the picture plane, cropped out a slice of vision, and then used the scrim of a coarse milliner's veil to arrest the eye and emphasize spatial recession. This complex veil, and the shadows that it casts, create a remarkable pattern. The net also provides a visual pun, as it restrains the flock of songbirds on the woman's necklace. Coupled with the feathers decorating the woman's hat, and her undeniable beauty, this peculiar motif reflects the influence of Surrealism. The texture and substance of fabrics and materials were important to Richards, who often used unusual lighting effects to emphasize their surfaces.

mysterious, and perhaps more beautiful, than she really is. With her face hidden, and her attention diverted, the young woman even appears flirtatious.

During the 1930s, Bing regularly exhibited her work at the gallery La Pléiade, along with other members of the Parisian avant-garde. She first visited New York in 1936, when her work was included in an exhibition at the Museum of Modern Art. Bing returned to Paris to marry the pianist and musicologist Konrad Wolff.[5] As German Jews, however, they were both interned by the Vichy Government while awaiting visas to sail to the United States. In New York, Bing continued to work as a photographer until 1959. Her lifelong *joie de vivre* is reflected by the motorcycling that she took up as a hobby when she was a septuagenarian.

A similar synthesis of vision and technical finesse is apparent in the work of **WYNN RICHARDS (119)**, a leading figure in the New York fashion community during the 1930s. The daughter of a judge in Greenville, Mississippi, Martha "Matsy" Wynn enjoyed a privileged, genteel childhood.[6] At age nineteen, she married Dorsey Richards of nearby Canto, Mississippi. Her photography hobby became more serious when she won second prize in a national contest sponsored by the *New York*

120

120

Herbert Bayer
American, born in Austria,
1900–1985

Metamorphosis, 1936

Gelatin silver print
25.9 x 34.3 cm
Charlotte E. W. Buffington
Fund, 1994.258

Fig. 6. Herbert Bayer, *László Moholy-Nagy*, 1927, gelatin silver print.

The Surrealist notion of subconscious association was combined with Bauhaus concepts of technical experimentation and virtuosity in the photographs of **HERBERT BAYER (120)**. The son of a rural government official, he was born in the village of Haag, near Salzburg.[8] After satisfying his national service, he apprenticed to the architects Georg Schmidthammer in Linz, and Emmanuel Margold in Darmstadt. By 1920, however, Bayer had come to prefer avant-garde architecture and to admire the work of Walter Gropius. He attended the Bauhaus, Gropius's progressive school of design in Weimar, and studied with the school's great professors, including Vassily Kandinsky and Paul Klee. He adopted their conviction that effective design should pervade all phases of modern life, and must derive from materials and manufacture. After graduation, Bayer joined the Bauhaus faculty when the school moved to Dessau in spring 1925. He became head of the new Printing and Advertising Workshop, creating both signage for the new campus and the school's printed materials. Bayer designed *Universal*, a geometric sans-serif font all in lower case, which became the standard style of all Bauhaus printing.

121

121

Raoul Ubac
Belgian, 1910–1985

Battle of the Penthesilieans,
1939

Gelatin silver print
29.0 x 39.0 cm
Charlotte E. W. Buffington
Fund, 1997.146

At that time, Bayer also became interested in photography, and his approach and enthusiasm were ignited by his former teacher and Bauhaus colleague, László Moholy-Nagy.[9] Like Aleksandr Rodchenko (no. 90), Moholy-Nagy believed photography to be the principal visual language for the modern era. Bayer used the camera to record and explore the geometry found in natural forms.[10] He experimented with confused perspective, closeups, and multiple exposures, striving for unexpected views of the mundane. This playfulness is apparent in one of Bayer's portrait snapshots of Moholy-Nagy (fig. 6), looking up at the bespectacled artist from beneath.[11] It was probably taken on a beach, a favorite destination for the photographic expeditions for Moholy-Nagy, his wife Lucia, Bayer, and his wife Irene, all serious photographers. Bayer left the Bauhaus and moved to Berlin in 1928, to work as art director of *Vogue* magazine. Through the 1930s he was active as a freelance graphic designer and worked for the German journal *Die neue Linie.* Solo exhibitions of his work in Germany and France included paintings, sculpture, photographs, and PHOTOMONTAGES.

Metamorphosis is one of Bayer's most mysterious photomontages. He skillfully pieced together several different negatives to create a complex artificial setting, in which the viewer gazes out from inside a rocky cave to a sunny landscape with grassy hills, beyond a silhouetted treeline, and beneath a sky filled with puffy clouds. Inside the grotto a jumble of white geometric forms — including spheres, cubes, cones, and cylinders — tumbles through the air, modeled by strong light and shadow from another source. For a decade, Bayer had used these strongly illuminated, white geometric forms in his photomontages, including the cover of the Bauhaus catalogue in 1928. Aside from the artist's favorite parallelism between pure and natural forms, this image also reflects his recurrent theme of the unstable reversals of positive form and negative space. The image incites association, but defies narrative and interpretation.[12]

The Surrealist combination of literary inspiration, psychological imagery, and technical experimentation are apparent in the remarkable photographs of **RAOUL UBAC (121).** Born and

raised in Malmédy, he first studied to become a forest ranger.[13] As a teenager he trekked across Europe on foot, and when he visited Paris in 1928 he was deeply impressed by Surrealist art. Two years later Ubac moved to Paris, where he studied at the École des Arts Appliqués, learning the techniques of photography. He lived in Montparnasse and associated with the authors and artists of the Surrealist group. Inspired by Max Ernst, who made collages of images cut from old engravings and magazine illustrations, Ubac began experimenting with photomontage. The young artist briefly collaborated with Man Ray (no. 94), sharing experiments with cameraless Rayographs.[14] In 1936, the year his photographs began to appear in the Surrealist magazine *Minotaure*, he also began making intaglio prints at Stanley William Hayter's Atelier 17.

The *Battle of the Penthesilieans* (*Combat des Penthesilées*) is one from a series of innovative photographs inspired by ancient literature, and points to events described in Homer's *Iliad* and other ancient accounts of the legendary Amazon Queen Penthesilea. A mythical race of female warriors, the Amazons were said to live in Asia Minor, at the very edge of the known world. They worshiped Artemis, goddess of the hunt, and Ares, the god of War. They were skilled hunters and ferocious warriors, renowned for their equestrian skills and expertise with the bow, axe, and spear. Penthesilea was a gallant Amazon queen, the daughter of Ares himself, who brought her troops to the aid of King Priam during the Trojan war. They fought courageously on the plains of Troy until Penthesilea was slain by Achilles. Yet her conqueror mourned her burial so openly that Thersites ridiculed him for being in love with her, and Achilles killed him in a fit of anger.

To envision the tale of the Amazons at Troy, Ubac created an image to evoke ancient literature and art that suggests a timeworn antique relief sculpture depicting a fierce battle. Fragmentary nude figures swirl together in an abstract melee, where flowing tresses can also be seen, along with motifs suggesting spears, swords, and nets. However, no heads or faces are visible, emphasizing the confusing impersonality of war, and the ravages of time and memory. To create this mysterious image, Ubac began by photographing models in active postures in the studio. He also photographed various patterns and granular, rocky textures. The artist cut up his photographic prints and pasted the fragments together in a new, compound image. Then he rephotographed the Surrealist abstraction. Finally, to create the effect of sculptural relief, Ubac solarized the image in the darkroom, briefly EXPOSING the NEGATIVE to light during DEVELOPING. The resulting reversal of tones is especially apparent along the edges of the COLLAGE elements that appear as white lines. Ubac was drawn to solarization as a creative process because of its unpre-

dictability, which introduced another element of chance into the creative process. The artist also developed the *brulage* technique, in which he burned the surface of negatives, melting the emulsion to create swirling organic effects.

In her innovative dance photographs, **BARBARA MORGAN (122)** explored the conjunctions between abstraction and representation, energy and stasis, creative movement and sculpture. Born Barbara Brooks in Buffalo, Kansas, she grew up in southern California and studied art at the University of California, Los Angeles (UCLA).[15] Two years after graduation in 1923, she married the photographer Willard D. Morgan and moved with him to Westchester County, New York. She continued to paint while raising two sons. Her husband became the first photo editor of *LIFE* magazine, and encouraged her to experiment with creative photography. In 1935, when Morgan attended a performance of the Martha Graham Dance Company, she was inspired to become serious about creative photography. An eminent American dancer and choreographer, Graham developed modern dance as a medium for the expression of primal emotions.[16] After a performance of *Primitive Mysteries*, Morgan went backstage to meet Graham, and they discovered an instant bond. Having drawn and painted live dancers at UCLA, she asked if she could bring her camera to the dancer's studio. A partnership gradually emerged that helped popularize modern dance, making Graham its leading exponent and establishing Morgan's career as a photographer. Over a period of five years, Morgan photographed Graham and her company, systematically depicting more than a dozen different dance programs. She photographed all of Graham's classes, rehearsals, and company performances. However, when shooting Graham herself, Morgan worked in empty theaters and studios, where every detail could be carefully controlled. Before each session, the two women sat silently on the floor about ten feet apart, meditating on the subject of the dance itself.[17] Morgan exposed hundreds of negatives and worked with Graham in choosing which of them to print.

"*War Theme*" is typical of Morgan's dramatic images of Graham alone in a posture and costume of her own invention. The dancer considered costume part of her choreography, conceiving garments that ranged from plain woolen and jersey gowns to flowing togalike robes. In some of her works Graham covered her body completely, moving underneath the fabric to simulate a continually transforming sculpture. Many of Morgan's images capture Graham in motion, her draped skirts of undulating fabric whirling about her. She swirls her skirt fluidly, emphasizing the spiral form by tossing her long hair and lifting her arms. To deny our identity with Graham's personality, and

122

Barbara Morgan
American, 1900–1992

Martha Graham, "War Theme," 1941

Gelatin silver print
36.9 x 49.0 cm
Stoddard Acquisitions Fund,
1998.80

force concentration on form, Morgan obscured the dancer's face in shadow. The photographer carefully illuminated her images, using techniques she developed herself. "Light is to the photographer what movement is to the dancer," Morgan wrote. "The best pictures . . . are portraits of energy; energy of imagination, generating motor energy and transfixed by light energy."[18] A selection of Morgan's photographs was published in the book *Martha Graham: Sixteen Dances in Photographs*, and the dancer used many of the images to promote her work.[19] Morgan built a distinguished career as a photographer, book designer, and editor; she and her husband established the publishing firm of Morgan & Morgan, which specialized in books on photography and art. As a photographer, she made pioneering experiments with lighting methods and techniques of photomontage.[20]

The conceptual ambiguities of Surrealism and an acute sense of human drama are apparent in the photographs of **BILL BRANDT (123)**. Born in Hamburg, he was the son of a wealthy British businessman and a German mother.[21] He suffered from tuberculosis as a child, and spent much of his early youth in a sanitarium in Davos, Switzerland. In 1927 Brandt moved to Vienna for a course of treatment that cured his respiratory ailments, and he was able to take a job in a photographic studio. He did a portrait of the author Ezra Pound, who provided an introduction to Man Ray (no. 94), in whose Paris studio Brandt worked for six months in 1929–30. There, he encountered the photographs of Eugène Atget, André Kertesz, and Brassaï (nos. 78, 91, 114) and experienced Surrealism in its heyday. When Brandt moved to London in 1931, he began a series of photographs exploring the British class structure, from upper-middle-class drawing rooms to the working-class pubs in London's East End. His first book, *The English at Home*, revealed an expressive style that dissolved boundaries between documentary and journalistic photography.[22] This was followed by Brandt's *Night in London*, an English echo of Brassaï's *Paris de nuit*.[23] He published his work in the pictorial news magazines *Weekly Illustrated* and *Picture Post*. During World War II, the British Ministry of Information engaged him to photograph London during the Blitz.

After the war, Brandt's photographs appeared in the literary magazine *Lilliput*, as he pursued several new directions. He depicted landscapes associated with historical poets and novelists, images later compiled in the book *Literary Britain*.[24] Another of his photoessays represented the London borough of Chelsea, famous for its artists and eccentrics. It seems that in preparation, Brandt became a Chelsea bohemian himself, frequenting pubs and studios with friends who lived in the district, including the *Lilliput* art director Mechtild Naviasky

and the poet Dylan Thomas.[25] Most of the photographs in the series represent the area's inhabitants, including two pensioners from the Chelsea Military Hospital, the artist Peter Rose-Pulham painting at an easel, and the portrait of Dylan and Caitlin Thomas in their home on Manresa Road. This famous image is fascinating in its eerie psychological disconnection, as each gazes ahead with an unfocused stare. We cannot be sure, however, whether the couple has quarreled or been seized by separate reveries. The latter is suggested in the shelf in the background filled with books, a symbol of knowledge, literature, and contemplation. However, the ambiguity is emphasized by a jumble of objects on the table before them: a metal jug, a bottle of beer, a fur muff. The mesmerizing image seems like a murky visual poem. Brandt's series on Chelsea appeared in *Lilliput* magazine in August 1944, along with captions written by Thomas.

In 1945, Brandt began photographing nudes for *Lilliput*, and continued as a personal obsession. He used an old mahogany camera designed for recording crime scenes that had a wide-angle LENS, which deformed closeup images. Brandt made a series of distorted nude studies that reflect the spirit of Surrealism, and published a selection in the book *Perspective of Nudes*.[26] Some of these images appeared in the joint exhibition *Three European Photographers*, at the Worcester Art Museum in 1965.[27]

LISETTE MODEL (124) brought the spirit of Surrealism to American photography. She was born Elise Felice Amélie Seybert in Vienna, the daughter of an affluent physician attached to the Imperial Army and later to the International Red Cross.[28] Growing up with an Italian father and French mother, she became fluent in three languages. She excelled in music, and at age nineteen she studied with the composer Arnold Schoenberg, the father of a schoolfriend. Her own father died in 1924, and two years later she moved to Paris to study voice with the Polish soprano Marya Freund. Around that time her mother moved to Nice, along with her younger sister, Olga, who began a career as a photographer. Seybert turned away from music in 1933 and began studying painting in the studio of André Lhote. She also became interested in photography, learning its fundamentals from her sister, and refined her skills as a darkroom technician in Paris. In 1934, while visiting her family in Nice, Seybert took her camera to the Promenade des Anglais, where she made a series of candid portraits of the corpulent, idle rich lounging in the sun. In the darkroom, she cropped the figures closely, emphasizing their bulk and creating the sense of arrogant confrontation. In 1935, some images from the series were published in the Communist periodical *Regards*, where they served as biting social criticism.

123

Bill Brandt
English, born in Germany, 1904–1983

Dylan and Caitlin Thomas, Manresa Road, Chelsea, 1944

Gelatin silver print
46.5 x 39.8 cm
Museum purchase, 1967.7

124

Lisette Model
American, born in Austria,
1901–1983

Street Reflections, about 1938

Gelatin silver print
42.4 x 34.6 cm
Gift of Irene Shwachman,
1974.108

125

Helen Levitt
American, 1918–

Worthmore Pleasure Club,
1942

Gelatin silver print
15.9 x 20.8 cm
Eliza S. Paine Fund, 1990.1

125

In 1937, Seybert married the painter Evsa Model and emigrated to the United States. Gradually she began to discover and photograph sights unique to New York City. She made a series of photographs of pedestrians' feet as they scurried along crowded sidewalks. Their different costumes, multiple directions, and presumed intentions create the sort of overlayered complexity and bustle that fascinated her. The same confusion is apparent in Model's photographs of Sammy's Bar, a rough bistro on the Lower East Side, where Weegee (no. 113) was a habitué and where she photographed New Yorkers' inebriated congeniality.

Street Reflections was one from another series that Model made during her first months of exploring New York. It may have been Eugène Atget's (no. 78) photographs that Berenice Abbott (no. 105) showed her that prompted Model to explore the plate-glass shop windows along Fifth Avenue. The photographer stood off to the side to avoid her own reflection, causing the buildings to appear to lean toward each other and suggest Cubist compositions. Fragmentary images of mannequins, pedestrians, and vehicles seem to interpenetrate and jostle for space and attention, suggesting the pace and complexity of modern life. "What we see in windows says a great deal about Americans and the civilization and the culture," Model said. "It was not just something I did for the beauty of it."[29]

The first solo exhibition of Model's photographs was mounted at the Photo League in Manhattan in 1941. A decade later Model began teaching at the New School for Social Research, where Abbott was on the faculty. She was an outstanding and influential teacher, but gradually turned away from her creative work.[30]

HELEN LEVITT (125) brought a compassionate personal touch to street photography, and transformed the vocabulary of social documentary into more creative means. Born in New York, she grew up in Brooklyn, and as a teenager learned the techniques of photography working in a commercial studio.[31] Inspired by the work of Henri Cartier-Bresson (no. 167), she purchased the hand-held Leica camera that he used, along with a right-angle viewfinder that enabled her — like Paul Strand (no. 75) — to observe and photograph people from a distance without their knowledge. She knew that disturbing her subjects' privacy would alter their attitudes. Levitt explored the streets of Harlem, Yorkville, and the Lower East Side with her camera in 1936, recording small social dramas. Her images all seem set on a stagelike platform defined by sidewalk and stoop. Levitt's favorite subject was children at play, and in her images of childhood fantasy, poignancy, and joy, we recognize our own histories and hidden emotions.

In 1938, Levitt studied with Walker Evans (no. 106), in whose studio she met James Agee. Both men influenced her habits of perception and encouraged her quest for direct artistic expression. When Levitt traveled to Mexico in 1941, she continued to photograph children and revealed the universality of human emotions and experiences.[32]

Worthmore Pleasure Club exemplifies the amiable forbearance of Levitt's imagery. It is the image of a neighborhood gathering place, where New Yorkers meet to enjoy friends and local gossip on a hot summer evening. Two men sit inside in their shirt sleeves, presumably at a card table, while two others sit outside and provide a running commentary on neighborhood activities. It is likely that Levitt shot this photograph with her right-angle viewfinder, for the men wear expressions of the slightly leering amusement they share when observing a young woman, which would become respectfully sober in her conscious presence. Levitt turned the tables and captured their goatish buffoonery. In a single, quick image, she transports the viewer into the milieus of neighborhood society and human nature.

In 1943, a solo exhibition of Levitt's photographs was presented at the Museum of Modern Art, and three years later a museum fellowship made it possible for her to gather material that became the book *A Way of Seeing*.[33] She collaborated with her friend Janice Loeb and Agee on the short film *In the Street*, which won awards at the Venice and Edinburgh Film Festivals when finally released in 1952. During the 1940s, Levitt's photographs regularly appeared in magazines like *Fortune*, *Cue*, and *Time*. In 1952, her work appeared in a joint exhibition with Frederick Sommer at the Institute of Design in Chicago. However, Levitt built a career as a film director and editor during the 1950s, and gave little attention to photography. Guggenheim Foundation fellowships in 1959–60 enabled her to study color photography, resulting in another solo exhibition of her work at the Museum of Modern Art in 1963.[34]

While a painter's humanist sensibilities are often comparable to those of the street photographer, the architect's practicality and uncompromising aesthetics are reflected by quite a different photographic sensibility. **JULIUS SHULMAN (126)** is identified with the International architectural style in California in the mid-twentieth century. Like Werner Mantz (no. 92), who represented this architectural style in Germany a generation earlier, Shulman built symbiotic, almost collaborative, professional relationships with the architects who were his patrons. His images of the work of Charles Eames, Raphael Soriano, and Richard Neutra are those by which we assess and remember the achievements of these great architects.

Born in Brooklyn, New York, Shulman spent his early childhood on a small family livestock farm near Central Village, Connecticut.[35] When he was ten years old he traveled with his mother to California, where his father had already moved to open a clothing store in Boyle Heights, East Los Angeles. Shulman learned the rudiments of photography in an art course at Roosevelt High School in Los Angeles. While studying in the School of Engineering at UCLA, he continued to make photographs, taking his camera to the beach and to the Santa Monica Mountains. Shulman continued his studies at the University of California, Berkeley, in 1934–35, and the following year he met the architect Richard Neutra. The photographer developed a thriving business in growing Los Angeles, receiving commissions from the leading architectural firms in the west. In 1938, he began to publish his work in *Art & Architecture*, and four years later he joined the magazine staff. Over the next three decades, Shulman's photographs appeared in many national magazines, including *LIFE*, *House & Garden*, and *Good Housekeeping*.

Crenshaw Theater, Los Angeles exemplifies Shulman's masterful ability to capture architectural experience. Designed by Paul László and built around 1940, this building reflects a Modernist take on the wondrous public environments of the motion picture palace from the preceding generation.[36] Shulman's night view of the open-air lobby presents a dynamized envelope of space, between a rectilinear floor grid and a pattern of swirling neon arabesques on the ceiling. Both perspectival systems lead the eye from inside the cavernous space out into the Southern California evening, where an automobile attendant assists moviegoers. This transitional space is unusual and stimulating, shaded and cool during the day, and brightly illuminated at night. Its Modernist grids and curves provide a vestibule from the real world of the street to the fantasy realm of cinema. Shulman emphasized the practical function of this space of welcome by placing the doorman in the center of the composition, standing alongside a late-model car, with its reflective, aerodynamic curves that accent the modernity of the image. Outside and beyond the theater we glimpse a car-lined street, a neon-blazoned diner, and a filling station, which define the automobile-centered culture of Southern California and its modernist promise. With an appreciation of the architect's theatrical intent, Shulman captured a sense of space and drama that remains startling, even when the image carries an unintended nostalgia. This visual immediacy, common to Shulman's architectural photographs was the key to his professional success.

126

Julius Shulman
American, 1910–

Crenshaw Theater, Los Angeles, 1941

Gelatin silver print
40.7 x 50.9 cm
Sarah C. Garver Fund,
1998.59

13 | The World at War

While Americans documented social and political problems during the 1930s, in Germany the National Socialist Party restricted photographers, requiring that they register with the government and, later, banning their activities. As its power grew, the Third Reich skillfully broadened its propaganda to include Heinrich Hoffmann's still photographs and Leni Riefenstahl's powerful films. Beginning in 1939, when American photojournalists traveled to Europe to cover World War II, their negatives and prints were transported home by the military, which censored images before allowing their publication. All sides were very sophisticated in the use of photography, which had become the primary vehicle of propaganda.

MARGARET BOURKE-WHITE (127), the first woman photographer accredited by the American Air Force, created some of the strongest photographs of the early war. She was the daughter of an engineer who introduced her to photography.[1] While attending Rutgers University, she studied photography with Clarence H. White (no. 65) at Columbia, and financed her further education working as a commercial photographer. She followed her widowed mother to Cleveland after graduating from Cornell University. In commissioned photographs of the Otis Steel Mill, Bourke-White conveyed the awesome power, scale, and drama of the industry. The publisher Henry Luce saw the photographs and hired her for his new business magazine *Fortune* in 1929. She documented a wide range of American business and industrial subjects for the magazine, even visiting the Soviet Union to photograph the transformation of its society through industry.[2] Bourke-White was one of the four original staff photographers of Luce's *LIFE* magazine, and her image of Fort Peck Dam in Montana appeared on the magazine's first cover in November 1936. During the Depression, Bourke-White collaborated with novelist Erskine Caldwell on a controversial book about southern sharecroppers, *You Have Seen Their Faces*.[3] They were married in 1939.

In summer 1941, Bourke-White was the only for-eign photographer to witness the German air raids over Moscow; she was on assignment for *LIFE*, and Caldwell was there as a CBS radio correspondent. To photograph the nightly attacks, they hid from hotel wardens, defying commands to flee to the shelters. She set up her cameras on the balcony outside her room in the National Hotel near the Kremlin, aiming them at the Soviet targets and the sky above. "The early raids," Bourke-White later wrote, "with living curtains of fire thrown into the upper reaches of the heavens by the Russian batteries, and the *Luftwaffe* tossing off flares which hung in slowly descending clusters like blazing suns, these were celestial sights that might have been directed by an archangel."[4] On the night she created *Path of a Parachute Flare*, Bourke-White pointed all four of her cameras toward the action, each set to a different EXPOSURE time. "The German airmen dropped flares, like the huge one on the right, to light the ground to help them find definite targets. In the foreground are the British Embassy buildings and the Moskva River. The star-topped tower toward the right is the Borovitsky Tower, and the main Kremlin gate. Shown dimly in back of it, with modern outlines, is the big new Lenin Library, where a fire bomb is just hitting the roof."[5]

ROBERT CAPA (128) achieved the reputation in the West as the most daring and resourceful combat photographer during World War II. He was born Endre Ernö Friedmann, in Budapest, where his parents ran a fashionable dressmaking salon.[6] At age fifteen, he began working with a documentary photographer, then studied journalism in Berlin. In 1933, Friedmann moved to Paris, where he met Gerda Taro, a German who first acted as his agent, then became a photographer and his partner. Together, they invented the myth of a heroic international photographer named Robert Capa. French publishers understood that he was a wealthy and renowned American photojournalist, and they told American magazines that he was French, thus extracting higher fees from both. In August 1936 Capa and Taro went to Barcelona to chronicle

127

127

Margaret Bourke-White
American, 1904–1971

*Path of a Parachute Flare,
Moscow,* 1941

Gelatin silver print
24.9 x 34.3 cm
Gift of the artist, 1971.20

the Spanish Civil War. Among the pictures of this campaign is Capa's famous image of a Loyalist militiaman near Córdoba in the instant after being killed by an enemy bullet. The mixture of savagery, humanity, and courage reflected in his photographs of the Spanish Civil War earned him international renown. In July 1936, Taro was killed near Brunete, Spain, and Capa was devastated.[7] In 1939 he photographed the Japanese invasion of China, and during World War II he covered the Allied campaign in North Africa for *Collier's* magazine.

Lover's Parting is one of the photographs Capa shot after dropping into Sicily with American paratroopers in summer 1943. It typifies the quiet, human images of war that usually accompanied his battle scenes. A typewritten label on the VERSO of the photograph from the Acme News Service describes the scene. "Heads bowed, they made their way over a dusty Sicilian road, an Italian soldier and his girl spend their last moments together walking to a temporary prisoner of war camp at Agrigento. It will be the last meeting for a long time. Captured Italians needed no guards as they voluntarily entered the camps after the fall of Agri-

gento."[8] In this image of uncertainty, young people go forward together, with no sense of what the future will bring. Capa also photographed the fighting on the Italian mainland.[9] On D-Day, June 6, 1944, Capa landed on Omaha Beach with the first wave of American troops, and shot four rolls of film while wading ashore under heavy fire. However, all but eleven frames were destroyed in the *LIFE* magazine processing laboratory in London. The surviving, blurry images of soldiers' faces, shrapnel smoke, and sinking ships powerfully evoked the danger of the chaotic landing and bravery under fire. They are considered the best shots of the invasion and masterpieces of documentary photography. Capa accompanied French troops in the liberation of Paris, and Americans in the Battle of the Bulge. He parachuted into Germany with the 17th Airborne Division in April 1945, and photographed what may have been the last soldier to die in the European war.

Capa legally changed his name when he became a naturalized American citizen in 1946. The following year he was one of the founding members of Magnum, the first international cooperative agency

128

128

Robert Capa
American, born in Hungary,
1913–1954

Lovers' Parting, Sicily, 1943

Gelatin silver print
14.5 x 21.0 cm
Austin S. Garver Fund,
1998.184

of freelance photographers. He photographed the Israeli war for independence, then served as director of the Magnum office in Paris. In 1954, Capa went to Vietnam to cover the French Indochina war for *LIFE*. There, while photographing French maneuvers on the Red River delta, he stepped on a land mine and was killed.

Most American photographers in the Pacific theater during World War II were organized by the Navy, under the command of Captain Edward Steichen (no. 85). Trained to accompany combat troops and produce aerial photography, they provided the great majority of Allied intelligence. The news photographers among them worked in pools, sharing images among all unit members, a scheme that simplified the censors' work but also introduced problems for later attribution of photographs. After scant coverage of the defense of Wake Island, however, the Marine Corps organized their own news organization in early 1942. Reporters, photographers, and cinematographers were recruited and trained to fight as Marines. Their assignment was "to inform and inspire America with tales of everyday deeds and of Marine valor and heroism on land, at sea and in the air."[10]

OBIE NEWCOMB, JR. (129), became one of the most celebrated of the Marine photographers. When the war began he was a freelance news photographer living in Crestwood, New York, who often sold his work to the Associated Press. Attached to the Second Division photo section, he was deployed to the Marines' staging base in New Zealand, where for a week he joined the retinue of Eleanor Roosevelt, chronicling the First Lady's tour of the Dominion. This was not the sort of assignment for which the hard-bitten thirty-four-year-old had endured the Parris Island training base. So in late November 1943, when word came of an invasion of Tarawa atoll in the Gilbert Islands, Newcomb volunteered for the first wave of the assault. On Betio, Tarawa's main islet, the Japanese had a strategic airstrip. It took seventy-six hours for the Marines to capture Betio, and during that time the Japanese killed or wounded more than forty Marines per hour, in this first battle of the American campaign in the Central Pacific.

It was also Newcomb's first battle. He accompanied twenty-six Marines on an amphibious vehicle, carrying a pistol, a knife, four days' rations, his 4 x 5–inch Speed Graphic camera, and film for 360 exposures. Five of his comrades died before land-

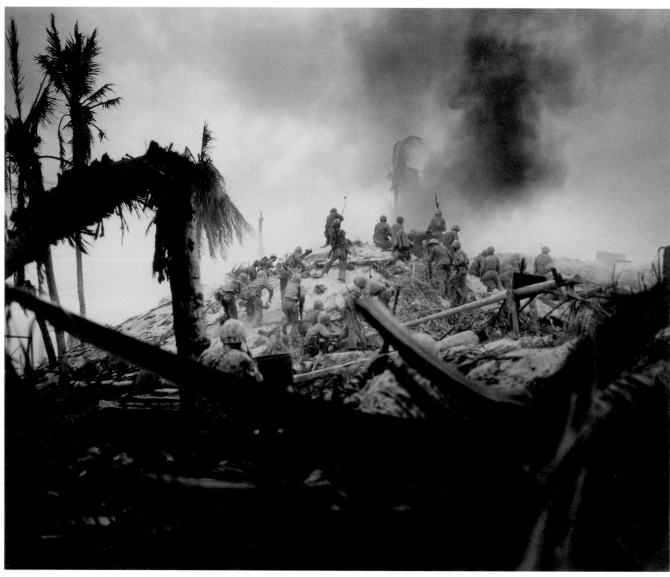

129

129

Obie Newcomb, Jr.
American, 1909–1979

*Marine Assault, Tarawa,
Gilbert Islands*, 1943

Gelatin silver print
21.0 x 25.4 cm
Transferred from Museum
archives, 2003.130

130

W. Eugene Smith
American, 1918–1978

Saipan, 1944

Gelatin silver print
34.4 x 26.6 cm
Alexander and Caroline
DeWitt Fund, 1991.225

ing. Newcomb dropped his camera and hit the beach, grabbing a rifle from a dead soldier and taking cover against the seawall. "Brother was I scared," he later recalled. "Lifting my head above that wall to take aim the first time was the toughest job I ever had in my life. But once I had fired the first round it was easy."[11] When fire subsided, he retrieved his camera and shot 192 photographs that day. The photographer spent the first two nights in a beach foxhole.

Newcomb's *Marine Assault, Tarawa* was taken on his third day on Betio, during the four-hour siege of a Japanese pillbox.[12] These strong emplacements withstood all but a direct hit from a naval gun. They had concrete walls five-feet thick, and were buried under twelve feet of sand and coral. The only way to defeat them was to fight up to the top, and then shoot down inside at the defenders. Moments after Major William C. Chamberlain ordered the charge, Newcomb snapped the image of the Marines swarming over the pillbox,

sustaining significant casualties in their attack. The Betio photographs brought the Pacific war to life for the American public.[13] "Probably no one got closer to the war at Tarawa, and came back to tell about it, than Newcomb," wrote the New York *Journal-American* columnist Louis Sobol. "With death in front of him, at his side, and missing him only by fractions of inches, Newcomb took his pictures — probably the best that will ever come out of the Tarawa action."[14] Afterwards Newcomb was promoted to Warrant Officer USMCR.[15] In 1946 he returned to Quantico, Virginia, where he and other battle-hardened journalists trained their replacements for active duty.

By striving to share the experiences of his subjects, **W. EUGENE SMITH (130)** revolutionized photojournalism. Smith made his first photographs at the airport in Wichita, Kansas, when he was fourteen years old.[16] He published aviation and sports images in local newspapers as a high school stu-

dent, and dreamed of being a photojournalist. However, when his father committed suicide, distorted newspaper accounts provoked a deep cynicism about journalism. After a year at the University of Notre Dame, Smith moved to New York to begin his career. He worked briefly for *Newsweek* magazine in 1937, but lost his job for using a hand-held camera. He was committed to the 35mm format, and often carried five or six cameras at once, hanging on straps from his neck and shoulders. Smith sold his photographs through the Black Star Agency to such magazines as *Collier's*, *Harper's Bazaar*, and the *New York Times*. He joined the staff of *LIFE* magazine in 1939, but was often in conflict with the editors for insisting on control over publication of his images.

When Smith first became a war correspondent in 1942, he was impassioned by patriotism. After working briefly in Europe, he went to the Pacific theater of war, where he was involved in twenty-six carrier combat missions and thirteen invasions. These experiences horrified Smith, and turned him decisively against all war. He bravely dedicated himself to photographing the terror, horror, and suffering that he witnessed, to communicate the experiences of combatants and victims. "Each time I pressed the shutter release," Smith wrote in a letter from Saipan, "it was a shouted condemnation hurled with the hopes that the pictures might survive through the years, with the hope that they might echo through the minds of men in the future — causing them caution and remembrance and realization."[17]

Saipan, one of Smith's best-known South Pacific photographs, brings the viewer into the soldiers' experience. By framing the image so tightly, the photographer not only created a close identification with the young men, but also conveyed the claustrophobic experience of the foxhole. The unshaven infantryman suffers in the heat; his perspiring face and a deep draught from his canteen suggest the grimy discomfort of the tropical island. He relaxes only slightly as his companion keeps watch. That soldier's wary lethality is emphasized by the diagonal barrel of his rifle, which directs the viewer back to the tension and fatigue in his companion's face. In 1944, Smith's powerful war photographs were part of a homefront controversy when *LIFE* magazine fought the government for the ability to show American wounded and dead, while it had been customary to show only enemy casualties.

On May 23, 1945, while Smith was photographing on Okinawa, he was struck in the face by a Japanese shell fragment. Two excruciating years of hospitalization and plastic surgery followed. He returned to the *LIFE* staff in 1947, and over the next several years he produced the defining photoessays of the era. Smith often spent weeks immersing himself in the lives of his subjects. The most important of his late projects was a photographic series on the Japanese village of *Minamata* that examined the lasting effects of industrial pollution, the images of which present an impassive yet powerful indictment of greed.[18]

Critical photographic reportage of war was matched by images of glory, like the triumphant *Soviet Troops on the Reichstag*, one of the most famous Soviet images of World War II. This is the work of **IVAN SHAGIN (131)**, a veteran photojournalist before the war. Born into a peasant family in the Yaroslav district, he was eleven years old when his father died, and he went to Moscow to support the family by a holding a succession of odd jobs, including that of a Volga boatman.[19] He began taking photographs in 1919, and over the next decade he developed his skills as a hobbyist. Shagin began to publish his images in the newspapers *Nasha Zhizn* (*Our Life*) and *Kooperativnaya Zhizn* (*Co-operative Life*) in the early 1930s. Although he favored straightforward frontal compositions for his press work, he used the foreshortened compositions and peculiar viewpoints advanced by Aleksandr Rodchenko (no. 90) for his creative portraits. In 1933, Shagin began working for the youth newspaper *Komsomolskaya Pravda* (*Young Communists' League Truth*), and many of his images from this era represent village life. During World War II, Shagin documented the training and campaigns of the Red Army and created stirring images from the snapshots he took on maneuvers. Several of Shagin's photographs of the Soviet Air Force and Navy that appeared in the magazine *USSR in Construction* achieved lasting acclaim.

Shagin was with the Soviet forces that began the final advance on Berlin in mid-April 1945. Six thousand tanks and two million men marched toward the city, which was fervently defended under Adolf Hitler's own command. Nearly a quarter of a million people perished there in the last few weeks of the war. Hitler committed suicide on April 30, 1945, hours after marrying his mistress, Eva Braun. Two days later, Shagin accompanied a group of soldiers through the smoky streets and into the flaming shell of the Reichstag, the German parliament building. Though fighting was fierce throughout the city, the building was undefended, for it had become little more than an empty shell following a devastating fire in February 1933. Nevertheless, it remained the symbol of historic German power and sovereignty. Climbing to the top of the edifice, Shagin snapped several frames of Soviet soldiers raising the flag and their arms in a gesture of triumph that mimics the sculptural pose of the mounted German knight, led to glory by the figure of Victory. Shagin's composition exploits the furling draperies of the sculpted goddess and the carved horse's head to emphasize the dramatic sweep of the Russian flag and the conquerors' jubilation. In

131

131

Ivan Mikhaylovich Shagin
Soviet, 1904–1982

*Soviet Troops on the
Reichstag,* 1945

Gelatin silver print
29.5 x 21.1 cm
Sarah C. Garver Fund,
1996.68

the background, smoke rises from the city of Berlin. Several versions of Shagin's photograph were printed and published, and it became a symbol of Soviet victory over the unimaginable hardships of the war.[20] It has been suggested that Joe Rosenthal's famous photograph of soldiers raising the American flag on the Pacific Island of Iwo Jima — taken four months earlier and transmitted around the world — prompted Shagin and his countryman Yevgeny Khaldei to create similar, ostensibly documentary, scenes of the Soviet flag flying over vanquished Berlin.[21]

After World War II, the world seemed a very different place. The ancient centers of Western culture had been under threat, modern art had been faced with systematic extinction, and the world had witnessed the use of weapons more powerful than any ever conceived before. For artists all over the world, these grave events prompted a deep reconsideration. Many sought to confront their difficult experiences of the war years in their creative processes. In the United States, the search by avant-garde artists for a new, distinctly American, metier that allowed this personal introspection gave rise to the development of Abstract Expressionism. Photographers, too, became more introspective. In the struggle to make sense of it all, looking for answers in psychology or in spirituality seemed more promising than looking to social reform.

CLARENCE JOHN LAUGHLIN (132) was a Southern photographer who created mystical images inspired by the region and its history. He was born in Lake Charles, Louisiana, and spent his first years on a country plantation near New Iberia.[1] His family moved to New Orleans, where his father died in 1918, leaving the teenager to support his family. He found solace in literature, particularly the work of French Symbolist authors such as Arthur Rimbaud and Charles Baudelaire (no. 39). During the Depression, Laughlin taught himself the techniques of photography with simple cameras and homemade ENLARGING equipment. Images of New Orleans architecture comprised his first solo exhibition at the Isaac Delgado Museum in 1936. An Army photographer during World War II, Laughlin documented the construction of Mississippi River levees for the Corps of Engineers, and later worked with the Office of Strategic Services at the National Archives in Washington, DC. After the war, he established himself as an architectural photographer in New Orleans. He also explored the countryside, photographing the material ruins of the antebellum South, and a selection of those photographs eventually appeared in his book *Ghosts Along the Mississippi*.[2]

The Magnificent Spiral #5 reflects Laughlin's

uncanny ability to animate images of buildings, evoking the people who erected and used them. It is one of his several studies of Afton Villa, a Gothic Revival mansion near Saint Francisville, Louisiana, subsequently destroyed by fire. This house was unique among Louisiana plantations for its twin, three-storeyed spiral staircases; each was different, though they were encased in matching turrets. "It swirls aloft with almost unequalled grace," Laughlin wrote, "its lines as pure as the inner whorls in a sea shell. At top, a light hangs like a suspended sun — this was very probably the most perfect tight spiral staircase in Louisiana. . . ."[3] Laughlin used the linear spiral of the bannister, progressively tightening from elliptical to circular down to the bottom. The vortex is echoed by the pendant lamp and its cover, which create a concentric form hanging from above. The composition is further enhanced by the shadows of the bannister cast against the wall, and by the ghostly reflections in the cover of the glass lamp. Laughlin sharpened his focus on the floorboards of the middle storey, leaving the upper and lower flights out of focus. The wear on the stairway's treads calls up the activities of generations of the mansion's inhabitants. Like many of Laughlin's photographs, abandoned objects and decaying buildings evoke the past and its unfulfilled dreams. "The physical object is, to me, merely a stepping stone to an inner world," Laughlin wrote, "where the object, with the help of subconscious drives and focused perceptions, becomes transmuted into a symbol whose life is beyond the life of the objects we know and whose meaning is a *truly human* meaning."[4] The intellectual artist photographer was well aware that the stairway is a common symbol of spiritual aspiration. By picturing the stairs's descent, he symbolized the decline of Southern culture.

HARRY CALLAHAN (133) found profound beauty in the seeming banalities of everyday life. His aesthetic and technical versatility, and his influence as a teacher, made him a pivotal figure in American photography of the late twentieth-century. Callahan

132

Clarence John Laughlin
American, 1905–1985

The Magnificent Spiral #5, 1947

Gelatin silver print
24.4 x 19.4 cm
Anonymous Fund, 1990.122

was born in Detroit, the son of a farmer turned factory worker.[5] He studied electrical engineering at Michigan State University from 1934 to 1936, married, and began working for the Chrysler Corporation in Detroit. In 1938, Callahan bought a Rolleicord twin-LENS camera and began taking photographs. He and his close friend, Todd Webb (no. 147), attended area camera club meetings, and often worked with Arthur Siegel, benefitting from his superior technical expertise. As a member of the Detroit Photo Guild, Callahan participated in its ten-day workshop given by Ansel Adams (no. 79) in 1941. Adams's work and practical advice helped Callahan realize that anything could be the subject of a great photograph. Over the next few years he explored a wide range of subject matter, and made technical experiments in high-contrast studies of weeds in snow, timed exposures of sunlight on water, and long EXPOSURES of neon lights. In 1946, the year Callahan's work was included in the exhibition *New Photographers*, at the Museum of Modern Art, László Moholy-Nagy invited him to teach at the

Institute of Design (ID) in Chicago. He proved an inspirational teacher, stressing technical skill and experimentation.

Rocks and Sand is one from a group of studies that Callahan made on the Chicago beach in the mid-1940s, and reflects the convergence of many influences on the artist at that time. He had begun making closeup landscape studies in Detroit in 1941. In Chicago he used this format to explore a wider range of subjects, such as grasses, leaves, and muddy swamp, moving closer to the ground, so that details fill the entire frame.[6] In his images of beach sand, he delighted in the varied texture of objects on the ground, employing light and shadow to accent them. One can see the rivulets in the sand where water drained away, leaving trails of their movement. This meditative image provokes contemplation of the passage of time, water and weather, and their effects on the earth. It also reflects Callahan's interest in Zen Buddhism and the simplicity of Japanese design. The shadowed rocks not only evoke a Zen garden, they also resemble

133

Harry Callahan
American, 1912–1999

Rocks and Sand, 1946

Gelatin silver print
19.2 x 24.3 cm
Gift of the artist, 1962.58

134

speeding subatomic particles, or comets hurtling through space with tails of cosmic dust. Informed by the work of his colleagues at the ID, Callahan consciously experimented with abstraction. "You open the SHUTTER and let the world in," he later recalled. "That was about the time Jackson Pollock was painting. Dripping. I think that was part of the time. I felt the same way about my camera movement that I thought Jackson Pollock felt."[7]

In 1961 Callahan was appointed to establish a photography program at the Rhode Island School of Design. The following year, he was one of ten photographers whose work was included in the exhibition *Ideas in Images*, organized by the Worcester Art Museum.[8]

A similar contemplation of nature is apparent in the photographs and paintings of **RICHARD POUSETTE-DART (134)**. An inventive photographer throughout his career, his pictures informed his work as a painter of the New York School. Born in Saint Paul, Minnesota, he was the son of the painter Nathaniel Pousette and the poet Flora Louis Dart.[9] He attended the private Scarborough School, and began studies at Bard College in 1935, but left in the first year to pursue his art independently in New York. Pousette-Dart briefly worked as

an assistant to the sculptor Paul Manship, and as a clerk in 1938–39 in the photography studio of Lyn Morgan, where he learned the fine points of photographic technique. He studied avant-garde art while working on his own paintings, sculpture, and photographs in the evenings, developing a personal abstract imagery of geometric and biomorphic forms. The first solo exhibition of Pousette-Dart's paintings was mounted at the Artist's Gallery in 1941, and months later he completed *Symphony Number 1: The Transcendental*, one of the first mural-scaled Abstract Expressionist paintings. Pousette-Dart associated with other painters of the New York School, sharing ideas as a member of the Artists' Club. In the mid-1940s, he used the camera to record motifs in nature that he developed further in drawings and canvases. Pousette-Dart also made portraits of his growing family and circle of friends. For example, he used multiple exposure to superimpose a portrait of Mark Rothko with the artist's biomorphic sketch drawn in the haze on a window.[10] "The camera is blind," the photographer wrote in his journal. "It is you who must see your own picture and persevere until you capture whomever, within their light, and with all that you cannot capture the reality of anyone. We all remain free and unrecordable."[11]

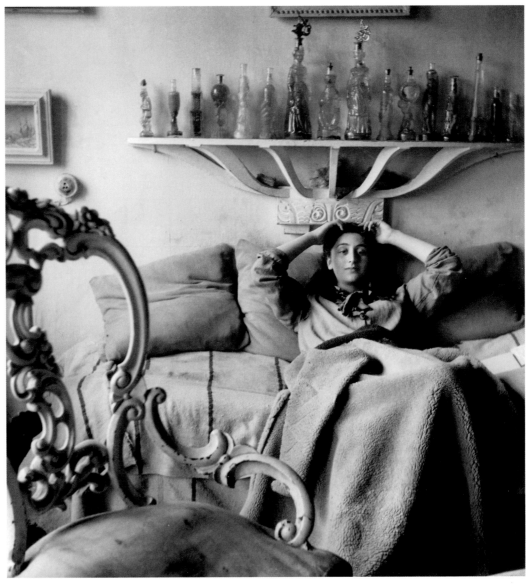

135

Ed van der Elsken
Dutch, 1925–1990

Paris, 1948

Gelatin silver print
14.0 x 11.3 cm
Anonymous Fund, 1986.79

135

Ice Study exemplifies Pousette-Dart's photographic exploration of nature. He rendered images of flowers, seed pods, minerals, or macroscopic landscapes abstract by tight framing and broad tonal range. In this small patch of ice — perhaps formed on the surface of a puddle during a cold snap followed by a chilly night — air bubbles created paper-thin, translucent layers, the sort that crackle under feet during a winter's walk. These thin wafers of ice are white, like the arboreal shocks of crystal at the top of the image, while the deeper parts of the puddle, where the ice is thickest, appear black. The artist framed his composition with the dark swath as a diagonal. From images like this, Pousette-Dart learned lessons of composition, and developed vocabularies of looped and jagged contour lines. For his paintings he translated these forms into tiny daubs of intensely hued impasto that seem to pulse and radiate energy, changing as the light falling upon them shifts.

"To my own light meter," Pousette-Dart wrote in his notebook, "calculator, computer, miracle of the mind, those human measurements, sized by intuition, soul, feeling, the mind and spirit of creative imagination, give me the perfection and the imperfection of the human hand and heart, give me the sublimity the realization and the fulfilment of what is right in front of my eyes."[12]

After the traumas of World War II, many young European artists searched for solace and support among their peers. **ED VAN DER ELSKEN (135)** documented their lives, their torments and confusions, and the challenge of an unknown future. An enigmatic portrait, taken in Paris, exemplifies the melancholy sense of his early work. Relaxing on a daybed, a striking young woman appears strangely regal. The surrounding pillows and foreground chair, with its carved Rococo arabesques, suggest some fantastic oriental throne, and the pile rug

over her knees is like the fur robe of an exotic queen. Raising her hands as she stretches, she seems to steady an enormous crown on her head. With its spreading veins, the magnificent diadem rises into sculpted glass prongs, some taking the form of crowned queens. Van der Elsken's beautiful subject, her unusual pose and setting prompt these daydreams — supported by the lingering fashion of Dada and Surrealism — and replace banal reality with a crystalline dream. Her unflinching confrontation of the camera and eerie detachment are typical of the artist's work.

Van der Elsken planned to be a sculptor, but his art studies were interrupted by the Nazi occupation of Amsterdam in 1943.[13] He went into hiding in the south Netherlands, and joined Allied liberation troops after the Battle of Arnhem. In 1947 he began taking street photographs in Amsterdam with his father's camera, learning his craft through support jobs in commercial studios. The violence, death, and destruction he witnessed transformed his view, and his expressive voice darkened. After his extended photographic expedition to Paris in 1948, he was elected to the GKf, the Netherlands' leading photographers' organization. He also associated with the avant-garde *Ondergedoken Camera* (Underground Camera) group in Amsterdam. Van der Elsken moved to Paris in 1950, where he frequented Saint-Germain des Pres, a neighborhood where young people gathered from across the world, all of them affected by the war. Embittered and confused, many of his contemporaries spent their days in cafés and bars, trying to soothe their anguish with drugs and alcohol. Van der Elsken documented their lives, sometimes against their wishes, and his style was forged by interior lighting, glassy reflections, and cigarette smoke.

In Paris 1953, Van der Elsken met Edward Steichen (no. 85), who included one of the young photographer's works in his landmark *Family of Man* exhibition, and later featured a group in his show *Post War European Photography* at the Museum of Modern Art.[14] After Steichen observed the narrative quality of Van der Elsken's photographs, he arranged them around a fictional narrative in *Love on the Left Bank*.[15] Some criticized the influential book for its cynicism, while others praised its honest portrayal of postwar malaise. Back in Amsterdam, Van der Elsken was introduced to American jazz by his flatmate, the journalist Jan Vrijman. He photographed the era's greatest musicians when they visited Holland, and published them in the book *Jazz*.[16] The two men collaborated on reports for newspapers like *De Volkstrant* and *Het Parool*. Their best-known piece investigated young hoodlums in Amsterdam.[17]

Commercial photography thrived amidst postwar prosperity in the United States, but the era was colored by threats of nuclear warfare and fear of Communism, engendering a complex, troubled ambiance captured by the day's finest photographers, including **IRVING PENN (136)**. Born in Plainfield, New Jersey, he began his studies of art at age eighteen at the Philadelphia Museum School of Industrial Art, where he was a pupil of Alexey Brodovitch.[18] Penn saved his wages from working at Saks Fifth Avenue department store. He moved to Mexico for a year, satisfying himself that a painting career was impracticable. Returning to New York, he became an assistant to Alexander Lieberman, art director of *Vogue* magazine. His suggestions for magazine covers, deflected by staff photographers, intrigued Lieberman. Penn borrowed a camera and shot a decorative still life of a brown leather handbag, which became the *Vogue* cover for October 1943, his first of over one hundred covers for the magazine. After serving with the American Field Service in Italy and India during World War II, he returned to Condé Nast Publications as a staff photographer, producing fashion images and celebrity portraits.

Penn's photograph, *Truman Capote*, shot on March 5, 1948, is one from his distinctive portrait series of midcentury. In his studio, the photographer set up two background flats to form a tight, shadowy corner. This simple device disturbed the customary comfort of his subjects before the camera, and their varied reactions made their personalities more accessible. Many of the day's celebrities posed in Penn's claustrophobic corner, including Noel Coward, Marcel Duchamp, the Duchess of Windsor, and Georgia O'Keeffe. The Southern novelist, journalist, and jetset gadfly, Capote is best known for his story and screenplay *Breakfast at Tiffany's*, and his dark novel *In Cold Blood*.[19] When Penn shot this portrait, Capote was enjoying his first recognition for a book about alienated youth, *Other Voices, Other Rooms*. In the studio, Penn asked him to take a characteristic pose. "I can mimic other people," Capote said, "but it's kinda difficult to mimic myself. You go away while I work something out."[20] Curled up in a greatcoat too big for him, with his knees tucked up, head hunched into his shoulders, and knitted brow, the young author appears withdrawn, timid, and percipient. The portrait's eerie impact seems to reflect a lingering postwar disquiet.

In 1950 Penn married the Swedish supermodel Lisa Fonssagrives, who became the subject of many of his most famous fashion photographs. Over the next two decades, he operated his own studio, maintaining international fashion and commercial accounts. His creative projects included an ongoing series of portraits of tradespeople, made in the course of his travels. Penn formally posed these subjects in everyday work clothes, confronting the camera with an almost ethnographic

136

Irving Penn
American, 1917–

Truman Capote, 1948

Gelatin silver print
25.5 x 20.5 cm
Eliza S. Paine Fund, 1990.132

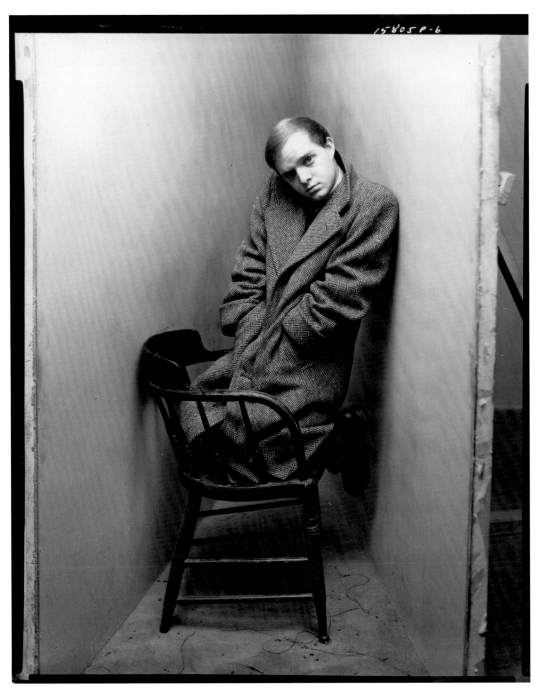

136

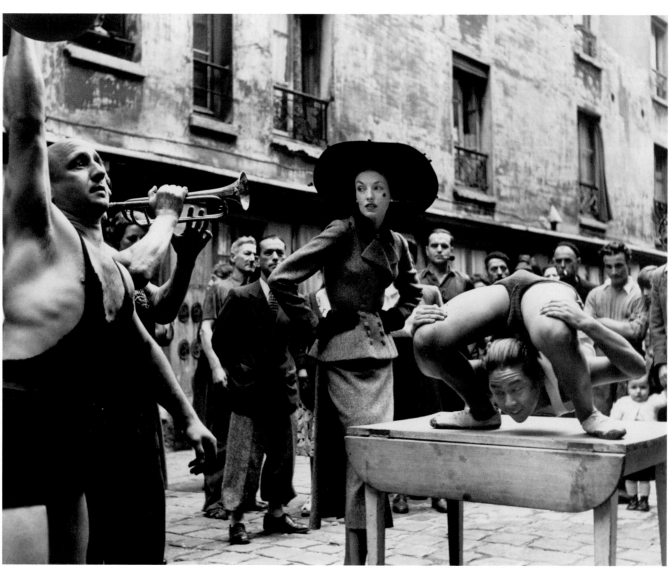

137

directness. In exotic locations like Nepal, New Guinea, and Morocco, he rented local workshops or set up in a portable canvas studio. A selection of these revealing photographs became the book *Worlds in a Small Room*.[21] During the 1970s Penn turned his attention to still life, printing monumental closeups in PLATINUM of small objects like cigarette butts, bones, or flowers. The scale of the photographs made these insignificant objects appear striking and sculpturesque.[22]

The invention and adaptability of the postwar years are also reflected in the work of **RICHARD AVEDON (137)**, another originative American master who established himself in fashion photography. He was born in New York City, the son of a Russian immigrant who worked in the fashion industry.[23] As a boy he saw magazines filled with the photographs of Edward Steichen, Man Ray (nos. 85, 94), and Martin Munkasci. In 1941–42 he studied at Columbia University and during World War II he served in the United States' Merchant Marine, taking identity photographs of servicemen. After his discharge, he became a pupil of Alexey Brodovitch at the New School for Social Research. Brodovitch hired Avedon at *Harper's Bazaar* magazine in 1945, and two years later Avedon traveled to Paris to photograph the couture collections, an annual journey that he continued to take for twenty years.

Elise Daniels in a Suit by Balenciaga exemplifies the brio of Avedon's postwar fashion work.[24] Munkasci's lingering influence is apparent in the photographer's preference for shooting on location, and a composition suggesting motion. In this remarkable image, however, the movement is concentrated on a troupe of Parisian street acrobats. After the war, Paris was popularly idealized as a place of style and romance. The novels of Colette and Ernest Hemingway, the eccentricities of Surrealism, and the vivid whimsy of the School of Paris painters all contributed to the illusion. It was the era of *An American in Paris*, when artists and writers lived on a shoestring, enjoying a rejuvenated bohemian culture. The couture style of "The New Look," pioneered by Christian Dior, added to the fantasy, with its cinched waists, immaculate tailoring, and flouncy skirts. Dressed in a suit of remarkable cut, an oversized hat, and veil, the impossibly svelte Daniels is a figure of caprice. Her costume is as stylized as the fantastic garments of the Bourbon courts. In fact, one of the spots decorating her veil resembles a patch used in the eighteenth century to cover small-pox scars. Such a hothouse flower is more like the circus performers around her than the audience in the street, or the photograph's viewer. This tension between the beautiful and the peculiar often recurs in Avedon's fashion work. "I have always been aware," he once said, "of a relationship between madness and beauty. Does this help to explain some of what appear to be contradictions in my work?"[25]

Handsome and sophisticated, Avedon was a celebrity himself. Stanley Donen's movie *Funny Face*, starring Fred Astaire and Audrey Hepburn, was loosely based on his career. Late in the 1950s he became dissatisfied with open-air locations and turned to studio photography. In 1965 Avedon joined the staff of *Vogue*, and his work reflected the energy and sexual liberality of the era.[26] When fashion photography became stultifying, however, he turned to portraiture. A selection of his celebrity portraits, along with the likenesses of prisoners, the mentally ill, and the poor, appeared in his book *Nothing Personal*.[27] Avedon's unflinching portraits of his dying father were exhibited at the Museum of Modern Art in 1974.[28] He made oversized, confrontational images of laborers for the series *In the American West*, shown at the Amon Carter Museum in Fort Worth in 1985.[29] Avedon's powerful portraits comprised a major segment of the retrospective exhibition of his photographs at the Whitney Museum of American Art in 1994.

Over six decades, **RUDY BURCKHARDT (138)** worked as a photographer, filmmaker, and painter, providing a link between artists of different generations in New York. Born into a prosperous family in Basel, he made his first photographs as a child with a pinhole camera.[30] At age nineteen he went to London to study medicine, but spent much of his time photographing the city. Back in Basel, Burckhardt met the American dance critic and poet Edwin Denby, and moved with him to New York in 1935. They shared a loft on West Twenty-first Street, next door to the painter Willem de Kooning, who introduced them to his circle of artists. Burckhardt experimented with film, and enlisted his friends for *145 West 21st*, his first of nearly one hundred films.[31] His early photographs of New York represent crowds of pedestrians, and tiny figures before soaring buildings. Burckhardt stole into skyscrapers to photograph the city skyline and the streets from above. Like Walker Evans (no. 106), he photographed surreptitiously on the subway. After applying for United States citizenship, Burckhardt was drafted into the Army during World War II. He turned to painting after the war, and befriended a younger generation of artists while studying with Amédée Ozenfant in 1948–49. Burckhardt's paintings are comparable to his photographs, representing details of everyday life and urban views. They were first exhibited at the Tanager Gallery in 1948, the same year his photographs were shown at the Photo League Gallery, and appeared in a volume of Denby's poetry.[32]

Jackson Pollock at Work was made for an article in *Art News* magazine, at a time when the artist's drip paintings revolutionized American art.[33]

137

Richard Avedon
American, 1923–2004

Elise Daniels in a Suit by Balenciaga, 1948

Gelatin silver print
35.5 x 44.8 cm
Eliza S. Paine Fund, 1994.225

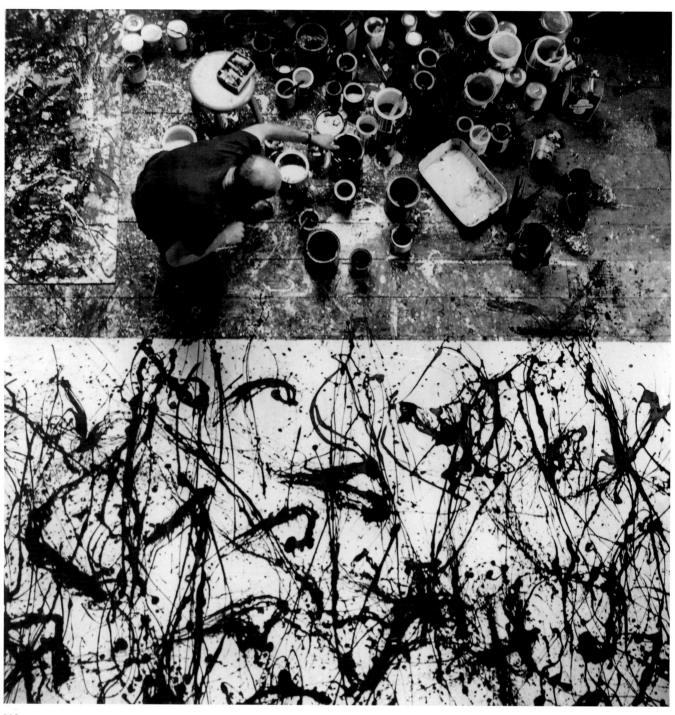

138

Pollock came to these expressive works after a career of inquisitive creativity. In October 1945, he married the painter Lee Krasner, and moved to Springs, on Long Island. There, working alone in the small barn behind his house, he developed his splash and drip style. Pollock spread unstretched canvas flat on the floor and stood over it, using sticks and trowels to ladle ribbons and spatters of paint into the air over the canvas. As he worked, he strove to open himself to subconscious sources of inspiration. Pollock's lyrical canvases are records of his dancelike movements, and split-second reactions to previous actions and imagery. In early sum-

mer 1950, Burckhardt drove to Springs with the painter-writer Robert Goodnough. There were fresh paintings on Pollock's studio floor, but the artist resisted disturbing them. Instead, he mimicked his process for the camera, stooping over the canvas, pretending to drip paint from a can with a brush. Burckhardt climbed a ladder to look down on the painting and the studio floor with the drippings and splashes that exceeded the edges of previous canvases. The linear electricity of Pollock's imagery makes an intriguing juxtaposition to the geometric shapes of paint cans, a stool, and Pollock's bald head, as he crouches among his materials.[34]

Rudy Burckhardt

American, born in
Switzerland, 1914–1999

Jackson Pollock at Work, 1950

Gelatin silver print
22.4 x 22.5 cm
Heald Foundation Fund,
1996.50

139

Wynn Bullock

American, 1902–1975

Child in the Forest, 1951

Gelatin silver print
18.8 x 24.2 cm
Gift of William H. and
Saundra B. Lane, 1981.34

WYNN BULLOCK (139) strove to represent cosmic truths and believed that photography was the universal language of his time. He was born in Chicago and grew up in Pasadena, California, where his divorced mother attended law school, later to become a Superior Court judge.[35] She encouraged his love of music and talent as a singer. At age nineteen, Bullock studied voice in New York, and a few years later he was performing as lead tenor in Irving Berlin's *Music Box Revue* on Broadway. After the show's successful run, he moved to Paris to study classical voice. In frequent visits to the Louvre, Bullock came to love art. He bought his first camera in Paris, and documented his travels around Europe.

During the Depression, Bullock returned to the United States and abandoned his musical career. In 1938 he studied photography at the Los Angeles Art Center School with Edward Kaminski, who introduced him to Surrealism. Bullock became a commercial and portrait photographer and made creative experiments with SOLARIZATION.[36] The Los Angeles County Museum of Art presented the

first solo exhibition of his creative photographs in 1941. At about that time, Bullock became interested in the work of Count Alfred Korzybski, a semantist who theorized that language interferes with perception.[37] He proposed replacing imprecise language and old mythology with new, all-embracing cultural symbols that might unlock the civilizing potential of humankind. With Europe consumed by war, these ideas seemed fresh and hopeful to the photographer, who became an enthusiastic adherent. While exploring visual symbols in his work, Bullock met Edward Weston (no. 82) in 1948. He turned away from technical imagery and devoted himself to straight photography of natural subjects. Gradually, he began to conceive of his images as representations of events rather than of objects or places.

Child in the Forest, one of Bullock's most striking photographs, exemplifies how the artist considered his images as "space-time events." Its startling juxtaposition was meant to jolt the viewer into contemplation. At first, the image of a nude child asleep in the lush forest undergrowth seems

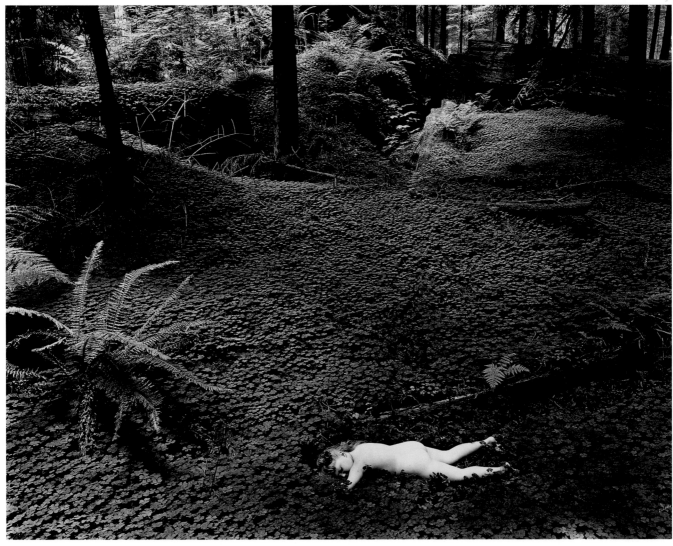

140

poetic, like a didactic myth. "My favorite backgrounds are the wild and untouched areas," Bullock later wrote, "or areas with old deserted buildings almost returned to nature. In such an environment the human figure, the trees, plants, ferns, and flowers manifest the cyclic forces of life and death in various characteristic stages of development. All blend into my experience, not just as objects with external physical qualities, but as events in time and space. Since I experience everything as events, I want my photographs to express events."[38] We are left to wonder about the child's awakening. Further, we consider the organic coexistence of plants, animals, their death, disintegration, and organic regeneration. In 1955, Edward Steichen (no. 85) included *Child in the Forest* in the landmark *Family of Man* exhibition. During the 1960s and 1970s the artist made many abstract closeup studies of natural subjects, and several of these were featured in the solo exhibition of Bullock's photographs mounted at the Worcester Art Museum in summer 1979.[39]

The painter **RALSTON CRAWFORD (140)** also used the camera to search for harmony and meaning in the visual world. The son of a Great Lakes ship captain, he was born in Saint Catherines, Ontario, and grew up in Buffalo, New York.[40] After high school he began his own pursuit of adventure, working on tramp steamers in the Caribbean and the Pacific. Crawford disembarked at Los Angeles, where he studied at the Otis Art Institute and worked briefly at the Walt Disney studios. Scholarships enabled him to continue his studies in Philadelphia, at the Pennsylvania Academy of the Fine Arts and the Barnes Foundation from 1927 to 1930. During that time, his paintings progressed from the influence of Paul Cézanne to works informed by Modernism and the simplified Cubism of Stuart Davis. Crawford went to Paris in 1932–33, with the support of a Tiffany Foundation grant, and attended the Académie Colarossi and the Académie Scandinave. While traveling in the South in 1937–38, Crawford began to devote serious attention to photography.[41] Though he sold some of his early images,[42] photography became a solitary, introspective pursuit, a discipline for looking. Crawford did not associate with other photographers, and only rarely did he exhibit his photographs. Instead, he employed both photography and printmaking to refine his creative practice.[43]

During World War II, Crawford worked in the Weather Division of the Army Air Force in Washington, DC, and was later posted to the China-Burma-India theater of war as an artist correspondent for *Fortune* magazine. He was deeply influenced by the sight of a test explosion of the atomic bomb at Bikini Atoll in 1946. Destruction and construction, chaos and order, became recurrent themes in his

work. He also synthesized imagery derived from shipyards and factories of his youth, along with the ocean's expanse and light.

Third Avenue Elevated is one of many photographs of New York that Crawford took while teaching at the Brooklyn Museum School in 1948–49. He printed at least six different views of the elevated railroad pier with its riveted diagonal crossbars and painted stripes.[44] "I firmly believe that a prolonged study and shooting of a subject from various angles and distances under several light conditions is highly rewarding. It is rewarding because the results are better. Sometimes I photographed a single subject with a whole roll of film in a Leica, Contax, or Rolleiflex — the choice being determined by what I am trying to do. These many shots may mean no more in relation to the final photograph than a few pencil lines would mean in relation to a completed oil painting. But, by making numerous exposures you learn not to be fooled by the seemingly final quality of any photo that appeals to you. You learn to ask yourself if it might not be better to take it from another angle in another way entirely; later on you are inspired to print the same negative in a variety of sizes and croppings. This is not drudgery, but an interesting activity all the way. You will make illuminating discoveries."[45] Crawford transformed the composition of *Third Avenue Elevated* into a sequence of lithographs that became progressively more refined in design.[46] In counterpoint to his images of balance and stillness, he also made many stirring photographs of bullfights, automobile racing, and Dixieland jazz musicians in Louisiana.[47]

With astute objectivity, **ANDREAS FEININGER (141)** made popular photographs that revealed the dilemma of man's place in nature in an atomic age. The eldest son of the American artist Lyonel Feininger, he was born in Paris, and grew up with two younger brothers in Zehhlendorf, near Berlin.[48] His father began teaching at the Bauhaus in 1919 in Weimar, and at age sixteen he became a student in the school's cabinetry shop. When his younger brother Theodore "Lux" Feininger (no. 93) became an ardent photographer, he learned its techniques as well. He built customized camera and DARKROOM equipment in the Bauhaus shop, and photographed his girlfriends, cars, and motor tours. After obtaining his Bauhaus certificate, Feininger studied architecture and structural engineering at the Anhaltische Bauschule. He graduated in 1928, and worked in a succession of architect's studios, earning occasional publication fees from the Berlin photographic agency DEPHOT. At that time Feininger was influenced by the work of Albert Renger-Patzsch (no. 103). After working in Le Corbusier's Parisian architectural studio, Feininger moved to Stockholm. As an architectural photographer, he made

140

Ralston Crawford
American, born in Canada,
1906–1978

Third Avenue Elevated, 1949

Gelatin silver print
34.2 x 23.0 cm
Anonymous Fund, 1987.19

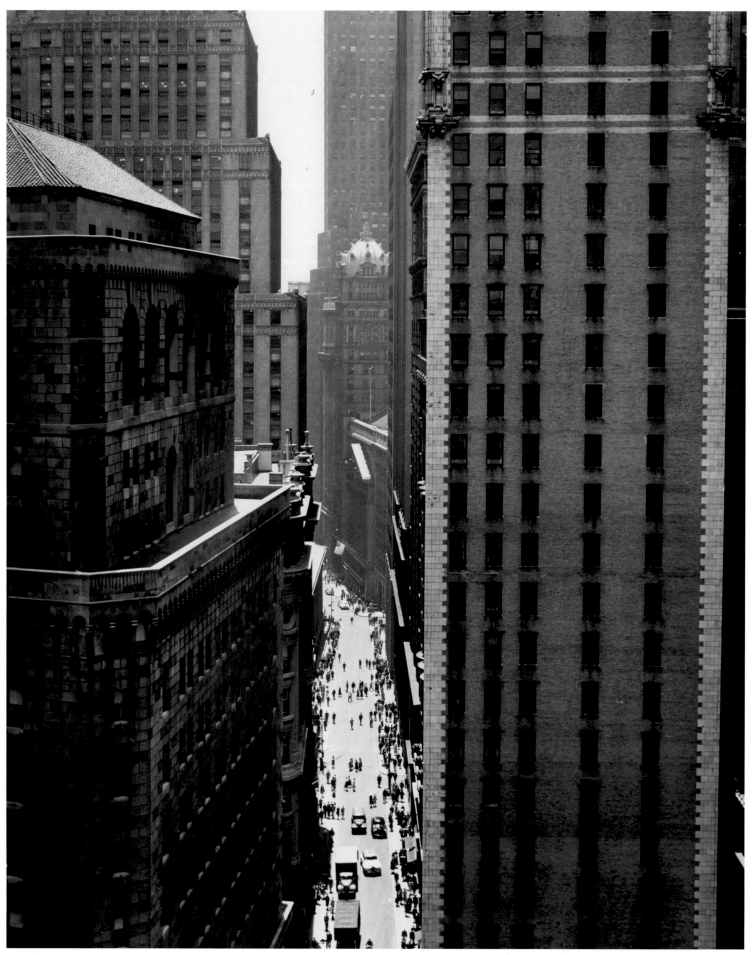

142

141

Andreas Feininger
American, born in France,
1906–1999

Nassau Street, New York,
1950

Gelatin silver print
48.7 x 40.0 cm
Gift of the artist, 1962.202

142

Otto Steinert
German, 1915–1978

Sidewalk, 1952

Gelatin silver print
27.5 x 40.3 cm
Eliza S. Paine Fund, 1993.63

views of that city and harbor with a telephoto cam-
era of his own construction, and published his first
picture book.

In 1939, Feininger sailed with his family to New
York, where assignments from the Black Star
Agency made him a more versatile photographer.
During World War II, he worked for the Office of
War Information, depicting the heroism of home-
front industry. Endlessly captivated by New York, he
photographed its streets and skyscrapers with a
growing array of his own custom equipment. In
April 1941, Feininger's first *LIFE* magazine cover
and photoessay comprised telephoto images of
Manhattan. He joined the magazine staff in 1943,
and his picture book of New York captured a tri-
umphal postwar mood in 1945.[49]

Nassau Street exemplifies Feininger's stunning
telephoto vistas of New York. Like Piet Mondrian,
László Moholy-Nagy, and other European Modernist
artists, his fascination with the city was based in
part on its rectilinear environment of astonishing
scale. The image depicts a sliver of empty space
where Nassau Street makes it way between the sky-
scrapers. By contrast to the immoveable buildings,
the street teems with life, with its diminutive cars
and trucks, and tiny human figures in motion.

Feininger's image emphasizes line, form, and
pattern. Its depiction of light and atmosphere
resembles Ansel Adams's (nos. 79) spacious pho-
tographs of Yosemite. Feininger, however, used a
super-telephoto camera that he built himself,
which captured a relatively narrow slice of imagery
in detail too distant to be legible to the unaided
eye. This is the world as it really is, undistorted by
the limitations of the human physiology.[50]

Over twenty years at *LIFE* magazine, Feininger
produced more than 340 features and photoessays.
He was one of ten photographers whose work was
included in the exhibition *Ideas in Images*, organ-
ized by the Worcester Art Museum in 1962; a
decade later, the Museum presented a solo exhibi-
tion of his photographs of New York.[51] After leaving
LIFE in 1962, Feininger concentrated on picture
books of natural subjects. Notable among them are
The Roots of Art and *Mountains of the Mind,* which
explores the miraculous design of organic evolu-
tion, ideas influenced by the writings of biologist
and anthropologist Loren Eisley.[52]

Following World War II, **OTTO STEINERT (142)**
led a movement to synthesize the divergent trends
of earlier German photography in a style that came

to be known as *Subjektive Fotografie*. These artists strove to combine the *Neue Sachlichkeit*, and its clear and impartial observation of the world, with the experimental styles explored at the Bauhaus, such as oblique and disorienting points of view, and theatrical Surrealism. Steinert was born and raised in Saarbrücken, where he constructed his own camera at age eleven, and made pictures of his dog, family, and friends.[53] He studied medicine and began practicing as a surgeon in 1939. During World War II, Steinert was a medical officer in the German Army, serving at the front and at the University Clinic in Kiel. During the postwar occupation of Germany, he was prevented from practicing medicine. He returned to Saarbrücken in 1947 to work in a photography supply store and as a portrait photographer. The following year Steinert began teaching photography at the Staatliche Schule für Kunst und Handwerk. To promote local creative photography further, he helped to start the Fotoform group, which first exhibited their work together at the Photokina exhibition in 1950.[54] Steinert also organized the first of three exhibitions titled *Subjektive Fotografie* in 1951, which emphasized the consolidation of the style, and also included a section on the work of László Moholy-Nagy, Man Ray, and Herbert Bayer (nos. 94, 120). Steinert published two books to explain the philosophy behind the exhibitions.[55]

Sidewalk exemplifies Steinert's work of the period, as well as the imagery and means of *Subjektive Fotografie*.[56] It combines strong design and an unusual perception in an image of everyday life. Looking down onto a sidewalk from above, the artist plotted a composition of basic geometric forms: large rectangular blocks of concrete pierced by a circular hole surrounding a tree, the trunk of which rises branchless to the top of the image. These basic shapes are ornamented by such details as the herringbone pattern of paving stones, and the decorative piercing of the iron grate around the tree. Lying in the middle of the sidewalk, a single dried leaf symbolizes the life of the tree, the passing of the seasons. It represents a time, scale, and pace quite different from that of a human being who passes through the image so quickly that only the millisecond's pause of his foot on the pavement is registered on the film. The choice of subject and its isolation from nature were important issues for Steinert and his colleagues and followers.

In 1952 Steinert became director of the photographic department of the Staatliche Werkkunstschule, and also taught in the department. Seven years later, he moved to Essen to become director of the Folkwangschule für Gestaltung. He also served as curator of photography at the Museum Folkwang, building an excellent collection and organizing many exhibitions on historic and contemporary photography. He perpetuated the ideas of *Subjektive Fotografie* through a series of seminars, *Otto Steinert und Schüler*, at museums throughout Europe.

As a photographer and as a teacher, **AARON SISKIND (143)** demonstrated the expressive potential of a medium still often dismissed as merely descriptive. The son of a tailor in the Lower East Side of Manhattan, Siskind grew up speaking Yiddish at home.[57] He attended De Witt Clinton High School, studied literature at the City College of New York, and then became a public school English teacher. Siskind received a camera as a wedding gift in 1929 and taught himself the techniques of photography. He joined the New York Workers' Film and Photo League, where amateurs and professionals — most devoted to documentary photography — shared rudimentary darkrooms, expertise, exhibitions, and publication projects. Siskind helped to establish the Feature Group at the Photo League, a production unit that created such independent films and photography series as *Dead End: The Bowery* and *Harlem Document*.[58] In 1932, Siskind began working as a freelance documentary photographer.

Late in the 1930s, Siskind began exploring abstraction in his work. While summering in Massachusetts in 1943, he made closeup studies of rocks, objects he found on the beach, and disintegrating signs, concentrating on graphic two-dimensional design rather than illusionistic space. These experiments coincided with the growing popularity of Abstract Expressionism and his friendships with painters such as Franz Kline and Willem de Kooning. In 1947 Siskind began showing his work at the Charles Egan Gallery, where a number of New York School painters exhibited.[59] In summer 1951 the photographer taught at the Black Mountain College Summer Art Institute, an experimental program where several of the Abstract Expressionists taught. At Black Mountain, Siskind met Harry Callahan (no. 133), who invited him to join the faculty of the Institute of Design of the Illinois Institute of Technology in Chicago.

In 1953, Siskind tentatively began to photograph divers, silhouetted against the sky in various positions. The project continued until 1955, when the images were published as *Terrors and Pleasures of Levitation*. A male figure is centered in each square of white, and seems to float in indeterminate space rather than fall toward the swimming pool. Using a hand-held twin-lens reflex camera, Siskind increased the contrast of the images through exposure and processing, obliterating detail and silhouetting the figures as abstract forms. Without context or scale, the human figures become as abstract as the splashes of ink or paint in an image of improvisational calligraphy.[60] Like a Zen koan, the poetic title of the photographic suite

143

Aaron Siskind
American, 1903–1991

Terrors and Pleasures of Levitation #471, 1954

Gelatin silver print
25.3 x 24.2 cm
Purchased through the gift of Mrs. Joseph Goodhue, 1982.89

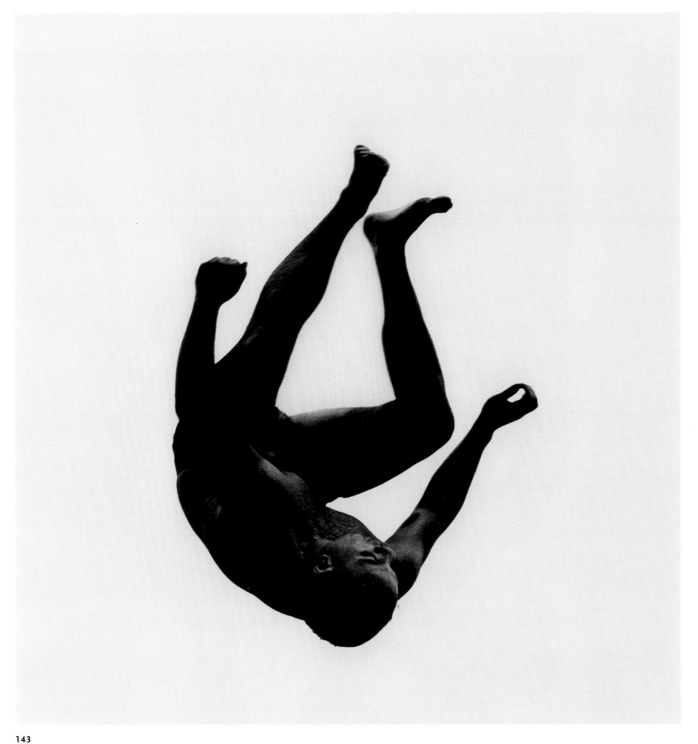

143

directs our consideration of these images. Each photograph represents one man, isolated and controlled by unseen forces. For a fleeting moment, however, his dancelike rolls or twists seem to express feelings of liberation, tension, or fear. In that suspended instant, anxiety and exhilaration are indistinguishable.[61]

GYORGY KEPES (144) employed a similar imagery of abstraction in the cause of self-expression. His works were among those challenging the assumption that the purpose of photography is to record the appearance of reality. Kepes spent his early years in the countryside near Selyp, Hungary, where he was born.[62] As a child he moved with his family to Budapest, where he studied painting at the Academy of Fine Arts from 1924 to 1928. He was a member of the avant-garde artists' group Munka (Work), which, agreeing with Aleksandr Rodchenko (no. 90) that painting had become irrelevant, concentrated instead on film, photography, and COLLAGE. In 1930, Kepes moved to Berlin, to become the assistant to László Moholy-Nagy, the Hungarian-born artist who had taught at the

145

144

Gyorgy Kepes
American, born in Hungary,
1906–2001

Free Form, 1956

Gelatin silver print
50.5 x 40.5 cm
Eliza S. Paine Fund, 1991.63

145

Arnold Newman
American, 1918–

Igor Stravinsky, 1946

Gelatin silver print
18.1 x 34.3 cm
Gift of the artist, 1962.63

Bauhaus. At that time, Kepes made experimental photographs that combined the eccentric angles and dominant geometry of Bauhaus photography with the transforming power of light.

In 1937 the artist followed Moholy-Nagy to Chicago and the New Bauhaus — later the Institute of Design. Kepes became head of the school's Light and Color Workshop, in which photography was just one of many ways to explore light. His photographs of 1937 to 1943 were very experimental, exploring the bold patterns of light and shadow in a city of skyscrapers. Kepes made PHOTOGRAMS of metal filings patterned by magnets, photographed distorted line drawings in parabolic mirrors, and created color abstractions by dropping dyes in water and photographing their rapid diffusion with a STROBOSCOPIC FLASH. Some of these ideas were described in his book *Language of Vision*,[63] which prompted an invitation to teach at the Massachusetts Institute of Technology (MIT). There the artist explored other media, including kinetic light installations, and stained glass and mosaic murals.

Free Form is one from an extended series of photograms that Kepes made at MIT during the 1950s, when he also explored improvisation and chance in his Abstract Expressionist paintings.[64] Unlike his earlier, complex photograms, these simple works are based on physics and chemistry. Kepes experimented with direct application of fluids and objects to photographic paper, producing organic abstract shapes. He also pressed mixtures of ink and casein between two plates of glass to mask photosensitive paper in the darkroom. His fluid, plasmic images possess an almost Asian

simplicity and serenity, offering graceful, minimal opposition of circle and line.[65]

Kepes often included his photographs in thematic exhibitions at MIT, including *The New Landscape*, which examined the dichotomy between the observations of artists and scientists.[66] In 1956, he began to organize seminars at MIT, resulting in the *Vision + Value* book series. The artist's concept of a collaborative community of artists and scientists evolved into the Center for Advanced Visual Studies, established at MIT in 1967. Center researchers pioneered lasers, holography, plasma sculpture, and sky art as tools of expression in public and environmental art.[67]

Creative photography profoundly influenced popular culture after World War II, through news magazines such as *LIFE*, *Look*, and the *Saturday Evening Post* in the United States, *Paris Match* and *Stern* in Europe, and similar publications throughout the world. The striking images they published became the epoch's cultural documents, and photographers' names became familiar. One of the most accomplished was **ARNOLD NEWMAN (145)**, who has photographed some of the most influential people of the mid-twentieth century. Born in New York, where his parents worked in the hotel industry, he grew up accustomed to seasonal moves between hotels in Miami Beach and Atlantic City.[68] Newman began to study art at the University of Miami, but financial hardship forced him to take a job in 1938 in a Philadelphia photography studio where he became a skillful photographic technician. Newman fell in with a group of stu-

dents from the Philadelphia Museum School of Industrial Art, several of whom — including Irving Penn (no. 136) — were pupils of Alexey Brodovitch. They freely shared their ideas, techniques, and nocturnal photography expeditions. Newman managed a portrait studio in West Palm Beach in 1939–40, and his photographs were first exhibited at the A-D Gallery in New York in 1941.

Newman's childhood recollection of a revealing photograph of a grinning Teddy Roosevelt with his big-game trophies, compared to a vacuous formal portrait of the president, led him to reason that a subject's familiar milieu could help to reveal their personality. He tested this idea in photographs of artists — his personal heroes — beginning with a portrait of painter Raphael Soyer in his studio. Pleased with the results, Soyer sent Newman to his friend the painter Chaim Gross, and other references followed. In 1945, the Philadelphia Museum of Art presented a selection of these portraits in the solo exhibition *Artists Look Like This*. Newman moved to New York in 1946, and his work appeared in such magazines as *Harper's Bazaar*, *Fortune*, and *LIFE*. He preferred to photograph in his sitter's home or workplace, using the objects, shapes, and textures available on the spot to create a revealing setting. Newman employed long exposures to keep both subject and background in sharp focus. This method required sitters to remain motionless for several seconds, sacrificing a momentary expression for a settled one.

Newman's famous portrait of Igor Stravinsky was made in December 1946 for *Harper's Bazaar*.[69] By that time, much of the Russian-born composer's work had entered the standard repertory. He combined influences of French Impressionist composers, such as Claude Debussy and Maurice Ravel, with primitive, irregular rhythms, especially in the ballets *Firebird* and *Le Sacre du printemps* (*The Rite of Spring*), composed for Serge Diaghilev's Ballets Russes. Newman had this formidable reputation in his mind when he was assigned to make the portrait. However, he had to do the sitting in a New York hotel room, far from the composer's California home. The photographer used a grand piano to symbolize Stravinsky's expansive, abstract musical world. Its grandeur almost overpowers the composer's form, which occupies only a small part of the composition. The shape of the open piano, resembling a half note, seems to point to the figure and enhance its prominence. The striking image is easily comprehended and is the most memorable portrait of the composer, even though Newman photographed him several more times for the book *Bravo Stravinsky*.[70]

The images of **PHILIPPE HALSMAN (146)**, another famed portraitist of the picture magazine era, were often distinguished by their spontaneity.[71]

He was born in Riga, Latvia, where his parents were a dentist and a grammar school principal.[72] After studying electrical engineering in Dresden, he moved in 1930 to Paris, where he studied humanities at the Sorbonne. Two years later, Halsman opened a portrait photography studio in Montparnasse. His bold, extemporary style attracted an admiring clientele, included authors, artists, and actors. His work appeared on book jackets and in such magazines as *Vu*, *Voilà*, and *Vogue*. The first solo exhibition of his work was mounted at the Galerie de la Pléiade in Paris.

This phase of Halsman's career ended abruptly when the Nazis occupied Paris in summer 1940. As a Latvian citizen, he had trouble obtaining a visa to leave France, and Albert Einstein — a longtime friend of Halsman's sister — helped him gain entry into the United States. Soon after arriving in New York, in November 1940, he began working for the Black Star Agency. In fall 1942, one of the images from his first assignment for *LIFE* was used as a cover, beginning an association that continued for the magazine's remaining thirty years, during which he created over a hundred cover images. Halsman photographed Martha Graham (no. 122) and her dance company in 1946, and made portraits of Einstein at Princeton University the following year. Extraordinary images, like *Dalí Atomicus*,[73] and bestselling picture books like *The Frenchman*, brought Halsman national celebrity.[74] At that time he designed an improved, 4 x 5–inch model of his twin-lens reflex camera — the Halsman-Fairchild — which he used throughout his career.

Marc Chagall was an old acquaintance when Halsman photographed him washing his hands at a Montparnasse well during the photographer's first return visit to Europe after the war. This candid shot is noteworthy for its anecdotal quality, which has much in common with the works of Robert Doisneau (no. 115). The painter concentrates hard on his task, unaware of the quizzical glance of a neighbor; she may be trying to place his familiar face, or wonder about his use of the public well for such a dirty chore. Halsman may have wished to show Chagall's inelegant, workaday life. When he made his first portraits of the painter in 1936, he tried hard to capture the essence of the great man. Halsman took those portraits to Chagall's home for review, and the painter seemed pleased. "Marc," asked the painter's wife, Bella, "do you think that these pictures are too good for the public? Do you think they look sufficiently Chagallian?" Years later, Halsman recalled the meeting: "I listened with horror — I was young then and Chagall's naïve and childlike paintings had created in me the feeling of a naïve and childlike painter. Now I had the feeling that the painter was fully conscious of what he was doing and that he tried hard to make each painting look as 'Chagallian' as possible. My disappointment

146

Philippe Halsman
American, born in Latvia, 1906–1979

Marc Chagall, 1951

Gelatin silver print
35.0 x 27.3 cm
William Grimm Memorial Fund, 1988.46

147

147

Todd Webb
American, 1905–2000

Studio Stove, Paris, 1950

Gelatin silver print
63.6 x 48.2 cm
Museum purchase, 1962.82

was so great that I still vividly remember the almost physical pain it caused."[75]

TODD WEBB (147) perceived a world full of poetry, and tried eagerly to capture as much of it as possible with his camera. The son of a pharmacist, Webb was born in Detroit into a strict Quaker family.[76] He studied for a year at the University of Toronto, and then became a successful stockbroker before the market crash of 1929. Afterwards he tried his hand at writing short stories, before taking a job at the Chrysler Corporation. Webb joined the

Chrysler Camera Club in 1938, and began a lifelong friendship with Harry Callahan (no. 133). Both were impressed and inspired by the ten-day workshop that Ansel Adams (no. 79) presented to the Detroit Photo Guild in 1941. During World War II, Webb served as a Navy photographer in the South Pacific. He settled in New York after his discharge, and explored the city with his view camera. Webb photographed sweeping urban landscapes, sensitive studies of ethnic neighborhoods, and street vendors along Third Avenue. The first solo exhibition of his photographs was presented by the

148

Museum of the City of New York in 1946. Later, he worked for *Fortune* magazine, and for Standard Oil Company, where Roy Stryker — former head of the Farm Security Administration Historical Section — helped him to balance the practicalities of making a living as a photographer with his artistic ambitions.

Studio Stove was made during Webb's three-year residence in Paris. The photographer explored Paris as he had New York, wandering in search of architectural spaces or human events to catch his eye. His photographs often reflect the weather and atmosphere that enabled him to capture the romantic illumination of Paris. In 1949, Webb and his new wife, Lucille, rented the studio of the American sculptor Mary Callery, where they lived until 1952. This image of the stove, chimney, and kettle in the studio exemplifies the two key elements Webb strove to incorporate into his images, a strong composition and the effects of light. He was sensitive to surfaces and their reflection or absorption of illumination. The stovepipes, bent and dented by time, reflected light off their dull but lustrous surfaces, creating different tonal effects from the reflections in the polished kettle and cast-iron stove. Each surface provided its own range of tones and reflective qualities. Webb's photograph also isolates the commonplace, forcing us to see these utilitarian objects as form. The shiny kettle and louvered stove command space in unexpected ways. The peculiar smokestack with its rectangular framelike diversions — designed to increase its radiance by augmenting its surface area — and the S-curved handle of its damper is a sculpture. These objects are like a ready-made combine sculpture by Marcel Duchamp, and carry all the consonant implications for their culture.[77]

The concept of visual poetry was also held by **MINOR WHITE (148)**, a charismatic leader of American photography at midcentury. Born in Minneapolis, the son of a bookkeeper and a dressmaker, he learned the rudiments of photography as a child from his maternal grandfather.[78] When White was a biology major at the University of Minnesota he used photography to aid his studies, and produced photomicrographs for the botany department. In 1937, he worked for the Works Progress Administration (WPA) Art Program in Portland, Oregon, photographing historic city buildings slated for demolition. He taught at the WPA art center in La Grande, Oregon, serving briefly as its director. A solo exhibition of White's photographs was mounted by the Portland Art Museum in Feb-

ruary 1942. Two months later he was drafted into the Army, then was posted to the Pacific during World War II. White participated in the Philippines invasion in 1944. Later, while stationed in Hawaii, he was baptized into the Roman Catholic Church.

After leaving the Army in 1945, White studied the history of art with Meyer Shapiro at Columbia University as a GI Bill student. He also worked at the Museum of Modern Art as an assistant to Beaumont Newhall, who introduced him to wider circles of art photographers. Thus it was that in 1946, Ansel Adams (no. 79) invited White to teach at the California School of Fine Arts (now the San Francisco Art Institute). An advocate of Adams's zone system, he developed curricula integrating advanced photographic techniques with serious studies of aesthetics and style.[79] White was among a group — including Adams, Beaumont and Nancy Newhall, Dorothea Lange, and Barbara Morgan (nos. 109, 122) — who founded *Aperture* magazine in 1952, and he was its first editor. The journal became one of the most influential forces in American creative photography. In 1953, White joined Newhall on the staff of George Eastman House, the museum of photography in Rochester, New York. His wide-ranging activities, distinctive advocacy for spiritual depth, and technical refinement established standards for American photography. In 1965 White joined the MIT faculty, where he pioneered the workshop format of teaching small groups of students. He also organized influential exhibitions at MIT, including a renowned cycle of shows exploring the spiritual aspects of photography.[80]

Bristol, Vermont exemplifies the metaphorical and contemplative quality of White's work at this time. Ordinary doors and windows were among the artist's favorite subjects, metaphors for opportunity. These portals might lead to unanticipated glimpses of fantastic yet momentary illumination. Throughout his life, White was interested in the study of comparative religions, including Zen and the Gurdjieff philosophy, and in astrology. He strove for monastic simplicity in his life, practiced meditation rituals; and incorporated these explorations into his teaching. White looked to the intensely detailed views and vigilant printing methods of Ansel Adams and Edward Weston, and their use of the straight photograph to convey metaphysical meaning. For a wide audience of creative photography White was perceived as a mystic, advocating the use of the camera for communication through visual poetry, and even as a means of self-discovery.[81]

148

Minor White
American, 1908–1976

Bristol, Vermont, 1968

Gelatin silver print
26.6 x 21.0 cm
Gift of Irene Shwachman,
1974.37

A sobering view of American life was presented in *The Americans* by **ROBERT FRANK (149)**, a publication that became a potent model for creative photographers and photojournalists, and helped transform the photography book into an independent art form. Frank was born in Zurich, the son of a German entrepreneur who imported Swedish radios to Switzerland.[1] To avoid the family business Frank began a volunteer apprenticeship in 1941 with the Zurich photographer Hermann Seegesser. The following year he began working in the studio of the industrial photographer Michael Wolgensinger. After completing his national service, Frank moved in 1947 to New York, where he worked in advertising and fashion photography. He admired Walker Evans's (no. 106) book *American Photographs*, and his work impressed Evans and other deans of American photography, who supported his successful application for a Guggenheim Fellowship in 1955. To explore the United States with his camera, Frank drove across the country, EXPOSING over twenty thousand NEGATIVES. He selected eighty-six images, reflecting his personal sense of the country and its people, photographs that depict an empty race of melancholy consumers, charmless despite their unequaled material prosperity.

Ranch Market, Hollywood represents one of the series' leitmotifs, the abundance of food, and its constant, unthinking consumption at restaurants, parties, and picnics. The American preoccupation with intemperate sensual gratification became a metaphor for impulsive excess. Glitzy diner interiors, with their polished metal walls and marble counters, were favorite places for Frank. In these gaudy settings the multitude consumed mass-produced food in quantity. At the Ranch Market, this prosperity is reflected in rows of packaged sandwiches and cartons of milk, along with the sensational advertisements for more food. The bounty is unimpressive to a waitress whose vacuous expression is anything but welcoming. Generally, people seem introverted and self-centered in Frank's photographs, and seldom find eye contact with each other. They show more concern for their own convenience. Their cars and highways, telephones and radios, represent the other recurring themes of motion and communication in the series. Frank used a 35mm hand-held camera to shoot quickly and furtively, and his photographs have an unpremeditated, accidental look. Those he selected for his series are often tilted, blurred, or grainy images, retaining imperfections usually corrected in printing. These choices seemed iconoclastic in comparison with the techniques of the day's most respected photographers, such as Ansel Adams and Minor White (nos. 79, 148).

Having difficulty finding an American publisher for his daring book, Frank arranged for a French edition, which included extensive commentary by renowned authors and made *Les Américains* more sociology than art.[2] When Grove Press finally produced an American edition, the glosses were replaced by a brief, stylish introduction by Frank's friend, the poet Jack Kerouac.[3] This edition identified the photographer with a youthful postwar counterculture. Frank lived and worked in New York among the Beat poets and the Abstract Expressionist painters, and his photographs were meant as an anti-authoritarian political statement.[4]

In contrast to Frank's misanthropic individualism, **DUANE MICHALS (150)** began his photographic career with images intended to draw people together. He went on to revolutionize the creative medium by expressing ideas in sequential images. Michals was born in McKeesport, Pennsylvania, the son of a Pittsburgh steelworker.[5] At age fourteen he took Saturday afternoon watercolor classes at the Carnegie Institute, and soon became interested in photography. Deeply influenced by poetry, he carried a copy of Walt Whitman's *Leaves of Grass* while serving in the Army during the Korean War. After his discharge, Michals attended the University of Denver and then the Parsons School of Design, planning a career as a graphic designer. However, within the year he had taken the first of several jobs in publishing. In 1958, when

149

Robert Frank
American, born in Switzerland, 1924

Ranch Market, Hollywood, 1956

Gelatin silver print
20.7 x 31.6 cm
Purchased through the gift of Mrs. Joseph Goodhue, 1983.34

149

150

Duane Michals
American, 1932–

Children in Leningrad, 1958

Gelatin silver print
12.6 x 17.9 cm
Museum purchase, 1967.31

150

Michals planned a trip to the Soviet Union, he borrowed a friend's camera.

Children in Leningrad is one of the photographs from Michals's Russian journey. At the height of the Cold War, he wandered around Soviet cities, making portraits of people who were supposedly adversaries of Western democracy. In their bleached pinafores and ties, these scrubbed children seem like characters from an earlier time. Their faces reveal very distinctive personalities, amusement, and mischievousness mixed with innocence. They are like children everywhere and reflect more common humanity than differences and antagonism. Their prosaic guilelessness is attractive and easy to understand. However, Michals cautioned about reading too much into photographic portraits. "Some photographers can be very presumptuous in their self-delusions about 'capturing' another person with their cameras. . . . What you see is what there is. It is also nonsense to reduce people to just their costumes, mere social, racial, and sexual cliches. That is looking at people with the pretensions of looking into them. We never see anyone at all."[6]

Michals's Russian experiences revealed a passion for photography. In 1961 he began working as a commercial photographer and publishing his work in *Esquire* and *Mademoiselle* magazines. The first solo exhibition of Michals's work, mounted at the Underground Gallery in New York in 1963, comprised his Russian photographs. He felt fortunate not to have attended photography school, for his

naïveté enabled him to redefine the medium to suit his own needs. Aiming to express ideas instead of capture images, Michals staged photographs and organized them into series that explore the confounding mysteries of the human condition.[7] The sequence of nine photographs, *Things Are Queer*, for example, begins with the image of a lavatory, with its shiny porcelain fixtures, and a mirror over a sink. An enormous foot appears in the second frame (fig. 7),[8] revealing that we have been viewing a model window display, not a real bathroom. As the camera draws back, the image is revealed as the illustration in a book; receding further, we see that the book is held by a bald man — Michals himself — seen from the back; the reader stands in a narrow brick lane; finally the retracting camera reveals that the reader was to be seen in the bath-

Fig. 7. Duane Michals, *Things Are Queer, Nine Photographs in Sequence, #2*, 1971, gelatin silver print.

151

151

Josef Sudek

Czech, 1896–1976

Glass and Bread, 1950

Gelatin silver print
16.4 x 12.7 cm
Sarah C. Garver Fund,
1990.152

room mirror in the first photograph of the sequence. "I want to get into something that I can't truly describe," Michals said. "It's the difference between reading a hundred love stories and actually falling in love."[9]

In diametric opposition to Michals's series was the late work of Czech photographer **JOSEF SUDEK (151)** who, rather than provoking meaning between photographs, tempted the viewer to go deeper into each image. He strove to communicate that poetry surrounds us all, if we only stop to perceive it. Born and raised in Kolín, Sudek taught himself the tech-

niques of photography as a hobby when he trained to be a bookbinder in Prague.[10] During World War I, he was drafted into the Austro-Hungarian Army and sent to the Italian front. Sudek was injured by an exploding grenade, and his right arm had to be amputated. Since this disability ended his career as a bookbinder, he returned to photography during a long recuperation in the Prague Military Hospital. As a founding member of the Fotoklub Praha (Prague Photo Club), he was influenced by the American Pictorialism of Drahomír Josef Růžička. Sudek also studied with Karel Novák at the State School of Graphic Art from 1922 to 1924, and

helped start the Ceska Fotograficka Spolecnost (Czech Photographic Society), which provided vital connections to avant-garde ideas. Sudek made a career in advertising photography, portraiture, and the reproductions of art in Prague. He concentrated his creative energies on documenting the postwar reconstruction of Saint Vitus's Cathedral and, in 1928, published the limited edition portfolio *Svatý Vít* (*Saint Vitus's Cathedral*), imbuing the Gothic building with Surrealist mystery by shooting in twilight and at night.[11] The first solo exhibition of Sudek's work was mounted at the Družstevní práce publishing house in 1932, and his work was included through the decade in noteworthy avant-garde photography shows in Prague. In 1940, Sudek was amazed to discover the quality of large-scale CONTACT PRINTS, and he stopped using the ENLARGER. He collected old cameras to make oversized NEGATIVES, and the technique changed his style.[12]

During World War II, Sudek secluded himself and concentrated on still-life photography. Gradually he progressed from isolated objects like an egg, or single flower in a vase, to more complex arrangements, proceeding with the systematic method of a true artisan. "I believe that photography loves banal objects," Sudek wrote, "and I love the life of objects."[13] *Glass and Bread* is one from this extended series, in which the photographer exploited all the refinement and visual detail that his medium allowed. Sudek chose familiar subjects, but his beautiful images make them seem as if we see them for the first time. For despite their simple forms, these objects have complex textures, colors, and transparencies, revealed by dramatic illumination. A simple drinking glass reflects and refracts light with the mysterious depths of a crystal ball. The photograph reveals every crevice in the loaf as a shadowy cavern, a scar is apparent from each blade pulled across the cutting board, and we see the tiny dried bubbles of beer foam sticking to the glass. These details evince recent actions, but the timeless scene might be centuries old.

Acute perception, an impeccable design sense, and insatiable visual curiosity characterize the work of **HANS HAMMARSKIÖLD (152)**, one of Sweden's leading photographers of the twentieth century. The son of a Stockholm businessman, he learned to use camera and DARKROOM in prep school at the Ostra Real from 1936 to 1944.[14] While still in school, he sold his first photographs to Swedish news and fashion magazines, and in 1947 he served as an apprentice to Rolf Winquist at the Uggla portrait studio in Stockholm. Afterwards, as Hammarskiöld began his own professional career, he frequented the studio of Sten Bellander in the Drottninggatan in Stockholm, a favorite meeting place for young photographers. His first book of

Swedish landscape photographs appeared in 1951.[15] The following year, Hammarskiöld's nature photographs won the coveted photography prize awarded by the newspaper *Svenska Dagbladet*, and his reputation became international when a show organized by the magazine *Unga Fotografer* was exhibited in New York.

In 1954, Hammarskiöld joined Condé Nast Publications in London, and his work regularly appeared in *Vogue* and *House and Garden* magazines. The photographer's international stature at the time is reflected by the inclusion of his work in Edward Steichen's (no. 85) *Family of Man* exhibition. Hammarskiöld's book *Objektivt sett med foto i fokus* (*Objective Photographs in Focus*), became one of the day's most popular and influential books in Europe.[16] He established a successful freelance studio in Stockholm, concentrating on commercial, architectural, and fashion work, as well as portraiture.[17] In 1958, he was one of the ten founder-members of the Tio Fotografer group. Their work had a significant impact on American photographers of the early 1960s with its fresh, life-enhancing approach that represented a full range of subjects in bold, simple designs derived from elemental natural forms.[18]

Frost-Covered Leaves shows Hammarskiöld's ability to find an engaging composition in the most familiar subjects. In this winter still life, dried leaves fallen randomly on the ground have become coated with the frost of a frigid morning. The diagonal framing of these motifs excites an energy that seems to twist and swirl the leaves together in a flat, shallow envelope of space. Bundles of parallel veins in long, twisted leaves are reminiscent of the expressive brushstrokes of then-current Abstract Expressionist or *tachiste*-style painters. By increasing the contrast of his image, through exposure and in the darkroom, the artist emphasized its linear and granular qualities. The sharp differences between gleaming white and rich black approximate the pictorial effects of intaglio printmaking.

Hammarskiöld combined his natural still lifes with a full range of photographic images during the late 1960s into multimedia performances he called "Pictoramas." These employed forty to sixty electronically controlled projectors, displaying hundreds of his photographs in synchrony with recorded music. At that time, Hammarskiöld also collaborated with the physicist Carl Frederik Reuterswärd on a study of the imagery of laser projection.[19] He began to explore color photography during the 1980s, favoring DYE-DESTRUCTION processes for projects as diverse as botanical still life, urban landscape, and historical photoessays.[20]

The special sensitivity to their surroundings apparent in the work of Sudek, Hammarskiöld, and many other photographers is apparent in the work

152

Hans Hammarskiöld
Swedish, 1925–

Frost-Covered Leaves, about 1959

Gelatin silver print
38.5 x 28.7 cm
John G. Berg Memorial Fund, 1987.167

153

153

Art Sinsabaugh
American 1924–1983

Midwest Landscape #5, 1961

Gelatin silver print
10.5 x 48.3 cm
Purchased through the gift
of Mrs. Joseph Goodhue,
1983.13

PRECEDING PAGES:
153 (DETAIL)

of **ART SINSABAUGH (153)**, who created some of the most affectionate and evocative images of the Midwestern states. Born in Irvington, New Jersey, he began making photographs as a boy with a Kodak Brownie and a cheap 8mm movie camera.[21] Sinsabaugh worked in a department store photography studio as a teenager, and served as a junior photographer for the United States War Department. During World War II he served as a sargeant photographer in the Army Air Corps in the Far East. After his discharge in 1946, he became a GI Bill student at the Institute of Design, where László Moholy-Nagy, Arthur Siegel, and Harry Callahan (no. 133) were among his teachers. After completing his bachelor's degree in 1949, Sinsabaugh joined the faculty at the Institute of Design, heading its evening photography program from 1952 to 1959. He moved to the University of Illinois, Urbana, in 1959, as chairman of the department of photography and cinematography. Sinsabaugh also founded the Visual Research Laboratory in Urbana and was codirector for several years. The first solo exhibition of his work was presented at Saint Mary's College in Notre Dame, Indiana, in 1959.

Midwest Landscape #5 is one from an inventive series of photographs in which Sinsabaugh made insightful use of technique. He used an old VIEW CAMERA known as a "banquet camera," developed at the turn of the century for making short, wide group portraits and photographs of social events. Experimenting with the instrument, Sinsabaugh realized its affinity to the broad, horizontal expanses of the American prairie. The photographer often created subtle, rhythmic compositions that emphasize the flat Midwestern landscape. This image of a farmstead shows a line of trees, undoubtedly planted generations ago as a windbreak, where the buildings of a small farm cluster. With its single electric line and windmill pump, the farm seems an isolated, self-sufficient operation. It is the sort of family farm that once abounded in rural America. The scale and breadth of the view is suggested by the three Black Angus cattle grazing in the foreground at the right. Though the farm seems otherwise deserted, we assume that the family is hard at work, in fields, barn, or kitchen.

As the wind blows the leafy trees, tall grass, and fluffy clouds, we are left to contemplate the loneliness, isolation, and peace of the rural lifestyle.

In 1963, a group of Sinsabaugh's friezelike landscapes were published with poems of Sherwood Anderson.[22] His work was also included in the exhibition *The Photographer and the American Landscape* at the Museum of Modern Art, and a solo exhibition of Sinsabaugh's photographs was mounted at the Art Institute of Chicago.[23] In that year, the Chicago Planning Commission engaged the photographer to produce a suite of urban landscapes, a project that he executed over two years. He took the opportunity to return to the Institute of Design for a master's degree. Sinsabaugh's urban landscapes and bucolic views were combined, in a variety of formats, in the solo exhibition of his work at the Museum of Modern Art in New York in 1978. In 1980, Sinsabaugh used a 12 x 20–inch camera to make remarkable panoramic views of the American Southwest, images that capture the expansive skies of the region.

In his early urban landscapes **RAY K. METZKER (154)** explored effects of light and shadow in the city, and the camera's potential to combine detail and broad abstraction. Growing up in a Milwaukee suburb, he began making photographs when he was thirteen years old with a Kodak ABC developing kit.[24] His photographs appeared in his high school newspaper and in the local journal, the *Whitefish Bay Herald*. In 1949 Metzker attended Beloit College in Wisconsin, and after graduation he worked as an assistant in a commercial studio in Cedarburg, Wisconsin. He was drafted into the Army, and served in Korea from 1954 to 1956. Metzker continued his studies at the Institute of Design in Chicago in 1957, where Harry Callahan and Aaron Siskind (nos. 133, 143) were among his teachers. His master's thesis, "My Camera and I in the Loop," is a portfolio of nearly two hundred street photographs and urban views taken in Chicago's downtown area bounded by the elevated transit line. Candid views of people on the streets are combined with architectural studies and the shadowy structure of the elevated railway. These photo-

154

graphs were featured in Metzker's first solo exhibitions, at Beloit College and at the Art Institute of Chicago in 1959. Edward Steichen (no. 85) purchased his early photographs for the Museum of Modern Art and assisted with his application for a Fulbright Fellowship, enabling the young photographer to travel in Europe in 1960–61. Metzker joined the faculty of the Philadelphia College of Art in spring 1962, and again found his imagery in the city. After the splendors of Europe, however, and the architectural muscularity of Chicago, the Philadelphia streets seemed narrow. So Metzker spent much of his time photographing in the relatively open areas near City Hall. "I walked the streets with the 35mm camera, seeing the city and orienting myself. . . . I took out the 4 x 5 view camera on the weekends when the streets were quiet."[25]

In his teaching and in his own work, Metzker explored juxtaposing the gestures of people on the street with the bold geometry of the buildings and their shadows. *Philadelphia* exemplifies those remarkable experiments with space, light, and shadow. A stone pier vertically bisects the image, also separating an arcaded sidewalk from the street. Soft sunlight falls from the left, illuminating the building, walkway, and one side of the column, casting a deep shadow. The light accents a motorcyclist standing in the street, and glints off his rearview mirror and a shiny parked car. The same shaft of cool evening light picks out the profile of a woman moving along the sidewalk. The figures seem insubstantial, isolated in their shadows amidst a cold cave of stone, glass, and polished steel. They also appear completely alienated from one another. Fascinated by geometry and shadow, Metzker progressively increased the contrast of images like this, to create images where figures emerge from hard-edged abstractions of black-and-white. He printed several related images in blocks, in abstract "Composites," analogous to Pop Art as Siskind's (no. 143) photographs paralleled Abstract Expressionism.[26]

The cosmopolitan photojournalist **LEONARD FREED (155)** has understood photography to be the universal language of our time, and the most powerful way to affect more people. "To be a poet-photographer is both saddening and challenging," he once mused. "Saddening to think that literary traditions are being lost to a language that is only in its infancy. Challenging in that one is free to be original."[27] Freed was born in Brooklyn, New York, the son of Jewish immigrants from Belarus, who were proudly working class and radical in their politics.[28] At age twenty, he bought a 35mm hand-held camera and sailed to Europe. He traveled widely, paying his way by working as a photographer. Freed married a Dutch woman, and learned the fine points of developing and printing by working in an

Amsterdam photography lab. Returning to New York in 1954, he tried his hand at painting and studied with Alexey Brodovitch, who reignited his interest in photography. Freed became a freelance photojournalist, and by 1958 his images appeared in such magazines as *LIFE*, the *New York Times Magazine*, the *Sunday Times Magazine* in London, as well as *Der Stern* and *Geo* in Germany. Recognition grew further when his photographs appeared in the book *Joden van Amsterdam* (*The Jews of Amsterdam*).[29] Living in the Netherlands again from 1960 to 1963, Freed worked for the journal of the Salvation Army. For Dutch television, he produced the film *Dansende vromen* (*The Dance of the Pious*) about Hasidic Jews in living in Jerusalem and in New York.

Civil Rights Demonstration is one of many photographs that Freed made in the mid-1960s that later appeared in his book *Black in White America*.[30] The volume includes wide-ranging images of African American culture, taken in homes, workplaces, and churches. Among them are Freed's famous photographs of Dr. Martin Luther King greeting well-wishers, and of Harlem children playing in water from a hydrant on a hot summer day. Freed captured many poignant images of the civil rights movement at a time when tragedy mixed with triumph. The blurred graininess of this image of a New York demonstration shows that Freed snapped the picture from a distance, then enlarged the image and framed it tightly in the darkroom. This close cropping brings the viewer into the intensity of the moment. As two policemen struggle to restrain a young black man, the well-dressed demonstrator wrestles to loosen the grip of one who grabs the knot of his tie. He crumbles into the lower corner of the composition. By contrast, the central policeman seems determined and certain, and stands as a powerful symbol of authority. This provocative image has a universally accessible impact. Such immediacy was Freed's goal and the strength of many of his photographs. "I look for the relationship of forms," he later wrote. "This is my super-art appreciation course. All of this while a beaten woman screams. And I tell myself, I'm doing this for her, so none will forget this day."[31]

Like Freed and many of his contemporaries, **JAMES KARALES (156)** was committed to confronting injustice and violence at their source. The son of Greek immigrants in Canton, Ohio, he attended Ohio University to study electrical engineering but became so fascinated by his roommate's work in the darkroom that he joined the photography program.[32] After graduating in 1955, Karales went to New York and applied for a job at the Magnum Photo agency. Instead, he was engaged as an assistant to W. Eugene Smith (no. 130). For the next two years, Karales lived with the

154

Ray K. Metzker
American, 1931–

Philadelphia, 1962

Gelatin silver print
15.1 x 22.4 cm
Purchased through the gift
of Mrs. Joseph Goodhue,
1983.22

155

155

Leonard Freed
American, born 1929

Civil Rights Demonstration,
1963

Gelatin silver print
26.1 x 37.5 cm
Sarah C. Garver Fund,
2003.5

Smith family, working without pay, chiefly helping the photographer with his Pittsburgh essay. In addition to becoming an outstanding printer, Karales came to adopt Smith's resolute view of the photographer's role and learned to immerse himself deeply in the subjects of his photoessays. He also strove to uphold his vision for each project, and as a result, even his most desolate photographs accentuate the humanity of his subjects.

In 1958, Karales returned to Ohio and photographed the ramshackle town of Readville. Once a stop on the underground railroad, the old mining center had become one of the few integrated working-class communities in the nation. These photographs became the subject of Karales's first solo exhibition at the legendary Limelight Gallery in New York, where Edward Steichen (no. 85) purchased two for the Museum of Modern Art. The Readville photographs also helped Karales to be hired as a staff photographer for *Look* magazine in 1960. The photographer documented pivotal events of that tumultuous era, and his images were noted for their circumspection and empathy. In 1962 Karales followed Dr. Martin Luther King on his crusade across the segregated South and afterwards produced a landmark *Look* magazine pho-

toessay. His most famous image of the period is a dramatic scene of marchers on the Freedom March from Selma to Montgomery, Alabama, carrying American flags along the crest of a hill.[33] The photoessay won the National Press Photographers Association award in 1965. By that time, Karales had spent almost three years alternating between projects on the civil rights movement and trips to Vietnam.

In 1963, Karales was one of the first photojournalists to go to Vietnam, at a time when the few American Special Forces in Indochina served chiefly as advisors. In this poignant image the presence of a South Vietnamese officer in battle gear suggests that the scene follows a military incident; the only offensive actions at that time were attempts to relieve hamlets threatened by the Viet Cong.[34] The American soldier is a member of a medical helicopter unit. Karales seems to have captured the sad aftermath of a mission to assist the South Vietnamese and evacuate military and civilian casualties to medical facilities. The deep distress on the young American's face may suggest his futile attempts to save the wounded child. Karales's photograph symbolizes the anonymous human toll of that protracted

war, only just beginning for the United States. "The picture offers a solemn tribute," reflected military historian Shelby Stanton, "to the uncounted, unsorted and anonymous legions of lost Vietnamese children, and the generation they would have represented — in stark contrast to the carefully recorded and tabulated scrolls of the dead United States military personnel arranged on the Vietnam Wall for everyone to read and remember."[35]

The extraordinary visual power of photography, in the command of a master, is reflected in an equally keen and persuasive image glorifying violence. *Dying Bull* is the work of **LUCIEN CLERGUE (157)**, much of whose oeuvre epitomizes the ambiance and culture of Provence, in southern France, and the character of his hometown of Arles.[36] Clergue took his first photographs at age ten, and when he was twenty years old, he created a widely recognized series representing children in the ruins of postwar Arles posed as Saltimbanques. These traveling performers had passed through the

city for centuries, but now would find only devastation. At that time, Clergue made other provocative photographs of dead animals, architectural ruins, and the equally ravaged culture of European Gypsies. Clergue's fascination with Romany music helped him overcome childhood fears and explore the mysterious Gypsy culture in his photographs.

In Arles, Clergue came to know Picasso, his principal mentor.[37] The painter introduced him to Jean Cocteau, who encouraged his interest in film. Clergue was a still photographer on the movie set of Cocteau's *Le Testament d'Orphée*.[38] The influence of both artists is apparent in Clergue's female nudes, begun in 1956, several of which were first published in *Corps mémorable*, a volume including poems by Cocteau and Paul Éluard, with a cover designed by Picasso.[39] Like his Saltimbanques, the photographer's nudes are types rather than individuals, meant to evoke the ancient allegorical function of the figure in European culture.[40] Picasso, Cocteau, and Clergue were afficionados of the bullfight, atavistically drawn to this ancient contest of

156

James H. Karales
American, 1930–2002

Vietnam, 1963

Gelatin silver print
27.10 x 34.4 cm
Stoddard Acquisition Fund,
2003.16

157

157

Lucien Clergue
French, 1934–

Dying Bull, 1964

Gelatin silver print
28.7 x 40.2 cm
Museum purchase, 1965.388

life and death. Its passion, pageantry, and even its erotic aspects provided enduring inspiration for their art. Clergue often photographed his friends at the *corrida* in the Roman amphitheater at Arles and at other bullrings in southern France and northern Spain. He collaborated with Cocteau on a picture book about the great matador Antonio Ordóñez, and on a photoessay on the bodies of vanquished bulls.[41] Clergue's photographs also illustrate a popular book with the testaments of several authors on the bullfighter known as "El Cordobe."[42]

Like the best photojournalists of his day, Clergue spent time getting close to his subjects, including the Gypsy guitarist "Manitas de Plata" and the matadors Antonio Ordóñez and El Cordobe. In *Dying Bull*, however, his aim was more aesthetic than documentary. His friendship with El Cordobe allowed him privileged access to the action at a bullfight in Nîmes. In this remarkable photograph the matador performs the *descabello*, dispatching a dying bull still on its feet.[43] Holding his *muleta*, or small cape, in his left hand, El Cordobe tempted the charging bull to drop its head, exposing the back of its neck. The matador struck the beast as it

passed, with a distinctive sword that has a crossbar four and a half inches from an extremely sharp point to prevent the blade from penetrating deeply. Thrusting the weapon into the spot where the bull's nerve attached to the skull, he severed the nerve, and killed the animal instantly. At that moment Clergue snapped his famous picture, which was featured in his joint exhibition at the Worcester Art Museum only months later.[44]

A very different relationship between man and animal is seen in *San Marcos, Texas* by **GARRY WINOGRAND (158)**, a photographer who found the extraordinary amidst the commonplace. His work characterized a new idiom of social landscape in American photography, one that valued the authenticity of the fleeting and the incidental. Winogrand was as sensitive to irony and human foibles as William Hogarth, Honoré Daumier, or other great artists of social satire. He was born in the Bronx, the son of a leatherworker, and a garment pieceworker.[45] Winogrand learned the techniques of photography as a weather forecaster for the Army Air Force when he was stationed in Georgia. After

his discharge, he studied art briefly at City College of New York. When he transferred to Columbia University and discovered that the art school darkroom was always open, he shot photographs during the day and printed them at night. In 1949, Winogrand also studied at the New School for Social Research with Alexey Brodovitch, who promoted a fresh, immediate style emphasizing intuition and expression instead of precise description and craft. In 1951, Winogrand became a freelance photojournalist in New York. His work photographs appeared in magazines like *Collier's*, *Pageant*, and *Sports Illustrated*, but he also made creative studies of the human figure in boxing gyms and on the ballet stage.

Around 1960, as television proliferated and the readership of illustrated magazines declined, Winogrand became an advertising photographer. The end of his marriage and fears of losing his children coincided with the Cuban missile crisis and an overarching sense of insecurity. Winogrand responded by burying himself in creative work. He exposed hundreds of film rolls, hoping that successful photographs or a thematic body of work might emerge. While many of the images he selected reflected his own insecurities, he did indeed begin to discover a unique talent for capturing human frailties.

In 1964 Winogrand was awarded a Guggenheim Fellowship, and he traveled to the Southwest and California. *San Marcos, Texas* is from these travels. Like many of the artist's photographs, the image of a performing piglet is immediately amusing. His size and proportions, compared to his trainer, seem cute, as does the ardor with which he follows a lure through the water. Longer examination reveals much more in the apparently incidental image. By contrast to the pig's fuzzy bulk, the female form is elegant and poised. The effects of underwater illumination are also intriguing, with their highlights, shadows, and refractions. Most interesting, however, is the evident interpersonal relationship between the swimmers. The woman's pose suggests a calm, encouraging, even nurturing demeanor, while the piglet works hard to please her. Winogrand had discovered that animals immediately overcome social defenses, making their true personalities more accessible to the camera. The photographer exploited this dynamic again when he observed visitors to the Central Park Zoo. He captured a peculiar combination of anthropomorphized creatures, and the culture that they shared with their viewers, in *The Animals*, the first solo exhibition of his work, mounted at the Museum of Modern Art in 1969.[46] A decade later Winogrand made use of this sympathy when he photographed livestock, barnyard animals, and their owners at the Fort Worth Fat Stock Show and Rodeo.[47]

158

Garry Winogrand
American, 1928–1984

San Marcos, Texas, 1964

Gelatin silver print
22.3 x 33.3 cm
William Grimm Memorial Fund, 1981.4

The darkness and desolation of postwar photography was leavened in the work of **BRUCE DAVIDSON (159)** with human empathy and hope. The artist derived these values from the pathos of Depression-era photography and the uncompromising rectitude of the wartime photojournalists. Born in Oak Park, Illinois, Davidson was raised by his mother, a single parent who worked in a factory during World War II.[48] He began making photographs at the age of ten, assisted a commercial photographer as a teenager, and in 1949, won first prize in the Kodak National High School Competition. Davidson was a pupil of Ralph Hattersley at Rochester Institute of Technology from 1953 to 1955, and then attended Yale University, where he studied philosophy, and art with Alexey Brodovitch, Herbert Matter, and Josef Albers. His college thesis, which documented the locker-room drama of college football players, was published in *LIFE* magazine in October 1955. Davidson was drafted into the Army and sent to Paris, where he worked as a photographer and darkroom technician. He sought out Henri Cartier-Bresson (no. 167) and they began a lifelong friendship. Davidson's strongest influence, however, were the *LIFE* magazine photoessays of W. Eugene Smith (no. 130), which showed how photography could communicate emotions and change minds.

In 1958, Davidson joined the Magnum agency, enabling him to accept assignments and pursue his own projects. He photographed a lonely clown in a traveling circus for his first widely recognized photoessay *The Dwarf*; for *The Brooklyn Gang* he followed neighborhood teenagers in Prospect Park and at Coney Island, chronicling the challenges of adolescence.[49] A selection of his photographs was shown at the Worcester Art Museum in 1962, when Davidson was one of ten photographers featured in the exhibition *Ideas in Images*.[50] In that year, a Guggenheim Fellowship made it possible for him to chronicle the civil rights movement, in events as diverse as an early Malcolm X rally in Harlem, steel worker strikes in Chicago, Ku Klux Klan cross burnings in South Carolina, and nonviolent demonstrations in Alabama.[51]

Davidson's portrait of a young couple on East 100th Street in New York reflects his ability to enter a seemingly unfamiliar realm, and portray it with authenticity.[52] In 1966 he was awarded the first artist's grant from the National Endowment of the Arts given to a photographer. Nearly every day for the next two years he returned to the same block in East Harlem, an area inhabited by African and Hispanic Americans, many of whom lived in desperate poverty. Davidson began by simply setting up his view camera on the street; gradually he became so familiar to the residents that curiosity overshadowed their suspicion. He made friends, became attuned to neighborhood gossip, and was permitted to photograph the people and their homes, often in situations of astonishing vulnerability. His photographs reflect strong community and family

159

Bruce Davidson
American, 1933–

Untitled, from the series
East 100th Street, 1966

Gelatin silver print
32.0 x 42.4 cm
Purchased through the gift
of Mrs. Joseph Goodhue,
1982.14

159

160

160

Danny Lyon
American, 1942–

New Orleans, Louisiana, 1965

Gelatin silver print
16.4 x 24.4 cm
Mr. and Mrs. Lennart
Lindberg Fund, 1985.317

relationships unallayed by deprivation or tragedy. This affection is evident in the faces of the young couple, whose comfortable, assured expressions reflect their trust of the photographer, their feelings for one another, and delight in being together. "I entered a lifestyle," Davidson wrote, "and, like the people who live on the block, I love and hate it and I keep going back."[53]

DANNY LYON (160) revealed one of the most common yet misunderstood segments of psychology and culture: the outlaw masculinity of working-class males, the sort of antihero common to novels and films of the 1960s. His work is at once a powerful psychological study of American life and an introspective exploration. "As a child I had been afraid of so many things," Lyon wrote, "but as soon as I had a camera in my hand, I began to expose myself to the very things that were foreign to me and that I had always feared."[54] Born in Brooklyn, Lyon grew up in Forest Hills, New York, the son of a German-born ophthalmologist who fled the Nazis. An enthusiastic amateur photographer, he chronicled his own life and instilled a love of photography in his son, who began taking pictures with a Brownie Hawkeye in summer 1955. Lyon studied history at the University of Chicago, and after graduating in 1963, became staff photographer for the Student Non-violent Coordinating Committee, traveling through the South to document the conflicts and progress of the civil rights movement.[55] The first exhibition of Lyon's work was mounted at the Art Institute of Chicago in 1966. By that time he had become a member of the

Chicago Outlaw Motorcycle Club, and he recorded their exploits and their often violent lifestyle with his camera. A selection of these photographs was published in the influential volume *The Bikeriders.*[56] Like a sociology or history book, it combines his forthright images with extensive text that Lyon collected, or wrote himself in the voices of his subjects.

New Orleans, Louisiana is one of the photographs that Lyon took on his travels with the Outlaws. Though not quite as tough as the motorcycle gang imagery, it captures a similar totemic image of American masculinity. It represents Sam Shirrah playing a shooting game in a New Orleans bar, typical of the tough, slightly seedy places of masculine refuge in America.[57] He stands in the center of the composition, dressed in denim, work boots, and a Western belt buckle, a costume filled with meaning. Aiming his gun at an electronic target out of frame, Shirrah stands against a wall separating the bar, where drinkers stare ahead, from a dance hall where middle-aged men in work shirts and caps stand around on a dirty old linoleum floor smoking and chatting. The ostensible subject of the photograph is a game of riflery skill, an amusement that employs an instrument of violence to prove and project power. This vintage print was one that Lyon submitted to the Magnum Photo agency; released in 1985, its VERSO is inscribed to show that Magnum kept the image filed under "The South," and "Violence."

Late in 1967 Lyon received unrestricted access to the Texas penitentiary system, and the unprecedented authorization to take his camera anywhere — except Death Row — without a guard. Over fourteen months, he worked in six prisons,

161

befriending inmates who helped to produce *Born to Lose*, a picture album named after a tattoo on an inmate's arm. An expression of the convicts' views, it had to be reproduced illicitly at night in a prison printshop, and smuggled out under Lyon's arm. The photographer expanded its format into *Conversations with the Dead* in 1971, a book that combined his photographs with texts taken from prison records and convicts' writings. Prominent were the letters of Billy McCune, a convicted rapist sentenced to death, whose ultimate release in 1975 was facilitated by Lyon's book.[58]

DIANE ARBUS (161) used her camera to explore inaccessible segments of society. She was drawn to people, who, whether by choice or by nature, had distinctive visible identities, like cross dressers, circus performers, and nudists. She cared about these people and represented them without sentimentality or idealization. Diane Nemerov was born in New York, where her father was head of Russek's Department Store on Fifth Avenue, a company founded by her immigrant grandfather.[59] She was raised by a nanny and enjoyed a privileged childhood, attending the Ethical Culture School in

Manhattan and the Fieldston School in Riverdale. A year after graduating high school, she married Allan Arbus. Soon after their marriage in 1940, the young couple began making the store's advertising photographs. During World War II, their techniques improved when Allan Arbus trained at the Signal Corps photography school. After the war, they opened a fashion photography studio, and images by "Diane & Allan Arbus" appeared in *Glamour*, *Harper's Bazaar*, and *Vogue* magazines.

After a decade of work, Diane Arbus quit the fashion photography business. She studied briefly with Berenice Abbot (no. 105) and Alexey Brodovitch, and then became a pupil of Lisette Model (no. 124). With Model's example and encouragement, she found new courage and confidence. Arbus's photographs rapidly evolved from grainy, distant shots cropped like closeups, to unsentimental intimacies. She and Allan separated in 1959, the year her photographs first appeared in *Esquire* magazine.[60] Thirty of Arbus's photographs, which were featured in the *New Documents* exhibition at the Museum of Modern Art in spring 1967, sparked controversy and drew a following.

"Most people go through life dreading they'll have a traumatic experience," Arbus said. "Freaks were born with their trauma. They've already passed their test in life. They're aristocrats."[61] She felt admiration for Eddie Carmel, who had been a friend for nearly a decade before she shot this famous portrait of him and his parents. Carmel was born in Israel in 1936, and suffered from acromeglia, a then-incurable condition caused by a tumor on his pituitary gland. Bright and funny, he was normal-size child, but began to grow uncontrollably in his teenage years. As an adult, the only work he could find exploited his abnormality. He starred in B-grade monster movies like *The Brain That Wouldn't Die*, made novelty records like *The Happy Giant*, and appeared with the Ringling Brothers Circus as "The Tallest Man on Earth." Of her many photographs of Carmel that strikingly show how mismatched he was in society, Arbus chose to publish this image that shows how incongruous he was at home, the one place that should have provided comfort.[62] He cannot share the apparent ease that his father seems to enjoy, with his smart suit and easy chair. The surprise and confusion on Mrs. Carmel's face seems to betray the constant sadness and futile concern that she must feel for her son. It is this sense of intimacy and empathy that makes Arbus's images so extraordinary.

An intimate glimpse into African-American culture was one of many revelations provided by the work of **GORDON PARKS (162)**, an author, poet, musician, composer, and influential filmmaker, as well as an eminent photojournalist. Parks was born in the prairie town of Fort Scott, Kansas, the youngest of fifteen children of a subsistence farmer.[63] After his mother's death in 1927, he lived with his sister in Minneapolis, working a succession of odd jobs. A decade later, Parks taught himself the techniques of photography, and was soon working as a photographer for a women's clothier in Saint Paul. He joined the Farm Security Administration (FSA) in 1942 and moved to Washington, DC, where he found the Southern city deeply divided by race and class. One of Parks's first FSA photographs was a portrait of Ella Watson, an African-American cleaner at a government agency. He posed her before an American flag hanging in the building lobby, with mop and broom upturned as she stared into the camera. Parks called this signature image *American Gothic*, after Grant Wood's famous painting. Roy Stryker arranged for Parks to move with him to the Office of War Information, for which he photographed the 332nd Fighter Group, the first black Air Corps. After the war, the photographer joined the staff of *Vogue* magazine, and he traveled to Europe. During this time he published his first two books on photographic technique.[64]

Parks joined the staff of *LIFE* magazine in 1948. In his first months there, he produced a series on New York and Paris fashions, as well as a photoessay on gang warfare in Harlem. He concentrated on the life of Red Jackson, a sixteen-year-old gang leader, whose trust and confidence provided Parks with unprecedented access and accuracy. Parks attained an international reputation at *LIFE*, reflected in his celebrity portraits. During the 1950s he served as a European correspondent, and after returning to New York, focused his efforts on documenting the civil rights movement.[65] In 1963 Parks published *The Learning Tree*, an autobiographical novel based on recollections of his Kansas childhood.[66]

For a special magazine section on race and poverty, in 1968, Parks made photographs of Harlem, Chicago, and Brooklyn that were published along with his own prose and verse. The image of a tearful man gazing from a broken window was the frontispiece to the series, accompanied by the poem *What I want, What I am, What you force me to be, Is what you are.*[67] "For I am you," Parks wrote, "staring back from a mirror of poverty and despair, of revolt and freedom. Look at me and know that to destroy me is to destroy yourself. You are weary of the long hot summers. I am tired of the long hungered winters. We are not so far apart as it might seem. . . . I am too America. America is me. It gave me the only life I know — so I must share in its survival. Look at me. Listen to me. Try to understand my struggle against your racism. There is yet a chance for us to live in peace beneath these restless skies. . . ."[68]

161

Diane Arbus
American, 1923–1971

A Jewish Giant at Home with His Parents in the Bronx, N.Y., 1970

Gelatin silver print
37.8 x 37.2 cm
Gift of Mr. and Mrs. Hall
James Peterson, 1974.30

162

162

Gordon Parks
American, 1912–

What I want, What I am,
What you force me to be,
Is what you are, 1968

Gelatin silver print
24.2 x 16.5 cm
Sarah C. Garver Fund,
1994.217

A similar spirit of social consciousness led a group of Boston photographers, including **IRENE SHWACHMAN (163)**, to donate their work for the promotion of Freedom House, a popular community center in the African-American neighborhood of Roxbury. Long an influential figure in the New England photographic community, Shwachman was an artist and teacher. Irene Shirley Quinto was born in New York, the daughter of an apparel manufacturer whose family had immigrated from Lithuania.[69] She made her first photographs at age twelve, for a contest sponsored by Eastman Kodak, and though her still-life images of gardeners' tools did not win a prize, they did ignite a lifelong enthusiasm. After attending the Calhoun School in New

York, Quinto continued her studies at Columbia University, majoring in theatrical production. She began working as a script girl in the Yiddish theater and dreamed of becoming a Broadway director. Instead, in 1944 she married Harry Shwachman, a pediatrician at Children's Hospital in Boston and faculty member of Harvard Medical School. They settled in Needham, Massachusetts, and raised three children.

After two of Shwachman's works were included in the exhibition *Abstraction in Photographs* at the Museum of Modern Art in 1951, she became more serious, studying with Lisette Model (no. 124) at the New School for Social Research in 1952–53. Shwachman also assisted Berenice Abbott (no. 105)

163

163

Irene Shwachman
American, 1915–1988

*Abandoned Schoolroom,
Blanchard, Maine,* 1965

Gelatin silver print
26.3 x 28.8 cm
Eliza S. Paine Fund, 1970.55

in printing Eugène Atget's (no. 78) glass negatives for a portfolio published to celebrate the centenary of his birth. Back in Boston, Shwachman photographed the city's West End, an area then slated for demolition, with the encouragement of her husband who had grown up there. A solo exhibition of Shwachman's city photographs was mounted at the Boston Public Library in 1965, and later shown at the New York Public Library.[70]

Abandoned Schoolroom, Blanchard, Maine, exemplifies Shwachman's photographs of the period, and her fascination with interior space. In her worldwide travels she searched for quiet, empty spaces that told vivid stories about their inhabitants, perhaps reflecting the influence of Atget's photographs. The image of a classroom in a remote village in rural New England is like a glance back in time. Old-fashioned rows of students' desks with their inkwells, and the teacher's desk with its bell and crank pencil sharpener, seem like elements from Shwachman's

own time as a student. The outdated map, and faded photographs of the Roman Colosseum and the Milan Cathedral, all evoke a time gone by. Even the flag has forty-eight stars. The image becomes a metaphor for enduring values of American education. When Shwachman attended a workshop with Minor White (no. 148) in 1967, she realized her affinity for this subject, and afterwards she concentrated more purposefully on interior views.

In 1966, Shwachman joined the faculty of the School of the Worcester Art Museum, and became an inspiring instructor in the tradition of Model and Abbott. The Museum presented a solo exhibition of her work in 1972, and her photographs were included in significant group exhibitions around New England.[71] When she retired from teaching in 1979, Swachman devoted herself to artist's books, appropriating images from her own work and family photographs, and combining them with found and original text.[72]

16 | The Physical Universe

During the 1960s, many photographers used rapidly improving technology to explore nature, for both scientific inquiry and poetic contemplation. Their images contributed to an evolving conception of the universe as ultimately comprehensible but unexpectedly fragile. This use of technology was not new; for example, earlier in the century Laure Albin-Guillot and Roman Vishniac (nos. 117, 116) became pioneers of microphotography, Berenice Abbott (no. 105) invented devices and techniques for scientific photography, and **HAROLD EDGERTON (164)** became the most influential scientific photographer of midcentury.

The son of a lawyer in Fremont, Nebraska, Edgerton studied electrical engineering at the University of Nebraska.[1] After graduation in 1925, he worked for the Nebraska Power and Light Company, diagnosing malfunctioning generators while they were running. To solve this difficult problem, Edgerton set out to build a light source that would flash in time with the cycling machine, making it appear still to the human eye. As a graduate student at the Massachusetts Institute of Technology (MIT) from 1926 to 1928, he designed an intense electronic light that illuminated rapidly in sequence, and developed the circuitry to control its rate. The scientist spent the next decade improving his STROBOSCOPIC FLASH, with lightbulbs containing argon, and then xenon, for brighter, quicker flashes. He perfected instruments to produce a searing flash lasting less than a microsecond, or one-millionth of a second. After completing his doctoral degree, Edgerton joined the MIT faculty and became a charismatic teacher. He applied stroboscopic technology to photography, building on the achievements of the nineteenth-century French scientist Étienne-Jules Marey, who deconstructed motion in multiple EXPOSURES on a single photographic plate.[2] Edgerton and his students created extraordinary, fleeting images, like the crownlike pattern of spattering droplets of milk and the wingbeats of a hummingbird in flight.[3]

Cutting the Card Quickly is an example of Edgerton's dramatic images of the 1960s. By that time,

he had progressed to color photographs, with the background hue calculated to provide revealing contrast to the subjects. The image arrests a precisely aimed .A30-caliber bullet, traveling at 2,800 feet per second, cutting through a playing card from edge to edge. The gun's report activated the stroboscopic illumination and electronic SHUTTER for a photographic exposure of less than one microsecond. As always, Edgerton's image allows surprising new observations, for the S-shaped fragment of paper falling between the halved Jack of Diamonds was released by the rotation of the speeding bullet, set spinning by the rifling of the gun barrel.[4]

During World War II, Edgerton worked as a consultant to the Army Air Force, developing illumination for aerial photographs of nocturnal troop movements. In the 1950s he shifted his attention to oceanography. The National Geographic Society organized a collaboration between Edgerton and the oceanographer Jacques Cousteau, and the two scientists enjoyed a lifelong friendship. Having designed the first successful underwater camera decades before, Edgerton now created watertight casings for cameras and FLASH equipment, enabling photographers to shoot in the deepest oceans.

Some of the most remarkable scientific photographs of the late twentieth century were glimpses from space, images that fundamentally transformed our impression and understanding of the universe. The night sky had always fascinated photographers, and some of the earliest astronomical photographs might have been made in Worcester. In 1848 Dr. Andrew Wemple Van Alstin invited visitors to his studio to see "a Daguerreotype of the MOON, the largest ever made."[5] Four years later, the Englishman Warren de la Rue made the first COLLODION negative of the moon, allowing wide distribution of the image. However, for many observers, these photographs only accentuated their curiosity about the moon's hidden, far side.

In the midtwentieth century there was a renascence of lunar studies, in anticipation of human

165

**National Aeronautics and
Space Administration**
American, twentieth century

*The Far Side of the Moon
(V-8-M)*, 1967

Gelatin silver print
46.3 x 42.0 cm
Sarah C. Garver Fund,
1999.388

166

Daniel Farber
American, 1906–1998

Purple and Pink Asters, 1968

Dye transfer print
32.9 x 48.2 cm
Gift of Irene Shwachman,
1976.31

travel to the moon.[6] In the mid-1950s, the United States Air Force sponsored a new lunar atlas based on telescopic study. Shortly after the establishment of the **NATIONAL AERONAUTICS AND SPACE ADMINISTRATION (165)** (NASA) in 1959, the Soviet satellite *Luna 3* made the first photographs of the far side of the moon. Three years later, President John F. Kennedy established the ambitious goal of putting a man on the moon by the end of the decade. To this end, NASA organized the Ranger, Surveyor, and Lunar Orbiter projects to study the moon. The Ranger and Surveyor missions returned panoramic television images, but they lacked the detail necessary to plan the manned *Apollo* landings. Thus, a detailed photographic survey was prominent among the goals of the five Lunar Orbiter missions of 1966 and 1967.

The Far Side of the Moon is a compound photograph produced by the fifth and final Lunar Orbiter mission, launched on August 1, 1967.[7] Circling about 1,500 kilometers over the lunar surface, the spacecraft sent back images of unprecedented clarity. *Lunar Orbiter V* employed technology developed for Cold War reconnaissance satellites. The spacecraft carried a dual-LENS camera system for wide-angle and telephoto views, using an 80mm lens for medium-resolution images, and a 610mm lens for

high-resolution photographs. The separate lens systems utilized one roll of 70mm film, simultaneously recording their images side by side. The film was processed onboard with a one-chemical DEVELOPING system, and transferred to video by an early slit-scan process. The information was telemetered to ground stations, to be recorded on magnetic videotape, and then translated into hundreds of 35mm film framelets.[8] These were then printed as GELATIN SILVER PRINTS on strips of paper, and fitted together like a mosaic. Since the lighting varied slightly for each sequence of exposures, the strips of framelets produced a Venetian-blind effect when placed side by side. Aside from its images of the far side of the moon, *Lunar Orbiter V* made thirty-six detailed photographs of possible *Apollo* landing sites, before crashing on the moon on January 31, 1968. The spacecraft also captured the first photograph of the full Earth, the astounding image of a blue droplet of life in the black vastness of space. It made Earth's natural systems and its limitations visible as never before, and became an enduring icon for the cause of environmentalism.

Striking images from space impressed the Worcester photographer **DANIEL FARBER (166)**, who had long sought to capture the majesty of

Fig. 8. Daniel Farber, *Peter Bancroft* (Auburn, Mass.), 1974, gelatin silver print.

nature on a more human scale. One of seven children, he was born in Worcester, where his father began a leather business in 1908.[9] When he was thirteen years old his father died, and after high school Farber joined his three brothers at the factory. They designed and built leather-processing machinery that attained commercial superiority for the L. Farber Company, making it the country's largest supplier of leather insoles and shoe welting. In 1931, Farber began taking a camera on hikes into the New England forests. After long work hours in the factory he found comfort in nature, and strove to capture this peace in his photographs. When color photography became practical, Farber eagerly learned its techniques. He was an avid gardener, and learned visual lessons of color and compositional balance from his flower garden. In 1953, while summering in Provincetown on Cape Cod, Farber began photographing the abstract shapes and colors reflected on the surface of the sea. He often shot from the town pier in the morning, when boats and buildings were illuminated, but before the sun rose high enough to penetrate the water. Some of Farber's Provincetown reflections were included in the exhibition *Photography in the Fine Arts IV* at the Metropolitan Museum of Art, and later a selection of Farber's reflection images were featured in a solo exhibition at the Worcester Art Museum.[10] One winter day in 1958, while exploring the countryside near Paxton, Massachusetts, the photographer became intrigued by the slate grave markers in an eighteenth-century cemetery. Concerned for their disintegration, he realized that photographic records could be invaluable research tools. He photographed colonial cemeteries (fig. 8),[11] and became an expert on their history and tombstone carvers. Farber refined his techniques to this task, shifting to black-and-white film for increased clarity, and mounting a large mirror on a tripod as a portable light reflector.[12]

Purple and Pink Asters exemplifies another distinctive phase of Farber's style, the soft-focus images of nature he called "diffusions." He found the technique most effective for flowers, to accentuate their form and color in bee's-eye views. "My favorite flower to photograph is the autumn aster," he wrote. "There are spaces between the aster's petals so that when the flowers are thrown out of focus the resulting diffusion produces a delicate, misty fog — or sometimes explosion — of color."[13] In a wildflower meadow, Farber often worked on his knees or prone on the ground, searching for a fixed composition in the viewfinder. "If my subjects need to be isolated from the jungle that surrounds it, I crop with my clippers. I study the subject from many angles . . . and hold it in varying positions in front of the lens. I experiment until everything seen contributes to the composition. Nothing remains neutral."[14] During 1960s, Farber's photographs were published in such magazines as *American Heritage*, *Saturday Review*, and *Horticulture*, and his images appeared on the jackets of Columbia Records albums.[15]

The hand-held camera had become the basic instrument for photographers in the field and on the street, and its originative pioneer, **HENRI CARTIER-BRESSON (167)**, was still in his prime when his work was exhibited at the Worcester Art Museum in 1968.[16] Born at Chanteloup, Seine-et-Marne, Cartier-Bresson began to study art at age fifteen in the Paris atelier of the Cubist painter André Lhote.[17] He also became interested in Surrealism, as much for its notions of inspiration and spontaneity as for its forms. In 1932, he became a serious creative photographer, using a hand-held camera just a few years after Erich Salomon (no. 104) began using a Leica for journalism. With André Kertész (no. 91) as his principal mentor, Cartier-Bresson synthesized influences from Post-Impressionism and Surrealism, always tending to strong design and formal structure. He was also influenced by Brassaï's (no. 114) taste for the unusual and psychologically revealing. From the first, Cartier-Bresson had an uncanny knack for choosing subjects, perspective, and the exact moment when a changing scene coalesced into its most descriptive. He joined an ethnographic expedition to Mexico in 1934, and visited the United States the following year to study cinematic technique with Paul Strand (no. 75).[18] In the late 1930s, he worked as a production assistant for filmmaker Jean Renoir. During the German occupation of France in World War II, Cartier-Bresson escaped imprisonment to join an underground photographic unit of the French Resistance. He photographed the Liberation of Paris in 1944–45, and a major retrospective of his work was mounted by the Museum of Modern Art in 1947.[19] Soon afterward, the photographer joined with colleagues David Seymour, George Rodger, and Robert Capa (no. 128) to establish the Magnum Photo agency.[20] In 1952, Cartier-Bresson published *Images à la sauvette* (*The Decisive Moment*), a collection of his work over two

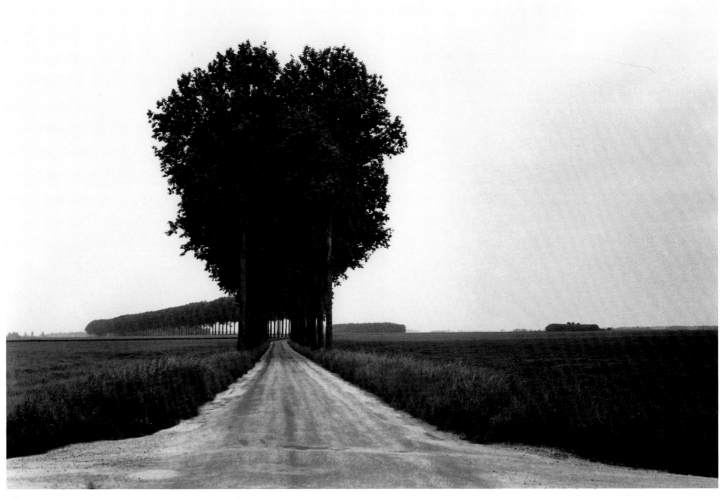

167

167

Henri Cartier-Bresson
1908–2004

Landscape near Paris, 1968

Gelatin silver print
23.3 x 34.4 cm
Eliza S. Paine Fund, in
memory of William R. and
Frances T. C. Paine, 1969.77

decades.[21] Its text elucidated his notion of spontaneity, his commitment not to intrude on his subjects, and his obligation to the original exposure, forbidding any cropping or alteration. Cartier-Bresson adopted new, fast films, accepting stark, grainy prints as a trade-off for immediacy and material authenticity. Beginning in the 1950s, he traveled the world with his camera, chronicling his journeys in a succession of popular books.

Landscape near Paris exemplifies Cartier-Bresson's way of finding beauty everywhere. It seems that he simply stopped his car along a country road to record a memorable image, a glimpse of human collaboration with nature. Seeing the world in compositional terms, he presents a magnificent avenue of trees — planted centuries ago to protect fields and road from the summer wind and sun — as if it were sculpture, or architecture. Cartier-Bresson positioned the camera to capture the receding line of tree trunks like an enormous natural colonnade. His viewpoint also expresses fully the height of the trees and the scale of the avenue as it winds around the fields. Other distant copses and plantings invite us to investigate their wonders. However there are no buildings or wires to mar the

view, and no present human activity. Instead, the image evokes the efforts of laborers, arborists, and designers long ago, who knowingly applied the laws of nature and the passage of time to create a distinctively French agricultural environment of elegance and harmony.

During the 1960s, the popular photographs of **ELIOT PORTER (168)** helped to foster the acceptance of color photography as an artistic medium. Like the work of Carleton E. Watkins and Ansel Adams (nos. 37, 79), his photographs also influenced the American environmental movement. Porter was born in Winnetka, Illinois, the son of a Chicago architect who was also an amateur photographer and naturalist.[22] The family summered at Great Spruce Head Island on Penobscot Bay in Maine. There, at age eleven, Porter photographed the woods and shores with a Kodak box camera.[23] He studied engineering at Harvard University, and earned a medical degree in 1929, when he began teaching bacteriology and biological chemistry at Harvard. A chance meeting with Ansel Adams encouraged Porter's continuing interest in photography; when he met Alfred Stieglitz (no. 62), he

168

eagerly accepted criticism and advice. Stieglitz mounted the first solo exhibition of Porter's photographs at An American Place in 1938, and its success prompted him to become a professional photographer. Birds became his primary subject, and he developed methods for photographing in the wild, using blinds and stroboscopic illumination.[24] In the late 1930s, the photographer began using the newly available Kodachrome color transparency film, and he later became expert in the challenging DYE TRANSFER process. In 1941, the support of a Guggenheim Foundation fellowship enabled him to travel across the country photographing birds. He developed a precise, macroscopic style that helped advance nature photography in color. In 1944–45, Porter assisted in the development of radar at the Massachusetts Institute of Technology. After World War II, he moved his family to Tesuque, New Mexico, where he explored the Southwest as photographer-at-large for *Audubon* magazine.[25] Porter continued his frequent visits to New England and began to couple his pictures with the writings of Henry David Thoreau. He exhibited his images with Thoreau's words, and published them together in the book *In Wildness Is the Preservation of the World*.[26] During the 1960s, Porter's work excited broad public appreciation of natural beauty, and taught about the delicacy of ecology. He became an ardent environmentalist, and served on the Sierra Club board of directors from 1965 to 1971.

Fallen Leaves, Congaree Swamp exemplifies Porter's vivid closeup images of the 1960s. It was taken in the swamp along the meandering Congaree River in central South Carolina, a renowned bird habitat that comprises the largest continuous tract of old growth floodplain forest in North America. Porter's closeup study of the wet ground reveals a fertile floor, where dried leaves, recently fallen, lie on layered decomposing leaves from seasons gone by. The gold hues of newly fallen leaves and evergreen needles, and their curling shapes, contrast with the silvery reflections from the older, sodden layers, flattened to the earth. Their shapes suggest motion, as if they were still fluttering from their branches. Thus, a humble, poetic still life implies the constant changes and cycles of nature. In 1969, when rising timber values prompted some area landowners to contemplate logging hardwoods from Congaree Swamp, Porter joined the Sierra Club and local residents in a grassroots campaign to protect the area. Gradually their efforts led to state protections, and in November 2003 the area became the fifty-seventh national park.

PAUL CAPONIGRO (169) has also endeavored to express great truths of the universe in images of nature. Born and raised in Revere, northeast of Boston, he bought an old Zeiss Ikon camera when he was sixteen years old and taught himself to develop and print his photographs with the guidance of a booklet from the camera shop.[27] Experience working at a souvenir photo concession on Revere Beach and in a local portrait studio honed his technical skills. Caponigro earned enough to buy a Speed Graphic camera and made studies of the sea-worn rocks at Nahant beach. The teenager was also a serious student of the piano, and contemplated a music career; in 1950–51 he attended the Boston University College of Music. In 1953 Caponigro was drafted into the military and assigned to an Army band. Posted to San Francisco, he transferred to duty as a Signal Corps photographer. He befriended the civilian photographer Benjamen Chinn, who introduced him to West Coast photographers including Ansel Adams, Imogen Cunningham, and Minor White (nos. 79, 83, 148). When the Army sent him to Yuma, Arizona, Caponigro photographed in the Sonora Desert, and came to love its stark beauty.

In 1957, Caponigro moved to Rochester, New York, to work as an apprentice to Minor White and assist in his Summer Photographic Workshops in Portland, Oregon, and San Francisco. The young photographer was influenced by White's ideals of technically superior photographs that convey deep, even spiritual, meaning. In 1960 he returned to Boston, where Ansel Adams recommended him as a research advisor at the Polaroid Corporation. This job provided time for his creative work, and in the mid-1960s Caponigro divided his time between Ipswich, Massachusetts, and New York. Even in the city, he preferred to explore still life in the studio to photographing in the street. In 1966 a Guggenheim Foundation fellowship enabled him to travel and photograph in Ireland.[28]

Around 1969, when a friend brought Caponigro a sunflower, he became fascinated by its combination of spiky and soft shapes, and its archetypal solar form. He began photographing all sorts of sunflowers, along country roadsides, in gardens, and in fields. His young son, John-Paul, planted and tended a sunflower especially for him to photograph. Caponigro's photograph of a stoneware pitcher full of sunflowers is an image of passion restrained. "Inwardly, silently, I was asking to see the aspect of the sunflower which the physical eye could not."[29] Juxtaposed with a velvet background and bulbous, softly modeled vessel, the blooms seem even more spiky and intricate. Caponigro used delicate lighting to emphasize the energy that seems to radiate from the curling leaves and soft petals. He continued photographing the flowers into the autumn as they dried, changed form, and took on an ethereal glow, like ancient burnished solar medallions. "Gradually, some very few photographs began to make visible the overtones of that dimension I sought," he later wrote. "Dreamlike, these

168

Eliot Porter
American, 1901–1990

Fallen Leaves, Congaree Swamp, 1969

Dye transfer print
26.3 x 20.3 cm
Purchased with funds granted by National Endowment for the Arts, 1974.317

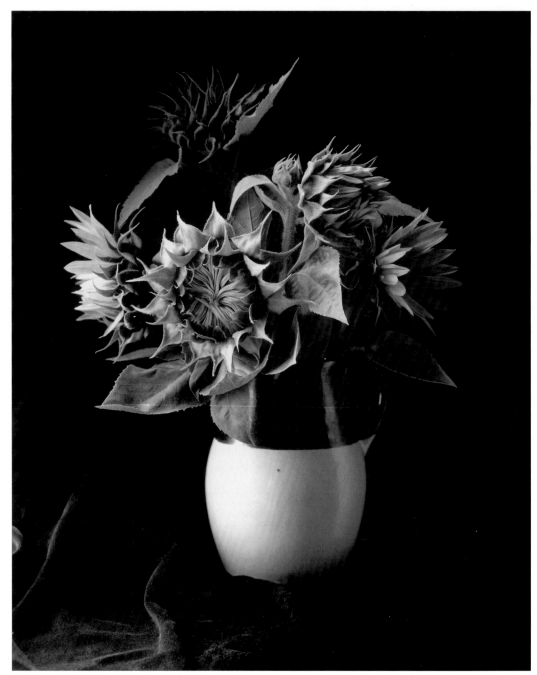

169

169

Paul Caponigro
American, 1932–

Sunflowers, 1969

Gelatin silver print
31.7 x 25.6 cm
Purchased with funds
granted by Artist's Resource
Trust, 1999.52

isolated images maintain a landscape of their own, produced through the agency of a place apart from myself."[30]

BRETT WESTON (170), the second son of the photographer Edward Weston (no. 82), left school at age thirteen to accompany his father to Mexico.[31] He observed his father's dedication to craft when the pioneering photographer shifted from a PICTORIALIST style to a sharp, incisive manner that emphasized bold forms and delicate textures. The boy displayed a natural proclivity in his first photographs. "He is doing better at fourteen than I did at thirty," the father wrote in his *Daybooks*. "To

have someone close to me, working so excellently, with an assured future, is a happiness hardly expected."[32] Edward Weston chose a group of his son's photographs for the landmark *Film und Foto* exhibition in Stuttgart, and the seventeen-year-old's images were published in European magazines. In the late 1920s, when father and son were partners in studios in San Francisco and Carmel, both made some of their most remarkable photographs at Point Lobos, closeups of natural objects and views of the windswept Pacific coastline.

In May 1930, Brett Weston set out on his own, opening a portrait studio in Glendale, California. Two years later a solo exhibition of his photographs

170

170

Brett Weston
American, 1911–1993

Untitled, 1970

Gelatin silver print
23.3 x 19.5 cm
Jerome A. Wheelock Fund,
1970.144

was mounted in San Francisco at the M. H. De Young Memorial Museum, and he also contributed to the GROUP *f*.64 exhibition there. During the Depression, Weston was a photographer for the Works Progress Administration, and a supervisor of the photographic section in the Federal Arts Project. He moved to Santa Barbara, during World War II, to work as a photographer for the Douglas and North American Aircraft Corporations. Drafted into the Army in 1941, he later was assigned to a photographic unit where he surveyed New York City from the rooftops and explored the Botanical Garden. Posted to El Paso, Texas, in 1945, he explored the White Sands National Monument in a series of

photographs that was continued during his post-service Guggenheim fellowship.[33] After the war, he returned to California to assist his father as he struggled with Parkinson's disease in the final decade of his life. In 1958, Weston traveled for the first time to Europe, where he made studies of space, form, and texture.[34]

In 1970 Weston made a long-anticipated journey to Japan. The artist captured poetic Japanese landscape, and Siskindesque (no. 143) shots of disintegrating signs and carved lichen-covered stone.[35] The image of a porch rail reflects his fascination with form for its own sake. A composition of opposing lines and angles is as taut as a spider's

171

B. A. King
Canadian, active in
United States, 1934–

Untitled, about 1972

Gelatin silver print
17.9 x 23.7 cm
Gift of the artist, 2003.80

web, cinched tight by the central stone newel. The shadows and reflections from each flat surface provide a clear, legible rendering of space to the Cubist composition. Weston captured the tactile differentiation from the varied materials, from coarse-grained stone to the weathered wooden handrail and smooth stucco wall. The play of shadows and stains of time emphasize these different materials. With silent comment, Weston pays homage to the precision of Japanese discernment, the culture's refinement of craft, and sensitive mastery of natural materials.

"I work mostly in familiar, even beloved places," **B. A. KING (171)** once observed, "because the strength of a photograph is affected by the quality of the photographer's presence at the time of its taking."[36] A quiet, passive observance distinguishes his naturalist photographs and his images of human culture striving to fit in. Bruce Anthony King was born and raised in Toronto, where early, often solitary, experiences of nature were among his most formative. When he was eleven years old, stepping onto the

train for summer camp, his mother gave him her camera so that he could share his experiences with her through his photographs. As a child he also frequently visited his grandparents' farm in Worcester County, and developed a deep affection for the country and traditions of New England. King taught himself the finer techniques of photography while studying French literature and international relations at Hamilton College, and he spent a year at the Sorbonne in Paris.

King's enchanting image of a spreading oak depicts the tree in the meadow behind his house in Southborough, Massachusetts. When his family moved into the old house in 1969 the venerable tree, mature before the American Revolution, took possession of them.[37] The four King children played around its trunk, climbed its branches, and portrayed it in their paintings. The tree was the center of family gatherings and the background for family pictures. King's glimpse of the old oak on a misty spring morning, its boughs heavy with sprouting leaves, reveals just one of its many moods.[38] He photographed the tree in all weather

and every season, the beehive that buzzed in its central hollow, garter snakes slithering through its crooks and niches, squirrels and songbirds in its branches, and families of raccoons and kestrels that reared there. The old oak became the potent symbol of home for King, a deeply cherished member of the family in its broadest sense.

In 1972, King's photographs illustrated James Houston's *Ojibwa Summer*, the first of over a dozen volumes of his work.[39] Two years later, the Worcester Art Museum exhibited *A Photographic Surprise from B. A. King*, in which his photographs were combined with his children's drawings in whimsical collages. In 1978, his photographs were shown along with sculpture by his friend Robert Cronin.[40] King established a reputation for sensitive images of New England, where peoples' lives have long been wedded closely to nature. His preference for strong, unadorned composition conveys Puritan authenticity and the beauty of an unyielding land. This sympathy is apparent in King's photographic series of Maine, of snowy Northeast-

ern winters, and of summertime swamps.[41] His photographs also provide revealing illuminations for the verse of Robert Frost and other New England poets.[42]

In fall 1995, King was away from home when news came that the old oak had uprooted and toppled over. The prone trunk revealed that for years it had been slowly rotting inside. While the despondent King family considered a memorial, new life began to inhabit the meadow. With more light and moisture available, new plants had taken root, including oak saplings. Flat on the ground, the tree was still a good place for mammals and reptiles to hide and nest. The continuing photographic series now depicted nature's cycles of fertilization and renewal. The oak tree was left where it fell, to disintegrate slowly back into the earth. "Like humans who die and leave an endowment of money or property, or a spiritual legacy," King reflected, "this tree continues as an extraordinary resource. It has a kind of afterlife. It has taught us that stories don't end."[43]

172

Emmet Gowin
American, 1941–

Mud Wasp Nests, 1973

Gelatin silver print
20.3 x 25.1 cm
National Endowment for the
Arts Purchase Fund, 1975.48

The work of **EMMET GOWIN (172)** also reflects a personal relationship with the land and its heritage. He was born in rural Danville, Virginia, where his father was a Methodist minister and his mother an organist for the church.[44] When he was two years old, the family moved to Chincoteague, Virginia, where a country childhood instilled a deep love of nature. Gowin began making photographs at age twenty. He attended the Richmond Professional Institute (now Virginia Commonwealth University) and, from 1965 to 1967, the graduate program at the Rhode Island School of Design, where he was a student of Harry Callahan (no. 133). After completing his master of fine arts degree, Gowin returned to Danville. He created an intimate photographic series depicting his wife, Edith, and her extended family, to represent universal human relationships.[45] These heartfelt images reflect the influence of Frederick Sommer, a mentor who strove to integrate his photography with broader interests in physics, philosophy, and poetry.[46] The photographer sensed a profound break with the past in 1972, when Edith Gowin's grandmother died. She and her husband had farmed their land and had a deep, lifelong connection to the earth, unknown to Gowin and most of his generation. By exploring their fallow, overgrown farm, planting some fruit trees and harvesting there, he gained a faint sense of these lost custodial ties to the land, and strove to express that sentiment in his photographs.

Mud Wasp Nests reflects Gowin's shift of intimacy from human subjects to natural ones. As in many of his Danville photographs, he used a 4 x 5–inch lens on his 8 x 10–inch camera, darkening the corners of the composition to concentrate the image and evoke age, as if the image were seen through a microscope eyepiece or early Kodak camera. On a cracked and weathered wooden deck — perhaps an old barn or a porch floor — is a litter of dried leaves and grasses, and the broken remains of mud wasps' nests. With their pupae hatched and flown, these empty structures have become abandoned architecture. Yet their adobelike forms and smoothed surfaces still reflect exertion and purpose. Like people, the mud-daubers gathered and moved the earth for their own temporary use, leaving time and weather to recycle the materials. Similar to the cracked wooden floor and the overgrown clearing beyond, these structures suggest the passage of time and the cycles of life.

In 1980, the eruption of Mount Saint Helens drew Gowin to Washington State. To best observe the volcano's effects, he chartered a light plane to photograph from above. The experience transformed his perception of the earth, and he went on to photograph aerial images of geology and topography across North America. These were featured in his solo exhibition at the Corcoran Gallery of Art.[47] In 1986, when Gowin flew over the Hanford Reservation, the apparent effects of nuclear waste changed his understanding of our epoch. Afterwards he photographed mines, waste dumps, nuclear test sites, and massive agricultural projects, documenting large, unapparent human effects on the earth. Gowin's photographs depict the earth as an organism, with animate beauty and vulnerability.[48]

172 (DETAIL)

As Pop and Conceptual Art became influential during the 1960s, the wide variety of artists drawn to photography often sought to convey ideas about their subject, rather than capture its descriptive image. Throughout his career, the painter **DAVID HOCKNEY (173)** has used photography as a creative and practical medium, making visual notes, preparatory studies for his paintings, and finished photographs. The son of an accountant's clerk, he was born in Bradford in the north of England.[1] During studies at the Bradford College of Art from 1953 to 1957, he distinguished himself as a brilliant draftsman. After two years of hospital work to fulfill his National Service, he continued his studies at the Royal College of Art in London from 1959 to 1962. Hockney explored abstraction under the influence of Alan Davie, and Pop Art with fellow student R. B. Kitaj. Pop syntax influenced the artist and he used photography to aid in compositional development, but he remained most interested in telling stories of twentieth-century life.

The first solo exhibition of Hockney's work was mounted at the Kasmin Gallery in London in 1963. Later that year he moved to Los Angeles, attracted by perpetual sunshine and Hollywood myth.[2] In California he shifted from oil paints to acrylics, and often carried a camera.[3] Hockney painted a series of canvases depicting swimming pools, palm trees, and sleek International-style architecture, images hovering between naturalism and abstraction. In October 1971, while shuffling a group of his photographs on the floor, he was struck by the relationship between the distorted figure of a swimmer underwater, and the sharp-focus image of a young man looking at the ground. Imagining himself in the pool with his partner, Peter Schlesinger, watching, Hockney began *Portrait of an Artist* in his London studio.[4] He became dissatisfied as the painting progressed, however, and decided to do a second version.[5] Requiring further photographic studies, he took his camera to the French Riviera — the closest location approximating the California setting — with his assistant

Mo McDermott and the photographer John Saint Clair as models.

John Saint Clair Swimming is one of hundreds of color studies that Hockney made at Le-Nid-du-Duc in April 1972, with his Pentax 35mm hand-held camera.[6] He photographed Saint Clair underwater in varied light and water conditions. Abstract patterns of blue, from dimples and ripples on the water surface caused by the swimmer below, distort and mottle light and shade. Bright highlights, reflected from the water, contrast with the tones of deep shadow. Back in London, Hockney recreated the photographs' colors in his painting, with their nearly complementary hues of aquamarine and poolside orange. The swimmer's deep-blue shadow on the bottom of the pool helped evoke a sunny atmosphere.

During the 1980s, Hockney glued scores of his Polaroid snapshots into continuous images that he called "joiners," which often approximate multiple Cubist viewpoints. He made experimental images with photocopiers and fax machines, and later used digital photography and inkjet printing to generate hand-drawn and photographic imagery. Fascinated by the Old Masters' understanding of optical and mechanical aids, Hockney investigated their use of convex mirrors, CAMERAS OBSCURA, and CAMERAS LUCIDA.[7]

A modern master of COMBINATION PRINTING, **JERRY N. UELSMANN (174)** has created an alternate visual reality in his photographs, in which dreams, hallucinations, and spiritual visions seamlessly merge with reality. Uelsmann was born and raised in Detroit, where his father, an independent grocer and amateur photographer, taught him to use the camera and DARKROOM.[8] From 1953 to 1957, Uelsmann studied with Ralph Hattersley and Minor White at Rochester Institute of Technology, refining his technical expertise and learning to imbue his images with deep meaning. He went on to graduate studies at Indiana University, where he was a pupil of Henry Holmes Smith, who broadened his ideas

173

173

David Hockney
English, 1937–

John Saint Clair Swimming,
1972

Dye coupler print
17.2 x 23.5 cm
Gift of Sidney and Rosalie
Rose, 1984.151

of the capabilities of photography. After completing his master's degree, Uelsmann taught photography at the University of Florida in Gainesville. His work gained national attention when it was included in the exhibition *Three Photographers* at George Eastman House in 1962. Five years later he won a Guggenheim Foundation fellowship for "Experiments in Multiple Printing Techniques in Photography," and a solo exhibition of his photographs was presented at the Museum of Modern Art.[9]

With meticulous craftsmanship, and modern equipment and materials, Uelsmann made expressive advances in combination printing. He used an array of techniques to synthesize images from different NEGATIVES, usually by splicing or sandwiching them together before printing.[10] He began by studying the achievements of Oscar Gustave Rejlander and Henry Peach Robinson, the nineteenth-century pioneers of combination printing.[11] While they used the technique for historical, literary, or melodramatic tableaux, Uelsmann created imaginative images that defy material reality.[12] Some of Uelsmann's images are reminiscent of René

Magritte's Surrealism, in which everyday objects are inserted into the wrong, but equally familiar, context. Other photographs represent enigmatic apparitions, challenging the boundaries between fact and fantasy, or employ Jungian archetypes to evoke sensibilities from deep in the psyche. The timely popularity of Uelsmann's work was reflected in a retrospective exhibition of his photographs at the Philadelphia Museum of Art in 1970.[13] He was appointed graduate research professor at the University of Florida in 1972, the year he received a National Endowment for the Arts fellowship.[14]

Uelsmann's image of an elegant study seems cozy and inviting, with its rich paneling, book-filled shelves, marble hearth, and Aubusson carpet on the parquet. Astoundingly, the ceiling opens directly to a dramatic sky, where the sun peeks over the edges of billowy clouds to cast intense rays into the room. Sunlight falls on a folding draftsman's table, which holds an open book with the figure of a man rising from its pages. He seems to stroll away from the viewer, gazing at the ground, with rolled-up sleeves and pants legs, as if walking along

174

a beach. Thus, Uelsmann expresses the wonder of literature, and suggests that exotic experiences are available to us all in the pages of a book. In this evocative image, and in many other photographs, Uelsmann prompts the viewer to find intellectual, subconscious, and even spiritual readings in his images. Despite his intended theme, he strives to provide an open reading, and viewers discover unique associations in their own perceptions, daydreams, and revelations.

The evocation of place is a hallmark of the photographs of **JOEL MEYEROWITZ (175)**, an influential pioneer in the creative use of color photography. Born in New York City, he studied painting and medical illustration at Ohio State University from 1956 to 1959, then began a career as an advertising designer in New York.[15] In 1962, when he accompanied Robert Frank (no. 149) on assignment, Meyerowitz was impressed by the photographer's artistry and the medium's potential. He taught himself the techniques of photography and explored New York

architecture, inside and out, with his camera. In the late 1960s Meyerowitz turned to color photography, sensing its unrealized expressive possibilities. Since DYE TRANSFER PRINTS were expensive, he used 35mm color film, and kept a meticulous log, noting conditions of light, colors, and shadows for each EXPOSURE. In the darkroom, these notes helped him gauge technical response and limitations, and progressively achieve unexcelled control of color processes. Meyerowitz began teaching color photography at Cooper Union in 1971, the year of his first Guggenheim Foundation fellowship. His second award, five years later, enabled him to buy a vintage 8 x 10–inch view camera with which he began a series of color photographs on Cape Cod. This instrument imposed a more deliberate method than his familiar hand-held cameras.

In *Porch, Provincetown*, Meyerowitz captured the extraordinary light and atmosphere of the shore on a dark rainy day. As a downpour thickened the air and stilled the sea, the porch remained dry and the cottage cozy. The photographer opened the

bottom half of a Dutch door to hide the source of the incandescent light, capturing only its radiance. Positioning his camera at the end of the porch, he used the diminishing row of columns and receding railing to define the architectural space. Meyerowitz calculated his exposure to pick out the repeated parallel hatching in the rustic architecture — stiles in the porch rail, the floorboards, and beadboard ceiling and door — contrasting these details with the soft tone and pale hues of the background. Thus he knowingly paid homage to his photographic predecessors: to Brassaï (no. 114), who often employed the device of hiding the light source, to Paul Strand (no. 75) with his sensitivity to underlying geometric form, and to Henri Cartier-Bresson (no. 167), whose "decisive moment" is captured perfectly at the instant of a lightning strike.[16]

In 1978, a selection of Meyerowitz's Cape Cod photographs was presented in a solo exhibition at the Museum of Fine Arts, Boston.[17] By that time he had joined the faculty at Princeton University. He produced a succession of diverse photographic projects, like *Wild Flowers*, *Redheads*, and the *Nutcracker* ballet, which became popular books.[18] Within days after the attacks on the World Trade Center on September 11, 2001, Meyerowitz began photographing at Ground Zero. He persistently returned to the site, documenting the painful efforts of rescue, recovery, and demolition, creating a historical and research archive in thousands of photographs. A selection became *After September 11: Images from Ground Zero*, which represented the United States at the Eighth Venice Biennale for Architecture.

CARLOS FREIRE (176) was born in Rio de Janeiro, the son of an accountant for a major publisher and a pediatric clinic nurse and medical administrator.[19] He grew up in a house filled with books, and learned to love language and literature. As a teenager, his sensibilities were also formed by poetry, particularly the work of W. H. Auden, Arthur Rimbaud, and Charles Baudelaire (no. 39). His father gave him a Yashica 35mm hand-held camera when he was fifteen years old. After high school, Freire studied English language and culture at the British Cultural Center in Rio and pursued his interest in other languages and cultures. In 1965, he began working for a Rio newspaper, writing chiefly on literature and film. He saved his wages to travel to Paris, planning to attend the film course at the IDHEC (Institut des hautes études cinématographiques). Instead, after he arrived he bought a still camera and taught himself the finer points of photographic technique. Freire earned a living as a freelance photographer, selling his work to magazines and newspapers, gradually building contracts with literary magazines and leading newspapers like *Le Monde* and the *Times* of London. He discov-

ered a natural affinity for portraiture, particularly with authors whose work he knew well, such as Lawrence Durrell, Jorge Luis Borges, Roland Barthes, and Claude Levi Strauss.[20] His revealing portraits brought international recognition, and by the late 1970s his photographs were appearing regularly in magazines all over the world. In 1975 the Pompidou Centre commissioned Freire to create a photo-essay on the town of Nogent-sur-Marne, and the following year he produced series of photographs to chronicle his travels in Singapore and Brazil.

Camel Herder, Rajasthan was made during Freire's first trip to India. Letters from Lotte Eisner introduced him to the cinema historian Aruna Vasudev in Delhi and the filmmaker Satyajit Ray in Calcutta, who both helped to orient him and to plan trips to different regions. In Rajasthan, Freire stayed five days with a tribe of camel herders, accompanying them as they worked from the back of a truck. He snapped the portrait of a young herder early on a November morning. With gold necklaces and earrings, a magnificent turban as a crown, and his herder's staff as a scepter, the young man makes a regal figure. The impression is enhanced by his unblinking stare and relaxed pose. His comfort, and that of his tribesmen, reflects Freire's ability to penetrate their unfamiliar milieu and their very personalities. "Though I could not speak Rajasthani," Freire recalled, "we could understand and communicate among us. I trusted my life and belongings to these people from a different culture than mine, they accepted me with tolerance. Those were the days, although not perfect in everything, when one felt good to live and travel, away from violence, hatred and mistrust."[21] In 1986, Freire's photographs of India were exhibited at the Maison des Sciences de l'Homme in Paris.[22] Since that time, he has continued to pursue personal projects around the world, producing photographic series from his journeys in Brazil, Naples in Italy, Alexandria in Egypt, Mount Athos in Greece, Alep in Syria, and Morocco.[23]

CINDY SHERMAN (177) became the most prominent photographer among a generation of artists who used the medium as a mode of presentation for works executed in other media. She was born in Glenn Ridge, New Jersey, and like others of her generation, she spent many childhood hours watching television. She developed a passion for movies and a fascination with dressing up.[24] From 1972 to 1976 she studied art, photography, and film at the State College at Buffalo, New York. As a student she attired herself in vintage clothing from thrift shops, and sometimes attended parties in character. In summer 1977, Sherman moved to New York City with her friend the artist Robert Longo, and that fall she began photographing herself as a movie character. She was inspired by the publicity

176

Carlos Freire
French, born in Brazil, 1945–

Camel Herder, Rajasthan,
1978

Gelatin silver print
53.8 x 36.0 cm
Sarah C. Garver Fund,
1996.64

177

Cindy Sherman
American, 1954–

Untitled Film Still #7, 1978

Gelatin silver print
23.9 x 18.9 cm
Charlotte E. W. Buffington
Fund, 1995.65

177

stills for low-budget films, then for sale by the hundreds around Forty-second Street. Sherman drew on her thrift-store wardrobe and her knowledge of mode, settings, and staging of old films. The artist often posed in a mirror while an automatic SHUTTER snapped the picture; on the New York streets, Longo and other friends handled the camera. In the darkroom, Sherman purposely made grainy, reticulated prints that seem careless. When she exhibited six selected photographs from the first roll as *Untitled Film Stills*, they brought her initial recognition as an artist. When Sherman returned to the series in fall 1978, she varied the characters more broadly, drawing her models from European

actresses and the lifelike informality of Neorealist filmmaking.

In *Film Still #7* Sherman appears in a tousled black wig, dressed in a slip, stockings, and sunglasses. She tugs on a garter as she looks up at the camera, feigning surprise at being watched. The setting also recalls the 1950s, with its sliding glass door ornamented with a kitschy seahorse design, gaudily printed curtains, and a foreground figure in a frilly maillot hidden beneath a wide straw hat. Sherman facetiously interwove sexuality with multiple levels of artifice. She had no conscious political agenda for *Untitled Film Stills*, but her understanding of the period she portrayed reflected mores that

were being challenged in the late 1970s. "I'm not sure if I was aware of the fact," Sherman later wrote, "that in most early films, women who don't follow the accepted order of marriage and family, who are strong, rebellious characters, are either killed off in the script or see the light and become tamed, joining a nunnery or something. Usually they die. I think I must have been unconsciously drawn to those types of characters. . . . I suppose unconsciously, or semiconsciously at best, I was wrestling with some sort of turmoil of my own about understanding of women."[25]

In 1980, Sherman shifted to color photography in her *Rear Screen Projections*, mimicking the cinematic device of the 1950s. Over the next twenty years, she donned costumes and created characters for a wide variety of photographic series drawn together by themes. She dressed as the glamour models in men's magazines and fashion models in women's magazines, as fairy-tale characters, Civil War soldiers, and the subjects of Renaissance and Baroque paintings. In 1992, Sherman began removing herself from the images in her *Sex Pictures*

series, employing mannequins and prostheses in explicit poses.

Throughout his eventful career as a photographer and filmmaker, **RALPH STEINER (178)** constantly searched for new ways of perceiving the world. This motivation is apparent in the series of cloud photographs from the end of his life that incorporate American notions of expanse and freedom, with the introspective exploration of psychology and spirit. The son of a Cleveland brewer, Steiner made his first photographs at age twelve.[26] In 1917 he attended Dartmouth College, where he studied chemistry and arranged for the biology professor D. O. Griggs to tutor him in photographic technique. Steiner photographed the New Hampshire landscape and college campus, and published his own *Dartmouth* portfolio.[27] After graduation he moved to New York to attend the Clarence H. White (no. 65) School of Photography, before beginning a freelance career. In 1928, Steiner had already begun making films when he met Paul Strand (no. 75). The following year, his

178

Ralph Steiner
American, 1899–1986

Atrocumulus Clouds,
about 1980

Gelatin silver print
20.0 x 25.3 cm
Gift of Dorothy and Gene
Prakapas, 1991.160

experimental art film H_2O, was shown — as were his still photographs — at the *Film und Foto* exhibition in Stuttgart.

During the Depression Steiner associated with the Group Theater, which met in his Manhattan studio. In 1934, they made the antiwar film *Café Universal*, based on George Grosz's World War I drawings. Steiner joined Strand and Leo Hurwitz on the filming of Pare Lorentz's landmark documentary, *The Plow That Broke the Plains*.[28] He partnered with the California photographer Willard Van Dyke in American Documentary Films, Inc.; notable among their productions was *The City*, which was shown continuously at the New York World's Fair in 1939.[29] After being employed during World War II as a director and cinematographer on several government-sponsored films, Steiner worked in Hollywood from 1943 to 1948. Returning to New York, he became a staff photographer for *Fortune* magazine, which led to a position with the public-relations firm Ruder and Finn, a job that sustained him until his retirement.

Atrocumulus Clouds is from Steiner's last series of photographs. Rather than pursue his subjects, the septugenarian waited for nature to form images for him, sitting at sundown on a promontory in Mexico, or on his porch on Monhegan Island in Maine. Skyscapes make demanding subjects for a photographer, because of their indeterminate depth of field and subtleties of illumination. Clouds provide the ideal challenge for an introspective virtuoso, as seen in Alfred Stieglitz's (no. 62) *Equivalents* series. *Atrocumulus Clouds* is unusual in Steiner's series in its inclusion of earthbound elements. He used the cool evening light to soften the seaside cottage into a shaggy Cubist tetrahedron. By juxtaposition, its hard form emphasizes the softness and delicacy of the clouds. The building also marks the scale of the prospect and its deep perspective. Steiner skillfully captured the elusive light, glowing at higher altitudes, while the bottoms of the clouds, and earth below, fall into evening shadow. In 1984, an exhibition of Steiner's *Clouds* was mounted at the Smith College Museum of Art, in Northampton, Massachusetts.[30] A selection from the series was included in Steiner's retrospective exhibition at the Hood Museum at Dartmouth College at the time of his death.[31]

In his color photographs, **JOEL STERNFELD (179)** has captured a vision of America in which remarkable things occur, although, as in life, they often seem overshadowed by context. Sternfeld grew up in New York City and attended Dartmouth College from 1961 to 1965.[32] After graduation, he returned to New York and worked as a street photographer. He used hand-held cameras for images of harried office workers and commuters, struggling with pressures of modern life. In 1971 he

joined the art faculty at Stockton State College in Pomona, New Jersey, and soon began experimenting with color photography. Sternfeld's preference for the ordinary allied him to contemporaries such as Robert Adams and Joseph Deal, who photographed modern life objectively.[33] While they strove to remain invisible from their work, Sternfeld's images usually reflected a wry irony. In 1976, the first solo exhibition of his photographs was mounted at the Pennsylvania Academy of the Fine Arts in Philadelphia.

In 1978, Sternfeld won a Guggenheim Foundation fellowship to continue his street photography, but the handsome award suggested unforseen possibilities. "I had the sense of having been born in one era and surviving to another," he later recalled. "The photographs which I made represent the efforts of someone who grew up with a vision of classical regional America and the order it seemed to contain, to find beauty and harmony in an increasingly uniform, technological, and disturbing America."[34] Sternfeld loaded his 8 x 10–inch view camera into a Volkswagen campervan and drove slowly across the country, following a seasonal itinerary suggested by the books of naturalist Edwin Way Teale.[35] Gradually a thematic structure emerged in photographs of an altered environment and the people who — sometimes unwittingly — change the land. Sternfeld strove to capture the simple truth of place, often reducing people and events to small, seemingly inconsequential motifs. Like Henri Cartier-Bresson (no. 167), he scrupulously remained an observer. The resulting images were first exhibited in 1984 at the Museum of Modern Art, and later gathered into the book *American Prospects*.[36]

McLean, Virginia, December 4, 1978 best crystallizes Sternfeld's new vision. Its title is like a news dateline, and the image depicts a momentous event. On a gray fall day a country house is on fire. Wind fans the flames, engulfing its roof and dormer porch. Firefighters position an elevated ladder to douse the fire, but disaster seems imminent. Meanwhile, in the foreground, a fireman in boots and helmet is perfectly oblivious to these events, as he calmly chooses the perfect pumpkin at a deserted farmstand. Sternfeld combined this moment of irony with an artful composition. A tall evergreen standing behind the McLean Farm Market echoes and emphasizes the mounting blaze, while pumpkins scattered in the foreground echo the fiery hue. Some pumpkins are smashed and rotting, a reduced foreshadowing of a disastrous outcome.

After teaching at Yale in 1984–85, Sternfeld joined the faculty at Sarah Lawrence College in Bronxville, New York. In 1997 he published the series *On This Site*, which depicts locations of the era's most infamous crimes, searching for clues to

179

Joel Sternfeld
American, 1944–

McLean, Virginia, December 4, 1978

Dye coupler print
34.3 x 43.2 cm
Purchased through the gift of Mrs. Joseph Goodhue, 1983.15

180

the beginnings of cultural myth.[37] Later, Sternfeld produced a series representing views on Hart Island, the melancholy site of the Potter's Field where the unclaimed remains of the destitute from New York City have been buried for centuries.[38]

WILLIAM EGGLESTON (180) was born in Memphis, Tennessee, and grew up on the family cotton plantation in Tallahatchie County, Mississippi.[39] When he began taking photographs at age eighteen, he found inspiration in the work of Henri Cartier-Bresson and Walker Evans (nos. 167, 106). However, the young photographer strove to replace Evans's reverberating vision of the Depression-era South with the updated view of a prosperous region of suburbs and shopping malls. Eggleston drifted from one college program to another, attending Vanderbilt University, Delta State College, and University of Mississippi, but never completed a degree. He experimented with color transparency film, and by 1967 had shifted almost exclusively to color. In 1974, the photographer published his first portfolio, *Fourteen Pictures*, and won a Guggenheim Foundation fellowship that enabled him to travel in the Southwest, where he compiled images for the series *Los Alamos*.[40]

In 1976, a solo exhibition of Eggleston's color photographs at the Museum of Modern Art, with its accompanying publication, *William Eggleston's Guide*, became an art-world controversy.[41] The show presented large-format color prints from transparencies shot around Memphis from 1969 to 1971. The photographs enshrined mundane images from everyday life, objects like a child's tricycle, a flaming barbeque grill, and direct portraits of anonymous Tennesseans. To some observers they seemed little more than banal snapshots, perversely intensified by their scale and supersaturated colors. However, exhibition organizer John Szarkowski claimed that Eggleston had virtually reinvented color photography, by replacing works in which hue was incidental or decorative with a metier for which color was essential to content, design, and expression. Eggleston employed a calculated formal and technical vocabulary to confront everyday America — as Robert Frank (no. 149) had done — providing an image of contemporary life that was prosaic, but not desolate or fatuous.

Eggleston's image of a Wonder Bread sign, from the series *Southern Suite*, demonstrates the banality that irritated some critics. The old sign stands at the edge of a muddy field in early spring, seldom noticed along the side of a highway. It is so rusted that its advertisement for the Village Grocery is hardly legible, and we wonder if the shop could still be in business. In this drab season the bright sign sounds a chord, in its faded red that is complementary in hue to the blue sky. Eggleston chose a distant view, surrounding the sign with plenty of space to allow a glimpse of isolated houses, and a receding line of utility poles to imply the flat expanse of the country. This old sign can be seen as a symbol of the past in a changing world. In the vast American geographic and cultural terrain, old voices, old ways, and old opinions continue to call out. In his travels Eggleston made a great many exposures. Later he carefully selected and edited the images, arranging them in narrative sequences with all the sensibilities of a Southern novelist. This is exemplified by *The Democratic Forest*, a visual record of an imaginary journey across America, to Berlin and back again.[42] Later Eggleston selected photographs to accompany a text by Willie Morris in *Faulkner's Mississippi*.[43]

A similar exploration of tradition with modern values and events is seen in the work of **HIROMI TSUCHIDA (181)**. Born and raised in Fukui Prefecture in Japan, he became an enthusiastic amateur photographer while studying engineering at Fukui University.[44] After graduation in 1963, he attended the Tokyo College of Photography. Tsuchida found a stable job as an advertising photographer for a cosmetics company, but longed to devote himself wholly to creative work. In 1971 he left his corporate position to pursue a freelance career. His work was introduced to Western audiences when it was included in the exhibitions *New Japanese Photography*, at the Museum of Modern Art in New York in 1974, and *Neue Fotografie aus Japan*, at the Municipal Museum in Graz in 1976. Tsuchida traveled around Japan photographing local traditions of ritual and celebration for his first book, *Zokushin (Gods of the Earth)*.[45] His images of Japanese customs, and their progressive transformation in the face of encroaching urbanization and Westernization, make up the series *Counting Grains of Sand*.[46] In 1978, Tsuchida turned his attention to the disastrous clash of Japanese culture with the outside world during World War II. He found inspiration in Arata Osada's *Genbaku no ko (Children of the A-Bomb)*, a postwar sociological study of young children who had survived the attack.[47] Thirty-three years after the event, Tsuchida located many of Osada's atomic bomb survivors, collecting their portraits and stories of their subsequent lives, and exposing the social stigma imposed afterwards by their countrymen.[48]

Lunch Box is a photograph from Tsuchida's third project on the war, *Hiroshima Collection*, which represents one hundred artifacts from the Hiroshima Peace Memorial Museum.[49] The project was timely, for the collection grew significantly in the mid-1970s as the survivors, then elderly, donated personal and family effects for perpetual safekeeping. Unlike Tsuchida's earlier series, which concentrated on people and the passage of time, this suite focuses on objects and a single moment on August 6, 1945.

180

William Eggleston
American, 1939–

Untitled, from *Southern Suite*, 1981

Dye coupler print
25.0 x 38.3 cm
Stoddard Acquisition Fund, 1995.6

181

181

Hiromi Tsuchida
Japanese, 1939–

Lunch Box, 1980–81

Gelatin silver print
36.6 x 44.4 cm
Gift of Martha Tepper
Takayama and Atsuyoshi
Takayama, in honor of Mr.
and Mrs. Stephen B.
Jareckie, 1995.69

182

James Casebere
American, 1953–

Waterfall, 1983

Dye coupler print on
polyester film, mounted on
lightbox
123.4 x 97.8 x 17 cm
Charlotte E. W. Buffington
Fund, 1995.66

Among the series' melancholy images are those of a Buddhist family altar, found in the ruins of a depopulated home, and the sandals of a lost child, cherished ever since by its mother. To place the artifacts in context, and convey their poignancy, Tsuchida provided captions on the photographs. Indeed, he conceived of his portfolio as a portable museum display, to disseminate the collection's message around the world.

The lunch box is propped open to reveal its incinerated contents. Formless masses of food and the distorted shape of the box evoke memories of its original form and use. Its smooth, rounded corners were designed to slide comfortably into a pocket, and the repoussé decoration of delicate lily stalks enhances its organic shape. A diagonal groove across the box cover was meant to contain a small pair of chopsticks. This graceful personal object makes a fitting symbol for the innocent girl who lost her life in the cataclysmic blast. "Reiko Watanabe (15 at the time)," states Tsuchida's caption to the photograph, "was doing fire prevention work under the Student Mobilization Order, at a place 500 meters from the hypocenter. Her lunch box was found by school authorities under a fallen mud wall. Its contents of boiled peas and rice, a rare feast at the time, were completely carbonized. Her body was not found."[50]

JAMES CASEBERE (182) is one of a generation of artists who emerged in the 1970s to claim photography as the means for presenting illusions and tableaux of their own creation, thus challenging its documentary conventions. He was born and grew up in Lansing, Michigan, and attended nearby Michigan State University from 1971 to 1973.[51] After transferring to the Minneapolis College of Art and Design, he began building and photographing cardboard models of suburban domestic interiors and Hollywood images of the Wild West. Casebere continued to work in these media as a graduate student at the California Institute of Arts in 1978–79. The first solo exhibition of his work, at Artists Space in 1979, depicted an artists' biography in ten photographs, from a suburban home and playground to New York City. He built tabletop models of paper, card-

183

board, styrofoam, and plaster, painted them white, photographed, and then abandoned them. After moving to New York, Casebere created models and images of public spaces like courtrooms and libraries. He was motivated by Aleksandr Rodchenko's (no. 90) Constructivist principles, later adopted by the Bauhaus, that art should be multidisciplinary, useful, and relevant to the full spectrum of society. Intent on placing his art before a wide public, Casebere plastered posters of his *Courtroom* on Manhattan buildings and bus shelters. In 1981 he began experimenting with enlarged photographic transparencies mounted to light boxes, a commercial application commonly used for store signs and advertisements.[52] This presentation likened his images to commercial design, conceived for universal accessibility, and to the powerfully formative black-and-white television of his youth. In 1983, Casebere installed five of his light boxes in the waiting room of the Saint George Terminal of the Staten Island Ferry in New York, where they hung amidst subway maps and advertisements.[53] With no identifying labels or explanatory text panel, they were an intriguing mystery to the viewing public.

Waterfall, one of these images, hung over the First Nationwide Bank in the Staten Island Terminal. It represents a jumble of marshmallowy rocks along the base of a cliff, from which a cascade falls. Dowel-like tree trunks frame the scene, and fat, abstracted vines hang from the rocky wall to evoke a forest setting. Beside the cliff, a curving flight of steps leads to a porch and the door to an imaginary cabin in the woods. The whole image is cast in a dramatic gray light, like a night illuminated by a bright full moon. To some extent, all of Casebere's images for the Staten Island Terminal project were inspired by advertising and its use of subliminal imagery. For *Waterfall*, the artist looked to the Kool cigarette advertisements, which often represented a cataract as a symbol of the product's invigorating menthol. Since cigarette ads often exploit ideas of freedom, he also intended to confront the traditions of American landscape painting, and its mythology of the unspoiled wilderness, where a rugged individual can begin a new life. The artist incorporated a human element in the stairway and cabin, to introduce the confrontation of an urban culture that draws sustenance from this wilderness — even to the point of destructive exploitation. Thus, it is interesting to compare Casebere's composition to that of Ansel Adams's *Vernal Fall* (no. 79).[54]

Delicate chiaroscuro also characterizes much of the work of **ROBERT MAPPLETHORPE (183)**, which challenged boundaries between fine art, commercial photography, and pornography in the 1980s. He was the son of an electrical engineer, born and raised in Queens, New York.[55] After graduating from prep school, Mapplethorpe studied at the Pratt Institute in Brooklyn. In 1967, when he was drafted into the Army in the midst of the Vietnam War, he appeared for his psychiatric interview under the influence of LSD, and avoided induction. Drugs were an enduring part of Mapplethorpe's life among the New York demimonde. He shared a Brooklyn brownstone, and later rooms at the Chelsea Hotel, with Patti Smith, the artist, poet, and musician.[56] He told his parents they were married, fearing disapproval of his homosexuality. However, in 1968, when the Stonewall riots energized the Gay Rights movement, he acknowledged his sexual orientation. Mapplethorpe made his first photographs when his friend John McKendry — a Metropolitan Museum of Art curator — gave him a POLAROID camera. He learned the history of photography from his partner and patron Sam Wagstaff, the scion of a wealthy New York family, and a leading photography collector. The first solo exhibition of Mapplethorpe's Polaroids, at the Light Gallery in 1973, included still lifes, portraits, and erotica, his principal subjects throughout his career. As he gained recognition and influence, he began exhibiting his aesthetic photographs apart from his erotic images, which explored the subculture of homosexual sadomasochism. For his more accessible images, he found ideal models in Ken Moody and Robert Sherman — an African American and a European American — who suffered from alopecia, a condition that left their skin glabrous, smooth, and sculpturesque. The photographer also explored sexual stereotypes in his images of the female bodybuilder Lisa Lyon.[57]

Hyacinth exemplifies Mapplethorpe's large, meticulous floral photographs.[58] "He came, in time, to embrace the flower as the embodiment of all the contradictions living within . . .," wrote Patti Smith. "He found them to be worthy conspirators in the courting and development of conflicting emotions."[59] The hyacinth's graceful forms are matched by an equally elegant setting, a spare, conical stoneware vessel sitting atop a table of pristine geometry. The flower's organic shapes contrast with the straight edges of the tabletop and striped shadows cast by Venetian blinds. Illumination clearly falls into the scene from the right, but the blooming stalk perversely leans away from the light, threatening to tip its top-heavy vase. The hyacinth reaches toward the darkness, like Mapplethorpe, who preferred the darkened studio, trendy nightclubs, and dangerous bars. Similar to the floral paintings of Georgia O'Keeffe and the photographs of Imogen Cunningham (no. 83), this image possesses an undeniable eroticism. "The image of splendor and sterility inextricably fused," wrote John Ashbery, "of a flower fashioned to appeal to every sense save that one that matters most, is emblematic of these photographs. They are cruel

183

Robert Mapplethorpe
American, 1946–1989

Hyacinth, 1987

Photogravure
82.7 x 81.2 cm
Gift of Mr. and Mrs. John
Lott Brown, 1995.70

and comforting, calm and disruptive, negative and life-affirming. For all the disillusion it enshrines, [Mapplethorpe's] work paradoxically gives us back joy."[60] In 1986, Mapplethorpe was diagnosed with AIDS. He pursued an ambitious schedule of projects and exhibitions as his health rapidly deteriorated, and was able to attend a retrospective exhibition of his photographs at the Whitney Museum of American Art mounted in 1988.[61]

In images of potent subtlety, **LINDA CONNOR (184)** uses the ostensibly factual medium of photography to represent visions of the insubstantial. Born in New York City, she attended the Friends' School in Poughkeepsie, and decided to become a photographer at age seventeen, when she received an Argus C3 camera as a gift.[62] From 1962 to 1967 Connor attended the Rhode Island School of Design, where she was a pupil of Harry Callahan (no. 133). She was also influenced by the formal structure of Walker Evans's (no. 106) work, and by the mystical implications in the photographs of Frederick Sommer. Connor continued her studies with Aaron Siskind (no. 143) at the Institute of Design in Chicago. She created photographs and collages that ponder her place in the world, in images of her experiences, family, and heritage. This work was included in the first solo exhibition of her work, at the School of the Dayton Art Institute. After receiving her master's degree, she joined the faculty at the San Francisco Art Institute.

In 1972, Connor's aunt and uncle gave her an 8 x 10–inch Century VIEW CAMERA, that had belonged to her great-aunt, Ethelyn McKinney, who had been a student of Clarence H. White (no. 65) in 1905. It had a custom-made, soft-focus lens, which Connor used for dreamy images of objects and landscapes that educe the viewer's associations. She completed these photographs on PRINTING-OUT paper, the sort of manufactured stock commonly used at the turn of the twentieth century. Clamping a negative and a sheet of paper together in a printing frame, the artist developed her photographs in the sunshine of her garden. Finally, she toned the prints with gold chloride to achieve a subdued antique glow.[63] In 1976, a National Endowment for the Arts grant enabled the photographer to travel in the Caribbean, Mexico, and Guatemala. Using her view camera and a sharp-focus LENS, she photographed holy places and revered objects of cultures across the world and throughout history, capturing an ineffable spiritual radiance in her images. A Guggenheim Foundation fellowship in 1979 enabled her to travel in Asia, including Bali and Nepal, and a selection of her work from this journey made up a solo exhibition at the Corcoran Gallery of Art in Washington, DC.[64]

Connor's evocative image of Machu Picchu seems to capture the transcendent spirit of people long absent. The ancient Incan city sits atop a remote Andean ridge, above the Urubamba River canyon cloud forest, northwest of Cuzco in modern Peru. Built during the 1460s by the ruler Pachacuti Inca Yupanqui, the royal estate and religious retreat was abandoned within generations. In Connor's image, clouds envelop ruins clinging vertiginously to the cliffs. The garden terraces, living and gathering spaces, seem to grow from the living rock. Little but an architectural skeleton, the site remains astounding in its formal beauty and technical achievement. The Conquistadors never reached Machu Picchu, and twentieth-century excavators discovered its *intihuatana*, or "hitching post of the sun," a ritual column that rarely survived Spanish subjection. As the winter approached and daily the sun was lower in the sky, an Incan priest ceremonially lashed the sun to this carved pier, ensuring that it could never disappear altogether. Perhaps the survival of the Machu Picchu *intihuatana* enabled this long-deserted place to retain the spirit of the people who built it and lived there so close to the majestic powers of nature.[65]

The photographs of **KEITH CARTER (185)** create a seductive, magical realm, where the eccentric appears conventional and the normal seems peculiar. He was born in Madison, Wisconsin, and raised in Beaumont, Texas.[66] His father left the family when he was five years old, and to support her three children, his mother returned to work as a portrait photographer, specializing in children. While growing up, Carter took little notice of her work, but one day in 1969 he became intrigued by the shimmering illumination of one of her outdoor portraits. He borrowed her camera to make his first serious photograph. Soon he was his mother's assistant, and when she retired he inherited her business. Over the next decade Carter made thousands of children's portraits, while struggling to pursue his own creative work. Encouragement came from David Cargill, a local sculptor, who taught him lessons of composition and art history, and loaned inspiring books like Henri Cartier-Bresson's (no. 167) *The Decisive Moment*.

Carter became an able photographic craftsman, but felt the absence of a personal vision. When he heard the playwright Horton Foote recall that surmounting his own creative struggle required that he "belong to a place," Carter realized that his subject was in the East Texas he knew so well. For his first book, *From Uncertain to Blue*, Carter visited a hundred curiously named Texas towns, making just one photograph in each. The quest revealed how the region is an exotic land, inhabited by extraordinary people and creatures. The confluence of Native American, Native Mexican, and African American cultures, to which animism and magic are common, results in an unusually diverse envi-

184

Linda Connor
American, 1944–

Machu Picchu, 1984

Gelatin silver on printing-out paper, toned with gold chloride
25.1 x 20.2 cm
Eliza S. Paine Fund, 1993.81

185

185

Keith Carter
American, 1948–

Atlas Moth, 1990

Gelatin silver print
37.4 x 37.3 cm
Charlotte E. W. Buffington
Fund, 1998.106

186

Flor Garduño
Mexican, 1957–

The Woman Who Dreams
1991

Gelatin silver print
33.7 x 45.6 cm
Eliza S. Paine Fund,
1994.245

ronment that had always been normal for Carter. As he opened himself to the eccentricity of his neighbors and the singularity of the land, he abandoned his tripod and began handling his camera more freely. Once the photographer grasped the wonder of his own vision, he carried it with him everywhere. His second book, *The Blue Man*, explores his wife's small hometown of Trinity, Texas, combining a local's welcome with a stranger's awe.[67] Carter's work became more empathetic as he strove to adopt the vantage point of his subjects, confronting children and animals at eye level, in the remarkable books *Heaven of Animals* and *Bones*.[68]

Atlas Moth typifies Carter's hypnotic imagery. The photographer captured the mesmeric gaze of an old black man surmounting the wings of a moth, designed by nature to mimic a large wide-eyed creature and thus repel predators. The visual combination is like a magic spell, powerfully connecting the man to nature. He seems to be a shaman, wielding supernatural forces through potent voodoo. His fearless, almost defiant glare —

and Carter's reflection in his pupils — emphasize his daring and apparent might. Even when we notice the pin through the moth's thorax, revealing it as a mounted specimen held in the man's teeth, the vitality of the image summons belief in his magic. The skillfully balanced alternating tone, and the way that the man's arching brows and nostrils echo the contours of the moth's wings, makes this a powerful and memorable image.[69]

The photographs of **FLOR GARDUÑO (186)** also straddle the threshold between temporal and spiritual worlds. Born in Mexico City, Garduño grew up on a farm, under the strong influence of nature and animals.[70] From 1976 to 1978 she studied art at the Antigua Academia de San Carlos of the Universidad Nacional de Mexico, where she was a student of Kati Horna. The style and vision of this Hungarian-born photographer, a combination of expressive and magical qualities, were deeply influential. Garduño became the darkroom assistant to Manuel Álvarez Bravo (no. 84) in 1979, and refined

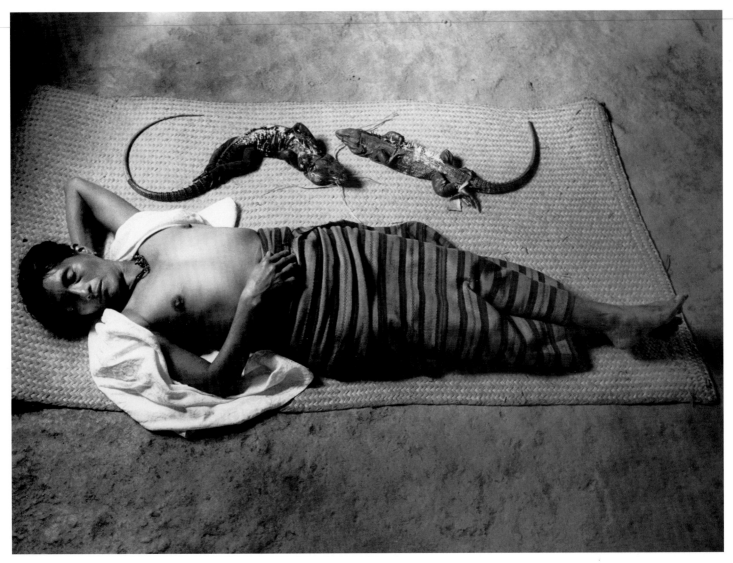

her technical skills by producing albums of high-quality silver, platinum, and palladium prints. In 1981–82 she joined a project sponsored by the government Insituto Nacional Indigenista (Secretariat of Education for Indigenous Communities), run by the photographer Mariana Yampolsky, which toured remote areas of Mexico capturing images of native peoples to illustrate reading primers. In this experience, Garduño discovered the richness of her ancient country and her own distinctive style. The first solo exhibition of her photographs was mounted at the Galeria José Clemente Orozco in Mexico City in 1982. Three years later Garduño published *Magia del juego eterno* (*Magic of the Eternal Game*), a selection of her photographs taken throughout Mexico and Central America.[71] It was followed, in 1987, by *Bestiarium*, a series reflecting the everyday interaction and complex relationships of native and country people with all sorts of animals.

With elegant economy, *The Woman Who Dreams* represents the ancient way of life of the Native Mexican woman. She has paused for a siesta during a tropical day's heat. Lying on a palm mat laid over a dirt floor, she dozes comfortably. Watching over her slumber are two iguanas, perhaps her morning's catch, prevented from escape by bound feet. They are awake and alert, and the energetic arabesques of their bodies and tails create a vital counterpoint to the woman's repose. Her posture and calm expression are very human, and easy to understand. We wonder about the dreams of such a woman, living so simply and close to nature. Perhaps she encounters magical images of forest spirits, or ancient Mayan gods. We cannot help but mourn her fate, as the modern world encroaches,

187

Lois Conner
American, 1951–

Saint George's Hotel, Brooklyn, 1991

Platinum print
17.3 x 42.0 cm
Eliza S. Paine Fund,
1994.244.1

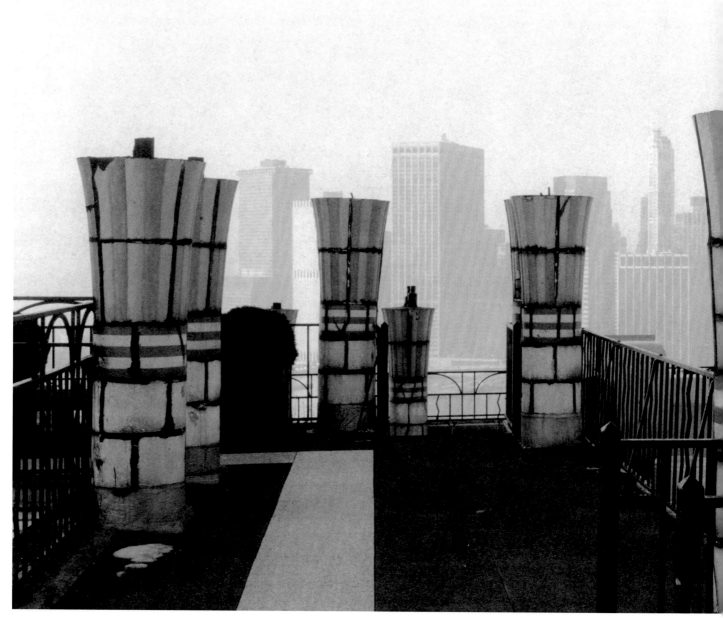

soon to change the lives of her people forever, and threatening to obliterate their traditions. *The Woman Who Dreams* is one of the images from Garduño's landmark project, *Testigos del tiempo* (*Witnesses of Time*), which brought international renown to the photographer.[72]

In the mid-1990s, Garduño shifted her approach, returning to the fundamentals of photography. She set up a studio in a little adobe shed beside her house in Tepoztlán, and concentrated on photographing still lifes and female nudes.[73] The small studio promoted a shallow depth of field against the neutral backdrop of cracked adobe floor and walls. Women friends became her models, and she encouraged them to choose their own poses. Themes of fertility and eroticism emerged, as well as the iconography of Pre-Columbian religions and Catholicism.

The mystique of place, and the close relations between the land and its inhabitants over time are also subjects in the photographs of **LOIS CONNER (187)**. She was born in Rockville Center on Long Island, New York, the daughter of an electrical engineer and optical-instrument designer, who taught her to make photographs when she was nine years old.[74] While growing up in Delaware and Pennsylvania, she learned to make her own clothes and, as a teenager, developed and printed her own photographs. Conner studied painting and art history at the University of Delaware, where she took her first serious photography courses. She transferred to the Fashion Institute of Technology in New York in 1971, but two years later finally decided on a career as a photographer, beginning studies at the Pratt Institute. Conner soon gravitated to the view camera and to PLATINUM PRINTING. In 1976 she

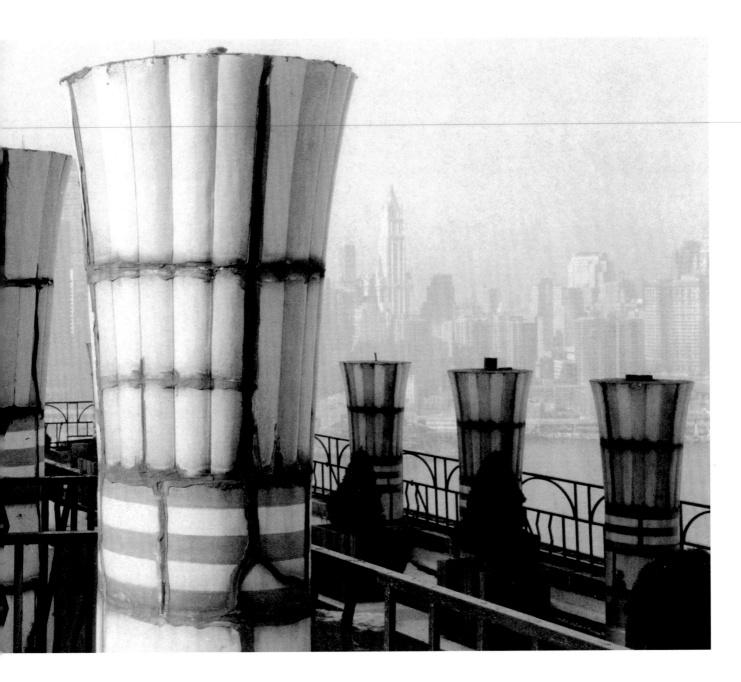

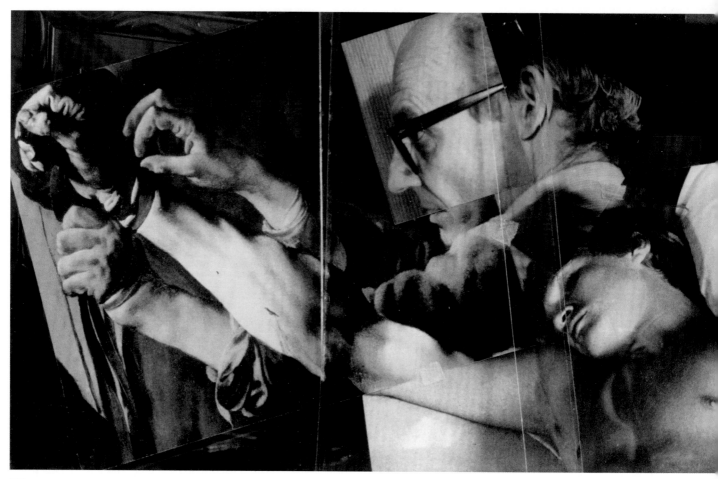

188

188

John O'Reilly
American, 1930–

In a Dutch Dream, 1990

Gelatin silver print collage
9.6 x 32.0 cm
Eliza S. Paine Fund, 1990.135

traveled to Africa, to photograph a housing project for the United Nations Development Corporation.

In 1978 Conner photographed New York City parks, and the following year, with the support of a National Endowment for the Arts grant, she began exploring the city from its rooftops. Her father pieced together her first panoramic "banquet camera," and she was invigorated by the fresh vision of landscape provided by its 7 x 17–inch format. At the time, Conner was studying the history of Chinese art, and she found insight into the painters who had worked with the hanging scroll and hand scroll format for centuries. Wondering whether there was something about the land that inspired these forms, Conner applied for a Guggenheim Foundation fellowship which enabled her to travel in China for eight months in 1984. Her panoramic photographs investigate Chinese conventions of reading pictures, which encourage the viewer to observe a small portion and move along, seeing the landscape change as in a journey. She traveled through the provinces of China by public transport, bicycle, and foot, carrying her camera and all of her own equipment, like a nineteenth-century expeditionary photographer. Often her views convey a sense of the country's appearance before mecha-

nization and good roads, a perspective quickly disappearing in the populous country.[75]

In 1991, the year Conner joined the faculty of Yale University, she shot a memorable view of a roof, *Saint George's Hotel, Brooklyn*, looking to the distant Manhattan skyline across the East River. The decorative columns of old canopies provide a ready-made sculptural installation. Like the ruins of an ancient Egyptian temple, the piers create a theatrical depth in their progressive diminution. They fill the entire width of the panoramic composition, and imply the horizontal breadth of the elevated rooftop perspective. The random lines of the asphalt repairs to the cracking columns soften the Art Deco geometry, emphasizing a sense of ruin and the entropy of nature. The delicate effects of illumination and modeling that Conner achieves through the platinum process creates a silvery delicacy, as well as atmospheric perspective and the sense of age.[76]

A dreamlike quality characterizes the photocollages of **JOHN O'REILLY (188)**, whose imagery unifies art, poetry, and self-revelation. He was born in Orange, New Jersey, and grew up in Red Bank, and carries memories of playing with the boys' cutout

books sold during World War II, and his childhood pleasure in building regiments of paper soldiers.[77] O'Reilly studied art at Syracuse University and went on to the School of the Art Institute of Chicago, where he concentrated on painting. After competing his master's degree in 1956, he went to Spain to study the Old Masters. Struggling to continue working on a meager budget, he collaged fragments cut from *Art News* magazines he received from home.

When O'Reilly returned to the United States in 1961, he decided to look for a job in New England, and was drawn to Worcester by his admiration for the Museum's director, Daniel Catton Rich, who had been at the Art Institute of Chicago when he was a student.[78] For a time O'Reilly taught art in the Worcester Public Schools, then he joined the staff at Worcester State Hospital, an acclaimed psychiatric facility. His work demonstrated its value, and the hospital sponsored his studies to become a registered art therapist. Collage remained O'Reilly's chief creative medium during the 1960s, when he was influenced by the work of Joseph Cornell and inspired by the poetry of Jean Genet and Constantine P. Cavafy. He grangerized a copy of Cavafy's biography, substituting images of himself

for the poet. This fanciful identification was suggested by O'Reilly's experiences with psychiatric patients. Over time, his own image came to dominate his collages, in fragments of his baby pictures, photobooth self-portraits, or photographs shot by his partner, the artist James Tellin. In 1984, O'Reilly acquired a vintage POLAROID 100 camera, which he used to photograph himself in black and white, posed for specific compositions. He combined photographs of his own nude body with settings and figures taken from Old Master painting and sculpture. Sometimes he incorporated the images of gay icons such as Genet, Walt Whitman, or Benjamin Britten, placing his own head on their bodies, or their faces on his figure. O'Reilly built a miniature set in his studio, and collected tiny props to add to his staging repertoire. In 1988, his work was facilitated by an artists grant from the National Endowment for the Arts.

In a Dutch Dream exemplifies the wondrous complexity of O'Reilly's collages. The image is dominated by a motif from the seventeenth-century painting *The Rescue of Saint Sebastian* by Hendrick Terbruggen, in which the tortured martyr is unbound by Saint Irene.[79] However, it is O'Reilly himself — with a determined glare behind heavy

189

black eyeglasses — who has become Sebastian's rescuer. The martyr has transformed into a young man asleep on a pillow, with another man's body lying next to him. The setting has also shifted, to a modern bedroom with gaudy bedclothes and the kitschy picture of a village smithy. The Surrealist quality of the scene is heightened by a glimpse into an artist's studio, where the miniature figures of a circus acrobat and a duck-billed pull-toy evoke childhood fancies and introspective adult dreams. Fourteen of O'Reilly's collages were included in the prestigious Whitney Museum Biennial exhibition in 1995.[80]

LORNA SIMPSON (189) has also used her own likeness, in moving images that consider issues of history, culture, and social roles from the perspective of an African American woman. The artist was born in Crown Heights, Brooklyn, and grew up in Queens.[81] Simpson studied photography at the School of Visual Arts in New York, where she received her bachelor's degree in 1982. During graduate studies at the University of California in San Diego, Simpson became convinced that documentary photography had lost its viability, and her work became more conceptual. After completing her master of arts degree in 1985, she undertook a succession of installation projects that combined photographic images with text, sculptural elements, and even sound. These works confronted problems of American culture, ethnic identity, topical events, and the private and public legacies of racial identity. A solo exhibition of Simpson's work was mounted at the Museum of Modern Art in 1990, the year she became the first African American woman to represent the United States at the prestigious Venice Biennale. Two years later, a solo exhibition of her work was shown at the Museum of Contemporary Art in Chicago.[82]

Counting exemplifies Simpson's combination of cropped photographic images and fragmented text, conceived to involve the viewer, and to reflect the ambiguity of modern perception.[83] Three superimposed images are flanked by textual glosses, providing keys to multiple readings in the context of African American experience. At the top is the cropped portrait of the lower face, neck, and chest of a black woman — a recurrent motif in Simpson's work of the period — dressed in a simple white shift. Along the neckline of the garment is a decorative pattern reminiscent of traditional African stitching. This fresh, virginal figure is flanked by a list of work hours — here added by screenprint in red — that seem draconian in their demands. The artist effectively dehumanizes the subject by providing only a fragmentary image; she also prevents empathy, forcing the viewer to confront the broader, political implication of her work. In the center of the composition is the photograph of a

Charleston smokehouse, in a structural form derived from African tribal architecture that was commonly used for slave huts in South Carolina. This adaptation of African traditions in America is suggested by the associated text, *310 years ago*, which identifies the duration of racism in America. The labor of constructing these buildings under duress is suggested by the pendant text, *1575 bricks*, which also reflects the stratagem of counting as an aid to accomplishing difficult work. For centuries, braiding hair has been an intimate family ritual among African American families, derived from traditions of slavery when the chore was turned into a counting game and a surreptitious way to teach arithmetic to children who were supposed to remain uneducated. Simpson's photograph of a coil of plaited hair superimposes an appropriate text: *25 twists, 70 braids, 50 locks*. However, this inscription also provides a more sinister analogy in its allusion to rope, the tool of imprisonment and lynching. Indeed, each instance of measurement echoes the dehumanizing and ubiquitous vestiges of slavery in African American culture.

An exquisite delicacy of perception, and a keen intellectuality, characterize the work of **HIROSHI SUGIMOTO (190)**. He first became interested in photography when his Tokyo elementary school teacher made PHOTOGRAMS for the class. Afterwards Sugimoto insisted on having his own photosensitive paper to continue the activity at home.[84] He studied economics at Rikkyo University, and after graduation he tramped the world with a backpack to avoid a salaried job. Settling in California, Sugimoto studied photography at the Art Center College of Design in Los Angeles. After completing his degree he moved to New York and supported himself as a dealer of Japanese art and antiques while working on his creative photographs. He began three concurrent, open-ended series of black-and-white photographs in the late 1970s: *Dioramas*, *Seascapes*, and *Theaters*. Despite their seeming disparity, Sugimoto has often declared that time was their common subject.[85] In the *Dioramas* series, he photographed displays in museums of natural history and science, framing the images to employ their spatial illusion.[86] He depicted a range of biological, anthropological, and historical exhibits as if they were objects and events frozen in time. Like photographs, the dioramas also depict the static conceptions of their creators. For his *Seascapes* series, Sugimoto pursued stark images of the sea and sky, in which a flat, featureless horizon bisects the horizontal frame.[87] With all reference to land eliminated, these delicate images mark the threshold of abstraction. The photographer traveled the world searching for lofty overlooks on seas inflected by different light and climatic conditions. He found his favorite subjects

189

Lorna Simpson
American, 1960–

Counting, 1991

Photogravure with screenprint
187.3 x 96.5 cm
Gift of Sheila Carroll and
Mark Lynch, 1994.221

190

190

Hiroshi Sugimoto
Japanese, 1948–

Metropolitan Los Angeles Theater, 1993

Gelatin silver print
42.3 x 54.1 cm
Purchased through the gift of Sylvan Barnet and William Burto in honor of Elizabeth de Sabato Swinton, 1994.223

in Jamaica, Newfoundland, and a promontory overlooking the Sea of Japan.

Metropolitan Los Angeles Theater is one from a series that Sugimoto began in 1978.[88] To capture the lavish interior decor of American movie theaters of the 1920s and 1930s, he set up his 8 x 10–inch view camera on the balcony of each dark, deserted auditorium. Programming the timer of his camera to the length of a feature film, he opened the shutter and had the projectionist run the movie. As the fleeting images played over the screen at twenty-four frames per second, their aggregation canceled each other out, allowing the searing white light common to every transparent film cell to reach the screen. The cool, gleaming light illuminated the theater architecture with mesmerizing subtleties of gray. Most intriguing, though, is the fact that Sugimoto has also photographed the duration of the film, capturing its essential component: time. The

artist described the images as "time exposed," explaining their phenomenon with the Zen Buddhist metaphor of a void as the consequence of fullness. After photographing many of the grand movie theaters in the eastern United States, Sugimoto took his camera to drive-in theaters across the country. In 1993 he photographed theaters in Los Angeles, in homage to the movie capital.[89]

The cool, objective vision that enthralled German photographers of the *Neue Sachlichkeit*, and that era's admiration for functional form, was reborn in the photographs of **BERND AND HILLA BECHER (191)**.[90] However, during the 1970s and 1980s, the epoch of Minimalism and Conceptualism, their methodical visual ordering carried new implications. The couple met in 1957, at the Troost Advertising Agency in Düsseldorf, and they married four years later. As students at Düsseldorf Art

191

Academy they began working together, collecting photographic images of the half-timbered workers' houses in South Westphalia.[91] In 1963, the first exhibition of the Bechers' collaborative work was mounted at the Galerie Ruth Nohl in Siegen. Their travels together led to a fascination with the sort of industrial architecture and machinery that Albert Renger-Patzsch (no. 103) depicted as symbols of national progress in the late 1920s. As a technological and information economy superseded industry in the 1960s, accompanied by environmentalism, structures like lime kilns, blast furnaces, winding towers, and mine-preparation plants faced obsolescence. The Bechers set out to record these often ignored structures while they were still in service. The comparative ease of air travel at the time throughout Western Europe and the United States enabled them to collect images of industrial architecture, and they discovered slight variations among these serviceable designs. Like August Sander's (no. 77) encyclopedic *Menschen des zwanzigste Jahrhunderts*, the Bechers organized their images in series. They paired the images of similar structures and, as time progressed, arranged them into objective groupings they called "Typologies," which provided methods of visual comparison parallel to the contemporary ideas of Conceptualism.

In 1970, the Bechers published the book *Anonymous Sculpture: A Typology of Technical Constructions*.[92] Two years later, their photographs were included in the influential exhibition of Conceptual Art, *Information*, at the Museum of Modern Art.[93] The Bechers photographed structures in black-and-white, often from an elevated point of view against a blank sky, employing the same direct orientation. They equated varied images by adjusting tonalities in exposure and printing. Each subject is closely framed to crop out extraneous features, allowing the photographs to be hung tightly together. The artists also designed the configuration in which a typological group is to be hung. In their typology of *Blast Furnaces*, the Bechers present structures of enormous fireboxes surrounded by complex ductwork systems for venting and exhaust. The ducts are supported and serviced by intricate superstructures with stairs, walkways, railings, and struts that reflect their enormity and create complex linear and geometric patterns. To the uninitiated viewer, however, the structures are like the fantastic stairs and walks to nowhere in Giovanni Battista Piranesi's seventeenth-century *Carceri d'invenzione* (*Imaginary Prisons*). The catwalks, built for practicality without regard to proportion or ornament, reinforce the enormous scale. Like biologists the Bechers stalk, observe, and catalogue the taxonomy of these fascinating industrial beasts, threatened with extinction.[94]

Teaching at the Staatliche Kunstakademie in Düsseldorf, the Bechers influenced German photographers of many generations, including such significant artists as Andreas Gursky, Thomas Struth, Candida Höfer, and **THOMAS RUFF (192)**. Born at Zell-am-Harmersbach in Bavaria, Ruff arrived at the Kunstakademie at age nineteen. Even as a student he was fascinated by the credulous acceptance of photographic representation, despite inconsistencies with direct perception.[95] In 1981, Ruff began making stark, bust portraits in profile, three-quarter, or frontal views, informed by the bureaucratic identification images that document us all. When shooting his friends and acquaintances at the Kunstakademie, he instructed them to face the camera without expression or thought. He emphasized the official anonymity of their images by using only the sitters' initials as titles. Following the covers of a popular German television magazine, Ruff used flat, colored backgrounds. But in 1985, when he began printing these images in monumental scale, the background hue became overwhelming, so he adopted a neutral gray-white.[96]

Portrait exemplifies one of these enormous photographs, which physically overwhelm the viewer.[97] As scale defines its own reality, the photograph becomes independent of the person it represents, and is less a document of the subject's individuality than of her anonymity. The size and impact of these images are analogous to billboard advertisements, meant to communicate their message at a glance, but never carrying any deeper significance. For this series Ruff selected models of similar age, and lacking any outstanding physical characteristics. The cumulative effect of the series is homogenizing rather than individualizing. The neutral pose, expressionless demeanor, and bright, even lighting of the face prevents any individual psychological interpretation. To emphasize the anonymity of these hauntingly empty likenesses, he gave each of them the same generic title: *Portrait*. This series came to an end in 1991 when the photographic paper Ruff used was taken out of production.

By that time, the photographer had begun to explore similar ideas in other standard genres, like architecture, reportage, and nude photography. He turned his camera on postwar German apartment buildings constructed in the 1950s and 1960s, structures made prosaic by their ubiquity. His series *Haus* (*House*) offers a visual definition of serviceable, generic architecture, and leaves a depressing view of the banality of modern life.[98] Ruff explored digital technology in the late 1990s, when he collected newspaper images of the preceding decade in the series *Zeitungsphoto* (*Newspaper Photos*). Separated from their topical context and explanatory captions,

191 (detail)

Bernd Becher
German, 1931–
and
Hilla Becher
German, 1934–

Blast Furnaces, 1994

Nine gelatin silver prints
40.1 x 31.0 cm (each)
Stoddard Acquisition Fund,
1995.31.1–9

193

192

Thomas Ruff
German, 1958–

Portrait, 1990

Dye coupler print
158.7 x 120.1 cm
Gift of the Friends of
Contemporary Art in
memory of Geraldine
Persons, 1993.22

193

Richard Billingham
English, 1970–

Untitled, 1995

Dye coupler print
119.37 x 78.73 cm
Austin S. Garver Fund,
1998.168

these images convey little information and expose the basic unreliability of reportage. For his series *Andere Porträts* (*Other Portraits*), Ruff used a Minolta Montage Synthesizer, equipment used by the German police to generate eye-witness images of criminal suspects.[99] Fusing his earlier portraits with these likenesses, the artist further collapsed any notion of photographic authenticity. In 1999, he appropriated images from pornographic web-sites for the *Nudes* series. Ruff cropped the images and adjusted the focus to semi-abstract blurs, stressing by their proliferation the anonymity of their purpose and use.[100]

Over the course of the twentieth century, as photography became omnipresent, being photographed ceased to be an occasion and subjects came to ignore the camera. In the 1980s, this dispassion created a new photographic genre in which photographers revealed their lives, and their families', with intimate candor. Nan Goldin, Sally Mann, and **RICHARD BILLINGHAM (193)** were among those artists.[101] When he was ten years old his father Ray lost his job as a machinist. Failing to find work, he succumbed to chronic alcoholism and seldom ventured from the family apartment. He quarreled with his wife, Liz, they separated briefly, and Social Ser-

vices removed his younger son from the home. When Billingham was a student at the Bourneville College of Art, in 1990, he began making black-and-white photographs of his father as figure studies for his paintings. His work expressed the tragedy of alcoholism and poverty. Despite his protective instincts, Billingham found that by identifying the experiences as his own, he could find some psychological resolution. By the time he transferred to Sunderland University in 1991, he was making color photographs of his family, not only for his artwork, but as an attempt to comprehend them, and himself. He used an auto-exposure camera loaded with inexpensive film, which was processed by drug store DEVELOPING machines. He photographed constantly, thus his family stopped noticing and there is no artifice in his snapshots.

The voyeuristic impact of Billingham's work is apparent in the image of his mother lolling on the sofa in a chintz shift and fuzzy slippers, her hands clasped behind her head as she concentrates on the television set. Her pose is reminiscent of the odalisque — a harem concubine — a common erotic subject in the history of art, from Francisco Goya's *Naked Maja* to Edouard Manet's *Olympia*. The image represents Liz Billingham as she truly is, a welfare beneficiary, overweight, and unkempt,

lazily wasting time in an untidy home. She is comfortable amidst the clutter, the stained furniture, and torn pillows. It is an affectionate likeness; she loves bright colors and pretty things, so the artist has captured her before riotous *chinoiserie* wallpaper and in her remarkable housedress. Billingham compiled a series of photographs in the family flat representing his parents, his brother, and their terrorized cat and dog. Some photographs represent dereliction, confrontation, violence, and frustration, others show laughter and affection.

Billingham's family represents authenticity and complexity, and prompts strong identification. Looking at these photographs reminds us of our own limitations, and make us wonder what will become of our images, of our memories, after we have left them behind. In 1994, Billingham's photographs were shown in the exhibition *Who's Looking at the Family?* at the Barbican Art Gallery. Michael Collins, editor of the London *Sunday Telegraph*, noticed the work, and helped publish it as the book *Ray's a Laugh*.[102] "My parents and brother are very happy about the book," Billingham said. "Neither I nor they are shocked by its directness because we're all well-acquainted with having to live in poverty. . . . It is certainly not my intention to shock, to offend, or to sensationalize, be political or whatever. Only make work that is as spiritually meaningful as I can make it."[103]

The work of **SHIRIN NESHAT (194)** employs poetry and paradox to investigate vexing issues of cultural conflict. The artist was born in Qazvin, Iran, and grew up in a home where poetry was passed by recitation from parent to child.[104] At age seventeen Neshat came to the United States to attend the University of California, Los Angeles. She enjoyed the personal freedoms of American life, but missed her family and culture. This sense of isolation increased in 1979, when the revolution in Iran established the regime of Ruhollah Khomeni and the Ayatollahs, and Neshat was prevented from going home. Twelve years passed before Khomeni's death enabled her to return to Iran, where she was stunned by the changes imposed by the theocratic regime. Repressive codes of dress and conduct were strictly enforced in previously cosmopolitan cities, where old Persian streets now

had Arabic and Muslim names. Neshat was especially disturbed by the proscriptions imposed on women. She experienced lasting emotions of dispossession, no longer comfortably belonging in Eastern or Western culture, and she felt compelled to express her dismay and concern in works of art.

In 1993, while living in New York, she began *Women of Allah*, a series of photographs investigating gender roles in Islamic fundamentalist society, meant as nonjudgmental images expressing her own lack of understanding and desire for respectful conciliation.[105] In each of the photographs Neshat herself appears, dressed in the Muslim chador. However, her authorship of the photographs and her own representation reflect her position outside the strictures of Islamic fundamentalism. On the finished prints Neshat inscribed the love poetry of Persian poets in elegant Farsi calligraphy. Usually she placed these words of devotion and passion on areas still exposed by the veil: the face, hands, and feet. The words provide a seductive invitation to the rest of the body, circumventing the veil and challenging its repression of desire. In many photographs, Neshat brandishes a gun, even aiming directly at the viewer. These confrontational images also question the role of women in the Iranian revolution. Must women assume roles of belligerent combatants, forsaking traditions of submission and nurturing commitment to the family?

In *My Beloved*, from the *Women of Allah* series, Neshat appears with her young son, who is enveloped in her arms and literally protected by the chador. In this context, the veil symbolizes not only the protection offered by maternity, but also by Muslim society and the Islamic faith. The comforting embrace expresses affection between mother and child, and their direct gaze evokes our sympathy. However, the prominent rifle nearby disrupts this accord, for it is difficult to know whether it functions as a symbol for the security of the family or the might of Islamic culture, whether the mother is raising her son to fight for Islam or is protecting him from the violence it symbolizes. Little resolution is provided in the calligraphy on the veil surrounding Neshat's face like a halo. The words are from a poem by Fourough Farokhzad, a contemporary Iranian feminist: "I die in you. . . . but you are my life!"[106]

194

Shirin Neshat
Iranian, active in the United States, 1957–

My Beloved, 1995

Gelatin silver print on resin-coated paper, with hand additions in India ink
81.3 x 54.6 cm
Sarah C. Garver Fund,
2002.35

As the twentieth century drew to a close, farsighted creative photographers explored methods and imagery that challenged the traditions of their medium, which had become the preeminent, and thus conventional, manner of perception. They worked at a time of mercurial changes in photography, when computers and information technology completely transformed the ways in which people saw and understood the world and visually communicated their ideas. In the last quarter of the century, film gave way to videotape, and then rapidly to digital recording. Professional still photographers grudgingly followed, recording their images digitally; soon personal DIGITAL cameras allowed everyone to grab an image and broadcast it everywhere immediately, via the World Wide Web. In a few short years, these cameras were incorporated into the cellular telephones carried in the pockets of millions of potential photographers.

Rather than optically recording a LATENT IMAGE in the chemical reactions borne on the surface of film or paper, these systems directly capture reflected photons, translating them into electrons that are then presented in pixels — or picture elements — illuminating the minute area of an electronic display screen, or printed on a physical surface. These digitized packages, collected through the LENSES of a camera or scanner on arrays of photosensitive cells, were electronically stored in computer circuits, where they could also be collated and manipulated, offering previously unimagined possibilities for creating and presenting visual images. In scientific and medical imaging, visual data were collected from reflected electrons instead of photons. In virtual imaging, pictures were created in electronic circuits, and employed light only in their transfer to the human eye. Creative photographers could strive to ignore these revolutionary changes, but it was impossible

to avoid either reacting to them or incorporating their influences.

Among the most provocative challenges to photographic vocabulary was the work of **UTA BARTH (195)**. Born in Berlin, she attended the University of California, Davis, and after graduating in 1982 she continued her studies at the University of California, Los Angeles.[1] The artist joined the faculty of the University of California, Riverside, and in 1990 she won a grant from the National Endowment for the Arts. Two years later Barth began a series of painterly photographs that evoke aesthetic and intellectual associations. For the *Ground* series, the artist photographed interior spaces, adjusting her camera to focus on an unoccupied middle ground, and thus casting all of the visual data into a blurred, immeasurable depth. Fuzzy objects appear, often at the perimeter of her compositions, recognizable enough to identify the space as a domestic interior, but not clear enough to ascertain anything about the space or its inhabitants, information that regularly engages us in such an image.

In *Ground #74*, a curtained window on the left filters the light as it comes into a room. Brighter illumination seems to flood in from the right, judging from the shadows cast by the edge of a piece of furniture, on which a framed photograph stands. By contrast, Barth extended her illusions by presenting her works mounted on dimensional panels, so that they float without frames, proud of the wall surface. We can identify the subject as a room, but it functions less as a living space than as a container for light, presenting an intriguing metaphor for the camera itself in an era when its demise is imaginable. At a time when technology created new possibilities for concrete representation and capricious manipulation, Barth used photography to create images with the insubstantiality of emotions of memories.[2]

195

Uta Barth
German, 1958–

Ground #74, 1996

Dye coupler print
43.8 x 57.0 cm
Alexander and Caroline
DeWitt Fund, 1998.188

195

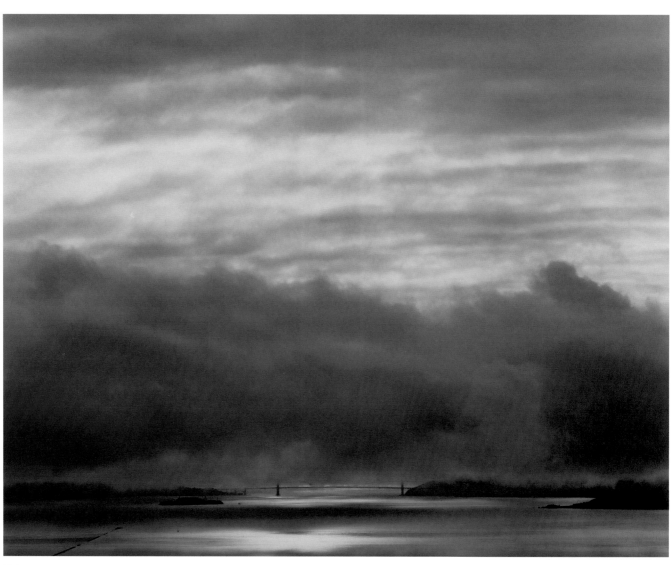

Despite his traditional photographic background, **RICHARD MISRACH (196)** has developed imagery that progressively tended toward the ethereal and abstract. He was born and raised in Southern California, where his father ran a sporting goods business in Los Angeles.[3] As a child Misrach made photographs with a Kodak Instamatic camera, and his interest reignited during his senior year at the University of California, Berkeley. He taught himself the fine points of technique, guided by the photography studio of the Associated Students of the University of California (ASUC), where he studied briefly with the topographical photographer William Garnett. After graduating in 1971, Misrach joined the ASUC Studio staff, which gave him DARKROOM access off-hours. With the support of a National Endowment for the Arts (NEA) artist's grant in 1973, he photographed Berkeley street culture, and created a photographic series that was exhibited and published as *Telegraph at 3 a.m.*[4]

In 1979, a second NEA grant and a Guggenheim Foundation fellowship enabled Misrach to photograph ancient Greek and Roman architectural ruins at night. He also explored the deserts of California and the Southwest with an 8 x 10–inch VIEW CAMERA, sometimes loaded with color negative film, and later organized the images into series suggested by Ezra Pound's epic poem, *Cantos*.[5] Misrach soon came to concentrate on color photography. In 1981 his work was included in the prestigious Whitney Museum of American Art Biennial exhibition. After being detained for photographing near the Yuma Marine Base in Arizona, the artist became increasingly aware of the large military presence in the western deserts. Later he photographed "Bravo 20," an enormous expanse of public land near Fallon, Nevada, where Navy pilots illegally tested high-explosive bombs in the 1950s.[6] Vast desert tracts are contaminated by radioactivity, and strewn with the debris of ordnance and materiel. Misrach's images make disturbing comparisons to the photographs of Carleton E. Watkins and Ansel Adams (nos. 37, 79).

In 1997 Misrach moved with his family to a home in the Berkeley hills, with a view of the Golden Gate Bridge that provided a remarkable perspective on changing effects of weather, atmosphere, water, and light. He set up his view camera in one place on the front porch, and shot at different times of day and under varied conditions. Misrach produced over seven hundred photographs, from which eighty-five were selected for the book *Golden Gate*.[7] On the afternoon of February 21, 1998, a thin ceiling of clouds hung over San Francisco Bay, allowing filtered sunlight to reach calm water. Late in the afternoon, lower banks of mist and cloud blew in swiftly. At 4:45 pm, when Misrach snapped his SHUTTER, this shifting cloudbank seemed to hover just above the deck of the bridge. The clouds created a stunning effect of light on the water, where cool highlights glow beside patches of deep gray. This color photograph represents delicate, nearly indistinguishable hues and dramatic chiaroscuro. By its context in an ongoing series that chronicles change, the artist succeeded in capturing not only the fugitive atmosphere, but fleeting time. Afterward, Misrach progressed to an equally ethereal subject in his sky photographs, which mediate between document, abstraction, and metaphor.[8] Later he created vivid, nearly abstract aerial images of beaches as powerful environmental and metaphysical thresholds.

In the grand tradition of Carleton E. Watkins, Ansel Adams, and Eliot Porter (nos. 37, 79, 168), the works of **ROBERT PARKEHARRISON (197)** champion the environment. His are not naturalist photographs, however, but fantastic parables in PHOTOMONTAGE, relating stories of human transgression against the earth. Robert Harrison was born at Fort Leonardwood in Missouri, the son of an Army officer, and he grew up in a military family that moved to many postings around the country.[9] He began making photographs as an undergraduate at the Kansas City Art Institute, where paintings composed his first solo exhibition in 1989. In Kansas City he met Shana Parkey, an employee at the Art Institute, who would become his wife and collaborator. Together they attended graduate school at the University of New Mexico in Albuquerque. There, in 1993, he began photographing himself in constructed tableaux, beginning the extended series that brought him wide recognition.[10]

In 1995 ParkeHarrison joined the art faculty at the College of Holy Cross in Worcester. His creative work became more elaborate, in eerie scenes of postapocalyptic heroism. The artist appeared as Everyman, the anonymous symbol of survivors who might be left in the wake of worldwide environmental cataclysm. Always garbed in the same dark suit, open white shirt, hefty boots, and close-cropped hair, he strives to assist the earth and its creatures in reviving its systems of life. In desolate landscapes, under gray skies, he performs obscure rituals or labors at parochial tasks, using simple equipment reinvented from the corroding scraps of civilization. Everyman fights to heal an ailing patient — which is the setting itself — straining to hear the messages that might allow diagnosis and treatment. In *Mending the Earth*, for example, Everyman wields an enormous needle to stitch up crevices in the ground; in *The Book of Life*, he gathers specimens and seeds of endangered plants, pressing them in a gigantic book. The dark humor

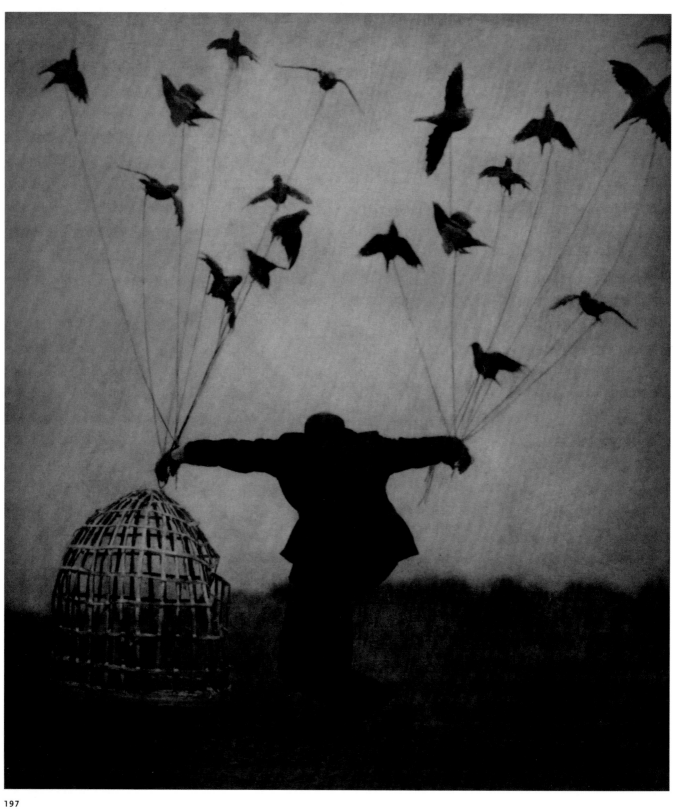

and irony of these images do not diminish their message of technological mismanagement and impending environmental catastrophe.

Flying Lesson, one from a suite of three PHOTO-GRAVURES, represents Everyman turning from the viewer as he tries to learn to fly.[11] Arms out-stretched, he crouches as if to leap, while a flock of birds tethered to his wrists struggles to pull him into the air. Everyman's posture reflects his steely determination, and the birds convey a similar zeal by furious flapping. The whole operation is super-vised, it seems, by a crow or raven in a rickety wicker cage, its door thrown open. Robert and Shana ParkeHarrison worked together over months, to develop the idea, to design and fabricate props of wood, fabric, plaster, and papier-maché, and to refine the choreography of pose.[12] Then, in an open, New England landscape, Robert assumed the carefully planned pose, while Shana helped adjust the posture while looking through the view-finder and then snapped the shutter. The artists made enlarged PAPER NEGATIVES from their shots in the field and in the studio, COLLAGING together separate images of background and figures. They amended the images with drawing and painting in a process of PHOTOMONTAGE similar to that of Raoul Ubac (no. 121). The image was then trans-ferred to photogravure plates, utilizing a medium that carries the cachet of Old Master prints by rein-forcing the impression of age and obsolescence. *Flying Lesson* was printed from two matrices, the first plate in black ink, the second inked in a sepia hue. Finally, ParkeHarrison covered the printed area with beeswax, buffing its surface to achieve the depth and glow of an old painting. Sometimes the artists present their images in life-size panels, reworking the photographically printed surfaces in other media, and finishing with varnishes. In 2003, a traveling exhibition of ParkeHarrison's work was presented at George Eastman House; its installa-tion included some of the props and Everyman's dark suit.[13]

IÑIGO MANGLANO-OVALLE (198) has used photography as a means to explore concepts of identity, at a time when science is transforming our understanding of biological individuality. The artist was born in Madrid, and grew up there and in Bogatá, Columbia, and Chicago, Illinois.[14] At Williams College in Massachusetts he studied art, as well as Spanish and Latin American literature. After graduation in 1983, Manglano-Ovalle went to the School of the Art Institute of Chicago. He com-pleted his master's degree in 1989, then joined the art and design faculty at the University of Illinois in Chicago. The versatile artist has employed a wide variety of media in provocative installation projects, including found sculpture, photography, video, and sound. Several of his works confront the changing concepts of individuality, race, displacement, and community, and grow from his own experiences living in different countries and cultures. In 1990, Manglano-Ovalle created *Assigned Identities* at Emmerson House, a Chicago community center serving Hispanic immigrants. Photographs of cen-ter participants were incorporated into designs based on United States government Immigration and Naturalization Service application forms and its alien resident permit, or green card. Manglano-Ovale's triptych *Rose*, of 1995, represented the genetic code of a bed of flowers. Here he conveyed how the rose, a common paragon of beauty, is actually a monstrous hybrid, modified by centuries of selective breeding to satisfy human notions of perfection.

In 1998, Manglano-Ovalle explored similar issues in *The Garden of Delights*, a commission from the Southeastern Center for Contemporary Art in Winston-Salem, North Carolina. This installa-tion filled a gallery with enveloping veils of bright abstraction in forty-eight lifesize photographic panels.[15] Manglano-Ovale derived the imagery for each panel from the genetic information of a different human subject. He invited sixteen people to choose two partners for the project, comprising "families" of three. Using a supplied collection kit, participants took their own DNA samples and mailed them to the Wake Forest University School of Medicine Genetics Laboratory in Winston-Salem. There, the samples were subjected to the standard polymerase chain reaction (PCR) tests, the same procedures used to ascertain paternity or criminal culpability. The results are conveyed in visual charts, with eight variegated, vertical bars describ-ing DNA sequences in blurs and blots. Manglano-Ovale scanned the PCR results into his computer, added color schemes chosen by the participants, then trimmed and embellished the images, like a portrait photographer touching-up blemishes in a negative. He printed the scans as DYE-COUPLER PRINTS, each as tall as a person. In the gallery, Manglano-Ovale hung the DNA images in familial triptychs, including the genetic family portrait of the artist Byron Kim, his partner, Lisa, and their son, Emmett.

Manglano-Ovale's images defy racial identifica-tion, and he conceived *The Garden of Delights* as a nonhierarchical view of contemporary America's ethnic spectrum. The series also presented an expansive notion of the family, combining biologi-cal groupings with social ones. Still, the images provoke troubling questions about possible uses of DNA classification in the future. For it is possible that genetic profiles could replace obvious physical characteristics of race as the basis of future classifi-cation and discrimination.[16]

197

Robert ParkeHarrison
American, 1968–

Flying Lesson, 2000

Photogravure with beeswax
46.0 x 51.8 cm
Sarah C. Garver Fund,
2004.7

198

Iñigo Manglano-Ovalle
Spanish, active in United
States, 1961–

Byron, Lisa, and Emmett,
from *The Garden of Delights,*
1998

Dye coupler prints
152.4 x 58.4 cm (each panel)
Eliza S. Paine Fund, 2002.37

199

199

Alexander Tsiaras
American, 1953–

Human Embryo:
Forty-Four Days, 2000

Digital ink-jet prints
53.7 x 42.7 cm (each)
Gift of the artist, 2004.72–73

A pioneer in the technologies of scientific and medical imaging, **ALEXANDER TSIARAS (199)** has drawn upon diverse knowledge and skill in his investigation of the human body and in his own creative work. The son of Greek immigrants, he was born and raised in Nashua, New Hampshire. At age nineteen, to research a book he planned on his parents' lives, Tsiaras moved for a year to rural Greece. He adopted his father's early occupation, and herded goats from the Albanian-Macedonian borders south to Mount Olympus. Then he settled in his mother's village near the base of the mountain. There, Tsiaras was drawn to customs of burial, thought to date from the time of Homer. After a death and interment, the family of the deceased celebrate a mourning ritual every morning and evening for five years. At the end of this period, the body is sacramentally exhumed by honored local women who, it is believed, can determine from the remains the fate of the soul in the afterlife. The amount of flesh still present on the bones is thought to reveal

the extent of sin committed during the life of the deceased. Commanding expert knowledge of anatomy, the exhumers ceremoniously wash the bones in wine and water, while singing haunting dirges. They rebury remains with vestigal flesh, and place the clean bones of the absolved in an ashery, or in a casket to be buried under the family home. Tsiaras recorded these practices for his first book, *The Death Rituals of Rural Greece.*[17]

After returning to New York, Tsiaras became an assistant to George Segal, the sculptor who expressed the psychodynamics of social interaction in the nuanced poses of his plaster figures. Later, he worked with Lucas Samaras, the painter and photographer who used instant prints from a POLAROID SX-70 camera, creatively manipulating their chemical surfaces as they dried. Searching for his own artistic milieu, Tsiaras aspired to the emotive power he had experienced in Greece. He began using x-rays, painting and drawing on those mysterious images that confront the body's materiality.

Research in radiology led him to investigate the surgical use of laser technology. He taught himself the necessary physics and mathematics, and designed an endoscope lens to facilitate photography inside the human body. Among Tsiaras's first anatomical photographs were those of a developing fetus seen from outside the amniotic sac, later published on the cover of *LIFE* magazine.[18] To collate, store, and process the imagery he was collecting, he was drawn to computer technology, then to the most advanced digital imaging methods, including Computed Tomography (CT) and Micro-Magnetic Resonance Imaging (MRI). These non-invasive imaging techniques work by revealing the relative densities of their subjects; since bone, cartilage, tissue, and blood all have different distinctive densities, reflective scans can distinguish one organ from another. Different imaging methods have characteristic advantages, for while CT scans are useful for showing bone, MRI is best for scanning soft tissue. Tsiaras transferred the algorithms governing the travel of light in endoscopes to virtual space, and wrote the necessary computer codes to synthesize their data. His techniques enable a skilled technician to isolate any object, magnify it, rotate it for viewing from any angle, and virtually peel away its surfaces, effectively seeing inside. Since the images are rendered in a subtle range of grays, the computer is used to color the images with hues based upon anatomical knowledge. Tsiaras first published his revolutionary images in *Body Voyage: A Three-Dimensional Tour of a Real Human Body*.[19]

Two images of *Human Embryo at Forty-Four Days*, created for Tsiaras's book *From Conception to Birth: A Life Unfolds*, demonstrate the astounding capabilities of the technology.[20] Both show the same living embryo, which is actually the size of a pea, at two states of transparency. The surrounding uterus has been blacked out to enhance clarity of the figure. One image is a full exterior view of the embryo, covered by its translucent, developing skin. A

200

200

Jet Propulsion Laboratory
American, twentieth century

Io over Jupiter, January 1, 2001,
2001

Digital ink-jet print
32.5 x 49.7 cm
Purchased through the gift of
Christopher Scholz, 2004.9

prominent eye is apparent beside the forming ear. In the second image the same figure is more transparent, revealing its developing liver, lungs, and a bulbous brain and spinal chord. At this point in its gestation, ninety-nine percent of the muscles in the body can be identified, each with its own blood supply. Limbs are clearly visible, as are the tiny bones of the fingers and toes, and the vertebrae of a developing spine.[21]

The image *Io over Jupiter*, an equally astounding vision of man's search outside himself, was captured by the Cassini space probe as it passed by the planet at the dawn of the new millennium.[22] The largest body in our solar system, Jupiter commands its own circumplanetary system of faint rings, dusty particles, asteroidlike moonlets, and large moons. The size of Earth's own moon, Io was discovered by Galileo Galilei in 1610, along with Jupiter's large moons Europa, Ganymede, and Mercury. *Io over Jupiter* is an unusual image simply for its existence, for it is one of only thousands to be edited and printed from millions of potential pictures.[23] In the first years of the twenty-first century, the Cassini probe, the Hubble Space telescope, and other National Aeronautics and Space Administration (NASA) spacecraft sent back to earth continuous streams of data, far more than scientists could manage. For just as digital imaging techniques have supplanted film photography, the collection of visual astronomical data from deep space instruments have replaced telescopic astronomical observation.

The Cassini probe was launched aboard a Titan IV-Centaur rocket from Cape Canaveral on October 15, 1997.[24] It destination was the ringed planet Saturn, but in the course of its journey the spacecraft made two gravity-assisted passes by Venus, one by Earth and one by Jupiter, all the while transmitting a constant stream of data. After a seven-year journey of nearly a billion miles, Cassini took up permanent orbit around Saturn in July 2004.[25] The spacecraft carried a new generation of digital imaging equipment, similar to that of the Hubble space telescope.[26] Cassini and its two onboard cameras were designed and built by the **JET PROPULSION LABORATORY (200)** of the California Institute of Technology in Pasadena, which managed the project for NASA. Cassini's digital cameras were parallel in their variance to the cameras on NASA's Lunar Orbiter (no. 165) of the 1960s, with a narrow angle — or telephoto — system that employs a reflecting telescope with a focal length of 2000mm and a field of view of 0.35 degrees; its wide-angle — or panoramic — refractor has a focal length of 200mm and a field of view of 3.5 degrees. Each instrument had an array of filters to span an enormous electromagnetic spectrum, so Cassini's cameras could see more colors than the human eye. Each had a light-detector array — analogous to an eye's retina, or a camera's film — with 1024 x 1024 pixels. The instruments collected light through their lenses, digitized the information, and electronically transmitted the data in a continuous stream across the 386 million miles from the Cassini orbit to Earth. For the image *Io over Jupiter*, terrestrial computers reconstructed the data from sequences collected during an hour's rotation on Jupiter, piecing together the complete view like a mosaic from twenty-seven segments. After positioning and pasting the segments together in the computer, the lighting of the image was adjusted to show the entire planet as it appeared under the illumination at the moment of the first image. To provide true color, the images were collected in red, green, and blue, so we can be certain that this view represents the planet and moon much as we would perceive them.

Glossary | BEN CHARLAND

An **albumen print** is a photographic print on paper in which light-sensitive SILVER SALTS are suspended in an egg-based EMULSION. Introduced by Louis-Desiré Blanquart-Evrard (1802–1872) in 1851 as an improvement to the SALT PRINT, albumen paper was produced by floating individual sheets on an egg-white froth containing salt, and then hanging them to dry. Once dry, albumen-coated paper was floated, albumen side down, in a silver nitrate solution in complete darkness. Following this bath the paper was ready for printing, usually in a printing frame beneath a NEGATIVE in sunlight. Printing times for albumen paper varied from minutes to hours. Because the paper would not keep well, it was sensitized, processed, and printed in the same day. Albumen prints are characterized by a purplish brown color and are capable of exacting detail. (no. 25)

The **ambrotype (collodion positive)** was officially introduced in 1851 as a result of James Ambrose Cutting's (1814–1867) controversial patent of preexisting photographic processes. An ambrotype is made by underexposing a glass COLLODION NEGATIVE and developing it as if for use in printing. The developed negative is then backed with an opaque material, causing an optical illusion in which the negative appears as a POSITIVE. Primarily used for portraiture, the ambrotype, known as collodion positive in England, remained popular for about fifteen years. Its small size, lack of surface reflection, speed of production, and economical price made it a competitive threat to the DAGUERREOTYPE market. (no. 10)

The term **aperture** comes from the Latin *apertura*, meaning "opening." On a camera or LENS, aperture refers to the opening through which light passes for the purpose of an EXPOSURE. The diameter of this opening, typically adjustable by an iris diaphragm or stop, directly influences DEPTH OF FIELD and exposure time.

An **Autochrome** is a full-color transparency on glass. The technique was invented and patented by Louis Lumière (1862–1954) in 1904, and became the first commercially available full-color photographic process. An Autochrome is made by preparing a glass plate with minute grains of potato starch that have been dyed with each of the primary colors. Above the layer of starch grains is applied a layer of EMULSION sensitive to all colors of light. The plate is then exposed from behind, so the light is filtered through the prism of colored starch grains before reaching the light-sensitive emulsion layer. The final image is achieved through a reversal process that transforms the NEGATIVE image into a POSITIVE. The Autochrome is meant to be viewed in transmitted light or by means of projection. Its distinguishing characteristic is its soft translucency and pointillistic appearance. (no. 71)

A **blindstamp (chop)** is an identifying mark, generally consisting of a photographer's name and address, embossed into paper without ink. The embossment usually appears on the mount to which a photograph is attached but can occasionally be found on the photographic image itself. Blindstamps are pressed into dry paper by interlocking metal discs held in a plierslike tool or small mechanical press.

The **bromoil transfer** process is an innovation to the oil PIGMENT PRINT process. The technique was introduced in 1907 by E. J. Wall (d. 1928) and C. Welborne Piper (1866–1917). A bromoil transfer print is made by first bleaching a gelatin silver bromide print in a solution of copper sulfate, potassium bromide, and potassium bichromate. The bleaching removes the image and selectively hardens the underlying gelatin. After it is FIXED and washed, the print is soaked in water to dampen the gelatin deposits that eventually form the image highlights. When a greasy printer's ink is applied, the damp gelatin areas repel the ink and an image is formed — the gelatin serving as highlights and the ink as shadows. An inked print is sometimes used as a kind of printing plate for transferring the image to another sheet of paper. When transferred, full color can be achieved through three-color separation tech-

niques. Bromoil prints are capable of broad tonal ranges but are characterized by low resolution. (no. 60)

The **cabinet card** developed during the 1860s from the CARTE-DE-VISITE. The cabinet card is composed of a stiff piece of cardboard, approximately 6¼ x 4¼ inches, with a slightly smaller ALBUMEN (later GELATIN SILVER or CARBON) photograph attached to it with paste. On the front, in either the top or bottom margin, the card is often printed or embossed with the photographer's name and address. Like *cartes-de-visite*, the most common subject is the full-length portrait.

Calotype (Talbotype), from the Greek *kalos*, meaning "beauty," is a process for producing photographic NEGATIVES patented by William Henry Fox Talbot (1800–1877) in 1841. In this technique, a high-quality writing paper is treated in the dark with a brushed-on silver nitrate solution. After EXPOSURE, the image is developed in gallic acid of silver nitrate and fixed with potassium bromide. In preparation for printing (usually as a SALT PRINT), the paper is sometimes waxed to increase its translucency. Although overshadowed in its day by the success of the daguerreotype and later eclipsed in use by the ALBUMEN PRINT, Talbot's calotype process established the negative/positive method as the predominant photographic technique. (no. 1)

The photographic **camera**, in its simplest form, consists of a light-tight box with a small hole or LENS at one end, and an arrangement at the other end for the insertion and withdrawal of a light-sensitive plate or film. Components of modern photographic cameras include viewfinders, lenses, mechanisms for focus, and electronic devices. The term became associated with image-producing devices in the 1600s when Johann Kepler (1571–1630) coined the phrase CAMERA OBSCURA to name a popular drawing tool used by artists. The word "camera," from the Latin meaning "chamber" or "room," was first used in a truly photo-

graphic sense by Nicéphore Niépce (1765–1833) in 1816.

The **camera lucida**, meaning "light chamber" in Latin, is a drawing tool introduced in 1806 by the British scientist William Hyde Wollaston (1766–1828). The instrument consists of a prism mounted to a telescoping stick. Through one face of the prism the user perceives a virtual image of an external object projected onto a drawing surface, where it can be traced.

The **camera obscura**, meaning "dark chamber" in Latin, was devised in the seventeenth century as a drawing tool and is considered a direct precursor to the modern photographic camera. The instrument was at first an actual darkened room and was later developed into a portable apparatus. It generally consists of a light-tight box with an APERTURE, a LENS for focusing, and a viewing screen or glass. As light enters the box through the aperture, a small inverted and reversed image of the outside view is projected on the wall opposite the opening. Sometimes a mirror is used to correct and direct the image to a usable surface. The optical phenomenon and fundamental mechanics of the device have been known since the seventh century.

A **carbon print** is a silverless POSITIVE image made from a NEGATIVE. It is produced by coating a thin sheet of paper with a gelatin potassium bichromate mixture and then CONTACT PRINTED with a negative. The contact print is processed by pressing it to a second sheet of paper that has been coated with a gelatin layer. When the two sheets are soaked in warm water, the unhardened gelatin is washed away and the hardened gelatin is transferred to the second sheet. The carbon print was introduced in 1855 by Alphonse Louis Poitevin (1819–1882), and the technique was perfected by Sir Joseph Wilson Swan (1828–1914) in 1864 as an archivally stable photographic print process. Carbon prints can be made in any color and exhibit a delicate tonal range. (no. 39)

The term **carbro** is a blend of the words carbon and bromide, the two principal processes from which it is derived. A monochrome carbro print is produced by pressing a wet silver bromide print to a piece of paper that has been sensitized with potassium bichromate and bleaching agents. While the bromide print and sensitized sheet are sandwiched, a chemical process occurs as the gelatin print hardens, and the silver is bleached away. Finally, the two sheets are separated and the sensitized sheet is placed onto a transfer paper. When the hardened gelatin moves to the transfer paper, a low-relief gelatin image is formed. Carbro prints are characterized by their relieflike quality and waxy surface. Full-color carbro prints can be achieved

through three-color separation techniques and the overprinting of three negatives.

The *carte-de-visite*, French for "visiting card," could be considered the calling card of the photographic age. Patented in 1854 by Andre-Adolphe-Eugène Disderi (1819–1889), it is composed of a stiff piece of card, approximately 4½ x 2½ inches, with an ALBUMEN photograph of nearly the same size attached to it with paste. Very often, the VERSO of the card is printed with the photographer's name and address. Subjects pictured on *cartes-de-visite* are almost always full-length portraits. During the 1860s they were collected in albums, and collecting those of politicians and celebrities was a popular activity. Technological innovations and industrious photographers facilitated the production of millions of *cartes-de-visite* in the 1860s. The format was replaced in the late 1870s by the CABINET CARD. (no. 29)

The term **cased photograph** describes photographs held in small protective cases, most commonly DAGUERREOTYPES, AMBROTYPES, and TINTYPES. In the United States it became typical to hold daguerreotypes, as painted portrait miniatures had been, in hinged cases made of wood, thermoplastic, or leather. For the purposes of protection and decoration, image cases were generally comprised of a tin mat, glass, and velvet lining. Case designs ranged from utilitarian to ornate. Decorative cases can be found with geometric designs, with mother-of-pearl inlay, and with molded pictorial tableaux. Those of thermoplastic are sometimes referred to as **Union Cases**. (no. 32)

A *cliché-verre* is produced by coating a glass photographic plate with an opaque ground. The artist scratches an image into the ground with a sharp stylus and then the plate is printed as a photographic NEGATIVE would be. During printing, light passes through the areas scratched away, exposing the photographic paper. The technique was developed by William Henry Fox Talbot (1800–1877) in the 1830s and later advanced by Adalbert Cuvelier (1812–1871). *Cliché-verre* was popular among French Barbizon artists, such as Jean François Millet (1814–1875) and Charles-François Daubigny (1817–1878). *Clichés-verre* are characterized by a sketchy, atmospheric line and tone, in which lines appear dark on a light background. (no. 15)

Collage and **photomontage** are two terms used interchangeably. French for "pasting," collage refers to the combination of various materials, photographic or otherwise, pasted on a common ground to create a single picture. "Photomontage" refers to the combination of diverse photographic images, either during

printing or through photography of collaged images to create a new work. (no. 188)

Collodion, from the Latin *collodium*, meaning "gluey substance," is a colorless, syrupy mixture composed of gun cotton, alcohol, ether, and potassium iodide, which dries hard. Collodion was invented in 1846 and used in photography as a binding agent, like gelatin, to suspend and attach light-sensitive silver salts to raw paper and glass. The employment of collodion led to the widespread use of glass NEGATIVES in photography. The **wet-collodion process**, though riddled with inconveniences, was the first utilizable method for producing glass negatives. In this process, a negative is prepared by pouring an even coating of collodion onto a glass plate. With the collodion coating still tacky, the plate is made sensitive to light in a bath of silver nitrate. Then, before the EMULSION dries, the plate is inserted into a camera and EXPOSED. Following exposure, the plate is immediately returned to a DARKROOM or darktent for development. Before the introduction of an efficient dry-plate process, photographs prepared in this way needed to be developed on the spot. For this reason, photography in remote locations meant carrying a darkroom to the site. The process was introduced in 1851 by Frederick Scott Archer (1813–1857) and became known as "wet" because of the correlation between the emulsion's light-sensitivity and its moistness. The **dry-collodion process** was introduced in 1855 as a modification to the wet-collodion process. Dry-collodion emulsion included an ingredient to keep light-sensitive collodion mixtures moist for extended periods of time. Albumen, gelatin, honey, and even raspberry syrup were used for this purpose. These ingredients, by extending the time that collodion was wet and thus capable of recording light, freed photographers from on-the-spot development, allowing them greater mobility. At first, users sacrificed the greater light sensitivity of the wet process for the liberties and conveniences provided by the dry technique.

Collotypes, from the Greek *kollo*, meaning "glue," are prints made by a photomechanical process of the early 1870s. A method of printing photographic images in ink, the collotype process closely resembles PHOTOLITHOGRAPHY, but utilizes glass instead of stone as its printing surface. A glass plate is coated with two layers of gelatin: a base layer of only gelatin, superimposed by a surface layer of gelatin with light-sensitive potassium or ammonium bichromate. Once the two EMULSION layers have dried, the plate is CONTACT PRINTED under a negative. When the plate is soaked in water, the unprotected gelatin expands, creating a microscopic low-relief image. The processed plate can then be printed in the same fashion

as a lithographic stone. A collotype is a detailed image exhibiting a wide and subtle tonal range, and is nearly indistinguishable from a silver-based photographic print. (no. 48)

In a **combination print**, multiple photographic NEGATIVES are combined or superimposed during printing to create a single image. During the 1850s photographers used combination printing to compensate for the oversensitivity of COLLODION to blue sky light. By joining a negative especially EXPOSED for the sky with a regularly exposed negative, a seamless image could be produced. Additionally, combination printing was useful for combining studio images, made in a controlled environment, with photographs made outdoors. Through the twentieth century, combination printing has been used for artistic effect by combining unrelated images to create fictional or striking juxtapositions. (no. 174)

Contact print is a general term used to describe any photographic image made by EXPOSING a light-sensitive paper or plate in direct contact with a NEGATIVE. A contact print is the size of the negative from which it is derived, and is an alternative to an enlargement or reduction print. Before ENLARGERS were perfected in the 1880s, contact printing was the primary method for producing prints. Because contact prints are not subject to magnification, they exhibit the highest resolution possible from a negative, with meticulous highlight and shadow details. (no. 37)

A **cyanotype** is a photographic print in which shadows are rendered white on a blue ground. Invented in 1842 by Sir John Herschel (1792–1871), the cyanotype was a pioneering photographic process. To create cyanotypes, raw paper is coated with a mixture of ammonia, citrate or iron, and potassium ferricyanide. When EXPOSED to light, the solution undergoes a chemical change that produces an insoluble Prussian-blue pigment. Coated paper may be contact printed, exposed under a negative or drawing, or used in the production of PHOTO-GRAMS. From the 1880s through the 1950s they were primarily used for making convenient and economical proofing prints and to copy architectural drawings as the "blue print." (no. 3)

Daguerreotype, the first practicable photographic process, was introduced in 1839 by Louis-Jacques-Mandé Daguerre (1787–1851) as the realization of the research of Nicéphore Niépce. In Daguerre's process, a thin coating of silver is applied to a copper sheet and polished to a mirror surface. Then, in a light-tight container the plate is subjected to iodine vapors that react with the silver to create the light-sensitive compound silver iodide. Next the plate is EXPOSED in a camera. After exposure, daguerreotypes are developed in another container wherein the plate is suspended over a heated dish of mercury. As mercury vapors react with the silver iodide, an alloy of silver mercury is generated. Finally, the image is FIXED through immersion in a saline solution and toned with gold chloride. The daguerreotype's distinguishing characteristic is its mirrored surface. (no. 4)

The term **darkroom** refers to the area used for handling and processing photographic materials that are light sensitive. In some respects, the term is a misnomer because the area for processing most light-sensitive materials need only prevent entry of light that affects photographic material.

Depth of field is a subjective term used to refer to the area of a photograph that appears sharply defined or in focus. APERTURE size, focal length, and the distance between the camera and the subject all work in conjunction to determine depth of field.

Development refers to the use of a chemical solution to make a LATENT IMAGE (captured on a negative, plate, or photographic paper) visible. The term is sometimes used as a catchall for describing the operations used in processing light-sensitive materials such as FIXING, washing, and drying.

Digital photograph is a generic term that refers to a method of capturing an image through photoelectric cells rather than chemical reactions. The photoelectric cells, acting as light detectors, proportionally convert light-level EXPOSURE to a number scale. In binary form the image information may be manipulated by computer or output by a computer-directed printer. Alternatively, a digital image may be transferred to film for analog printing. The first truly digital camera to become commercially available was the Apple Quick Take in 1994. The term may also be used loosely to refer to an analog photograph digitized through scanning.

Dry plate is the general term for glass or metal plates holding a dry emulsion sensitive to light. Like DRY-COLLODION NEGATIVES, gelatin- and albumen-based dry plates struggled for popularity after their introduction. At first, dry-plate EMULSION was slower than preexisting WET-COLLODION mixtures. With improvements, in a short time dry plates entirely replaced wet-collodion negatives, eliminating the need for on-the-spot chemical preparations. Soon after a practical version of the dry plate was introduced by Richard Maddox (1816–1902) in 1871, sensitized plates became commercially available, sized for varying camera models.

Duratran is the trade name for DYE COUPLER transparencies, designed for backlighting, and manufactured by the Kodak and Fuji companies. A similar product with different characteristics is the Cibatran. With backlighting, Duratrans appear luminous and vibrant. Duratrans are most frequently used in advertising.

Dye coupler prints (C-prints) are made by a color-print process that produces full-color prints from color transparencies or NEGATIVES. The photographic paper contains not one, but three EMULSION layers of silver salts. Each layer is sensitized to a corresponding primary color, and during development chemical dyes are added that adhere to their respectively sensitized silver salts. Used by commercial photography labs, the dye coupler process produces prints alternatively known as **Ektacolor prints**, chromogenic prints or C-prints. (no. 192)

Dye destruction (Cibachrome) prints are made by a color-print process in which the central step involves bleaching unnecessary dyes from the EMULSION. Dye destruction prints are made from color transparencies or NEGATIVES on photographic paper containing three emulsion layers. Each layer is sensitized to one of the three primary colors, and when exposed, reacts to its respective hue. In addition, the layers contain complementary color dyes. During EXPOSURE, silver images are formed in each emulsion layer. Afterwards, these images are developed and then bleached out. During the bleaching process, a proportional amount of the dye is destroyed. When the print is FIXED and washed, the residual dyes, viewed against the white support of the paper, produce the appearance of a full-color image. Cibachrome is a trade name for prints made using this process. Dye destruction prints are characterized by vibrant color and high surface gloss.

A **dye transfer print** is a full-color print made with dye on gelatin-coated paper. It is created by first EXPOSING three black-and-white NEGATIVES of the same image: one through a red filter, one through a green filter, and one through a blue filter. Each of the three negatives carries a portion of the color composition. Molds are then made from each negative, inked with their respective dyes, and printed successively in exact registration. The combination of the three dyes produces a full-color image. Though labor intensive and time consuming, the dye transfer process allows superior control during printing. Because the prints are rendered in dye rather than metal, dye transfer prints maintain archival stability. The process for producing dye transfer prints originated in the 1870s. (no. 168)

Ektacolor print: See **dye coupler print**

In the production of daguerreotypes, **electroplating (galvanizing)** refers to a technique for applying a silver surface to a copper plate by means of electricity. After suspending a copper plate, along with a source metal, in a solution of potassium cyanide, and then wiring the two to an electrical current, molecules of metal are transferred to the plate surface by electrolysis. The technique allows for a uniform and blemishless coat of silver to be applied to the plate, eliminating the need for hand application. The technique was developed by Daniel Davis, Jr. (1813–1887), and publicized in 1842. The method became known internationally as the "American Process."

Emulsion refers to any light-sensitive coating applied to a film, paper, plate, or other substrate. In its basic form, it consists of SILVER SALTS and a binding agent, like gelatin or albumen, that suspends and binds the light-sensitive silver salts to a support.

An **enlarger** is a projection device used in the DARKROOM to increase the size of a photographic image, from a NEGATIVE or transparency, through printing. In its simplest form the instrument consists of an enclosed light source and projection LENS. Photographic prints produced with enlargers are generically referred to as "enlargements." The earliest enlargers, used in the 1850s, were sunlight powered. As the light-sensitivity of photographic paper improved, gas and electric enlargers could be used practically.

An **exposure** is a quantitative measurement of light, or the act of submitting photographic material, such as printing paper or film, to the action of light by means of a CAMERA, ENLARGER, or printing frame.

Fix: See **hypo**

Flash is the momentary addition of light to a subject to aid EXPOSURE. During the later half of the nineteenth century, magnesium wire and magnesium powder became the first viable methods for producing flash. The electric flash bulb was introduced in 1925.

A **Fresson print** is a proprietary variation of the process for producing a CARBON PRINT. Invented in 1899 by Theodore-Henri Fresson, the exact formula and process remain a family secret but are believed to be based on a color separation process with EXPOSURES made on paper treated with oil pigments. Like carbon prints, Fresson prints are valued for their archival stability. The prints are characteristically subtle in impression. (no. 117)

A **gelatin silver print** is made on paper coated with an emulsion of gelatin containing light-sensitive silver halides. Since its introduction in the 1880s, the gelatin silver print has been the main technique for producing black-and-white photographs. Gelatin silver paper is versatile and can be CONTACT PRINTED or used for producing ENLARGEMENTS. (no. 79)

A *giclée* **print (IRIS print)**, like an ink-jet print, is produced from a digital image by a computer-controlled printer. *Giclée* prints can be printed onto any high-quality paper or substrate, which is wrapped around a drum in the printer. As the drum turns, a computer-controlled nozzle sprays up to four million microscopic droplets of ink per second. Droplets of cyan, magenta, yellow, and black overlay to produce a continuous tone image. *Giclée* prints, from the French, "to spurt," are commonly referred to as IRIS prints after the IRIS Graphics Company, a supplier of ink-jet printers. *Giclée* images appeared in the mid-1990s and were used in the graphic arts before being used as a fine arts medium. The tonal quality and archival stability of the IRIS print rivals analog techniques.

Group *f*.**64** was the name of an informal group of California photographers dedicated to the practice and promotion of STRAIGHT PHOTOGRAPHY. Founded in 1932, the group was chartered by Ansel Adams (1902–1984), Imogen Cunningham (1883–1976), Henry P. Swift (1890–1960), Willard Van Dyke (1906–1986), Sonya Noskowiak (1900–1975), John Paul Edwards (1884–1968), and Edward Weston (1886–1958). The term "*f*.64" refers to a small APERTURE setting that insures extreme DEPTH OF FIELD.

Introduced in 1894, a **gum bichromate print** is produced by coating a sheet of paper with an even coating of diluted gum arabic mixed with colored pigment and potassium bichromate. After the paper is dried, it is sensitive to light and may be CONTACT PRINTED under sunlight or ultraviolet light. During EXPOSURE, the bichromate causes the colored gum arabic to harden in proportion to the amount of light received. The shadows, or the areas of the EMULSION not receiving light, remain soluble in water. The print is DEVELOPED by washing away the soluble areas. Because prints can be exposed and reprinted a number of times, the gum bichromate process was popular with art photographers who desired maximum control over the final print. Gum bichromate prints are characterized by broad tonal effects, rather than fine detail, and resemble crayon and charcoal drawings. (no. 67)

Halftone is a process for reproducing photographs with text. An image is reproduced in halftone by photographing it through a screen to produce tiny dots. The dot size and proximity correspond to areas of light and shadow in the original image to be reproduced. The EXPOSURE may be made with a special film used to transfer the image to a printing plate, or it may be made directly onto a specially prepared plate. After the halftone process was perfected in the 1880s, photographs began to appear regularly with text in newspapers and magazines.

Hypo is a general term used to describe chemical solutions that arrest and dissolve light-sensitive photographic materials. When it was introduced by Sir John Herschel (1792–1871) in 1839, the compound was hyposulphite of soda. Contemporary hypo solutions are most commonly sodium thiosulfate. The term is used interchangeably with **fix**.

The term **latent image** refers to an image invisible to the eye, as it is held on any light-sensitive material (such as film or paper) after EXPOSURE. The latent image is made visible during DEVELOPMENT.

A **lens** is a disc of optical glass or polymer acrylic, used in a photographic camera to direct light rays onto a NEGATIVE or plate. Modern lenses are shaped for desired effects, such as wide angle, telephoto, soft focus, enlarging, and zoom.

A **miniature camera** is a portable, hand-held camera that uses roll film. The term came into popular use at the end of the nineteenth century when the first 35mm cameras became commercially available. Miniature cameras are markedly smaller than VIEW CAMERAS and offer photographers the benefit of increased mobility, speed, and the possibility of making multiple EXPOSURES before film DEVELOPMENT. The first miniature camera was the Kodak No. 1, introduced in 1888.

A **negative** is a photographic record in which the lights and shadows of the natural world are reversed. Negatives are used in an ENLARGER or in CONTACT PRINTING to create POSITIVES. William Henry Fox Talbot's (1800–1877) discovery of the negative and realization that a single negative could yield multiple positives established the negative-to-positive method in photography. Nearly all photographs produced since have been made using a negative-to-positive method. (no. 23)

The **paper negative** was the earliest form of the photographic NEGATIVE. It was first made and used by William Henry Fox Talbot (1800–1877) to produce CALOTYPES. Talbot's negatives were made from high-quality writing paper that was sensitized and EXPOSED. WAXED-PAPER NEGATIVES were a later innovation in which paper was waxed before exposure to increase the neg-

ative's resolution and sensitivity. The technology and principles of the paper negative are the cornerstone for the negative-positive photographic process. Prints made from paper negatives are easily identifiable by their fuzzy, impressionistic appearance, caused by the diffusion of light as it passes through the paper's fibers.

A **photogram** is a unique, cameraless photographic image. Photograms are made by placing an object in direct contact with photographic paper or film and EXPOSING it to a light source. In the areas where the object blocks the paper, the sheet remains unexposed and light in tone. When semi-translucent materials are used to block the light source, a corresponding partial exposure is achieved. The final print is characterized by contrasting light and dark areas. (no. 3)

A **photogravure** is made by a photomechanical process traditionally used for reproducing photographs in ink in large numbers. In the photogravure process, a copper plate is prepared by dusting with an acid-resistant material. Next, a POSITIVE transparency of the photograph to be reproduced is made and CONTACT PRINTED to a sheet of tissuelike transfer paper. The paper is adhered to the copper and developed in water to transfer the image to the plate. The plate is then etched, inked, wiped, and in the manner of conventional intaglio printing, the image is printed on paper in a press. The method was introduced in 1879 by the Austrian printer Karel Klíč (1841–1926). The origin of Klíč's process can be found in the tradition of etching and in William Henry Fox Talbot's (1800–1877) process of photoglyphic engraving. Photogravure prints are recognizable by a velvety appearance and by the presence of plate marks. (no. 189)

Photolithography is a photomechanical process, used for printing photographs in ink, that depends on the principles of lithography. In photolithography a flat stone or metal plate is coated with a layer of gelatin that has been sensitized with potassium bichromate. The sensitized surface is exposed by CONTACT PRINTING under a NEGATIVE. Due to the qualities of bichromated gelatin, the exposed areas, or the shadows, harden in proportion to the amount of light received. As these areas harden they create an insoluble seal with the stone. The remaining soluble areas are then washed away with water. When the stone is dampened, and a greasy printer's ink is applied, the ink adheres to the areas of hardened gelatin and is repulsed by the areas of moist, unsealed stone. The stone is then printed in a press as in traditional lithography. Photolithographs are characterized by a delicate, flat finish. The process was developed in the 1850s by Alphonse Louis Poitevin (1819–1882). (no. 17)

Photomontage: see **collage**

The term **Pictorialism** came into use during the last decade of the nineteenth century in reference to art photography. In general, Pictorialists were less interested in fact and literal photographic description, and more concerned with the beauty, composition, and emotive potential of photographic images. Above all, Pictorialists considered the photograph an art object. Pictorialism remained dominant until the end of 1910s. As editor of *Camera Notes* and owner of the New York gallery known as 291, Alfred Stieglitz (1864–1946) played a definitive role leading and defining the Pictorialist movement.

A **pigment print** is a photographic print rendered in pigment rather than metal. It can be one of two varieties. In one method, exemplified by the CARBON PROCESS, the pigment is formed in the EMULSION and FIXED in place during EXPOSURE. In the other, exemplified by the BROMOIL process, exposure generates a receptive surface for the addition of pigment. The later half of the nineteenth century saw growth in non–silver-based processes as photographers strove to increase print longevity. Pigment was found to provide greater archival stability than metal. In addition to archival advantages, pigment prints were more economical to produce than metal-based images. Pigment processes offer great control during printing.

The **platinum print (platinotype)** process, patented by William Willis (1841–1923) in 1873, depends on the light sensitivity of iron salts. Like SILVER SALTS, iron salts rapidly transform when EXPOSED to light. A platinum print is produced by sensitizing a piece of paper with a solution of potassium-chloro-platinate and ferric oxalate (an iron salt). When the coating is dried, the sheet is CONTACT PRINTED under a NEGATIVE in sunlight until a faint image — due to the reaction of light with the iron salt — is visible. Next, the print is developed in a potassium oxalate solution that dissolves unexposed iron salts and transforms the exposed salts into platinum. The print is finished with a wash in hydrochloric acid to remove excess iron salts and stains. Though superior in detail and tonal range to silver-based prints, the platinum print fell out of use due to the inflated price of platinum at the time of World War I. Print quality and archival stability made the platinum print a favored print medium for art photographers. (no. 81)

Polaroid (instant photography) is a trade name for any photograph made through an instant process. Instant photography was introduced in 1948 when Edwin H. Land (1909–1982) devised a camera and film capable of producing a NEGATIVE and a POSITIVE instantaneously. The film contains a sensitive material for producing a negative, nonsensitized paper for producing a positive, and pods of developer. At the time of EXPOSURE, the developer is automatically applied to the negative and positive. Subsequent chemical processes are contained within the camera. Polaroid photographs are characterized by a glossy surface, muted colors, and a soft overall impression.

The term **positive** refers to a photograph in which lights and shadows are reproduced as they appear in nature. The term is usually used for describing photographic images reproduced on glass. It was first used in 1840 by Sir John Herschel (1792–1871) to describe the direct opposite of a NEGATIVE. (no. 23)

Printing-out paper (p.o.p.) refers to photographic paper capable of producing a final print by EXPOSURE to light alone without the use of a development process. The term "printing-out paper" is specifically applied to commercially manufactured paper, with a gelatin-based EMULSION that contains silver chloride. Following exposure, printing-out paper requires only washing and toning to complete the process. Prints on printing-out paper appear purplish brown if untoned. From the 1880s to the 1920s printing-out paper was primarily used for portraiture. (no. 184)

RC print (resin coated) is the trade name used to identify gelatin-silver prints made on resin-coated paper. The resin serves as a prophylactic to prohibit chemicals from reaching the paper support during DEVELOPMENT. By restricting developing chemicals to the EMULSION layer only, shorter wash times and shorter drying times become possible. The economy of time and water make RC prints ideal for producing proof prints. (no. 194)

Recto and **verso** refer to the sides of a sheet of paper. The side that contains an image is called the "recto," as distinguished from the backside, or "verso." When a photograph is mounted to a board or sheet of paper, "verso" refers to the back of the mount rather than the back of the photograph itself.

Sabattier effect: see **solarization**

The **salt print** was the earliest method for producing photographic images on paper. Invented by William Henry Fox Talbot (1800–1877) in 1840, the salt print was a direct product of his earliest experiments with photogenic drawings. Talbot produced these prints by sensitizing sheets of writing paper in a salt solution and then coating one side of the sheet with silver nitrate. When the salt solution and silver nitrate combine chemically, light-sensitive silver salts

form within the paper fibers, making the paper sensitive to light. The paper was dried and then CONTACT PRINTED for up to two hours. Following EXPOSURE the print was fixed in a solution of sodium thiosulfate, washed, and dried. Overall, a salt print is matte in finish with a reddish brown color or, if toned, can appear purplish brown. Salt prints were most commonly printed from PAPER NEGATIVES (CALOTYPES) but were occasionally made from COLLODION glass negatives. The salt print was superseded after the introduction of the ALBUMEN PRINT in 1851, which offered greater light sensitivity and a higher gloss finish. (no. 12)

A **shutter** is a mechanism that opens and closes an APERTURE by which EXPOSURE may be accurately regulated.

Silver salts are the chemical building blocks of photography. Silver salt compounds are produced through the chemical union of the element Silver with any of the four Halogen elements: Chlorine, Bromine, Fluorine, and Iodine. Of these four, the three used in photography are: Silver Chlorine, Silver Bromine, and Silver Iodine. Silver salts, in a process known as photochemical decomposition, rapidly decompose into metallic silvers, and darken in the presence of light energy. The light sensitivity of silver salts was identified by the German physician Johann Heinrich Schulze (1687–1744) in 1727.

Solarization and **Sabattier effect** are terms used to describe the reversal of tone in a photographic print. In a solarized print, some highlights that would ordinarily appear white instead appear black. Such prints are further characterized by a distinct black outline that is sometimes visible where solarized areas meet nonsolarized areas. Although the two techniques produce a nearly identical effect, they are achieved in different ways. Solarization is produced by the extreme over-EXPOSURE of a NEGATIVE in a CAMERA. Sabattier effect is produced by exposing a partially developed negative or print to light during development. The techniques are unpredictable and difficult to control. Surrealist photographers employed them during the 1920s.

Stereoscopic photography and **stereograph** refer to a method of taking and exhibiting photographs that allows them to appear three-dimensional when viewed in a special viewer. The technique is based on the principle of binocular vision, which is the foundation of human depth perception. A stereograph is a pair of photographic images, most commonly albumen prints on 3 x 4½-inch card stock, made by two camera LENSES. At the time of EXPOSURE the lenses are spaced laterally at the same distance as human eyes, and record what the respective eyes would view. When the two images are viewed together through a stereoscope, they stimulate the experience of three-dimensional depth perception. Stereographic daguerreotypes were made shortly after the introduction of the daguerreotype. The stereograph enjoyed great popularity from the 1850s into the twentieth century as the ALBUMEN print (no. 28).

Straight photography is a subjective term used to refer to photographs printed without manipulation on photographic paper. Practitioners of straight photography strive to make prints that reflect the veracity of information held on a NEGATIVE. Straight photography may be contrasted with PICTORIALIST photography, which sought artistic control and the expressive effects possible in printing.

A **stroboscopic flash** allows precise control of bright, high-speed electronic flashes to illuminate photographic EXPOSURES. The instrument was named by its inventor Harold Edgerton (1903–1990), who during the early 1930s found that synchronizing a flash to pulse each time a subject reaches exactly the same point in a cycle created an optical illusion by melding several images into one. In multiple-exposure photography, a stroboscopic flash is either timed to pulse electronically at metered intervals or is released manually at irregular intervals to keep time with a subject moving at a variable rate. Beginning in the twentieth century, the stroboscopic flash has been used primarily for studying motion and interaction between moving parts. Consequently, the stroboscope is of great use as a diagnostic tool in manufacturing and engineering industries. (no. 164)

A **tinted photograph** is any photograph exhibiting an overall tone as a result of dyes built into the photographic EMULSION or the paper base of a print. A tinted photograph differs from a toned photograph, which is an aftermarket manipulation.

A **tintype (ferrotype)** is a variation on the basic principles of the AMBROTYPE. Tintypes are made on thin sheets of iron that have been coated with an opaque black or chocolate-colored enamel. To produce a tintype, an enameled plate is coated with light-sensitized COLLODION immediately before EXPOSURE and DEVELOPED immediately afterward as in the WET-COLLODION PROCESS. The tintype was introduced in the 1850s and the technique remained popular until around 1940. Primarily used for portraiture, the tintype was employed by itinerant photographers for the relative instantness by which it could be taken and processed. Tintypes are often CASED like daguerreotypes. They have a creamy appearance and exhibit a muted tonal range. (no. 32)

Toning is the general term for any process that manipulates the overall color or tone of a photographic print. Toning is done in a variety of ways, most commonly by soaking in a bath during or after DEVELOPMENT. Dyes or teas are the most common toning materials used. Today the effect is chiefly used for aesthetic purposes, but toning with certain metals such as gold or platinum was used during the nineteenth century to increase a photograph's archival stability. Historically, photographs have been commonly toned purple, brown, and sepia, but the possible color range achieved through the technique is unlimited.

Union Case: See **cased photograph**

Verso: See **recto**

View cameras, or field cameras as they are known in England, are noted as large-format cameras due to the size of the NEGATIVES they produce. They incorporate an accordion-like bellow and require a tripod and dark cloth for focusing. Unless specially equipped, view cameras are capable of making only a single EXPOSURE at a time.

The **waxed-paper negative**, introduced by Gustave Le Gray (1820–1884) in 1851, improved the resolution of the photographic print from a CALOTYPE negative by making the negative more translucent. Waxed-paper negatives could be prepared up to two weeks in advance, which made them popular among expeditionary photographers. Though more cumbersome, the glass-plate negative eventually replaced waxed paper in use for its capacity for sharpness. (no. 20)

A **Woodburytype** is produced by a photomechanical process. First a sheet of glass is prepared with a layer of talc and COLLODION. After this has dried, a further layer of bichromated gelatin is applied. The combined layer is then stripped from the glass plate and EXPOSED under a photographic NEGATIVE. During exposure the bichromated gelatin, which has the quality of hardening proportionally when exposed to light, generates a paper-thin low-relief image. Following exposure the unhardened bichromated gelatin is washed away, leaving only the relief. The gelatin relief is then pressed hydraulically into a piece of softened lead to create a mold. The mold is "inked" using pigmented gelatin, placed in contact with a sheet of paper, and printed using a hand press. Woodburytypes were popularly used during the nineteenth century for producing book illustrations. They can be printed in any color

and are characterized by fine resolution and sharp detail. The process was patented by Walter Bentley Woodbury (1834–1885) in 1865. (no. 52)

The **zoopraxiscope**, a primitive motion-picture projector invented by Eadweard Muybridge (1830–1904) in 1879, was named from the Greek words for "animal," "action," and "optical instrument." The invention combined the technologies from the lantern projector and the *zoetrope*, a popular children's toy. Muybridge mounted his sequential photographs of animals (no. 48) to a disk, and painted them to appear as silhouettes. A strong light was then projected through the rotating disk, while a counterrotating slotted disk, moving at the same speed, acted as a SHUTTER to create the illusion of fluid movement. The projected sequence of still photographs created an optical illusion of a moving image, like a child's flipbook. Muybridge's machine helped usher in the invention of a practical motion-picture camera and projector. The later innovations of the Kinetoscope and Kinetograph by Thomas Edison (1847–1931) and the cinematograph by August and Louis Lumière (1862–1954; 1864–1948) realized the invention.

Photography Exhibitions at the Worcester Art Museum

1904–2004

Exhibition of Photographs, November 25, 1904, to January 2, 1905

Second Annual Exhibition of Photographs, November 12 to December 10, 1905

Third Annual Exhibition of Photographs, October 19 to November 19, 1906

Fourth Annual Exhibition of Photographs, November 1 to December 1, 1907

Fifth Annual Exhibition of Photographs, October 30 to November 30, 1908

Sixth Annual Exhibition of Photographs, October 30 to November 29, 1909

Exhibition of Work by Pictorial Photographers of America, December 9 to 30, 1917

Exhibition of Photographs of Old Worcester by Benjamin T. Hill, June 19 to July 24, 1921

Exhibition of Photographs Selected by "American Photography," May 14 to June 11, 1922

Exhibition of Work by Members of the Worcester Photo Clan, October 5 to 26, 1924

Exhibition of Work by Members of the Worcester Photo Clan, October 4 to 25, 1925

Photographs by Man Ray, April 15 to 29, 1927

Exhibition of Photography by Members of the Worcester Photo Clan, May 1 to 15, 1927

Exhibition of Photography by Members of the Portland Camera Club and the Worcester Photo Clan, May 13 to June 3, 1928

Exhibition of Photography by Members of the Portland Camera Club and the Worcester Photo Clan, May 5 to May 19, 1929

Worcester Photo Clan, November 9 to 30, 1930

Worcester Photo Clan, November 15 to 30, 1931

Photographs of Persian Islamic Architecture (circulated by the American Institute for Persian Art and Archaeology), March 12 to 28, 1933

Worcester Photo Clan, April 9 to 30, 1933

Photos of the Gay Nineties from the Collection of Therese Bonney, March 17 to April 1, 1934

Worcester Photo Clan, April 9 to 30, 1934

Worcester Photo Clan, April 4 to 21, 1935

Worcester Photo Clan, May 3 to 17, 1936

Worcester Photo Clan, the Consolidated Camera Club, and Photos from the Museum of Modern Art, New York; with Daguerreotypes loaned by the American Antiquarian Society and Miss Mary C. Stone, and early photographs made in Edinburgh in 1843–48, May 2 to 16, 1937

Photographs of Worcester Architecture, December 1, 1937, to January 2, 1938. Organized by Professor Henry Russell Hitchcock.

Worcester Photo Clan and Consolidated Camera Club, May 1 to 12, 1938

Camera Week, Worcester Telegram and Gazette Newspaper: National Snapshot Awards, January 15 to 29, 1939

Photographs of Worcester Photo Clan, Worcester News Photographers, and the Consolidated Camera Club of the Public High Schools of Worcester, May 10 to 21, 1939

Worcester Photo Clan, April 14 to 28, 1940

Photographs by Members of the Worcester Photo Clan, May 13 to 21, 1941

Worcester Photo Clan, May 13 to 31, 1942

Wings over America, July 15 to 31, 1943. Organized by U.S. Army Air Corps.

Our Navy in Action, July 11 to August 7, 1943. Organized by the U.S. Navy Department.

Worcester Photo Clan, May 15 to 30, 1943

Worcester Photo Clan, May 16 to 30, 1944

Photographs by the Boston Press Photographers Association, May 13 to July 10, 1945

Worcester Photo Clan, May 20 to June 3, 1945

Power in the Pacific, September 9 to October 7, 1945. Organized by the Museum of Modern Art, NY.

Photographs by the Boston Press Photographers Association, April 6 to 21,1946

Worcester Photo Clan, May 14 to 28, 1946

Edward Weston, November 11 to December 2, 1946. Organized by the Museum of Modern Art, NY.

National Photography Exhibition, April 30 to May 21, 1947

Artists Look Like This: Portraits of Artists in America by Arnold Newman, January 4 to February 1, 1948. Organized by the Philadelphia Museum of Art.

First Worcester County Exhibition of Photography, July 11 to August 8, 1948

Worcester Photo Clan, 25th Anniversary, April 17 to May 8, 1949

Photographs by Worcester Telegram and Evening Gazette Staff Photographers, September 7 to 28, 1949

Egypt: LIFE Magazine Photographic Exhibiton, November 10 to 22, 1949

Venice: LIFE Magazine Photographic Exhibition, October 19 to November 19, 1950

Ideas in Images, October 17 to December 16, 1962.

Reflections: Color Photographs by Daniel Farber, January 23 to April 17, 1963

Photographs by Brassaï, June 1 to September 3, 1963

Photographs by Atget, February 23 to April 26, 1964

Photographs by Richard A. Heald, November 20, 1964 to January 17, 1965

Three European Photographers: Bill Brandt, Lucien Clergue, Paolo Monti, June 15 to September 7, 1965

Frederick H. Evans, March 1 to April 10, 1966. Organized by George Eastman House, Rochester, NY.

Photographs by Dr. Roger Kinnicutt, June 15 to September 6, 1966

Photographs by Dorothea Lange, October 15 to December 1, 1966. Organized by the Museum of Modern Art, NY, in collaboration with the Los Angeles County Museum of Art, the Oakland Museum, and the Worcester Art Museum.

Photographs by Paul Strand, July 8 to September 5, 1967

Recent Accessions in Photography, March 17 to May 19, 1968

Cartier-Bresson: Recent Photographs, and a Retrospective Group of Photographs, October 17 to December 1, 1968. Organized by the Museum of Modern Art, NY.

The Photography Collection Grows: Gifts and Purchases, 1968–1969, December 20, 1969 to February 1, 1970

Hans Finsler: Pioneer Photographer and Theorist, October 27 to November 24, 1970. Organized by IBM.

Thomas Eakins: His Photographic Works, December 3, 1970, to January 24, 1971. Organized by the Pennsylvania Academy of the Fine Arts.

Opus Donatelli: Clifford West's Photographic Studies of a Renaissance Monument, February 24 to March 11, 1972.

Photographs by Bill Brandt and André Kertész, October 6, 1971, to February 11, 1972

Western American Photographs, February 11 to September 17, 1972

Portraits and People: Photographs by Peter Pollack, May 2 to 28, 1972

Photography in Printmaking, September 14 to October 15, 1972

New York Photographs by Andreas Feininger, September 21, 1972, to January 11, 1973

Photographs by Clarence White, December 21, 1972, to January 21, 1973. Organized by the Museum of Modern Art, NY.

Photographs by Berenice Abbott and Irene Shwachman, January 12 to May 31, 1973

The American Photographic Portrait, April 26 to August 19, 1973

Photographs by Brassaï and Cartier-Bresson, June 1 to December 30, 1973

Photographs by Diane Arbus, June 26 to August 19, 1973. Organized by the Museum of Modern Art, NY.

Photographs by Brett Weston, January 3 to May 19, 1974

A Photographic Surprise from B. A. King, January 19 to March 3, 1974

China Day by Day: Photographs by Richard J. Balzer, March 30 to April 28, 1974

19th-Century British Photographs from the Museum Collection, May 24 to September 8, 1974

Photographs by Eadweard Muybridge, Animal Locomotion, September 17 to October 27, 1974

Angkor, Monuments of the God-Kings: Photographs by Béla Kalman, November 2 to December 8, 1974

Ancient Art: Photographs by Clarence Kennedy, closed February 9, 1975

Photographs by Ansel Adams, January 15 to February 23, 1975. Organized by the Metropolitan Museum of Art, NY.

Photographs by Blumberg, Michals and Uelsmann, March 1 to May 11, 1975

Photographic Portraits: Recent Acquisitions, May 17 to July 27, 1975

Portuguese Photographs by Ann Parker, August 5 to September 28, 1975

Contemporary Photographers, September 30 to December 14, 1975

Maine Photographs by Eliot Porter, December 16, 1975, to March 7, 1976

Photographs by Margaret Bourke-White and Walker Evans, April 13 to June 20, 1976

American Photography: 1840–1900, June 2 to July 25, 1976.

Color Photographs from the Collection, August 31 to October 30, 1976

Continental Photographers of the 19th Century, December 7, 1976, to February 13, 1977

Selections from the Photography Collection, March 15 to May 22, 1977

Photographs by Nicholas Nixon and Stephen Shore, June 14 to August 21, 1977

Photographs by Ron MacNeil and Wendy MacNeil, September 27 to December 4, 1977

Refractions: Photography by Dennis Wixted, September 28 to October 28, 1977

Recent Acquisitions in Photography, January 24 to April 2, 1978

Photographs by Jerry N. Uelsmann, April 25 to July 9, 1978

Photographs by Aaron Siskind, July 18 to September 24, 1978

A Memorial to Peter Pollack (1911–1978): Photographs from the Museum's Collection, October 24, 1978, to January 7, 1979

Portrait of a Friendship, Composed of Photographs by B. A. King and Works of Art by Robert Cronin, November 15 to December 15, 1978

Photographs by Wynn Bullock (1902–1975), April 10 to July 8, 1979

Images of the City: Faces and Facades, September 25 to November 25, 1979

Court House: A Photographic Document, an exhibition of photographs from the Court House Project commissioned by Joseph E. Seagram & Sons, Inc., July 24 to August 19, 1979. Organized by the National Trust of Historic Preservation and the American Federation of Arts.

Art of the State, February 19 to March 30, 1980. Organized by the Massachusetts Artists Foundation.

Photographs by Kipton Kumler, April 22 to June 22, 1980. Organized by Harcus Krakow Gallery, Boston, MA.

Recent Accessions in Photography, July 1 to September 7, 1980

Treasures of the Royal Photographic Society, September 17 to November 2, 1980. Organized by International Exhibitions Foundation.

19th Century European Photographs from the Museum Collection, September 27 to December 14, 1980

Photographs by Paul Caponigro, March 17 to May 17, 1981

Photographs by Bill Brandt, September 1 to October 15, 1981. Organized by the International Exhibitions Foundation.

American Landscape, November 24, 1981, to January 3, 1982. Organized by the Museum of Modern Art, NY.

Close-ups, May 25 to August 1, 1982

Visions of City & Country: Prints and Photographs of Nineteenth-Century France, January 7 to March 3, 1983

Collecting 20th Century Photographs, November 22, 1983, to February 5, 1984

The Photo-Secession: The Golden Age of Pictorial Photography in America, December 16, 1983, to January 29, 1984. Organized by Currier Gallery of Art, Manchester, NH.

André Kertesz: Form and Feeling, March 27 to May 6, 1984. Organized by Hallmark Photographic Collection, Kansas City, MO.

Garry Winogrand: A Memorial Presentation, April 17 to July 8, 1984

Ansel Adams: In Memoriam, May 9 to July 8, 1984

Time in New England: Photographs by Paul Strand, May 15 to June 24, 1984. Organized by the Paul Strand Foundation.

Lee Friedlander: Factory Valleys, September 4 to October 14, 1984

Bruce Davidson: A Survey, March 12 to April 21, 1985. Organized by the Center for Creative Photography, University of Arizona.

Jim Dow: Baseball Panoramas, June 11 to September 1, 1985

In Focus: Photographs from the Sanford Rose Collection, November 6, 1985, to January 5, 1986.

Edward Steichen: The Portraits, November 19, 1985, to January 5, 1986. Organized by the Minneapolis Institute of Art.

Photographers of the Weimar Republic, February 2 to March 16, 1986

Brett Weston: Photographs of Japan, July 8 to August 31, 1986

The Galleria Series: Photographs by Stephen DiRado, September 23 to November 30, 1986

Todd Webb: Photographs of New York and Paris 1945–1960, December 16, 1986, to February 1, 1987. Organized by Hallmark Photographic Collection, Kansas City, MO.

19th Century British Photography, July 14 to September 13, 1987

A Panorama of Photography: 150 Years Since Daguerre, November 21, 1987, to January 31, 1988

Harry Callahan: New Color, November 5, 1988, to January 8, 1989. Organized by Hallmark Photographic collection.

Summertime: Photographs by Duncan McCosker, September 2 to October 29, 1989

New York, New York: The City in Photographs, January 20 to March 4, 1990

American Photography 1839–1900, April 13 to June 16, 1991. Organized by George Eastman House, Rochester, NY.

Paths Untraveled: French 19th Century Prints, Drawings, and Photographs, April 30 to June 2, 1991

Eye on the Ball: The Camera's Focus on Basketball, March 19 to June 21, 1992

Clarence John Laughlin: Visionary Photographer, August 11 to September 27, 1992. Organized by Hallmark Photographic Collection, Kansas City, MO.

Photostroika: New Photography from the Soviet Union and Baltic Republics of Lithuania, Estonia, and Latvia, December 14, 1991, to February 23, 1992. Organized by Aperture Foundation, NY.

Tradiciónes: Photographs of Rural Life in Latin America by Ann Parker, April 15 to July 3, 1993

Seeing Straight: The f.64 Revolution in Photography, March 29 to May 29, 1994. Organized by the Oakland Museum, CA.

Arnold Newman's Americans, April 23 to July 10, 1994. Organized by the National Portrait Gallery, Washington, DC.

The Photographer's Vision of the Industrial Age, November 8 to December 31, 1994

Fabulous Photos: Celebrating Our Finest Acquisitions, April 20 to August 4, 1996

Modern Czech Photography: Selective Visions, February 1 to April 13, 1997. Organized by the Harn Museum of Art, University of Florida.

After the Photo-Session: American Pictorial Photography, 1910–1955, August 23 to October 19, 1997. Organized by the Minneapolis Institute of Art.

Building Form: Ansel Adams and Architecture, August 15 to October 18, 1998. Organized by the Center for Creative Photography, University of Arizona.

Recent Acquisitions in Photography, July 24 to September 26, 1999

Robert Capa Photographs, April 2 to June 4, 2000. Organized by the Alfred Stieglitz Center of the Philadelphia Museum of Art.

Linda McCartney's Sixties: Portrait of an Era, May 6 to July 2, 2000. Organized by the Estate of Linda McCartney and the Bruce Museum, Greenwich, CT.

Insight: Women's Photographs from the George Eastman House Collection, September 16 to November 26, 2000. Organized by George Eastman House, Rochester, NY.

Lewis Wickes Hine: The Final Years, April 1 to June 10, 2001. Organized by the Brooklyn Museum of Art.

Dressing Up: Photographs of Style and Fashion, November 10, 2001, to January 20, 2002

Staged! Contemporary Photography by Gregory Crewdson, Rosemary Laing, and Sharon Lockhart, December 15, 2001, to March 24, 2002

Weegee's World: Life, Death and the Human Drama, April 5 to June 2, 2002. Organized by the International Center of Photography, NY.

A Gift of Light: Photographs in the Janos Scholz Collection, September 6 to November 30, 2003. Organized by the Snite Museum of Art, University of Notre Dame.

Notes

Creative Photography at the Worcester Art Museum

1. Robert Doty, *Photo Secession: Photography as a Fine Art*, Rochester, NY, 1960, p. 14.
2. Worcester Camera Club Records, minutes for October 9, 1885, Worcester, MA, American Antiquarian Society, p. 15.
3. Worcester Camera Club Records, minutes for October 16, 1885, p. 17.
4. Worcester Camera Club Records, minutes for December 10, 1885, p. 23.
5. Worcester Camera Club Records, minutes for October 11, 1888, p. 59.
6. Francis became one of the founding directors — later called trustees — of the Worcester Art Museum in 1896.
7. The Worcester Camera Club minutes cease on October 10, 1889, in the only extant volume of club records, originally housed by the Natural History Society, and now at the American Antiquarian Society.
8. *Worcester Art Museum*, 1898, gelatin silver print, 14.9 x 20.0 cm, Worcester Art Museum archives.
9. Worcester Camera Club Records, minutes for January 10, 1889, p. 65.
10. Worcester Art Museum *Annual Report*, 1905, p. 6.
11. Louis Fabian Bachrach (1881–1963) established himself as a portraitist in Worcester in 1904, when he purchased the studio of William H. Fitton, at 1 Chatham Street. Bachrach went on to build a chain of portrait studios in the East and Midwest, and maintained his Worcester studio until 1940. In 1895 Langdon B. Wheaton founded a photographic supply company in Worcester, which is still in business over a century later. On Stephen C. Earle, see above p. 104; on Dwight Davis, see above p. 127. Figure 2: C. F. Darling, *Man in a Row Boat*, about 1900, platinum print, 21.1 x 16.2 cm. Purchased through the gift of Karl and Dorothy Briel, 2003.118.
12. Frederick Haven Pratt, *Landscape*, from *Camera Work*, 1914, photogravure, 21.3 x 16.1 cm. Gift of Dorothy and Eugene Prakapas. 1991.143.
13. William Innes Homer, *Alfred Stieglitz and the Photo-Secession*, Boston, Little, Brown, 1983, p. 44.
14. *Worcester Sunday Telegram*, November 5, 1905, p. 6. The reviewer apparently overlooked the previous year's exhibition by stating "This will be the first display."
15. *Worcester Daily Telegram*, August 30, 1908; the jurors were the Reverend Austin S. Garver, Frederick S. Pratt, Dwight Davis, the landscape painter Joseph H. Greenwood, Miss Jeanie Lee Southwick, J. Chauncey Lyford, and Charles H. Lincoln. Adhering to a national trend, the Worcester jury included painters to lend artistic validity to the exhibition. This jury remained essentially unchanged, and judged photography annuals through 1908.
16. Homer 1983, pp. 51–57.
17. In a letter from Stieglitz to the Worcester Art Museum, dated October 30, 1905. The last section in the catalogue of the *Second Annual Exhibition of Photographs* in 1905 is devoted to the *Photo-Secession Collection* and lists works by twelve artists: Alice M. Boughton of New York; Alvin Langdon Coburn of Boston; William B. Dyer of Chicago; Frank Eugene; Herbert G. French of Cincinnati; Joseph T. Keiley of Brooklyn; William B. Post of Fryeburg, Maine; Eva Watson Schütze of Chicago; Sarah C. Sears of Boston; Edward J. Steichen of New York; Alfred Stieglitz of New York; and Clarence H. White of Newark, Ohio. Yale Collection of American Literature, Beinecke Rare Book and Manuscript Library, Yale University.
18. Heywood wrote to Stieglitz on September 21, 1906, "I hope that the Photo-Secession will be able to give us another group this year. Last year the work of the Photo-Secession was far and away the best we showed." There is no record of a reply. Yale Collection of American Literature, Beinecke Rare Book and Manuscript Library, Yale University.
19. Arthur Wesley Dow, *Poppies*, about 1895, cyanotype, 19.4 x 11.9 cm, Sarah C. Garver Fund, 1997.74.
20. Steichen's photographs were added to the exhibition when it went on to be shown at the New York Public Library.
21. Edward Weston, *In a Glendale Studio*, 1923, platinum print, 15.4 x 21.5 cm. Gift of William H. and Saundra B. Lane, 1981.339.
22. See Aline B. Saarinen, *The Proud Possessors: The Lives, Times and Tastes of Some Adventurous American Art Collectors*, New York, Random House, 1958, pp. 243–44. Reference to Museum of Modern Art in the corporate title of the Société Anonyme has no connection with the Museum of Modern Art founded in 1929.
23. Quoted from an unidentified newspaper review in the Worcester Art Museum files. Dr. Roger Kinnicutt's print *Edith* and eleven other photographs were donated by Mrs. Roger Kinnicutt to the Worcester Art Museum in 1962. These prints became the first photographs to enter the Museum's newly inaugurated photography collection in 1962. Mrs. Kinnicutt donated twenty additional prints by Dr. Kinnicutt in 1966.
24. G. W. Eggers, catalogue foreword, *Exhibition of Photography by Members of the Worcester Photo Clan*, 1927.
25. *Second Annual Worcester Photo Clan Exhibition* installation at the Worcester Art Museum, 1929, gelatin silver print, 19.3 x 24.1 cm, Worcester Art Museum archives.
26. The art historian Horst Woldemar Janson gained international fame for his introductory survey, *Key Monuments of the History of Art: A Visual Survey* (Englewood Cliffs, NJ, Prentice-Hall, 1958). Born in Russia, Janson (1913–1982) first studied at universities in Hamburg and Munich and completed his graduate education at Harvard. Janson served as Worcester Art Museum docent from 1936 to 1938. He was professor of fine arts at New York University from 1949 until his retirement in 1979.
27. Two prints, a calotype, *Six Gentlemen, Edinburgh* (no. 2), and a modern print titled *Mr. and Mrs. Chalmers* (1966.51), from the

Hill and Adamson group shown in 1937, were donated by Mrs. Roger Kinnicutt to the Museum in 1966.

28. Since no catalogue exists for the 1937 exhibition, a record of the show's content was compiled by examining correspondence and entry and shipping books in the Museum archive.

29. Janson secured support from Beaumont Newhall, director of the Museum of Modern Art's groundbreaking exhibition, *Photography 1839–1937*. Newhall used the exhibition as the basis for his incisive book *The History of Photography from 1839 to the Present Day* (New York, Museum of Modern Art, 1949), which has gone through many revisions and remains an important source for information.

30. Imogen Cunningham, *Portrait of Alfred Stieglitz*, 1934, gelatin silver print, 24.2 x 19.2 cm. Purchased with funds granted by the National Endowments for the Arts, 1975.53.

31. Henry Russell Hitchcock, an architectural historian and noted fine arts professor at Smith College, created the Museum's next exhibition, *Photographs of Worcester Architecture* in December 1937. Hitchcock traced Worcester architecture from eighteenth-century farmhouses to the city's modern-day buildings in sixty contemporary photographs. Some were copies of the early prints and old photographs that Hitchcock found in the American Antiquarian Society (AAS). The Worcester Art Museum *News Bulletin and Calendar* for December 1937 states that the AAS material was "supplemented by photographs, taken expressly for the exhibition, of modern buildings and old houses which are still standing." Hitchcock, who wrote an informative caption for each picture, praised prominent nineteenth-century buildings like Worcester's early court house, designed by Charles Bulfinch, and Stephen Salisbury II's Greek Revival mansion, designed by Elias Carter.

32. Charles H. Sawyer served as director of the Worcester Art Museum from 1940 through July 1, 1947. When Sawyer took a leave of absence to enter the Army in June 1943, his place was taken by two succeeding acting directors, Kester D. Jewell (who held the position for four months before joining the American Red Cross) and Louisa Dresser (who served from November 1943 through January 1946).

33. U.S. Army Signal Corps, *Lola Lane visits the "Wings over America" at the Worcester Art Museum*, 1943, gelatin silver print, 19.5 x 24.3 cm, Worcester Art Museum archives.

34. Including such photographers as Berenice Abbott, Ansel Adams, Manuel Álvarez Bravo, Walker Evans, Dorothea Lange, Helen Levitt, Lisette Model, Eliot Porter, Charles Sheeler, Paul Strand, and Alfred Stieglitz. These were supplemented by independent loans from Harry Callahan and Todd Webb. The Worcester Art Museum acquired work by all of these photographers after collecting activity began in 1962.

35. The portraits lent by Ansco included those of General George Armstrong Custer, General Ulysses S. Grant, and General Philip Henry Sheridan. Among the cameras was an 1885 Novelette view camera, and two Buster Brown hand-held cameras from 1910.

36. *Patent Academy Camera,* manufacturers, Marion & Co., 22 & 23 Soho Sqr., London, 10.9 x 12.5 x 6.5 cm, Gift of Mrs. Kingsmill Marrs, 1925.613

37. See below p. 72. Waite donated this object to the Museum in 1952. It is also valued today for its contents; a colored tintype portrait titled *A Union Army Sergeant* (no. 32).

38. In November 1949 the Museum hosted *Egypt*, an exhibition of images by Eliot Elisofon, which grew out of a photoessay for *LIFE* magazine ("Art of Egypt," January 19, 1948). The show was organized by W. C. Hayes, an Egyptologist at the Metropolitan Museum of Art, who wrote labels providing historical information on the subjects.

39. *Daniel Catton Rich and Georgia O'Keeffe at the Worcester Art Museum*, 1960, gelatin silver print, 15.5 x 20.3 cm, Worcester Art Museum archives.

40. Creilly Pollack, *Peter Pollack*, 1965, gelatin silver print, 25.4 x 20.3 cm, Worcester Art Museum archives.

41. Peter Pollack, *Ideas in Images*, Exhibition catalogue, Worcester Art Museum, 1962; Peter Pollack, "Ideas in images," *PSA* [Photographic Society of America] *Journal*, vol. 29, January 1963, pp. 15–24. The exhibition presented photographs by Ansel Adams, Margaret Bourke-White, Harry Callahan, Bruce Davidson, Andreas Feininger, William Garnett, Gyorgy Kepes, Arnold Newman, Gordon Parks, and Todd Webb. Figure 11: *Ideas in Images* installation at the Worcester Art Museum, 1962, gelatin silver print, 23.2 x 18.0 cm, Worcester Art Museum archives.

42. Rich called on me to work in photography after he noticed that I listed photography as a leisure interest on my resumé. My interest dates from 1939 when I learned to take pictures with a box camera and to develop film by a hand method at summer camp. I took photographs for my high school yearbook in Madison, New Jersey, and in college I joined the Lehigh University Camera Club. I learned in the late 1940s about Ansel Adams and Edward Weston, who were greatly admired by Lehigh club members. I photographed buildings in an upstate mill town to produce illustrations for my master's thesis, *An Architectural Survey of New York Mills from 1808 to 1908*, submitted to Syracuse University's Graduate School in June 1961. In my first museum job at Munson-Williams-Proctor Institute, I helped install Edward Steichen's exhibition, *The Family of Man*, for the Utica showing in May 1956, just fifteen months after the exhibit first opened at the Museum of Modern Art.

43. Museums in the 1940s, 1950s, and early 1960s employed various methods for installing photographic exhibitions. Steichen led the way in the 1940s when he exhibited photographs mounted on panels. In his installations, he varied panel sizes, paid careful attention to visual design, and established traffic patterns to guide viewers through his exhibitions at the Museum of Modern Art. Rich's ideas about exhibiting unglazed photographs were not uncommon for the time.

44. Nathan Lyons later became associate director and curator of photography at George Eastman House, and promoted emerging photographers through his important exhibitions, *Contemporary Photographers Toward a Social Landscape* (1966), *The Persistence of Vision* (1967), and *Vision and Expression* (1969), a comprehensive survey of contemporary photography. In 1969 Lyons left George Eastman House to establish the Visual Studies Workshop in association with the State University of New York at Buffalo. Lyons trained curators and teachers over three decades. A practicing photographer, he helped found the Society for Photographic Education in 1964. Figure 12: Hans Hammarskiöld, *Edward Steichen and His Dog, Tripod*, 1968, gelatin silver print, 37.6 x 28.1 cm, John G. Berg Memorial Fund, 1987.168.

45. Nancy Newhall, ed., *Daybooks of Edward Weston*, vol. 1, Rochester, NY, George Eastman House, 1961.

46. See Lawrence Durrell and Chapman Mortimer, *Bill Brandt: Perspective of Nudes*, New York, Amphoto, 1961.

47. See Jean Petit, ed., *Toros Muertos: Photographies de Lucien Clergue*, with poems by Jean Cocteau, New York, Brussel & Brussel, Inc., 1966; Jean Petit, ed., *Naissances d'Aphrodite*, photographs by Lucien Clergue, text by Fédérico Garcia Lorca, New York, Brussel and Brussel, 1966.

48. Beaumont Newhall, *Frederick H. Evans*, Rochester, NY, George Eastman House, 1963; see also Beaumont Newhall, *Frederick H. Evans: Photographer of Majesty, Light, and Space of the Medieval Cathedrals of the England and France*, Millerton, NY, Aperture, 1973.

49. George P. Elliott, *Dorothea Lange*, Exhibition catalogue, New York, Museum of Modern Art, 1966.

50. Henri Cartier-Bresson, *The World of Cartier-Bresson* (New York, 1968), n.p.

51. Henri Cartier-Bresson, *Henri Matisse*, 1946,

gelatin silver print, 23.7 x 35.3 cm, Eliza S. Paine Fund in memory of William R. and Francis T. C. Paine, 1969.67.

52. Deac Rossell, "The Mind's Eye of Diane Arbus," *Boston Sunday Globe*, July 1, 1973, pp. 37, 41.

53. Pollack 1962, p.46.

54. Mary Melikian, *Stephen B. Jareckie*, 1991, dye coupler print, 25.3 x 20.3 cm, Worcester Art Museum archives.

55. The Polaroid pictures reflect the fact that Ansel Adams kept current by trying new processes as they came on the market. A friend of Polaroid's founder, Dr. Edwin H. Land, Adams served as a consultant to Polaroid Corporation and produced a body of work with Polaroid products. The forty Polaroid photographs in the Metropolitan Museum of Art exhibition *Ansel Adams Photographs* were reproduced in *Ansel Adams: Singular Images*, Morgan & Morgan, Hastings-on-Hudson, NY, 1974, published in connection with the exhibition.

56. Stephen B. Jareckie, *American Photography, 1840–1900*, Exhibition catalogue, Worcester Art Museum, 1976.

57. Alexander Döblin, *Alexanderplatz, Berlin: The Story of Franz Bieberkopf*, English translation by Eugene Jolas, New York, Viking Press, 1931.

58. Stephen B. Jareckie, *Photographers of the Weimar Republic*, Exhibition catalogue, Worcester Art Museum, 1986. *Photographers of the Weimar Republic* traveled in 1986 and 1987 to four American museums.

59. August Sander, *Master Pastry Cook*, 1928, gelatin silver print, 29.5 x 21.2 cm, Museum Purchase, 1975.118.

60. A cross-fertilization took place between German and American photographers in the late 1920s. The Deutsche Werkbund included Americans in their exhibition, *Film und Foto*, at Stuttgart in 1929. Berenice Abbott, Imogen Cunningham, Charles Sheeler, Edward Steichen, and Edward and Brett Weston were invited to participate in the Stuttgart showing.

61. Garry Winogrand, *Couple Dancing* from the series *Women Are Beautiful*, 1969, gelatin silver print, 22.4 x 33.3 cm. Gift of Schorr Family Collection, 1991.265.

62. James A. Welu, *Todd Webb, Harry Callahan, and Aaron Siskind at the Worcester Art Museum, for the opening of "Harry Callahan: New Color, 1988,"* Kodachrome color transparency, Worcester Art Museum archives.

63. See Keith F. Davis and Todd Webb, *Todd Webb: Photographs of New York and Paris 1945–1960*, Exhibition catalogue, Kansas City, MO, Hallmark Cards, Inc., 1986.

64. See Keith F. Davis, *Harry Callahan, New Color: Photographs 1978–1987*, Exhibition catalogue, Kansas City, MO, Hallmark Cards, Inc, 1988.

65. See Keith F. Davis, ed., *Clarence John Laugh-lin: Visionary Photographer*, Kansas City, MO, Hallmark Cards, Inc., 1990.

66. Like Daniel Farber (no. 166), Parker and her husband, Avon Neal, were also experts in the study of New England funereal art, and made a visual survey of gravestones in the region in stone rubbings; see Ann Parker and Avon Neal, *A Portfolio of Rubbings from Early American Stone Sculpture Found in the Burying Grounds of New England*, North Brookfield, MA, 1963, Worcester Art Museum, Thomas Hovey Gage Fund, 1974.41–82.

67. See Ann Parker and Avon Neal, *Los Ambulantes: The Itinerant Photographers of Guatemala*, Cambridge, MIT Press, 1982. Figure 18: Ann Parker, *The Red Window, Higüey, Dominican Republic*, 1982, dye coupler print, 49.9 x 33.4 cm, Alexander and Caroline Dewitt Fund, 1993.54.

68. During the 1920s, Professor Kennedy was unable to find suitable slides to use in teaching his college students, so he made his own photographs. These fine platinum prints representing ancient Greek and Roman sites and objects, and Italian Renaissance sculpture, turned out be far more than teaching aids. These include *Studies in the History and Criticism of Sculpture*, Volume I, *The Greek Bronzes*, *The Erechtheum*, Volume II, *The Tomb of Carlo Marsuppini by Desiderio da Settignano and Assistants*, Volume III, *Certain Portrait Sculptures of the Quattrocentro*, Northampton, MA, Smith College, 1928, Worcester Art Museum, Transferred from Library, 1972.156–159.

69. *Weegee's World: Life, Death and the Human Drama*, installation at the Worcester Art Museum, 2002, gelatin silver print, 25.5 x 20.5 cm, Worcester Art Museum archives.

The Invention of Photography

1. *The Camera Obscura or Dark Chamber*, engraving from Frederick Barlow's *The Complete English Dictionary* (London, 1772), 8.7 x 14.8 cm, The Peabody Library, Baltimore.

2. See David Hockney (*Secret Knowledge: Rediscovering the Lost Techniques of the Old Masters*, New York, Viking Studio, 2001, pp. 202–25), who reviews much of the archival evidence for artists' use of optics.

3. See Philip Steadman, *Vermeer's Camera: Uncovering the Truth behind the Masterpieces*, Oxford University Press, 2001.

4. See Decio Gioseffi, *Canaletto: Il quaderno delle gallerie veneziane e l'impiego della camera ottica*, Trieste, Università degli studi di Trieste, 1959.

5. Larry J. Schaaf, *Tracings of Light: Sir John Herschel and the Camera Lucida, Drawings from the Graham Nash Collection*, San Francisco, The Friends of Photography, 1989.

6. *Using a Camera Lucida to enlarge a drawing*, woodcut from Jabez Hogg, *Elements of Experimental and Natural Philosophy* (London, 1853), 95 x 7.5 cm, The Peabody Library, Baltimore.

7. Thomas Wedgwood, Esq., with observations by Humphry Davy, "An Account of a Method of Copying Paintings upon Glass, and of Making Profiles by the Agency of Light upon the Nitrate of Silver," in John Davy, ed., *Collected Works of Sir Humphry Davy*, London, Smith, Elder and Co., 9 vols., 1839, vol. 2, pp. 240–45.

8. On Niépce, see J. L. Marignier, *Nicéphore Niépce, 1765–1833: l'invention de la photographie*, Paris, Berlin, 1999; also Pail Jay, *Niépce: premiers outils, premiers résultats: description des objets du Musée Nicéphore Niépce concernant l'invention de la photographie*, Chalon-sur-Saône, Musée Nicéphore Niépce, 1978; Odette Joyeux, *Le troisième oeil, la vie de Nicéphore Niépce: la référence des dates, celle des événements, et la liberté l'imagine*, Paris, Ramsay, 1990.

9. Joseph Nicéphore Niépce, *View from the Window at Le Gras*, about 1826, heliograph, 25.8 x 29.0 cm, Gernshein Collection, Harry Ransom Humanities Research Center, University of Texas at Austin.

10. On Daguerre, see below, p. 34.

11. *Boston Daily Evening Transcript*, "Gouraud Public Demonstration in Boston," March 7, 1840, p. 2; François Fauvel-Gouraud, *Description of the Daguerreotype Process, or a Summary of M. Gouraud's Public Lecture, According to the Principles of M. Daguerre, with a Description of a Provisory Method for Taking Human Portraits*, Boston, Dutton & Wentworth, 1840 (reprint, New York, Arno Press, 1973); François Fauvel-Gouraud, "A Description of the Daguerreotype Process by Daguerre's Agent in America," *IMAGE*, vol. 9, March 1960, pp. 18–37.

12. On Davis, see Francis Everett Blake, *History of the Town of Princeton, in the County of Worcester, Commonwealth of Massachusetts*, Princeton, published by the town, 2 vols., 1915, vol. 1, pp. 297–99; vol. 2, pp. 75–76.

13. Daniel Davis, Jr., *Self-Portrait*, about 1840, daguerreotype, 9.5 x 8.0 cm (case), Princeton Historical Society.

14. This partnership continued until Page became an examiner of electric patents in 1839, and moved to Washington, DC; see Sherman, Roger, "Charles Page, Daniel Davis, and Their Electromagnetic Apparatus," *Rittenhouse: Journal of the American Scientific Instrument Enterprise*, vol. 2, 1988, pp. 34–47.

15. Daniel Davis, Jr., edited by John Bacon, Jr., and William F. Channing, *Davis's Manual of Magnetism, Including also Electro-Magnetism, Magneto-Electricity, and Thermo-Electricity, With a Description of the Electrotype Process, for the Use of Students and Literary Institu-*

tions, with 100 Original Illustrations, Boston, Daniel Davis, Jr., Magnetical Instrument Maker, No. 11 Cornhill, 1842; see also *The Medical Application of Electricity, with Description of Apparatus and Instructions for Its Use*, Boston, Daniel Davis, Jr., Magnetical Instrument Maker, 1846.

16. See Daniel Davis, Jr., *Book of the Telegraph*, Boston, D. Davis, 1851.

17. *Advertisement*, 1853, Worcester Municipal Directory, p. 23. Worcester Public Library.

18. On Van Alstin (1811–1859), see John S. Craig, *Craig's Daguerrean Registry*, Torrington, CT, vol. 3, 1996, p. 577.

19. Now in the Worcester Historical Museum, where there is also a daguerreotype portrait of the photographer. Both came to the collection as a gift from Van Altsin's stepdaughter Ann Prudence Richardson.

20. See "Great Fire in Worcester!!," *Massachusetts Spy*, June 21, 1854. Andrew Wemple Van Alstin, *Merrifield Fire*, 1854, daguerreotype, 9.0 x 8.0 cm (case). From the collections of Worcester Historical Museum.

21. For Barnard's Oswego daguerreotypes, see Robert A. Sobieszek, *Masterpieces of Photography from the George Eastman House Collections*, New York, Abbeville, 1985, pp. 48–49.

22. On the Hathaway Brothers, see John S. Craig 1996, vol. 2, pp. 254–55. In 1857 Thomas Hathaway moved to Bath, New York, and then to Elmira, New York, where from 1857 to 1860 he operated the Chemung Ambrotype Company at 22 Lake Street, the Nicholas Building. William Hathaway seems to have left Worcester in 1860 to return to Providence.

23. Thomas and William Hathaway, *Joshua Stoddard with His Steam Calliope*, about 1856, ambrotype, 15.0 x 12.0 cm (case). From the collections of Worcester Historical Museum.

24. See Carl W. Mitman, "Joshua C. Stoddard," *Dictionary of American Biography*, vol. 18, 1936, pp. 56–57.

25. Curtis Hammar, "That Old Circus Calliope: Sure Cure for Mully-Wumbles," *Worcester Telegram*, June 6, 1978.

26. See Raymond A. Lajoie, "Joshua C. Stoddard: Inventor of the Steam Calliope," *Contemporary Keyboard*, vol. 3, March 1977, pp. 14–15, 26. Stoddard's business acumen did not match his ingenuity and he was forced out of the business in 1860. He continued to work as an inventor, however, obtaining fifteen more patents, the best known for improvements for horse-drawn hay-rakes.

1 | Foundations and Conventions

WILLIAM HENRY FOX TALBOT (1)

1. William Henry Fox Talbot, *The Pencil of Nature*, London, Longman, Brown, Green, & Longmans, 1844 (reprints, New York, Da Capo Press, 1969; New York, Hans P. Kraus, Jr., 1989).

2. See Larry J. Schaaf, *Out of the Shadows: Herschel, Talbot, and the Invention of Photography*, New Haven, Yale University Press, 1992.

3. Talbot's early photogenic drawings were unstable; some darkened and others lightened when exposed to light. Herschel, who later coined the terms "photography" and "snapshot," invented hypo, the solution of hyposulphate of soda, in 1839 to fix Talbot's early photographs.

4. For biographical information on Talbot, see Larry J. Schaaf, *The Photographic Art of William Henry Fox Talbot*, Princeton, Princeton University Press, 2000.

5. See Angus Buchanan, *Brunel: The Life and Times of Isambard Kingdom Brunel*, London, Hambledon and London, 2002.

6. Several prints of this photograph are known, and the waxed-paper negative is now in the National Museum of Photography, Film, and Television (1937-3948), which also holds sixteen prints (1937-3949/1–16).

7. Talbot, 1844.

8. Schaaf 1992, p. 161.

HILL AND ADAMSON (2)

9. For biographical information on Hill and Adamson, see Sara Stevenson, *The Personal Art of David Octavius Hill*, New Haven, Yale University Press, 2002; Bodo von Dewitz and Karin Schuller-Procopovici, *David Octavius Hill & Robert Adamson: van den Anfängen der künstlerischen Photographie im 19. Jahrhunderts*, Exhibition catalogue, Cologne, Museum Ludwig / Agfa Photo-Historama, 2000.

10. Along with Fraser (1819–1914) on the left, this photograph depicts from left to right the Reverend James Walker (1812–1891) of Carnwath, the Reverend Robert Taylor (b. 1824) of Kirkurd, the Reverend Dr. John Murry (1820–1868) of Auchencairn and Northshields, the Reverend Dr. John Nelson (1829–1878) of Greenock and Northshields, and the Reverend Dr. William Welsh (1820–1892) of Broughton and Mossfennan. All of the sitters of this group became Free Church Minsters; see Sara Stevenson, *David Octavius Hill and Robert Adamson: Catalogue of Their Calotypes Taken Between 1843 and 1847 in the Collection of the Scottish National Gallery*, Edinburgh, National Galleries of Scotland, 1981, Group 103–5.

11. Two of these are at the National Gallery of Scotland; see Stevenson 1981, groups 103 and 105.

12. Reproduced in Stevenson 1981, p. 86.

ANNA ATKINS (3)

13. For biographical information on Anna Atkins, see Larry J. Schaaf, *Sun Gardens: Victorian Photograms by Anna Atkins*, New York, Aperture, 1985.

14. John George Children, ed., "Lamarck's Genera of Shells," *The Quarterly Journal of Science, Literature, and the Arts*, vol. 15, 1823.

15. Atkins's familiarity with the printing and publishing professions is shown in at least two lithographs that she drew after 1825, depicting a view of her married home and of Wooton Church in Warwickshire, prints produced by the London lithographer Charles Hullmandel; see Schaaf 1985, pp. 23–24.

16. Atkins's *British Algae: Cyanotype Impressions*, 3 vols., Halstead Place, Sevenoaks, 1843–1853, which she published herself in stages, was the first book with photographic illustrations. On the history of cyanotype, see Larry J. Schaaf, *Out of the Shadows: Herschel, Talbot, & the Invention of Photography*, New Haven: Yale University Press, 1992, pp. 127–31.

17. See Sotheby's Belgravia, *Photographic Images and Related Material*, Wednesday, October 28, 1981, London, lot 220. Disbound and broken up for its sale in 1981, the album was bound in leather and stamped in gilt: *A.A. to A.D. 1854*.

UNKNOWN PHOTOGRAPHER (4)

18. For biographical information on Daguerre, see Helmut and Alison Gernsheim, *L. J. M. Daguerre: The History of the Diorama and the Daguerreotype*, rev. ed., New York, Dover, 1968.

19. On daguerreotypy in the United States, see Merry A. Foresta and John Wood, *Secrets of the Dark Chamber: The Art of the American Daguerreotype*, Washington, DC, Smithsonian Institution Press, 1995; Harold Francis Pfister, *Facing the Light: Historic American Portrait Daguerreotypes*, Washington, DC, Smithsonian Institution Press, 1978; Floyd Rinhart and Marion Rinhart, *The American Daguerreotype*, Athens, GA, University of Georgia Press, 1981.

20. On Stephen Salisbury (1746–1829) and his family, see the Salisbury family archives at the American Antiquarian Society, Worcester.

21. On Stephen Salisbury II (1798–1884), see Nathaniel Paine, *Memoir of Stephen Salisbury*, Boston, 1906.

22. See Clarence Saunders Brigham, "Stephen Salisbury House," unpublished typescript, Worcester, American Antiquarian Society, 1942.

23. Unknown photographer, American, nineteenth century, *Salisbury Mansion, Worcester*, 1850s, daguerreotype, full plate, 16.2 x 21.2 cm. Bequest of Stephen Salisbury, III, 1907.600. Both daguerreotypes are still in their original, matching wood and compo frames, decorated with reeding and rocaille corners, completely stained brown. Each is contained in a glass mat, reverse-painted in glass, and with a stripe of gold leaf.

UNKNOWN PHOTOGRAPHER (5)

24. Unidentified photographer, American, nineteenth century, *A Heifer*, daguerreotype, half-plate, 1907.573; *A Cow*, daguerreotype, half-plate, 1907. 574. The three daguerreotypes came into the collection in the bequest of Stephen Salisbury III (1835–1905), the founder and benefactor of the Worcester Art Museum; they are enclosed in matching leather-covered cases, measuring 9.5 x 12.0 cm, closed.
25. I am grateful to Larry Burditt of the Department of Animal Science, Oklahoma State University, for his comments on the bull calf. He noted the loss of the tail switch in all three animals represented in these daguerreotypes.
26. In August 1848, Salisbury, as chairman of the Committee of Arrangements, composed the broadside announcement of the Worcester Agricultural Society Annual Fair, enumerating the appointed organizing committee members for each event. This was the first year that the Society relinquished the "Exhibition of Manufactures" to the Worcester County Mechanics' Association, which had enough resources to mount their own exposition in a town quickly shifting to an industrial center. Perhaps as a result of the changes, the farmers seem to have felt the need to pull together and to encourage the younger generation of farmers to support the Association that had been so meaningful to their fathers and forebears.
27. Stephen Salisbury, Jr., "The Worcester County Agricultural Society," manuscript of an essay written on September 19, 1850 (American Antiquarian Society, Salisbury Papers, Box 33, Folder 5).
28. On daguerreotypists in Worcester, see Edward F. Coffin, "The Daguerreotype Art and Some of Its Early Exponents in Worcester," *Proceedings of the American Historical Society*, 1921, pp. 432–39.

MARCUS AURELIUS ROOT (6)

29. For biographical information on Root, see Beaumont Newhall, "Introduction," in M. A. Root, *The Camera and the Pencil, or the Heliographic Art*, reprint, Pawlet, VT, Helios, 1971, pp. 5–9; Clyde H. Dilley,

"Marcus Aurelius Root: Heliographer," *Daguerrean Annual*, 1991, pp. 42–47.
30. The course Root offered is described in his *Prospectus of the System of Penmanship: Taught at the Writing Rooms, South-west Corner of Arch and Eighth Street*, Philadelphia, United States Job Office, 1842. His most important writing book is *Philosophical Theory and Practice of Penmanship*, 4 parts, Philadelphia, Apollos W. Harrison, 1842–43.
31. T. S. Arthur, "American Characteristics; No. V. — The Daguerreotypist," *Godey's Lady's Book*, vol. 38, May 1849, pp. 352–55.
32. On Dorothea Dix (1802–1887), see Francis Tiffany, *Life of Dorothea Lynde Dix*, Boston, Houghton Mifflin Co., 1890; Thomas J. Brown, *Dorothea Dix: New England Reformer*, 1998. Dix's papers are at Houghton Library, Harvard University.
33. Dorothea Dix, *Conversations on Common Things, of a Guide to Knowledge, by a Teacher*, 3rd ed., Boston, Munroe and Francis, 1829.
34. As suggested by Linda Ayres, in Harold Francis Pfister, *Facing the Light: Historic American Portrait Daguerreotypes*, Exhibition catalogue, Washington, DC, National Portrait Gallery, Smithsonian Institution, 1978, pp. 133–35.
35. Marcus A. Root, *The Camera and the Pencil, or the Heliographic Art*, Philadelphia, J. B. Lippincott, 1864 (reprint, with introduction by Beaumont Newhall, Pawlet, VT, Helios, 1971), p. 128.

RUFUS ANSON (7)

36. For biographical notes on Anson, see John S. Craig, *Craig's Daguerrean Registry*, Torrington, CT, vol. 2, 1996, p. 14. Carol Johnson, curator of photography at the Library of Congress, suggested that the photographer may be identical with the Rufus Anson mentioned in the Latter Day Saints Ancestral File, who was born in Washington, Duchess County, New York, and died March 21, 1886. An obituary for Rufus Anson, Jr., is in the (Poughkeepsie) *Sunday Courier*, March 21, 1886, p. 2. In the 1879 census records of Manhattan's 21st Ward, District 2, a Rufus Anson, born in 1822, is listed as a woodcarver, living in a household headed by Christopher Bourne. This may suggest that Anson worked as a woodcarver after retiring from his career as a photographer.
37. Marcus A. Root, *The Camera and the Pencil, or the Heliographic Art*, Philadelphia, J. B. Lippincott, 1864 (reprint, with introduction by Beaumont Newhall, Pawlet, VT, Helios, 1971), p. 128.
38. Henry Hunt Snelling, "The Photographic Galleries of America," *Photographic and Fine Art Journal*, January 1, 1856, p. 276.
39. The "wreath plate" hallmark represents a bust in a vertical ellipse, surrounded on the

sides by sprigs of laurel leaves that are tied at the bottom; see O. Henry Mace, *Collector's Guide to Early Photographs*, Iola, WI, Krause Publications, 1999, fig, A-12. Located in Waterbury, Connecticut, this manufacturer and supply company had an outlet near Broadway, where they offered a full line of equipment and materials, including cameras, plates, brass mats, preservers, and Union Cases. When collodion replaced daguerreotypy in the late 1850s, Holmes, Booth, and Hayden shifted to tintype plates and to camera production.

LAURE MATHILDE GOUIN BRAQUEHAIS (8)

40. On early erotic photography, see Graham Ovenden and Peter Mendes, *Victorian Erotic Photography*, London, Academy, 1973; Denis Pellerin, "File BB3 and the Erotic Image in the Second Empire," in Françoise Reynaud, Catherine Tambrun, and Kim Timby, *Paris in 3D: From Stereoscopy to Virtual Reality, 1850–2000*, Exhibition catalogue, Paris, Museum of the History of Paris, in association with the Musée Carnavalet, pp. 91–95.
41. On Bruno Braquehais, see Ernest Lacan, "Revue photographie: Études d'après nature," *La Lumière*, vol. 4, September 16, 1854, p. 147; Bernard Marbot and Weston J. Naef, *After Daguerre: Masterworks of French Photography (1848–1900) from the Bibliothèque Nationale*, Exhibition catalogue, New York, Metropolitan Museum of Art, 1980. cat. nos. 40–41.
42. On Laure Gouin, see Serge Nazarieff, *Le nu stéréoscopique 1850–1930*, Paris, Filipacchi, 1985, and Berlin, Taco, 1987.
43. As suggested by Serge Nazarieff, *Early Erotic Photography*, Cologne, Benedikt Taschen, 1993, pp. 37–57.

LOUIS-ADOLPHE HUMBERT DE MOLARD (9)

44. For biographical information on the artist, see Bernard Chéreau, Jacques Py, and Jean Bergeret, *E. Bacot, A. de Brebisson, A. Humbert de Molard: Trois photographes en Basse-Normandie au XIXe siècle, Naissance d'un art: la photographie*, Caen, Ardi, 1989.
45. A naval captain and connoisseur, Robillard was noted for the remarkably lifelike wax botanical models of tropical plants that he made when stationed on Mauritius in 1802. He called his lifesize waxwork jungle the Carporama, and brought it back to Paris, hoping it would become a key French resource for botanical study. Humbert offered the Carporama to the nation, which then declined the gift. Finally, in 1853 he sold it to the Jardin des Plantes in Paris, where it is still preserved today. See André Jammes and Eugenia Parry Janis, *The Art of the French Calotype*, Princeton University Press, pp. 191–93.

JAMES AMBROSE CUTTING (10)

46. On the technique of ambrotype, see the period technical manuals, M. H. Ellis, *The Ambrotype and Photographic Instructor, or, Photography on Glass and Paper*, Philadelphia, Myron Shew, 1856 (reprint, Arcata, CA, P. E. Palmquist, 1990); Nathan G. Burgess, *The Ambrotype Manual*, New York, 1856 (reprint, New York, Arno Press, 1973).

47. For biographical information on Cutting, see Carl W. Mittman, "James Ambrose Cutting," *Dictionary of National Biography*, vol. 5, New York, Charles Scribner's Sons, 1930, pp. 18–19.

48. Cutting also secured a British patent for ambrotype in April 1854. One of his modifications, a bromide accelerator process, was essential to the production of paper photographs as well.

49. Reprinted by William S. Johnson, *Nineteenth-Century Photography: An Annotated Biography, 1839–1879*, Boston, G. K. Hall, 1990, p. 161.

2 | Topographical and Travel Photography

MAXIME DU CAMP (11)

1. Baron Vivant Denon, *Voyage dans la basse et la haute Égypte*, London, Peltier, 1802; Victor Hugo, *Les Orientales*, 5th ed., Paris, Charles Gosselin, 1829.

2. See Elizabeth Anne Macauley, "The Photographic Adventure of Maxime Du Camp," *The Library Chronicle of the University of Texas at Austin*, vol. 19, 1982, pp. 19–51; see also Kathleen Stewart Howe, *Excursions Along the Nile: The Photographic Discovery of Ancient Egypt*, Exhibition catalogue, Santa Barbara Museum of Art, 1993; Bodo von Dewitz and Karin Schuller-Procopovici, *Die Reise zum Nil, 1849–1850: Maxime du Camp und Gustave Flaubert in Ägypten, Palästina und Syrien*, Exhibition catalogue, Cologne, Museum Ludwig / Agfa Photo-Historama, 1997.

3. Maxime Du Camp, *Le Nil*, Paris, Librarie Nouvelle, 1855, p. 340.

4. In 1851, the photographer deposited albumen prints from his 214 negatives in the Institute de France. The photographs include many images of life in Arab villages and studies of archaeological sites. Louis-Désiré Blanquart-Évrard printed some of the most appealing images — including *The Peristyle of the Tomb of Osymandias* — which were published by Gide et Baudry in 1852.

CHARLES MARVILLE (12)

5. For biographical information on Marville, see Constance Cain Hungerford, "Charles Marville, Popular Illustrator, The Origins of a Photographic Sensibility," *History of Photography*, vol. 9, July–September 1985, pp. 227–47; Marie de Thézy and Roxanne Debuisson, *Marville: Paris*, Paris, Hazan, 1994; Philippe Mellot, *Le nouveau Paris sense dessus dessous: Marville, photographies 1864–1877*, Paris, M. Trinckvel, 1995.

6. Charles Nodier, *La Saone et ses bords*, Paris, Alexander Mure de Pélanne, 1835; *La Seine et ses bords*, Paris, Alexander Mure de Pélanne, 1836. Both books include illustrations designed by both Marville and Foussereau.

7. See Bruno Foucart, *Adrien Dauzat et les voyages pittoresques dans l'ancienne France du Baron Taylor*, Paris, Fondation Taylor, 1990.

8. On Blanquart-Évrard, see Isabele Jammes, *Blanquart-Évrard et les origines de l'édition photographique française, catalogue raisonné des albums photographiques édités, 1851–1855*, Paris / Geneva, Librarie Droz, 1981. From 1851 to 1855, Marville often dated his prints, perhaps suggesting that he was involved with developing and printing them.

BISSON BROTHERS (13)

9. For biographical information on the Bisson brothers, see Milan Chlumsky, Ute Eskildsen, and Bernard Marbot, *Die Brüder Bisson: Aufsteig un Fall eines Fotografenunternehmens im 19. Jahrhunderts*, Exhibition catalogue, Essen, Museum Folkwang, 1999.

SAMUEL MASURY (14)

10. For biographical information on Masury, see *Ballou's Pictorial Drawing Room Companion*, vol. 16, March 26, 1859, p. 205; Martha A. Sandweiss, ed., *Photography in Nineteenth-Century America*, Exhibition catalogue, Forth Worth, TX, Amon Carter Museum, 1991, p. 326.

11. *Salem Gazette*, vol. 66, no. 65, June 1, 1847, when Masury opened a new studio on Essex Street.

12. See Harold Francis Pfister, *Facing the Light: Historic American Portrait Daguerreotypes*. Washington, DC, Smithsonian Institution Press, 1978, pp. 164–68.

13. Also among Masury's photographs is a remarkable picture of a rocky landscape vignette with two stable boys, framed by an arched stable door, now in the National Museum of American Art. See Merry A. Foresta, *American Photographs: The First Century, from the Isaacs Collection in the National Museum of American Art*, Exhibition catalogue, Washington, DC, Smithsonian Institution, 1997, pp. 38–39, 137.

14. Charles Greeley Loring (1828–1902) was the son of a prominent Boston lawyer. While he was at Harvard College — where he rowed on its first crew — his father purchased twenty-five acres of oceanfront property at Pride's Crossing on the North Shore, and built the first summer cottage in Beverly, Massachusetts. Loring completed a master's degree at Harvard in 1851, and the following year he traveled with his father to Europe. On an expedition along the Nile, he became devoted to the study of ancient Egyptian art. At the outbreak of the Civil War, Loring joined the Union Army. He quickly rose through the ranks of the Ninth Army Corps as a quartermaster, engaging in all its campaigns, and even briefly having command. Loring was breveted three times, and ultimately reached the rank of major-general. In 1872, the Boston Athenaeum engaged him in organizing an exhibition of Egyptian antiquities from the Way Collection, which became the core of the Museum of Fine Arts. Loring became a trustee of the fledgling organization, and when its own building was erected in Copley Square he became curator and executive head of the institution, a title changed to director in 1881. See Edward P. Loring, Charles Henry Pope, *Loring Geneology*, Farmington, ME, Knowlton & McLeary Co., 1971, pp. 264–66.

15. See John Paul Driscoll and John K. Howat, *John Frederick Kensett: An American Master*, Exhibition catalogue, Worcester Art Museum, 1985, pl. 23.

16. The mount to which the photograph is glued is inscribed, recto: *On piazze E.S.L. Mrs. Putnam George, Pat. / Hector*, lower right, *1857*; on verso: *Old House*, lower right, *This series taken by Masury 1857*. The numeral 5 is photographically imprinted at the lower right corner of the salt print itself. The woman identified as "E. S. L." is Elizabeth Smith Loring (1822–1869), the wife of Caleb William Loring (1819–1897). The figure identified as "Pat" is probably Patrick Tracy Johnson, Jr. (b. 1844), the nephew of Caleb Loring and General Charles Loring. The woman identified as "Mrs Putnam" is likely a relative of either Elizabeth S. Loring, who was the daughter of Joseph August and Louisa Putnam Peabody, or Caleb and General Loring's mother, Ann Putnam Loring. "George" has yet to be identified.

Despite the inscription, and Masury's other work at Pride's Crossing in 1857, Katherine Peabody Loring ("The Earliest Summer Residents of the North Shore and Their Houses," *Essex Institute Historical Collections*, vol. 68, July, 1932, pp. 196–201) reproduced this photograph, dating it to 1861.

EUGÈNE CUVELIER (15)

17. For biographical information on Eugène Cuvelier, see Ulrike Gauss, ed., *Eugène Cuvelier, 1837–1900*, Ostfildern-Ruit, Cantz,

1996; Malcolm Daniel, *Eugène Cuvelier: Photographer in the Circle of Corot*, Exhibition catalogue, New York, Metropolitan Museum of Art, 1996.

18. On *cliché-verre*, see Elizabeth Glassman and Marilyn F. Symmes, *Cliché-verre, Hand-drawn, Light-printed: A Survey of the Medium from 1839 to the Present*, Exhibition catalogue, Detroit Institute of Arts, 1980, p. 70; Ranier Michael Mason, *Le cliché-verre: Corot et la gravure diaphane*, Exhibition catalogue, Geneva, Musée d'Art et d'Histoire, Cabinet des Estampes, 1982.

19. Charles François Daubigny, *The Goatherdess*, 1860s, *cliché-verre*, 37.0 x 30.0 cm, Charlotte E. W. Buffington Fund, 1987.76. Though the Cuveliers became the champions of this brief flourish of *cliche-verre*, just one of these prints by Eugène Cuvelier, the image of a forest path, and none by his father survives.

20. Claude-François Dencourt, *Guide du voyageur dans le palais et la forêt de Fontainebleau, ou Histoire et description abrégées de ces lieux remarquables et pittoresques*, Fontainebleau, F. Lhuillier, 1840.

CHARLES NÈGRE (16)

21. For biographical information on Nègre, see James Borcoman, *Charles Nègre, 1820–1880*, Ottawa, National Gallery of Canada, 1976; Françoise Heilbrun, *Charles Nègre, photographe, 1820–1880*, Exhibition catalogue, Arles, Musée Réattu, Paris, Musée de Luxembourg, 1988.

22. Ernest Lacan, "Revue photographique," *La Lumière*, vol. 3, September 10, 1853, p. 147.

23. See Heilbrun 1988, pp. 26–27.

24. Charles Nègre, *Le Midi de la France, sites et monuments historiques photographies*, Paris, Goupil & Vibert, 1854.

25. On Poitevin, see Michèle and Michel Auer, *Photographers Encyclopedia International: 1839 to the Present*, Geneva, Editions Camera Obscura, 1985, vol. 2, n.p.; In 1866 Nègre published his photogravure technique: *De la gravure héliographique, son utilité, son origine, son application à l'étude de l'histoire des arts et des sciences naturelles*, Nice, V. E. Gautier.

26. Honoré d'Albert, duc de Luynes, *Voyage d'exploration à la Mer Morte, à Petra et sur la rive gauche du Jourdain*, with photogravures by Nègre from negatives by L. Vignes, Paris, Arthur Bertrand, 1871–1875.

27. See James Borcoman and Joseph Nègre, *Charles Nègre: First Photographs of the Cote d'Azur (1852–1865)*, Aix-en-Provence, Edisud, 1991.

28. See Borcoman 1976, pl. 193.

HENRI LE SECQ (17)

29. See Anne de Mondenard, *La mission héliographique: cinq photographes parcourent la France en 1851*, Paris, Centre des monuments nationaux, 2002.

30. For biographical information on Le Secq, see Eugenia Parry and Josian Sartre, *Henri Le Secq, photographe de 1850 à 1860: catalogue raisonné de la collection de la Bibliothèque des arts décoratifs, Paris*, Exhibition catalogue, Paris, Musée des arts décoratifs, 1986.

PAUL-ÉMILE MIOT (18)

31. For biographical information on Miot, see Michèle Chomette, and Pierre Marc Richard, *Paul-Emile Miot, 1827–1900: Un marin photographe; I. Terre-Neuve 1857–59; II.Amerique du Sud 1868–70; III. Oceanie 1869–70 er Senegal 1871*, Paris, Editions Galerie Michèle Chomette, 1995.

32. I am grateful to Guy Tessier, of the National Archives of Canada, for identifying the photograph as one from Miot's first two voyages to Newfoundland, and for other revelations on the photographer.

33. On Cloué, see Etienne Taillemitte, *Dictionnaire des marins français*, Paris, Editions Maritimes et d'Outre-mer, 1982, pp. 101–108.

34. James Cook and Michael Lane, *Le pilote de Terre-Neuve; ou, Recueil de plans de côtes et de ports de cette île. Pour l'usage des vaisseaux du roi, et des navires de commerce destinés a la pêche, d'après les plans...Publié par ordre du roi*, Paris, Ministere de la marine, 1784.

35. For Miot's Canadian photographs, see Michael Wilkshire and Gerald Penney, "Five Micmac Photographs," *Newfoundland Quarterly*, vol. 86, Spring 1991, pp. 12–16; Guy Tessier, "The Portfolio: Nineteenth-century French Photographs of Newfoundland," *Archivist: Magazine of the National Archives of Canada*, vol. 108, 1995, pp. 5–12.

36. See Arthur, comte de Gobineau, *A Gentleman in the Outports: Gobineau and Newfoundland*, Ottawa, Carleton University Press, 1993; Michael Wilkshire and Gerald Penney, "Five Micmac Photographs," *Newfoundland Quarterly*, vol. 86, Spring 1991, pp. 12–16.

37. On Miot's Polynesian photographs, see Chomette / Richard 1995, vol. 3.

ROGER FENTON (19)

38. For biographical information on Fenton, see John Hannavy, *Roger Fenton of Crimble Hall*, Boston, David R. Godine, 1976; Richard Pare, *Roger Fenton, 1819–1869*, New York, Aperture, 1987. The largest single collection of his works, the gift of his descendants, is housed at the Royal Photographic Society in Bath.

39. It is assumed that Delaroche recommended the new medium to his students, since Gustave Le Gray (no. 20), Édouard Baldus (no. 25), Charles Nègre (no. 16), Henri Le Secq (17), and Fenton studied with him, and all progressed from the use of photography as a tool in preparation for painting.

40. Fenton made a photograph of the van with his assistant Marcus Sparling on the box, supposedly taken before their descent into the "Valley of the Shadow of Death"; the image and the wood engraving after it, published in the *Illustrated London News*, are reproduced in Hannavy 1976, p. 51.

41. See Pare 1981, pp. 7–8. The text of Fenton's lecture delivered at the Photographic Society, London, "Narrative of a Photographic Trip to the Seat of the War in the Crimea," is reprinted in Hannavy 1976, pp. 50–60.

GUSTAVE LE GRAY (20)

42. For biographical information on Le Gray, see Sylvie Aubenas, *Gustave Le Gray, 1820–1884*, Exhibition catalogue, Paris, Bibliothèque nationale de France; Los Angeles, Getty Publications, 2002.

43. Gustave Le Gray, *Traité pratique de photographie sur papier et sur verre*, Paris, Plon frères, 1850.

44. See Anne de Mondenard, *La mission héliographique: cinq photographes parcourent la France en 1851*, Paris, Centre des monuments nationaux, 2002, pp. 150–83.

45. Ken Jacobson, *The Lovely Sea-View: A Study of the Marine Photographs Published by Gustave Le Gray, 1856–1858*, Petches Bridge, K. & J. Jacobson, 2001; This process was similar to that which Édouard Baldus (no. 25) employed for his *Cloister of Saint-Trophîme, Arles*, created for the Mission hèliographique in 1851. Sometimes Le Gray would reuse the same negatives, and one can see the same formation of clouds appearing in different images.

46. In 1860, the French General Lamoriciere formed the Papal Zouaves to defend the Papal states. Following the occupation of Rome by Victor Emmanuel in 1870, the Papal Zouaves went to France to serve the government of National Defense in France during the Franco-Prussian War. In the United States, several Zouave regiments were organized from American soldiers during the Civil War, adopting the name and uniform inspired by the North Africans.

47. Indeed, Raffet's suite of lithographs representing the Russian army in the Crimean War published serially during the 1840s represents the czar, his troops' encampment, group portraits of soldiers, and foreign warriors with their exotic garb and weaponry; see Henri Zerner, "Gustave Le Gray, Heliographer-Artist," in Aubenas 2002, pp. 222–23.

ROBERT MACPHERSON (21)

48. For biographical information on Macpherson, see Marjorie Munsterberg, "A Biographical Sketch of Robert Macpherson," *Art Bulletin*, vol. 68, March 1986, pp. 142–53; Piero Becchetti and Carlo Pietrangeli, *Robert Macpherson: Un inglese fotografo a Roma*, 1987.

49. Stefan Grundmann, ed., *The Architecture of Rome*. Stuttgart / London, Edition Axel Menges, 1998.

50. *The Art-Journal*, July 1859, p. 226.

CARLO NAYA (22)

51. For biographical information on Naya, see Italo Zannier, *Venice, the Naya Collection*, Venice, O. Böhm, 1981; Janet E. Buerger, "Carlo Naya: Venetian Photographer, The Archeology of Photography," *IMAGE*, 16, March 1983, 1–18.

52. Ruskin (*The Stones of Venice*, New York, John Wiley and Sons, 1883, vol. 3, p. 305), noted that the city had turned it over to the Austrians for use as an army barracks. Today the Foscari Palace is part of the University of Venice.

JOHN MURRAY (23)

53. For biographical information on Murray, see Sotheby's, *Early Photographs of India: The Archive of Dr. John Murray*, Exhibition / auction catalogue, London, 1999.

54. See R. Nath, *Agra and Its Monumental Glory*, Bombay, D. B. Taraporevala Sons & Co., Private Limited, 1997; John Lall, *Taj Mahal and the Glory of Mughal Agra*, Varanasi, New Delhi, Lustre Press Private Limited, 1982. Figure 2: John Murray, *The Ladies Tower — Agra Fort*, 1862, waxed-paper negative, 35.7 x 45.4 cm. Stoddard Acquisition Fund, 2000.13.

55. Murray took his last photographs in 1865. In late 1870, after a final journey across India, he returned to England. In retirement, Murray published his book *Observation on the Pathology and Treatment of Cholera: The Result of Forty Years' Experience*, London, Smith, Elder, 1874, and served as president of the Epidemiological Society of London from 1877 to 1879.

WILLIAM NOTMAN STUDIOS (24)

56. For biographical information on Notman, see Stanley R. Triggs, *William Notman: The Stamp of a Studio*, Toronto, Art Gallery of Ontario, 1985.

57. Three of Notman's seven children, William MacFarlane (1857–1913), George (1868–1921), and Charles (1870–1955), became photographers. When the patriarch died, his eldest son, William MacFarlane, took over the business with his brother Charles as a partner. In 1935, Charles retired and the business was sold. Its archive of over 400,000 photographs, office records, and family correspondence later became part of the collection of the Notman Photographic Archives at the McCord Museum of McGill University in Montreal, where it remains as the outstanding documentation of nineteenth-century Canadian life.

58. Charles Roger, *Quebec: As It Was and As It Is, or, A Brief History of the Oldest City in Canada*, Quebec, Charles Roger, 1867, p. 101.

ÉDOUARD-DENIS BALDUS (25)

59. For biographical information on Baldus, see Malcolm R. Daniel and Barry Bergdoll, *The Photographs of Édouard Baldus*, Exhibition catalogue, New York, Metropolitan Museum of Art, 1994.

60. See Anne de Mondenard, *La mission héliographique: cinq photographes parcourent la France en 1851*, Paris, Centre des monuments nationaux, 2002.

61. See Françoise Heilbrun and Geneviève Bresc-Bautier, *Le photographe et l'architecte: Édouard Baldus, Hector-Martin Lefuel et le chantier du nouveau Louvre du Napoléon III*, Exhibition catalogue, Paris, Louvre, 1995.

3 | Photographs To Buy

LEONIDA CALDESI (26)

1. A bill from Caldesi and Montecchi, now in the Royal Archives, enumerates traveling expenses to Osborne, as well as prints and portraits made between March and July 1857. See Frances Dimond and Roger Taylor, *Crown and Camera: The Royal Family and Photography, 1842–1910*, Harmondsworth / New York, Viking, 1987.

2. On Princess Alice Maud Mary (1843–1878), see *Harper's Bazaar*, "A Queen's Daughter: Princess Alice Maude Mary," February 16, 1884; Jerrold M. Packard, *Victoria's Daughters*, New York, St. Martin's Press, 1998.

FURNE AND TOURNIER (27)

3. Lady Eastlake, "Photography," (London) *Quarterly Review*, vol. 101, April 1857, p. 4.

4. For biographical information on Furne and Tournier, see Catherine Troprès, *La Bretagne en relief: premiers voyages photographiques en Bretagne*, Quimper, Musée départemental breton, 2000.

5. See François René, vicomte de Chateaubriand, *Mémoires d'outre-tombe*, Paris, 12 vols., E. & V. Penaud frères, 1849–1850.

6. On French stereography see Françoise Reynaud, Catherine Tambrun, and Kim Timby, *Paris in 3D: From Stereoscopy to Virtual Reality, 1850–2000*, Exhibition catalogue, Paris, Museum of the History of Paris, in association with the Musée Carnavalet, 2000.

R. E. MOSELEY (28)

7. See Liam Sullivan et al., *Through the Lens: Early Newburyport Photographers and Photographs, 1839 to 1900*, Historical Society of Old Newburyport, n.d.

8. I am grateful to Jay Williamson, of the Newburyport Historical Society, for identifying the location of the photograph.

9. On this stereo card, each separate print measures about 7.0 x 7.0 cm; the card mount is 8.3 x 17.1 cm. The recto of the card is blindstamped: PHOTOGRAPHED / — BY — / R.E. MOSELEY.; a label pasted on the verso of the stereo card is printed in letterpress: Newburyport and its Environs. / _____ / PHOTOGRAPHED AND PUBLISHED BY / R.E. MOSELEY, STATE STREET, NEWBURYPORT, / No.; inscribed in the center blank line, in pen and black ink: *January 31st. 1866.*

10. On Meinerth (1825–1892), see William C. Darrah, "Carl Meinerth, Photographer," *The Photographic Collector*, vol. 1, Winter 1980–81, pp. 6–9. In 1877 Meinerth gave up the State Street studio, and moved 58 Federal Street, where he continued to photograph and to teach music. At 62 State Street the photographer William Cushing Thompson established a studio in 1895, and worked there well into the twentieth century.

ANDRÉ-ADOLPHE-EUGÈNE DISDÉRI (29)

11. For biographical information on Disdéri, see Elizabeth Anne McCauley, *A. A. E. Disdéri and the Carte-de-visite Portrait Photograph*, New Haven, Yale University Press, 1985.

12. At the Worcester Art Museum is one of the popular *carte-de-viste* portraits of *Major Robert Anderson*, taken by Jeremiah Gurney in New York (1907.64); see Stephen B. Jareckie, *American Photography: 1840–1900*, Exhibition catalogue, Worcester Art Museum, 1976, pp. 18–19.

GEORGE KENDALL WARREN (30)

13. For biographical information on Warren, see Mary Panzer, "The George Kendall Warren Photography Collection at the National Museum of American History," *History of Photography*, vol. 24, Spring 2000, pp. 24–30; Patricia H. Rodgers, Charles M. Sullivan, et al., *A Photographic History of Cambridge*, Cambridge, MA, 1984, pp. 133–46.

14. See Florence Thompson Howe, "George

Kendall Warren: His Agile Camera," *Yankee*, March 1959, pp. 58–61.

15. Conrad Wright, *Harvard and the First Parish: A 350th-Anniversary Retrospect*, Cambridge, MA, First Parish Church, 1987.

CUTTING AND BRADFORD (31)

16. On Poitevin, see M. Alphonse Davanne, *Notice sur la vie et les travaux de A. Poitevin*, Paris, Gautier-Villars, 1882.

17. Quoted by Henry Hunt Snelling, *Photographic and Fine Art Journal*, vol. 7, January 1854, p. 31.

18. For biographical information on L. H. Bradford, see Bettina Norton, "Tappan and Bradford: Boston Lithographer with Essex County Associations," *Essex Institute Historical Collection*, vol. 114, July 1978, pp. 149–60; David Tatham, "The Photolithographs of L. H. Bradford," in James O'Gorman, ed., *Aspects of American Printmaking, 1800–1950*, Syracuse, NY, Syracuse University Press, 1988, pp. 119–21, 134.

19. For biographical information on Turner, see David A. Hanson, "A. A. Turner, American Photolithographer," *History of Photography*, vol. 10, July–September 1986, pp. 193–211.

20. Patent No.19,626, registered in March, 1858.

21. Bradford's portrait appeared in the magazine's April issue; *Portrait of Lodowick H. Bradford*, 1858, photolithograph on Chine appliqué, 19.3 x 12.0 cm (image), Worcester, American Antiquarian Society (Lithf CuttB Brad).

22. Jerry Ryan, *The Forgotten Aquariums of Boston*, Boston, New England Aquarium, 2000.

23. G. A. Whithorne (printer), *The Domestic History of the Learned Seals, "Ned" and "Fanny," at the Boston Aquarial Gardens*, 21 Bromfield Street, New York, 1860.

4 | American Conflict and Exploration

UNKNOWN PHOTOGRAPHER (32)

1. George S. Cook created the most famous of these portraits of Major Anderson, see Mary Warner Marien, *Photography: A Cultural History*, New York, Harry N. Abrams, Inc., 2002, p. 92 ; another portrait of Anderson was the *carte-de-viste* taken by Jeremiah Gurney in New York, see Stephen B. Jareckie, *American Photography: 1840–1900*, Exhibition catalogue, Worcester Art Museum, 1976, pp. 18–19.

2. Clifford and Michele Kraink, and Carl Walvoord, *Union Cases: A Collector's Guide to the Art of America's First Plastics*, 1998, p. 39. Figure 3: Peck and Halvorson, *The Capture of Major André* (thermoplastic Union Case), about 1860, 10.0 x 12.4 cm. Gift of Emma Forbes Waite, 1953.36.

3. Asher B. Durand, *The Capture of Major André*, 1833, oil on canvas, 63.5 x 77.5 cm, Museum purchase, 1933.161 Rather than from the painting, the die maker worked from the engraving by Alfred Jones, James Smillie, and Robert Hinschelwood, published by the American Art Union in 1846 (Worcester Art Museum, 1933.162).

MATHEW BRADY (33)

4. William S. Johnson, *Nineteenth-Century Photography: An Annotated Bibliography*, Boston, G.K. Hall, 1990, p. 84.

5. For biographical information on Brady, see Roy Meredith, *Mr. Lincoln's Camera Man, Mathew B. Brady*, New York, Charles Scribner's Sons, 1946 (2nd rev. ed, New York, Dover, 1974); Dorothy Meserve Kunhardt and Philip B. Kunhardt, Jr., *Mathew Brady and His World*, Alexandria, VA, Time-Life Books, 1977; Alan Trachtenberg, "Brady's Portraits," *Yale Review*, vol. 73, 1984, pp. 230–53.

6. On Brady's portraits, see Mary Panzer, *Mathew Brady and the Image of History*, Exhibition catalogue, Washington, DC, National Portrait Gallery, 1997.

7. While Brady was en route, President Lincoln was shot and killed by John Wilkes Booth on April 14; ironically, Brady had photographed both the victim and assassin.

8. Four of Brady's photographs from this sitting are reproduced in Meredith 1946 (2nd rev. ed, New York, Dover, 1974), pls. 112–15; the fifth in Robert S. Lanier, ed., *The Photographic History of the Civil War*, Blue & Grey Press, 1987, vol. 5, p. 67 .

9. What survived of Brady's glass-plate negatives are in the National Archives in Washington, DC, and 2,000 photographs are stored in the War College. Anthony & Company of New York had a less complete set, which Brady used to settle his bill for photographic supplies.

TIMOTHY O'SULLIVAN (34)

10. For biographical information on O'Sullivan, see James D. Horan, *Timothy O'Sullivan, America's Forgotten Photographer: The Life and Work of the Brilliant Photographer Whose Camera Recorded the American Scene from the Battlefields of the Civil War to the Frontiers of the West*, Garden City, New York, Doubleday, 1966.

11. The captions were printed on separate sheets in the portfolio. The photographic mount is lithographed with tone, and carries the following legend, printed in letterpress: "Negative by Timothy O'Sullivan. Entered according to act of Congress in the year 1865, by A. Gardner, in the Clerk's Office of the District Court of the District of Columbia. Positive by A. Gardner, 511 7th

St. Washington. Incidents of the War. FIELD WHERE GEN. REYNOLDS FELL, GETTYSBURG. July, 1863. Published by Philip & Solomon, Washington."

12. On O'Sullivan's later career as a survey photographer, see Joel Snyder, *American Frontiers: The Photographs of Timothy H. O'Sullivan, 1867–1874*, Exhibition catalogue, Philadelphia, Alfred Stieglitz Center, Philadelphia Museum of Art, 1981.

GEORGE N. BARNARD (35)

13. For biographical information on Barnard, see Keith F. Davis, *George N. Barnard: Photographer of Sherman's Campaign*, Kansas City, MO, Hallmark Cards, 1990; see also George N. Barnard, *Photographic Views of Sherman's Campaign*, New York, 1866 (reprint, with an introduction by Beaumont Newhall, New York, Dover, 1977).

14. See Robert A. Sobieszek, *Masterpieces of Photography from the George Eastman House Collections*, New York, Abbeville, 1985, pp. 48–49.

15. George N. Barnard, *Photographic Views of Sherman's Campaign, from Negatives Taken in the Field*, New York, Press of Wynkoop and Hallenbeck, 1866.

UNKNOWN PHOTOGRAPHER (36)

16. See William D. Edson, *Keystone Steam and Electric: A Record of Steam and Electric Locomotives Built for the Pennsylvania Railroad since 1906*, New York, Wayne Publications, 1974; Betty Wagner Loeb, *Altoona and the Pennsylvania Railroad: Between a Roar and a Whimper*, Altoona, Pennsylvania Railroad Technical and Historical Society, 1999.

17. Loeb 1999, pp. 40–41.

18. *A Collection of Photographs of Locomotives Typical of Each Class on the Pennsylvania Railroad at This Date . . .*, Altoona, PA, PRR Motive Power Department, May 1, 1868; see Linda A. Ries, *Guide to Photographs at the Pennsylvania State Archives*, Harrisburg, Commonwealth of Pennsylvania, Pennsylvania Historical and Museum Commission, 1993, p. 126.

19. Paul T. Warner, *Locomotives of Pennsylvania Railroad, 1834–1924*, Chicago, O. Davies, 1959, p. 18. A Baldwin Locomotive Works employee, and later a railroad historian, Warner had access to surviving files at the time of his research in the 1950s. He published this image and the most pertinent information on No. 166.

20. The best accounts of the trip of the Prince of Wales over the Pennsylvania Railroad can be found in the *United States Railroad and Mining Register* (later *Railway World*), a trade paper published in Philadelphia. Additional material may be found in Philadelphia papers such as the *Public Ledger*.

21. I am grateful to railroad historian Thomas Taber and to Christopher T. Baer of the Hagley Museum and Library for valiant attempts to locate these records and the photographer's identity.

CARLETON E. WATKINS (37)

22. For biographical information on Watkins, see Peter E. Palmquist, in Douglas R. Nickel, *Carleton Watkins: The Art of Perception*, Exhibition catalogue, San Francisco Museum of Modern Art, 1999, pp. 216–19.

23. See Peter E. Palmquist, *Carleton E. Watkins: Photographer of the American West*, Exhibition catalogue, Fort Worth, TX, Amon Carter Museum, 1983, p. xiv; Weston J. Naef, James N. Wood, and Therese Thau Heyman, *Era of Exploration: The Rise of Landscape Photographs in the American West, 1860–1895*, Buffalo, Albright-Knox Art Gallery, 1975, pl. 17.

24. As suggested by Paul Hickman, "Carleton E. Watkins in Yosemite Valley, 1861–66: Geological Theory and Photographic Practice," *History of Photography*, vol. 20, no. 1, Spring 1996, pp. 82–88.

25. Josiah Dwight Whitney, *The Yosemite Book: A Description of the Yosemite Valley and the Adjacent Region of the Sierra Nevada and of the Big Trees of California*, with twenty-four photographs by Carleton E. Watkins, and four by W. Harris, New York, J. Bien, 1868.

26. Albert Bierstadt, American, born in Germany, 1830–1902, *Yosemite Falls*, about 1865–70, oil on canvas, 91.4 x 66.4 cm. Gift from the estate of Mrs. William H. Sawyer, 1954.66.

WILLIAM HENRY JACKSON (38)

27. For biographical information on Jackson, see Peter Bacon Hale, *William Henry Jackson and the Transformation of the American Landscape*, Philadelphia, Temple University Press, 1988; LeRoy R. Hafen and Ann W. Hafen, eds., *The Diaries of William Henry Jackson, Frontier Photographer: To California and Return, 1866–67; and with the Hayden Surveys to the Central Rockies, 1873, and to the Utes and Cliff Dwellings, 1874*, Glendale, CA, A. H. Clark Co., 1959.

28. See Thurman Wilkins, *Thomas Moran: Artist of the Mountains*, rev. ed., Norman, OK, University of Oklahoma Press, 1998.

29. Geological and Geographical Survey of the Territories, *Photographs of the Yellowstone National Park, and Views of Montana and Wyoming Territories, W. H. Jackson, Photographer*, Washington, DC, Government Printing Office, 1873; William Henry Jackson, *Descriptive Catalogue of Photographs of the United States Geological Survey of the Territories, for the Years 1869 to 1873, Inclusive*, Washington, DC, Government Printing Office, 1874.

30. See Stanley Wood, *The White City (as It Was)*, Chicago, White City Art Company, 1894; Selim H. Peabody and Stanley Wood, *Jackson's Famous Pictures*, Chicago, White City Art Company, 1895.

31. Jim Hughes, *The Birth of a Century: Early Color Photographs of America*, New York, Tauris Parke Books, 1994.

5 | Literary Images

ÉTIENNE CARJAT (39)

1. For biographical information on Carjat, see Elizabeth Fallaize, *Etienne Carjat and "Le Boulevard" (1861–1863)*, Geneva / Paris, Editions Slatkine, 1987, pp. 25–43; Sylviane Heftler, *Etienne Carjat, 1828–1906: Photographe*, Exhibition catalogue, Paris, Musée Carnavalet, 1982, pp. 20–21.

2. See Joanna Richardson, *Baudelaire*, London, J. Murray, 1994; see also *American Photographer*, "Baudelaire on Photography," vol. 2, March 1979, p. 17.

3. Charles Baudelaire, *Les Fleurs du mal*, Paris, Poulet-Malassis et de Broise, 1857.

THOMAS ANNAN (40)

4. For biographical information on Annan, see Sara Stevenson, *Thomas Annan, 1829–1887*, Exhibition catalogue, Edinburgh, National Galleries of Scotland, 1990.

5. See J. Buchanan, *The Old Country Houses of the Old Glasgow Gentry*, Glasgow, J. MacLehose, 1870; Alexander Hasties Millar, *The Castles and Mansions of Ayrshire; Illustrated in Seventy Views with Historical and Descriptive Accounts*, plates by Messrs. Annan, Glasgow, Edinburgh, W. Paterson, 1885.

6. See above, pp. 30–32.

7. There are three portraits from the series in the Worcester Art Museum: *Robert Berry*, 1871, carbon print, 21.4 x 16.5 cm, 1989.185; *George A. Ramsay*, 1871, carbon print, 21.4 x 16.5 cm, 1989.186; and *Edmund L. Lushington*, 1871, carbon print, 21.4 x 16.5 cm, 1990.174. See also Thomas Annan, *University of Glasgow Old and New: Illustrated with Views and Portraits in Photogravure*, Glasgow, T. & R. Annan & Sons; James MacLehose & Sons, 1891.

8. *Photographs of Old Closes and Streets of Glasgow* was originally published in Glasgow in 1871, illustrated with albumen prints. A second edition appeared in 1877 containing carbon prints from the old negatives, and in 1900 the T. & R. Annan & Sons published a posthumous edition with photogravure illustrations; reprint, with introduction by Anita Ventura Mozley, New York, Dover, 1977. See also Julie Lawson, "The Problems of Poverty and the Picturesque: Thomas Annan's *Old Closes and Streets of Glasgow*,

1868–1871," *Scottish Photography Bulletin*, ii, 1990.

9. See W. Buchanan, *The Art of the Photographer: J. Craig Annan*, Edinburgh, 1992. Craig Annan became a Pictorialist photographer, and member of the Brotherhood of the Linked Ring. He was friendly with the etchers David Young Cameron, Muirhead Bone, and William Strang, whose support and influence helped him to become a master of photogravure.

LEWIS CARROLL (41)

10. For biographical information on Carroll, see Stuart Dodgson Collingwood, *The Life and Letters of Lewis Carroll*, 2nd ed., London, T. F. Unwin, 1899; Morton N. Cohen, ed., *Lewis Carroll and the Kitchins*, New York, Lewis Carroll Society of North America, 1980; Edward Wakeling, ed., *Lewis Carroll's Diaries: The Private Journals of Charles Lutwidge Dodgson*, Luton, Lewis Carroll Society, 1993.

11. Lewis Carroll, *The Rectory Umbrella and Mischmasch*, London, Cassell and Co., 1832.

12. The methodical Dodgson invented his pen name by Latinizing and reversing his own Christian names: Lutwidge (his mother's maiden name, and his middle name) = Ludovicus = Lewis; Charles = Carolus = Carroll.

13. The son of Queen Victoria's physician, the younger Brodie (1817–1888) was later knighted, like his father before him; see William H. Brock, "Sir Benjamin Collins Brodie (1817–1880)," *HYLE: International Journal for Philosophy of Chemistry*, vol. 8 no. 1, 2002, pp. 49–54.

14. The subjects from left to right are Lilian (1853–1916), Margaret Anne (b. 1850), Ida Philomena (1852–1917), and Ethel (1856–1926). The sister missing from this photograph is Mary Isabel (b. 1858); the year after the photograph, the sisters were joined by a brother, Benjamin Vincent Sellons Brodie (1862–1938). See Stevenson 1981, pp. 172, 181.

15. Carroll may have trimmed the upper corners to excise the blurred bright areas surrounding fasteners that held the sheet to the negative during developing.

16. Lewis Carroll, *Alice's Adventures in Wonderland*, London, Macmillian & Co., 1865; on Alice Pleasance Liddell Hargreaves (1852–1934), see Anne Clark Amor, *The Real Alice, Lewis Carroll's Dream Child*, London, M. Joseph, 1981; Sally Brown, *The Original Alice: From Manuscript to Wonderland*, London, British Library, 1997.

17. Lewis Carroll, *Through the Looking-Glass*, London, Macmillan & Co., 1870.

JULIA MARGARET CAMERON (42)

18. For biographical information on Cameron, see Helmut Gernsheim, *Julia Margaret Cameron: Her Life and Photographic Work*, London, Gordon Fraser, 1975; Amanda Hopkinson, *Julia Margaret Cameron*, London, Virago, 1986; Victoria Olsen, *From Life: Julia Margaret Cameron and Victorian Photography*, London, Aurum Press, 2003.

19. In 1874, Cameron began the manuscript "Annals of My Glass House," a biography left unfinished.

20. See Charles W. Millard, "Julia Margaret Cameron and Tennyson's 'Idylls of the King,'" *Harvard Library Bulletin*, vol. 21, April 1973.

21. At the Worcester Art Museum, the photograph is accompanied by the quote from Tennyson's verse, written in the photographer's hand on a separate sheet.

22. *Morning Post*, "Mrs. Cameron's New Photographs," January 11, 1875.

23. "A Reminiscence of Mrs. Cameron," by a Lady Amateur, *Photographic News*, London, January 1886.

NADAR (43)

24. For biographical information on Nadar, see Maria Morris Hambourg, Françoise Heilbrun, and Paul Néagu, *Nadar*, Exhibition catalogue, New York, Metropolitan Museum of Art, 1995.

25. On Baron Taylor (1789–1879), see Élaine Maingot, *Le Baron Taylor*, Paris, Éditions É. de Bocard, 1963; Anita Louise Spadafore, *The Voyages pittoresques: Baron Taylor's Letters to Adrien Dauzats*, Quebec, Éditions Naaman de Sherbrooke, 1984.

26. On the *Voyages pittoresques et romantiques dans l'ancienne France*, see Michael Twyman, *Lithography 1800–1850: The Techniques of Drawing on Stone in England and France and Their Application in Works of Topography*, London, Oxford University Press, 1970, pp. 226–53; Anita Louise Spadafore, "Baron Taylor's *Voyages pittoresques*," PhD. diss., Northwestern University, 1973.

27. See Hambourg / Heilbrun / Néagu 1995, p. 85.

28. Nadar's portrait of Baron Taylor appeared in Oscar Comettant, "Baron Taylor," *Galerie contemporaine*, vol. 3, Paris, Paul de Lacroix, 1886, n.p. Each issue of this popular weekly, published from 1876 to 1885, was devoted to a different personality, including France's greatest writers, artists, musicians, scientists, and politicians. Many issues included portrait photographs, some made much earlier by a wide variety of photographers and printed by Maison Goupil. They seem all to be contact prints, in the size of the original negatives, though some are the size of half a stereoscopic plate.

6 | Art and Photography

CHARLES-HIPPOLYTE AUBRY (44)

1. See Elizabeth Anne McCauley, *Industrial Madness. Commercial Photography in Paris, 1848–1871*, New Haven, Yale University Press, 1994.

2. For biographical information see [Elizabeth] Anne McCauley, "Photographs for Industry: The Career of Charles Aubry," *Getty Museum Journal*, vol. 14, 1986, pp. 157–72; also Elizabeth Anne McCauley et al., *Charles Aubry photographe*, Exhibition catalogue, Paris, Bibliothèque nationale de France, 1996.

3. Among Aubry's friends was Albert Carrier-Belluse, a younger sculptor and industrial designer, who taught, exhibited his work in the Salon, and advocated state support of the industrial arts. From 1850 to 1855 Carrier-Belluse was in England, where he taught and designed for the Minton china factories. He probably noted the use of Talbot's (no. 1) calotype process to photograph works in the London Exhibition in 1851, was aware that The British Museum hired Roger Fenton (no. 19) to record its collections in 1854, and knew that Thurston Thompson became staff photographer at the new South Kensington Museum — later the Victoria and Albert — in 1855.

4. Reprinted by McCauley 1996, p. 245. The gift of the album, which is dated May 31, 1864, was acknowledged by a medal from the emperor, but the hoped-for commission to furnish photographs to French schools was not forthcoming.

5. According to the catalogue of the Société Français de Photographie exhibition in 1864, which featured a number of Aubry's leaf photographs.

GUGLIELMO MARCONI (45)

6. See Gabriel Weisberg, *Beyond Impressionism: The Naturalist Impulse*, New York: Harry N. Abrams, 1992, pp. 148–52.; Marina Vaizey, *Painter as Photographer: Delacroix, Rossetti, Degas, Eakins, Breitner . . .*, Exhibition catalogue, Arts Council of Great Britain, 1982.

7. For biographical information on Marconi, see Weston J. Naef and Bernard Marbot, *After Daguerre: Masterworks of French Photography (1848–1900) from the Bibliothèque Nationale*, Exhibition catalogue, New York, Metropolitan Museum of Art, 1980, cat. nos. 92–94.

AUGUST KOTZSCH (46)

8. For biographical information on Kotzsch, see Ernst Hirsch, Matthias Griebel, and Volkmar Herre, *August Kotzsch, 1836–1910: Photograph in Loschwitz bei Dresden*,

Munich, Schirmer / Mosel, 1986; Ulrike Gauss, *August Kotzsch, 1836–1910: Pionier de deutschen Photographie*, Exhibition catalogue, Stuttgart, Staatsgalerie Stuttgart, Graphische Sammlung, 1992.

9. A print from this negative in the artist's estate is inscribed in pencil on verso probably by the artist's son, Otto Kotzsch: *Fräulein Neubert, spätere Frau Reichel / Otto Kotzsch / keine Platte / Abb.3 Felsners Brunnen / Photogr. Aufn. Von August Kotzsch.*

ALPHONSE MUCHA (47)

10. For biographical information on Mucha, see Jiří Mucha, *Alphonse Maria Mucha: His Life and Art*, London, Academy Editions, 1989.

11. Alphonse Mucha, *Documents décoratifs*, Paris, Renouard, 1898; Alphonse Mucha, *Figures décoratives*, Paris, Librarie Centrale des beaux-arts, 1905; see also Alphonse Mucha, *Lectures on Art*, London, Academy Editions, 1975.

12. On Mucha as a photographer, see Jiří Mucha, *Alphonse Mucha: Posters and Photographs*, London, Academy Editions, 1971; Graham Ovenden, *Photographs: Alphonse Mucha*, London, Academy Editions, 1974; Jiří Řapek, *Alfons Mucha fotografem*, Prague, Památník národního písemnictví, 1988; Daniela Mrázková and Vladimír Remeš, *Cesty Československe fotografie*, 1989, pp. 34–35.

EADWEARD MUYBRIDGE (48)

13. See Rebeccca Solnit, *Motion Studies: Eadweard Muybridge and the Technological Wild West*, London, Bloomsbury, 2003.

14. For biographical information on Muybridge, see Philip Prodger and Tom Gunning, *Time Stands Still: Muybridge and the Instantaneous Photography Movement*, Exhibition catalogue, Iris and Gerald B. Cantor Center for the Visual Art, Stanford University, 2003.

15. Anita Ventura Mozley, ed., *Eadweard Muybridge: The Stanford Years, 1872–1882*, Stanford, CA, Department of Art, Stanford University, 1972.

16. William D. Marks et al., *Animal Locomotion: The Muybridge Work at the University of Pennsylvania*, Philadelphia, J. B. Lippincott, Co., 1888.

17. Eadweard Muybridge, *Animal Locomotion: An Electro-Photographic Investigation of Consecutive Phases of Animal Movements*, published under the auspices of the University of Pennsylvania, J. B. Lippincott, 1887. A copy of the elaborate prospectus, in Worcester Art Museum files, provides a description of Muybridge's equipment and procedure, and a list of all of the plates from which subscribers could choose. There are seventy-seven plates in the Worcester Art Museum

set, which was purchased from Muybridge by the sculptor John Rogers, who donated the set to the Worcester Art Museum during his lifetime. It was housed in the library until 1973, when it was transferred to the Department of Photographs.

THOMAS EAKINS (49)

18. For biographical information on Eakins, see Darrel Sewell et al., *Thomas Eakins*, Exhibition catalogue, Philadelphia Museum of Art, 2001; William Innes Homer, *Thomas Eakins: His Life and Art*, New York, Abbevile Press, 1992.

19. At the Worcester Art Museum there is an oil sketch of the head of Gross, a preparatory sketch for the painting. In 1878, when Jefferson Medical College completed construction of a new building, its alumni association purchased *The Gross Clinic* for the school.

20. William C. Brownell, "The Art Schools of Philadelphia: With Illustrations by the Pupils," September 1879. Wood engravings based on monochrome paintings by Eakins's best pupils showed student experiences in the dissection room with cadavers.

21. On Eakins as a photographer, see Susan Danly and Cheryl Liebold, eds., *Eakins and the Photograph: Works by Thomas Eakins and His Circle in the Collection of the Pennsylvania Academy of the Fine Arts*, Philadelphia, Pennsylvania Academy of the Fine Arts, 1994; Ronald J. Onorato, *The Olympia Galleries Collection*, Exhibition catalogue, New York, 1976; Gordon Hendricks, *The Photographs of Thomas Eakins*, New York, Grossman Publishers, 1972.

22. Based on the theories of French photographer Étienne-Jules Marey, these experiments also provided accurate time intervals between exposures, enabling the photographer to calculate absolute and relative velocity of motion in any part of the body; see Marta Braun, *Picturing Time: The Work of Étienne-Jules Marey (1830–1904)*, Chicago, University of Chicago Press, 1992.

ARTHUR WESLEY DOW (50)

23. For biographical information on Dow, see Arthur Warren Johnson, *Arthur Wesley Dow: Historian — Artist — Teacher*, Ipswich, Massachusetts, Ipswich Historical Society, 1934; Frederick C. Moffatt, *Arthur Wesley Dow (1857–1922)*, Exhibition catalogue, Washington, DC, National Collection of Fine Arts, Smithsonian Institution, 1977; Nancy Green, *Arthur Wesley Dow and American Arts and Crafts*, Exhibition catalogue, New York, American Federation of Arts, 1999.

24. See Gabriel Weisberg, *Beyond Impressionism: The Naturalist Impulse*, New York: Harry N. Abrams, 1992, pp. 148–52.

25. On Fenollosa, see Lawrence W. Chisholm, *Fenollosa: The Far East and American Culture*, New Haven: Yale University Press, 1963; Marianne W. Martin, "Some American Contributions to Early Twentieth-Century Abstraction," *Arts*, vol. 54, June 1980, pp. 158–65.

26. On Dow as a photographer, see James Enyeart, *Harmony of Reflected Light: The Photographs of Arthur Wesley Dow*, Exhibition catalogue, Santa Fe, NM, Anne and John Marion Center for Photographic Arts, 2001.

27. Among Dexter's works now in the collection of the Ipswich Historical Society are a portrait of David Dow, the artist's father, and views of the artist's summer cottage on Spring Street.

28. Arthur Wesley Dow, *View of the Marshes*, about 1900–05, Worcester Art Museum, oil on canvas, 45.7 x 60.9 cm, Stoddard Acquisition Fund, 1996.37.

29. It seems doubtful that Dow exhibited any of his photographs. At the Ipswich Historical Society there is a cyanotype representing salt marshes, which is inscribed on its verso: First Prize Boston Photo Club 1892. It has been used to suggest that Dow exhibited his cyanotypes (see Moffatt 1977, p. 145, n. 198; Green 1990, p. 13). However, no documentary evidence can be found for this exhibition, nor, indeed, the organization. The leading photographers' organization of the day was the Boston Camera Club, and Dow's work was absent from their 1892 exhibition. That association evolved from the Boston Society of Amateur Photographers, which was founded in 1881, and reincorporated in 1886 as the Boston Camera Club. It appears as such in the Boston Directory of 1892, but there is no Boston Photo Club. In 1892, the Triennial Exhibition of the Massachusetts Charitable Mechanic Association was also shown in Boston. It featured a photography section with works by members of the Boston Camera Club, the Providence Camera Club, and others. This exhibition did not include works from artists affiliated with the Boston Photo Club, or Dow's photographs; see *Report of the Eighteenth Triennial Exhibition of the Massachusetts Mechanics Association*, Boston, Rockwell and Churchill, 1893, pp. 175–76.

30. Arthur Wesley Dow, *Composition: A Series of Exercises in Art Structure for the Use of Students and Teachers*, Boston, J. M. Bowles, 1899.

PETER HENRY EMERSON (51)

31. For biographical information on Emerson, see Neil McWilliams and Veronica Sekules, eds., *Life and Landscape: P. H. Emerson: Art and Photography in East Anglia, 1885–1900*, Exhibition catalogue, Norwich,

Sainsbury Centre for Visual Arts, 1986; Peter Turner and Richard Wood, *P. H. Emerson: Photographer of Norfolk*, London, Gordon Fraser, 1974.

32. Peter Henry Emerson and Thomas F. Goodall, *Life and Landscape on the Norfolk Broads*, London, Sampson Low, Marston, Searle and Rivington,1886.

33. Peter Henry Emerson, *Pictures from Life in Field and Fen*, London, G. Bell and Sons, 1887.

34. Emerson, Peter Henry, *Naturalistic Photography for Students of Fine Art*, London, Sampson Low, Marston, Searle, and Rivington, 1889 (reprint, New York, Arno Press, 1973).

35. Peter Henry Emerson, *The Death of Naturalistic Photography*, London, P. H. Emerson, 1890 (reprint, New York, Arno Press, 1973).

7 | **Commonplace to Exotic**

JOHN THOMSON (52)

1. For biographical information on Thomson, see Stephen White, *John Thomson, Life and Photographs: Street Life in London, Through Cyprus with the Camera*, London, Thames and Hudson, 1985; Richard Ovenden, David Putnam, and Michael Gray, *John Thomson (1837–1921) Photographer*, Edinburgh, National Library of Scotland, 1997.

2. Quoted in John Warner, ed., *China, The Land and Its People: Early Photographs by John Thomson*, Hong Kong, John Warner Publications.

3. John Thomson, *Illustrations of China and Its People*, London, 4 vols., London, Sampson, Marston, Low, and Searle, 1873–74.

4. John Thomson and Adolphe Smith, *Street Life in London*, London, Sampson, Low, Marston, Searle, & Rivington, 1877 (reprint, New York, Benjamin Blom, Inc., 1969).

5. Gaston Tissandier, translated by John Thomson, *A History and Handbook of Photography*, London, Sampson, Low, Martston, Searle & Rivington, 1878, p. 215.

6. Thomson / Smith 1877, p. 73.

7. Thomson / Smith 1877, p. 73.

JACOB RIIS (53)

8. Jacob Riis, "Flashes from the Slums: Pictures Taken in Dark Places by the Lightning Process," *New York Sun*, February 12, 1888 (reprinted in Beaumont Newhall, *Essays and Images*, New York, Museum of Modern Arts, 1980, p. 156).

9. *How the Other Half Lives*, New York, Charles Scribner's Sons, 1890 (reprint, Millerton, NY, Aperture, 1993).

10. For biographical information on Riis, see his autobiographical writings *The Making of*

an American, New York, Macmillan Company, 1901; *Jacob A. Riis: A Sketch of His Life and Work, with Portrait*, New York, Macmillan Company, 1904; see also Bonnie Yochelson, *Jacob Riis*, New York, Phaidon, 2001.

11. A series of Riis's articles on slum life was serialized in *Scribner's Magazine* in December 1889, and the following year published as the book *How the Other Half Lives*, New York, Charles Scribner's Sons, 1890 (reprint, Millerton, NY, Aperture, 1993).

12. Stricken by tuberculosis, Riis left New York and in 1901 moved to rural Massachusetts, far from coal smoke and fog that made breathing difficult. He died in 1914, and was buried at Barre, in Worcester County.

13. The image from the left half of a stereographic negative, the Worcester Art Museum print of *Bandit's Roost* was made by Alland in the late 1940s; see Alexander Alland, Sr., *Jacob A. Riis: Photographer and Citizen*, Millerton, NY, Aperture, 1974.

STEPHEN EARLE (54)

14. For biographical information on Earle, see Charles Nutt, *History of Worcester and Its People*, New York, Lewis Historical Publishing Company, 1919, vol. 3, pp. 89–90; Curtis Dahl, *Stephen C. Earle: Shaping Worcester's Image*, Worcester, Worcester Heritage Preservation Society, 1987.

15. Worcester Art Museum, *Exhibition of Photographs*, Exhibition catalogue, November 25, 1904 – January 2, 1905, cat. nos. 150–60.

16. The building is now the home of the Performing Arts School of Worcester. Since the organization purchased the property in 1890, and occupied the building the following year, this photograph must date to 1890.

17. This was the home of Thomas Moore Rogers (1818–1901) at 28 High Street, built in 1867. Rogers was a shoe manufacturer who later became president of the Worcester Electric Light Company. Rogers became very wealthy, largely through the shrewd investment of his capital in real estate. He built the first large brick block on Front Street west of Church Street and east of Harrington Corner in 1863; in 1869 he built the Rogers Block, and eleven years later, in partnership with Edwin Morse, he built the Odd Fellows Block on Pleasant Street; in 1883 he erected a business building in Salem Square. See *Art Work of Worcester*, Chicago, W. H. Parish Publishing Company, 1894.

SENECA RAY STODDARD (55)

18. For biographical information on Stoddard, see Jeffrey L. Horrell, *Seneca Ray Stoddard: Transforming the Adirondack Wilderness in Text and Image*, Syracuse, NY, Syracuse University Press, 1999; Jeanne Winston Adler, *Early Days in the Adirondacks: The Photo-*

graphs of Seneca Ray Stoddard, New York, H. N. Abrams, 1997.

19. See Paul Schneider, *The Adirondacks: A History of America's First Wilderness*, New York, Henry Holt and Company, 1997.

20. Seneca Ray Stoddard, *The Adirondacks Illustrated . . .*, 41st ed., Glens Falls, NY, the author, 1911.

21. Seneca Ray Stoddard, *Auto-roadmap of the Adirondacks, Compliments of the Lake Placid Club*, Glens Falls, NY, Glens Falls Publishing Company, 1914.

22. Lettered into the negative is the caption: *452. Game in the Adirondacks, Copyright 1889, by S. R. Stoddard, Glens Falls, N.Y.*

23. See Seneca Ray Stoddard, "Wonders of Flashlight Photography," *New York Daily Tribune*, March 2, 1890; reprinted in Maitland De Sormo, *Seneca Ray Stoddard: Versatile Camera-Artist*, Saranac Lake, NY, Adirondack Yesteryears, 1972, pp. 86–88.

SZE YUEN MING AND COMPANY (56)

24. See Régine Thiriez, "Ligelang: A French Photographer in 1850s Shanghai," *Orientations*, vol. 32, November 2001, pp. 49–54.

25. See Clark Worswick and Jonathan Spence, *Imperial China: Photographs 1850–1912*, New York, Penwick Publishing, 1978.

26. I am grateful to Clark Worswick, consulting curator at the Peabody Essex Museum, for the attribution of this photograph to Sze Yuen Ming and Company.

27. Salem, Massachusetts, Peabody Essex Museum, acc. nos. PH36.33–35.

28. See Dennis George Crow, *Historic Photographs of Hong Kong, Shanghai, and Peking*, Exhibition catalogue, Hong Kong, 2001, p. 51. This photograph is inscribed in the negative with the studio name and address.

29. The title of this photograph, inscribed in pen and ink on its mount, was probably written there by Frances Clary Morse (1855–1933). The Worcester native traveled in East Asia in 1899, and collected nearly a hundred studio photographs on her trip. She mounted them in two matching albums now in the Worcester Art Museum; the first (1970.158.1–46) includes forty-six photographs of Chinese subjects, stock views made by commercial studios for western consumers. Also among them is a business card from a Canton guide, Mr. Ah Cum, Jr., with his tiny portrait photograph attached. The second album (1970.159. 1–47) includes forty-seven photographs of Hawaii, the Sandwich Islands, and Japan that seem to document a tour through Nara, Kyoto, Nagoya, Tokyo, and Nikko.

Their order in the folios implies Morse's itinerary. Her companion on the adventure was her sister, Alice Morse Earle (1851–1911), a historian of colonial America, and

the author of nearly twenty popular books on life in early New England (for example, *Customs and Fashions in Old New England*, New York, Charles Scribner's Sons, 1893; *Stage Coach and Tavern Days*, New York, Macmillan, 1912). Morse herself authored a study of American furniture that was the authoritative reference at the turn of the twentieth century (*Furniture of the Olden Time*, New York, Macmillan Co., 1902); see also "Notable Career Ended by Death," *Worcester Evening Gazette*, March 23, 1933, pp. 3–4; "Miss Morse To Be Buried Saturday," *Worcester Daily Telegram*, March 24, 1933, p. 8.

ROSE AND HOPKINS (57)

30. For discussion of photography of Native Americans, see Paula Richardson Fleming and Judith Lynn Luskey, *Grand Endeavors of American Indian Photography*, Washington, DC, Smithsonian Institution Press, 1993; Paula Richardson Fleming, *Photographic Portraits of North American Indians in the Gallery of the Smithsonian Institution: The Shindler Catalogue*, Washington, DC, Smithsonian Institution Press, 2003.

31. John K. Rose was born on November 15, 1849, in Ayr, Ontario, Canada. He came to Colorado in 1881 and worked in the Bohm Photography studio in Denver. He married Nellie M. Hopkins in 1882, and they had three children. He worked for W. L. Bate in Denver and Chicago. In 1885 he returned to Denver and opened a photography gallery with Benjamin Hopkins. Benjamin (Bennie) S. Hopkins was born in 1859 in Saint Catherine's, Ontario, Canada. He came to Colorado in 1881, and opened a photography studio in Denver in 1882. In 1885, he and Rose purchased the studio of W. L. Bates in the Tabor Block on Sixteenth and Larimer Streets. He died at age fifty-six on March 26, 1915. In Denver, their studio produced photographic portraits, landscapes, and architectural views of the city. The firm's archives are now in the Hurlbert Photography Collection, Western History Department, of the Denver Public Library.

32. Peace Medals were produced in silver for presentation to Native American chiefs and warriors from the administration of George Washington to that of Benjamin Harrison, when they were an integral part of government relations with Native Americans. The style and imagery developed during Thomas Jefferson's administration became the model for the rest of the series, with a formal bust of President Jefferson in low relief on the obverse, and the image of clasped hands and the motto "Peace and Friendship" on the reverse. Throughout the years until 1849, only the presidential portraits, especially commissioned for each medal,

changed. On their expedition of discovery from 1804 to 1806, Lewis and Clark took along three large Jefferson medals, thirteen of the medium size, sixteen small, and fifty-five of the Washington Season Medals, which they presented to Native American chiefs along their route. See Francis Paul Prucha, *Indian Peace Medals in American History*, Madison, State Historical Society of Wisconsin, 1971.

33. Denver Public Library Hurlbert Photography Collection, Western History Department, acc. no. H-427.

34. Denver Public Library Hurlbert Photography Collection, Western History Department, acc. no. H-421.

EDWARD SHERIFF CURTIS (58)

35. Edward S. Curtis, "Introduction," *The North American Indian*, vol. 1, Cambridge, MA, University Press, 1907.

36. For biographical information on Curtis, see Barbara A. Davis, *Edward S. Curtis: The Life and Times of a Shadow Catcher*, San Francisco, Chronicle Books, 1985; Victor Boesen and Florence Curtis Graybill, *Edward Sheriff Curtis: Photographer of the North American Indian*, New York, Dodd, Mead, and Company, 1977.

37. Edward S. Curtis, *The North American Indian*, 20 vols., vols. 1–5, Cambridge, MA, University Press, 1907–1911; vols. 6–20, Norwood, CT, Plimpton Press, 1918–1930 (reprint, New York, Johnson Reprint Corp., 1970).

ARNOLD GENTHE (59)

38. For information on Genthe's life, see his autobiography, *As I Remember*, New York, Reynal & Hitchcock, 1936; see also Jerry E. Patterson and Dorothy Wilcox Neumeyer, *Arnold Genthe, 1869–1942*, Exhibition catalogue, Staten Island (NY) Museum, 1975; Toby Gersten Quitslund, "Arnold Genthe: A Pictorial Photographer in San Francisco," PhD. diss., George Washington University, 1988.

39. Arnold Genthe, *Pictures of Old Chinatown*, with introduction by Will Irwin, New York, Moffat, Yard and Company, 1908 (reprint, John Kuo Wei Tchen, *Genthe's Photographs of Old Chinatown*, New York, Dover, 1984).

40. After the disaster, he reestablished his studio in San Francisco, and published a selection of the early images in the book *Pictures of Old Chinatown*.

41. In 1911, Genthe moved to New York, to open a successful portrait studio. Among his distinguished subjects were Theodore Roosevelt and other American presidents, Andrew Mellon, and John D. Rockefeller. He also specialized in photographing dancers, including Ruth St. Denis and Anna Pavlova,

who are featured in his *Book of the Dance* (with introduction by Shaemas O. Sheel, Boston, International Publishers, 1916); see also Arnold Genthe, *Isadora Duncan: Twenty–four Studies*, with foreword by Max Eastman, New York, M. Kennerley, 1929.

8 | Pictorialism

ROBERT DEMACHY (60)

1. See Douglas Collins, *The Story of Kodak*, New York, Harry N. Abrams, Inc., 1990.

2. Quote by Bill Jay, *Robert Demachy: Photographs and Essays*, London, 1974.

3. For biographical information on Demachy, see R. Martinez, *Robert Demachy*, Paris, 1976; Musée Nicéphore Niepce, *Robert Demachy*, Exhibition catalogue, Chalon-sur-Saône, 1977.

4. Robert Demachy and Constant Puyo, *Les procédés d'art en photographie*, Paris, Photo-Club de Paris, 1906 (reprint, New York, Arno, 1979).

5. Margaret Harker, *The Linked Ring: The Secession Movement in Photography in Britain, 1892–1910*, London, William Heinemann, Ltd., 1979.

6. Robert Demachy, "My Experience of the Rawlins Oil Process, *"Camera Work*, October 1906, pp. 17–23.

7. See Nancy Newhall, *P. H. Emerson: The Fight for Photography as Fine Art*, New York, Aperture, 1975, p. 23.

FREDERICK H. EVANS (61)

8. For biographical information on Evans, see Margaret Harker, *The Linked Ring: The Secession Movement in Photography in Britain, 1892–1910*, London, William Heinemann, Ltd., 1979, pp. 151–52.

9. The Worcester Art Museum owns a print of Evans's famous portrait of Beardsley, with his head in his hands (Jerome Wheelock Fund, 1966.58), a photogravure mounted on a platinotype reproduction of the artist's illustrated border, which is itself a photograph of one of Beardsley's drawings related to the *Morte d'Arthur* (London, 1893, chapter heading, Book 2, Chapter 1).

10. "Forasmuch as it has pleased Almighty God of his great mercy to take unto himself the soul of our dear brother departed: we thereupon commit his body to the ground; earth to earth, ashes to ashes, dust to dust; in sure and certain hope of the Resurrection to eternal life through our Lord Jesus Christ."

ALFRED STIEGLITZ (62)

11. For biographical information on Stieglitz, see Richard Whelan, *Alfred Stieglitz: A Biography*, Boston, Little, Brown and Company,

1995; Sue Davidson Lowe, *Stieglitz: A Memoir/Biography*, New York, Farrar Straus Giroux, 1983.

12. Alfred Stieglitz, *Outward Bound: Lotte Linthicum about the Bourgogne*, 1893, platinum print, 18.6 x 15.3 cm, Eliza S. Paine Fund, 2003.117

13. See Sarah Greenough et al., *Modern Art and America: Alfred Stieglitz and His New York Galleries*, Exhibition catalogue, Washington, DC, National Gallery of Art, 2000.

14. Alfred Stieglitz, "Four Happenings," *Twice a Year*, nos. 8–9, Fall/Winter 1942, p. 128.

ALVIN LANGDON COBURN (63)

15. For biographical information on Coburn, see Helmut and Alison Gernsheim, eds., *Alvin Langdon Coburn Photographer: an Autobiography*, New York, Praeger, 1966; Karl Steinorth, ed., *Alvin Langdon Coburn: Photographs, 1900–1924*, Exhibition catalogue, Rochester, New York, George Eastman House, 1998.

16. See Gernsheim 1966, p. 22.

17. *Camera Work*, April 6, 1904.

18. Alvin Langdon Coburn, *London* (with a foreword by Hillaire Belloc), London, 1909; *New York* (with a foreword by H. G. Wells), London, Duckworth & Co., 1911.

19. Alvin Langdon Coburn, *Men of Mark*, London, Duckworth & Co., 1913; *More Men of Mark*, London, Duckworth & Co., 1913. Some of Coburn's most innovative and influential photographs were made after he moved permanently to Britain in 1912. In London he associated with the Vorticists, a group of avant-garde artists including Wyndham Lewis, Henri Gaudier-Brzeska, and Charles R. W. Nevinson. In 1916, Coburn transferred their ideas to his work by photographing through a "Vortoscope," a triangular tunnel of mirrors that created faceted, abstract images related to those viewed in a kaleidoscope. Though he only produced these "Vortographs" for a few weeks, they were among the first totally abstract photographs, and profoundly influential. See Reinhold Mißelbeck, "Alvin Langdon Coburn's Vorticist Experiments," in Steinorth 1998, pp. 177–79.

FRED HOLLAND DAY (64)

20. For biographical information on Day, see Estelle Jussim, *Slave to Beauty: The Eccentric Life and Controversial Career of F. Holland Day, Photographer, Publisher, Aesthete*, Boston, D. R. Godine, 1981; James Crump, *F. Holland Day: Suffering the Ideal*, Santa Fe, NM, Twin Palms, 1995.

21. See Thomas G. Boss, "Copeland and Day and the Art of Bookmaking," in Patricia J. Fanning, ed., *New Perspectives on F. Holland Day*, North Easton, MA, Stonehill College/

Norwood Historical Society, 1999, pp. 17–24; Copeland and Day also published the American *Yellow Book*, a progressive literary journal.

22. See Verna Posever Curtis and Jane van Nimmen, eds., *F. Holland Day: Selected Texts and Bibliography*, Oxford, Clio Press, 1995.

23. See Robert A. Sobieszek, *Masterpieces of Photography, from the George Eastman House Collections*, New York, Abbeville Press, 1985, pp. 206–7.

24. Gibran (1883–1931) became an artist, poet, and the author of *The Prophet* (New York, Knopf, 1923); see Robin Waterfield, *Prophet: The Life and Times of Kahlil Gibran*, New York, Saint Martin's Press, 1998.

25. In 1894, Day was a founding member of *Athenes Therapes*, a Boston literary society that shared the study and discussion of classical Greek literature, a common sort of club in many cosmopolitan cities, in response to the writings of Walter Pater, Edward Carpenter, and John Addington Symonds. Day's own writings on artistic use of the male nude share affinities with Symond's *Studies of the Greek Poets* (London, Smith, Elder, 1873), in which a subtext of homoeroticism underlies the celebration of sensuality in pagan culture.

CLARENCE H. WHITE (65)

26. That summer, White made many several photographs of related imagery, including *The Pipes of Pan* and *The Tree Toad*. The outstretched arms and bold nudity of *Boy Among the Rocks* are reminiscent of *The Bat* by Gertrude Käsebier. White implied that he was instrumental in this photograph of his wife, Jane, taken in August, 1902, when Käsebier visited the Whites in Newark, Ohio; see Barbara L. Michaels, *Gertrude Käsebier: The Photographer and Her Photographs*, New York, Harry N. Abrams, 1992.

27. For biographical information on White, see Maynard P. White, Jr., *Clarence H. White*, Millerton, NY, Aperture, 1979.

28. By the time of this jury, which also included Fred Holland Day, Gertrude Käsebier, Frances Benjamin Johnson, and Henry Toth, he had met and befriended the major photographers of the day, including Stieglitz.

29. Including one entire issue in 1908.

30. A charming account of the acquisition, move, and restoration of the house was written by White for a popular women's magazine in 1924, when the restoration was reasonably complete (Clarence H. White, "The House That Moved to the Sea," *Woman's Home Companion*, July 1924).

31. Among them were Margaret Bourke-White (no. 127), Dorothea Lange (no. 109), Paul Outerbridge (no. 81), and Ralph Steiner (no. 178); see Bonnie Yochelson and Kathleen A. Erwin, *Pictorialism into Modernism:*

The Clarence H. White School of Photography, New York, 1996; Marianne Fulton, *Pictorialism into Modernism: The Clarence H. White School of Photography*, Exhibition catalogue, Detroit Institute of Arts, and Rochester, NY, George Eastman House, 1996.

FREDERICK HAVEN PRATT (66)

32. For biographical information on Pratt, see *The National Cyclopedia of American Biography*, vol. 46, 1963, p. 556; the photographer was born on July 19, 1873; he died in Wellesley Hills, Massachusetts on July 11, 1958. For information on the Pratt family, see Charles Nutt, *History of Worcester and Its People*, New York, Lewis Historical Publishing Company, 1919, vol. 4, pp. 733–34.

33. I am grateful to Stephen D. Pratt, the photographer's son, for access to biographical materials from the family archives.

34. See Susan E. Strickler, "John Singer Sargent in Worcester," *Worcester Art Museum Journal*, vol. 6, 1982–83, pp. 19–39.

35. The first of these is now in the Worcester Art Museum, John Singer Sargent, *Portrait of Katherine Chase Pratt*, 1890, oil on canvas, Gift of William I. Clark, 1983.96.

36. Worcester Art Museum, *Exhibition of Photographs*, Exhibition catalogue, November 25, 1904 – January 2, 1905, cat. nos. 246–326.

37. Further evidence of the photographer's activities in Day's circle is the manuscript, among Pratt's papers, of his musical composition for *Round Rabbit*, with words by Agnes Rand Lee. The bibliophile Francis Watts Lee was one of Day's close friends; the head of the Boston Public Library printing department, he dabbed as a photographer, presumably at Day's instigation. His wife, Agnes Rand Lee, was a poet and author of children's books. She and her daughter Peggy are familiar to us as the subjects of Gertrude Käsebier's famous photograph *Blessed Art Thou Among Women*. The first of at least six of Agnes Rand Lee's children's books was *The Round Rabbit and Other Child Verse*, published by Copeland and Day. See Barbara L. Michaels, "Portraits of Friendship: Fred Holland Day, Gertrude Käsebier and Their Circle," in Patricia J. Fanning, ed., *New Perspectives on F. Holland Day*, North Easton, MA, Stonehill College / Norwood Historical Society, 1999, pp. 25–38.

38. It is possible that this photograph was one of the five *Mother and Child Studies* that Pratt exhibited in the *Third Annual Exhibition of Photographs* at the Worcester Art Museum in 1906 (nos. 97–101).

39. Ruth "India" Ruyl Woodbury (1905–2002), studied at Hingham High School and graduated from Boston University in 1926. After teaching school in the Boston area, she married David O. Woodbury, and moved to

Ogunquit, Maine, where the couple ran the Ship and Compass Bed and Breakfast in the mid-1930s. See "Obituaries: Ruth R. 'India' Woodbury," *York County Coast Star*, May 9, 2002.

40. See Beatrice Baxter Ruyl, *Little Indian Maidens at Work and Play*, New York, E. P. Dutton, 1911.

41. *Camera Work*, April 1914; an impression is in the collection of the Worcester Art Museum, gift of Dorothy and Eugene Prakapas, 1991.143.

GERTRUDE KÄSEBIER (67)

42. For biographical information on Käsebier, see Barbara L. Michaels, *Gertrude Käsebier: The Photographer and Her Photographs*, New York, Abrams, 1992; William Homer, *A Pictorial Heritage: The Photographs of Gertrude Käsebier*, Exhibition catalogue, Wilmington, Delaware Art Museum, 1979.

43. *Camera Work*, January 1903.

44. See "Five Striking Silhouettes by Gertrude Käsebier," *Vanity Fair*, March 1915, p. 334. I am grateful to Barbara Michaels for identifying the subject of this photograph and leading me to its publication.

45. See Alice Van Leer Carrick, *Shades of Our Ancestors: American Profiles and Profilists*, Boston, Little, Brown, and Company, 1928.

46. Gertrude Käsebier, "Picture Making: A Talk to the Department of Photography, Brooklyn Institute," *American Photography*, vol. 9, April 1915, pp. 224, 226.

HEINRICH KÜHN (68)

47. For biographical information on Kühn, see Ulrich Knapp, *Heinrich Kühn: Photographien*, Salzburg, Residenz, 1988.

48. Kühn published in serials like *Photographische Rundscahu* and *Das Deutsche Lichtbild*; several of these articles were collected in Kühn's book, *Technik der Lichtbildnerei*, Halle / Saale, 1921; and in 1926 his essays "Zur photographischen Technik," appeared in the *Enzyclopadie Photographie Kinematische*, vol. 109, Halle / Saale, 1926.

KARL STRUSS (69)

49. For biographical information on Struss, see Susan and John Harvith, *Karl Struss: Man with a Camera, The Artist-Photographer in New York and Hollywood*, Exhibition catalogue, Bloomfield Hills, MI, Cranbrook Academy of Art, 1976; Bonnie Yochelson et al., *New York to Hollywood: The Photography of Karl Struss*, Exhibition catalogue, Fort Worth, TX, Amon Carter Museum, 1995.

50. *Camera Work*, April, 1912.

51. See Toby A. Jurovics, "Karl Struss: Composing New York," *History of Photography*, vol. 17, Summer 1993, pp. 193–201.

DWIGHT DAVIS (70)

52. For biographical notes, see *Worcester Telegram*, "Dwight A. Davis, Stationer, Dies," April 18, 1943; *Worcester Telegram*, "Davis & Bannister Sells Office Supply Business" June 14, 1957.

53. Following Putnam's retirement, Davis promoted Charles Bannister, who had been with the firm since 1888, to junior partner; see *Worcester Telegram*, "Davis & Bannister Sells Office Supply Business" June 14, 1957.

54. *Exhibition of Photographs*, Exhibition catalogue, Worcester Art Museum, November 25, 1904 – January 2, 1905, nos. 126–43.

55. *Second Annual Exhibition of Photographs*, Exhibition catalogue, Worcester Art Museum, November 12 – December 10, 1905; the show included eleven of his photographs, nos. 55–66.

56. Curtis Bell organized the American Salon to provide a national venue for creative photographers and a forum for sharing knowledge. In its first years it excited some interest, but was outstripped by the Photo-Secession, and progressively declined until ceasing to operate in 1912; see William Innes Homer, *Alfred Stieglitz and the Photo-Secession*, Boston, Little, Brown, and Company, 1983, p. 116–17.

57. In a letter to John M. Cushman, Secretary of the Jamestown (New York) Camera Club of December 1, 1909, ". . . [I] would refer you especially to Mr. Dwight A. Davis, 120 Lincoln Street, who is particularly interested in amateur photography and who has even done some charming things in the color plates. Although he is a very busy businessman he is always most helpful to us in these exhibitions and if you are able to secure an example of his work you may be sure that you will have something that is really worth while."

58. See "Exhibition Notes," *Platinum Print*, October 1913, p. 14.

59. When the exhibition traveled to Minneapolis and to Newark, Davis substituted his photographs for each venue; see Christian A. Peterson, *Index to the Annuals of the Pictorial Photographers of America*, Minneapolis, Christian A. Peterson, 1993.

60. In 1971 the Photo Clan donated funds to the museum for an ongoing acquisitions fund in his name. "Since the Worcester Photo Clan was founded upon and throughout its entire existence devoted its aims towards pictorial photography," wrote the club's Kenneth H. Colvin, "it is our desire that this tradition be maintained and the name of Dwight A. Davis be retained in order to perpetuate the love and respect we all feel for one of our founding members."

GEORGE SEELEY (71)

61. See Paul Génard and André Barret, *Lumière: les premières photographies en coleurs*, Paris, André Barret, 1974; it was Louis Lumière and his elder brother Auguste who pioneered the development of the motion picture.

62. See J. Nilsen Laurvik, "The New Color Photography," *Century Magazine*, vol. 75, January 1908, pp. 323–30.

63. Edward Steichen, "Color Photographs," *Camera Work*, No.22, April 1908, pp. 13–24.

64. See William Innes Homer, *Alfred Stieglitz and the Photo-Secession*, Boston, Little, Brown, and Company, 1983, p. 137.

65. For biographical information on Seeley, see Homer 1983, pp. 132–37; George Dimock and Joanne Hardy, *Intimations and Imaginings: The Photographs of George H. Seeley*, Exhibition catalogue, Pittsfield, MA, Berkshire Museum, 1986.

66. *Camera Work*, July 1906; six more of Seeley's photogravures were published in *Camera Work* in October 1907; and ten more in January 1910.

67. Stieglitz was listed officially as chairman of the exhibition; his fellow jurors were Alvin Langdon Coburn, Paul Haviland, Laurvik, and Seeley.

EDWIN HALE LINCOLN (72)

68. For biographical information on Lincoln, see Frederick Dana Hawes, "Lenox Naturalist, 85, Travels 2,000 Miles To Take Picture of One Orchid for Great Photo Collection," *Boston Herald*, October 18, 1931; William B. Becker, "'Permanent Authentic Records'; The Arts and Crafts Photographs of Edwin Hale Lincoln," *History of Photography*, vol. 13, January–March 1989, pp. 19–30.

69. Lincoln's ship photographs were apparently printed on several occasions over a period of many years; a series of ninety-nine platinum prints, believed to be from the 1920s, is in the collection of the Boston Public Library, with smaller groupings in the same institution and the John Crear Library. At the Lenox Library there are fifty-three photographs, dated 1929, entitled *Platinum Prints of Ships, Whalers, Barks, Brigs, and Brigantines, Coasting and Fishing Schooners; Typical Wooden Vessel of the Nineteenth Century*. He later made platinum prints from a selected series of early dry-plate negatives, and published them in the folio *Racing and Cruising Yachts of the Nineteenth Century, 1883–1889*, Pittsfield, MA, Edwin Hale Lincoln, 1934.

70. See Edwin Hale Lincoln, *A Pride of Palaces: Lenox Summer Cottages, 1833–1933*, edited by Walter Hilton Scott, Lenox, MA, Lenox Library Association, 1910–14.

71. Edwin Hale Lincoln, *Wild Flowers of New England*, Pittsfield, MA, 1905; most extant examples of the portfolio consist of selected photographs chosen by the subscriber. Lincoln continued to photograph wild flowers, and in 1914 he issued an expanded edition of his portfolio, with 400 photographs in eight volumes, examples of which may be found at the Lenox (Massachusetts) Library and the Boston Public Library.

ROGER A. KINNICUTT (73)

72. For biographical information on Kinnicutt and his family, see Charles Nutt, *History of Worcester and Its People*, New York, Lewis Historical Publishing Company, 1919, vol. 3, pp. 723–24; John Nelson, *Worcester County: A Narrative History*, New York, American Historical Society, 1934, vol. 3, pp. 174–75. Roger A. Kinnicutt was born in Worcester on February 12, 1880, and died there on February 2, 1961.

73. Worcester Art Museum, *Exhibition of Work by Members of the Worcester Photo Clan*, Exhibition catalogue, October 5–26, 1924.

74. According to Mrs. Roger Kinnicutt, in an interview with Stephen Jareckie on March 22, 1966, this the office of Lincoln Kinnicutt, the photographer's son, in the Commerce Building or the Slater Building at 340 Main Street in Worcester; see Stephen B. Jareckie, *Photographs by Dr. Roger Kinnicutt*, Exhibition pamphlet, Worcester Art Museum, June 15 – September 6, 1966.

75. See Worcester Art Museum, *First Worcester County Exhibition of Photography, Sponsored Jointly by the Worcester Art Museum and the Worcester Photo Clan*, Exhibition pamphlet, July 11 – August 8, 1948. The Harvard student and museum docent Horst W. Janson assisted with the show, which included historical works from Kinnicutt's own collection.

76. After Kinnicutt's death (*Worcester Telegram*, "Dr. Kinnicutt, Civic Leader, Dies at 80," February 3, 1961), when the Worcester Art Museum accepted the gift of twelve photographs in September 1962, it initiated the formal collection of the Museum's permanent collection of photography, and became the nucleus of this collection, adding to the earlier accumulation of photographs.

9 | A Changing World

LEWIS WICKES HINE (74)

1. For biographical information on Hine, see Naomi Rosenblum and Alan Trachtenberg, *America and Lewis Hine: Photographs 1904–1940*, New York, Aperture, 1977.

2. See Verna Posever Curtis and Stanley Mallach, *Photography and Reform: Lewis Hine and the National Child Labor Committee*, Milwaukee, WI, Milwaukee Art Museum, 1981.

3. Jonathan Doherty, ed., *Lewis Wickes Hine's Interpretive Photography: The Six Early Projects*, Rochester and Chicago, University of Chicago Press, 1978.

4. Daile Kaplan, *Lewis Hine in Europe: The Lost Photographs*, New York, Abbeville Press, 1988.

5. Lewis Hine, *Men at Work: Photographic Studies of Modern Men and Machines*, New York, Macmillan Company, 1932.

PAUL STRAND (75)

6. For biographical information on Strand, see Sarah Greenough, *Paul Strand: An American Vision*, Exhibition catalogue, Washington, DC, National Gallery of Art, 1990; Maria Morris Hambourg, *Paul Strand: Circa 1916*, Exhibition catalogue, New York, Metropolitan Museum of Art, 1998.

7. Whitman's poems were "Crossing Brooklyn Ferry," 1856, and "Manhatta," 1860. See Charles Wolfe, "Paul Strand and Charles Sheeler's *Manhatta*," in Jan-Christopher Horak, ed., *Lovers of Cinema: The First American Film Avant-garde, 1919–1945*, Madison, University of Wisconsin Press, 1995.

8. Nancy Newhall, *Paul Strand: Photographs, 1915–1945*, Exhibition catalogue, New York, Museum of Modern Art, 1945.

9. Paul Strand, *Paul Strand: A Retrospective Monograph, 1915–1968*, Millerton, NY, Aperture, 1970.

ADOLPH DE MEYER (76)

10. On Casati, see Dario Cecchi, *Coré: vita e dannazione della Marchesa Casati*, Bologna, L'inchiostroblu / Ritz Saddler, 1986; Scott D. Ryersson and Michael Orlando Yaccarino, *Infinite Variety: The Life and Legend of Marchesa Casati*, New York, Viridian Books, 1999.

11. For biographical information on de Meyer, see Robert Brandau and Philippe Jullian, *De Meyer*, New York, Knopf, 1976; see also Anne Ehrenkranz, *A Singular Elegance: Photographs by Adolph de Meyer*, Exhibition catalogue, New York, International Center of Photography, 1994.

12. See Jennifer Dunning, Richard Buckle, and Ann Hutchinson Guest, *L'après-midi d'un faune: Vaslav Nijinski, 1912, Thirty-three Photographs by Baron Adolf de Meyer*, London, Dance Books, 1983.

AUGUST SANDER (77)

13. For biographical information on Sander, see Susan Lange and Manfred Heiting, *August Sander, 1876–1964*, Cologne, Taschen, 1999; Gerd Sander and Christoph Schreier, *August Sander: "In photography there are no unexplained shadows!,"* Exhibition catalogue, Cologne, August Sander Archive, Kulturstiftung Stadtsparkasse; London, National Portrait Gallery, 1996.

14. *Menschen des zwanzigste Jahrhunderts* organized social archetypes into seven groups, following major employment groupings of the time: The Peasant, The Skilled Tradesman, The Woman, Classes and Professions, The Artists, The City, and The Last People (which included the gypsies and beggars, the insane, the aged, and the dead). The comprehensive collection of photographs was published only after the artist's death; see Susanne Lange, Gabriele Conrath-Scholl, and Gerd Sander, *August Sander: Menschen des 20. Jahrhunderts*, 7 vols., Munich / Paris / London, 2002.

15. August Sander, *Antiltz der Zeit: Sechzig Aufnahman deutscher Menschen des 20. Jahrhunderts*, introduction by Alfred Döblin, Munich, Transmare Verlag, 1929.

16. See Oliver Lugon, *August Sander: Landschaften*, Exhibition catalogue, Cologne, Mediapark, 1999.

17. See Rolf Sachsse and Michael Euler-Schmidt, *August Sander: Köln wie es war*, Cologne, Kölnisches Stadtmuseum, 1988.

EUGÈNE ATGET (78)

18. For biographical information on Atget, see John Szarkowski, *Atget*, New York, Museum of Modern Art, 2000.

19. See Molly Nesbit, *Atget's Seven Albums*, New Haven, Yale University Press, 1992.

20. See William Howard Adams, *Atget's Gardens: A Selection of Eugène Atget's Garden Photographs*, Exhibition catalogue, London, Royal Institution of British Architects, 1979.

21. The American photographer Berenice Abbott (no. 105) befriended Atget in the mid-1920s, and after his death she bought all 1,500 of his glass-plate negatives of Paris, which were later acquired by the Museum of Modern Art in New York. See Clark Worswick, *Berenice Abbott, Eugene Atget*, Santa Fe, NM, Arena Editions, 2002.

ANSEL ADAMS (79)

22. For biographical information on the photographer, see Ansel Adams and Mary Street Alinder, *Ansel Adams: An Autobiography*, Boston, Little, Brown and Company, 1985; Mary Street Alinder, *Ansel Adams: A Biography*, New York, H. Holt, 1996.

23. On Group *f*.64, see below, p. 184.

24. Ansel Adams, *Making a Photograph: An Introduction to Photography*, London, The Studio, 1935.

25. Ansel Adams and Nancy Newhall, *This Is the American Earth*, San Francisco, Sierra Club, 1960.

CHARLES SHEELER (80)

26. For biographical information on Sheeler, see Carol Troyen and Erica Hirschler, *Charles Sheeler: Paintings and Drawings*, Exhibition catalogue, Boston, Museum of Fine Arts, 1987; Martin Friedman, *Charles Sheeler*, New York, Watson-Guptil Publications, 1975.

27. Charles Sheeler, *Zinnia and Nasturtium Leaves*, 1915, gelatin silver print, 24.4 x 19.6 cm, Worcester Art Museum, Anonymous gift, 1977.144.

28. On Sheeler as a photographer, see Theodore E. Stebbins, Jr., Gilles Mora, and Karen E. Haas, *The Photography of Charles Sheeler*, Exhibition catalogue, Boston, Museum of Fine Arts, 2003; Theodore E. Stebbins, Jr., and Norman Keyes, *Charles Sheeler: The Photographs*, Exhibition catalogue, Boston, Museum of Fine Arts, 1987.

29. See Carol Troyen, in Susan E. Strickler, ed., *American Traditions of Watercolor*, Exhibition catalogue, Worcester Art Museum, 1987, pp. 174–75.

30. Museum of Modern Art, *Charles Sheeler: Paintings, Drawings, Photographs*, with an introduction by William Carlos Williams, Exhibition catalogue, New York, 1939.

10 | Modern Life

PAUL OUTERBRIDGE, JR. (81)

1. For biographical information on Outerbridge, see see Elaine Dines and Graham Howe, eds., *Paul Outerbridge, A Singular Aesthetic: Photographs and Drawings, 1921–1941, a Catalogue Raisonné*, Santa Barbara, Arabesque Books, 1981.

2. See Max Weber, *Essays on Art*, New York, W. E. Rudge, 1916.

3. Paul Outerbridge, "Visualizing Design in the Common Place," *Arts and Decoration*, vol. 17, September 1922, p. 320ff.

4. Later, Outerbridge became interested in color photography, and set up a color studio at his home in Monsey, New York, where he experimented with the carbro process. He shared his knowledge in the book *Photographing in Color* (New York, Random House / U.S. Camera, 1940), and in the column he wrote for *U.S. Camera* magazine from 1954 until his death in 1958.

EDWARD WESTON (82)

5. For biographical information on Weston, see Ben Maddow, *Edward Weston, His Life in Photographs: The Definitive Volume of His Photographic Work*, rev. ed., Millerton, NY, Aperture, 1979; Gilles Mora, ed., *Edward Weston: Forms of Passion*, New York, H. H. Abrams, 1995.

6. Nancy Newhall, ed., *The Daybooks of Edward Weston*, 2nd ed., New York, Aperture, 1990.
7. On Modotti, see Letizia Argenteri, *Tina Modotti: Between Art and Revolution*, New Haven, Yale University Press, 2003; Pino Cacucci, *Tina Modotti: A Life*, New York, Saint Martin's Press, 1999.
8. On Group *f*.64, see below, p. 184.
9. Edward Weston and Charis Wilson, *California and the West*, 1940.
10. Walt Whitman, *Leaves of Grass*, with photographs by Edward Weston, Limited Editions Club, 1941.

IMOGEN CUNNINGHAM (83)

11. For biographical information on Cunningham, see Judy Dater, *Imogen Cunningham: A Portrait*, Boston, New York Graphic Society, 1979; Richard Lorenz, *Imogen Cunningham: Ideas without End, A Life in Photographs*, San Francisco, Chronicle Books, 1993.
12. On Group *f*.64, see below, p. 184.
13. Her vigor diminished little in her maturity, and at age ninety-two she began a series of portraits of people aged ninety years or older. See Imogen Cunningham, *After Ninety* with an introduction by Margaretta Mitchell, Seattle, University of Washington Press, 1977.

MANUEL ÁLVAREZ BRAVO (84)

14. In a letter to Nancy Newhall, quoted by Fred R. Parker, *Manuel Álvarez Bravo*, Exhibition catalogue, Pasadena, Pasadena Art Museum, 1971.
15. For biographical information on Álvarez Bravo, see Susan Kismaric, *Manuel Álvarez Bravo*, Exhibition catalogue, New York, Museum of Modern Art, 1997.
16. Mirea Eliade, *Patterns in Comparative Religion*, translated by Rosemary Sheed, Lincoln, University of Nebraska Press, 1958, p. 157.

EDWARD STEICHEN (85)

17. For biographical information, see Edward Steichen, *A Life in Photography*, Garden City, NY, Doubleday, 1963; see also Ronald J. Gedrim, *Edward Steichen: Selected Texts and Bibliography*, Oxford, Clio Press, 1996.
18. Mary Anne Goley and Barbara Ann Boese Walanin, *From Tonalism to Modernism: The Paintings of Eduard J. Steichen*, Exhibition catalogue, Washington, DC, Board of Governors of the Federal Reserve System, 1988.
19. Steichen's paintings and photographs regularly appeared in *Camera Work*; see, for example, Sadakichi Hartmann, "A Visit to Steichen's Studio," *Camera Work*, April 1903, pp. 25–28; Steichen's work dominated a double issue in 1913.

20. Worcester Art Museum, *Exhibition of Paintings by Eduard J. Steichen, December 11–31, 1910*, Exhibition catalogue, Worcester, 1910; when an expanded version of this exhibition was mounted at the New York Public Library, photographs were included.
21. Patricia A. Johnston, *Real Fantasies: Edward Steichen's Advertising Photography*, Berkeley, University of California Press, 1997.
22. Steichen saw action himself in the Pacific aboard the USS *Lexington*, and later described his experiences in the book *The Blue Ghost: A Photographic Log and Personal Narrative of the Aircraft Carrier U.S.S. Lexington in Combat Operation*, New York, Harcourt, Brace, 1947; see also above p. 211.
23. *Wings over America*, an exhibition circulated by United States Army Air Corps, at the Worcester Art Museum, July 15–31, 1943; *Our Navy in Action*, circulated by the Navy Department, at the Worcester Art Museum, July 11 – August 7, 1943; *Power in the Pacific*, circulated by the Museum of Modern Art, at the Worcester Art Museum, September 9 – October 7, 1945. See also Captain Edward J. Steichen and Lieutenant Roark Bradford, *Power in the Pacific: A Dramatic Sequence of Official Navy, Coast Guard and Marine Corps Photographs, Depicting the Men, the Sea, the Ships and Planes, Bombardments, Landing Operations and Attacks on the Enemy's Fleet*, New York, Museum of Modern Art, 1945.
24. Edward Steichen, *The Family of Man*, prologue by Carl Sandburg, 30th anniversary edition, Exhibition catalogue, New York, Museum of Modern Art, 1983. Circulated around the world by the U.S. Information Agency, the exhibition was seen by almost nine million people in thirty-seven countries; see Eric J. Sandeen, *Picturing an Exhibition: The Family of Man and 1950s America*, Albuquerque, University of New Mexico Press, 1995.

LAURA GILPIN (86)

25. Three more prints from the series of Gilpin's eleven portraits of Eggers are now in the Amon Carter Museum in Fort Worth, Texas, which also owns glass and nitrate negatives of the others. The artist bequeathed her personal papers, photographs, and negatives to that institution.
26. Eggers (1883–1958) was director of the Worcester Art Museum from 1926 to 1930. During that time, working closely with the city's immigrant Swedish community, he organized the first exhibition of American art to travel to Sweden. The show was accompanied by Eggers's book *A Brief History of American Painting*, published by the Scandinavian-American Foundation. In 1930, following the presentation of the exhibition in Stockholm, King Gustav of Sweden awarded Eggers Knight of the

North Star. Eggers left Worcester to return to teaching at the City College of New York, where he headed the art department and remained on its faculty until his retirement in 1948. He died in 1958. On Eggers, see his obituaries, *New York Times*, September 26, 1958; *Worcester Telegram and Gazette*, September 28, 1958.
27. For biographical information on Gilpin, see Martha Sandweiss, *Laura Gilpin: An Enduring Grace*, Exhibition catalogue, Fort Worth, TX, Amon Carter Museum, 1986.
28. Gilpin's book *The Enduring Navaho* (Austin, University of Texas Press, 1968), became her most important publication, conveying the photographer's deep sense of identification with the Navajo people.

HUGO ERFURTH (87)

29. See Stephen B. Jareckie, *Photographers of the Weimar Republic*, Exhibition catalogue, Worcester Art Museum, 1986, pp. 9–16.
30. For biographical information on Erfurth, see Bernd Lohse, ed., *Hugo Erfurth: 1874–1948, Fotographien der Goldenen Zwanziger Jahre*, Seebruck-am-Chiemsee, Heering, 1977; Bodo von Dewitz and Karin Schuller-Procopovici, *Hugo Erfurth, 1874–1948: Photograph zwischen Tradition und Moderne*, Cologne, Wienand, 1992.
31. On Otto Dix, see Johann-Karl Schmidt and Sabine Gruber, *Otto Dix*, Exhibition catalogue, Stuttgart, Galerie der Stadt, 1999.
32. A selection of them were published in 1930, consolidating his reputation: Hugo Erfurth, *Porträts: Hugo Erfurth-Porträtphotograph*, Dresden, 1930; see Bodo von Dewitz and Yvonne Langwara, *Hugo Erfurth: Menschenbild und Prominentenportrait 1902–1936*, Exhibition catalogue, Bayer-Kulturabteilung, Cologne, 1989.

ARKADY SHISHKIN (88)

33. On Soviet photography, see Sergei Morozov, ed., *Soviet Photography: An Age of Realism*, New York, Greenwich House, 1984; David Elliott, *Photography in Russia, 1840–1940*, London, Thames and Hudson, 1992; Margarita Tupitsyn, *The Soviet Photograph, 1924–1937*, New Haven, Yale University Press, 1996.
34. On Shishkin, see Anatoly Alleksevich Fomin, *Fotoreporter Arkadio Shishkin*, Moscow, Izdatelstvo "Iskusstvo," 1969; Anatoly Alleksevich Fomin, *Arkadio Shishkin: Izbrannye fotographii*, Moscow, Izdatelstvo "Planeta," 1979.
35. Inscribed in Russian on the verso of the photograph, this stanza may be translated: "How bitter you are, woman's lot (fate)."
36. In 1846, N. A. Nekrasov (1821–1877) bought and edited Pushkin's literary review *The Contemporary*, and made it the finest review

of its day. He discovered and published Leo Tolstoy, Andrei Goncharov, and Fyodor Dostoyevsky. Nekrasov made original use of the prosaic diction and rhythms of peasant oral literature, and strove through his verse to improve social conditions. Later, his words became slogans for revolutionaries. See Sigmund S. Birkenmayer, *Nikolai Nekrasov: His Life and Poetic Art*, The Hague, Mouton, 1968.

GEORGY ZELMA (89)

37. For biographical information on Zelma, see Boris Arkadévich Vilenkin, *Izbrannew fotografi: Georgii Zelma*, Moscow, Planeta, 1978.
38. See Daniela Mrázková and Vladimir Remeš, *The Russian War: 1941–1945*, New York, E. P. Dutton, 1975, pp. 69–70.

ALEKSANDR RODCHENKO (90)

39. For biographical information on Rodchenko, see Anne-Laure Oberson, in Magdalena Dabrowski, Leah Dikerman, and Peter Galassi, *Aleksandr Rodchenko*, Exhibition catalogue, New York, Museum of Modern Art, 1998, pp. 300–312.
40. On Rodchenko as a photographer, see Aleksandr Nicolaevich Lavrentiev, *Alexander Rodchenko Photography 1924–1954*, Edison, NJ, Knickerbocker Press, 1996.
41. Stepanova, who published a detailed article on Rodchenko's Workers' Club, insists on the economy, standardization, and multifunctionalism of the club equipment; see Dabrowski / Dikerman / Galassi 1998, pp. 178–85.

ANDRÉ KERTÉSZ (91)

42. For biographical information on Kertész, see Pierre Borhan, *André Kertész: His Life and Work*, Exhibition catalogue, Paris, Pavillon des Arts, 1994; Sandra S. Phillips, David Travis, and Weston J. Naef, *André Kertész of Paris and New York*, Exhibition catalogue, Art Institute of Chicago; New York, Metropolitan Museum of Art, 1985.
43. On Mondrian, see Marty Bax, *Complete Mondrian*, Aldershot, Lund Humphries, 2001.
44. For the artist's collected writings, see Piet Mondrian, *Plastic Art and Pure Plastic Art, 1937, and Other Essays, 1941–43*, New York, Wittenborn and Company, 1945.
45. André Kertész, *Kertész on Kertész*, New York, Abbeville Publishers, 1985, p. 53.

WERNER MANTZ (92)

46. For biographical information on Mantz, see Reinhold Mißelbeck and Wolfram Hagspiel, *Werner Mantz: Vision vom neuen Köln, Fotografien 1926–1932*, Exhibition catalogue, Cologne, Museum Ludwig, 2000; William Pars Graatsma, ed., *Werner Mantz. Fotograaf*, Nuth, Drukkerij Rosbeek bv, 1990.
47. Wilhelm Schürmann, "Interview with Werner Mantz," *Camera*, vol. 55, January 1977, p. 13.
48. For other images of *Kalker Feld*, see Klaus Honnef and Gregor Kierblewsky, *Werner Mantz: Fotografien 1926–1938*, Exhibition catalogue, Bonn, Rheinisches Landesmuseum, 1978, pls. 66–79.

T. LUX FEININGER (93)

49. For biographical information on Feininger, see Wolfgang Büche, *T. Lux Feininger, von Dessau nach Amerika: Der Weg eines Bauhäuslers*, Exhibition catalogue, Halle, Staatliche Galeries Mortizburg Halle, 1998.
50. See Erika Rödiger-Diruf, Ursula Merkel, and Sylvia Bieber, *Feininger: Eine Künstlerfamilie*, Exhibition catalogue, Stadtische Galerie Karlsruhe, 2001.
51. See Jeannine Fiedler, ed., *Photography at the Bauhaus*, Cambridge, Massachusetts, 1990, pp. 45–48. In the Worcester Art Museum collection is one of Feininger's snapshot portraits of his father, T. Lux Feininger, *Portrait of Lyonel Feininger*, 1927, gelatin silver print, 10.8 x 7.8 cm, Worcester Art Museum, 1989.158.
52. Included in the photograph are: G. Fulda, banjo, Heinrich Koch, rhythm stick or washtub bass, Werner Jackson, drums, Xanti Schawinski, saxophone, Andor Weininger, piano, Clemens Röseler, banjo.
53. See Oskar Schlemmer, László Moholy-Nagy, and Farkas Molnár, *The Theater of the Bauhaus*, translated by Arthur S. Wensiger, edited with an introduction by Walter Gropius, Middletown, CT, Wesleyan University Press, 1961.

MAN RAY (94)

54. Emmanuel Radnitsky was born in Philadelphia, the son of a tailor who had immigrated from Russia. He studied architecture at New York University, and art at the National Academy of Design and Art Students League, and continued to paint while working as a graphic designer. After his family changed its surname to Ray around 1912, he preferred a single name, calling himself simply Man Ray. For biographical information on the artist, see Man Ray, *Self Portrait*, Boston, Little, Brown, 1963; Man Ray, *Man Ray*, New York, Abrams, 1995.
55. See Giulio Carlo Argan, ed., *Rayograph*, Turin, Martano, 1970; Emmanuelle de L'Ecotais, *Man Ray: Rayographies*, Paris, L. Scheer, 2002, 1998.
56. On Cunard (1896–1965), see Hugh D. Ford, ed., *Nancy Cunard: Brave Poet, Indomitable Rebel, 1896–1965*, Philadelphia, Chilton Book Co., 1968; Anne Chisholm, *Nancy Cunard: A Biography*, New York, Knopf, 1979.
57. Cunard assumed a similar pose, to show off her bracelets, in a contemporaneous portrait by Cecil Beaton (no. 95), see Philippe Garner and David Alan Mellor, *Cecil Beaton*, London, J. Cape, Random House, 1994, p. 111.
58. See Nancy Cunard, ed., *Negro: An Anthology*, edited and abridged, New York, Continuum, 1996.
59. The content of *Photographs by Man Ray* (Worcester Art Museum, April 15–29, 1927) can be interpolated by the artist's foregoing exhibition at the Daniel Wolf Gallery in New York.
60. Man Ray, "Photography Is Not Art," *View*, no. 1, ser. 3, April 1943, p. 23; no. 2, ser. 3, October 1943, pp. 77–78, 97.

CECIL BEATON (95)

61. For biographical information on Beaton, see Hugo Vickers, *Cecil Beaton: The Authorized Biography*, London, 1985; Philippe Garner and David Alan Mellor, *Cecil Beaton*, London, Jonathan Cape, Random House, 1994.
62. See Fred Astaire, *Steps in Time*, New York, Harper, 1959.
63. Cecil Beaton, *The Book of Beauty*, 1930.
64. Hugo Vickers, ed., *The Unexpurgated Beaton: The Cecil Beaton Diaries As He Wrote Them*, New York, Random House, 2003.
65. Beaton's wartime photographs of the siege of Britain were published in the book *Winged Squadrons* (1942); see also Peter Quennell and Gil Buckland, *Cecil Beaton: War Photographs, 1939–45*, Exhibition catalogue, London, Imperial War Museum, 1981.
66. See C. Spencer, *Cecil Beaton: Stage and Film Designs*, London, 1976.

FLORENCE HENRI (96)

67. For biographical information on Henri, see Diana C. Dupont, *Florence Henri, Artist-Photographer of the Avant-Garde*, Exhibition catalogue, San Francisco Museum of Modern Art, 1990; Catherine Pulfer, Giovanni Battista Martini, and Alberto Ronchetti, *Florence Henri*, Exhibition catalogue, Fréjus, Willa Aurélienne, 1995.
68. See Carol Armstrong, "Florence Henri: A Photographic Series of 1928: Mirror, Mirror on the Wall," *History of Photography*, vol. 18, Autumn 1994, pp. 223–28.
69. For the photographs, montages, and a discussion, see Paolo Barbaro, *Florence Henri, 1927–1940: Fotografie nella raccolte Centro studi a archivio della communicazione (dell'Università di Parma)*, Milan, Electa, 1998, pp. 76–91.

ADOLF SCHNEEBERGER (97)

70. See Vladimír Birgus, ed., *Czech Photographic Avant-garde, 1918–1948*, Cambridge, MA, MIT Press, 2002.

71. For a review of the avant-garde in Prague, see Lenka Bydžovská, in Timothy O. Benson and Éva Forgács, *Between Worlds: A Sourcebook of Central European Avant-gardes, 1910–1930*, Exhibition catalogue, Los Angeles County Museum of Art, 2002, pp. 81–89.

72. For biographical information on Schneeberger, see Antonín Dufek, *Adolf Schneeberger*, Prague, Odeon, 1983.

73. Christian A. Peterson and Daniela Mrázková, *The Modernism Pictorialism of D. J. Růžička*, Exhibition catalogue, Minneapolis Institute of Arts, 1990.

FRANTIŠEK DRTIKOL (98)

74. For biographical information on Drtikol, see Vladimír Birgus, *František Drtikol*, Paris, Édition Photo Poche, Nathan, 2002; Stanislav Dolezal, Anna Fárová, and Petr Nedoma, *Frantisek Drtikol: The Photographer, Painter, Mystic*, Exhibition catalogue, Prague, Rudolfinum Gallery, 1998.

75. František Drtikol and Augustin Škarda, *Z dvorůa dvorečků staré Prahy*, Prague, Artěl, 1911.

76. František Drtikol, *Le nus de Drtikol*, Paris, Librare des arts décoratifs, 1929; František Drtikol, *Žena ve světle*, Prague, Eduard Beaufort, 1938. See also Vladimír Birgus, *Frantisek Drtikol — Modernist Nudes*, Exhibition catalogue, San Francisco, Robert Koch Gallery, 1997.

JAROMÍR FUNKE (100)

77. For biographical information on Funke, see Antonín Dufek, *Jaromír Funke: Pioneering Avant-garde Photography (1896–1945)*, Exhibition catalogue, Brno, Moravská galerie, 1996.

78. See Daniela Mrázková and Vladamír Remes, *Jaromír Funke: Fotograf und Theoretiker*, Leipzig, Fotofinoverlag, 1986.

79. Jaromír Funke, *Fotografie vidi povrch* (*Photography Sees the Surface*), Prague, 1935.

FRANTIŠEK VOBECKÝ (101)

80. For biographical information on Vobecký, see František Smejkal, *František Vobecký: Early Work, 1926–1938*, Exhibition catalogue, Prague, Galerie hlavniho mesta Prahy, 1985.

81. "František Vobecký: Photomontages from 1936," *Creative Camera*, no. 120, June 1974, pp. 202–5.

PAUL WOLFF (102)

82. For biographical information on Wolff, see Michèle and Michel Auer, *Photographers Encyclopedia International: 1839 to the Present*, Geneva, 1985, vol. 2, n.p.

83. Paul Wolff, *Aus zoologischen gärten*, Königstein Langewiesche, 1929; Paul Wolff and Martin Möbius, *Formen des Lebens: botanische Lichtbildstiudien*, Königstein im Taunus, K. R. Langewiesche, 1933; Wilhelm Pinder and Paul Wolff, *Drei Kaiserdome: Mainz, Worms, Speyer*, Königstein im Taunus, K. R. Langewiesche, 1933.

84. Paul Wolff, *Meine Erfahrungen mit der Leica*, Frankfurt-am-Main, Breidenstein, 1934.

85. Including a corporate report on the sheet-metal industry (L. Schuler A.-G., *Hundert Jahre Schuler, 1839–1939*, Göppingen, L. Schuler, 1939), and a book on automobile design and manufacture at Adam Opel A.G. (Heinrich Hauser, Heinrich, *Im Kraftveld von Rüsselsheim*, Munich, Knorr and Hirth, 1942).

86. Paul Wolff, Alfred Tritschler, and Rudolf Hermann, *My Experiences with Color Photography*, New York, Grayson / Cinephot International, 1952.

ALBERT RENGER-PATZSCH (103)

87. For biographical information on Renger-Patzsch, see Ann and Jürgen Wilde, and Thomas Weski, eds., *Albert Renger-Patzsch: Photographer of Objectivity*, Cambridge, MA, MIT Press, 1997.

88. Albert Renger-Patzsch, *Die Welt ist schön*, introduction by Carl Georg Heise, Munich, K. Wolff, 1928.

89. See Klaus Honnef and Gregor Kierblewsky, *Albert Renger-Patzsch, Industrielandscaft, Industriearchitektur, Industrieprodukt: Fotographien 1925–1960*, Exhibition catalogue, Rheinisches Landesmuseum Bonn, 1977; Ann and Jürgen Wilde and Dieter Thomas, *Albert Renger-Patzsch: Ruhrgebiet-Landschaften 1927–1935*, Cologne, DuMont, 1982.

90. During World War II, Renger-Patzsch's entire photographic archives were destroyed during an air raid. He moved to Wamel-am-Möhnesee in 1944 and focused his attention once again on nature, photographing landscape and still lifes in the field. See Ann and Jürgen Wilde, Christoph Schreier, and Stefan Gronert, *Albert Renger-Patzsch: Das Spätwerk, Bäume, Landscaften, Gestein*, Exhibition catalogue, Kunstmuseum Bonn, 1996.

ERICH SALOMON (104)

91. For biographical information on Salomon, see Peter Hunter-Salomon and Han de Vries, *Erich Salomon: Portrait of an Age*, New York, Macmillan, 1967; Peter Hunter, *Erich Salomon*, Millerton, NY, Aperture, 1978.

92. See Reinhard Kaiser, *Erich Salomon: Ermanox-Aufnahmen 1928 bis 1932*, Exhibition catalogue, Nördlingen, F. Greno, 1988.

93. Erich Salomon, *Berühmte Zeitgenossen in unbewachten Augenblicken*, Stuttgart, J. Engelhorns, 1931 (reprint Munich, Schirmer / Mosel, 1978).

94. Erich Salomon, "Harvard University: A Portfolio," *Fortune Magazine*, January 1932.

95. For more photographs from this series, see Hunter-Salomon / De Vries, 1967, pp. 78–89.

96. The end to Salomon's career was tragic. During World War II, the Jewish photographer went into hiding, and then fled to Holland with his family. They were betrayed to the Nazis, captured, and sent Auschwitz, where Salomon, his wife, and son perished in May 1944.

BERENICE ABBOTT (105)

97. For biographical information on Abbott, see Julia Van Haaften, *Berenice Abbott, Photographer: A Modern Vision*, Exhibition catalogue, New York Public Library, 1989.

98. The catalogue has an introduction by Jean Cocteau, who was among her sitters.

99. See Berenice Abbott, *The World of Atget*, New York, Horizon Press, 1964. Abbott's archive of Atget's work went to the Museum of Modern Art in 1968.

100. Described by John Canaday, in Hank O'Neal, *Berenice Abbott, American Photographer*, 1982.

101. Berenice Abbott and Elizabeth MacCausland, *Changing New York*, New York, Dutton, 1939 (reprint, *New York in the Thirties*, New York, Dover, 1973); see also Bonnie Yochelson, *Berenice Abbott at Work: The Making of Changing New York*, New Press, Museum of the City of New York, 1997.

102. See Berenice Abbott, "The Image of Science," *Art in America*, vol. 47, Winter 1959, pp. 76–79.

11 | A Critical Eye

WALKER EVANS (106)

1. For biographical information on Evans, see Belinda Rathbone, *Walker Evans*, 1995.

2. Lincoln Kirstein, *Walker Evans: Photographs of Nineteenth-Century Houses*, Exhibition catalogue, New York, Museum of Modern Art, 1933.

3. James Agee, *Let Us Now Praise Famous Men*, with photographs by Walker Evans, Boston, Houghton Mifflin, 1941. The book received little attention in 1941; however, its republication in 1960 to excited acclaim as one of the most important American books

of its time began the reexamination of the FSA documentary photographs deposited in the Library of Congress. A burgeoning collectors' market for photographs created a new appreciation for Evans's work.

4. Lincoln Kirstein, *American Photographs*, Exhibition catalogue, New York, Museum of Modern Art, 1938 (reprint, New York, East River Press, 1975).

P. H. POLK (107)

5. For biographical information on Polk, see Pearl Cleague Lomax, *P. H. Polk: Photographs*, Atlanta, Nexus Press, 1980; University Gallery, University of Delaware, *Through These Eyes: The Photographs of P. H. Polk*, Exhibition catalogue. Newark, DE, 1998.
6. On Carver, see Linda O. McMurry, *George Washington Carver: Scientist and Symbol*, New York, Oxford University Press, 1981.

BEN SHAHN (108)

7. On the Resettlement Adminstration and the Farm Security Administration, see Roy Emerson Stryker and Nancy Wood, *In This Proud Land: America, 1935–1943, As Seen in the FSA Photographs*, Boston, New York Graphic Society, 1973; James Curtis, *Mind's Eye, Mind's Truth: FSA Photography Reconsidered*, Philadelphia, Temple University Press, 1989.
8. Jack F. Hurley, *Portrait of a Decade: Roy Stryker and the Development of Documentary Photography in the Thirties*, Baton Rouge, Louisiana State University Press, 1972.
9. For biographical information on Shahn, see Howard Greenfield, *Ben Shahn: An Artist's Life*, New York, Random House, 1998.
10. On Shahn as a photographer, see Davis Pratt, *The Photographic Eye of Ben Shahn*, Cambridge, MA, Harvard University Press, 1975; Deborah Martin Kao, Laura Katzman, and Jenna Webster, *Ben Shahn's New York: The Photography of Modern Times*, Exhibition catalogue, Cambridge MA, Fogg Art Museum, 2000.

DOROTHEA LANGE (109)

11. For biographical information on Lange, see Milton Meltzer, *Dorothea Lange: A Photographer's Life*, New York, Straus, Farrar & Giroux, 1978; Pierre Borhan et al., *Dorothea Lange: The Heart and Mind of a Photographer*, Boston, Little, Brown, 2002.
12. Willard Van Dyke, "The Photographs of Dorothea Lange: A Critical Analysis," *Camera Craft*, vol. 41, October 1934, pp. 461–67; see also Suzanne Reiss, *Dorothea Lange: The Making of Documentary Photographer, an Interview*, Berkeley, University of California, Regional History Office, Bancroft Library, 1968.

13. See Beaumont Newhall, *Dorothea Lange Looks at the American Country Woman*, Fort Worth, TX, Amon Carter Museum, 1967.
14. Dorothea Lange and Paul Schuster Taylor, *An American Exodus: A Record of Human Erosion*, New York, Reynal & Hitchcock, 1939 (reprint, New York, Arno Press, 1975); see also John Steinbeck, *The Grapes of Wrath*, New York, P. F. Collier, 1939. Lange also created photoessays on Mormon culture, the internment of Japanese-Americans during World War II, and war-related industry at the Richmond, California, shipyards for the Office of War Information. She married Paul Schuster Taylor, and they collaborated on studies of agricultural communities in Egypt, South America, and Vietnam. Full recognition of Lange's photographs came only in 1966, after her death, when the Museum of Modern Art organized the first major retrospective exhibition of her work (George P. Elliott, *Dorothea Lange*, Exhibition catalogue, New York, Museum of Modern Art, 1966), an exhibition shown at the Worcester Art Museum.

MARION POST WOLCOTT (110)

15. For biographical information on Wolcott, see Jack F. Hurley, *Marion Post Wolcott: A Photographic Journey*, Albuquerque, University of New Mexico Press, 1989; Paul Hendrickson, *Looking for the Light: The Hidden Life and Art of Marion Post Wolcott*, New York, Knopf, 1992.
16. The enlarged exhibition print in the collection of the Worcester Art Museum was mounted for exhibition in the FSA shows that traveled constantly to town halls and libraries across the country from 1936 to 1943. Mounted on a large card, its title and caption are photographically printed on strips of paper, and pasted onto the mount. See Sally Stein, *Marion Post Wolcott, FSA Photographs*, Carmel, CA, Friends of Photography, 1983.
17. In 1941, after a whirlwind courtship, Post married Leon Oliver Wolcott, an official in the Roosevelt Administration Agriculture Department. She resigned from the FSA early in 1942, to raise two stepchildren and two of her own children in the country outside Washington, DC.

JAMES VANDERZEE (111)

18. For biographical information on VanDerZee, see Rodger C. Brit in Deborah Willis-Braithwaite, *VanDerZee: Photographer, 1886–1983*, Exhibition catalogue, Washington, DC, National Portrait Gallery, 1993. The photographer's papers are in the Schomburg Center for Research in Black Culture and History at the New York Public Library.
19. In 1978 VanDer Zee published, in conjunction with poet Owen Dodson and artist Camille Billops, *The Harlem Book of the Dead* (Dobbs Ferry, New York, Morgan & Morgan, 1978), a book of poems and photographs of African-American funeral rites, ceremonies, and mourning customs in Harlem, and he became the first recipient of the New York Archdiocese Pierre Toussaint Award.
20. Reginald McGhee, *The World of James VanDerZee: A Visual Record of Black Americans*, Exhibition catalogue, New York, Metropolitan Museum of Art, 1969. At the time of the exhibition, the Metropolitan Museum of Art also acquired the artist's archives for its permanent collection.

SONYA NOSKOWIAK (112)

21. See Therese Thau Heyman, ed., *Seeing Straight: The f.64 Revolution in Photography*, exhibition catalogue, Oakland, CA, Oakland Museum, 1992.
22. For biographical information on Noskowiak, see: William Johnson, "Sonya Noskowiak," *Center for Creative Photography*, Tucson, University of Arizona, 1979; see also Donna Bender, Jan Stevenson, and Terrence R. Pitts, *Sonya Noskowiak Archive*, *Center for Creative Photography*, Tucson, University of Arizona, 1982.
23. See Nancy Newhall, ed., *The Daybooks of Edward Weston*, 2nd ed., New York, Aperture, 1990, p. 180.
24. A portrait of Steinbeck by Noskowiak is in the Worcester Art Museum collection; acc. no. 1993.13.

WEEGEE (113)

25. For biographical information on Fellig, see *Weegee by Weegee: An Autobiography*, New York, Ziff-Davis, 1961 (reprint, New York, Da Capo Press, 1975); Miles Barth, et al., *Weegee's World*, Boston, Little, Brown, 1997.
26. Weegee, *Naked City*, New York, Essential Books, 1945 (reprint, New York, Da Capo Press, 1975).

BRASSAÏ (114)

27. For biographical information Brassaï, see Alain Sayag and Annick Lionel-Marie, eds., *Brassaï: the Monograph*, Boston, Little, Brown and Company, 2000; Anne Tucker et al., *Brassaï: The Eye of Paris*, Exhibition catalogue, Houston, Museum of Fine Arts, 1999.
28. Brassaï, *Paris de nuit*, Paris, Editions "Arts et métiers graphiques," 1933 (translated as *Paris by Night*, Paul Morand, New York, Pantheon, 1987).
29. Brassaï, *The Secret Paris of the 30's*, translated by Richard Miller, New York, Pantheon Books, 1976.

30. See Brassaï, *Camera in Paris*, London, Focal Press, 1949.

ROBERT DOISNEAU (115)

31. Robert Doisneau, *Paris, 148 Photographs*, translated by Princess Anne Marie Callimachi, with preface by Blaise Cendrars, New York, Simon & Schuster, 1956, p. 4.
32. For biographical information on Doisneau, see J. F. Chevrier, *Robert Doisneau*, Paris, 1982; Peter Hamilton, *Robert Doisneau, Retrospective*, Exhibition catalogue, Oxford, Museum of Modern Art, 1992.
33. Doisneau gave an account of his work as well as of his meetings with such artists as Braque, Brancusi, Leger, and Picasso in *A l'imparfait de l'objectif: souvenirs et portraits*, Paris, P. Belfond, 1989. His books from the 1950s include *Sortilège de Paris* (1952), *Les Parisiens tel qu'ils sont* (1954), *Gosses de Paris* (1956), *Bistrots* (1960), and *Le Banlieue de Paris* (1960).

ROMAN VISHNIAC (116)

34. For biographical information on Vishniac, see Cornell Capa and Bhupendra Karia, eds., *Roman Vishniac*, New York, Grossman Publishers, 1974; Mara Vishniac Kohn and Miriam Hartman Flacks, *Children of a Vanished World: Roman Vishniac*, Berkeley, University of California Press, 1999.
35. Roman Vishniac and Abraham Joshua Heschel, *Polish Jews: A Pictorial Record*, New York, Schocken Books, 1947; see also Roman Vishniac, *A Vanished World*, New York, Farrar, Straus, and Giroux, 1983.
36. See Roman Vishniac, *Building Blocks of Life: Proteins, Vitamins, and Hormones, Seen through the Microscope*, New York, Scribner, 1971.

12 | Stylized Perspectives

LAURE ALBIN GUILLOT (117)

1. For biographical information on Albin Guillot, see Christian Bouqueret, *Laure Albin Guillot, ou La volonté d'art*, Exhibition catalogue, Evreux, Musée de l'ancien evêché, 1996.
2. Laure Albin Guillot, *Micrographie décorative*, Paris, the artist, 1937.
3. See, for example, Paul Valéry and Laure Albin Guillot, *La Cantate de Narcisse*, Paris, the artist, 1936; Pierre Louÿs and Laure Albin Guillot, *Chansons de Bilitis*, Paris, the artist, 1937; Henry de Montherland and Laure Albin Guillot, *La déesse Cypris*, Bordeaux, Rousseau Brothers, 1946.

ILSE BING (118)

4. For biographical information on Bing, see Nancy C. Barrett, *Ilse Bing: Three Decades of Photography*, Exhibition catalogue, New Orleans Museum of Art, 1985; Hilary Schmalbach, *Ilse Bing: Fotografien 1929–1956*, Exhibition catalogue, Aachen, Suermondt-Ludwig-Museum, 1996.
5. Wolff continued his distinguished career in the United States, as a performer, teacher, and scholar; his primary written work is *Masters of the Keyboard: Individual Style Elements in the Piano Music of Bach, Haydn, Mozart, Beethoven, and Schubert*, Bloomington, Indiana University Press, 1983.

WYNN RICHARDS (119)

6. For biographical information on Richards, see Bonnie Yochelson, *Wynn Richards*, Exhibition catalogue, New York, Photofind Gallery, 1989.
7. Taylor compiled the biographies of a group of professional photographers who were Richards's friends and colleagues, and published them along with short interviews in *My Best Photograph and Why*, New York, Dodge, 1937.

HERBERT BAYER (120)

8. For biographical information, see Herbert Bayer, *Herbert Bayer: Painter, Designer, Architect*, New York, Reinhold, 1967; Arthur A. Cohen, *Herbert Bayer: The Complete Work*, Cambridge, MA, M.I.T. Press, 1984.
9. On Moholy-Nagy as a photographer, see Andreas Haus, *Moholy-Nagy: Photographs and Photograms*, New York, Pantheon Books, 1980; *László Moholy-Nagy: Photographs from the J. Paul Getty Museum*, Malibu, CA, J. Paul Getty Museum, 1995.
10. On Bayer as a photographer, see Beaumont Newhall, *Herbert Bayer: Photographic Works, An Exhibition*, Exhibition catalogue, Los Angeles, Arco Center for Visual Art, 1977.
11. Herbert Bayer, *László Moholy-Nagy*, 1927, gelatin silver print, 7.4 x 4.7 cm, Worcester Art Museum, Stoddard Acquisition Fund, 1987.99.
12. Fleeing the Nazis, Bayer followed Gropius to the United States in 1938. He settled in New York and became a successful freelance graphic designer. Alfred Barr engaged him to design the benchmark Bauhaus exhibition at the Museum of Modern Art in 1938 and its catalogue (Walter Gropius, Ise Gropius, and Herbert Bayer, *Bauhaus, 1919–1928*, New York, Exhibition catalogue, Museum of Modern Art, 1938 [reprint, New York, Abrams, 1975]). After becoming an American citizen in 1944, Bayer moved to Aspen, Colorado, in 1946 to become the principal designer at the Aspen Institute for Humanistic Studies, which planned the mountain resort community. There, he melded landscape architecture and sculpture — anticipating the earthworks of the 1960s — in massive environmental sculptures that combine the natural world and pure geometry.

RAOUL UBAC (121)

13. For biographical information on Ubac, see André Frénaud, *Ubac: 1948–1981*, Exhibition catalogue, Alès de Cévennes, Musée Bibliothèque Pierre André Benoit, 1995; Musée de Pontoise, *Raoul Ubac: rétrospective*, Exhibition catalogue, Pontoise, 2000.
14. On Ubac as a photographer, see Galerie A. Maeght, *Raoul Ubac: photographies des années trente*, Exhibition catalogue, Paris, 1983; Christian Bouqueret, *Raoul Ubac: Photographie*, Paries, Editions Leó Scheer, 2000.

BARBARA MORGAN (122)

15. For biographical information on Morgan, see Deba Prasad Patnaik, *Barbara Morgan*, New York, Aperture Foundation, 1999; see also Peter Bunnell, *Barbara Morgan*, Hastings-on-Hudson, NY, Morgan & Morgan, 1972.
16. See Martha Graham, *Blood Memory: An Autobiography*, New York, Doubleday, 1991.
17. Andrea Lublinski, "Photographer Recalls Martha Graham Years," *New York Times*, April 1, 1984, sec. 22, p. 26.
18. See B. Confino, "Barbara Morgan: Photographing Energy and Motion," *Saturday Review of Literature*, October 7, 1972, pp. 62–66.
19. Barbara Morgan, *Martha Graham: Sixteen Dances in Photographs*, New York, Duell, Sloan, and Pearce, 1941 (reprint, Dobbs Ferry, New York, Morgan & Morgan, 1980).
20. See George Eastman House, *Barbara Morgan — Photomontage*, Exhibition catalogue, Rochester, NY, 1980.

BILL BRANDT (123)

21. For biographical information on Brandt, see Paul Delany, *Bill Brandt: A Life*, Stanford, CA, Stanford University Press, 2004; Mark Haworth-Booth and David Mellor, *Bill Brandt: Behind the Camera, Photographs, 1928–1983*, Exhibition catalogue, Philadelphia Museum of Art, 1985.
22. Bill Brandt, *The English at Home: Sixty-Three Photographs*, introduced by Raymond Mortimer, London, B. T. Batsford, Ltd., 1936.
23. Bill Brandt, *Night in London*, New York, Charles Scribner's Sons, 1938.
24. John Haward, *Literary Britain: Photographs by Bill Brandt*, London, Cassell, 1951; see also, John Hayward and Mark Haworth-

Booth, *Literary Britain: Photographed by Bill Brandt*, Exhibition catalogue, London, Victoria and Albert Museum, 1984.

25. Delany 2004, p. 214.
26. Lawrence Durrell and Mortimer Chapman, *Bill Brandt: Perspective of Nudes*, New York, Amphoto, 1961.
27. *Three European Photographers: Bill Brandt, Lucien Clergue, Paolo Monti*, Worcester Art Museum, June 15 – September 7, 1965.

LISETTE MODEL (124)

28. For biographical information on Model, see Ann Thomas, *Lisette Model*, Exhibition catalogue, Ottawa, National Gallery of Canada, 1990.
29. Joe Cuomo, "The Fearless Eye," *Darkroom Photography*, vol. 6, January / February 1984, p. 45.
30. The photographer had faded into obscurity when Aperture published a monograph on her photographs with an introduction by Berenice Abbott (*Lisette Model*, Millerton, NY, Aperture, 1979). With the publication a new generation came under her influence.

HELEN LEVITT (125)

31. For biographical information on Levitt, see Sandra S. Phillips and Maria Morris Hambourg, *Helen Levitt*, Exhibition catalogue, San Francisco Museum of Modern Art, 1991; Peter Weiermair, *Helen Levitt*, Exhibition catalogue, Frankfurter Kunstverein, 1998.
32. See James Oles, *Helen Levitt: Mexico City*, New York, Center for Documentary Studies, 1997.
33. Helen Levitt and James Agee, *A Way of Seeing*, New York, Horizon Press, 1965.
34. See Roberta Hellman and Marvin Hoshino, *Helen Levitt: Color Photographs*, Exhibition catalogue, El Cajon, CA, Grossmont College Gallery, 1980.

JULIUS SHULMAN (126)

35. For biographical information on Shulman, see Joseph Rosa and Esther McCoy, *A Constructed View: The Architectural Photography of Julius Shulman*, Rizzoli; Julius Shulman and Peter Gössel, *Architecture and Its Photography*, Cologne, Benedikt Taschen Verlag, 1998.
36. For more on the architect's work, see Paul László, *Interiors, Exteriors*, Beverly Hills, California, P. László and Company, 1947; Paul László, "The House of the Future, and LA Architect Envisions the Home of the Atomic Age," *Fortnight*, December 24, 1951, pp. 16–17.

13 | The World at War

MARGARET BOURKE-WHITE (127)

1. For biographical information on Bourke-White, see Margaret Bourke-White, *Portrait of Myself*, New York, Simon and Schuster, 1963; Vicki Goldberg, *Margaret Bourke-White: A Biography*, Addison-Wesley Publishing Company, 1986.
2. Her photographs appeared in *Fortune* and the *New York Times Magazine*, and in 1931 were published in her book *Eyes on Russia* (New York, Simon and Schuster).
3. Erskine Caldwell and Margaret Bourke-White, *You Have Seen Their Faces*, New York, Modern Age Books, 1937 (reprint, New York, Arno Press, 1975). In their three years together, Bourke-White and Caldwell collaborated on two other books: *North of the Danube*, New York, Viking Press, 1939; *Say, Is This the U.S.A.?*, New York, Duell, Sloan, and Pearce, 1941.
4. Margaret Bourke-White, *Shooting the Russian War*, New York, Simon and Schuster, 1942, p. 117.
5. Bourke-White 1942, p. 191. Bourke-White was one of ten photographers whose work was included in the exhibition *Ideas in Images*, organized by the Worcester Art Museum in 1962; see Peter Pollack, *Ideas in Images*, Exhibition catalogue, Worcester Art Museum, 1962, cat. nos. 11–20.

ROBERT CAPA (128)

6. For biographical information on Capa, see Richard Whelan, *Robert Capa: The Definitive Collection*, London, Phaidon, 2001.
7. Capa memorialized their war experiences together in his book *Death in the Making*, New York, Convici-Friede, 1938.
8. The typewritten label bears the date of the negative's exposure: 8 / 13 / 43.
9. Capa's *The Battle for Naples: The Infantry Takes Position*, 1943, gelatin silver print, 16.0 x 24.0 cm, Worcester Art Museum, Gift of Mack and Paula Lee, 2003.82, depicts American action on the Italian mainland.

OBIE NEWCOMB, JR. (129)

10. Quoted by Dick Hannah, *Tarawa: Toughest Battle in Marine Corps History*, New York, U.S. Camera / Duell, Sloan & Pearce, 1944, pp. 110–11.
11. Hannah, 1944, p. 10.
12. On its verso, the photograph bears a rubber stamp, in blue ink: Unit…RELEASED OFFICIAL NAVAL PHOTOGRAPH / Unpublished, / Credit Line must Read / "OFFICIAL U.S. NAVY PHOTOGRAPH" and written in graphite: U.S. Marine Corps. typewritten on gummed label: "USMC 63458. At the order to charge, Marines swarm over a heavily-reinforced pillbox on Tarawa, braving fire on all sides. The only way to silence the stubborn pillbox defenders was for the Marines to fight to the top and shoot down inside at the Japs."
13. Newcomb's photograph is from a group that came to the Museum with the exhibition *Power in the Pacific*, which opened in Worcester in winter 1945, soon after VJ Day. Organized by Captain Edward Steichen, U.S.N.R. (no.85) for the Museum of Modern Art, the show included 156 photographic enlargements mounted on panels arranged according to a thematic preconceived layout. See Edward Steichen, *Power in the Pacific: Official U.S. Navy, Marine Corps, and Coast Guard Photographs . . . A Pictorial Record of Navy Combat Operations on Land, Sea, and in the Sky*, Exhibition catalogue, New York, Museum of Modern Art, 1945; Christopher Phillips, *Steichen at War*, New York, Harry N. Abrams, 1981.
14. Quoted by Hannah 1944, p. 115.
15. At the beginning of 1946, Newcomb was stationed in Honolulu, Hawaii, where he married WAVE administrator Vivian Danforth (b. 1913) on January 31, over the telephone from Mason, Texas. Mrs. Danforth boarded the S.S. *Arthur Middleton* and sailed to Honolulu, where the vows were renewed in St. Andrews Cathedral.

W. EUGENE SMITH (130)

16. For biographical information on Smith, see Jim Hughes, *W. Eugene Smith, Shadow and Substance: The Life and Work of an American Photographer*, New York, McGraw-Hill, 1989.
17. Quoted in *Aperture*, vol. 4, Winter 1969, n.p.
18. W. Eugene Smith and Aileen Mioko Smith, *Minamata: Life — Sacred and Profane*, Tokyo, Soju-Sha, 1973 (American edition, New York, Holt, Rinehart, and Winston, 1975).

IVAN SHAGIN (131)

19. For biographical information on Shagin, see Valery T. Stignejew and Margot Blank, *Heimat, Front: Iwan Shagin, Kriegsfotografie, 1941–1945*, Exhibition catalogue, Berlin, Deutsch-Russischen Museum Berlin-Karlshorst, Elephanten Press, 1999, pp. 11–31.
20. See Ivan Shagin, *Ivan Shagin*, Moscow, Izdatelstvo Planeta, 1975, pls. 50–52.
21. See the discussion of Rosenthal's photograph in Vicki Goldberg, *The Power of Photography: How Photography Changed Our Lives*, New York, 1991, Abbeville Press, pp. 242–47.

CLARENCE JOHN LAUGHLIN (132)

1. For biographical information on Laughlin, see Keith Davis, ed., *Clarence John Laughlin: Visionary Photographer*, Kansas City, MO, Hallmark Cards, Inc., 1990.
2. Clarence John Laughlin, *Ghosts Along the Mississippi: An Essay in the Poetic Interpretation of Louisiana's Plantation Architecture*, New York, C. Scribner's Sons, 1948.
3. In the artist's captions: *Clarence John Laughlin: The Personal Eye*, Exhibition catalogue, Philadelphia Museum of Art and Millerton, NY, Aperture, 1973, p. 123. Laughlin's systematic organization of his oeuvre into "photographic groups" is reprinted in John H. Lawrence and Patricia Brady Smith, *Haunter of Ruins: The Photography of Clarence John Laughlin*, Boston, Little Brown, 1997, pp. 97–103.
4. Quoted by Jonathan Williams, *Clarence John Laughlin: The Personal Eye*, Millerton, NY, Aperture, 1973, p. 14.

HARRY CALLAHAN (133)

5. For biographical information on Callahan, see Harry Callahan, "A Life in Photography," in Keith F. Davis, *Harry Callahan*, Exhibition catalogue, Kansas City, MO, Hallmark Cards Inc., 1981, pp. 50–64; Sarah Greenough, *Harry Callahan*, Exhibition catalogue, Washington, DC: National Gallery of Art, 1996.
6. See Katherine Ware, *Elemental Landscapes: Photographs by Harry Callahan*, Exhibition catalogue, Philadelphia Museum of Art, 2001.
7. "Harry Callahan, 1912–1999: A Conversation with John Paul Caponigro," *Camera Arts*, July–August 1999, p. 12.
8. Peter Pollack, *Ideas in Images*, Exhibition catalogue, Worcester Art Museum, 1962, cat. nos. 21–30. A solo exhibition of Callahan's color photographs, organized by the Hallmark Photographic Collection, was exhibited at the Worcester Art Museum from November 5 to January 8, 1989; see Keith F. Davis, *Harry Callahan, New Color: Photographs 1978–1987*, Exhibition catalogue, Kansas City, MO, Hallmark Cards, Inc, 1988.

RICHARD POUSETTE-DART (134)

9. For biographical information on Pousette-Dart, see Ingrid Ehrhardt and Katia Hilbig, *The Living Edge: Richard Pousette Dart, 1916–1992, Works on Paper*, Exhibition catalogue, Frankfurt, Schirn Kunsthalle, 2001, pp. 191–95; Robert Hobbs and Joanne Kuebler, *Richard Pousette-Dart*, Exhibition catalogue, Indianapolis Museum of Art, 1990.

10. This photograph is in the collection of the Worcester Art Museum along with a portrait of Barnett Newman. Richard Pousette-Dart, *Mark Rothko*, about 1948, gelatin silver print, 20.0 x 25.2 cm, Heald Foundation Fund, 1996.55; *Barnett Newman*, about 1948, gelatin silver print, 20.0 x 25.0 cm, Heald Foundation Fund, 1996.56.
11. Reprinted in "Richard Pousette-Dart: Photographs and Journal Entries," *Aperture*, no. 145, Fall 1996, p. 58.
12. Reprinted in *Aperture* 1996, p. 58. In 1951, Pousette-Dart appeared among "The Irascibles," in a famous *LIFE* magazine photograph that for many defined the Abstract Expressionist movement. However, by that time the nonconformist artist had moved with his family to Rockland County, New York, seeking respite from commercial pressures of the art world. In 1953, Pousette-Dart won third prize in an international photography competition sponsored by *Photography* magazine.

ED VAN DER ELSKEN (135)

13. For biographical information on Van der Elsken, see Hripsime Visser, *Van der Elsken*, London, Phaidon Press, Limited, 2002.
14. Edward Steichen, *Post War European Photography*, Exhibition catalogue, New York, Museum of Modern Art.
15. Ed van der Elsken, *Love on the Left Bank*, London, A. Deutsch, 1956.
16. Ed van der Elsken, *Jazz, met taksten van Jan Vrijman*, Amsterdam, De Bezige Bij, 1959.
17. In the late 1950s, Van der Elsken created the book *Sweet Life* (Amsterdam, De Bezige Bij, 1966), which grew from an extended trip around the world. In 1966 photographs from Van der Elsken's world trips were shown at the Stedelijk Museum, Amsterdam, in the exhibition *Hey . . . Did You See That?* During the 1960s, he produced travel documentaries for Dutch television, and film gradually became his second medium, including *Bye*, a film documenting his struggle with terminal cancer.

IRVING PENN (136)

18. For biographical information on Penn, see John Szarkowski, *Irving Penn*, Exhibition catalogue, New York, Museum of Modern Art, 1984; see also Jan-Erik Lundstrom and Ulf Hård Af Segerstad, *Irving Penn Photographs: A Donation in Memory of Lisa Fonssagrives-Penn*, Exhibition catalogue, Stockholm, Moderna Museet, 1996.
19. For biographical information on Capote, see George Plimpton, *Truman Capote: In Which Various Friends, Enemies, Acquaintances and Detractors Recall His Turbulent Career*, New York, Anan A. Tlese / Doubleday, 1997.

20. See Rosamond Bernier, "Some Early Portraits by Irving Penn," in Colin Westerbeck, ed., *Irving Penn: A Career in Photography*, Exhibition catalogue, Art Institute of Chicago, 1997, p. 135.
21. Irving Penn, *Worlds in a Small Room*, New York, Grossman, 1974; see also Irving Penn, *People in Passage*, Milan, Photology, 1992.
22. John Szarkowski, *Still Life: Irving Penn Photographs 1938–2000*, Boston, Little, Brown, 2001. Penn continued to explore the impact of scale in his *Earthly Bodies* series, using his own, older negatives of female torsos redeveloped and printed in monumental scale; see Maria Morris Hambourg, *Earthly Bodies: Irving Penn's Nudes, 1949–50*, Exhibition catalogue, New York, Metropolitan Museum of Art, 2002.

RICHARD AVEDON (137)

23. For biographical information see Richard Avedon, *An Autobiography*, New York, 1993.
24. Harry Brodkey, *Avedon: Photographs 1947–1977, 30 Years of His Fashion Photographs*, Farrar, Straus & Giroux, 1978.
25. Nicole Wisniak, "An Interview with Richard Avedon," *Egoïste*, no. 9, September 1984 (reprinted in *Black & White*, Yale University, Spring 1986, pp. 8, 26–31).
26. See Richard Avedon and Doon Arbus, *Avedon: The Sixties*, New York, Random House, Inc., 1999.
27. Richard Avedon and James Baldwin, *Nothing Personal*, New York, 1964; see also Maris Morris Hambourg and Mia Fineman, *Richard Avedon Portraits*, Harry N. Abrams, Inc., 2002.
28. "Jacob Israel Avedon," *Camera*, November 1974, p. 13.
29. Richard Avedon, *In the American West, 1979–1984*, New York, Harry N. Abrams, Inc., 1985.

RUDY BURCKHARDT (138)

30. For biographical information on Burckhardt, see Robert Storr and Vincent Katz, *Rudy Burckhardt*, Exhibition catalogue, Valencia, Spain, IVAM Valencià d'Art Moderna, 1998; John Ashbery and Robert Storr, *Rudy Burckhardt: New York Photographs*, Exhibition catalogue, New York, Tibor de Nagy Gallery, 2003.
31. Among Burckhardt and Denby's friends who appeared in *145 West 21st* and assisted with its production were Paul Bowles, Aaron Copland, John Latouche, and Virgil Thomson. During the 1950s Burckhardt progressed from travelogues, documentaries, and silent comedies to films structured by the sound of music or poetry. Burckhardt created over 100 films, most under thirty-minutes long, and shot in 16mm. He collaborated with Joseph Cornell on four short

films in the mid-1950s, most notably, *What Mozart Saw on Mulberry Street*. In 1987, the Museum of Modern Art presented a retrospective of Buckhardt's films.

32. Edwin Denby, *In Public, In Private, Poems*, foreword by Willem de Kooning, photographs by Rudy Burckhardt, Prairie City, IL, Decker, 1948.

33. Robert Goodnough, "Pollock Paints a Picture," *Art News*, vol. 3, May 1951, pp. 38–41, 60–61.

34. Pollock's Springs neighbor, the photographer Hans Namuth, also took pictures of the painter in the studio around the same time; see Kirk Varnedoe and Pepe Karmel, *Jackson Pollock*, Exhibition catalogue, New York, Museum of Modern Art, 1998; Steven Naifeh and Gregory White Smith, *Jackson Pollock: An American Saga*, New York, C. N. Potter, 1989.

WYNN BULLOCK (139)

35. For biographical information on Bullock, see Barbara Bullock-Wilson, *Wynn Bullock: Photography, A Way of Life*, Dobbs Ferry, NY, Morgan & Morgan, 1973.

36. Bullock developed a method of solarization that captured the outlines of objects instead of a tonal image, a procedure he patented.

37. Alfred Korzybski, *Science and Sanity: An Introduction to Non-Aristotelean Systems and General Semantics*, Lancaster, PA, The International Non-Aristotelean Publishing Co., 1933.

38. Quoted in Barbara Bullock [-Wilson], *Wynn Bullock*, San Francisco, Scrimshaw Press, 1971, n.p.

39. *Photographs by Wynn Bullock (1902–1975)*, Worcester Art Museum, April 10 – July 8, 1979. In 1976, a year after Bullock's death, a retrospective exhibition of Bullock's photographs was mounted at the Metropolitan Museum of Art.

RALSTON CRAWFORD (140)

40. For biographical information on Crawford, see Barbara Haskell, *Ralston Crawford*, Exhibition catalogue, New York, Whitney Museum of American Art, 1985.

41. On Crawford as a photographer, see James Johnson Sweeney, *Ralston Crawford*, Exhibition catalogue, Baton Rouge, Louisiana State University Art Gallery, 1950; Norman A. Geske, *The Photography of Ralston Crawford*, Exhibition catalogue, Lincoln, Sheldon Memorial Art Gallery, University of Nebraska, 1974; Edith A Tonelli and John Gossage, *Ralston Crawford: Photographs / Art and Process*, College Park, MD, University of Maryland Art Gallery, 1983; Keith Davis, *Ralston Crawford: Abstracting the Vernacular*, Exhibition catalogue, New York, Laurence Miller Gallery, 1995.

42. For example, a photogram by Crawford was used as the cover for Ruth Darby's mystery novel *Death Conducts a Tour*, Crime Club, New York, 1940.

43. On Crawford as a printmaker, see Richard B. Freeman, *Ralston Crawford Lithographs*, Lexington, University of Kentucky Press, 1962.

44. See Tonelli / Gossage 1983, fig. 1.

45. Quoted by Edith Tonelli (Tonelli / Gossage 1983, n.p.).

46. See David Acton, *A Spectrum of Innovation: Color in American Printmaking, 1890–1960*, Exhibition catalogue, Worcester Art Museum, 1990, pp. 188–89.

47. Several of Crawford's photographs of jazz musicians were published during the 1950s (see "New Orleans Today," *Jazz Journal*, vol. 7, December 1954; "New Orleans in Pictures," *Jazz Journal*, vol. 9, December 1956). In 1961 his images were also featured on the album covers for the "New Orleans, Living Legends" series of record albums, published by Riverside Records. In 1961 Crawford served as Photographic Research Consultant, Tulane University.

ANDREAS FEININGER (141)

48. For biographical information on Feininger, see Andreas Feininger, *Andreas Feininger: Photographer*, New York, Harry N. Abrams Publishers, 1986; Joel Smith, *Andreas Feininger*, Exhibition catalogue, Poughkeepsie, New York, Frances Lehman Loeb Art Center, Vassar College, 2003.

49. Andreas Feininger, *New York*, with introduction by John Erskine, picture text by Jacquelyn Judge, Ziff-Davis Publishing Company, New York, 1945.

50. See Feininger's brief explanation of telephoto technology in Susan E. Lyman, *The Face of New York: The City As It Was and As It Is*, with photographs by Andreas Feininger, New York, Crown Publishers, Inc., 1954, p. x–xi.

51. See Peter Pollack, *Ideas in Images*, Exhibition catalogue, Worcester Art Museum, 1962, cat. nos. 41–50; *New York Photographs by Andreas Feininger*, Worcester Art Museum, September 21, 1972 – January 11, 1973.

52. See Smith 2003, pp. 17–18; Andreas Feininger, *Roots of Art: the Sketchbook of a Photographer*, New York, Viking Press, 1975; *The Mountains of the Mind: A Fantastic Journey into Reality*, New York, Viking Press, 1977.

OTTO STEINERT (142)

53. For biographical information on Steinert, see Ute Eskildsen, *Der Fotograf Otto Steinert*, Göttingen: Steidl, 1999; Fritz Kempe, *Otto Steinert: Der Initiator einer fotografischen Bewegung*, Exhibition catalogue, Essen, Museum Folkwang, 1976.

54. The Fotoform group included Peter Keetman, Toni Schneiders, Ludwig Windstosser, Wolfgang Reisewitz, Siegfried Lauterwaser, and Heinz Hajek-Halke. It continued until 1955.

55. Otto Steinert, *Subjektive Fototgrafie: ein Bildband moderner europäischer Fotografie*, Exhibition catalogue, Saarbrücken, Staatliche Schule für Kunst und Handwerk / Deutsche Gesellschaft fur Photographie, 1952; Otto Steinert, ed., and J. Adolf Schmoll Eisenwerth, *Subjektive Fototgrafie, 2: ein Bildband moderner europäischer Fotografie*, Munich, Brüder Auer, 1955.

56. Steinert enumerated the characteristics of the style of *Subjektive Fototgrafie* in 1955, which are reprinted in translation by Kempe 1976, pp. 19–21.

AARON SISKIND (143)

57. For biographical information on Siskind, see Deborah Martin Kao and Charles A. Meyer, *Aaron Siskind: Toward a Personal Vision, 1935–1955*, Exhibition catalogue, Chestnut Hill, MA, Boston College Museum of Art, 1994.

58. See Ann Banks, ed., *Aaron Siskind, Harlem Document, Photographs, 1932–1940*, Providence, RI, Matrix, 1981.

59. See Elaine de Kooning, *The Photographs of Aaron Siskind*, Exhibition catalogue, New York, Charles Egan Gallery, 1951; Georgine Oeri, "Aaron Siskind's Abstract Photographs," *Graphis*, vol. 7, July 1951, pp. 354–57.

60. Indeed, some are reminiscent of the energetic paintings by Franz Kline, Siskind's close colleague in the mid-1950s. See Harold Rosenberg, *Aaron Siskind's Photographs*, New York, Horizon Press, 1959.

61. Siskind was professor of photography at the ID until 1959, when he became head of the photographic department. He joined Callahan once again to teach at the Rhode Island School of Design from 1971 to 1976.

GYORGY KEPES (144)

62. For biographical information on Kepes, see Judith Wechsler, *Gyorgy Kepes: The MIT Years, 1945–1977*, Exhibition catalogue, Cambridge, MA, Massachusetts Institute of Technology, 1978; Eva Choung Fux, *Gyorgy Kepes*, Exhibition catalogue, Vienna, Gesellscaft Bildender Künstler Wiens, 1976.

63. For more on Kepes's attitude toward artistic process, see *Language of Vision*, Chicago, Paul Theobald, 1944, pp. 186–87.

64. A solo exhibition of Kepes's paintings was presented at MIT in 1959: *Gyorgy Kepes: Recent Paintings*, Exhibition catalogue, Cambridge, MA, Charles Hayden Memorial Library, Massachusetts Institute of Technology. The Worcester Art Museum owns one of Kepes's paintings, *Spring Promise*, 1966,

oil and sand on canvas, 72 1/8 x 40 in., Anonymous gift, 1967.71.

65. Kepes was one of ten photographers whose work was included in the exhibition *Ideas in Images*, organized by the Worcester Art Museum in 1962; see Peter Pollack, *Ideas in Images*, Exhibition catalogue, Worcester Art Museum, 1962, cat. nos. 61–70.

66. This project later coalesced into the book *The New Landscape in Art and Science* (Chicago, P. Theobald, 1956). Notable among Kepes's exhibitions of this period were *Art in Science: An Exhibition of Paintings, Drawings, and Prints, from the Pages of* Scientific American, Exhibition catalogue, New York, American Federation of Arts, 1957, sponsored by *Scientific American*, circulated by AFA; *Light as a Creative Medium*, Exhibition catalogue, Cambridge, MA, Carpenter Center for the Visual Arts, Harvard University, 1965.

67. In 1973, the year before Kepes's retirement from MIT, a solo exhibition of his work at the Museum of Science in Boston included paintings, designs, photographs, and projects. See also Eva Choung Fux, *Gyorgy Kepes*, Exhibition catalogue, Vienna, Gesellscaft Bildender Künstler Wiens, 1976; Jan Van der Marck, *Gyorgy Kepes*, Exhibition catalogue, Cambridge, MA, Hayden Gallery, Massachusetts Institute of Technology, 1978.

ARNOLD NEWMAN (145)

68. For biographical information on Newman, see Robert Sobieszek, *One Mind's Eye: The Portraits and Other Photographs of Arnold Newman*, Boston, D. R. Godine, 1974.

69. On the composer's life, See Marcel Marnet, *Stravinsky*, Paris, Seull, 1995.

70. Robert Craft, *Bravo Stravinsky: Photos by Arnold Newman*, Cleveland, World Publishing Company, 1967. Arnold Newman was one of ten photographers whose work was featured in the exhibition *Ideas in Images*, organized by the Worcester Art Museum in 1962; see Peter Pollack, *Ideas in Images*, Exhibition catalogue, Worcester Art Museum, 1962, cat. nos. 71–80. In 1994, the Museum hosted the exhibition *Arnold Newman's Americans* (April 23 – July 10), organized by the National Portrait Gallery, see Arnold Newman and Alan Fern, *Arnold Newman's Americans*, Exhibition catalogue, Washington, DC, National Gallery, Smithsonian Institution, 1992.

PHILIPPE HALSMAN (146)

71. In 1950, when NBC television hired Halsman to photograph its popular comedians, he noticed that some, including Groucho Marx, Milton Berle, and Sid Caesar, often jumped in front of the camera while staying in character. Later, to relieve the tension of

difficult assignments, Halsman often asked apprehensive subjects to jump for his camera. Many of these photographs were collected in *Philippe Halsman's Jump Book* (Simon and Schuster, 1959), and in a *LIFE* cover story on November 9, 1959.

72. For biographical information on Halsman, see Mary Panzer, *Philippe Halsman: A Retrospective, Photographs from the Halsman Family Collection*, Exhibition catalogue, National Portrait Gallery, Smithsonian Institution, 1998, pp. 205–9.

73. On Halsman's friendship and collaborations with Dalí, see Yvonne Halsman, *Halsman at Work*, New York, 1989, Harry N. Abrams, Inc., pp. 82–94; Mary Panzer, *Halsman / Dali*, Exhibition catalogue, New York, Howard Greenberg Gallery, 2004.

74. Philippe Halsman, *The Frenchman: A Photographic Interview* (with actor and comedian Fernandel [Contandin Fernand]), New York, Simon and Schuster, 1949.

75. Yvonne Halsman, ed., *Portraits / Halsman*, New York, McGraw-Hill, 1983, cat. no. 42.

TODD WEBB (147)

76. For biographical information, see Todd Webb, *Looking Back: Memoirs and Photographs*, Albuquerque, University of New Mexico Press, 1991.

77. Webb was one of the photographers whose work was included in the exhibition *Ideas in Images*, organized by the Worcester Art Museum in 1962; see Peter Pollack, *Ideas in Images*, Exhibition catalogue, Worcester Art Museum, 1962, cat. nos. 91–100. In 1996, the Museum hosted the exhibition *Todd Webb: Photographs of New York and Paris 1945–1960* (December 16, 1986 – February 1, 1987), organized by the Hallmark Photographic collection; see Keith F. Davis, and Todd Webb, *Todd Webb: Photographs of New York and Paris 1945–1960*, Exhibition catalogue, Kansas City, MO, Hallmark Cards, Inc., 1986.

MINOR WHITE (148)

78. For biographical information on White, see Peter C. Bunnell, Maria B. Pellerano, and Joseph B. Rauch, *Minor White: The Eye That Shapes*, Exhibition catalogue, Princeton, NJ, Princeton University Art Museum, 1989, pp. 1–13; James Baker Hall, *Minor White: Rites and Passages, His Photographs Accompanied by Excerpts from His Diaries and Letters*, Millerton, NY, Aperture, 1976.

79. Minor White, *Zone System Manual: Previsualization, Exposure, Development, Printing: The Ansel Adams Zone System as a Basis of Intuitive Photography*, rev. ed., Hastings-on-Hudson, NY, Morgan & Morgan, 1968; Minor White, Richard Zakia, and Peter Lorenz, *The New Zone System Manual*,

Dobbs Ferry, NY, Morgan & Morgan, 1977.

80. Notable among these exhibitions was a cycle reflecting his interest in the spiritual and esoteric aspects of photography: "Being without Clothes"; *Light / Photos: An Exhibition on a Theme*, Exhibition catalogue, Cambridge, MA, Hayden Gallery, Massachusetts Institute of Technology, 1968; *Octave of Prayer: An Exhibition on a Theme*, Exhibition catalogue, Cambridge, MA, Hayden Gallery, Massachusetts Institute of Technology, 1972; Minor White, Jonathan Green, *Celebrations: A Exhibition of Original Photographs*, Exhibition catalogue, Cambridge, MA, Hayden Gallery, Massachusetts Institute of Technology, 1974.

81. See also Minor White, *Mirrors, Messages, Manifestations*, New York, Aperture, 1969. In 1970, a retrospective exhibition of White's photographs was presented by the Philadelphia Museum of Art. He retired from MIT four years later, and completed his tenure as editor of *Aperture* in 1975.

15 | Real Life

ROBERT FRANK (149)

1. For biographical information on Frank, see Sarah Greenough, and Philip Brookman, *Robert Frank: Moving Out*, Exhibition catalogue, Washington, DC, National Gallery of Art, 1994.

2. Robert Frank, *Les Américains*, edited by Alain Bosquet, Paris, Robert Delpire, 1958.

3. Robert Frank, *The Americans*, with introduction by Jack Kerouac, New York, Grove Press, 1959.

4. During the 1960s, Frank concentrated on filmmaking. His return to photography in the 1970s produced more personal images, with ragged, scratched, resurfaced photographs that convey a raw emotion often enhanced by handwritten words or messages. See Ann Wilkes Tucker, ed., *Robert Frank: New York to Nova Scotia*, Exhibition catalogue, Houston, Museum of Fine Arts, 1986; Ute Eskildsen, *Robert Frank: Hold Still — Keep Going*, Exhibition catalogue, Essen, Museum Folkwang, 2001.

DUANE MICHALS (150)

5. For biographical information on Michals, see Marco Livingstone, *The Essential Duane Michals*, Boston, Little, Brown, 1997.

6. Duane Michals, *Album: The Portraits of Duane Michals, 1958–1988*, Pasadena, CA, Twelvetrees Press, 1988, n.p.

7. See Duane Michals, *Sequences*, Garden City, NY, Doubleday and Company, 1970.

8. Duane Michals, *Things Are Queer*, 1971, nine gelatin silver prints, Worcester Art Museum, each 12.7 x 8.0 cm (sheets), 8.8 x

12.9 cm (images), William Grimm Memorial Fund, 1972.98–106. Figure 7: Duane Michals, *Things Are Queer, Nine Photographs in Sequence, #2*, 1972.99.

9. Duane Michals, *Questions Without Answers*, 2nd ed., Santa Fe, Twin Palms, 2002.

JOSEF SUDEK (151)

10. For biographical information on Sudek, see Sonja Bullaty and Anna Fárová, *Sudek*, New York, Clarkson and Potter, 1978.
11. Josef Sudek, *Svatý Vít*, Prague, Družstevní práce, 1928.
12. Including a Linhof 13 x 18 cm, Zeiss 18 x 24 cm, a Goldmann & Hrdlička 24 x 30 cm, and Kodak 10 x 30 cm cameras.
13. Quoted in Bullaty / Fárová 1978, p. 26. On Sudek's later landscape photography, see Anna Fárová, *Josef Sudek — Poet of Prague*, New York, Aperture, 1990; Anna Fárová and Manfred Heiting, *Josef Sudek — The Pigment Prints, 1947–1954*, Los Angeles, Cinubia, 1994.

HANS HAMMARSKIÖLD (152)

14. For biographical information on Hammarskiöld, see Rune Jonsson, *Hans Hammarskiöld*, Helsingborg, Fyra förläggare, 1979; Leif Wigh, *Hans Hammarskiöld: Subjektivt sett*, Exhibition catalogue, Stockholm, Fotografiska museet, 1993.
15. See Eva Wennerstrom-Hartmann and Hans Hammarskiöld, *Värmland, det sköna*, Stockholm, Wahlström & Widstrand, 1951; see also Marianne Höök, *Stockholmskärlek*, photographs by Hans Hammarskiöld, Stockholm, Wahlström & Widstrand, 1953.
16. Hans Hammarskiöld, *Objektivt sett med foto i fokus*, Stockholm, Nordisk rotogravyr, 1955.
17. See Anna Tellgren, *Tio fotografer: Självsyn och bildsyn, Svensk fotografi under 1950 — talet i ett internationellt perspektiv*, Linköping, Informationsförl, 1997.
18. There are two of Hammarskiöld's portraits in the collection of the Worcester Art Museum: *Edward Steichen with His Dog, Tripod*, 1968, gelatin silver print, 37.4 x 28.0 cm, John G. Berg Memorial Fund, 1987.168; *Carl Sandburg*, 1959, gelatin silver print, 34.1 x 27.9 cm, John G. Berg Memorial Fund, 1987.169.
19. Carl Fredrik Reuterswärd and Hans Hammarskiöld, *Laser*, Stockholm, Wahlström & Widstrand, 1969.
20. See Tony Lewenhaupt and Hans Hammarskiöld, *Nära Linné*, Höganäs, Wiken, 1993; Hans Hammarskiöld, *Stockholm: The Four Seasons*, Stockholm, Wahlström & Widstrand, 1998; Erling Matz, *I lejonets tid: skeppet Vasa & svenskt 1600-tal*, with photographs by Hans Hammarskiöld, Stockholm, Bökforlaget Max Ström, 1999; Anita Theorell and Per Wëstberg, *Minets stigar: en resa bland svenska krykogårdar*, with photographs by Hans Hammarskiöld, Stockholm, M. Ström, 2001.

ART SINSABAUGH (153)

21. For biographical information on Sinsabaugh, see Keith F. Davis, *American Horizons: The Photographs of Art Sinsabaugh*, New York, Hudson Hills Press, 2004.
22. *6 Mid-American Chants* by Sherwood Anderson, *11 Mid-west Photographs* by Art Sinsabaugh, with a note on Anderson's poetry by Edward Dahlberg, Highlands, NC, J. Williams, 1964.
23. See John Szarkowski, ed., *The Photographer and the American Landscape*, Exhibition catalogue, New York, Museum of Modern Art, 1963.

RAY K. METZKER (154)

24. For biographical information on Metzker, see Evan H. Turner, *Ray K. Metzker, Landscapes*, Exhibition catalogue, Philadelphia Museum of Art, 2000, pp. 141–44; Anne Wilkes Tucker, *Unknown Territory: Photographs by Ray K. Metzker*, Exhibition catalogue, Museum of Fine Arts, Houston, 1984, pp. 120–30.
25. Quoted by Tucker 1984, p. 122.
26. See Ray K. Metzker, *Composites*, Exhibition catalogue, New York, Laurence Miller Gallery, 1990. After retiring from teaching in 1983, Metzker turned to landscape in 1985 and has produced a bright, colorful body of photographs in which nature presents metaphors for the human condition; see Turner 2000.

LEONARD FREED (155)

27. Quoted in Cornell Capa, Robert Sagalyn, and Judith Friedberg, *The Concerned Photographer: The Photographs of Werner Bischof, Robert Capa, David Seymour ("Chim"), Andre Kertesz, Leonard Freed, Daniel Weiner*, New York, Grossman Publishers, 1968, n.p.
28. For biographical information on Freed, see Michèle and Michel Auer, *Photographers Encyclopedia International: 1839 to the Present*, Geneva, 1985, vol. 2, n.p.; Stephanie Rosenkranz, *Leonard Freed: Photographs 1954–1990*, Manchester, Cornerhouse, 1991.
29. Max L. Snijders, *Joden van Amsterdam*, Amsterdam, Bij, 1958.
30. Leonard Freed, *Black in White America*, New York, Grossman Publishers, 1969.
31. Quoted in Capa / Sagalyn / Friedberg 1968, n.p. Freed employed his still images and original film footage in his film for Dutch television, *The Negro in America* in 1966. During the later 1960s, Freed continued to photograph the Jewish diaspora, publishing in the book *Deutsche Juden Heute* (Hans Hermann Köper, *Deustche Juden Heute*, Munich, Rütten and Loening, 1965). Among Freed's later books were photoessays on life in Germany (*Made in Germany*, New York, Grossman Publishers, 1970 ([rev.ed., *Leonard Freed's Germany*, London, Thames and Hudson, 1971]); on his experiences in Holland during the 1960s (*Amsterdam: The Sixties*, Amsterdam, Focus Publishing, 1997); and a series on American police that is both respectful and provocative (*Police Work*, with foreword by Studs Terkel, New York, Simon and Schuster, 1980).

JAMES H. KARALES (156)

32. For biographical information on Karales, see Margarett Loke, "James Karales, Photographer of Social Upheaval, Dies at 71," *New York Times*, July 1999, p. C-11.
33. Vicky Goldberg, "Beyond a Famous Shot, The Art of a Lifetime," *New York Times*, July 23, 1999.
34. For a historical review of the Army in Vietnam, see Shelby L. Stanton, *The Rise and Fall of an American Army: U.S. Ground Forces in Vietnam, 1965–1973*, New York, Dell Publishing Company, 1985. I am grateful to Captain Stanton (U.S. Army, Ret.) for his explanation of the salient details of Karales's photograph, unapparent to the uninitiated viewer.
35. In a letter to the author, dated August 25, 2003.

LUCIEN CLERGUE (157)

36. For biographical information on Clergue, see Marianne Fulton, *Lucien Clergue: Eros and Thantos*, Exhibition catalogue, Rochester, New York, George Eastman House, 1985.
37. See Lucien Clergue, *Picasso, mon ami*, Paris, Éditions Plume, 1993.
38. See David LeHardy Sweet and Lucien Clergue, *Jean Cocteau and the Testament of Orpheus: the Photographs*, New York, Viking Studio, 2001.
39. Paul Eluard, *Corps mémorable*, Paris, P. Seghers, 1957.
40. The nude became the perennial subject for Clergue and he published not only photoessays (Federico Garcia Lorca, *Aphrodite*, Ernst Battenberg Verlag, 1963; Lucien Clergue, *Née de la vague*, Paris, Éditions Pierre Belfond, 1968), but also photographic technical manuals (*Nude Workshop*, New York, Viking Press, 1982; *Practical Nude Photography*, London / Boston, Focal Press, 1983).
41. Jean Cocteau, *Numero uno*, with photographs by Lucien Clergue, Paris, Editec, 1963; Jean Petit, ed., *Toros Muertos: Photographies de Lucien Clergue*, with poems by

Jean Cocteau, New York, Brussel & Brussel, Inc., 1966.

42. Paco Tolosa et al., *El Cordobe: 77 photographies de Lucien Clergue*, Paris, Le Jeune Parque, 1965.

43. Described by James Michener in his introduction (p. 32) to Ernest Hemingway, *The Dangerous Summer*, New York, Charles Scribner's Sons, 1985.

44. *Three European Photographers: Bill Brandt, Lucien Clergue, Paolo Monti*, June 15 – September 7, 1965.

GARRY WINOGRAND (158)

45. For biographical information on Winogrand, see John Szarkowski, *Garry Winogrand: Figments from the Real World*, Exhibition catalogue, New York, Museum of Modern Art, 1988.

46. John Szarkowski, *Garry Winogrand: The Animals*, Exhibition catalogue, New York, Museum of Modern Art, 1969.

47. Ron Tyler, *Stock Photographs: The Fort Worth Fat Stock Show and Rodeo by Garry Winogrand*, Austin, Texas, University of Texas Press, 1980.

BRUCE DAVIDSON (159)

48. For biographical information on Davidson, see Henry Geldzahler, *Bruce Davidson Photographs*, New York, Agrinde Publications, 1978.

49. Bruce Davidson, *Brooklyn Gang*, Santa Fe, Twin Palms, 1998.

50. See Peter Pollack, *Ideas in Images*, Exhibition catalogue, Worcester Art Museum, 1962, cat. nos. 31–40.

51. Bruce Davidson, *Time of Change: Civil Rights Photographs, 1961–1965*, with introduction by Deborah Willis, Saint Ann's Press, 2002.

52. Bruce Davidson, *East 100th Street*, Cambridge, MA, Harvard University Press, 1970, published in connection with an exhibition at the Museum of Modern Art in New York.

53. Davidson 1970, n.p. Among Davidson's subsequent photoessays are *Subway* (New York, Knopf, 1984) and *Central Park* (introduction by Marie Winn, New York, Aperture,1995), n.p.

DANNY LYON (160)

54. See Danny Lyon, *Knave of Hearts*, Santa Fe, NM, Twin Palms, 1999, the photographer's autobiography.

55. See Lorraine Hansberry, *The Movement: Documentary of a Struggle for Equality*, New York, Simon and Schuster, 1964; Danny Lyon, *Memories of the Southern Civil Rights Movement*, Chapel Hill, NC, University of North Carolina Press, 1992.

56. Danny Lyon, *The Bikeriders*, New York, MacMillan, 1967 (reprint, San Francisco, Chronicle Books, 2003).

57. Nathan Lyons, *Contemporary Photographers: Toward a Social Landscape*, Exhibition catalogue, Rochester, NY, George Eastman House, 1966.

58. Danny Lyon, *Conversations with the Dead: Photographs of Prison Life, with the Letters and Drawings of Billy McCune #122054*, New York, Holt, Rinehart, and Winston, 1971.

DIANE ARBUS (161)

59. For biographical information on Arbus, see Patricia Bosworth, *Diane Arbus: A Biography*, New York, Knopf, 1984; Doon Arbus and Marvin Israel, eds., *Diane Arbus*, New York, Aperture, 1972.

60. Doon Arbus and Marvin Israel, eds., *Diane Arbus: Magazine Work*, Exhibition catalogue, Lawrence, KS, Spencer Museum of Art, New York, Aperture, 1984.

61. Quoted in Arthur Lubow, "Arbus Reconsidered," *New York Times Magazine*, September 14, 2003, p. 28.

62. This is one of a box of ten photographs in an edition of fifty, selected and designed by the artist in 1970, published subsequently by her daughter, Doon Arbus, with photographs printed by her former student, Neil Selkirk.

GORDON PARKS (162)

63. For biographical information, see Gordon Parks, *Voices in the Mirror: An Autobiography*, New York, Doubleday, 1990. He also published several volumes of verse illustrated by photographs, including *The Poet and His Camera* (1968), *Whispers of Intimate Things* (1971), and *Moments without Proper Names* (1975).

64. Gordon Parks, *Flash Photography*, New York, Grosset & Dunlap, 1947; *Camera Portraits: The Techniques and Principles of Documentary Portraiture*, New York, Watts, 1948.

65. Parks was one of ten photographers whose work was included in the exhibition *Ideas in Images*, organized by the Worcester Art Museum in 1962; see Peter Pollack, *Ideas in Images*, Exhibition catalogue, Worcester Art Museum, 1962, cat. nos. 81–90; see also Peter Pollack, *The Picture History of Photography: From the Earliest Beginnings to the Present Day*, rev. ed., New York, Harry N. Abrams, Inc., 1969, pp. 672–79.

66. Gordon Parks, *The Learning Tree*, New York, Harper & Row, 1963. After directing a film adaptation of *The Learning Tree*, Parks became a leading African-American director during the 1960s and 1970s, creating a succession of ten successful movies, including *Shaft* in 1971.

67. Inscribed on the verso of the photograph in the artist's hand, in blue ballpoint pen: "*life:*

8/3/68 *What I want, what I am, what you force/me to be is what yout. [sic]/Race of [sic] Poverty (page. 48/49)/Gordon Parks.*"

68. *LIFE*, March 8, 1968, p. 49.

IRENE SHWACHMAN (163)

69. For biographical information on Shwachman, see Stephen B. Jareckie, *Irene Shwachman, A Retrospective Exhibition*, Exhibition pamphlet, Boston, Photographic Resource Center, November 3–30, 1989.

70. See Jacob Deschin, "Techniques of Photojournalism," *New York Times*, November 14, 1965, p. 32.

71. For example, *New Exposures*, Museum of Fine Arts, Boston, 1976; *Four Photographers*, Boston, New England School of Photography, 1977; Clifford S. Ackley, *14 New England Photographers*, Exhibition catalogue, Museum of Fine Arts, Boston, February 14 – April 20, 1978; Elsa Dorfman, *Sightlines by Irene Shwachman. A Retrospective Exhibition of Photographs 1953–1978*, Brockton Art Center, Fuller Memorial, November 1 – December 31, 1978.

72. In *We Grew Up in Manhattan: Notes for an Autobiography* (Boston University, Photographic Research Center, 1984), for example, Shwachman reflected on the shifting mores of time, through recollections of her early life in the city and images from old family snapshots.

16 | The Physical Universe

HAROLD EDGERTON (164)

1. For biographical information on Edgerton, see Estelle Jussim and Gus Kayafas, *Stopping Time: The Photographs of Harold Edgerton*, New York, Harry N. Abrams, Inc., 1987, pp. 152–61.

2. See Marta Braun, *Picturing Time: The Work of Étienne-Jules Marey (1830–1904)*, Chicago, University of Chicago Press, 1992.

3. See Harold Edgerton and James R. Killian, Jr., *Moments of Vision: The Stroboscopic Revolution in Photography*, Cambridge, MA, MIT Press, 1979; Douglas Collins et al., *Seeing the Unseen: Dr. Harold E. Edgerton and the Wonders of Strobe Alley*, Exhibition catalogue, Rochester, NY, George Eastman House, 1994.

4. Jussim/Kayafas 1987, p. 123.

NATIONAL AERONAUTICS AND SPACE ADMINISTRATION (165)

5. See above, p. 28 (introduction). It may be that this was one of the daguerreotypes of the moon made by John Adams Whipple, who hailed from Grafton in Worcester County. If Van Altsin did exhibit one of

Whipple's daguerreotypes of the moon in Worcester, the connection may suggest an acquaintance between the two photographers, and perhaps even Van Altsin's activity in Whipple's studio.

6. See Beaumont Newhall, *Airborne Camera: The World from the Air and Outer Space*, New York, Hastings House, 1969.

7. See David E. Bowker and Jay Kenrick Hughes, *Lunar Orbiter Photographic Atlas of the Moon*, NASA, 1971.

8. On August 6, 1967, at 11:22 GMT (Julian Day 2439708.9736), photograph centered on Longitude -111.50, at a latitude of 59.72. See Bruce K. Byers, *Destination Moon: A History of the Lunar Orbiter Program*, NASA, April 1977, NASA Report No. TM X-3487.

DANIEL FARBER (166)

9. For biographical information, see Daniel Farber, *Reflections on a Trail Taken*, Boston, D. R. Godine, 1991, pp. 152–64.

10. *Reflections: Color Photographs by Daniel Farber* (January 23 – April 17, 1963) was the first solo exhibition organized by the Museum's newly formed photography program. See also "Color Photograph by City Man Part of World's Fair Exhibit," *Worcester Telegram*, May 31, 1965. Later, Farber set up a small pool in his studio, adding black dye to the water, in order to shoot the reflection of painted designs.

11. Daniel Farber, *Peter Bancroft* (Auburn, Mass.), 1974, gelatin silver print, 39.7 x 50.3 cm. Gift of Daniel Farber, 1976.40.

12. During the 1960s, when new construction was planned for Worcester Common, Farber helped excavate a forgotten burial ground where over 200 headstones had been laid flat and buried a century before. He and his colleagues relocated graves and markers to Hope Cemetery, except for sixteen of the finest headstones, which were installed around the Timothy Bigelow monument on the Common. Farber's supreme achievement in this study is *Sculpture on Early Massachusetts Gravestones*, a visual repertoire of 750 carved gravestones that provides an enduring tool for study of the sculptures, their time, and their creators. See Marilyn W. Spear, "New Albums of Gravestones Give Artistic Record of Early Settlers," *Worcester Telegram*, October 12, 1970, p. 20. Complete editions of Farber's survey are to be found at the American Antiquarian Society in Worcester and at the Yale University Art Gallery.

13. Farber 1991, p. 155.

14. Farber 1991, p. 155.

15. Farber also photographed artworks for museums; see Department of American Decorative Arts, *American Pewter in the Museum of Fine Arts, Boston*, photographs by Daniel Farber, Boston and Greenwich, CT, New York Graphic Society, 1974.

HENRI CARTIER-BRESSON (167)

16. *Cartier-Bresson: Recent Photographs, and a Retrospective Group of Photographs*, on view at the Worcester Art Museum from October 17 – December 1, 1968, was organized by the Museum of Modern Art, New York. Five years later, the Worcester Art Museum organized its own show, *Photographs by Brassaï and Cartier-Bresson*, June 1 – December 30, 1973.

17. For biographical information on Cartier-Bresson, see Mark Haworth-Booth, "Henri Cartier-Bresson," *The Dictionary of Art*, vol. 5, London, 1996, pp. 896–98.

18. See Peter Galassi, *Henri Cartier-Bresson: The Early Work*, Exhibition catalogue, New York, Museum of Modern Art, 1987.

19. Lincoln Kirstein and Beaumont Newhall: *The Photographs of Henri Cartier-Bresson*, Exhibition catalogue, New York, 1947 (rev. ed., New York, 1963).

20. See Werner Bischof et al., *When the War Was Over: 168 Masterpieces by Magnum Photographers*, London, Thames and Hudson, 1985; Magnum Photographs, Inc., *A l'est de Magnum, 1945–1990*, Paris, Arthaud, 1991.

21. Henri Cartier-Bresson, *Images à la sauvette*, Paris, Éditions Verve, 1952; translated into English as *The Decisive Moment* (New York, Simon and Schuster, 1952).

ELIOT PORTER (168)

22. For biographical information on Porter, see *Eliot Porter*, photographs and text by Eliot Porter, foreword by Martha A. Sandweiss, Exhibition catalogue, Fort Worth, TX, Amon Carter Museum.

23. See *Summer Island: Penobscot Country* (San Francisco, Sierra Club, 1966), Porter's photographic and prose reminiscence of Great Spruce Head Island. A solo exhibition of Porter's photographs of Maine was mounted at the Worcester Art Museum (*Maine Photographs by Eliot Porter*, December 16, 1975 – March 7, 1976).

24. See Eliot Porter, *American Birds: 10 Photographs in Color*, New York, McGraw-Hill, 1953; *Birds of North America: A Personal Selection*, New York, E. P. Dutton, 1972; John Rohrbach and W. Powell Cottrille, *A Passion for Birds: Eliot Porter's Photography*, Exhibition catalogue, Fort Worth, TX, Amon Carter Museum, 1997.

25. See Eliot Porter, *The Place No One Knew: Grand Canyon on the Colorado*, San Francisco, Sierra Club, 1963; *Eliot Porter's Southwest*, New York, Holt, Rinehart and Winston, 1985.

26. Henry David Thoreau, and Eliot Porter, *In Wildness Is the Preservation of the World*, San Francisco, Sierra Club, 1962.

PAUL CAPONIGRO (169)

27. For biographical information on Caponigro, see Paul Caponigro, *Seasons*, Boston, New York Graphic Society / Little, Brown, and Company, 1988, pp. 75–93; David Stroud, *Paul Caponigro: Masterworks from Forty Years*, Carmel, CA, Photography West Graphics, Inc., 1993.

28. Paul Caponigro, *Megaliths*, Boston, Little, Brown, 1986.

29. Paul Caponigro, *Sunflower*, New York, Filmhaus, 1974, n.p.

30. Caponigro 1974, n.p. *Photographs by Paul Caponigro* was mounted at the Worcester Art Museum in 1981 (March 17 – May 17), the year the Photography Gallery in Philadelphia presented a retrospective exhibition of his work; see Douglas Wharton Mellor and Peter C. Bunnell, *Paul Caponigro Photography: 25 Years*, Exhibition catalogue, Philadelphia, 1981.

BRETT WESTON (170)

31. For biographical information, see Brett Weston, *Voyage of the Eye*, with afterword by Beaumont Newhall, rev. ed., New York, Aperture Foundation, Inc., 1975.

32. *Daybooks*, November 5, 1926.

33. In 1949, twelve of the photographs were published in the portfolio *White Sands*, with an introduction by Nancy Newhall.

34. See Merle Armitage, *Brett Weston Photographs*, New York, E. Weyhe, 1956.

35. Brett Weston, *Fifteen Photographs of Japan*, 1970, gelatin silver prints, Jerome A. Wheelock Fund, 1970.136–150.

B. A. KING (171)

36. Quoted by Carolyn Cohen (*B. A. King: Visual Poetry*, Exhibition catalogue, Boston, Pucker Gallery, 2001, n.p.), who also provides biographical information.

37. See Barbara Matchem, "Family Tree: Life lessons are learned at the huge red oak in Tony King's yard," *Boston Globe*, February 22, 2001, pp. H-1, 7.

38. B. A. King, *This Proud Place: An Affectionate Look at New England*, Woodstock, VT, Countryman Press, 1983, n.p.

39. James Houston, *Ojibwa Summer*, with photographs by B. A. King, Houston, Barre Publishers, 1972. In 1976, the Sierra Club published books with King's photographs of the Great Lakes and New England: Jonathan Ela, *The Faces of the Great Lakes*, San Francisco, Sierra Club, 1976; Hal Borlund, *A Place to Begin: The New England Experience*, San Francisco, Sierra Club Books, 1976.

40. *Portrait of a Friendship, Composed of Photographs by B. A. King and Works of Art by Robert Cronin*, Worcester Art Museum, November 15 – December 15, 1978.

41. See B. A. King, *My Maine Thing*, Boston, Black Ice Publishers, 1981; *Time and Quiet*, Kennebunkport, ME, Black Ice Publishers, 2001.

42. Edward Connery Lathem, ed., *Robert Frost: Versed in Country Things*, with photographs by B. A. King, Boston, Bullfinch Press — Little, Brown and Company, 1996; Edward Connery Lathem, ed., *Snow Season*, New London, NH, Safe Harbor Press, 2001, combines King's photographs with verse by Robert Frost, Oliver Wendell Holmes, Henry Wadsworth Longfellow, James Russell Lowell, and John Greenleaf Whittier. See also Robert Frost, *From Snow to Snow: A Poem for Each Month of the Year as Selected by the Poet Himself, together with Photographs by B. A. King*, Peachem, VT, Perpetua Press, 2003.

43. Quoted by Matchem 2001, p. H-7.

EMMET GOWIN (172)

44. For biographical information on Gowin, see Jock Reynolds, *Emmet Gowin: Changing the Earth, Aerial Photographs*, Exhibition catalogue, New Haven, Yale University Art Gallery, 2002.

45. Clifford S. Ackley, *Private Realities: Recent American Photographs by Emmet Gowin*, Exhibition catalogue, Boston, Museum of Fine Arts, 1974; see also Emmet Gowin, *Photographs*, New York, Knopf, 1976.

46. See John Weiss, ed., *Venus, Jupiter and Mars: The Photographs of Frederick Sommer*, Wilmington, Delaware Art Museum, 1980; Frederick Sommer and Nancy Solomon, *Sommer — Images*, Tucson, Center for Creative Photography, University of Arizona, 1984; Dianne Perry Vanderlin, *Frederick Sommer: The Mistress of This World Has No Name*, Denver, Denver Museum of Art, 1987.

47. Peter C. Bunnell, *Emmet Gowin: Photographs, 1966–1983*, Exhibition catalogue, Washington, DC, Corcoran Gallery of Art, 1983.

48. See Martha Chahroudi, *Emmet Gowin: Photographs*, Exhibition catalogue, Philadelphia Museum of Art, 1990; Reynolds 2002.

17 | Plurality of Vision

DAVID HOCKNEY (173)

1. For biographical information on Hockney, see Peter Webb, *Portrait of David Hockney*, London, Chatto and Windus, 1988; Caroline Hancock, in *Exciting Times Are Ahead: David Hockney*, Exhibition catalogue, Bonn, Kunst- und Ausstellungshalle der Bundesrepublik Deutschland, 2001, pp. 217–60.

2. See David Livingstone, ed., *Hockney in California*, Exhibition catalogue, Tokyo, Takashimaya Gallery, 1994.

3. On Hockney as a photographer, see David Hockney and Alain Sayag, *David Hockney: Photographs*, London, Petersburg Press, 1982; Reinhold Mißelbeck, *David Hockney: Retrospektive Photoworks*, Exhibition catalogue, Cologne, Museum Ludwig, 1998.

4. *Portrait of an Artist*, 1972, oil on canvas, 214 x 275 cm, is now in a private collection, see Marco Livingstone and Kay Heymer, *Hockney's People*, Boston, Bulfinch Press, 2003, pp. 112–16.

5. See the accounts of Hockney (Hockney/ Sayag 1982, pp. 13–14), Webb (1988, pp. 123–25), and Livingstone (Livingstone/ Heymer 2003, pp. 112, 116).

6. These were later professionally printed and published in the *Sonnabend Portfolio of Twenty Photographic Pictures by David Hockney*, 1976, edition 200.

7. David Hockney, *Secret Knowledge: Rediscovering the Lost Techniques of the Old Masters*, New York, Viking Studio, 2001.

JERRY N. UELSMANN (174)

8. For biographical information on Uelsmann, see James L. Enyeart, *Jerry N. Uelsmann, Twenty-Five Years: A Retrospective*, Boston, Little, Brown, 1982.

9. John Szarkowski: *Jerry N. Uelsmann*, Exhibition catalogue, New York, Museum of Modern Art, 1967.

10. These processes are distinct from photomontage — as in the work of Raoul Ubac (no. 121) or Herbert Bayer (no. 120) — where photographic prints are cut and pasted together, and then rephotographed.

11. See Margaret F. Harker, *Henry Peach Robinson: Master of Photographic Art, 1830–1901*, Oxford, B. Blackwell, 1988; Leif Wigh, *Oscar Gustave Rejlander, 1813–1875*, Exhibition catalogue, Stockholm, Moderna Museet, 1998.

12. In 1964 Uelsmann imagined himself as their successor in his photograph *Self Portrait as Robinson and Rejlander*.

13. Michael Hoffman and Peter C. Bunnell, *Jerry N. Uelsmann*, fables by Russell Edson, Exhibition catalogue, Alfred Stieglitz Center, Philadelphia Museum of Art, 1970.

14. In 1975, Uelsmann's photographs were featured in a joint exhibition at the Worcester Art Museum (*Photographs by Donald Blumberg, Duane Michals and Jerry N. Uelsmann*, March 1 – May 11, 1975), followed three years later by a solo exhibition (*Photographs by Jerry N. Uelsmann*, April 25 – July 9, 1978).

JOEL MEYEROWITZ (175)

15. For biographical information on Meyerowitz, see Colin Westerbeck, *Joel Meyerowitz*, London, Phaidon, 2001.

16. See Meyerowitz's work as a photographic historian in Colin Westerbeck and Joel Meyerowitz, *Bystander: A History of Street Photography*, London, Thames and Hudson, 1994 (second ed., with a new afterword on street photography since the 1970s, Boston, Little, Brown, 2001); see also Joel Meyerowitz, *Creating a Sense of Place: Photographs*, Washington, DC, Smithsonian Institution Press, 1990.

17. Joel Meyerowitz, *Cape Light: Color Photographs*, foreword by Clifford S. Ackley, interview by Bruce K. MacDonald, Exhibition catalogue, Boston, Museum of Fine Arts, 1978; see also *Bay/Sky*, foreword by Norman Mailer, Boston, Bulfinch Press, 1993.

18. Joel Meyerowitz, *Wild Flowers: Photographs*, Boston, Little, Brown, 1983; *A Summer's Day*, New York, Times Books, 1985; *Redheads*, New York, Rizzoli, 1991; *George Balanchine's "The Nutcracker,"* Boston, Little, Brown, 1993.

CARLOS FREIRE (176)

19. For biographical information on Freire, see Michèle and Michel Auer, *Photographers Encyclopedia International: 1839 to the Present*, Geneva, 1985, vol. 1, n.p.

20. Among the many other authors whom Freire has portrayed are Mary McCarthy, Octavio Paz, Samuel Beckett, Elizabeth Hardwick, Jorge Luis Borges, Stephen Spender, Graham Greene, and Doris Lessing. Freire is also well-known for his portraits of artists, which include Henry Moore, Lisette Model (no. 124), Bill Brandt (no. 123), André Kertész (no. 91), and many others. Among his published portrait series are *Niki de Saint-Phalle*, São Paulo, Brazil, Pinacoteca de São Paulo, 1996; *Marguerite Yourcenar le dernier voyage*, Beirut, Musée Sursok, 2002; and *Francis Bacon par Carlos Freire*, Paris, Galerie Dina Vierny, 2004. In 1992, a traveling exhibition of his *Portraits d'artistes*, sponsored by the French Ministry of Foreign Affairs, was shown in eighty-two countries.

21. In an e-mail note to the author, June 10, 2004.

22. Maison des Sciences de l'Homme, *Lumière del'Inde: Photographies de Carlos Freire*, introduction by Charles Morazé, Exhibition catalogue, Paris, 1986.

23. See Carlos Freire, *Brésil des brésiliens*, Exhibition catalogue, Paris, Centre Georges Pompidou, 1982; *L'Espirit des lieux*, introduction by Lawrence Durrell, Exhibition catalogue, Paris, Exposition Espace AGF, 1989; *Napoli Il Reame della Gente*, introduction by Cesare de Seta, Exhibition catalogue, Naples, Villa Pignatelli, 1992; *Alexandrie l'Egyptienne*, introduction by Robert Solé, Exhibition catalogue, Paris, Musée du Petit Palais, 1998; *Le Mont Athos*, introduction by Jacques Lacarrière, Exhibition catalogue, Festival de Montauban, 2002; *Alep*, Exhibition catalogue, Paris, Institut du Monde Arabe,

2004; *Morocco*, introduction by Abdelkibir Khatibi, Paris, Hazan, 2005.

CINDY SHERMAN (175)

24. For biographical information on Sherman, see Peter Schjeldahl and Lisa Phillips, *Cindy Sherman*, Exhibition catalogue, New York, Whitney Museum of American Art, 1987; Els Barents, Stedelijk Museum, *Cindy Sherman*, Exhibition catalogue, Amsterdam, 1982.
25. Cindy Sherman, *The Complete Untitled Film Stills*, New York, Museum of Modern Art, 2003, p. 9; see also Arthur C. Danto, *Untitled Film Stills: Cindy Sherman*, Munich, New York, Rizzoli, 1990.

RALPH STEINER (178)

26. For biographical information on Steiner, see *Ralph Steiner, A Point of View*, Middletown, CT, Wesleyan University Press, 1978; Joel Stewart Zucker, *Ralph Steiner: Filmmaker and Still Photographer*, New York, Arno Press, 1978.
27. Ralph Steiner, *Dartmouth*, with a foreword by Homer Easton Keyes, Brooklyn, Albertype Company, 1922.
28. See Jan-Christopher Horak, ed., *Lovers of Cinema: The First American Film Avant-garde, 1919–1945*, Madison, University of Wisconsin Press, 1995.
29. Produced for a commission from the American Institute of City Planners, *The City* had original music by Aaron Copeland and was screened continuously throughout the New York World's Fair in 1939.
30. Ralph Steiner, *In Pursuit of Clouds: Images and Metaphors*, Albuquerque, NM, University of New Mexico Press, 1985; to draw viewers into the pictures, the photographer asked visitors to name the images and describe their associations, and related these comments in his book.
31. Ralph Steiner and Caroline Steiner, *In Spite of Everything, Yes*, Exhibition, Hanover, NH, Hood Museum of Art, Dartmouth College, 1986.

JOEL STERNFELD (179)

32. See William Jenkins, *New Topographics: Photographs of a Man-Altered Landscape*, Exhibition catalogue, Rochester, NY, George Eastman House, 1975.
33. For biographical information on Sternfeld see Jenkins 1975.
34. From an artist's statement provided by the Daniel Wolf Gallery in 1983.
35. Edwin Way Teale, *North with Spring: A Naturalist's Record of a 17,000 Mile Journey across through the North American Autumn*, with photographs by the author, New York, Dodd, Mead, 1951; *Autumn across America: A Naturalist's Record of a 20,000 Mile Journey across through the North American Autumn*, with photographs by the author, New York, Dodd, Mead, 1956.
36. Joel Sternfeld, *American Prospects*, with introduction by Andy Grundberg, and afterword by Anne Tucker, New York, Times Books, in association with the Museum of Fine Arts, Houston, 1987.
37. Armin Harris, ed., *Joel Sternfeld: On This Site, Landscape in Memoriam*, San Francisco, Chronicle, Books, 1996.
38. Melinda Hunt, and Joel Sternfeld, *Hart Island: Joel Sternfeld*, Zurich, Scalo, 1998.

WILLIAM EGGLESTON (180)

39. For biographical information on Eggleston, see Sophie Clark in Emma Dexter and Thomas Weski, eds., *Cruel and Tender: The Real in the Twentieth-Century Photograph*, Exhibition catalogue, London, Tate Modern, 2003, p. 259.
40. See Thomas Weski and Walter Hopps, *William Eggleston: Los Alamos*, Zurich, 2003.
41. John Szarkowski, *William Eggleston's Guide*, Exhibition catalogue, New York, Museum of Modern Art, 1976.
42. William Eggleston and Eudora Welty, *The Democratic Forest*; see also P. Schneider, "The Berlin Series," *Aperture*, vol. 96, 1984, pp. 60–75.
43. Willie Morris, *Faulkner's Mississippi*, with photographs by William Eggleston, Birmingham, AL, Oxmoor House, 1990. See also the catalogues of retrospective exhibitions of Eggleston's photographs in Europe: Mark Holborn, *Ancient and Modern*, Exhibition catalogue, London, Barbican Art Gallery, 1992; Thomas Weski, Walter Hopps, and Ute Eskildsen, *William Eggleston*, Zurich, Berlin, New York, 1999.

HIROMI TSUCHIDA (181)

44. For biographical information on the artist, see Luisa Orto in Anne Wilkes Tucker et al., *The History of Japanese Photography*, Exhibition catalogue, Houston, TX, Museum of Fine Arts, 2003, p. 365.
45. Hiromi Tsuchida, *Zokushin (Gods of the Earth)*, Yokohama, Otto's Books-sha, 1976.
46. Hiromi Tsuchida, *Suna o kazoeru (Counting Grains of Sand) 1976–1989*, Tokyo, Tōseisha, 1990.
47. Arata Osada, *Children of the A-bomb* (translation of *Genbaku no ko*), London, Taylor and Francis, 1980.
48. This was followed by the series *Hiroshima 1945–1978* (Tokyo, Asahi Sonorama, 1979), which was first exhibited at the Ginza Nikon Salon in 1978.
49. See Hiromi Tsuchida, *Hiroshima Collection: Hiroshima Heiwa Kinen Shiryōkan zō* (Hiroshima Peace Memorial Museum), Tokyo, Nippon Hōsō Shuppan Kyōkai, 1995.
50. During the 1980s, Tsuchida returned to his photographic expeditions, documenting the discord between Japanese culture and the modern world; see *Nihon no seiiki: Jinjū to Iseji*, (Sanctuaries of Japan: Ise Shrine and Iseji Road), Tokyo, Kōsei Shuppansha, 1982; and *Oku no hosomichi o araku* (Walking the Road to the Deep North), Tokyo, Shinchōsha, 1989.

JAMES CASEBERE (182)

51. For biographical information on Casebere, see Adam A. Weinberg, Anthony Vidler, and M. Wigley, *Architectural Unconscious*, Exhibition catalogue, Andover, MA, Addison Gallery, Phillips Academy, 2000; Real Lussier, *James Casebere*, Art Books International Limited, 2004.
52. *Waterfall* was produced by the Duratran process, a tradename for large chromogenic transparencies, designed for backlighting, and manufactured by the Kodak and Fuji companies. A similar product with different characteristics is the Cibatran.
53. Hal Foster, "Uncanny Images," *Art in America*, November 1983, pp. 202–204.
54. During the 1990s, Casebere abandoned the lightboxes, and presented his images as oversized photographic prints. He progressively simplified his architectural spaces until they became a single room, a prison cell, informed by the nineteenth-century Quaker reform movement. In a project for the Addison Gallery at Phillips Academy in Andover, Massachusetts, Casebere built models based on the hallways of two classroom buildings, ornamented with neoclassical details (see Weinberg/Vidler/Wigley 2000). For the first time, he retained the halls' pink and the blue colors, and flooded these spaces with water, which evokes the passage of time and the temporality of human works. See also Christopher Chang, Anthony Vidler, and Jeffrey Eugenides, *James Casebere: The Spatial Uncanny*, Milan, Charta, 2001.

ROBERT MAPPLETHORPE (183)

55. For biographical information, see Patricia Morrisroe, *Mapplethorpe: A Biography*, New York, Random House, 1995.
56. Mapplethorpe's portrait of Patti Smith was used for the cover of her debut recording, *Horses*, Arista, 1975.
57. Bruce Chatwin, *Robert Mapplethorpe: Lady*, New York, Viking Press, 1983.
58. See Sam Wagstaff, *Robert Mapplethorpe: Flowers*, Exhibition catalogue, Tokyo, Galerie Watari, 1983; *Black Flowers*, Madrid, Fernando Vijande Editor,1985. This is one of several of Mapplethorpe's photographs printed in small editions at the Graphicstudio workshop at the University of South

Florida; see Ruth E. Fine and Mary Lee Corlett, *Graphicstudio: Contemporary Art from the Collaborative Workshop at the University of South Florida*, Exhibition catalogue, Washington, DC, National Gallery of Art, 1991, cat. no. 149, pp. 193–94.

59. Patti Smith, "Final Flower," in *Flowers: Mapplethorpe*, foreword by Patti Smith, Boston, Bulfinch Press / Little, Brown, and Company, 1990, n.p

60. Quoted by John Ashbery, in Mark Holborn and Dimitri Levas, eds., *Pistils: Mapplethorpe*, New York, Random House, 1996, p. 7.

61. Richard Marshall, ed., *Robert Mapplethorpe*, Exhibition catalogue, New York, Whitney Museum of American Art, 1988. After the artist's death, the Institute of Contemporary Art in Philadelphia mounted a memorial exhibition including the full range of his work. See Janet Kardon, ed., *Robert Mapplethorpe: The Perfect Moment*, Exhibition catalogue, Philadelphia, Institute of Contemporary Art, 1988. The show sparked controversy when it was scheduled to travel to the Corcoran Gallery of Art in Washington, DC, which canceled the exhibition rather than endanger federal funding. When the exhibition was shown at the Cincinnati Contemporary Arts Center in 1990, its director was tried on obscenity charges and acquitted.

LINDA CONNOR (184)

62. For biographical information on Connor, see Anita V. Mozley, in Laurie Collier Hillstrom and Kevin Hillstrom, eds., *Contemporary Women Artists*, 1999, Detroit, Saint James Press, pp. 148–49.

63. A selection of these mysterious images appeared in Connor's *Solos*, Millerton, NY, Apeiron Workshops, 1979.

64. Corcoran Gallery of Art, *Linda Connor*, Exhibition catalogue, Washington, DC, 1982. See also Denise Miller-Clark and Rebecca Solnit, *Linda Connor: Spiral Journey, Photographs 1967–1990*, Exhibition catalogue, Chicago, Museum of Contemporary Photography, Columbia College, 1990; Linda Connor, *Luminance*, Exhibition catalogue, Carmel Valley, CA, Center for Photographic Art, 1994; Jeffrey Hoone, *Linda Connor: Visits*, Exhibition catalogue, Syracuse, NY, Syracuse University, Robert B. Menschel Photography Gallery, 1996.

65. In the mid-1990s, Connor combined some of her own photographs with images of the night sky that she printed from nineteenth-century glass-plate negatives from the collection of the Lick Observatory at the University of California. Exhibited along with documents of eclipses, constellations, and comets, these images of human spirituality acquire an even broader context; see Charles Simic, *On the Music of the Spheres*,

photographs by Linda Connor, New York, Library Fellows of the Whitney Museum of American Art, 1996.

KEITH CARTER (185)

66. For Carter's recollections of his childhood, see Keith Carter, *From Uncertain to Blue*, with introduction by Horton Foote, Austin, Texas Monthly Press, 1988.

67. Keith Carter, *The Blue Man*, afterword by Anne Wilkes Tucker, Houson, TX, Rice University Press, 1990.

68. See Keith Carter, *Heaven of Animals*, afterword by Greil Marcus, Houston, TX, Rice University Press, 1995; *Bones*, San Francisco, Chronicle Books, 1996.

69. In 1995, Carter became the Walles Chair of the art department at Lamar University in Beaumont, Texas. See also his books, *Mojo*, introduction by Rosellen Brown, Houston, TX, Rice University Press, 1992; *Ezekiel's Horse*, Austin, University of Texas Press, 2000; *Holding Venus: Keith Carter*, Santa Fe, NM, Arena Editions, 2000.

FLOR GARDUÑO (186)

70. For biographical information on Garduño, see Tereza Siza, *Flor*, Heidelberg, Edition Braus, 2002.

71. Flor Garduño and Eraclio Zepeda, *Magia del juego eterno*, Juchitán, Oaxaca, Guchachí Reza, 1985.

72. Flor Garduño, *Testigos del tiempo*, introduction by Carlos Fuentes, Mexico City, Redacta, 1992 (English ed., London, Thames and Hudson, 1992).

73. Verónica Volkow, *Flor Garduño: Inner Light, Still Lifes and Nudes*, Boston, Little, Brown, and Company, 2002.

LOIS CONNER (187)

74. For biographical information on Conner, see Richard B. Woodward, in *Panoramas of the Far East: Photographs by Lois Conner*, Washington, DC, Smithsonian Institution Press, 1993, pp. 59–60.

75. See Geremie Barmé, *China: The Photographs of Lois Conner*, New York, Callaway, 2000. Later, Conner executed a photographic series on the Dunhuang Caves, some of which are illustrated in Roderick Whitfield, Susan Whitfield, and Neville Agnew, *Cave Temples of Mogao: Art and History on the Silk Road*, photography by Lois Conner and Wu Jan, Los Angeles, Getty Conservation Institute and the J. Paul Getty Museum, 2000.

76. In 1999, the artist began a series of images of women in the later stages of pregnancy. Printed nearly lifesize, the photographs of dissimilar women, varied in age, setting, and mood in the series *To Be* celebrate the

pregnant body as a symbol of life, renewal, and rebirth.

JOHN O'REILLY (188)

77. For biographical information on O'Reilly, see Klaus Kertess, *John O'Reilly: Assemblies of Magic*, Exhibition catalogue, Andover, MA, Addison Gallery of American Art, Phillips Academy, 2002.

78. On Daniel Catton Rich and his importance for the Worcester Art Museum, see above, pp. 16–17.

79. Hendrick Terbruggen, Dutch, 1588–1629, *The Rescue of Saint Sebastian*, 1625, oil on canvas, 149.5 x 120.0 cm, Oberlin, OH, Allen Memorial Art Museum, 53.256.

80. See Sara Rimer, "A Somewhat Reluctant, Sort of Overnight, 65-Year-Old Sensation," *New York Times Magazine*, February 26, 1995, p. 35. See also Howard Yezerski Gallery, *John O'Reilly: Self-Portraits, 1977–1995*, Exhibition catalogue, Boston, 1996; Klaus Kertess, *John O'Reilly: Occupied Territories, Works from 1967–1999*, Exhibition catalogue, Boston, Howard Yezerski Gallery / New York, Julie Saul Gallery / Chicago, Stephen Daiter Gallery, 1999.

LORNA SIMPSON (189)

81. For biographical information on Simpson, see Kellie Jones, Thelma Golden, and Chrissie Ides, *Lorna Simpson*, London, Phaidon, 2002, pp. 146–57, passim.

82. Beryl J. Wright and Saidya V. Hartman, *Lorna Simpson: For the Sake of the Viewer*, Exhibition catalogue, Museum of Contemporary Art, Chicago, 1992.

83. *Counting*, 1991, produced in collaboration with printers Patricia Branstead and Deli Sacilotto at the Branstead Studio in New York, February through May 1991. The edition was printed on Somerset Satin wove paper by Sally Mara Sturman in April and May 1991. Published by Brooke Alexander, Inc., in association with the Josh Baer Gallery, New York.

HIROSHI SUGIMOTO (190)

84. For biographical information on Sugimoto, see Luisa Orto, in Anne Wilkes Tucker et al., *The History of Japanese Photography*, Exhibition catalogue, Houston, The Museum of Fine Arts, 2003, pp. 361–62.

85. See John Yau, "Hiroshi Sugimoto: No Such Thing as Time," *Artforum*, vol. 22, April 1984, pp. 48–52; Thomas Kellein, *Hiroshi Sugimoto: Time Exposed*, New York, Thames and Hudson, 1995.

86. See Nancy Spector, "Reinventing Realism," in Tracey Bashkoff and Nancy Spector, *Sugimoto: Portraits*, Exhibition catalogue, Berlin, Deutsche Guggenheim, 2000.

87. See William Wilson, "Sugimoto's Sea of Meditation at MOCA," *Los Angeles Times*, March 4, 1994, pp. F24, 30.

88. See Jean-Christian Fleury, "Hiroshi Sugimoto: Théâtres du Vide," *Camera International*, vol. 40, Summer 1995, pp. 70–77; Peter Hay Halpert, *Motion Picture by Sugimoto*, Exhibition catalogue, Locarno, Galleria SPSAS, 1995.

89. In 1995, a solo exhibition of Sugimoto's photographs was mounted at the Metropolitan Museum of Art. Among his subsequent photographic series are a suite on architecture (Francesco Bonami, Marco De Michelis, and John Yau, *Sugimoto: Architecture*, Exhibition catalogue, Chicago, Museum of Contemporary Art, 2003), and wax museums (Bashkoff / Spector 2000).

BERND AND HILLA BECHER (191)

90. For biographical information on the artists, see Susanne Lange, *Bernd and Hilla Becher: Industrial Landscapes*, Munich, Schirmer / Mosel, and Cambridge, MA, 2002.

91. Bernd and Hilla Becher, *Framework Houses from the Siegen Industrial Region*, Munich, 1977 (reprint, London / Cambridge, MA, 2001).

92. Bernd and Hilla Becher, *Anonyme Skulpturen: Eine Typologie Technischer Bauten*, Düsseldorf, 1970.

93. Kynaston McShine, *Information*, Exhibition catalogue, New York, Museum of Modern Art, 1972.

94. In 1990, the Bechers' photographs represented Germany at the Venice Biennale; see Biennale di Venezia, *Bernd and Hilla Becher, Tipologie = Typologien = Typologies*, Exhibition catalogue, Münster, K. Bussmann, 1990.

THOMAS RUFF (192)

95. For biographical information on Ruff, see Matthias Winzen and Per Bj Boym, *Thomas Ruff: 1979 to the Present*, Exhibition catalogue, Baden-Baden, Staatliche Kunsthalle, 2001.

96. Kasper Konig et al., *Thomas Ruff: Portraits*, Cologne, Verlag der Buchhandlung Walther Konig, 1988.

97. See Hanna Humeltenberg, "The Magic of Reality in Thomas Ruff's Pictures," *Parkett*, no. 19, 1989, pp. 24–27; Annelie Pohlen, "Deep Surface," *Artforum*, vol. 29, April 1991, pp. 114–18; Thomas Wulffen, "Thomas Ruff: Reality So Real It's Unrecognizable," *Flash Art*, vol. 26, January–February 1993, pp. 64–67.

98. Els Barents, *Thomas Ruff: Portraits, Houses, Stars*, Amsterdam, Stedelijk Museum, 1989.

99. Stephan Dillemuth, *Thomas Ruff: Andere Porträts + 3D*, Exhibition catalogue, Venice, Biennale, 1995.

100. The artist has gone on to create a series representing machines (see Caroline Flosdorff, ed., *Thomas Ruff: Machines = Maschinen*, Exhibition catalogue, Hanover, Kestner Gesellschaft, 2003).

RICHARD BILLINGHAM (193)

101. For biographical information on Billingham, see Michael Tarantino, *Richard Billingham*, Exhibition catalogue, London, Ikon Gallery, 2000, pp. 90–91.

102. Richard Billingham, *Ray's a Laugh*, Zurich / New York, Scalo, 1996.

103. Billingham interviewed in 1996, *Camera Austria*, no. 55, 1996, p. 4.

SHIRIN NESHAT (194)

104. For biographical information on Neshat, see Giorgio Verzotti, ed., *Shirin Neshat*, Exhibition catalogue, Rivoli, Castello di Rivoli, Museo d'arte contemporanea, 2002, p. 179.

105. Shirin Neshat, *Women of Allah*, Turin, Marco Noire Editore, 1997; see also Susan Edelson, ed., *Shirin Neshat: Women of Allah*, Exhibition catalogue, Vancouver, BC, Artspeak Gallery, 1997.

106. In 1996, Neshat began working in video and developing a distinctive style. She used two simultaneous programs on separate screens, facing each other or side by side, which represented conceptually opposing voices: the contention between male and female, for example, private versus public, or Eastern versus Western culture; see Farideh Cadot, Jean-Luc Monterosso, and Andrea Holzherr, *Shirin Neshat, Women of Allah: Photographies, films, vidéos*, Exhibition catalogue, Paris, Maison européenne de la photographie, 1998; Bill Horrigan, *Shirin Neshat: Two Installations*, Exhibition catalogue, Columbus, Wexner Center for the Visual Arts, Ohio State University, 2000.

18 | The End of Photography

UTA BARTH (195)

1. See Elizabeth A. T. Smith, *Uta Barth*, Exhibition catalogue, Los Angeles Museum of Contemporary Art, 1995.

2. In 1995, Barth followed her *Ground* photographs with a series entitled *Field*, which explores exterior spaces in unfocused images; see Sheryl Conkelton, *Uta Barth: In Between Places*, Exhibition catalogue, Seattle, Henry Art Gallery, University of Washington, 2000.

RICHARD MISRACH (196)

3. For biographical information on Misrach, see Lauri Nelson, in Anne Wilkes Tucker

and Rebecca Solnit, *Crimes and Splendor: The Desert Cantos of Richard Misrach*, Exhibition catalogue, Houston, Museum of Fine Arts, 1996, pp. 181–83.

4. Richard Misrach, *Telegraph 3 a.m.: The Street People of Telegraph Avenue, Berkeley, California*, Berkeley, Cornucopia Press, 1974.

5. Reyner Banham, *Richard Misrach: Desert Cantos*, Exhibition catalogue, Oakland, CA, the Oakland Museum, 1987; Susan Sontag, *Violent Legacies: Three Cantos by Richard Misrach*, New York, Aperture, 1992.

6. Richard Misrach and Myriam Weisang, *Bravo 20: The Bombing of the American West*, Exhibition catalogue, Las Vegas, Donna Beam Fine Art Gallery, University of Nevada, 1990.

7. Richard Misrach, *Golden Gate*, Santa Fe, NM, Arena Editions, 2001.

8. Richard Misrach and Rebecca Solnit, *The Sky Book*, Santa Fe, NM, Arena Editions, 2000.

ROBERT PARKEHARRISON (197)

9. See William Stanley Merwin, *The Architect's Brother: Robert ParkeHarrison*, Santa Fe, NM, Twin Palms Press, 2000.

10. See Mark Van De Walle, "Robert Harrison, *Artforum*, March 1995, vol. 33, pp. 95–96; John Wood, "A Grand and Solitary Epic," *21st: The Journal of Contemporary Photography*, vol. 2, 1999; Vicki Goldberg, "Everyman Tries To Save the Earth, One Image at a Time," *New York Times*, February 4, 2000; Sarah Bayliss, "Excuse Me, while I Fix the Sky," *ArtNews*, vol. 100, March 2001, pp. 114–15.

11. *Flying Lesson* was printed on white BFK Rives wove paper, 67.5 x 58.0 cm (sheet), in collaboration with James Stroud at Center Street Studio in Boston. Pendants in its suite are *The Waiting*, 2000, photogravure, 67.7 x 58.2 cm (plate), Sarah C. Garver Fund, 2004.5; and *Book of Life*, 2000, photogravure, 58.2 x 64.8 cm (plate), Sarah C. Garver Fund, 2004.6.

12. Indeed, the artists work so closely together in every phase of the creative process, that in 2000 they began acknowledging their collaboration by signing their work jointly.

13. See Diana Gaston, "Robert ParkeHarrison at George Eastman House," *Art in America*, vol. 91, January 2003, p. 114.

IÑIGO MANGLANO-OVALLE (198)

14. For biographical information on the artist, and bibliography related to his work, see Irene Hofmann, *Iñigo Manglano-Ovalle*, Exhibition catalogue, Bloomfield Hills, MI, Cranbrook Art Museum, 2001, pp. 62–66.

15. See Ron Platt and Maureen P. Sherlock, *Iñigo Manglano-Ovalle: The Garden of Delights*, Exhibition catalogue, Winston-

Salem, NC, Southeastern Center for Contemporary Art, 1998.

16. See Barbara Pollack, "The Genetic Esthetic," *Artnews*, vol. 99, April 2000, pp. 134–36; Marvin Heiferman, Carole Kismaric, and Ian Berry, *Picturing the Genetic Revolution Now*, Exhibition catalogue, Saratoga Springs, NY, Tang Museum, Skidmore College, 2001; Carol Squiers, *How Human: Life in the Post-Genome Era*, Exhibition catalogue, New York, International Center of Photography, 2003.

ALEXANDER TSIARAS (199)

17. Loring M. Danforth, *The Death Rituals of Rural Greece*, photographs by Alexander Tsiaras, Princeton, NJ, Princeton University Press, 1982.

18. Claudia Glenn Dowling and Alexander Tsiaras, "A 21st Century Anatomy Lesson," *LIFE*, February 1997, pp. 75–81.

19. Alexander Tsiaras, *Body Voyage: A Three-Dimensional Tour of a Real Human Body*, New York, Warner Books, 1997.

20. Alexander Tsiaras and Barry Werth, *From Conception to Birth: A Life Unfolds*, New York, Doubleday, 2002.

21. Tsiaras / Werth 2002, pp. 140–43. See also Alexander Tsiaras and Barry Werth, *The Architecture and Design of the Man and Woman: The Marvel of the Human Body, Revealed*, New York, Doubleday, 2004.

JET PROPULSION LABORATORY (200)

22. The timing and imagery of this remarkable photograph evoke Stanley Kubrick's landmark science-fiction film *2001: A Space Odyssey* (Warner Brothers, 1968). Derived from short stories by Arthur C. Clarke, in collaboration with the author, the film tells the tale of a mission to Jupiter as an allegory on the nature of God, the evolution of terrestrial life, and the role of technology in human existence. Indeed, the film includes a fictional representation of the surface of Jupiter.

23. The space probe was named for the Italian-born French astronomer Giovanni Domenico Cassini (1625–1712), best known for his studies of Saturn. It was he who discovered the four moons of Saturn and the gap in the planet's rings, now known as the Cassini division.

24. For an overview of the mission, see Linda J. Spilker, *Passage to a Ringed World: The Cassini-Huygens Mission to Saturn and Titan*, Washington, DC, National Aeronautics and Space Administration, 1997; Christoper T. Russell, *The Cassini-Huygens Mission: Overview, Objectives, and Huygens Instrumentarium*, Boston, Kluwer Academic, 2003.

25. From its orbit around Saturn, Cassini gathered information on the planet's polar regions, as well as its equatorial zone. The craft also carried the European-built Huygens probe, a vehicle that descended from orbit onto the surface of Saturn's moon Titan, to beam its findings to Cassini to be relayed back to Earth.

26. Michael Benson, *Beyond: Visions of the Interplanetary Probes*, New York, Harry N. Abrams, Inc., 2003.

Index

Note: Page numbers in *italic* refer to illustrations.

Photo Credits

DESIGNED BY SUSAN MARSH | COPYEDITED BY DENISE BERGMAN

TYPE COMPOSED IN SCALA SANS BY TINA THOMPSON | PRINTED BY SNOECK-DUCAJU & ZOON, GHENT, BELGIUM